The HDRI Handbook 2.0

Christian Bloch

The HDRI Handbook 2.0

High Dynamic Range Imaging
for Photographers and CG Artists

rockynook

Christian Bloch, www.hdrlabs.com

Publisher: Gerhard Rossbach
Editor: Jocelyn Howell
Copyeditor: Judy Flynn
Project Manager: Matthias Rossmanith
Layout: Petra Strauch
Cover Design: Helmut Kraus, www.exclam.de
Cover Photos: Christian Bloch
Printer: Everbest Printing Co. Ltd through Four Colour Print Group, Louisville, Kentucky
Printed in China

ISBN 978-1-937538-16-3

1st Edition 2012
© 2012 Christian Bloch

Rocky Nook, Inc.
802 E. Cota Street, 3rd Floor
Santa Barbara, CA 93103

www.rockynook.com

Library of Congress Cataloging-in-Publication Data

Bloch, Christian, 1976-
 [HDRI handbook]
 The HDRI handbook 2.0 : high dynamic range imaging for photographers and CG artists / by
Christian Bloch. -- 1st edition.
 pages cm
 Rev. ed. of: The HDRI handbook / Christian Bloch. 2007.
 ISBN 978-1-937538-16-3 (soft cover : alk. paper)
 1. Photography--Digital techniques--Handbooks, manuals, etc. 2. Image
processing--Digital techniques--Handbooks, manuals, etc. 3. High dynamic range imaging-
-Handbooks, manuals, etc. I. Title.
 TR267.B587 2012
 777--dc23
 2012031746

Distributed by O'Reilly Media
1005 Gravenstein Highway North
Sebastopol, CA 95472

Table of Contents

Foreword

Though one could argue that the image is a human invention, high dynamic range is not. Light spans an enormous range, and our eyes can adapt from the dim level of a starlit night to intense daylight, spanning over eight orders of magnitude (100 million to 1). This is comparable to the energy difference between getting going on a bicycle and taking off in a jumbo jet.

With this kind of range in real-world illumination, how have we gotten by so long with image contrast ratios of less than 100 to 1? The answer is deceptively simple. Although the range of light is enormous, our brain cares most about reflectance, and its range is comparatively modest. In fact, it is very difficult to create a surface that reflects less than 1 percent of the light it receives, and reflectances over 100 percent are forbidden by conservation of energy. Since the brain is trying to figure out surface reflectances based on what it sees, the huge range of illumination is often more of a hindrance to perception than a help. Therefore, an artist who skillfully removes the excess dynamic range in a painting is actually doing your brain a favor, making it easier for you to see what he (or she) sees. Skill and practice are required to accomplish this feat, for a painter who is inexperienced and does not know how to create the illusion of range within the limited reflectances available will create something more like a cartoon than a rendition. Realistic painting techniques were perfected by the Dutch masters during the Renaissance and are little practiced today.

Photography poses a similar problem in a different context. Here, we have the ability to record an image equivalent to that which lands on your retina. Starting from a negative, skill is once again required to render a positive that captures what matters to the brain within the limited reflectances of a black-and-white or color print. For scenes that contain little dynamic range to begin with, nothing needs to be done and the whole process can be automated. For more challenging subjects, such as storm clouds over mountains or the shadowed face of a child in the sunshine, the darkroom technique of dodging and burning is indispensable. With this method, either a round obstructer on a stick is used to "dodge" overexposed regions or a piece of cardboard with a hole cut out is used to "burn" underexposed regions during enlargement. This is an arduous, manual process that requires considerable talent and experience to achieve good results. The move to digital cameras has made such exposure adjustments even more difficult due to their limited dynamic range, which is one reason professional photography has been so slow to migrate from film.

High dynamic range imaging (HDRI) enables the centuries-old practices of renowned artists in a new, digital arena. HDRI permits photographers to apply virtual burn-and-dodge techniques in their image editing process, leaving as little or as much to automation as they wish. Digital artists using HDRI are able to create virtual worlds that are as compelling as the real world because the physics of light can be simulated in their full glory. When physically based rendering and image-based lighting are used, HDR photography and virtual scenes and objects may be seamlessly combined. This is common practice for mainstream productions in special effects houses around the world, and even television studios are getting into the act. Enthusiasts, both professional and amateur, are also pushing the envelope, and commercial software, shareware, and freeware are available to assist the transition from a traditional imaging and rendering pipeline to HDRI.

Of course, not everyone needs HDRI. If the starting point is low dynamic range and the

ending point is low dynamic range, there is little need for HDR in between. For example, a graphic artist who creates on a digital canvas and prints his work on paper gains no immediate benefit since reflection prints are inherently low dynamic range. It may be easier using existing tools to simply stick to printable colors and create the desired "look" using a conventional WYSIWYG paradigm. In the long run, even such an artist may enjoy features and effects that HDRI enables, such as lens flare and the like, but these will take time to reach the mainstream. Meanwhile, there is much for the rest of us to explore.

In this book, Christian Bloch introduces the topic of high dynamic range imaging and how it relates to the world of computer graphics, with an emphasis on practical applications. Starting with film photography, Mr. Bloch reexamines the digital image, looking at file formats and software for storing and manipulating HDR images and going on to discuss how such images can be captured using conventional digital cameras. This is followed by a description of tonemapping operators that can transform HDR images into something viewable and printable on conventional devices. Then, a more complete discussion of HDR image editing introduces color in the larger context of illumination rather than simple reflectance. A chapter covering the specialized topic of HDR panorama capture and reconstruction then leads into the final chapter on computer graphics imaging and rendering, describing the techniques that have revolutionized the film industry.

Whether you are an artist, a hobbyist, a technician, or some exotic mixture, these pages offer valuable explanations, methods, and advice to get you started or to take you further on the path of high dynamic range imaging.

Greg Ward of Dolby Canada

Introduction

What you can expect from this book

This book will unravel all secrets behind high dynamic range imaging (HDRI).

You heard this term before, and maybe you have even worked with HDR images. The simple fact that you're holding this book in your hand shows that the topic is not all that new to you. But still, you want to know more. You want to know the full story, and I know exactly why.

To cut a long story short, high dynamic range imaging is a method used to digitally capture, store, and edit the full luminosity range of a scene. We're talking about all visible light here, from direct sunlight down to the finest shadow details. Having all that available in one image opens the door for immense opportunities in post-processing. HDRI is a quantum leap; it is just as revolutionary as the leap from black-and-white to color imaging. Or for a more suitable analogy, HDRI is to a regular image what hi-fi sound is to cassette tape. If you're serious about photography, you will find that high dynamic range imaging is the final step that puts digital ahead of analog. The old problem of over- and underexposure—which is never fully solved in analog photography—is elegantly bypassed. Correct exposure is not an on-site decision anymore; it becomes a flexible parameter that can be dealt with in entirely new ways. An HDR image is like a digital negative on steroids, closer to a true representation of the scene than a mere photographic image. You can even take measurements of true world luminance values in an HDR image. For example, you can point at a wall and determine that it reflects sunlight equal to 40,000 candelas per square meter (cd/m²). Even better, if the HDR image is panoramic, you can shine all the captured light onto 3D objects.

Many questions are still open, even for folks who have been using HDRI for years, because *using* something is different from *understanding* something. Only if you really understand the nature of HDRI will you be able to develop your own way of working with it. That's why this book digs deeper than a footnote or a single chapter in a software-specific tutorial book. Reading it from cover to cover will build a comprehensive knowledge base that will enable you to become intuitively proficient with HDR imaging. Regardless of whether you are a photographer, a 3D artist, a compositor, or a cinematographer, this book is certain to enlighten you.

What's new in this second edition?

In one word, it's a whole new book. All that's left from the original *HDRI Handbook* is the skeleton, the methodical structure of one topic building the foundation for the next one. Don't be fooled by the similarities in the table of contents. Literally every single chapter is updated. Some chapters are extended to answer questions that frequently came up in the forums. How does color management work in HDR? What can be done against ghosting? How does that fit into a RAW workflow? Other chapters had to be rewritten from the ground up. For example, all new is the overview of the current state of HDR image sensors, the practical tutorials on tonemapping, and the reviews of HDR software on the market.

Five years ago, when I wrote the first edition, this field had just emerged from the depths of obscurity. Barely anybody in the photographic community knew about it, and aside from scientific publications, my book happened to be the first one on the subject. Now things are

very different: Many new HDR programs have surfaced, some have already disappeared again, and there are countless tutorials and HDR galleries on the Internet. Numerous other HDR tutorial books are out now, so many in fact that the German Amazon store has a special HDR subcategory. I realize that the bar is set higher this time around, but I'm still dedicated to making this the ultimate reference guide. That's why I put even more time and effort into this second edition. One might think I took the opportunity to make it timeless and spare myself the trouble of a third revision, but instead I turned it into the opposite. *The HDRI Handbook 2.0* is more specific, more detailed, and more up-to-date than ever.

Along with the first book, I opened up the companion website HDRLabs.com. It turns out I created a monster. At this point you may just as well consider this book a paper companion to the website. Over the years, HDRLabs has become a giant buzzing hub of information. Contributors from all over the world have added valuable tips and tricks, do-it-yourself projects, and freeware programs for all sorts of HDR-related purposes. People in the community forum continue to help each other out with an enthusiasm that is hard to find anywhere else. Instead of the common "Hey look at me" posts, our forum is filled with fruitful discussions on exploring new techniques and genuinely helpful advice.

I would like to send a million thanks to everybody in this big HDRLabs family, which spans from California to New Zealand, from The Netherlands to Florida, from Savannah to Norway, and pretty much everywhere in between. I'm happy to report that in just five years of existence, this website had an impact on HDR imaging itself. Maybe not in making HDR more popular—that happened all by itself—but in making it better and more accessible. For example, the Promote Control (a universal bracketing controller) had many features invented by users

in an epic 5000-page thread in the forum. We also have an entire section with do-it-yourself bracketing controllers. The developers of most HDR programs hang out there, as well as some of the most amazing photographers. Along with everybody else, I learned much more about HDR processing in the years past. Hopefully the new photographs in this book show some of that progress.

A Brief History of HDR

I promise, I won't stretch this out. But it's good to know where HDR came from to see the trajectory of where it's heading.

Technically, you can trace HDR back to the 1950s, when Charles Wyckoff photographed nuclear explosions. Not surprisingly, he couldn't capture the mushroom cloud in a single exposure, so he used multiple films with different sensitivities and sandwiched the negatives together somehow. Quite frankly, I wouldn't know any other way today; the EMP shock alone would fry any digital camera. And I probably wouldn't even want to take an assignment for photographing nukes anyway.

The history of HDR as we use it today starts in the digital age. Completely unnoticed by most of us, it had its first boom around 1997. In academic circles HDR was whispered about from door to door, traded as the new cool thing to write hot algorithms for. It was a revolutionary new way to deal with image data, and it was said to be your best chance to show your old professor that all he told you about digital images was bogus. In best renaissance tradition, students started discussing the nature of light again and how to represent it digitally. Along the way, this research had a dramatic impact on simulating light behavior and expressing it in render algorithms.

Around 2002 this caused a big splash in the computer graphics community. All of a sudden

there was the "Make it look real" button that everybody was looking for. HDR was a huge buzzword, and every digital artist was giving it a shot, even if it meant hours of staring at a progress bar until a single image was rendered. But it looked so damn sexy, unlike anything you could achieve before. All the big VFX-heavy blockbuster movies were made with HDR, paving the ground for production-ready implementations. By 2005 it had become a standard toolset, wrapped up in workflow shortcuts, speedup cheats, and real-time applications. HDR was not considered breathtaking anymore; it was just there. Still, even to this day few 3D artists know how to shoot an HDR panorama, or what is really behind all this. Photographers are actually laughing at us because we have just now discovered the importance of color management and a linear workflow.

The third big wave hit around 2007, this time in the world of photography. It came from a different perspective, though. The topic emerged from discussions about taking better pictures in difficult lighting conditions, and it turned out that HDRI is just the right tool to address this challenge. Photographs with surreal and impressionist character surfaced on the web, made possible by the magic of tonemapping. HDR quickly became a catchy thing to do and fanned out into new forms of artistic expression. It was dragged through the hipster mill for two or three years and became insanely popular. Professionals picked it up and turned it into a standard tool for architectural and landscape photography. For most photographers, HDR has found its niche, either in an eye-popping look or as a useful tool for exposure control. Both are certainly here to stay. Still, few members of the photographic community—software makers and users alike—seem to grasp the full scope of HDR. The things that got scientists so excited in the first place have much broader consequences.

If you followed the five-year pattern you will ask, What's with the 2012 boom? Well, it may be delayed to 2013. Blame the economy, the war, or the impending doom of mankind. If you prefer positive reasoning, let's just say the academics from the first HDR wave had to graduate first, with honors of course, and start immensely successful careers. The real HDR revolution comes in hardware, with new HDR cameras and insanely brilliant flat-screen monitors. Some of these devices already appeared in 2011, but they lack the wow factor because they are chained down to old restrictions. The tricky part is that everything between camera and screen has to be HDR as well, and this is where behemoths like Adobe, Canon, and Apple turn out to have a hard shell. In the long run it's inevitable that all digital imaging in the future will happen in high dynamic range. HDR video is just around the corner, and from there we're heading straight to the 2020 milestone of light field photography, holographic telepresence, and walk-in virtual reality.

What HDR Means Today

HDR is very trendy these days. Some may say it's so hip that the really cool folks consider it to be out again. Some even argue against HDR; the former Gizmodo editor John Mahoney went as far as using the words "messes of clown vomit" to label a link to the Flickr HDR group. Well, I'm here to tell you that it's rather pointless to despise HDR in general. That would be the same as proclaiming black and white as the only true form of imaging just because there are so many awful color images out there. The disputable HDR look is merely a subset of the much larger field of high dynamic range imaging.

At this point we can distinguish between two types of HDR.
One is a particular artistic style. It looks somewhat like the image on the right. Some people love it with a passion, some people hate it to

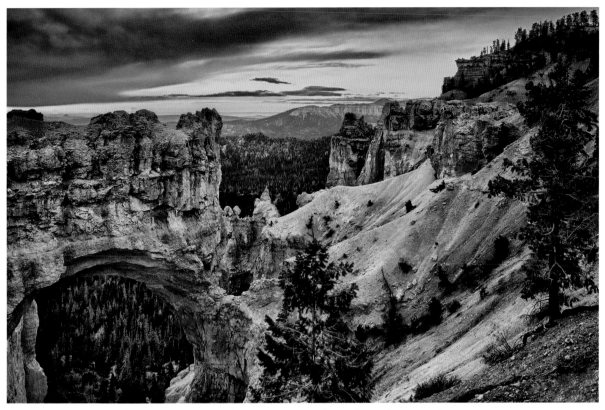

The distinctive HDR look is fun and fascinating, but it represents only one facet of HDR imaging.

death—but in any case, this style is highly effective in calling out strong emotions. From an artistic point of view, such intense love-or-hate reactions are always good; it means the work cannot be ignored. It also is a slightly addictive style because the process of creating these images becomes an explorative journey for the creative photographer.

The second kind of HDR is a powerful tool to control exposure and tonal values in digital image editing. Professionals use it as a digital intermediate step like RAW to maximize the quality of the final product. Improved color fidelity, superior tonal range, smooth gradients, and most important, lossless image editing—these are the advantages of a full HDR workflow valued by pros. This type of HDR imaging is not bound to a particular style. It's all about the path and not the destination.

There is a very clear distinction between HDR as a tool and HDR as a style; they just happen to go by the same name. After you're done reading this book, the difference will be very obvious to you, just as you're completely aware of the difference between a rocket fired on the Fourth of July and a rocket launched to the International Space Station. One is pretty and colorful; the other is a technological milestone.

While most other books concentrate on the HDR look, this book is about all aspects. It's the craft, the nuts and bolts of HDR imaging that you will learn here. Of course you will also find out how to create expressive looks—because that is a part of it. It's one of the fun parts, and most people pick it up in a day. Really mastering it is harder, and that's where being fluent in the overall craft becomes important. Picasso didn't start out with painting noses upside down; his

Vectorscope | 3D-Histogram | Waveform Monitor

Image metrics for HDR images are literally off the charts: endless highlight data, unlimited gamut, and quasi-analog color fidelity.

first works of art are actually quite photorealistic. And so should you earn your street cred first with the serious kind of HDR imaging: using the HDR toolset to maximize image quality. That's where you need a certain amount of background knowledge from this book. That's what will make you a pro. What you will make out of it, artistically, is up to you.

Five advantages of HDRI for professional image editing

One of the things you will take home from this book is that all the creative aspects of RAW development, which have recently revolutionized photography, are just a precursor to a full HDR workflow. Professional image editing on a whole new level is on the horizon. The sole nature of HDR is taking care of preserving image quality. It lets us finally stop worrying about degrading pixel data so we can focus on the creative jam instead.

Highlight recovery. With RAW files, you can often recover one or two f-stops of detail. Beyond

that, the image will be blown out. When editing an HDR image, there is no explicit limit; you can recover anything. Also, in a RAW workflow, you would have to commit to a chosen amount of recovery first, and only then can you edit it further in Photoshop. In an HDR workflow, you can recover everything anytime.

Color precision. Yesterday's rule of thumb was that each editing step slightly degrades the image data. Pros do their image editing in 16-bit mode to keep the losses low, but nevertheless, there is a loss. HDR, on the other hand, is lossless by nature—the color precision is nearly infinite and your image data is flexible like goo.

Infinite color gamut. Color management has always been a compromise and over time turned into a convoluted mess that only few can handle correctly. All it takes is one profile-agnostic program in the chain to break everything. Not so with HDR. Here the entire spectrum of visible colors is always accessible regardless of the color profile attached.

Photographic thinking. Digital imaging has always been more complicated than necessary. For example, to apply a 2-stop ND filter, you had to multiply with a dark color or fiddle with an arbitrary brightness slider. In HDR editing, you would literally apply a 2-stop ND filter, just as you would in a camera.

Optical effects just work. Effects like vignetting, motion blur, glow, and bloom always required lots of care to look realistic. That's because our traditional images were assumed to be dry paint on paper. In HDR, we're dealing with light, and such simulations of optical effects automatically benefit from real-word light values.

HDRI means all those things and more. But most important, *it puts the fun back into photography.* I've talked to many photographers who snapped the shutter for over 30 years, and all of them agree that the advent of HDR made them finally get excited about photography again. It's such a wonderfully experimental playground and such a wild, open field of new expressions to discover. Finding the right words to describe this delightful feeling of newfound artistic freedom is not easy, and anybody who had a first dive into the world of HDR knows what I'm talking about. Something tells me that you have already caught that spark. That's why you got this book. But if you never even tried making an HDR image before, you should totally absolutely by all means do the workshop in the next section. Believe me, it's electric! Reading won't do. You have to actually grab your mouse and follow the steps on your computer to feel the HDR vibe yourself.

➤ Quick Start Tutorial

Is this a book for beginners? Absolutely yes! Is it a book for advanced users? Yes, sir!

This book is designed to propel you from 0 to 110 percent. It's suitable for all levels and even includes a few extra tips for experts. We have a pretty big hill to climb in front of us. The only way to do this properly is to take one step after another. It may seem like I'm complicating things by putting a lot of theory upfront. But ironically that background knowledge is exactly what many practitioners initially missed out on, leaving them with many questions later and some sort of mystical understanding of HDR.

The truth is that HDR is really easy to do. It takes only 30 minutes to complete this initiation walk-through. If you've never made an HDR image before, now is the time to get your feet wet.

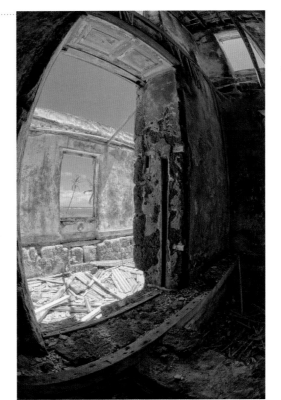

Abandoned ruins are perfect subjects for HDR photography, especially when they're overlooking a secret beach in Barbados. An opulence of details is hidden in the shadows, and the tropical midday sun guarantees an extremely high scene contrast.

1 Install a 30-day demo version of HDR Express. You'll find it in the Software folder on the DVD.

2a Put your camera on a tripod and set it to manual exposure mode. Set and lock ISO, aperture, focus, and white balance. Now take three images: underexposed, normal, and overexposed. Use shutter speed to vary exposure—for example, 1/1000 s, 1/250 s, 1/60 s. This is called *exposure bracketing*. Take more exposures if you want, but no fewer.

2b Alternatively, use the Harry Smith B example set from the Brackets folder on the DVD. This is a set of nine exposures, shot in a scene with extremely high contrast. ▼

HarrySmithB_01.JPG HarrySmithB_02.JPG HarrySmithB_03.JPG

HarrySmithB_04.JPG HarrySmithB_05.JPG HarrySmithB_06.JPG

HarrySmithB_07.JPG HarrySmithB_08.JPG HarrySmithB_09.JPG

3 Drag and drop all images onto the HDR Express program icon at once. ▼

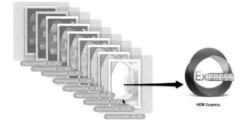

4 Follow the on-screen prompts and click OK. ▼

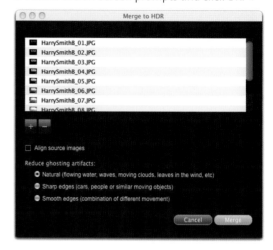

5 Now you have your first HDR image. That's the mythical 32-bit file that contains all information from all source images. HDR Express plays a little animation now, ramping through the entire range of exposures. ▼

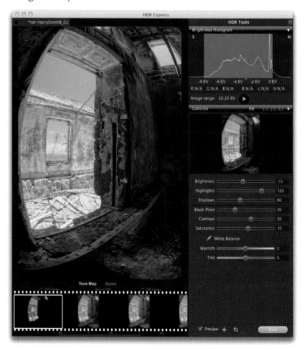

6 Now it's your task to make the best out of this HDR image. This step is called *tonemapping,* or just *toning* for short. The animation has just shown you how much detail is hidden in the shadows and the light portions. With the sliders on the right, you can now make them appear all at the same time.

7 The general strategy is to go through all the sliders, starting at the top. Drag each slider to both extremes first and observe what that does to the image. Then find the setting in the middle that looks best to you.

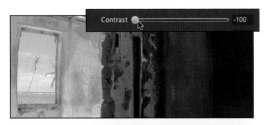

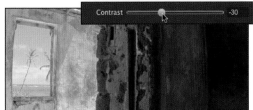

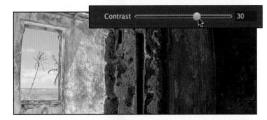

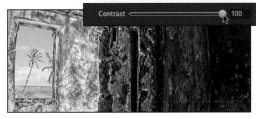

8 Notice the dramatic effect of the Contrast slider ▲. Every tonemapping software has such a super-slider, sometimes called Microcontrast,

Detail, Structure, or something similar. It can also be a whole group of sliders, which may even affect each other. These are the new algorithms that heavily benefit from having all that glorious exposure data in one HDR file, and these are also the most pivotal sliders to define the artistic style of the image.

9 Keep playing until you're happy with what you see; then save the image as 16-bit TIFF.

10 Open it in Photoshop, Lightroom, or the image editor you normally use.

11 Fine-tune contrast, color, and saturation al gusto. Spice it up with a sharpen filter and polish with some noise reduction (if necessary).

12 Convert to 8-bit and save as JPEG.

13 Done! Print it. Post it. Send it to your friends.

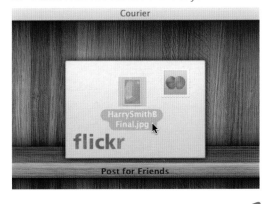

Granted, this was an extremely simplistic recipe, not much different from tutorials you can find all over the Internet. But after about 30 minutes of dabbling around, you will have sent out an email with the subject line "My first HDR." I promise.

However, chances are there are many questions left. How do I shoot the right exposures, and how many do I really need? Do I have to buy HDR Express now, or is there something better or cheaper I can use? Any freeware, maybe? What exactly should I do for fine-tuning contrast and colors? How can I make it look more natural/surreal/grungy/hyperreal/artistic? What software can give me more control, and how can I get the most out of it? Can I do that with every image? How is this working anyway? Is this witchcraft or what?

See, the tricky thing with HDR is that each answer only leads to more questions, and from there it goes down the rabbit hole. That's why this book starts with some basic theory that answers the fundamental questions you will end up with when you just keep digging deep enough. A solid foundation will put everything in the right perspective, and it will ensure that you have an intuitive understanding of HDRI instead of just a rough idea how to use a particular software.

Doing each of the previous steps carefully and considering the ideal workflow for all sorts of special situations require a full chapter on each topic: selecting the right tools, shooting bracketed exposures, merging exposure to an HDR image, and toning that image in a perfectly controlled manner. These are major topics of this book, for quick reference marked with icons at the top of each right-hand page. And if you have already mastered all these things, the later chapters will get you up to speed on true 32-bit image editing, HDR panoramic photography, and making 3D objects look absolutely realistic using HDR lighting techniques.

Road Map

Chapter 1 is an in-depth explanation of the ideas and concepts behind HDR imaging. This chapter is the foundation on which everything else is built. To understand the full range of opportunities, we must question some very basic concepts of digital and analog photography. You will be amazed to find out what little progress digital imagery has made until now and how a simple twist on the basic premise of digital—on the bits and bytes—can suddenly push it beyond the boundaries of what has been ever thought to be possible in analog.

Chapter 2 presents all the tools needed for an HDR workflow. Conventional image formats have proven to be insufficient, and conventional software is still depressingly limited when dealing with HDR images. I will introduce and compare new image formats and programs, rate them, and give advice on how to integrate them into your own workflow. This chapter is most useful as a quick reference that will come in handy on a million occasions.

Chapter 3 is all about capturing HDR images. You get to know both the scientific way and the easy way. I will walk you through different methods and compare the results so you can choose the shooting method that suits you best. Helpful gear is introduced, some developed by good friends as open source. Also, we take a peek into some research labs and learn about the future of taking HDR images. It's only a question of time before HDR will be the standard and not the exception. So let's look ahead to be prepared for tomorrow's standard.

 Chapter 4 is dedicated to tone-mapping. This chapter is especially designed for photographers because here is where you learn to create superior prints from HDR images. You'll be introduced to automatic algorithms as well as creative methods to reduce the tonal range of an HDR image while preserving all the details. Tutorials in this chapter are hard-core boot-camp style; follow them step-by-step with the images from the DVD and you'll be up and running in no time. Together we will look at several different styles, from natural to artistic, and put special emphasis on common artifacts and aesthetic considerations. There is no right or wrong here; there is only creative potential to be explored.

 Chapter 5 reveals new opportunities for image editing and compositing. You will see a wide variety of workshops that can easily be re-created with the material on the DVD. The results will be compared to those of traditional methods. Learn how the pros work with HDRI to create more lifelike composites for film and television. There is a great wealth of well-established techniques that can easily be applied to still image editing as well.

 Chapter 6 is dedicated to panoramic HDR photography, which is a cornerstone of this book because this is where the worlds of photography and computer graphics come together. Large parts of this chapter are contributed by Austrian panorama authority Bernhard Vogl. Together, we show you several different ways of shooting panoramic HDR images; compare them all and rate them based on the necessary workload, equipment expense, and quality of the results.

 Chapter 7 demonstrates how HDR images can be used in 3D rendering. I will break down the technical background and explain how rendering algorithms work and how you can make them work better for you. Step-by-step, you will find out what the ideal lighting setup looks like. Then I'll take it a step further and present a smart lighting toolkit that automates the most common HDRI setup. On top of that, you'll find out about some unconventional applications that encourage creative uses of HDR images.

I am proud to present this book as a complete guide to high dynamic range imaging. You can read it from cover to cover, and I highly recommend you do so. Some sections are dedicated to hard facts and may appear hard to digest at first glance. The more boring a topic sounds, the more jokes I have hidden in the text just to grab your attention. Don't worry about remembering everything; some chapters are really meant for browsing. It's perfectly fine to skim over them once and only remember the general topic. Come back later when you need them as reference. You may need to make a choice about image formats or you may hit a wall attempting a specific task and want to peek at a tutorial again. Or maybe you find yourself stuck in old habits and realize that it's time to try some new approaches.

Let this book be your crib sheet. It's full of practical hints and tips, software tests, workshops, and tutorials. There's an old German saying that goes "Knowledge means knowing where it's written." Well, it's all written here. That is all you need to know.

Chapter 1:
The Background Story

As HDR has become more popular, it has also become a maze of false assumptions and conflicting ideas about what HDR really means. To avoid further misunderstandings, let's first get on the same page about some basic terms and fundamental concepts.

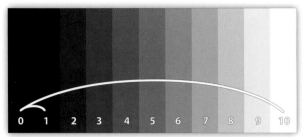

Figure 1-1: *Test image with a dynamic range of 10 : 1.*

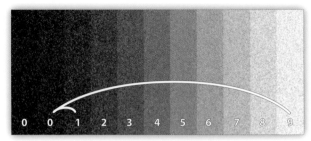

Figure 1-2: *In reality, every image source introduces some noise, making the contrast ratio harder to evaluate.*

1.1 Basic Questions

1.1.1 What is dynamic range?

Dynamic range (DR) is the highest overall contrast that can be found in an image.

It is often also called the contrast ratio, but this name is somewhat less defined and doesn't sound as cool. As with any ratio, it is a proportional value; for example, 500 : 1. These numbers refer to the difference between the brightest and the darkest color values. Black itself doesn't count as a value; you cannot compare anything to black. Black is like a zero. So 500 : 1 really means that the maximum contrast in an image is 500 times the smallest, just barely noticeable step in brightness.

Confused? Okay, come with me, together we can figure this out. I painted a simplified test image (figure 1-1). Let's look at the lowest image contrast first. If the black bar marks our zero point, the first bar would be the first step up in brightness. This difference, marked with an arc, shall be the base contrast of 1. Now, if we want to compare the outer bars, we can say they have a 10 times higher contrast. So the contrast ratio of that image—its dynamic range—is 10 : 1.

It is important to remember that the DR always depends on two factors: the overall range of brightness and the smallest step. We could enhance the dynamic range of this image if we used smaller steps in brightness or if we could somehow add an extra bar that is brighter than the paper this is printed on.

In a real-world scenario, the test image would actually look more like figure 1-2. Every

image source introduces some sort of noise artifact. Your old film camera has grain, your digital camera has noise, and even render algorithms in 3D programs nowadays tend to have noise. It's usually stronger and more obvious in the darkest areas, where noise quickly overpowers any useful image information. That's why in real images the smallest noticeable brightness step is critical for determining the dynamic range, because we're really talking about the first detail we can tell apart from the noise.

This is the basic definition of dynamic range, based on pure ratio. We will need that later on when we talk about how a computer sees an image. Photographers and cinematographers prefer to use units that are more grounded in the real world. For all practical purposes, the dynamic range is measured by the number of *exposure values* contained in an image.

1.1.2 What was an exposure value again?

Exposure value, or just EV, is a photographic scale for the amount of light that gets through the lens and actually hits the film. This amount depends on the shutter speed and aperture size, and so the exposure value is a combination of both numbers. Neutral-density filters can also be used to vary the amount of light, so they play into this number as well.

In practice, the exposure value is often referred to as *stop*. Technically, the term *f-stop* applies to the aperture size only, whereas *EV* can apply to shutter speed as well. To avoid confusion, I will stick to calling it EV throughout the book.

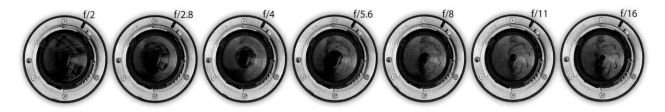

Figure 1-3: *Aperture blades at different f-stop settings. What counts is the pupil left open by this iris mechanism. That's what the f-numbers refer to, and that's also what causes the shape of lens flares and bokeh circles.*

The International Organization for Standardization (ISO) defines EV 0 as an aperture size of 1 and 1 second of exposure time. You get the same exposure with numerous other pairs, like f/1.4 and 2 seconds. Note that the f-number is written behind a slash. It is technically a fractional value referring to the size of the hole left between the aperture blades. Raising the f-number to 1.4 is actually cutting the area of this opening in half. And by doubling the exposure time, you allow the same total amount of light to get through. The table below shows the exposure values as defined at a film sensitivity of ISO 100, sometimes also referred to as light value.

Unfortunately, this table has become unfashionable with the invention of automatic light meters. All that is left on consumer-grade cameras is an exposure adjustment, often labeled with −−/−/0/+/++ EV.

Nobody can tell for sure if this exposure compensation changes shutter speed or aperture, and the absolute exposure value is completely neglected. Today, only professional cameras allow you to set a fixed EV and thus reference the amount of captured light directly. Unfortunately, this sloppy handling has transitioned over to HDRI. It would have been very easy to declare this absolute exposure scale to be our

APERTURE SIZE (F–STOP) ⟶

EXPOSURE TIME (SHUTTER)

	f/1	f/1.4	f/2	f/2.8	f/4	f/5.6	f/8	f/11	f/16	f/22	f/32	f/45	f/64
15 s	−4	−3	−2	−1	0	1	2	3	4	5	6	7	8
8 s	−3	−2	−1	0	1	2	3	4	5	6	7	8	9
4 s	−2	−1	0	1	2	3	4	5	6	7	8	9	10
2 s	−1	0	1	2	3	4	5	6	7	8	9	10	11
1 s	0	1	2	3	4	5	6	7	8	9	10	11	12
1/2 s	1	2	3	4	5	6	7	8	9	10	11	12	13
1/4 s	2	3	4	5	6	7	8	9	10	11	12	13	14
1/8 s	3	4	5	6	7	8	9	10	11	12	13	14	15
1/15 s	4	5	6	7	8	9	10	11	12	13	14	15	16
1/30 s	5	6	7	8	9	10	11	12	13	14	15	16	17
1/60 s	6	7	8	9	10	11	12	13	14	15	16	17	18
1/125 s	7	8	9	10	11	12	13	14	15	16	17	18	19
1/250 s	8	9	10	11	12	13	14	15	16	17	18	19	20
1/500 s	9	10	11	12	13	14	15	16	17	18	19	20	21
1/1000 s	10	11	12	13	14	15	16	17	18	19	20	21	22
1/2000 s	11	12	13	14	15	16	17	18	19	20	21	22	23
1/4000 s	12	13	14	15	16	17	18	19	20	21	22	23	24

Table 1-1: *Exposure values at ISO 100. This table has been an essential part of the photographer's toolset for ages.*

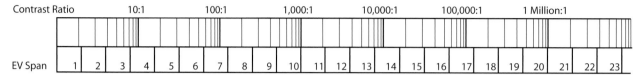

Contrast Ratio		10:1		100:1		1,000:1		10,000:1		100,000:1		1 Million:1											
EV Span	1	2	3	4	5	6	7	8	9	10	11	12	13	14	15	16	17	18	19	20	21	22	23

Figure 1-4: *Conversion scale: Dynamic range measured as contrast ratio and EV span.*

unified measurement base when HDRI standards were introduced. It would have enabled us to directly access the real-world luminance values right from HDRI pixel values, and since all HDRI software would be calibrated on the same scale, it would be much easier to switch back and forth between them. In fact, the founding father of HDRI, Greg Ward, once defined a nominal EV as that which would be embedded in a crude metadata style in every HDR image. But that feature has simply not been implemented in most HDR-capable software because the programmers didn't care about this tiny photographic detail.

1.1.3 How can we use EVs to measure the dynamic range?

I talked about contrast ratio as the standard way of measuring the dynamic range. But it's a very abstract system, coming up with numbers like 4000 : 1 or 20,000 : 1, and it is very hard to visualize what that actually means. Exposure values are much easier to understand. When I say that my HDR image covers in total 12 EVs of the scene light, everything is clear. You have an instant understanding of how far apart the deepest shadow details are from the brightest highlights. And you have a real-world relation to all the shades in between.

So let's take a look at the unit conversion between contrast ratio and EV span.

The contrast ratio directly refers to the difference in light intensity. Double that number means double the light. So this is a linear scale.

Exposure values are in a logarithmic scale. Each increase by 1 doubles the light, meaning it also doubles the ratio number. It's very easy to convert in one direction. The formula goes like this:

$$Contrast\ Ratio = 2^{EVspan}$$

For example, if you have a dynamic range that spans 12 EVs, that is $2^{12} = 4,096$. So, that DR can also be called a contrast ratio of roughly 4,000 : 1.

Converting in the other direction is a bit more tricky. You need to calculate the base 2 logarithm, or the binary logarithm as the scientists call it. Chances are your desktop calculator doesn't have a \log_2 button. Mine doesn't, not even the one on my computer. There is just a plain log key, but that refers to \log_{10} instead of \log_2. But luckily, by a happy math coincidence, there is a fixed conversion factor. Well, actually it is a math law that says there shall be 3.321928 used here. Usually 3.32 is all the precision you need. So that would be as follows:

$$EVspan = \log_2(CR) = \log_{10}(CR) \times 3.32$$

For example, 4000 : 1 simply means $\log_{10}(4000) \times 3.32 \approx 12$ EVs.

Figure 1-5:
Consumer-grade cameras often neglect the absolute exposure value; all that's left is exposure compensation.

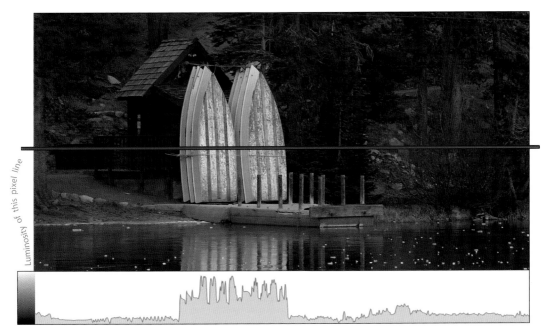

Luminosity of this pixel line

Figure 1-6: *Images can be considered a signal. For example, I got this waveform by mapping the luminosity of a pixel line in a graph.*

If you don't feel like doing the math at all, you can also use the conversion scale on the previous page. This scale shows very clearly how much more sense it makes to use EV span to put a number on dynamic range. EVs just compare so much easier than contrast ratios. For example, the difference between 20,000 : 1 and 30,000 : 1 is not even a single stop, no matter how impressive these numbers might sound. As a rule of thumb, the contrast ratio needs to double at least before the difference reaches one EV.

Photographers who are used to Ansel Adams's zone system will instantly recognize that one EV span equals one zone. If it would make you feel more comfortable, you could substitute these terms for the rest of the book. However, since the zone system is strictly aligned to the limitations of film, I will stick to using the open-ended scale of EV spans—occasionally mixed in with a jovial "*stop.*"

1.1.4 Isn't dynamic range an audio unit?
Yes, indeed. Well pointed out!

Sound has a dynamic range as well, and it is very closely related to ours. Dynamic range has always been around in the glorious world of engineering, specifically in the signal processing department. For digital imaging engineers, it is an important quality grade of sensor chips.

Engineers define this technical dynamic range as the logarithmic ratio between the largest readable signal and the background noise, and the unit is decibel. So it is the big brother of the good old signal-to-noise ratio; the only difference is that dynamic range applies to the entire image. That makes sense when you consider an image to be a signal.

Let's try that. Let's look at an image as a signal. For simplicity, I picked a single line of pixels and mapped the luminosity in a graph.

Looks like Beethoven, doesn't it? You can clearly see how the bright underside of the boats show up as towering peaks. And look at the dark brown fence next to the boats: in the graph, it shows up as a small sawtooth pattern. And the bushes on the other side are just a wiggly line. There is a lot of fine detail here, but it is generally dark and low contrast.

For comparison, here's Beethoven:

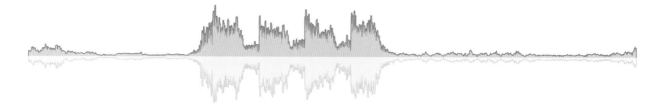

Figure 1-7: *The first beats of Beethoven's Symphony no.7 in A Minor, op. 92.*

Once again, we have huge towering peaks. This is the part where the volume is pushing you back in your chair. It has to be loud and powerful. You need a good set of speakers to really enjoy this part without distortions. And right after that, we have the delicate melody part. An audiophile would insist on a recording in which this is so low in volume that he can barely hear it. But in his soundproof living room, he can appreciate the crystal-clear quality of the recording, replicating every single nuance the maestro played originally. The difference between the full orchestra playing their hearts out and the subtle sound of a single violin—that's the dynamic range in audio.

Same goes for the image signal. When the recording device has an insufficient dynamic range, you cannot tell the bushes from the noise. You could buy the most expensive output device you could get, but if the image doesn't contain the subtle details in crystal-clear quality as well as the unclipped intensity peaks, it will not look like the real thing.

Admittedly, this signal approach is strange when it comes to images. But from an engineering standpoint, it does not make a difference. Audio, photo, video—it all boils down to signals being processed. Engineers always see the signal curve behind. From this particular perspective, HDR is also called *Hi-Fi imaging*, which I personally consider a badass term. When an engineer talks about high frequencies in an image, he's referring to the fine texture details. It's just a special tech lingo that sounds like geek chatter

to untrained ears. But engineers are smart, and we rely on them to supply us with all the gadgets we need to get creative. Specifically, they need to keep building better and stronger imaging sensor chips. And they measure this technical dynamic range in decibels to determine the bit depth that a digital camera is capable of.

1.1.5 Ah... bit depth! So 32-bit images are HDR images, right?

Hold on, not so fast. We will get to that later. We haven't even tapped into digital yet.

In the practice of image editing, the dynamic range is often confused with color depth and measured in bits. But that is not entirely correct. It's also not entirely wrong. A digital image with a high dynamic range has to have more than the usual 8 bits, but not every image with higher bit depth also holds a high dynamic range.

You cannot just convert an 8-bit image to 32-bit and expect it to be a true HDR image. That would be the same as zooming into a landscape picture that was taken with a camera phone and expecting to clearly read the license plate of a car. Such things only work on TV, but the TV folks have the magic "Enhance" button, which is really a guy sitting in a closet operating the playback controls. If the original data isn't there, it won't ever come back.

The bit depth of an image is a weak indicator of its dynamic range anyway. For example, there are true HDR images that have only 16 bits. It's not just about counting bits. The real innovation

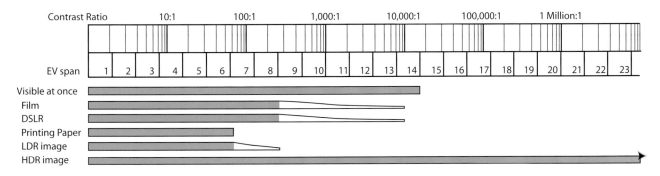

Figure 1-8: *Dynamic range limits in comparison, clearly illustrating how HDR can hold more light than any other technology. When the bar gets pale and thin, so does the dynamic range some media can deliver reliably.*

is of a much more fundamental nature. You have to clear your mind and try to forget everything you knew about digital images.

1.1.6 Tell me then, what is HDRI?

HDR imaging (HDRI) describes light values digitally with unprecedented precision. HDRI is Hi-Fi imaging. It can be found right on the junction where photography, computer graphics, programming, and engineering meet, and it has been researched from all these different perspectives. New toolsets have emerged that provide solutions for old nagging problems of photography. New methods for dealing with image data have been developed that feel much more like analog procedures than digital image manipulation. New algorithms in 3D programs make virtual camerawork and lighting tasks directly relate to their real-world counterparts. HDRI is the key element that blends everything together. We are steering toward a convergence point that leads to entirely new levels of imaging.

See, the essence of all imaging is light. Photography, cinematography, computer graphics—whatever imaging method you choose, light is always the central part. And HDRI is the ultimate digital representation of light. It can hold more light than any technology before, and it does it better than any other.

To really understand the revolutionary concept, we have to go back and revisit how we perceive light.

1.2 How We See the World

The human eye is an incredible thing. In a single view it can differentiate contrasts up to 10,000 : 1. That's a dynamic range of about 14 EVs. But it goes even further: the eye can adapt to almost any lighting situation, stretching the total perceivable range to approximately 1,000,000,000 : 1.

1.2.1 Adaptation

For example, the sun is a million times brighter than candlelight. Still, you can see perfectly when walking in a sunny park as well as inside a church. Such extreme contrasts cannot be seen at the same time. When you step into the dark entrance of that church, you experience a short moment of blindness. Within seconds, your eyes begin to work: your pupils widen and your vision brightens up again. This physical reaction is called adaptation.

You could argue that this is not that big of a deal because the aperture blades in a camera do exactly the same thing. But the point is, the receptors in your eye are sensitive enough to adapt to much lower light levels than any

Figure 1-9: *Adaptation enables you to see perfectly inside a church as well as in a sunny park.*

aperture size can ever allow. Have you ever tried to digitally photograph an object lit by starlight only? It will drive you nuts because you can clearly see it, sitting right there, but your camera will insist on taking a noisy black image. Human vision knows neither noise nor grain, and if you spend all day in a dim environment, you can even adapt to the point where your eyes can detect as little light as 30 photons.

Have you ever wondered why pirates wear an eye patch? It's adaptation of course! Covering up one eye keeps it perfectly adapted to the dark, even in the harsh daylight of the Caribbean. When the pirate has to run under deck to check on the loot, he simply flips the eye patch over to cover the bright-adapted eye. In an instant he can see just fine in that greasy cabin, where the common sense safety code for wooden ships prohibits burning candles.

But even when the field of view doesn't change, the perceivable dynamic range can be enormous. Even though the sky is generally a thousand times brighter than the inside of a room, we have no problem seeing all the details in the fluffy clouds and the inside of the much darker room at the same time.

This incredible achievement is accomplished by two different mechanisms: nonlinear response and local adaptation.

1.2.2 Nonlinear response

First, our eyes don't react to light in a linear manner. Instead, the response roughly follows a logarithmic curve. This is a common trick of nature; all our senses work that way. In acoustics, this is a well-known phenomenon: You can double the power that pumps through your speakers, but it won't necessarily sound twice as loud. Instead, you need to increase the power logarithmically. The higher the volume already is, the more power it takes to further increase it by a perceived equal amount. That's why you need giant speaker towers to power a rock concert.

Our visual sense works the same way. When an object is measured as twice as bright, provenly reflecting the double amount of photons, it still doesn't appear twice as bright. Instead, the perceived difference is gradually smaller the brighter it gets. Highlights and luminous light sources may well be 5,000 times brighter than their surroundings, but the receptors in our eyes naturally compress them. This is an important safety mechanism; without it our ancestors would have never left the cave because they would have been blinded all day and eaten by lions.

1.2.3 Local adaptation

Our eyes are smart enough to apply a different sensitivity to different areas of the field of view. This effect is called local adaptation. And even though it is a vital part of our vision, local adaptation is hard to simulate with traditional imaging systems. This is where the professional photographer has to deal with all kinds of partial lens filters and gradient filters just to get close to a natural-looking image.

We don't even know for sure how exactly this incredible mechanism works because we cannot directly analyze the raw output image that our eye generates. Scientists have collected long lists of empirical data by measuring the tiny currents in those light-sensitive receptors. Some doctors have even picked mouse brains. But the results are impossible to interpret. At best they can show the difference between a healthy and a sick eye. Deciphering the secrets of human vision turned out to be so incredibly difficult that surgeons nowadays are certain of only one fact: The human eye is not just a mechanical apparatus like a camera; rather, it is an integral part of our brain. Literally. The optic nerve is a bundle of a million neuronal cells, each cell stretching directly from the retina to the visual cortex in the back of your head. There's no way to tell where the eye starts and the brain ends—in a strictly anatomical sense it's all one thing.

The actual perception of contrasts is always accompanied by an interpretation and thus is already an intelligent process. It happens subconsciously; you cannot prevent it. Try it for yourself: Look at the image below. Can you believe that the two circles have identical brightness? I swear, they do! Use a colorimeter on this page if you don't believe me.

You see, the impression of brightness has little in common with the true, physically measured luminosity. How exactly this impression

Figure 1-10:
The harsh daylight of the Caribbean forced pirates to wear an eye patch.

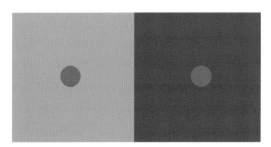

Figure 1-11: *Local adaptation tricks your mind. Both circles have the same brightness value; they are measurably identical. Seriously.*

is shaped is impossible to find out. After all, we are talking about a cognitive experience here. Our senses are nothing but a link between the outer and the inner world. We never experience the outer world directly; all we see is the inner world that we reconstruct from our sensual impressions. If our senses were structured differently, we would live in an entirely different world. Have you ever wondered what the world would look like if you could see radio transmissions or cell phone signals? We're surrounded by things we cannot sense, but still we assume that what we see is the real world. This is why the science of cognition operates where physiology, psychology, and philosophy meet.

For our core problem, how the mind makes you see different levels of gray, the cognition expert Robert R. Hoffman offers a superb explanation: First, to construct the gray tone of a specific point, you are not just looking at the brightness level at that point. Furthermore, you are not only using the brightness levels of the immediate surroundings of that point. Instead, you gather large areas of the image and group them together by applying complex rules, which we have not discovered yet. Perceiving a gray tone is part of a coordinated construction process that considers shapes, colors, light sources, and transparent filters.

So that is the situation. Human vision is a complicated beast. We understand some basic principles, like adaptation and nonlinear response. But still, we know little about how we really perceive the world through our eyes.

1.3 How Lifelike Is Film Photography?

Film has been the primary medium for a century now when it comes to picturing a piece of the real world. In fact, photorealism has set the bar high and is still considered the ultimate goal for 3D renderings. But is film material really that good in capturing what a human observer can see? Is it really true to life?

The answer is, not quite. But it is the best we have so far. Let's take a look at the inner workings of film to better understand the advantages and shortcomings.

1.3.1 The chemistry that makes it work

All analog photography is based on the same chemical reaction: the decay of silver halide caused by light. On the microscopic level, film material is covered with millions of silver halide crystals. These crystals are commonly known as film grain. Each grain crystal consists of billions of silver ions that carry a positive charge (Ag+). Also, it holds about the same amount of halide ions, carrying a negative charge. That can be a chloride (Cl−), bromide (Br−), or iodide (J−). It doesn't really matter which one—all halides have one thing in common: they have one electron to spare, and they are more than happy to get rid of it when light hits them and gets them all excited. That's where the silver ions come in—they catch that electron, so they can turn into pure silver. That's right, pure silver! When we are talking about the density of a negative, we are really talking about the chemical density of silver that is on the film. It explains why shooting on film is so expensive: there might be more silver bound in film negatives than in coins these days.

Figure 1-12:
The photochemical reaction of exposing film.

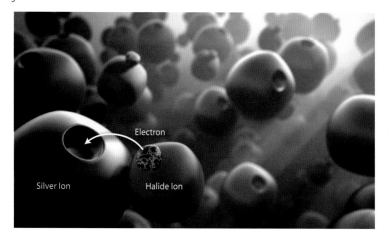

So, exposure is a photochemical reaction. As such, it progresses in a logarithmic manner. If a certain amount of light has turned half of a grain crystal into silver already, the same amount of light will transform only half of the remainder. This is very convenient for us because it roughly matches the nonlinear response of our eyes. Herein lies the secret, why film appears so natural to us: film grain reacts to light just as the receptors in our eyes do.

By the way, this chemical reaction is actually very slow. It would take hours to convert an entire piece of grain into pure silver. In practical photography today, much shorter exposure times are used only to plant an exposure seed. Later, when we develop the film, we can grow that seed through a chain reaction and amplify the original exposure a million times. If you ever watched a Polaroid photo develop, you've seen this amplification in action. This basic concept hasn't really changed for a century. Color film is just a refinement accomplished by using several layers of film grain divided by chromatic filters.

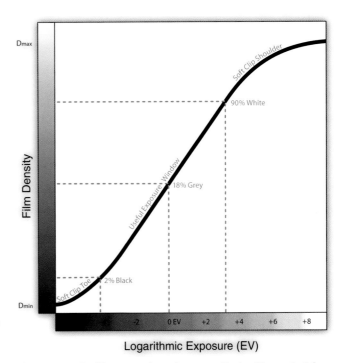

Figure 1-13: *The film curve shows how a particular film material reacts to exposure.*

1.3.2 Where the chemistry is flawed

There is a minimum amount of light required to get this reaction going. On the other side, the film grain reaches a saturation point when hit by a certain amount of light, that is, when all the grain consists of silver. For a scene to be captured with all its tonal values, the light beam hitting the film has to fit into this interval, the *tonal range* of the film. If parts of the film get too much or too little light, you end up with entirely saturated or entirely virgin grain crystals, commonly referred to as the evil twin sisters Overexposure and Underexposure. What really ends up on film are the light intensities in between.

An S-shaped curve is typically used to map film density to exposure on a graph. Shown on the right is an idealized average curve. In reality, the film curve is slightly different for each type, brand, even individual stocks of film material—

as unique as a fingerprint. Note that exposure is measured logarithmically too. Each increase of 1 EV relates to the double amount of light being allowed to shine in the film. A perfectly logarithmic response would show up as a straight line in this diagram. Film does that only in the middle portion of the curve. At the upper and lower end, the curve has a smooth roll-off, called shoulder and toe. These are the spots where the grain pieces are almost saturated or have received just enough light to start reacting. Even in the most sophisticated film material these thresholds are slightly different for every single grain crystal, so they show up as increasing noise in the toe and the shoulder ends of that curve.

The trick now is to set the exposure right, meaning to tweak the amount of incoming light to fit in that window of useful film response. You can do that with the aperture size

or exposure time or by putting filters in front of the lens. This can work well under more or less homogenous lighting conditions, preferably in a studio where the photographer is in control of the light. But a landscape photographer can tell you stories about the pain of having an overcast sky, sparkling reflections, or even the sun itself in the picture. The DR of the real world often exceeds the DR of film by far, and so the photographer has to make a choice. He can either expose for the darks or expose for the lights. In both cases, the image does not represent what a human observer would see. If the photographer decides for the lights, all details in the shadows get mushed up in one big black stain of unexposed grain. If he exposes for the shadows, he sacrifices all detail of the brighter areas. And the worst is that this on-site decision is irreversible; whatever details get clamped out are gone forever.

1.3.3 How about analog postprocessing?

Modern film material can capture a dynamic range of 5 to 8 EVs in the good-quality portion of the curve. By comparison, human vision easily comprehends about 14 EVs, so only half of the light nuances you can see end up on film. The tonal range of photo paper is usually lower; only premium-quality paper reaches 6 EVs. Obviously, this depends on the lighting conditions when you look at the print, but even under perfect gallery lighting, the limit is set here by the level of darkness that it can reach. Even the darkest black will always reflect some light; you can't get paper as dark as a black hole just by printing ink on it. So the photographer has to clamp out another part from the light that is caught on film. This is done in postexposure, when the exposure seed is chemically amplified. By choosing just the right chemicals, the photographer can change the gradation curve and shift the exposure about 1½ EVs up or down with no regrets. Obviously, some light information is thrown away here, but the result is still using the full DR of the output media, the photo paper.

That is the great thing about it: The photographer has a bigger range at his disposal than he needs for the output. Within that film range, he can move the smaller window of printable range up and down—the print range will always be fully used. This is analog postprocessing, a method for brightening and darkening that delivers a maximum-quality output. Many professional photographers were resisting the switch to digital for exactly that flexibility. As of right now, a RAW-based workflow is the only digital alternative that comes close. But it's not quite there in terms of quality because digital images start off from a different premise.

1.3.4 What's wrong with digital?

Whenever a digital image is brightened or darkened, there is data loss. If you are applying a digital gradation curve to spread out some tonal values, you always crunch together the rest. You can never slide the exposure as you can with the analog post process. You can simulate it, but you won't recover new details in the highlights or shadows. Instead, the more you tweak the tonal values digitally, the more banding and clipping will occur and you end up entirely ruining the quality. And you know why? Because unlike in analog postprocessing, the dynamic range of the source material is identical to the output.

Those are some bold statements. Let me explain a bit deeper how digital imagery works and where it is flawed.

1.4 Traditional Digital Images

Computers are very different from our good buddy film. Computers are more like the IRS. All that matters are numbers, they operate based on an outdated book of rules, and if you make a mistake, they respond with cryptic messages. Everything you tell them has to be broken down into bite-sized pieces. That's what happens to images: pixel by pixel they get digitized into bits.

1.4.1 Let's talk about bits.

Figure 1-14: *A bit resembles a simple on/off switch.*

A bit is the basic information unit that all digital data is made of. It resembles a very simple switch that can be either on or off, black or white. There is no gray area in a bit's world. If you want some finer differentiation, you need to use more bits.

And this is how it works: With a single bit, we can count from 0 to 1. To count further, we have to add another bit, which can be either on or off again. That makes four different combinations: 00, 01, 10, 11. In human numbers that would be 0, 1, 2, 3. As humans we have a slight advantage here because we're not running out of symbols that fast. Computers have to start a new bit all the time. For example, it takes a third bit to write eight different numbers: 0, 1, 10, 11, 100, 101, 110, 111, whereas we would just count 0, 1, 2, 3, 4, 5, 6, 7, 8. What looks like a 3-bit number to a computer would still fit within a single digit in our decimal system. However, the basic way of constructing higher counts is not that different at all. When we've used up all the symbols (0 through 9), we add a leading digit for the decades and start over with cycling through the sequence of number symbols. It's just more tedious in binary numbers because there are only 0 and 1 as symbols. But with every new bit we add, we can count twice as far. Thus, the formula $2^{(\text{amount of bits})}$ is a shortcut to find out the highest number that amount of bits can represent.

To sum it up: Bits represent the digits of computer numbers. The more we have, the higher the number we can represent and thus the more unique values we have available.

1.4.2 Great, that's math 101. But how about images?

Traditionally, 24 bits are used to describe the color of a pixel. This is the general practice, laid out in the sRGB standard. All digital devices, from cameras to monitors and printers, are aware of it and support it. You might be tempted to call this a 24-bit image format—but wait! In reality, it's just an 8-bit format. Those 24 bits are broken down into three channels, where 8 bits each are used to describe the intensity of the individual color channels red, green, and blue. Eight bits allow $2^8 = 256$ different values. So the darkest color possible is black (0,0,0) and the brightest is white (255,255,255). To change the brightness of a pixel, you have to change all three channels simultaneously—otherwise, you also change the color. Effectively, each pixel can have only 256 different brightness levels. This is not even close to what our eyes can see.

Ironically, this format is labeled *truecolor,* a name that stems from an age when computers had less processing power than a modern cell phone. Back then, 256 values per channel was considered high end compared to a fixed palette of 32 colors total.

Don't get confused with the different counting methods for bits. sRGB is 8-bit, when you look at the individual channels. The other counting method would be adding all channels up, and then you would get $3 \times 8 = 24$ bits. Some call that cheating, but it makes sense when you want to indicate that an image may have more than the three color channels. A common bonus is an alpha channel that describes a transparency mask. The short name for that kind of image would be RGBA, and if you sum up all four channels, you get 32 bits. But it's still 8 bits per channel, still the same old not-so-true-color format. To avoid all this confusing bean counting, I will stick to the per-channel notation and call this format 8-bit for the rest of the book, or simply low dynamic range (LDR).

Also notice that there is a limitation built right in. Nothing can be brighter than 255 white, and nothing can be darker than 0 black. There is just no way; the scale ends here.

1.4.3 Born to be seen through gamma goggles

So, 256 levels are not much to begin with. But it gets even weirder: these levels are not evenly distributed. How come?

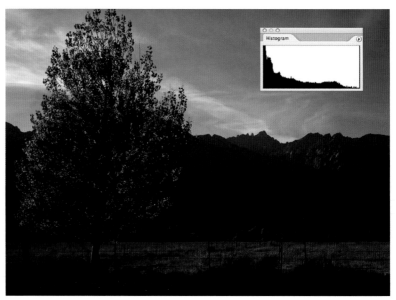

Figure 1-15: A midday landscape in linear color space, as it appears to a digital imaging sensor.

Let's see what happens to an image from digital capture to display on-screen. First of all, digital sensors do not share the logarithmic response of film and our eyes. They just count photons, in a straight linear fashion.

Figure 1-15 shows how a scene looks in linear space, just as a digital sensor would see it. Mind you, this is a simulation. You'd never actually get to see the raw sensor output like this because it just looks wrong: much too dark and high contrast. In this case, it might have a certain appeal, but we can all agree that it looks far from natural. There are large black areas where we expect to see shadow details and several sudden jumps in brightness. It appears more like an evening shot than a broad daylight scene. What happened?

I made up two diagrams to illustrate what our sensor has just captured. They show the identical curve, but with the scene luminance mapped in two different ways: linear scale is what the physical luminance really is, with a steady increase of light. However, we like to think in terms of exposure, where each increasing EV is doubling the amount of light. This corresponds better to how we perceive light, and so the second diagram is in logarithmic scale. For comparison, the film curve is overlaid in gray.

These diagrams tell us that half of the available values are taken by the brightest EV. The remaining half is divided between the second brightest EV and all the lower ones. If you do that repeatedly for a camera that captures 6 EVs in total, and you try to represent them all with a total of 256 values, you end up with only two levels left for the EV containing the darkest shadow details. Most of the image ends up darker than you would see it, crunched together in fewer and fewer values. It's like cutting half off a birthday cake again and again, until only a tiny crumb is left for the last party guest.

That wouldn't work well, would it?

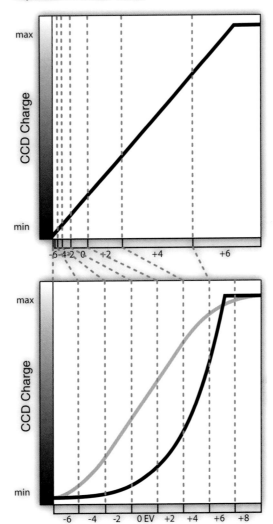

Exposure in Linear Scale

Exposure in Logarithmic Scale

Figure 1-16: As a digital sensor captures linear light levels, it does a poor job when transferred to the logarithmic domain of our eyes. Film curve overlaid in gray for comparison.

Traditional Digital Images 29

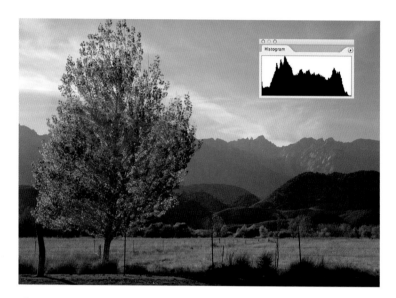

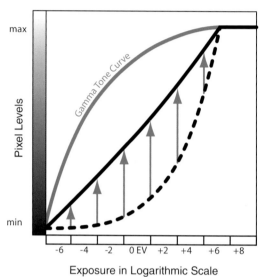

Figure 1-17: *Gamma encoding reallocates our digital values, so they better fit our logarithmic perception.*

To the rescue comes a little trick called *gamma encoding*. And this is where the trouble starts. Mathematically, the gamma is applied as a power law function, but that shouldn't bother us right now. What's important to remember is that gamma encoding has the effect of applying a very steep tone curve. It pulls the tonal values up, strongest in the middle tones and weakest in the highlights. The result in figure 1-17 is a much more natural-looking distribution of tonal values. Most noticeably, the darker EVs are back—hurray. And the middle EVs stretch almost across the entire tonal range available.

Note that this is not a creative process; it is done in the background without you noticing it. The gamma is the most rudimentary form of color management; in fact, one of the essential ingredients of each color profile is this gamma curve. Even if a program is not fully color managed, and doesn't care about color profiles at all, the gamma is always there, baked into the image data. Gamma encoding is a built-in property of all LDR imagery, and it is necessary to make better use of our 256 digital values. It is a hack that distorts their allocation to light inten-

sities, born out of the limitations of the digital Bronze Age.

With gamma encoding, the 8-bit image has been cheated to work nicely on a cathode ray tube (CRT) monitor. I don't want to bore you with more technical graphs. Let's just say that they are made for each other. CRT monitors can show all the nuances that 8-bit can deliver, and it's getting as close to human vision as this technology can get. Traditionally, other output devices are calibrated to this gamma value too. Printers, LCD monitors, television sets—they all expect their input feed to come with a gamma-distorted level distribution, and it is their own responsibility to turn that into an output that is pleasing to the eye. That is why we call 8-bit imagery an output-referring standard.

1.4.4 Limitations of this output-referring standard

Here comes the catch: As soon as you want to edit a digital image, the pitfalls become quite apparent.

Especially critical are the shadows and dark tones. Brightening an image up will reveal that

gamma encoding has just pretended to preserve detail in those areas, just enough so you don't see the difference on your monitor. The truth is, the lower EVs did not have many different digital values to begin with. Spreading them out across a larger set of values introduces nasty posterizing effects, most noticeable in the large blue-brown color fills that are supposed to be the shaded side of the mountain. Also, the histogram now looks like it just went through a bar brawl, exposing large gaps all over.

Okay, this adjustment was done with a very primitive tone curve. Yes, there are more advanced tools, using more sophisticated algorithms to reconstruct the intermediate tonal values. Such specialty tools might be more or less successful in filling the gaps, but in the end all they can do is guesswork. It's very unlikely that they will discover new details that have not been there before. No new pebble or bush will emerge from the shadows.

The next thing to consider is that all the brighter EVs are now stacked up on the right side of the histogram. These tonal values have snapped together. There is no way to separate them anymore. We even pushed a lot of them to the maximum value of 255. Remember, in 8-bit imaging this is a hard limit. Almost the entire sky is just white now, and the clouds are gone. Now and forever. We dumped the data.

Any subsequent change has to deal with an even smaller set of distinguishable values. For demonstration purpose, I tried to craft an inverse tone curve to bring the image back to what it was before. As you can see in figure 1-19, this didn't work out so well. The photo can only be declared dead. Bye-bye fluffy clouds. What's left in the sky is just some cyan fade, where the blue channel got clipped off before red and green. The tree looks like an impressionist painting, entirely made of uniform color splotches. And our histogram just screams in pain. Apparently, I could not get the image back to the original that easily.

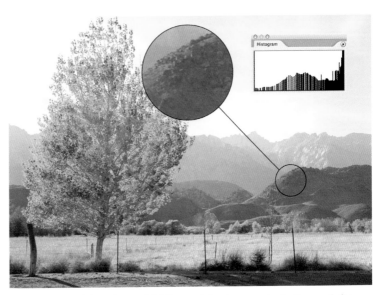

Figure 1-18: *Brightening an 8-bit image introduces posterization and clipping artifacts.*

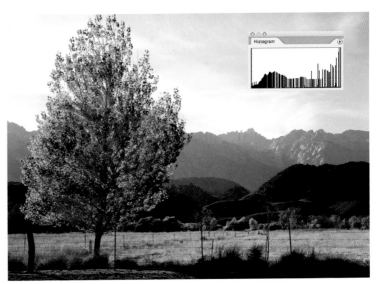

Figure 1-19: *Darkening the image down, in an attempt to bring it back to where it was in figure 1-17.*

1.4.5 More bits

I know what you're thinking. It was very unprofessional to make such harsh adjustments in 8-bit mode. If I'm that crazy about histograms, I should have used the higher precision that a 16-bit mode offers. Indeed, here I have more digital values available for each EV, and that certainly helps when doing incremental editing steps. If you do the math, 16-bit mode has actually just 15 bits because the first bit is used for something else. But that still leaves me $2^{15} =$ 32,768 unique levels to work with.

Wouldn't that be enough?

Not really. It doesn't give me back the fluffy clouds. It doesn't even save the sky from getting burned into cyan. Using 16-bit is no revolutionary solution; it's just more of the same old. It has a maximum and a minimum limit, where color values get rudely chopped off. And even if you don't make such hardcore adjustments as I just did, you never know where a sharpening filter or some other fine detail processing step will throw individual channels out of range.

Keep in mind that 16-bit is an output-referring format as well. It carries the gamma-encoded nonlinear level distribution, so most of the extra precision gets added in the highlights, where you need it the least. And it uses a fixed number of discrete values. There might be more of them, but that still means your levels get chopped up into a fixed number of slices. The more you tweak, the more rounding errors you'll see and the more unique values you'll lose.

1.4.6 Nondestructive editing

Here is a somewhat working solution: Instead of applying multiple editing steps one after another, you could just stack them up and apply them all at once to the original image. That would take out the rounding errors and preserve the best quality possible.

Photoshop's adjustment layers follow this idea, and other image editors use similar concepts. The drawback of this approach is that the flexibility ends at the point where you actually commit all your changes. But you have to commit your changes when you take an image through a chain of multiple programs. An example would be when you develop a RAW file in your favorite RAW converter, tweak the levels in LightZone because you just love the zone system, and then do additional tweaks through dodging and burning in Photoshop. You can dodge and burn all day, but you will not get details back that have been cut out by the RAW converter. The farther down the chain, the more of the original data you'll lose.

1.5 Splitting the Bit

What we really need to do is reconsider the basic premise that digital imaging is built upon. We need to split the bit. We need to use *floating-point numbers*.

See, the hassle started with our limited set of values, ranging from 0 to 255. Everything would be easier if we would allow fractional numbers. Then we would have access to an infinite amount of in-between values just by placing them after the decimal point. While there is nothing between 25 and 26 in LDR, floating point allows 25.5 as a totally legitimate color value and also 25.2 and 25.3, as well as 25.23652412 if we need it. HDRI is that simple — yet that revolutionary!

We need no gamma because we can incrementally get finer levels whenever we need them. Our image data can stay in linear space, aligned to the light intensities of the real world. And most important, we get rid of the upper and lower boundaries. If we want to declare a pixel to be 10,000 luminous, we can. No pixel deserves to get thrown out of the value space. They may wander out of our histogram view, but they don't die. We can bring them back at any time because the scale is open on both ends.

For all practical purposes, actual pixel values in an HDR file are settled between 0.0 as black and 1.0 as white point. This has become a de facto standard to make file exchange easy and reliable, and it also simplifies working with numerical info palettes. Think of 1.0 as the new 255. Color values beyond 1.0 are entirely valid, but they will be hidden behind the monitor's white. If you really think about it, this numerical convention even makes more *sense!* Learning that 255 would be associated with white was one of the first "huh?" moments in every photographer's life. On the other hand, 0.0 to 1.0 can easily be substituted with 0% to 100% brightness, and you can just assume there's a practically infinite number of steps in between.

Of course, nothing is really infinite. In real numbers, we have about $2^{32} = 4.3$ billion unique brightness values available. Hold this against 256 steps, and you'll see that for all practical purposes, HDR data can be considered virtually step-less. Even if it may not be mathematically unlimited, HDR provides several thousand times more precision than what any of your imaging sources can deliver. It's plenty enough to stop worrying about doing irreversible damage to the original data by image editing.

Figure 1-20:

Color precision experiment, part 1: Desaturating an HDR image almost entirely and saving it to disk.

1.5.1 Seeing is believing

Here is a little experiment to illustrate what I'm talking about: I load an HDR image into Photoshop and reduce the saturation by −99. I do it the destructive way, with a brute force Hue/Saturation from the IMAGE ▸ ADJUSTMENT menu. Yes, I'm crazy like that.

Now I save that image to disk. No trickery, no adjustment layer, just the pure pixel values in the HDR image file. And I can still load this seemingly black-and-white image back into Photoshop, go to IMAGE ▸ ADJUSTMENTS ▸ HUE/SATURATION, and bring the saturation back up.

Insane, isn't it?

As long as I stay in 32-bit floating point, the precision will stay the same. My changes affect only the position of the decimal point, but all the information is still there. All pixels still have unique color values, even if they differ by something like 0.000000815. Okay, the restored result is not quite identical; Thomas Knoll alone might know what a saturation tweak of −99 means for Photoshop. But I promise, bumping saturation by another +25 mysterious Photoshop units will bring it precisely back to where it was. Try it for yourself; there are plenty of HDR images on the DVD!

Obviously this would be impossible with an 8- or even 16-bit image. I don't have to waste paper just to show you. Only the close-to-infinite precision in real 32-bit HDR images makes this stunt possible. Granted, this was a silly example, but the implications for digital image editing are enormous. I can edit this image as often as I want without fear of degrading because the precision of the original data is always maintained—that's what a true 32-bit HDR workflow is all about. We're done with 8-bit anyway. Atari, Amiga, and DOS computers were based on 8-bit. Windows and Mac OS have just made the leap from 32- to 64-bit, and so have Intel and AMD processors. Only our images have been stuck in the '80s.

Figure 1-21:

Part 2: Loading the black-and-white image from disk again, and boosting saturation back up.

1.5.2 Rethinking color management

One of the most frequently asked questions, especially from seasoned pro photographers, is "How can I save my HDR image in ProPhoto color space?" Well, the short answer is, You don't have to.

And here is why: Consider the premise of why we use different color profiles in the first place. It really is an extension of the gamma encoding hack we just talked about. With a limited range of values at our disposal, we need to make sure to use them wisely. Our RGB triplets may be combined to form a color value, but that is pretty meaningless unless we define what the individual primary colors look like.

That's where the famous CIE 1976 color chart, dubbed horseshoe diagram, comes in. It is the ultimate color reference, the mother of all color spaces. It was derived from the spectral sensitivity of our eyes and encompasses the full spectrum of visible colors. The long sweeping arc is a rainbow of all the wavelengths we can actually register. The odd shape stems from the fact that the diagram also takes into account how well we can distinguish between two similar colors. This diagram is where we have to pin down the meaning of red, green, and blue—effectively anchoring these primaries in the real world.

The regular sRGB color space is defined by the location of the RGB primaries as in figure 1-22. Together they form a triangle, which is also called the *gamut* of this color space. All the possible combinations of values for red, green, and blue fall within this triangle. Colors outside of this triangle cannot be accessed with any combination of RGB values and thus fall out of the sRGB color space.

Conventional wisdom says if we want more colors, we need a bigger triangle. That's exactly what alternative color spaces like AdobeRGB or ProPhoto are doing. They use modified locations for these primaries, so they enclose more of the visible colors. Figure 1-23 illustrates this concept. For example, AdobeRGB slightly extends the

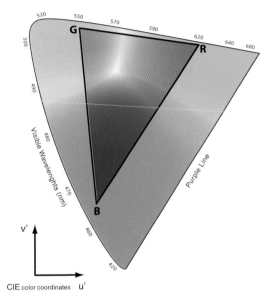

Figure 1-22:
The location of the primary color in this CIE 1976 diagram gives RGB values their meaning. Here they define the standard sRGB color space.

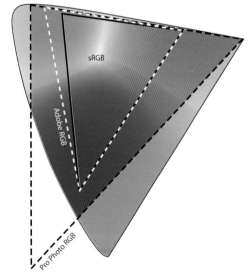

Figure 1-23:
Alternative color spaces stretch the triangle to enclose more of the visible colors, but that comes at the expense of color resolution.

meaning of green, which enables it to represent almost all colors that can be printed with CMYK inks as well as more accurately depict Peter Pan flying through treetops. In ProPhoto, the meaning of blue is cheated entirely, just so the triangle is stretched even further to cover almost all colors we can find in nature. Mind you, in 8-bit this additional coverage actually comes at the

expense of color resolution. We might be able to reach colors that were previously off-limits, but all neighboring color values are now spaced farther apart. It's a trade-off, once again rooted in having only 255 values at our disposal. Pro-Photo especially only makes sense in 16-bit precision, otherwise we'd get visible banding and posterization because 8-bit doesn't give us enough unique values to describe really subtle transitions.

But hold on—in 32-bit HDR land, we have practically unlimited in-between values, don't we? Indeed, but it gets even better: Nobody said our values need to be positive either. We could have negative color values as well. Mathematicians can tell you long stories about "imaginary numbers," so a simple minus sign in front of a color value isn't really such a nutty idea after all. Indeed, at first thought it makes no sense, but in practice it turns the entire color theory upside down: If we are allowed to use negative color values, we can represent any color outside the RGB triangle, without fiddling with the location of the primaries. How come?

Let's look at figure 1-24. Notice the little white dot I painted on the upper edge of the triangle. It's opposing the blue corner, which means the marked color has no blue mixed in at all. Blue is zero and stays like that for this example. Only green and red are assigned; that's why the dot is on the line between these two colors. Now imagine we lower the red value and raise green. The dot wanders to the left, into the green corner, right? But now let's keep moving that dot further. we can raise green above 1.0, and we can lower red further into the negative realm. And voila, we arrive at a color that was previously inaccessible. Negative red values alone open up the entire left side of the diagram for us, as indicated with the overlay in figure 1-24.

We could do the same for all three colors, and the entire horseshoe diagram becomes accessible. That RGB triangle is not a hard wall anymore. It actually doesn't matter what we choose

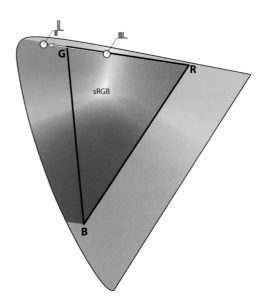

Figure 1-24: *Negative color values in 32-bit HDR space allow us to break free of the RGB triangle. No more trade-offs.*

as primaries; their position is now irrelevant in terms of color preservation. Of course, it should be a *known* position, so we can uniquely identify each mixed color. But we might just as well stick to standard sRGB primaries at all times; there's no need to move them around and make the triangle itself bigger.

That's why HDR images are traditionally set in a linear RGB color space, and unless there is another set of primaries defined in the metadata, they are assumed to be the same as in sRGB. Adobe calls it the *sRGB (Linear)* color space. Microsoft uses the name *scRGB*, although it also defines the arbitrary limits of −0.5 and 7.5 for all color values. That sounds a bit counterproductive, but what gives? Sony has used the negative color trick for years; it's an integral part of its *xvYCC* video standard. Although it doesn't include over-white values at all, negative color values provide the magic sauce for Sony's BRAVIA monitor line, digital cinema projectors, and recent video cameras.

The fact to remember is that with true 32-bit HDR, you can work in a wider gamut than with

any other color space, without all the profile confusion. In HDR you don't need Adobe RGB or ProPhoto as working color space anymore. You can use the good old sRGB primaries, which means the conversion to a monitor space is actually simplified. The original idea behind color management was to use a device-independent working space and then convert to your monitor or printer via device-specific profiles. Real 32-bit HDR images are considered scene-referring, which is the ultimate in device independence. If it would have existed back in the days when color management was invented, I'm pretty sure a linear HDR space with its fenceless color gamut would have always been the anchor that all ICC profiles are referencing, the unified central working color space. That would have saved us several years of foul compromises.

Of course, that doesn't mean it's all just unicorns and rainbows from here on. Color profiles are still important when converting to (or from) traditional LDR formats. Color management still remains a challenge, presenting itself as a confusing mess to beginners and a slippery tightrope to pros. Even color science experts consider accurate color matching, that fully takes into account all spectral mismatches between devices, a largely unsolved problem—even with HDR RGB data. In some respects, color matching is even unsolvable, not just hard. The problem of metamerism (two spectrally different colors can look the same to a human observer) is unavoidable, and it can create some very strange effects when converting between color spaces. The only way around that is to use significantly more than the bare minimum of three color channels, preferably dozens or more. This is called *hyperspectral color,* and it has been a sort of holy grail for color image research for a good while. However, just as 8-bit color has cemented itself firmly in standards, consumer products, and existing content, the restriction to three channels (RGB) seems just as rigid and hard to change, perhaps worse.

1.5.3 So, HDR workflow is better than RAW workflow?

Well, they are closely related.

RAW has extended a photographer's capabilities to digitally access the untreated sensor data. Most RAW files are linear by nature and look very much like the first example picture with the tree, in section 1.4. By processing such a file yourself, you get manual control over how these linear intensities are mapped to the gamma-distorted color space. There are other hardware-dependent oddities to RAW files, like low-level noise and each pixel representing only one of the primary colors. The image you get to see on-screen is essentially reconstructed by interpolation. It's called RAW development, and it really is just as elaborate of a process as analog film development. But having control over all aspects of this process is an essential ingredient for squeezing out the maximum image quality.

RAW also incorporates the concept of extra image data hidden beyond the monitor white, and so exposure compensation has become the first and foremost reason to get into RAW photography. Recovering highlights and fine-tuning exposure—these are the things photographers treasure most about RAW. It's just that you inevitably keep hitting the limitations of your sensor, and if you ever tried to change exposure by −4 EVs in Lightroom you know what I'm talking about. With full HDR, that wouldn't be a problem. Even if you have a camera of the newest hottest generation, that can actually capture a lot of extra range in the RAW headroom, you will find that traditional RAW recovery algorithms break apart quickly. They are conceptually not designed to do meaningful things with that much dynamic range. Instead, you can see a boomerang effect from HDR processing. New features in RAW developers like "digital fill light" and "clarity" are essentially tone-mapping operators that sprung out of HDR research. Such features are becoming increasingly successful

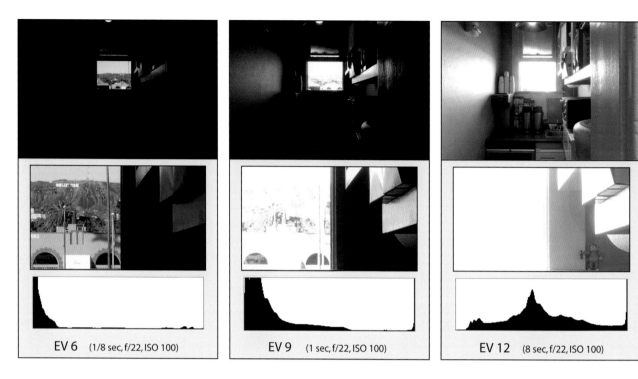

| EV 6 (1/8 sec, f/22, ISO 100) | EV 9 (1 sec, f/22, ISO 100) | EV 12 (8 sec, f/22, ISO 100) |

Figure 1-25: *Kitchen at EdenFX. It is very important for VFX artists to see the Hollywood sign while they're pouring massive amounts of fresh coffee. Unfortunately, none of the single exposures can capture that experience.*

and give you a glimpse of what a full HDR workflow could actually do for you.

With RAW you're also walking on a one-way road. Processing is done first, and any subsequent editing relies on the data that is left. Not so with HDR; it preserves everything. You can edit HDR images, take them from one program to another, and even in the last round of processing you'll still have access to residual highlight data. As long as you stay in floating-point HDR space, no data will be lost.

RAW is also bound to specific hardware: the capturing sensor. HDRI is not. HDRI is a much more standardized base that is truly hardware independent. You can generate HDR images that exceed what a sensor can capture by far, and you can use them in a much wider field of applications. In the case of computer graphics (CG) renderings, there is no physical sensor that would spit out RAW images. Instead, HDR images take the position of RAW files in the CG world.

Think of it like this: HDR imaging is the next generation of a RAW workflow. Right now, they go hand in hand and extend each other. But sooner or later all digital imaging will happen in HDR. It won't be a sudden change of habits; instead, it's a gradual transition that has already started.

1.5.4 But what is the immediate advantage?

When a RAW image represents what a sensor captures, an HDR image contains the scene itself. It has enough room to preserve all light intensities as they are. You can re-expose this "canned scene" digitally as often as you want. By doing so, you take a snapshot of the HDR and develop an LDR print.

This technique is called tonemapping, and it can be as simple as finding the perfect exposure setting or as complicated as scrambling up all the tonal levels and emphasizing details in light and shadow areas. You can even simulate the local adaptation mechanism that our eye

is capable of. Or you can go to the extreme and find new, painterly styles. Tonemapping puts you back in control. You choose exactly how the tonal values are supposed to appear in the final output-referring file. None of this slap-on gamma anymore. This is also not just a simple highlight recovery anymore. This is designing the photograph the way you want it, reshaping it out of the data captured.

Let me give you an example: a shot of an interior scene that includes a window to the outside, which is a classic case for HDR photography. In conventional imaging, you wouldn't even try this. There is just too much dynamic range within the view; it stretches across 17 EVs. Neither analog nor digital cameras can capture this in one shot.

But once they are merged into an HDR image, exposure becomes an adjustable value. You can slide it up and down to produce any of the original exposures, or you can set it somewhere in between to generate new exposures. You can also selectively re-expose parts of the image, very akin to the classic dodge-and-burn workflow that is as old as photography itself. In this case, it was quite simple to draw a rectangular mask in Photoshop and reduce the exposure just for the window.

Other methods are more sophisticated and allow you to squash and stretch the available levels to wrangle out the last bit of detail. The second image was treated with a multitude of dedicated tonemapping programs and selectively blended in Photoshop.

You see, there is an immense creative potential to be explored here. Tonemapping alone opens a new chapter in digital photography, as well as in this book. There is really no right or wrong—tonemapping is a creative process, and the result is an artistic expression. Exactly that is the beauty of it. Whether you like it or not is a simple matter of personal taste.

So much for the teaser. The thing to remember is that HDR is everything we always hoped

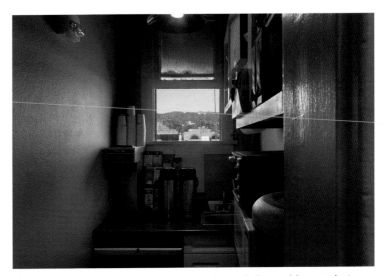

Figure 1-26: *Manual tonemapping using simple dodge-and-burn techniques can show the entire scene.*

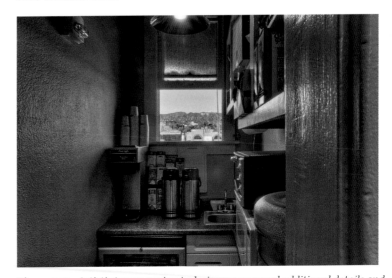

Figure 1-27: *Artistic tonemapping techniques can reveal additional details and emphasize textures.*

RAW would be but never was. It's a device-independent, flexible, accurate representation of the scene in front of you. HDR preserves the original color precision through multiple editing steps, even when applying extreme image manipulations. We only have to leave the HDR realm when output devices come into play.

Figure 1-28: *The legendary BrightSide DR37-P, world's first HDR display.*

Tonemapping ends the HDR pipeline and takes an image from a scene-referred to an output-referred state. Every device has a specific tonal range it can handle, which can be fully utilized when the HDRI is broken down. And how far you have to crunch it down depends on the range limitation of the final output.

1.6 Output Media

For photographers, the final output will often be a print on paper. As mentioned earlier, only quality photographic paper can hold a dynamic range of 6 EVs (or 100 : 1). Most papers are even lower, and ultimately it depends on the lighting conditions where the print is displayed. Hence, tonemapping all the way down to an 8-bit output will continue to be a prime goal for photographers. However, our modern world offers plenty of other media options, and they all rely on digital images. And this is where the importance of an HDR workflow comes in. Let me finally prove the bold statement that all digital imaging in the future will happen in high dynamic range.

1.6.1 The death of the cathode ray tube

Let's face it: CRT technology is outdated. Liquid crystal display (LCD) panels have taken the lead now, and nobody regrets this step. Even though they do not necessarily deliver a higher dynamic range, LCDs have to be cheated to work properly with gamma-encoded 8-bit imagery. Unlike with CRTs, this is just not native to them. The foundation that our house of 8-bit cards is built on has disappeared already.

The next wave in display technology will be HDR displays. A company called BrightSide Inc. has developed the first commercially available display of this type. Yes, they are real. And yes, the difference is huge! When I first saw the prototype at SIGGRAPH 2004, I couldn't believe my eyes. It looks more like an open window than any monitor you have ever seen. Crystal-clear highlights that truly shine. And a black level that is so low your eyes actually have to adapt to shadow details. Remember how you stood in awe watching the first color TV in your life? It's that kind of feeling. You feel somewhat like you have always been betrayed because everything else literally pales in comparison.

And this display is not even that hard to build. Once again, Greg Ward was among the team members figuring it out. What they did was replace the uniform backlight with an LED screen. So the backlight now has pixels, too, that can be leveled up and down. Where there are shadows in the image, there is no backlight at all. The screen gets totally black (or as black as the room lighting allows). Only where there is brightness in the image is there light shining off the screen. The LCDs make the color, and the LEDs the luminance. In full words: it is a liquid crystal display with a light-emitting diode screen behind it. Sandwiching them both into one device is the perfect blend of these two technologies.

1.6.2 The chicken-and-egg problem

Samsung, Sony, LG, Sharp, and many other TV
makers have adopted this technology very
quickly. If you keep an eye out for the "local dim-
ming LED backlight" feature, you will find ad-
vertised contrast ratios between 100,000 : 1 and
300,000 : 1 (roughly 16.5 to 18 EVs). Compare this
to 600 : 1 (or 9 EVs) that the old cathode ray tube
could display! It actually has become a ridicu-
lous race for numbers already, with some com-
panies using the loose definition of the "small-
est value other than black" to test their TVs
under darkroom lab conditions and then an-
nouncing 5,000,000 : 1 or even a bold "infinite
contrast ratio." However, none of these new TV
sets currently available can give you the full
sensation because all these companies have
come up with their own method of boosting the
contrast of regular 8-bit media streams. Al-
though the hardware would be capable of
showing HDR images in their full glory, there
are no drivers, no connectivity, no unified HDR
consumer media yet. Speaking in the audio
equivalent, it resembles that time when you
could get a surround sound speaker system but
all music was mastered in plain old stereo on
cassette tapes and you'd hear only a simulated
surround experience. We're dealing with a typi-
cal chicken-and-egg problem here: real HDR
media is useless without a true HDR display,
and a true HDR display cannot be fully appreci-
ated with LDR content only.

Right now, the best we have are the Display-
Port and HDMI 1.3 standards, which support at
least 10 bits per channel. It's called the *Deep-
Color* mode, and it could theoretically go up to
12 and 16 bits per channel (although I'm not
aware of any devices that fully exploit these). If
you happen to have two HDMI 1.3–compliant
devices connected—for example, a Playstation
3 and a recent LED-backlit screen—make sure to
turn on DeepColor mode. It will blow you away
how crystal clear the picture suddenly gets, and

Figure 1-29: *The Dolby PRM-4200 Professional Reference Monitor.*

that is only a small glimpse of what future HDR
displays will have in store for us.

In the meantime, Dolby Laboratories has
acquired BrightSide, along with all the original
inventors of this technology, which shouldn't
come as a surprise to you, with all the hints I
dropped about audio technology throughout
the whole chapter. Considering HDR as Hi-Fi
imaging makes Dolby Labs a perfectly suitable
mother ship. These people know exactly what
they're doing, they have refined the hard- and
software details to perfection, and they license
the technology under the label "Dolby Vision."
For example, it turned out that a hexagonal
grid works better for the LEDs because that
distributes the contrast enhancement more
evenly across the image. And instead of white
LEDs, they use now sets of RGB-colored LEDs to
increase the color gamut and make bright colors
really pop off the screen. Just to prove a point,
the Dolby folks manufacture the PRM-4200 Ref-
erence Monitor entirely themselves, and it was
honored with the Superior Technology Award
2010 at NAB Las Vegas. It would be an ungodly
expensive TV to hang on your wall, but it serves
as gold standard for professional media produc-
tion studios and benchmark display for all other
display manufacturers. SIM2, maker of high-end
projectors, is the first company teaming up
with Dolby and selling 47-inch HDR LCD panels
based on this reference design. Of course, SIM2
starts at the top and targets the new HDR47
display line at CAD engineers, media creators,
and research centers first. But the trajectory is

that dives deep into the structure of matter itself.

Any invention made in the twenty-first century is so much more sophisticated than CRT tubes. They were analog devices just like film, only instead of using chemical reactions they were drawing pictures using raw electrical power. It sounds quite archaic these days to point a ray gun at the TV viewer and bend the electron beam by using a magnetic field that pumps at the same rate the power from the outlet happens to oscillate. The United States has a 60 hertz power frequency—fine, give them 60 frames per second. Europe's power grid has 50 hertz—well then let's refresh the screen just 50 times per second. Doesn't that sound like sledgehammer tactics?

Indeed, it is about time for some modern display technology. And believe me, as soon as you have an HDR display at your house, you won't have much fun with your old LDR image archive anymore. The images will look faded and washed out. It will be the visual equivalent to playing back your old mono tapes on a hi-fi stereo.

Learn how to handle HDR images now! Preserve the dynamic range of your photographs instead of tonemapping everything down. Be prepared for tomorrow's displays. It's just a matter of time until they show up at your local Best Buy. Even at the risk of leaning myself out of the window again, my guess would be four years from now. That would be 2016. Then you will wish all your images would shine like the new ones. And then I won't even mind rewriting this chapter all over again.

obvious; fast-forward a few years and this technology will be in every home theatre.

As a consumer my plea to the industry is this: Stop messing around! Give me Dolby Vision certified flat-screen TVs! Remaster classic movies from the original film print and sell me my favorite Blu-rays once more with the Dolby Vision sticker on them! And then let me see the difference just as I have become accustomed to hearing the difference!

1.6.3 On into a bright future

There are more display technologies coming up. Canon and Toshiba joined forces to create the surface-conduction electron-emitting display (SED). It's actually overdue now and has the potential to deliver a contrast of 100,000 : 1, which roughly equals 17 EVs. Then we have laser projection coming up, which might even turn out to be holographic and coming from a device not bigger than a cigarette pack. And there are plenty of new variations to the organic light-emitting display (OLED) technology coming on thin flexible screens. Sony already has the handy PVM-740 field monitor on the market, based on OLED and capable of showing the full dynamic range of the RAW output from modern digital cameras. The key to all these new inventions is nanotechnology, the miracle science

1.7 Chapter 1 Quiz

Congratulations, you made it through the first chapter! Now let's see if you remember at least 20 things. Feel free to scribble on this page; the book is yours and that's what this paper medium is good for. I won't tell anyone. There's no explicit solution table anywhere in the book, but all the answers are certainly on the pages you just read.

1. Greek letter for the power law function that is applied in traditional 8-bit image encoding.
2. Iris behind the lens in a camera. Also name of a parameter for setting the exposure.
3. Abstract unit for measuring dynamic range, based on a proportional value like 10,000 : 1.
4. Type of numbers used to describe tonal values in an HDR image.
5. Classification that all 8-bit images fall in, as opposed to HDR.
6. Upper part of the film curve, characterized by a smooth roll-off.
7. Substance film material consists of, responsible for photochemical reaction.
8. Currently dominant display technology for flat-screen TVs.
9. Last century's dominant medium for capturing photographic images.

10. Short for high dynamic range.
11. Color mode introduced in the HDMI 1.3 standard, enabling the display of 10 to 16 bits per channel and wide color gamut.
12. Phenomenon of human vision that enables us to see a vast dynamic range within the same field of view.
13. Photographic scale for the amount of light that hits the film or digital sensor. Combination of exposure time, aperture size, and ISO sensitivity.
14. Type of response that characterizes how film material and our eyes (approximately) react to light.
15. File format representing the direct data stream from a digital sensor.
16. Artifact of digital images that limits dynamic range on the dark end.
17. Basic information unit that all digital data is made of.
18. Physical reaction of the pupil widening and closing to compensate for extreme changes in light intensity.
19. Original name of the Canadian company that built the first HDR display with local dimming LED backlight.
20. Process of converting an HDR image into an LDR image by rearranging the tonal values.

In this second edition I will mix things up a bit. The HDR scene has grown tremendously since last time. It has diversified in many professional and artistic directions, filled with talents coming from different backgrounds and with different intentions. Curious about what they have to say? Yes, me too. That's why I interviewed some exceptional HDR shooters for you, all top dogs in their respective field. This "Meet the Pros" section will be a reoccurring format, mixed in after each chapter.

1.8 Spotlight: Trey Ratcliff

Trey Ratcliff is probably the most popular HDR photographer around. He runs the travel blog StuckInCustoms.com, where he keeps publishing a jaw-dropping image every day from the most remote areas of the world. Trey's work has inspired millions, and with his tutorials and workshops, he got many other photographers hooked on HDR as well.

Trey is an avid proponent of tonemapping for creative purposes. One could say he pioneered the dark arts of hyperreal and impressionistic looks. His images are sometimes experimental, sometimes provocative, sometimes even controversial, but they are never forgettable or boring. Let's see if we can figure out what his secret sauce is.

CB: You helped so many people discover HDR photography. But how did you get into it? Can you still remember how you discovered HDR yourself?
TR: I came into it about four or five years ago. HDR was super niche. Now of course, everyone knows what it is.

So I went out and took a photo, and I didn't like the result. Something about it just did not *feel* right. It was a flat representation of the actual scene. My background is computer science and math, so I started looking into some algorithms to help with the software processing. Stumbling into some of the early, rough HDR algorithms, I began to use those as a starting point for my own experimentation.

I think other people discovered it while I was discovering it— I just started sharing my opinions and findings before the others. Really, this is

all still the beginning stages of HDR, and I think we are all learning together, yes?

CB: Is there such a thing as an "HDR look"?
TR: Yes, I think there is certainly an "HDR look." Sometimes I amp mine up and other times I don't. It depends on my mood and whatever I'm trying to communicate. However, there is one important thing to notice. Only other photographers notice the "HDR look." Regular people just see it as a cool or interesting photo (if it's well executed, of course).

CB: Do you think there is more to come, photographic styles and HDR techniques that are yet to be explored?
TR: I think HDR will splinter into many different subgenres of the sport. It's still so new, and there are so many talented photographers out there using it—I think we're only at the tip of the iceberg.

CB: Looking at your portfolio, it seems like your own style has evolved quite a bit. While earlier images had a distinctive grunge look to them,

your newer photos seem more atmospheric, more subtle maybe.
TR: Well, things change over time, like a river. I look back at my own work with today's lens, so to speak, and I don't like it as much as my newer works. But, at the same time, I'm not overly judgmental. It made sense then, and it was the right thing to do at that time. It's silly to look down a mountain and criticize the path you followed.

Maybe over time I've come to understand a more poetic harmony of objects, light, and color. I take more time in setting up the shot because there's a visual story I want to communicate. I don't know if I always achieve success with my works, but I enjoy the struggle.

CB: What do you consider a well-toned HDR image now?
TR: I think that's just an image that is truly evocative—and different in sort of a mysterious way. Something that leaves an *impression* of a scene, that's often more effective than the *actual* scene. It's hard for me to wrap words around that idea.

CB: Is it maybe approaching photography with a painter's eye, where you take the role of a creator rather than just a documentarist?

TR: Yes, I see myself more as an artist than as a photographer. Really, actually, I don't even categorize. I think the camera is just a starting point. It's a great starting point because it captures so much of what is already there. But to me, the parts that make it evocative are the parts that are unseen. Usually, if I am somewhere interesting, thousands of other photographers are at the same spot. Anyone can take a photo. But so many times, they just come out as actual representations of the plain objects of matter. It's like a courtroom reporter's drawing—stale, boring, predictable. Now, you don't have to do HDR to turn a photograph into art at all. It's just a tool I use along with composition, timing, and other postprocessing tomfoolery.

CB: Do you already visualize the final image at the time of shooting? Or is the final look something you discover during processing?

TR: I usually figure it out while I'm shooting the image. I know what the final shot is going to look like 80% or 90% of the time. Sometimes later, during processing, I make some changes based on the feeling that I want to give the image.

My process is very slow. Sometimes I take an image and I don't process it for months or years. And all that time, I'm figuring out the problem space in the back of my brain, letting my subconsciousness just cook away. So by the time I need to arrive at an answer, something has already bubbled up from underneath that makes it more obvious.

CB: What's your top advice for HDR photographers?

TR: Don't worry about what other photographers think of your work. I find that people send me their work all the time and say, "Hey Trey, what do you think of this shot?" Who cares what I think? It doesn't matter. I'm just a guy with an opinion.

You should do whatever *you* think is interesting and form your own path. Because if you're so busy getting feedback from everybody, you don't know what's good advice and what's bad advice. And that's the thing about Flickr too. Everyone

dumps their comments on there. And it all has equal weighting, so you don't know if one person's advice is better than another. And most people out there that leave a comment don't even know what the heck they're talking about. If you take it to heart, you end up designing by committee. That's why you'll never see a statue of a committee.

If you take all this feedback from everybody and integrate it into your own work cycle, then your work ends up being designed by everybody else rather than something unique that comes from inside of you.

CB: Thank you, Trey. Very inspiring.

If you want to hear more of Trey's tricks directly from the horse's mouth, check out his website StuckInCustoms.com. He offers ebooks, videos, training sessions, and more—all excellent material to satisfy your hunger for artistic inspiration.

Chapter 2:
New Tools

This chapter introduces all the file formats and programs that come with HDRI.

In some cases, it may get a little technical, but I will refer to the practical application whenever possible. The main goal is to give you an overview of all the tools that can be incorporated into an HDRI workflow. Whether you adopt the workflows proposed later in this book will be a decision only you can make, but this chapter enables you to make educated choices.

If you're in a hurry to get out and shoot HDR images, you may skip this chapter. I'm sure you will come back and use it as a reference guide, possibly many times, even long after you're done reading the rest of this book. That's okay. I'll be here waiting for you.

2.1 HDR File Format Reviews

Okay, so 8 bits are clearly not enough. You learned in Chapter 1 that HDR images are made of 32-bit floating-point numbers. This is the image data that sits in the computer memory when an HDR image is edited or displayed. These are huge chunks of data, much bigger and with a very different structure than the regular 8-bit image. So new image formats are required as vehicles.

Each image format has its own way of wrapping all this data into a file on disk. Important for practical usage are some key elements: How good does each file format preserve the dynamic range? How widely is it supported? And most important, how much space does it take?

2.1.1 RAW Formats (.raw/.nef/.crw/.orf/.dng/ ...)

RAW formats are used as output for digital cameras, and there are as many variants as there are cameras out there. There is no such thing as one standard RAW format; they are all different from each other. Most variants deliver 10, 12, or 14 bits, which qualifies them as prime examples for a medium dynamic range format. It holds more range than in an 8-bit LDR image, but it's not quite a true HDR image.

The Good, the Bad ...

Essentially, RAW is the direct digital equivalent of an unprocessed film negative. The data from the image sensor is dumped on the storage card with minimal alteration. Interestingly, most image sensors react to light in a linear fashion, so a RAW file is already set up in a linear color space, just as HDR images are.

Many digital photographers prefer to process this raw image data, just as many traditional photographers used to rent out a darkroom and develop the film themselves instead of taking it to the drugstore around the corner. This analogy really holds up because RAW files generally include 1 to 2 EVs more at both ends of the exposure, which simply get clipped by the in-camera JPEG compression. And just as the film negative eventually drowns in grain, a RAW file reveals all the sensor noise that is inherent close to the extremes of light and shadow.

Theoretically, shooting a RAW file would require minimal processing power since it really is just the plain uncompressed sensor data. In real life, the huge file size means it takes longer to save the file to the storage card than it would for the slowest processor to compress it. So the real bottleneck is the storage card—speed and capacity are both maxed out with RAW files.

Camera manufacturers quickly realized these problems, and many of them decided to apply some kind of compression anyway. Some compress in lossless ways; some use lossy algorithms. Also, the architecture of the sensor chips can be substantially different from camera to camera, so the raw data stream is almost never conforming to a standard format. And just as EXIF data becomes more and more elaborate, there is more and more metadata embedded in RAW files these days. But unlike with the JPEG format, there has never been an official standard notation for metadata in a RAW file. So every manufacturer just makes up its own standard.

... and the Ugly

The result is a big mess of more than 100 different RAW formats that can drive software developers up the wall. Serious programming effort is needed to support them all; not even Adobe, with an army of coders, can do that. Unless your camera is highly successful in the mass market, like the Canon Digital Rebel line, chances are its RAW files can be read by only the manufacturer's software. And if your camera manufacturer decides to drop the support for a three-year-old model, or simply happens to go out of business, you are in serious trouble. You might be left with your entire photo collection as unreadable garbage data.

The worst is that most manufacturers treat their own RAW variant as proprietary format, with no public documentation. Software developers have to reverse-engineer these formats, a very time-intensive, expensive, potentially faulty, and entirely boring thing to do. On top of that, some manufacturers even apply encryption to parts of their RAW files—a mean move that can have no other intention than to cripple compatibility to other companies' brands of software.

This is unacceptable from a user's standpoint. That's why a group of concerned photographers came together in 2006 and formed OpenRAW.org, a public organization that tried to convince the industry of the importance of documenting RAW formats for the public. It had limited success. But it really is in the industry's best interest because it has been shown in the past that compatibility and sticking to open standards can get a company much farther than proprietary secrets and isolation. What happened to Minolta, whose JPEGs didn't even comply to EXIF standards? What happened to SGI and its proprietary IRIX OS? People saw their software choices limited and were voting with their dollars for a competitor that plays well with others.

Where is our savior?

Adobe's answer was the introduction of the DNG file format in late 2004. DNG stands for *digital negative,* and it's supposed to unify all possible RAW configurations into one format. It still contains the original data stream from the image sensor, which is different each time. But DNG adds some standardized metadata that precisely describes how this data stream is supposed to be deciphered. The file structure itself is very similar to TIFF and is publicly documented. Obviously, it is a format designed to replace all the RAWs on the camera level. But that hasn't happened yet. Only a handful of high-end professional cameras capture DNG directly now, and the support in the software world is just as sparse. Sadly, for a photographer, DNG is yet another RAW variant right now.

And just when it looked hopeless, a man named David Coffin came into the game, saw the mess, rolled up his sleeves, and created an open-source freeware RAW decoder that supports them all. He called it dcraw (after his initials), and it looks like he really succeeded. At last count, it supports about 400 different cameras, and most applications that support RAW these days do it through dcraw. One man took on the burden of an entire industry by untangling that knot. Thank you, David, for this generous gift to the community!

But there is no such thing as a free lunch. Even dcraw is troubled. Over time it has become pretty complicated to configure, and it also suffers from a hush-hush update syndrome when yet another camera with a new RAW format comes out. Most applications that piggyback their RAW support on dcraw are notoriously behind or deliver medium-quality conversion at best. Artifacts like vignetting, lens distortion, chromatic aberration, and noise are best removed early on, and this is what dcraw-dependent programs all struggle with (read "all HDR utilities equally suck at this"). That's where dedicated RAW developers like Lightroom,

Aperture, and Bibble are still the better choice. DxO Optics Pro represents the pinnacle in terms of conversion quality because the DxO people maintain an excellent database of lenses, tested under lab conditions. They are well aware of every sensor's dynamic range limits and tune their algorithms specifically for individual camera/lens combinations.

Okay, so does it make sense to shoot in RAW format?

Absolutely yes, when you want to get the most out of your camera in a single shot. You will see later on that you can get way more out of multiple shots, and in that case, you might be fine with JPEGs.

But does it make sense to archive my RAW pictures?

Maybe, but you should not rely solely on it. You must be aware that your camera-specific RAW format will have a life span that does not exceed the life span of your camera. But the purpose of an archive is to give you a chance to safely restore all data at any point in the future. A standard HDR format like OpenEXR is much better suited for archiving because this standard is here to stay. The quality of the preserved data would be the same because an HDR image has even more precision and dynamic range built in than any of today's cameras' RAW files.

However, given the complexity of such a task with today's software, DNG would at least be a future-proof alternative. It's quite unlikely that Adobe will disappear anytime soon, and Lightroom, Photoshop, and Bridge already offer convenient ways to do exactly this conversion in a more convenient manner. Here again, DxO Optics Pro is ahead by writing the pre-corrections back into a DNG file, so you can feed clean image data to HDR programs that feature a native RAW development.

2.1.2 Cineon and DPX (.cin/.dpx)

Cineon was developed in 1993 by Kodak as the native output format of its film scanners. It quickly became the standard for all visual effects production because it is designed to be a complete digital representation of a film negative. Essentially, it's the RAW format of the movie industry. What's not in the Cineon file hasn't been shot.

One important difference between RAW and Cineon is that Cineon files are meant to be worked with. They start their life on film, then they get digitally sweetened with all kinds of manipulations and color corrections, and then they are written back onto film material. There is no room for anything to slip. Cineon is a so-called *digital intermediate*. That means it is the vehicle between the film reel that was shot on set and the film reel you see in the theatre.

How to file a film negative

What sets Cineon apart is that it stores color values that correspond directly to film densities. As discussed in Chapter 1, film has a logarithmic response to light. That's why color values in a Cineon file are stored logarithmically. It even has a mechanism built in to compress the contrasts at the upper and lower knee, just as in the density curve of film. In many ways a Cineon file is more closely related to HDR images than traditional 8-bit images, even though it uses

only 10 bits. That gives it $2^{10} = 1,023$ different intensity values, which is not much to cover the whole dynamic range of film. Only the logarithmic distribution makes it possible to have enough of those values available for the middle exposures—the meat of the shot. This "sweet spot" exposure range usually is set between the black point at value 95 and the white point at 685. Lower or higher values are the extra dynamic range, values brighter than white or darker than black.

A Cineon file is not made to be displayed as it is. You have to convert the logarithmic intensities to linear values, ideally with a so-called lookup table, or LUT. A LUT is a tone curve that was generated by accurately measuring the light response of film. They are slightly different for each film stock and usually created by the film manufacturer. Often, a generic conversion curve is good enough, but if you know the film stock that was used, you should use the LUT specific to the film stock. This way, each value in a Cineon file is precisely tuned to match the density of the film negative, and it also points to a linear RGB value that can be displayed on-screen.

These 10 logarithmic bits expand to roughly 14 bits when you stretch them out to linear space, so it makes a lot of sense to convert into a higher bit depth. In 8-bit, you will inevitably loose a lot of details. A 16-bit format is better in precision but still of limited use here because it does not follow the logic of having über-white or super-black values. You can cheat it by setting a white and black point somewhere within the intensity, but either the image you see on-screen will appear to be low contrast or you clip off the extra exposures. However, 16-bit images are not made for that. Exposure information beyond the visible range is clearly the domain of HDR imagery, where there is no explicit upper or lower limit.

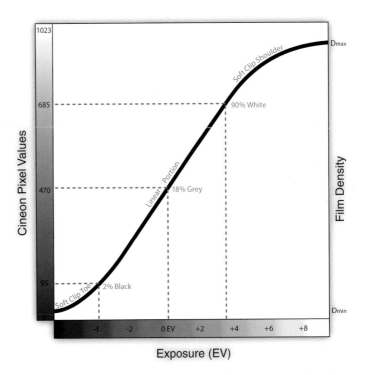

Figure 2-1: *Pixel values in a Cineon file directly correspond to densities on film material, thus sharing film's S-shaped response curve toward captured light intensities. Note that EV is a logarithmic scale, so the linear portion of the curve should be read as "precisely logarithmic."*

Unfortunately uncompressed

There is no compression for Cineon files, so they are always wastefully big. Each pixel on disk even includes 2 entirely unused bits. That's because 10 bits in three channels equals only 30 bits; they have to be rounded up to 32 to fit the next magic computer number. Cineon files are painful to work with in a compositing environment since it involves dealing with multiple sequences of numbered frames, which become huge in this case. A standard 2 K resolution film frame takes up 12 MB. Always. There is no such thing as playing this back directly from disk at 24 frames per second on a desktop machine.

Digital Picture eXchange (DPX) is the successor of the Cineon format. It is slightly modernized by allowing a larger variety of metadata information. This makes it less dependent on

the specific Kodak film scanner devices and more applicable for general use. However, the basic encoding is still the same: uncompressed 10 bits per channel.

DPX and Cineon both only qualify as medium dynamic range formats. Even though they can hold more range than a traditional image, they are limited to represent what can be captured on film. They do catch up with film but don't exceed to fully use the potential of digital imaging. And as digital sensors start to exceed film, Cineon and DPX will fall back.

2.1.3 Portable Float Map (.pfm/.pbm)

Let's move the focus over to the really high dynamic range formats. Portable Float Map is a very simple format; it's almost identical to the representation of a 32-bit floating-point image in memory. Essentially, it is a fully fledged RAW for HDR images.

A big dumb space eater

We are talking here about full 32 bits per pixel and color in a constant stream of floating-point numbers without any kind of compression. If you add that up, you need 96 bits, or 12 bytes per pixel; that is almost 25 MB for a simple HD frame, or 120 MB for a 10-megapixel photo. It's huge! This format will eat its way through your disk space in no time!

The advantage of this format is its simplicity. Each PFM file starts with a little header that states in plain text the pixel dimensions of the image. Even a novice programmer can now design software that reads the image data stream. Every programming language on the planet knows the standard IEEE notation for floating-point numbers, so it really is a piece of cake to read one number for red, one for green, one for blue. And voilà—we have an HDR pixel! Do that for all pixels in a row (the header told you how many there are), and then start the next row. No compression, no math, no confusion. Simple and straightforward.

Consequently, you are likely to see this format in prototyped software. HDRI is a very interesting medium for young computer scientists to develop revolutionary imaging technologies. The programs they write are considered a proof of concept, are often bare bones, and sometimes they perform only a single function. It can be very adventurous and a lot of fun to give them a shot, and in that case, the PFM format will be your buddy. Maybe that single function is a killer feature and you have no idea how you could live without it. In any other scenario, the Portable Float Map is just a waste of space.

Please note that Photoshop prefers to call this format Portable Bitmap Map and uses the filename extension .pbm. The file itself is identical to a PFM file, only the filename extension limits portability. So in case a program chokes on a PBM file, you just have to rename it using .pfm.

2.1.4 Floating-Point TIFF (.tif/.tiff/.psd)

Hold on—aren't we talking about *new* file formats? Nothing is older than TIFF!

Yes, indeed. Today's TIFF files still follow a specification that dates back to 1992. And that was already revision 6 of the format. Who knows, it might have been invented before color monitors.

The TIFF format comes in many flavors, and when Adobe bought the format in 1994, it added even more variations. One substandard even applies a JPEG compression to the image data, mixing up the whole concept of different file formats having different characteristics. Adobe acquired TIFF for a very practical reason: Photoshop's PSD format is very similar. It's extended with adjustment layers and a lot of proprietary metadata, but the basic structure of PSD files is definitely inspired by TIFF. That's why for all practical purposes, anything said in the following sections applies to PSD files as well.

Whatever you want it to be

In programmers' terms, TIFF is considered a wrapper—because the image data is wrapped in descriptive tags. It's the tagged file structure that makes a TIFF file so versatile because it allows all kinds of different image data to be included. Color space can be RGB or CMYK or something fancy like CIE L*a*b*, compression can be ZIP or RLE, the bit depth can be anything from 1 bit (black and white) to 32 bits per channel. You name it. As long as the data is labeled with the proper tag, an application knows how to deal with it. TIFF is really just an acronym for *tagged image file format*. Well, that sounds good in theory. In reality, not every application supports every compression method or data format, and so it is quite easy to produce an incompatible TIFF. In fact, some features are supported only by the owner, Adobe.

Has all the features, but none of them reliable

Even the original specification allows a 32-bit floating-point variant, often referred to as FP-TIFF, TIFF32, or TIFF Float. This is pretty much the same raw memory dump as the PFM format, and so the file size is just as huge. Compression could technically be used here, but this limits the compatibility again. It doesn't make much sense anyway because old-school compression algorithms like LZW and ZIP are not made for crunching down floating-point data. The added overhead can even cause a compressed TIFF32 file to be slightly bigger than an uncompressed one.

And since all features of TIFF can be combined however you want, a TIFF32 file can also have layers and extra channels, they can be cropped to a specific area, and they can have color profiles embedded. It's just that every program has its own way of reading and writing a TIFF, and so there is no guarantee that a feature will work. In a practical workflow, the plain uncompressed TIFF32 is usually the only one that works reliably.

For a long time the TIFF32 variant was considered a purely hypothetical, ultimate preci-

Figure 2-2: *Confusing variety of options for saving a floating-point TIFF, only in Photoshop.*

sion format. In the nineties, you would need a Cray supercomputer to deal with it, and so it was used primarily in scientific applications like astronomical imaging and medical research. Even though our twenty-first century laptops are able to beat these old refrigerator-like behemoths with ease, it would be a wasteful habit to use TIFF32 for all our HDR imagery. We would spend all day watching loading and saving progress bars.

What it's good for

There are some occasions when this format comes in handy. In a workflow using multiple programs in a row, you can use uncompressed TIFF32 for the intermediate steps. This way you eliminate the possibility of image degradation when the image is handed back and forth. There are other formats that minimize degrading, but nevertheless, even so-called lossless encoding/decoding can introduce tiny numerical differences. Only the straight memory dump method of uncompressed TIFF32 and PFM makes sure the file on disk is 100.00% identical to what was in memory. The same goes for PSD, since that's just Photoshop's own variant of TIFF32. It is good practice, however, to get rid of these intermediate files when you're done—before you spend all your money on new hard disks.

2.1.5 Radiance
(.hdr/.pic)

The Radiance format is the dinosaur among the true high dynamic range formats, introduced in 1987 by Greg Ward.

Accidentally founding HDRI

Greg's original intention was to develop an output format for his 3D rendering software called Radiance, which was so revolutionary itself that it practically founded a new class of render engines: the physically based renderers. Unlike any other renderer before, the Radiance engine calculates an image by simulating true spectral radiance values based on real physical luminance scales. For example, the sun would be defined as 50,000 times brighter than a light bulb, and the color of an object would be defined by a reflectance maxima. Chapter 7 will give you a more elaborate insight on physically based render engines.

Anyway, these light simulations require the precision of floating-point numbers, and they take a long time. They are still expensive today, but back in 1985 there must have been an unbearably long wait for an image. Concerned about retaining all the precious data when the result is finally saved to disk, Greg Ward introduced the Radiance format. Initially, he chose .pic as the filename extension, but this was already used by at least three entirely different image formats. Paul Debevec later came up with the suffix .hdr, which has been the primary extension ever since. This is how they both laid the foundation for high dynamic range imaging, which turned out to evolve into a field of research that has kept them busy ever since.

The magical fourth channel

Back to the actual format. Radiance is the most common file format for HDR images, and the filename extension basically leads to the assumption that it would be the one and only. It does use a very clever trick to encode floating-point pixel values in a space-saving manner. Instead of saving a full 32 bits per channel, it uses only 8 bits for each RGB channel. But it adds an extra 8-bit channel that holds an exponent. In short notation, the Radiance format is called

RGBE. What this exponent does is free up the RGB values from the extra burden of carrying the luminance information and multiplies the possible brightness range. The real floating-point value of a pixel is calculated with this formula:

$$\frac{(R, G, B)}{255} \times 2^{(E-128)}$$

It's a simple math trick, but very effective. Let's look at an example: A Radiance pixel is saved with the RGBE color values (100,100,130,150). The first three values describe a pale blue. Now, watch the exponent at work:

$$\frac{(100, 100, 130)}{255} \times 2^{(150-128)}$$

$$= 1640000, 1640000, 2140000$$

Compare this to a pixel with the same RGB values but a different exponent, let's say 115:

$$\frac{(100, 100, 130)}{255} \times 2^{(115-128)}$$

$$= 0.0000479, 0.0000479, 0.0000622$$

See, the exponent really makes the difference here between blue as a desert sky and blue as the entry of a cave in moonlight. It is a very elegant concept, and a math-minded person can easily see the poetry in its simplicity. Using only 32 bits in total, symmetrically split in RGBE channels, we can store a color value that would have taken 96 bits all together. That's why even an uncompressed Radiance image takes up only a third of the space a floating-point TIFF would need.

More range than we'd ever need

Note that we changed the exponent by only 35. But just as with the 8-bit color channels, we have 256 different exponent levels at our disposal. The full numerical range is more than seven times higher than in our example. Actually, this example was chosen carefully to stay within the numerical range that a human mind can grasp. It literally goes into the gazillions and the nanos. The dynamic range that this format is able to hold is truly incredible. Speaking in photographic terms, it's 253 exposure values, much higher than any other format can offer. It's even higher than nature itself. From the surface of the sun to the faintest starlight visible to the naked eye, nature spans about 44 EVs. An earthly scene doesn't exceed 24 EVs, even under the most difficult lighting conditions.

Technically, that much available variable space is a waste. Since we will never need that much range for an image, uncompressed HDR files always contain a whole bunch of bits that are just plain zeros. Instead of having 10 times the range that we could possibly use, the format could have 10 times the precision. That way, the colors we actually use would be even better preserved and we would have even less of a risk to get banding and posterization through subsequent editing steps. However, the precision of the Radiance HDR format is still way beyond any 8- or 16-bit format, and since every image source introduces at least some kind of noise, the Radiance format is more than precise enough for general photographic use. Also, there is a run-length encoding (RLE) compression available for this format, which means that the filled-in zeros get crunched down to almost nothing. It's a lossless compression by nature, so you should definitely use it—you can save roughly 30 to 50 percent disk space with it.

But there is another, more serious caveat to the Radiance format. Since the base color values are limited to positive values, it suffers from a limited color gamut just like many other traditional RGB formats. It's not exactly as tight because it can keep color consistent through the whole range of intensities. The available color palette in 8-bit RGB gets very limited close to white and black—simply because all three

values are so close to the limit that you have no room left for mixing colors. A Radiance HDR would leave the RGB values alone and change the exponent instead. However, as explained in section 1.5, color management is tremendously simplified with negative color values because this will even preserve colors previously considered outside of the color space. In a Radiance HDR, they will just be clipped, which will become apparent when you shot your original exposures in a wide gamut color space like Pro-Photo or AdobeRGB.

Clipping colors is pretty much the opposite of the preservative concept behind HDRI. And even though the Radiance format specifications feature a variant in XYZ color space, that doesn't help us much because this variant is not widely supported.

So when should we use this format, then?
We should use the Radiance format whenever dynamic range is the main concern over color precision. In image-based lighting, for example, we are aware of the colors getting all scrambled up in our render engine anyway. It's the intensities that we want to feed these algorithms so they can deliver a good lighting solution. We will talk about the details in Chapter 7.

The second major advantage is portability. Radiance HDR is very widely supported; for HDR programs it's the most common denominator. That might be due to its elegant formula and the simplicity of implementation. You would not even need a library or DLL because even a novice can hard-code this conversion. It might also be due to the historical age of the format or simply the filename extension .hdr that makes it so popular. We don't know. Fact is, Radiance HDR is a well-established standard format, and you are doing good using it when you want to keep all software options open.

2.1.6 TIFF LogLuv (.tif)

Oh no, not another TIFF format!

Yes. TIFF is a 10-headed hydra, and this is yet another head. It's by far the one with the most human-looking face because it stores colors based on human perception.

Greg Ward, once again, developed this format in 1997 when he realized that the popularity of his Radiance format took off in unexpected ways. He was entirely aware of the color and precision limitations that are inherent in the RGBE encoding. So he went back to the drawing board and sketched out the ultimate image format, designed to become the future-safe standard for high dynamic range imaging.

Made to match human perception
And indeed, technically the LogLuv encoding is superior to all others in overall performance: It can represent the entire range of visible colors and stretches over a dynamic range of 16 EVs with an accuracy that is just on the borderline of human vision. And it manages to pack all that information in 24 bits per pixel—just the same amount of space that a traditional LDR image takes. It's that efficient.

How is that even possible?

First, instead of the RGB color space, it uses the device-independent LUV color space, the same space that the reference CIE horseshoe diagram is set in. That's how it makes sure that

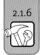

it can really show all visible colors. *L* represents the luminance, which is logarithmically encoded in 10 bits. That means the smaller the value, the smaller the increments, which is pretty close to the way film reacts to light intensities. And as we discussed in section 1.2, this just happens to be the way the receptors in our eye respond too.

Now, what it does to the UV color coordinates is so ingenious, it's almost crazy! Instead of picking three primary colors and spanning a triangle of all the representable colors (as RGB, CMYK, and all other color spaces do), it simply puts an indexing grid on the entire horseshoe shape of visible colors. It basically assigns each color a number, starting the count from the low purple-bluish corner. The resolution of this grid is set so high that the color differences are just imperceptible to the human eye. Fourteen bits are used for this index, so we are talking about $2^{14} = 16,384$ true colors here.

Sounds good, doesn't it? Everything perfectly aligned to the margin of human vision. The perfect image file for a human beholder, but a perfect nightmare for a programmer. This is just not a convenient way of encoding. It is superefficient, but converting RGB to LUV color space first and then using a lookup table to find the color index—all this is somewhat missing the elegance.

There is a variant that uses 32 bits per pixel instead of 24. This one is a little easier, and it's also more precise. Here we have 16 bits instead of 10 for the luminance, and the color values are stored separately in U and V coordinates with 8 bits each. That way it's better suited for images that are not yet in the final stage of editing because there is more room to push pixel values around without having their differences break through the threshold of human vision.

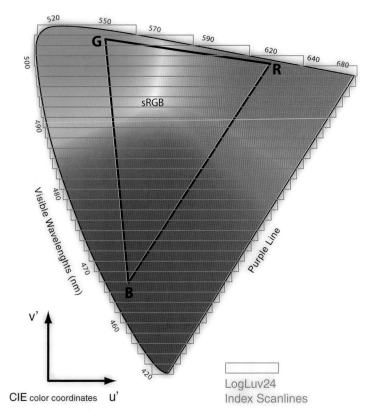

Figure 2-3: *TIFF LogLuv's indexed color scheme covers the entire range of visible colors.*

Using TIFF LogLuv in practice

Even though the overall performance and efficiency of LogLuv encoding is unmatched, it never became the standard that it was designed to be. Only a few programs fully support it. Some applications can load it but don't offer it as a saving option. Some support the 32-bit variant but not the indexed 24-bit version. Some programs even think they are loading a floating-point TIFF and load it up as pixel garbage. And from a user standpoint, it is a disaster that it shares the common .tif filename extension because there is no other way of determining the level of support than the old trial-and-error game. The problem lies within the fact that every program uses a different way of reading and writing TIFFs. If they all would just

link to Sam Leffler's library, everything would be fine. But then again, they would be missing other TIFF features that are only available in other libraries.

Bottom line: TIFF LogLuv is just too good to be true. You simply can't rely on it as an exchange format unless you run a test.

2.1.7 OpenEXR (.exr/.sxr)

OpenEXR is the shooting star among the HDR image formats. It was born in visual effects production and is specifically designed for image editing and compositing purposes. It's also the only image format that won an Oscar.

Florian Kainz developed this format at Industrial Light & Magic (ILM) in 2000 because he saw that none of the existing formats really fit the needs of visual effects production. For those few readers who have never heard of ILM, it's the company George Lucas started specifically to create the effects in the *Star Wars* saga. The first movie ever completed entirely in EXR was *Harry Potter and the Sorcerer's Stone,* and since then this format is used exclusively in all the in-house tools at ILM. It seems to serve them well.

ILM released this format to the public in 2003 as open source. It comes with a great package for developers that includes detailed documentation, code pieces from working implementations, and even example pictures that can be used for tests. Obviously, that was a move to encourage software vendors to make their products fit into ILM's production pipeline. And the response was overwhelming—everybody wants to have ILM on their client list. The beauty of it is that this made OpenEXR widely available for the rest of us too.

16 is the new 32

OpenEXR is indeed a beautifully crafted format. The core specification is based on the so-called "half" data type. That means it rounds each color channel's 32-bit floating-point numbers down to 16 bits. That might sound like a drastic decrease, but in reality it's all the precision you need. It's certainly much more precision than Radiance HDR and TIFF LogLuv have to offer because it keeps the color channels separate at all times. So all three RGB channels add up to 48 bits per pixel, 16 in each channel. Don't confuse this with a traditional 16-bit format—those are all regular integer numbers, but we are talking about floating-point numbers here. They are substantially different because they are not capped off at the white point!

The 16 bits here are split into 1 sign bit, 10 bits mantissa, and 5 bits for an exponent. Effectively, this mantissa allows you to save $2^{10} = 1,024$ different color values for each channel. If you multiply all three channels, you get about 1 billion possible colors—independent from the exposure. So these are 1 billion colors per EV. This is more than any other format can offer (except maybe the space hogs PFM and TIFF32). And in terms of dynamic range, this is what's carried in the exponent; each exponent roughly equals one EV. That means OpenEXR can hold about $2^5 = 32$ EVs, which is very reasonable for photographic image sources.

For true dynamic range freaks, there is also a full 32-bit floating-point variant. In most applications this is just bloat, though, and all it does is slow you down. It's comparable to the floating-point TIFF again. The 16-bit version is significantly faster to work with. First of all, it loads and saves faster, but more interesting is the

Figure 2-4: *OpenEXR files can have layers, which makes them formidable containers for 3D renderings. Photoshop, however, needs a little help from the ProEXR plug-in before it can handle multilayered EXR files.*

native support by modern graphic cards from NVidia and ATI. If you are shopping for a new graphics card, look for the "CG shader language" feature. The next generation of image editors will be able to use this for doing all kinds of heavy-lifting work on the GPU, and then you won't even notice the difference between editing an HDR or an LDR image anymore. It seems that 16-bit floating-point is on the fast lane to becoming one of the hottest trends right now. Programs like Fusion and Nuke already offer 16-bit FP as color depth to work in, and hopefully more will follow this model.

Compression and features

OpenEXR also offers some very effective compression methods. Most widely used is the PIZ compression, which is a modern wavelet compressor at heart. It is visually lossless and specifically designed to crunch scanned film images down to something between 35 to 55 percent.

Another common lossless compression is ZIP, which is slightly less effective but faster. Where speed is a concern, as it is for 3D texture mapping or compositing with many layers, this is a better alternative. PIZ and ZIP are both widely supported, and you can't go wrong with either one. There are many other compression methods possible in OpenEXR, and the format is prepared to have new ones included.

Sounds good? Wait—here is the real killer feature! OpenEXR supports layers and arbitrary channels. So besides a red, a green, and a blue channel, it can also include an alpha channel. And others, too—like depth, shadow, motion vectors, material—you name it. These channels can have different compression, different precision (16- or 32-bit), and even different pixel resolutions. That makes it the ideal output format for CG renderings because it gives you the freedom to fine-tune every single aspect of a rendered image in a compositing software.

There's even a recent update to the format to support stereo imaging. That simply defines one image layer for each eye; the filename extension is .sxr for Stereo eXR.

Another pretty unique feature is the separation of pixel size and viewer window. For example, an image can have a 100-pixel margin all around the actual frame size. These out-of-frame pixels are normally invisible. But whenever a large-scale filter is applied to the image, like a Gaussian blur or a simulated camera shake, this extra bit of information will be invaluable. On the flip side, the pixel space can also be smaller than the actual frame size. That way, you have a predefined placement for the pixel image, which can be convenient for patching a small piece of a 3D rendering that went wrong. Well, at least it works great for ILM artists, but both of these features are sparsely supported in applications on our side of the fence. Currently, Nuke is the only compositing application that can work with it, and all 3D apps have to be patched with third party plug-ins. It's coming, though. Photosphere, for example, is using this window property as the default clipping frame for display. And with the plug-ins infiniMap (for Lightwave) and V-Ray (for 3ds Max), you can even create tiled EXR files. That means the image data is cut into several tiles and layers of varying resolution that are precisely positioned with the viewer window. From the outside it still looks like a single file, but with these plug-ins, you don't actually have to load the whole image into memory. You can use a gigapixel-sized image as a texture map, and it will load only the pixel information that is shown on-screen. Believe me, it's nice to pan around in a 50,000-pixel-wide image while keeping render times under 10 seconds.

OpenEXR is a true workhorse. It's so powerful and flexible that even Pixar abandoned its own image format, which used to be a logarithmic TIFF variant similar to the Cineon format. Instead, Pixar jumped on the EXR bandwagon and even contributed a new compression scheme called PXR24.

The only reason not to use EXR would be when your favorite software doesn't support it. In that case, you should instantly write a complaint email to the developer and then go on using the Radiance format instead.

Update: Current state of EXR support

Looks like many first-edition readers have followed my call for rebellion. As of 2011, EXR really is the standard format that all HDR software can handle. Most programs, however, support only the minimum set of features (I'm looking at you, Photoshop!). Thankfully there are third-party developers. The ProEXR plug-in from Fnordware teaches Photoshop to work with layers and channels in an EXR file—in whatever compression scheme you desire. As long as you stay away from adjustment layers, ProEXR is a much better alternative to using the 32-bit PSD file format: it keeps all your layers intact, yet it's roughly 10 percent of the file size.

Even though most compositing programs support layers and channels (see section 2.6), these features get limited use in the practice of compositing CG renderings. The portability issue may be one reason. But an even bigger problem is cumulative file size. Including every possible render buffer in one monolithic file sounds more convenient than it really is. It adds a lot of loading time for layers that may not even be used, it strangles the bandwidth of network file servers, and the workflow gets really messy when only a single layer needs to be updated. Therefore, most CG artists embed only the essential buffers (alpha, z-depth, maybe xy-motion) and save all the rest (reflection, ambient occlusion, etc.) as individual EXR files. See section 7.3.2 for a detailed introduction to multilayer rendering.

2.1.8 High Dynamic Range JPEG (.jpg/.fjpg)

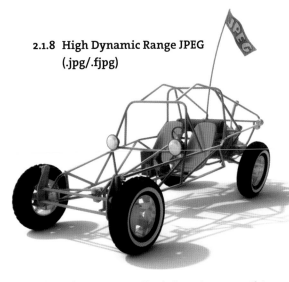

All the formats we talked about have one thing in common: they preserve the image in a loss-less way. Saving and reloading the file will cause no loss in quality; ideally, the file will be identical down to the bit. This is great for editing and archival, but even the smartest encoding method will produce quite a large file.

But high dynamic range imaging is reaching a state where the applications are appealing to a wider audience. It's inevitable that it will replace traditional imaging in the not-so-distant future. There are already HDR monitors commercially available, and if you have been to a modern movie theatre lately, you might have seen a digital projection that reproduces more DR than traditional images can handle. Digital cameras are tapping into higher ranges too, but the only way to benefit from this is through a jungle of RAW formats. Most people don't really shoot RAW because they prefer demosaicing the sensor data themselves. It's the extra bit of dynamic range, and the ability to fine-tune exposure settings, that attracts 90 percent of the RAW users, according to a survey from Open-RAW.org. And this is just the beginning. Over the next couple of years, both ends of the digital imaging pipeline, input and output devices, will become high dynamic range capable.

What we desperately need is a compressed HDR format so we can feed those images efficiently through low-bandwidth channels to all our new gadgets. Common bandwidth constraints are the Internet, wireless networks, and just the limited capacity of a consumer-grade device. We need an HDR format that is comparable to JPEG, with a compression ratio that might be mathematically lossy but visually acceptable.

The story of ERI

A first attempt to craft a highly compressed HDR format was made by Kodak. In 2002, it introduced the ERI-JPEG, which stands for *Extended Range Imaging JPEG*. Kodak's trick was to generate a regular JPEG image and use the EXIF metadata as carrier for additional range

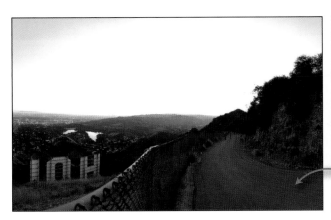

Figure 2-5: *Base JPEG as seen by any regular viewer.*

Residual ERI image, hidden inside the metadata.

Figure 2-6: *Website visitors can change exposure with the + and – keys, directly in the browser. Made possible by FJPEG displayed with the free PTViewer applet.*

information. It literally hides a second JPEG inside that holds the additional shadow and highlight details of areas where the regular image is clipped off. For an image where the whole range actually fits in, this additional data is down to nothing. And so the file is just as big as the primary plain JPEG. When there is additional dynamic range, the file size increases accordingly, which is very reasonable for the amount of extra information. It is at least a million times more efficient than preserving extra dynamic range with RAW files.

The resulting ERI-JPEG is fully compatible to the EXIF2.1 standard. Software that doesn't understand the extra range information can still open the low dynamic range part without any problems.

Unfortunately, this applies to almost every program. After being around for 10 years, ERI-JPEGs can still be interpreted only by Kodak's own software, like DSC Photo Desk and FFM Photoshop Importer. We're back to the old problem of proprietary RAW formats. We are even dealing with a prime example here because the camera line that this format was originally developed for, the Kodak DCS Pro, has been discontinued after only two years on the market.

So if you happen to be the owner of one of these $5,000 to $8,000 cameras, you'd better convert your photo library to OpenEXR soon because official support from Kodak expired in 2008, probably along with the warranty of the last camera sold.

It seems as if Kodak was a bit too far ahead of its time. Apparently, it is not making any effort to implement ERI-JPEGs in its consumer-grade cameras either. Doctor, I think it's safe to declare this patient dead.

The way of FJPEG

FJPEG stands for *Floating Point JPEG*, which was developed by Helmut Dersch in 2003. Professor Dersch holds a hero status in the panorama community for the creation of his PanoTools software suite, which represents the foundation for most high-quality panoramic stitching software today. We will get back to that in section 6.4.6.

In essence, FJPEG follows the same approach of abusing the metadata for dynamic range data. But the range increase is achieved differently. Dersch adopted the RGBE approach from the Radiance format. Remember? The math trick with the exponent? Each of the RGBE channels in itself is just regular 8-bit. So, Dersch simply splits the RGB channels off and makes a regular JPEG out of it. The E channel is used to form a grayscale image and sneaked into the file. If that sounds like a hack, that's because it is.

But it works. It's a true HDR format that works on the Internet. That's because it was originally written for Dersch's own PTViewer, a free Java applet. This is a nice little compatibility shortcut because Java applets don't require the installation of anything extra. They can be run off the server that hosts the images. As long as the browser is Java enabled, it can display the HDR image directly. The image is dynamically tonemapped for display with a very simple exposure+gamma method. You can either set

the exposure via shortcuts or pan around in autoexposure mode.

However, the drawback is that the PTViewer applet is the one and only piece of code that reads FJPEG. There is no sign of direct application support anywhere, and if Dersch hadn't made a command-line utility for converting HDR to FJPEG, we couldn't even generate an FJPEG. Also, support by all HDR-capable software might not be the best option because the format itself is seriously flawed.

The RGB part of a Radiance HDR image, and thus the base image of an FJPEG, looks entirely scrambled when seen with a regular JPEG viewer. These channels were never intended to be seen without getting scaled up to their true exposure level by the exponent. Hence, every EV is forming a separate band of hues and shades.

The exponent, on the other hand, is not applied on a per-pixel basis but rather shared across an 8×8-pixel block. This has something to do with the way JPEGs are encoded in general; the geek term for the encoding method is *Discrete Cosine Transformation (DCT)*. We have all seen the effect of it a million times as JPEG blockiness, mostly pronounced as artifacts at low-quality settings. You see, 8×8-pixel blocks are somewhat like the atomic elements of a JPEG. It is a very crude assumption that the whole block would be on the same exposure level and could share the same exponent. That works fine for smooth gradients and mostly continuous areas, but on hard edges with very strong contrast, this assumption falls entirely flat. Backlit objects and sharp highlights are where the regular JPEG artifacts are getting amplified, until that pixel block is totally wrecked.

This is FJPEG. Far from perfect, but the best we have right now. Actually, these pictures don't really do it justice; the actual sensation of adjustable exposure in a web image is still a breathtaking experience. Make sure to check out the gallery on www.hdrlabs.com!

Figure 2-7: *Drawback: In a regular image viewer, FJPEGs look completely scrambled.*

Figure 2-8: *High contrast edges are severely wrecked in an FJPEG.*

The future of JPEG-HDR

Once again, we have a format that was made by Greg Ward, teaming up this time with Maryann Simmons from Disney. They crafted this format in 2004, so we have a nice constant flow of high dynamic range JPEG formats popping up every year. Except that this time, they got it right.

JPEG-HDR uses the same metadata trick, but it goes one step beyond by adding another level of preparation. The base image is a tonemapped representation of the original HDR image and fully complies with the existing JPEG standard. The extra dynamic range is hidden in the EXIF

Figure 2-9: *JPEG-HDR looks just fine in a regular image viewer ...*

Figure 2-10: *...except that all the extra details are fully preserved and can still be extracted to manually tonemap the image.*

metadata in the form of a ratio image. This ratio image is substantially different from the other formats—it is much smaller while preserving much more dynamic range.

Old-school applications think it is a regular JPEG and show the tonemapped version instead. That means even an application that is limited to work with 8-bit imagery doesn't show clipped highlights. The image is preprocessed to maintain all color information. Unlike the ERI format, where the base image shows only the middle exposure window, this one

shows all the details across all the exposure levels within.

Smarter applications that can find the hidden ratio image can recover the original HDR image. In Photosphere, for example, I could tap through the exposures and it would look just like the FJPEG in PTViewer—but without the artifacts. I could even go ahead and manually tonemap it into exactly what I want for print. Because everything is still there.

Using JPEG-HDR is an excellent way of handling backward compatibility. That is an important issue because the legacy of 8-bit imaging is huge. JPEG has an immense installment base; every device or program that has even remotely something to do with digital images can handle JPEGs. And this is not likely to change anytime soon. Having a compatible HDR format like this, one that even takes the limitations of 8-bit imaging into account, allows for a smooth transition. If the new camera model XY can handle internally a higher dynamic range than it can fit into a JPEG, this is a true alternative to inventing yet another RAW format. The algorithms for encoding a JPEG-HDR are especially optimized for speed and portability, so it's rather easy to implement it directly in a camera's firmware. Convenient for us, the same metadata trick even works for MPEG and other movie formats. So, this could really be the missing link in an end-to-end HDR pipeline from camera to monitor.

Are we there yet?

Unfortunately, not quite. Even though JPEG-HDR is documented well, every implementation has to be licensed by Dolby, who owned this format for years. This is really just Dolby's way to guarantee a quality standard of implementation, but it brings to mind images of a big red neon sign labeled "outside dependency" in management offices. What it takes is a major player to throw the first stone. Someone who can push a monolithic device into the market

with enough momentum that it establishes a de facto standard. Personally, I would wish for Apple or Sony to get over their pride. "Dolby Vision" is not the worst sticker to slap on the box.

So, what's the state of high dynamic range JPEGs? Kodak's ERI-JPEG was a nice try, but it hasn't come very far. FJPEG is an ugly hack, but it works in most browsers here and now. JPEG-HDR is the sleeping princess that is locked away in a remote tower somewhere on top of Dolby Laboratories.

JPEG-HDR support is coming, though. The chipmaker Qualcomm has licensed it for the Snapdragon S4 processor, which is expected to power the next generation of Android smart phones and tablet devices. Let's hope this is the snowball that launches an avalanche of true HDR capabilities in consumer devices.

2.1.9 Windows JPEG-XR/HD Photo (.wdp/.hdp/.jxr)

Microsoft premiered this image format in Windows Vista, and it's built into the system ever since. It started its life in 2006 as Windows Media Photo, was then renamed to HD Photo, and has lately been knighted by the independent JPEG committee under the name JPEG-XR. Note that all these names refer to exactly the same file format. For example, you can use the free HD Photo Photoshop plug-in to save an .hdp file. Just rename it with the .wdp or .jxr filename extension and then open it in Windows Live Photo.

Unlike the latest name, JPEG-XR, suggests, this format is not compatible with older JPEG readers. Instead, it is a completely new standard with the architecture of a TIFF-like container format. That means it can hold all sorts of image data, as long as it's properly labeled and tagged. Most good encoding methods that make other formats successful can be used here as well. JPEG-XR supports the 16-bit floating-point notation from OpenEXR as well as the RGBE Radiance encoding in full 32-bit. On top

Figure 2-11:
The Dolby Theatre in Hollywood is the home of the Academy Awards. It also is a statement that Dolby is serious about high fidelity imaging.

of that, it can have embedded EXIF and XMP metadata, ICC profiles, alpha channels for transparency, even color channels in CMYK for printing. Another strong selling point is a novel compression scheme, which is outperforming JPEG in quality and speed. It's a wavelet compression, similar to JPEG2000 or the PIZ compression known from OpenEXR.

One particularly cool feature is called tiling, which is the ability to read and decode only a requested part of an image. This is great for navigating massive collections of images at interactive rates. PhotoSynth, SeaDragon, DeepZoom—all the cool futuristic technology that came out of the Microsoft labs over the last couple of years rely on this tiling feature.

Even though this format is now technically an integral part of Windows Vista and Windows 7, each program cherry-picks the features to support. For example, Windows Live Photo

Gallery can deal with wide gamut color spaces in a JPEG-XR but not the HDR data this format may hold. Same goes for Photosynth, Silverlight DeepZoom, and Internet Explorer 9. For a very brief moment in history, Microsoft HD View could show gigapixel-sized HDR panoramas with real-time tonemapping, but that feature got somehow swept away in the whirlwind zone called Microsoft Live Labs.

So the good news is that this format is getting around a lot. Microsoft even offers a free Device Support Developers Kit, in the hope that camera makers will offer JPEG-XR as an alternative to JPEG and RAW. The bad news is that it has been largely ignored so far by HDR software makers, and the support is largely limited to the Windows platform. Three different names for the same format doesn't really help JPEG-XR's popularity either. It still has a hard time running up against already well-established standards, especially when even Microsoft's own applications only use the old-school 8-bit variant, where there are established standards that deliver equal or better quality and are superior in portability and availability.

2.1.10 Private Formats

As numerous programs started working in 32-bit floating point, developers added their own file format. These proprietary file types are not standardized at all; some are not even documented. Usually they are intended to work only in the software they come with. Even if a third party claims to support a particular file type, that support is only possible by reverse-engineering and might stop as soon as the owner changes the specification or adds new features without notice. Happens all the time; that's the whole point about having a private file format.

So be careful! Here is just a quick list:

PSD (.psd): Photoshop file; a close relative of floating-point TIFF

PSB (.psb): Photoshop big files that can grow bigger than 2 GB

FLX (.flx): LightWave's native 32-bit format; can have extra channels embedded

RLA (.rla): Ancient SGI format used as render output; can have extra channels

RPF (.rpf): Autodesk's Rich Pixel Format, retains a lot of extra render data

ATX (.atx): Fhotoroom (formerly Artizen) file; allows layers

MAP (.map): Softimage XSI texture map; direct memory dump

CT (.ct): mental ray floating-point image

PFS (.pfs): Used as exchange format between command-line modules of pfsTools

MIFF (.miff): ImageMagic's intermediate file format; capable of 32-bit precision

SPH (.sph): Raw panorama files captured with a SpheronVR camera

BEF (.bef): HDR Expose's native 32-bit format; comes with Photoshop plug-in

VFB (.vrimg): Multi-layered V-Ray framebuffer file; can be converted to EXR with a command-line utility or loaded in Photoshop with the Pro-EXR plugin from Fnordware

XDepth (.xdp): Compressed HDR format by Max Agostinelli, similar to JPEG-HDR; free plugins available for Photoshop, Picturenaut, Lightwave, and Internet Explorer; also exists as HDR video codec (with a dedicated video player)

There might be more; these are just some of the most common ones. The noteworthy point is that none of them makes a good exchange format.

2.2 HDR File Format Comparison

Based on the detailed reviews, I compiled a comparison table for you. It sums up all the important points and can be used as a quick guide for setting up a high dynamic range workflow.

Table 2-1: *Tech specs of HDR file formats.*

	TGA* (8-bit RGB reference)	PFM	TIFF float	Cineon, DPX*	TIFF LogLuv 24/32	Radiance HDR	OpenEXR	JPEG-HDR	Windows JPEG-XR (HD Photo)
Channels	RGB (+Alpha)	RGB	RGB (+Alpha +Layers +...)	RGB	L+Index/Lu'v'	RGBE	RGB (+Alpha +Depth +...)	YCC	RGBA/ CMYK +...
Total Bits per Pixel	24	96	96	32	24/32	24	48	variable	variable
Compression	RLE	–	ZIP, LZW	–	RLE	RLE	PIZ, ZIP, RLE, PXR24, ...	JPEG	wavelet
Covers All Visible Colors (Gamut)	–	–	✓	–	✓	–	✓	✓	–
Colors per EV**	≈2 million	4.7×10^{21}	4.7×10^{21}	90 million	1 million/ 33 million	16 million	1 billion	variable	variable
Precision	●○○	●●●	●●●	●●○	●●○	●●○	●●●	●○○	●○○
Dynamic Range (EVs)	8	253	253	12	16/126	253	32	30	variable
Application Support Level	●●●	●○○	●●○	●●○	●●○	●●●	●●●	●○○	○○○

Notes:

* Targa, Cineon, and DPX are not real HDR formats. They have just been included as common reference points for comparison.

** Colors per EV is my own scale to quantify the color precision independent from the dynamic range performance of a format. Actual numbers were derived with varying methods. For a format that has a separate exponent, it's simple: Let's say OpenEXR uses 10 bits of mantissa for each color, which makes 2^{10} = 1024 values per channel, which makes $1024^3 ≈ 1,000,000,000$ colors. Since each exponent can roughly be seen as one EV, that would be 1 billion unique colors per EV.

For 8-bit TGA, it's an entirely different case. Here I divided all the colors possible by the stops this format can properly handle, such as $256^3/8$ = 2,000,000. Be aware, though, that this is a very rough estimation since this number is seriously skewed by gamma encoding.

2.2.1 Size matters!

So how big are these files really? For practical usage, this is probably the most interesting factor. I picked three different test images of varying complexity and image dimensions. Each image was saved with the most common compression option. Windows HD Photo was left out because nobody really uses this format anyway, but its file size would fall within the same realms as JPEG-HDR. Note that LZW compression in TIFF Float can be a compatibility problem. The safe route is uncompressed TIFF Float, in which case these files are just as big as PFM files.

Table 2-2: *File size of real-world photographs in different HDR file formats.*

	TGA* (8-bit reference)	PFM	TIFF Float	Cineon, DPX*	TIFF LogLuv 24	Radiance HDR	OpenEXR	JPEG-HDR
Compared Compression	RLE	—	LZW	—	RLE	RLE	PIZ	JPEG quality "Best"
Full HD Frame (1920×1080)	6.0 MB	23.8 MB	13.2 MB	8.0 MB	5.0 MB	6.2 MB	6.4 MB	0.5 MB
10 MP Photograph (3872×2592)	26.2 MB	115.0 MB	104.1 MB	38.4 MB	22.2 MB	24.5 MB	18.7 MB	1.8 MB
32 MP Panorama (8000×4000)	88.9 MB	366.3 MB	140.2 MB	122.2 MB	58.8 MB	87.8 MB	59.6 MB	4.8 MB

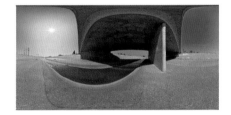

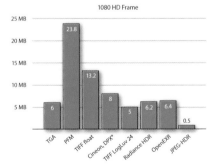
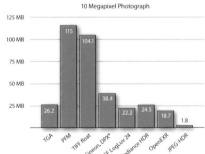
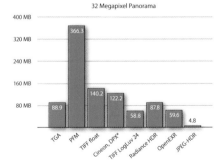

2.2.2 Conclusion

OpenEXR offers the best overall performance, with a balanced mix of efficient compression, sufficient range, and superior color precision. Its unique ability to handle arbitrary channels makes it the perfect choice for compositing and postproduction.

Radiance HDR comes in second place, with extreme dynamic range but less accuracy in color preservation. The absence of an alpha channel is one particular drawback that makes it less useful for compositing and image editing. Radiance used to have the broadest support base, which made it a fail-safe choice for compatibility. But this sole advantage is fading quickly. All the new breed of HDR software supports OpenEXR; some even dropped Radiance support, which ultimately is a good thing.

Note that both formats are not bigger than a Targa image and certainly much smaller than Cineon or DPX.

2.3 HDR Software Reviews

Parallel to these new image formats, new software had to be developed. This was an urgent necessity because traditional applications used to work internally with 8 bits per color channel. Supporting a 32-bit format in such an application requires quite a bit more than just a simple loader plug-in. The entire architecture needs to be updated to work in floating-point precision, which in turn means that literally all image processing functions have to be rewritten. Obviously, this can be a heavy task when an application is already big and loaded with functionality. Photoshop, for example, is having a hard time catching up here.

Other applications, which were designed from the start to work in floating-point precision, have it much easier. They might offer less general functionality than Photoshop, but they are definitely ahead when it comes to performing specific HDR tasks. In particular, tonemapping and merging multiple exposures are essential cornerstones in the high dynamic range workflow, and both areas have been flooded with new tools in recent years.

These tools seem to evolve in waves, and there have already been several generations by now. Survivors from the first wave are generally more robust and filled with workflow features born directly out of user feedback. Latest-generation tools, however, bring refreshing new approaches and jump ahead with killer features or revolutionary new algorithms. And while it holds true that the photographer's imagination is the most important ingredient for the final look of an image, it makes a big difference if the software helps or hinders the process. If you're focused enough, with a clear goal in mind, you can create any look with any software. Yet some programs gently steer you more toward the photo-real/natural side, some more toward the experimental/surreal side.

By no means can this overview be considered complete. There are simply not enough pages in this book to review every HDR software package out there. Some oldies from the first edition had to be dropped to make room for new rising stars. You can find a full listing online at www.hdrlabs.com/tools, along with direct links to each application's download page, brief three-line reviews, and user ratings. Interactive filters will also help you strip that list down so it's easier to weed out what you need. Keep this book at hand when browsing this page because it will enable you to unlock coupons for almost every software package listed. I negotiated exclusive rebates beyond the reasonable for you, more than you will find on any public website. If you'd decide to buy them all, you'd save more than $500 just by owning this book. All you need to do is answer a simple password question. If your book is an international edition, you can also gain access by typing the infamous Konami Code,

Figure 2-12: *See the entire pack and pick up your coupon code at www.hdrlabs.com/tools.*

↑ ↑ ↓ ↓ ← → ← → B A, anywhere on the page. But remember: this unlock code is our secret. I trust you on that. You earned these rebate coupons by purchasing this book, so don't spill the beans to unworthy cheapskates!

Please note that none of the developers pays me for anything, and I'm not getting a cut of any coupon sales. I wouldn't want it any other way. Reflected here is my own opinion, as unbiased as it can be. It's not a completely objective view either, because that would be just plain boring. Instead, these reviews mirror my personal, highly subjective experiences with these programs.

In the first edition of this book, all programs were grouped in three major sections: HDR image viewers and browsers, utilities for HDR merging and tonemapping, and fully fledged image editors. But lately the dividing lines have become rather fuzzy. Some HDR utilities turned out to be excellent image viewers; others have become so powerful that they can serve as general-purpose image editors. It's really hard to draw a line between them, and that's why I'm presenting them in one big list now. The general order of rising complexity in the software is still present in the following sections, they are just no longer grouped by function.

Instead, each program is now characterized by an ID-card. These are handy overviews of the general functionality that should give you an instant idea of how well suited a program is for some typical tasks. The rating scores are not just fantasy numbers; they reflect the amount and quality of features in each area. I really

tried to make some science out of this. In section 2.4 you will find a massive comparison table that will shed some light on what features count toward the score in each category.

Some particular features are so important they deserve special badges:

- If you want to speed up repetitive tasks with batch processing, look out for the *Batch* light.
- Panorama photographers should keep an eye on the *Panosafe* badge. It means that this program does not mess up the seam in a 360 pano.
- Apps marked with a *Plugin* badge are also available as a plug-in for Photoshop, Lightroom, and/ or Aperture. Great for workflow integration.
- CG artists must pay special attention to the *IBLsafe* badge. It indicates that a program can actually save 32-bit HDR files with unclipped highlights and therefore qualifies for preparing images for image-based lighting.

Okay, ready?

2.3.1 Mac OS X

 Mac users have a slight advantage here because OS X has support for OpenEXR built right in. OpenEXR images show up as thumbnails in a Finder window like any other image. Although these thumbnails can take a very long time to generate, they are automatically cached and show up when you revisit the folder later. Also, the standard Preview image viewer as well as Quick Look are able to display EXR and HDR files natively. Or, I should say, they show a crude representation of them so you can at least tell what's on the picture.

There is a significant difference between OS X versions, and sadly, I must report that HDR support has degraded in 10.6 (Snow Leopard). When it was introduced in 10.4 (Tiger), you could actually open an EXR file in Preview and change the exposure with the Image Corrections palette from the Tools menu. It used to be awfully slow and suffered from a lack of color management, but at least it was giving you access to the full dynamic range found in the file.

You could actually see highlight details emerge when changing the exposure slider. That functionality is gone now.

Snow Leopard and Lion clearly prefer EXR files over Radiance HDR, displaying them much faster now. The trade-off is that Apple's graphic system, CoreImage, converts EXR files internally to 8-bit just for the sake of showing them on-screen. So when you dial down the exposure, highlights beyond a value of 1.0 will be clipped and turn into gray mush. Even worse, HDR images are displayed with the gamma applied twice, making all colors appear washed out. To make the confusion perfect, some thumbnails are left in linear space, presumably when the image was saved in Photoshop. So the display is either too dark or washed out but never correct. Someone at Apple managed to mess that up completely. To see an EXR in Snow Leopard's Preview at least approximately close to what you'd expect, you have go to the menu, select VIEW ▸ APPLY PROFILE and pick an sRGB profile. But beware, when closing the preview window

press spacebar for Quick Look

Figure 2-13: *Mac OS X can natively show HDR files but disappoints in matters of color management. Thumbnails and previews are either too dark or too bright, but never correct.*

Figure 2-14: *In Tiger (OS X 10.4), you could adjust viewing exposure in the Preview app, but in recent versions (Snow Leopard, Lion, and Mountain Lion), any such attempt will ruin the HDR file.*

it asks you to save the file, which you have to deny with a horrified look on your face. In Lion or Mountain Lion you shouldn't even try this because it will overwrite the file without warning. Don't allow Preview to ruin your EXR files!

Just look, don't touch!

Just remember this fundamental rule: *Never save HDR files in 8-bit applications!* If you stick to that, such system-level HDR support is a wonderful thing because it automatically trickles down to many other image and thumbnail organizers. The simple applications are affected, applications that have no internal image decoder and rely on the system graphics to get an image from disk to display. Such applications are, for example, VitaminSEE, ThumbsUp, PhotoReviewer, GraphicConverter, even the wildly popular Pixelmator image editor. However, such coincidental HDR support is always very basic—although some show HDR images less ugly than Preview does, these apps don't know what to do with them, and there is, of course, no exposure adjustment. That's because they all work internally in 8-bit only. They are good for having a peek but disqualified for editing and saving HDR files.

2.3.2 FastPictureViewer Codec Pack

Windows does not share OS X's problem of slowly degrading HDR support. It simply doesn't support any HDR files at all, never did, period. But here's the good news: Windows 7 and Vista have a plug-in interface instead, called Windows Imaging Component (WIC). This is where the FastPictureViewer Codec Pack hooks in.

Once you have this codec pack installed, your system will be able to show EXR, HDR, PSD, even RAW files like CR2 and NEF, everywhere. The standard Windows Explorer can suddenly display these files as thumbnails and lets you edit metadata. Windows Photo Viewer now lets you browse through EXRs at blazing speed. You can even navigate your HDR collection from the couch using Windows Media Center. In addition, all programs that use the system's native image file support (said WIC) get the same benefit. That includes the video editor Sony Vegas Pro 9 and the photo organizer iMatch as well as FastPictureViewer from the maker of this codec pack. But most important, the standard system file requester is also affected—so you can now see thumbnails when you load or save an HDR file in any application.

The catch? It's $14.99. I know, sounds odd to pay for software that doesn't even have an interface and doesn't do anything on its own. But consider that it's not a service update from

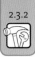

Figure 2-15: This codec pack installs system-wide support for most HDR formats and RAW files.

Figure 2-16: Now you can browse, view, and organize HDR files with all standard Windows tools.

Microsoft. It comes from Axel Rietschin, an independent programmer who spent a lot of time picking up the ball that Microsoft obviously dropped. He did it with so much care that even the Microsoft imaging team started using his codec pack themselves. Pretty much the entire VFX industry does, and that's why there are even site licenses available to "fix Windows" company-wide. Also consider that it gives your entire system a lift, enhancing a dozen programs at once, taking the pain out of managing HDR files once and for all. The sister application FastPictureViewer is also a nice addition to your arsenal because it really is incredibly fast for viewing RAWs and large image files. But it's not as essential as the codec pack.

The second catch is that the Windows enhancement only goes as far as a basic display task. You can't change the exposure and you have no access to the highlight data beyond the monitor white point. At least Windows is fully aware of its own limitations, so the picture viewer doesn't lure you into doing adjustments in 8-bit and then trashing your EXR files by saving over them. Not every program may be that graceful, so stay alert. The codec pack is already doing a nice job by converting HDR images to gamma space. Thumbnails and image previews look absolutely correct. Much better than native OS X, actually. Finally here's your chance to show it to your turtlenecked Mac buddies.

⤷ www.fastpictureviewer.com/codecs/

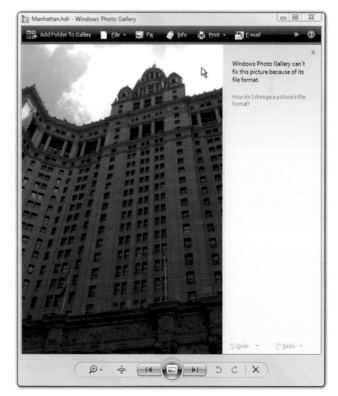

Figure 2-17: Windows Photo Gallery now opens EXR files just like any other image, but it politely refuses to perform any edits, which is good and safe behavior. Unlike Mac OS, Windows is at least fully aware of its limitations.

2.3.3 Adobe Bridge

With Adobe's Creative Suite comes Bridge, which is a content management system for all file types associated with any Adobe product. You could also call it a generic thumbnail viewer. CS5 also introduced Mini-Bridge as Adobe's very own file requester. It's pretty fast and responsive, once all the thumbnails are generated and stored in some secret folder.

The good news is that Bridge can show a hell of a lot of file types: HDR, EXR, TIFF in all its flavors—you name it. But it doesn't really show the image itself. All it will ever display is a crude preview image that was generated along with the thumbnails. To show the real HDR image, Bridge needs to launch Photoshop, which is not exactly what I would call a lightweight image viewer and certainly overkill for having a quick look. The problem is that Bridge's pregenerated JPEG preview doesn't remotely give you any

representation of the dynamic range that was in the original HDR image. The colors look all wrong because it shows the straight linear values without compensating for the display gamma. You cannot tune the viewing exposure. You can't even fully zoom in. Don't let Bridge fool you; it's playing with hidden cards that are cut down so it can fit more into its sleeves. It's good in pulling them out quickly, but to play the cards it relies on big brother Photoshop.

As a pure file manager Bridge is fairly useful. At least it shows HDR images with *some* sort of thumbnail. Bridge can also autodetect exposure brackets and panorama sets based on time stamps and group them into stacks. And the tight link to Photoshop actually becomes an advantage because you can call Photoshop's Merge to HDR function directly from a thumbnail selection.

See, the real pity is that Adobe Lightroom is completely ignorant of 32-bit images. Most

Figure 2-18: *Adobe Bridge can organize a lot of file formats, but it only shows poorly converted preview JPEGs.*

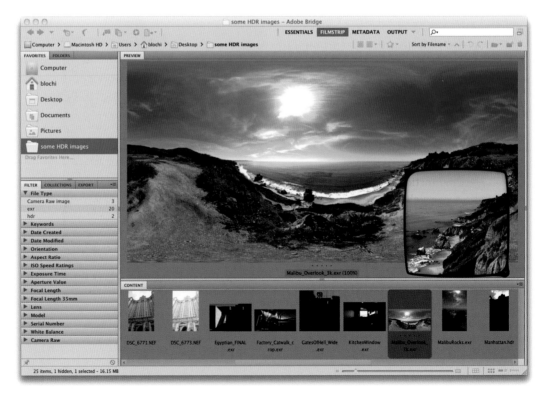

photographers I know don't even bother deal-ing with Bridge. They use Lightroom for man-aging their files. The ability to stack exposures and send them to Photoshop is a useful feature you can also find in Lightroom, but only Bridge actually acknowledges the existence of EXR and HDR files. The unofficial promise from Light-room engineers is that real HDR will be sup-ported one day. But as Adobe generally seems to progress with the speed of a continental drift, Bridge is really all we get to manage our HDR files.

2.3.4 XnView

This program is very similar to Adobe Bridge, except it's free, launches quickly, and doesn't feel like bloatware. It's a compact thumbnail viewer that can show more than 400 image formats—among them Radiance HDR and OpenEXR, but also layered PSD files and most common RAW formats. It has several useful management functions, like keeping a list of favorite folders and image ratings. XnView can also show per-channel histograms, list metadata, and tag images with keywords, and it has handy batch processing/renaming functions built right in. You can even run Photo-shop plug-ins directly from the menu.

However, when it comes to viewing HDR im-ages, it's not much better than Bridge. XnView also doesn't let you tap through the exposures, and handy extra functions (like convert, rotate, scale, flip) are unavailable for HDR files. That's because behind the scenes XnView works only in 8-bit. For some mysterious reason, it also seems to be unable to preserve the aspect of EXR files when generating thumbnails, but at least it gets the display gamma right.

Bottom line: It's a solid general-purpose im-age browser but of limited use for HDR images.

↪ www.xnview.com

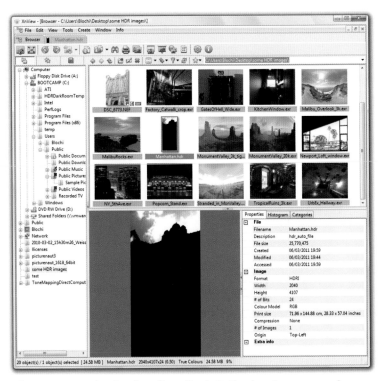

Figure 2-19: *XnView is a free alternative to Bridge, handy as a general-purpose image browser but of limited use for HDR images.*

2.3.5 Bracket

Bracket is a free thumbnail browser, specifically made for dealing with HDR images. It supports all major HDR file formats: OpenEXR, HDR, and all flavors of TIFF (including LogLuv). It can also merge exposure sequences and perform some basic tonemapping, but these functions are rather slow and cumbersome and done better elsewhere. The focus is clearly on image management.

Nothing beats Bracket in accuracy when showing a folder full of HDR files. Thumbnails have the correct gamma applied and the aspect is maintained. Just double-click and you'll get a real HDR image viewer, also properly adjusted to your monitor gamma. Pressing Ctrl+ the up or down arrow key lets you quickly switch the viewing exposure so you can inspect the full dynamic range. This is what you could never get from an 8-bit image browser. Especially

Figure 2-20:

Bracket is the most accurate HDR thumbnail browser and includes a decent HDR image viewer.

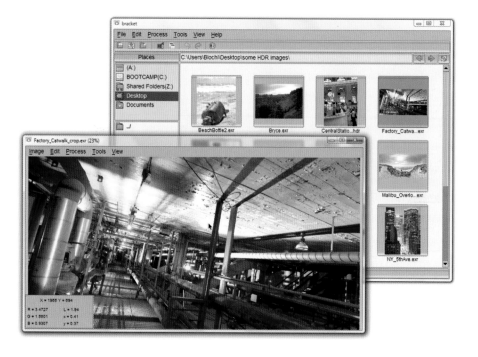

handy for inspection is a Pixel Info overlay with precise readouts of the color values under the mouse pointer. In addition, Bracket can rotate, flip, and resize entire stacks of HDR images with one click, which is a surprisingly unique feature in the world of HDR imaging.

The downside is that Bracket feels a little rough around the edges. It can't deal with RAW files, the thumbnail size is very limited, and the purple interface color doesn't really fit my personal definition of "pretty." Bracket also has very little runtime optimization built in, which makes it a bit sluggish and unstable when working with images larger than 30 megapixels. The OS X version is slightly better in this regard, maybe because it's a 64-bit application.

Bracket is available for every platform and completely free. Highly recommended as base equipment, hence included on the DVD.

↪ www.tinyurl.com/bracketHDR

2.3.6 Photosphere

Greg Ward's Photosphere is a legendary HDR thumbnail browser for Mac OS X. It served as test bed for all his later inventions, which resulted in many advanced features that you just wouldn't expect in a freeware program.

The big advantage is that Photosphere supports every single HDRI format out there, including the rare JPEG-HDR. It also features some advanced tonemapping operators that are permanently used in the viewer portion of the program. That doesn't make it the fastest viewer, but it's surely one of the most accurate ones.

The function for assembling an HDR image from multiple exposures is both easy to use and photometrically precise. It was first to feature a ghost removal algorithm, which is basically an early prototype of the ghost removal Greg wrote five years later for Photoshop CS5. Only in Photosphere can you make HDR images from

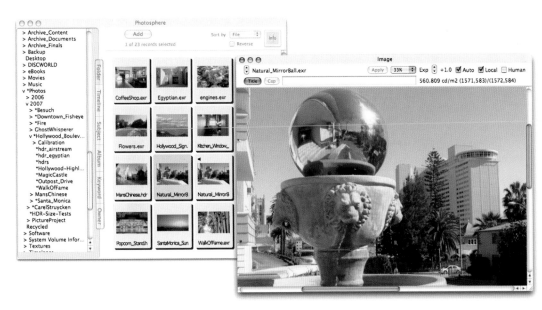

Figure 2-21: Photosphere is an old classic. It's not very pretty on the surface, but it's functional with top-notch algorithms under the hood.

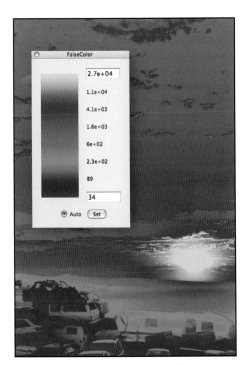

Figure 2-22: With photometric calibration and false-colored luminance maps, Photosphere is the only HDR app that qualifies for scientific purposes and lighting analysis.

which you can obtain accurate luminance measurements, just by picking the pixel values. It can also generate false-colored luminance maps, which is very useful for all you professional lighting designers. So for applications in the architectural field, Photosphere is unbeatable.

The downside is the user interface, which is somewhat lacking the sophistication we are used to seeing in other modern thumbnail browsers. It does feel very homegrown, less configurable, less dynamic, less polished, less optimized, and rather slow at times. Let's just say it's functional. As soon as you start looking past the interface layer, you will discover a lot of goodies in this program. Considering the fact that it's free, you couldn't ask for more.

The real downer is that it is still restricted to Mac OS X only. Even though Greg Ward has been trying to get it ported to Windows for years, it hasn't happened yet.

[→ www.anyhere.com

2.3.7 HDR Shop

HDR Shop is the granddaddy of high dynamic range programs. It emerged in 1997 from the Creative Technology labs at the University of Southern California, where a project group lead by Paul Debevec worked out the principles of image-based lighting. Hence, HDR Shop is specifically tailored to prepare HDR images for exactly that purpose.

In many regards, HDR Shop is still the Swiss Army knife of HDR editing. It can quickly expose an image up or down and do basic resizing and panoramic conversion tasks. But, although the name might imply it, it does not sport painting tools, layers, or any of the advanced features known from Photoshop. The menus look very basic and somewhat cryptic. You have to know what you're doing because HDR Shop doesn't guide you anywhere. It takes some scientific mindset to use it for assembling multiple exposures into an HDR image because it exposes all the inner workings of the algorithms, ready to be tweaked. Some HDRI professionals love it. Some artist types hate it, and most people just get confused.

One particular feature, which has been unmatched until this day, is the sneaky way it can steal any regular image editor's features. It works like this: You select an area that you want to edit and properly expose for it. HDR Shop can bake out the visible exposure slice as an 8-bit BMP image and send it directly to... let's say Photoshop Elements. Here you can use all the tools you want—you can paint, use layers, clone stuff around, whatever. You just have to make sure you don't push a pixel into total white or black. When you're done and switch back to HDR Shop, it detects the pixels that have changed. Then it injects those changes back into the HDR image just by sorting in the new pixels at the proper exposure level. It's a crazy hack, but it works. Effectively, it allows editing HDR images with any low dynamic range image

Figure 2-23: HDR Shop is hopelessly out-of-date by modern standards, but it still has a few unique tricks up its sleeves for HDR editing.

editor. It's limited, though, since you can only work in one exposure level at a time. So there are no global image filters allowed, and it fails entirely for edges with contrasts that exceed a dynamic range that would fit in one exposure view.

Other than that, HDR Shop is clearly showing its age. No ghost removal, not even exposure alignment, and certainly no innovative tone-mapper to be found here. Things we take for granted in 2012 simply hadn't been figured out 15 years ago.

Some basic features, like support for RAW and EXR, were added to HDR Shop 2 in 2004, but nothing revolutionary enough to justify the price jump from $0 to $400. Version 3 lingered in the shadows for several years and was finally released in 2012 for $200. This time it's fully featured and even includes a JavaScript scripting interface. But don't expect any further updates or support. If you still have the original HDR Shop 1.03 you should hold on to it. It can no longer be downloaded, but it's still free to use for academic and noncommercial projects.

\rightarrow www.hdrshop.com

Figure 2-24: *Picturenaut's no-fuzz interface with excellent controls for the viewport exposure makes it the perfect HDR viewer. Some classic tone-mappers are included, and the list can be extended with plug-ins.*

2.3.8 Picturenaut

Picturenaut is a lightweight freeware utility. It was designed to provide open access to high-quality HDR imaging for everyone, filling the void that was left when HDR Shop got abandoned. Picturenaut's history is somewhat interwoven with this book: Marc Mehl, a gifted programmer and photo enthusiast himself, read this book when it existed only in preliminary diploma thesis form. Back then, this software chapter was depressingly thin because there really was not much around. So Marc instantly sat down to create Picturenaut. It spread like a wildfire through photo communities and was consistently improved over the past eight years. During that time Marc and I became good friends, and I had quite an impact on the interface and functionality of his program. So yes, I might not be fully objective in this review. But it's a fact that Picturenaut was repeatedly voted the best free HDR utility in this increasingly competitive market, holding its ground as a risk-free entry point for many people before they try their hands on a commercial solution.

Picturenaut launches quickly, reads every HDR file format, and has an excellent HDR viewer. The display is properly gamma-corrected, there's a lightning-fast exposure slider, and it can even autotune the viewing exposure to the displayed image content. So, if you pan around in your HDR image with Picturenaut, it feels very much like panning with your DSLR in autoexposure mode. That's the way it should be, and it's surprisingly unique in Picturenaut.

HDR merging is fully featured by modern standards, with automatic alignment, ghost removal, RAW import, and more options for manual overrides than you will find in many commercial applications. Tonemapping is kept simple, leans toward natural output, and is

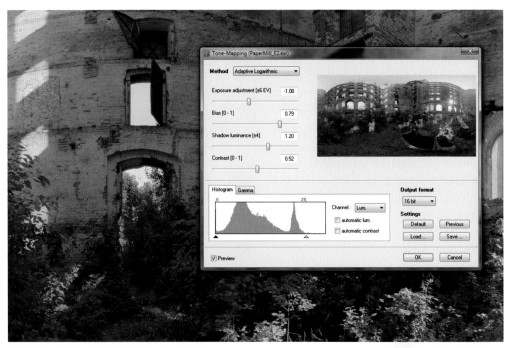

Figure 2-25: *Tonemapping in Picturenaut tends to produce natural looks and is superinteractive with real-time preview on the full-size image.*

screaming fast thanks to a mighty multi-processor engine. Other unique features are the ability to export an HDR image to an HTML viewer with a real exposure slider, preservation of the alpha channel of an OpenEXR file during tonemapping, compliance with the broadcast color specification Rec709, and a full palette of high-quality sampling algorithms for resizing and rotating images. Don't let the plain interface of Picturenaut fool you—we kept it intentionally clean and simple. Under the hood is one of the slickest and most powerful architectures you'll find anywhere, superfast and stable with very large images.

Even better, it has a plug-in interface and an open-source software development kit (SDK). Anybody interested in prototyping a new HDR algorithm will find the perfect platform in Picturenaut. No need to reinvent image loading/saving routines just for the sake of testing a new tonemapping idea. If you build on Picturenaut's foundation architecture, you can get your idea running in no time, while your plug-in enjoys the same multiprocess-

ing and real-time preview benefits as the rest of Picturenaut. It's particularly well suited for student projects because of the instant gratification factor and the rewarding experience of contributing a plug-in that actually gets used by photographers. There's already a great wealth of plug-ins available, ranging from experimental local tonemappers over full-precision motion blur to specialty functions for 3D lighting like a CIE physical sky generator, light source extraction, and custom filters. An essential plug-in pack is included in the standard installation on this book's companion DVD, generously provided by Francesco Banterle.

Overall, you cannot go wrong giving Picturenaut a try. As HDR viewer and conversion utility it is unbeatable. It is free for personal and academic use, and a donation is highly recommended when you use it in a commercial project. I strongly encourage you to do so anyway, to show your appreciation and encourage Marc to keep delivering updates to this fine piece of software.

\rightarrow www.hdrlabs.com/picturenaut

2.3.9 Photomatix Pro

Geraldine Joffre's Photomatix has become the market leader in the HDR scene and is largely responsible for the popularity of HDRI among photographers. That fame might be grounded in the fact that it did not emerge from a science lab but rather from photographic practice. When it was released in 2003, Photomatix was a tool for merging two or three differently exposed images into one LDR image right away, automating the tedious exposure blending workflow that has been used in photography for a long time. Going through the intermediate step of creating an HDR image and then deriving a final LDR image by tone-mapping were features added to an already established program. Photomatix was originally not designed as HDR software; it rather evolved into one.

HDR creation and tonemapping are clearly the focus features now. In both parts of the workflow, Photomatix offers a nice balance of automatic algorithms and manual control. Geraldine is very good at listening to user feedback, and so she managed to stay ahead of the

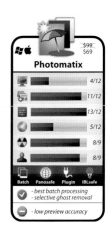

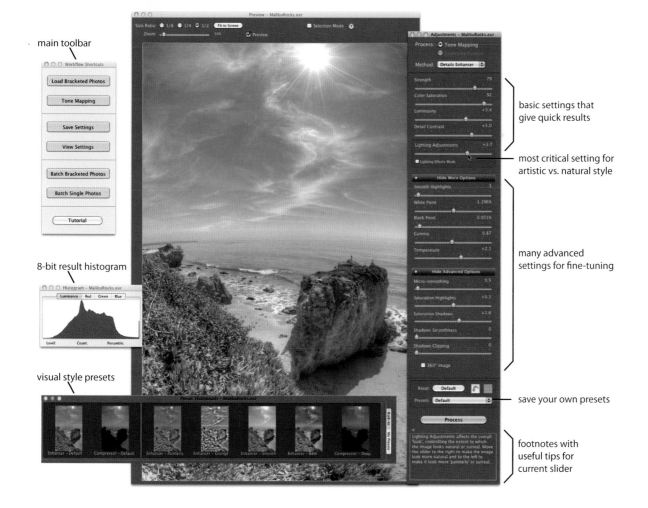

main toolbar

8-bit result histogram

visual style presets

basic settings that give quick results

most critical setting for artistic vs. natural style

many advanced settings for fine-tuning

save your own presets

footnotes with useful tips for current slider

Figure 2-26: *The inaccurate preview is a traditional Achilles' heel of Photomatix because the algorithm is too expensive to run interactively on the full-size image.*

pack with innovative features that deliver exactly what people requested. For example, Photomatix 4.0 introduces a unique semiautomatic ghost removal, where you can tell the program what part of which exposure should be kept in the merged HDR. The tonemapping algorithms have been consistently improved as well. In the beginning, images could very easily tip over into halo-riddled cartoonish looks, which made Photomatix the prime target of passionate criticism. Those days are gone; now it has a lot of fine granular controls that allow a balanced range of looks between natural and artistic. It's a great all-rounder: not the easiest, not the most realistic, not the most artistic, not the most halo resistant, yet pretty good in all these fields.

The principal advantage of Photomatix is usability. Even if you have never heard of HDRI, you can very quickly get to a result because it guides you through every step of the process. The user interface is very functional (although not overly pretty) and everything is well explained. Beginners will appreciate the small footnotes that give very specific hints about when a feature is useful and when it might screw up.

For power users, Photomatix features the most versatile batch processing mode. That makes it easy to create a whole bunch of HDR images and tone them right away—super convenient for those extensive shoots when you come home with 1,000 images and an absolute necessity for HDR panorama stitching. My only gripe with Photomatix is that the initial display of HDR images is in linear color space. It's part of the program's philosophy, that the HDR image is just an intermediate step and requires tonemapping. Other weak points are that there is no real color management built in (although it preserves the profiles of the source files), and the final images does not always match the preview. The amount of advanced sliders is also a mixed blessing because they all seem to counteract each other and it's sometimes tricky to find the right balance. Definitely check out the extended Photomatix tutorial in section 4.4.1.

PRO-TIP The 64-bit version of Photomatix is able to handle really big images. I tried 800-megapixel panoramas, and it still performs great. HDR images of that size are too big for most image formats. PSB (a.k.a. Photoshop's big image format) is really the only option here. Although not officially supported, Photomatix is well capable of loading 32-bit PSD and PSB files, as long as they are flattened to one background layer.

Photomatix is high on my list of recommended applications. It's the most common denominator and has something for everybody. It is available for Mac and PC for $99, but for you that's only $69. For the last five years all updates have been free of charge, which is completely awesome. There is a trial version that does not time out and has no restrictions in the HDRI generation department; it only applies watermarks to the toned results.

⊳ www.hdrsoft.com

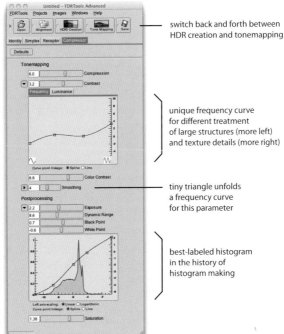

switch back and forth between
HDR creation and tonemapping

unique frequency curve
for different treatment
of large structures (more left)
and texture details (more right)

tiny triangle unfolds
a frequency curve
for this parameter

best-labeled histogram
in the history of
histogram making

2.3.10 FDRTools Advanced

FDRTools is a golden oldie from Andreas Schömann. FDR stands for *full dynamic range* and might refer to its ability to work with the full dynamic range found in RAW files. Merging different exposures to an HDR image and enhancing details through tonemapping are the two sole purposes of this software. It emerged around the same time as Photomatix and offers a very similar scope of features, although it never enjoyed the same popularity. Yet it survived and still gets updated regularly—not so much out of commercial success but rather out of the author's dedication.

What makes FDRTools unique is the HDR merging process. Instead of making it as easy as possible, this software always concentrated on making this process as customizable as possible. For example, it lets you selectively choose the histogram levels from individual exposures, which are taken into account for the merge. You can choose to blend them with your own custom weighting curves or have each pixel in the HDR image come exclusively from the single exposure where it looked best. The latter is a

crude approach to ghost reduction, sometimes even successful, but ultimately wasteful with the image data. Customizable weighted blending typically delivers better results and is still to this day unmatched in other programs.

Tonemapping is just as configurable and offers curves for deep customization of individual

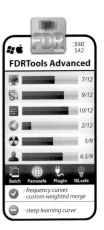

FDRTools Advanced

🖥️	7/12
	9/12
	10/12
⚙️	2/12
☢️	5/9
👤	6.5/9

Batch Panosafe Plugin IBLsafe

✓ - frequency curves
 - custom weighted merge

⊖ - steep learning curve

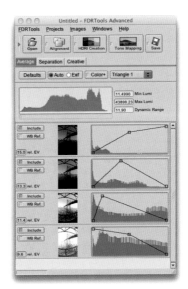

Figure 2-27: *FDRTools offers an unrivaled level of customization over the HDR merging process.*

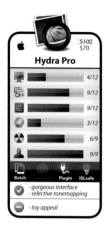

parameters. For example, you can change contrast based on the size of details found in the image with a *frequency curve*. It's not for beginners, but after you've done the tutorial in section 4.1.2, you will appreciate these unique possibilities. FDRTools is also one of the only programs that lets you seamlessly switch back and forth between HDR merging parameters and tonemapping. Maybe you've been there before: During tonemapping your image starts to break apart or drowns in noise, and you're wondering if maybe you should have tried a different option during HDR merge to extract some better data from the source material. Well, in FDRTools, you simply switch back to the HDRI Creation tab and see the effect of a different merging option, even with your current tonemapping settings applied. Pretty cool, eh? You can even wrap all the parameters (merging and tonemapping) into a project template, ready for batch processing.

In the quickly evolving landscape of computational photography, you'll most likely see focus stacking and other experimental merging modes appear in FDRTools—simply because it has the underlying architecture for such things. The Creative HDRI Creation mode is already endlessly customizable for relighting purpose.

Downsides? Exposure alignment is very basic, and there's no magic ghost removal. The interface has a distinctive Unix smell to it; it's functional but not exactly what I would call pretty. Stability and interaction speed are rather substandard, and as mentioned earlier, there is an unusual learning curve involved. Nevertheless, FDRTools remains a powerhouse for advanced users.

A free version of FDRTools is available, but all the power features can only be used in the advanced version, which is still a bargain at $50 (for you, $42). And there is a Photoshop plug-in as well.

⤷ www.fdrtools.com

2.3.11 Hydra Pro

Hydra ties in with the system's media browser, is optimized for Apple's GPU acceleration, and uses extremely stylish panels for all settings. It has a pixel-perfect interface design. Almost too beautiful to be taken seriously. But beware, don't let the good looks fool you. Just as a gorgeous tall blonde may very well have a PhD in biochemistry, Hydra is indeed capable of quality HDR processing. In some specific areas, it's even ahead of the pack.

Hydra's trick to appeal to beginners and advanced users alike is pretty cool. Its tonemapping sliders are stripped down to the minimum: Details, Brightness, Contrast, Hue, and Saturation. The real power lies in the Scope feature, which means that you can apply a different set of slider settings to the dark, bright, red, green, and blue tones found in your image. The net effect is an immense amount of control over the final look. In the Pro version you can even create a custom scope by picking specific areas in your image with a control point. This works just like the U-Point feature in HDR Efex (see section 2.3.18), maybe even a bit more versatile.

PRO-TIP If you ever feel the need to have a slider go just a little bit further, Hydra actually allows numerical values beyond the slider range. Sounds simple, but most other HDR programs will not let you "turn it up to 11."

The HDR merging module has a unique alignment method that will rescue even the most hopeless cases. It works with reference markers that grab on to image features across all exposures. You can pin down your own markers, as many as necessary, and conveniently fine-tune them in an ingenious Alignment panel. Hydra will then warp and deform each exposure to match up all markers perfectly. This alignment really is the most sophisticated semi-manual method you will find anywhere, probably because Craceed has a bit of history in morphing software (remember the nineties?). You can also

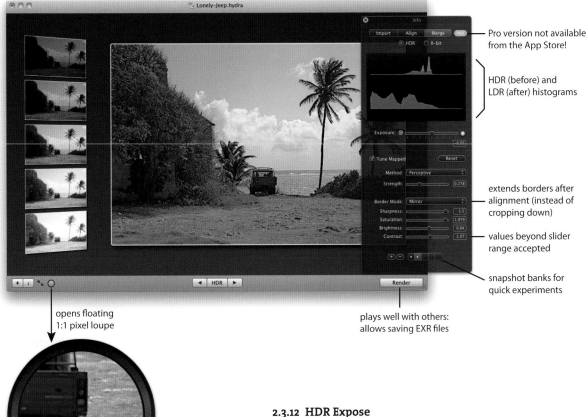

Pro version not available
from the App Store!

HDR (before) and
LDR (after) histograms

extends borders after
alignment (instead of
cropping down)

values beyond slider
range accepted

snapshot banks for
quick experiments

plays well with others:
allows saving EXR files

opens floating
1:1 pixel loupe

export the prealigned exposures as individual images and then merge the HDR image in your favorite app.

Hydra also has a selective ghost removal feature (similar to Photomatix) and comes bundled with plug-ins for Aperture and Lightroom. My main points of critique are that even the Pro version is limited to 7 exposures (the Express edition, just 3), the processing can be slow at times, and it's not very stable with large images. Still, overall, Hydra offers a lot of bang for your buck. It's available in the Mac App Store, but to use your coupon code you need to buy it directly from Craceed's website. There you can also grab a free demo version.

⊳ www.craceed.com/hydra

2.3.12 HDR Expose

Previously called HDR PhotoStudio, this software brings a refreshingly new approach to the table: You can edit your HDR image in full 32-bit up until the end, when you save it. If you just need to polish an HDRI for 3D lighting, you may only need white balance, color correction, and noise reduction. The original dynamic range will be fully maintained, and you can save it as an EXR file again. Or maybe you want to take this cleaned-up HDRI to another tonemapper, for that matter.

Originally, there wasn't even a predefined order of operations. Instead, you could freely pick the tools you need from a tools palette and apply them in any order you liked. For example, if you wanted to extract local contrasts with the Highlight/Shadow tool twice, you could just add this effect again. Sadly, this powerful capability was lost in HDR Expose 2. The open workflow paradigm (my favorite feature in version 1) was abandoned in favor of a more

HDR Expose

$150
$100

5/12
5/12
8/12
10/12
5.5/9
9/9

Batch Panosafe Plugin IBLsafe

- custom operation stack
- 32-bit color tweaks

- resource hungry

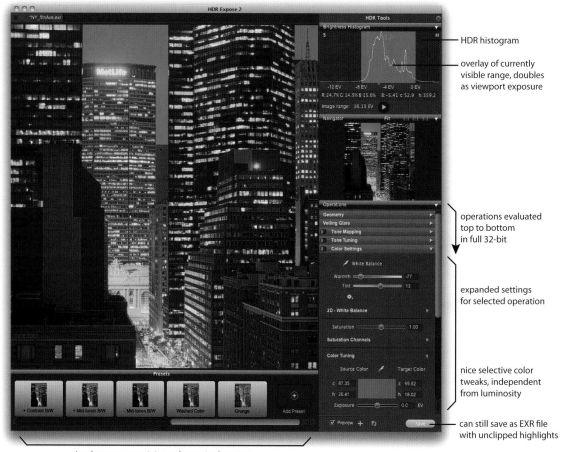

HDR histogram

overlay of currently visible range, doubles as viewport exposure

operations evaluated top to bottom in full 32-bit

expanded settings for selected operation

nice selective color tweaks, independent from luminosity

can still save as EXR file with unclipped highlights

visual presets, containing only required settings

beginner-friendly list of predefined operations. HDR Expose 2 will always default to a standard workflow: geometric correction, veiling glare removal, tonemapping, tone tuning, color correction, sharpening, and noise reduction.

Frankly, in the tonemapping department this program is not really a champion—at least not the restructured version 2. You can no longer adjust the detail radius or the quality of the halo reduction. Both features used to be slow but mighty powerful, and both are now replaced by fast but mediocre automatic processing. Oh well. HDR merging is also substandard, always has been. Alignment, ghost removal, and batch processing are technically included but are easily outperformed by other programs.

The real strength of HDR Expose lies in the end-to-end HDR workflow. The underlying processing core is really superb. If you disable the tonemapping section (or apply only a small detail boost), all the operations that follow have access to the unclipped 32-bit data. Curves, white balance, selective color correction, noise reduction—all these tools are perfectly suited to process HDR data directly. The result is still a perfectly valid OpenEXR file. That is completely unique; not even Photoshop offers these tools in 32-bit mode.

The end-to-end HDR workflow is the reason I still highly recommend this program.

Chapter 2: New Tools

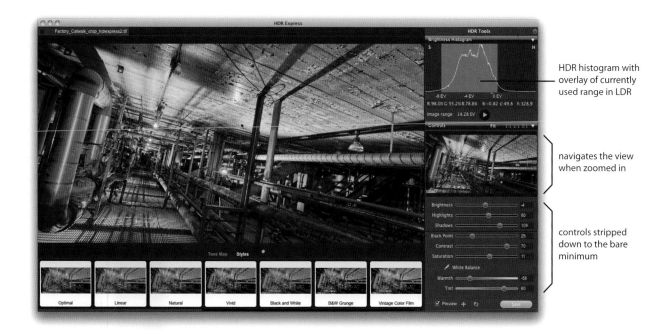

HDR histogram with overlay of currently used range in LDR

navigates the view when zoomed in

controls stripped down to the bare minimum

In fact, I consider the plug-in version of HDR Expose (called 32Float) the perfect companion to Photoshop because it delivers all the features that Adobe locked away in 32-bit mode. It's indispensable to CG artists for fine-tuning HDR lighting maps and highly recommended to photographers for cleaning up their master HDR image. Check out the hands-on tutorial in section 3.3.3 to see how amazing white balance adjustments work in HDR Expose.

\rightarrow www.unifiedcolor.com

2.3.13 HDR Express

This is the little brother of HDR Expose. They share the same high-quality processing core and the user interface is obviously forged from the same mold, but HDR Express is clearly aimed at beginners. It has only one box of sliders, stripped down to the minimum. It processes images lightning fast and delivers a crisp and clean toning style from natural to slightly hyperreal. Halo reduction is all automatic and always on. There is literally no learning curve involved. If you know how to use Lightroom, the slider names and their effects will feel familiar right away.

The flip side is that there is very little depth in this program. You learn it on the first day, and then there isn't much else to discover anymore. Advanced users miss finer granular controls for local contrast, targeted color tweaks, and sharpness or haze adjustments. Instead of halos, extreme slider settings can introduce some odd oversharpening artifacts, so always make sure to inspect high-contrast edges at 100 % zoom

$100
$80

HDR Express

	2/12
	5/12
	5/12
	2/12
	8/9
	9/9

Batch Panorama **Plugin** IBLsafe

✓ - simplicity

- simplicity

levels. HDR Express also has the same easy-but-weak HDR merging module as HDR Expose, but this slight disadvantage is exaggerated by the fact that it can't load premade HDR files.

PRO-TIP The ability to handle EXR and Radiance files is actually in there, you just have to enable it. The secret unlock code goes like this: Start the program while holding down the Command key (Ctrl in Windows). Hold it down until the start screen comes up, and then press F in addition. HDR Express will now kindly offer to enable extended export formats. Click OK and voilà! From now on it will load and save all common HDR file formats. Nifty trick, eh?

Figure 2-28: *Support for all HDR formats is an Easter egg that you have to unlock first.*

Anyway, the targeted audience is beginners, where ease-of-use and quick satisfaction win over feature richness. Considering the top-quality engine that runs under the hood, I would recommend HDR Express for anyone's first-time contact with HDR. Still, the price of $99.99 (for you, $80.00) is a bit steep for such a limited set of functions; you can get more bang for your buck elsewhere.

↪ www.unifiedcolor.com

2.3.14 Dynamic Photo HDR

DPHDR, as it's called for short, has yet another completely unique user interface. But this time it's very consistent and well thought out; instead of just adding visual fanciness, it actually leverages functionality. Custom drag-wheel controls allow very fine adjustments of some key values, and custom Curves panels are visually so clean that the screen won't look cluttered even when there are five of them visible at once.

The range of features is deep in every department, from merging over to tonemapping all the way to post-processing. DPHDR was the first to introduce selective ghost removal by drawing masks. It still has the best interface for painting these masks, although Photomatix has lately snatched the crown with a better algorithm behind the actual ghost removal process.

The tonemapping dialog has evolved to include several extra functions to solve common problems. Skin tone protection, noise reduction specifically for skies, a de-haze function—you will hardly find these features anywhere else. When you click the preview window, it will create a thumbnail patch that acts as temporary preset—very handy for creative jam sessions, when you're playing with different settings and looks. There is a great live preview, so you see each slider's effect happening in real time. On the flipside, the preview is limited to roughly 570 by 430 pixels, which is not nearly large enough to judge anything. So it's important to frequently click the 2x Fine or Full Size preview button.

Another notable highlight feature is the Match Color function, which even comes preloaded with images of Van Gogh and other classic masters of the brush. Although DPHDR seems to have an odd tendency to oversaturate images, creative color tweaks are really its big strength. Color temperature, color equalizer, different controls for saturation and vividity, all

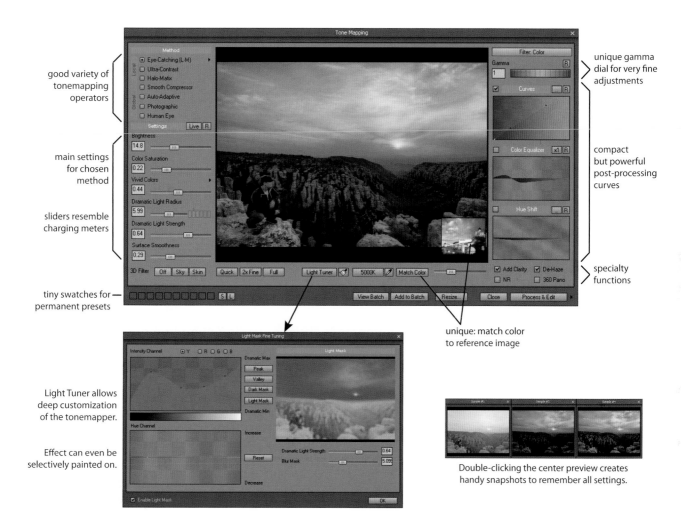

good variety of
tonemapping
operators

main settings
for chosen
method

sliders resemble
charging meters

tiny swatches for —
permanent presets

unique gamma
dial for very fine
adjustments

compact
but powerful
post-processing
curves

specialty
functions

unique: match color
to reference image

Light Tuner allows
deep customization
of the tonemapper.

Effect can even be
selectively painted on.

Double-clicking the center preview creates
handy snapshots to remember all settings.

these tools are always right at your fingertips. After tonemapping, you would usually do final adjustments in 16-bit mode. Of all programs in its class, DPHDR has hands down the most tools for post-processing. In fact, it beats Photoshop Elements in the amount of filters and adjustments. What you see in the screenshot is just the tonemapping module, which is followed up by a very comprehensive image editor for post-processing.

Downsides? Well, the fiddly preview gets annoying, EXR support is very deeply missed, and so are visual tonemapping presets. The Mac version is only cobbled together and doesn't hide the fact that it's actually the PC program wrapped in an emulator. The sheer amount of options and the nonstandard user interface present a bit of a learning curve. However, the help assistant is excellent, with some of the most detailed and straightforward tips I've ever seen. And priced at $54 (for you, $38), Dynamic Photo HDR is certainly worth a shot.

↳ www.mediachance.com/hdri/

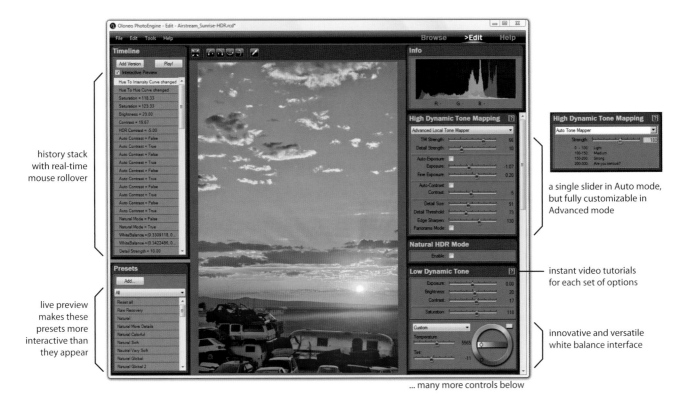

history stack with real-time mouse rollover

live preview makes these presets more interactive than they appear

a single slider in Auto mode, but fully customizable in Advanced mode

instant video tutorials for each set of options

innovative and versatile white balance interface

... many more controls below

2.3.15 PhotoEngine

A new contestant in this highly competitive field, Oloneo's Photo-Engine offers an interesting mix of innovative features. HDR/Tone-mapping is only one of the modules. It can also combine a stack of noisy exposures into a single perfectly smooth image. Another interesting module deals with relighting: You shoot the same scene multiple times with a different light source turned on in each image. Photo-Engine will then extract each light's contribution and lets you change light colors and intensities individually.

For now, back to the core functions: HDR merging is pretty convenient, although not overly powerful. The program always launches with a big thumbnail browser where you can select your bracketed exposures visually. For some strange reason, premade HDR files are not shown with thumbnails, but you can still open them by double-clicking the generic file icon. The tonemapper itself is very powerful and

fast, with decent halo suppression and intuitive color controls. Not only is there a novel color wheel for flexible white balance and duotone tint, there is also a full set of customizable color equalizers and curves.

Figure 2-29: *Most controls have advanced customization options on right-click.*

PhotoEngine
$149
$110

Batch Panosafe Plugin @Lsafe
- ReLight mode
- zero noise stacking
- killer features only in LDR

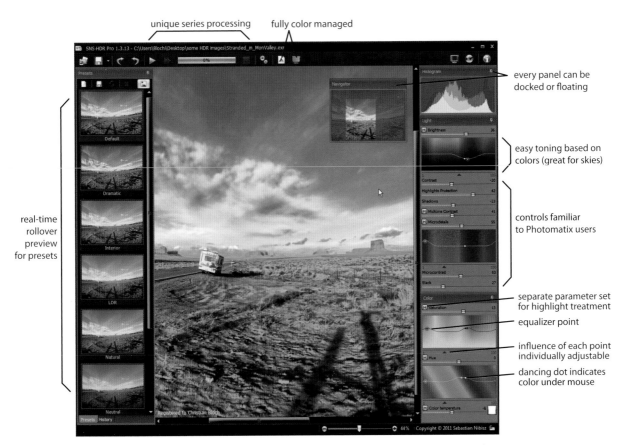

unique series processing

fully color managed

every panel can be docked or floating

easy toning based on colors (great for skies)

controls familiar to Photomatix users

real-time rollover preview for presets

separate parameter set for highlight treatment

equalizer point

influence of each point individually adjustable

dancing dot indicates color under mouse

Some noteworthy innovation lies in the very first slider, simply called Strength. Instead of changing only a single parameter from low to high, it cycles through a whole variety of look adjustments. From 0 to 100 it reduces the global contrast, from 100 to 200 it additionally enhances local detail, and beyond 200 it aggressively boosts every contrast it can find. Combined with live feedback, that single slider alone can lead to instant satisfaction. In fact, when you work in Auto mode, that Strength slider is all you have. Local mode gives you more control over exposure, detail, and contrast. And the Advanced Local mode finally drills the detail setting further down to tweak every individual aspect of the tonemapping engine.

PhotoEngine is very young. At the time of this writing, not all modules can use 32-bit image data, RAW conversion is rather bare bones, and there is no Mac version yet. It's a great start, however. If PhotoEngine manages to stick

around it surely has what it takes to rise to the top. The modular approach naturally lends itself to be extended with focus stacking and other futuristic techniques from the land of computational photography. Section 4.4.2 gives you a hands-on introduction to PhotoEngine's tonemapping module.

⊳ www.oloneo.com

2.3.16 SNS-HDR Pro

This software with the somewhat cryptic name was written by Sebastian Nibisz, a photo enthusiast from Poland. Without big company backing, he put together a very impressive tonemapper that deserves my personal newcomer award. It's superintuitive due to full-on real-time feedback and extremely halo resistant. Parameters like Microcontrast and Microdetails mimic the classic settings in Photomatix, but in addition there are separate

controls called Highlights Protection and Mid-tone Contrast. These two sliders really make a difference; in other programs these parameters can be affected only indirectly by getting a bunch of conflicting sliders in a delicate balance.

SNS-HDR also includes excellent hue/saturation equalizers. These color tools are not completely unique by themselves, but they are rarely implemented with such a simple interface and so much flexibility. No other tool will let you fine-tune the color range affected by each equalizer control point or set up a separate equalizer curve that affects only the highlights. In fact, most parameters can have a separate value for highlights, indicated by a little H button. This extra bit of highlight control is insanely useful in practice and very easy to use. Thumbnail presets, history, a white balance tool with color picker, color management with monitor profiles—all the important features are there and implemented with excellence.

A unique treat is the Series Processing function, which is exclusive to the Pro version. Series Processing is just like Batch Processing, except that it stops for each set and lets you adjust the toning parameters. This is faster than manually digging through an entire folder of brackets, and you're completely in control of the result. Very cool.

So what's missing? Well, there is no HDR or EXR output. This is rooted in the fact that SNS-HDR is actually based on exposure fusion. It can load a pre-merged HDR image just fine; it simply breaks it down into a stack of LDR files in the background. The built-in merge function is okay, but it can't be top of the class without more RAW options and manual control over alignment and ghost removal. All this is just nitpicking; for purely photographic purposes it's hard to find a serious flaw in this fine program.

There are three editions: First, there is a free command-line version, which is just a fire-and-forget tonemapper and may be interesting for

setting up an automated workflow. The Home and Pro editions are really what I was talking about here, priced at $40 and $110, respectively. Both are largely identical, except the Pro edition includes batch processing and is licensed for commercial work. For the casual hobby HDR shooter, I recommend the $40 Home edition in a heartbeat. Sebastian is nice enough to grant you an exclusive 30 percent discount, so you can get the Pro edition for $77. If you're a former Photomatix user and want to ramp up your game in the natural tonemapping department, SNS-HDR is an excellent companion app. The separate highlight treatment and tendency to produce a natural appearance makes it the real estate photographer's best friend.

⊏→ www.sns-hdr.com

2.3.17 HDR Photo Pro

 This program may look like a newcomer, but it really isn't. The core tonemapping algorithm is highly evolved. It stands in the tradition of Project Wukong, EssentialHDR, and HDR Darkroom. All of them have gathered a decent fan base because this strain of tonemapping algorithms delivers crisp details and halo-free results without much hassle.

Figure 2-30: *That's the entire HDR merging dialog.*

HDR Photo Pro aims at consolidating the entire photographic HDR workflow into one step. Its interface feels very native on Windows, kept in stylish black and built around a big center

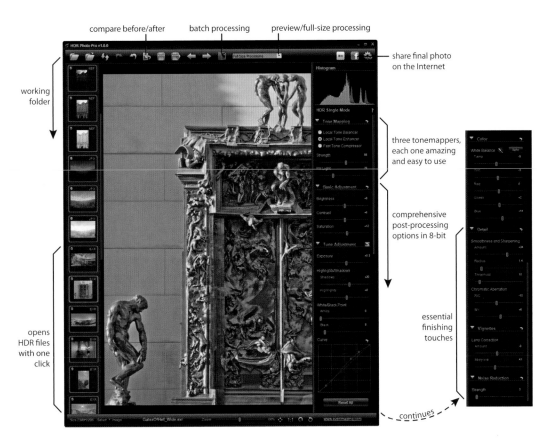

compare before/after　　batch processing　　preview/full-size processing

share final photo
on the Internet

working
folder

three tonemappers,
each one amazing
and easy to use

comprehensive
post-processing
options in 8-bit

essential
finishing
touches

opens
HDR files
with one
click

continues

viewport. Instead of opening a single image, you point it to a work folder and all images within are shown as a thumbnail strip. OpenEXR and HDR thumbnails are displayed with correct gamma and tagged with a blue dot. JPEGs carry a green dot, RAW files a red dot. Technically you could Shift-select a bracketed set and drag them into the main viewport for merging. But the HDR merging options are pathetic, so don't even bother! It's also advertised for tonemapping single RAW files, but that would be a fatal mistake because like many other programs in this class, it ignores all the extra highlight data found in RAWs. Pretty much defeats the purpose of shooting RAWs in the first place.

So, let's just assume the ideal starting point for HDR Photo Pro is a folder full of premerged EXR files. Then it actually works very well. Similar to Lightroom, a single click on the thumbnail opens an image—except it's like Lightroom for HDR!

Toning controls are well sorted in the most efficient order of adjustment. All three tonemapping methods give pleasing results and are different enough to offer room for experimentation. Just keep in mind that all post-processing in this program is limited to 8-bit, so highlights that are clipped in the first section can no longer be recovered with any of the other adjustments. Most sliders should be familiar. Curves, Highlight/Shadows, White Balance—all work exactly like the typical finishing touches you'd otherwise need Photoshop or Lightroom for. Sharpness triggers the good old Unsharp Mask filter with enough range for a decent boost. Noise Reduction does a good job at preserving edges and also allows very aggressive settings. With Chromatic Aberrations and Vignetting thrown in, this is a comprehensive set of controls to really finish an image in one swoop. Missing are only color equalizers to selectively fine-tune hues and shades.

Oh, and there are no presets. Nothing, nada, not even a simple pull-down list. This really hurts. All the convenience of quickly finishing an image goes out the window when you have to start over every time. There is comprehensive batch processing that can propagate the current settings to an entire folder, but you simply can't keep a picture style beyond quitting the program.

Would I recommend HDR Photo Pro? Maybe. It may make sense when paired up with Photomatix for batch HDR generation, specifically for photographers who want to eliminate post-processing in Lightroom or Photoshop from their workflow. The tonemapping algorithm alone might be a motivation because it delivers a clean style and is well suited for natural to hyperreal looks. However, in my opinion the official price tag of $129 is not really justified. EverImaging gives you, as my reader, a hefty 45 percent rebate, which brings it down to $70. The OS X version (without batch processing) is sold for $9.99 exclusively in the Mac App Store, but under the name HDR Darkroom Pro, which is a bit confusing, but at that price point it's hard to argue.

↪ www.everimaging.com

2.3.18 HDR Efex Pro

 As new rising star, HDR Efex from Nik Software focuses on creative image enhancements and interactive tonemapping on a whole new level. It is primarily designed as a plug-in for Photoshop, Bridge, Lightroom, and Aperture to integrate seamlessly into a photographic workflow. But it really needs these host applications just as a launchpad. The plug-in is a screen-filling program on its own.

The interface is gorgeous and well laid out. On the left is a very comprehensive preset bar, sorted by categories of visual styles ranging from Surreal to Natural. While many other programs have such a thumbnail preset feature,

Figure 2-31: *HDR Efex is technically just a plug-in, but it installs itself everywhere.*

Nik tops them all with artist-submitted variety in the presets themselves. You're almost certain to find a great starting point here.

Tonemapping controls are stripped down to the minimum for ease of use. The most dramatic influence on the outcome is the Method drop-down menu, offering a slew of 20 tonemapping operators with esoteric names like Fresco, Dingy, or Gradual Large. In HDR Efex Pro 2 this unintuitive menu was replaced with three individual parameters that actually make sense: Depth, Detail, and Drama. Each of these parameters can be set in 5 steps, and in combination these settings allow an unprecedented range of artistic looks.

The killer feature, completely unique to HDR Efex, is Nik's U-Point technology. It allows tagging an area in your image with a control point and lets you change tonemapping parameters locally. This allows very targeted adjustments without affecting the rest of the image. Pulling the exposure down just for that window over there or bringing out more texture on a particular wall becomes a breeze with these control points. There is some powerful selection voodoo at work here, a mix between a falloff radius and a range of similar colors like the one directly under the control point. Sadly, only the radius can be changed; the color range is fixed. Let's hope Nik's patents cover only to the user interface of these control points because I would love to see other people's take on targeted adjustment features.

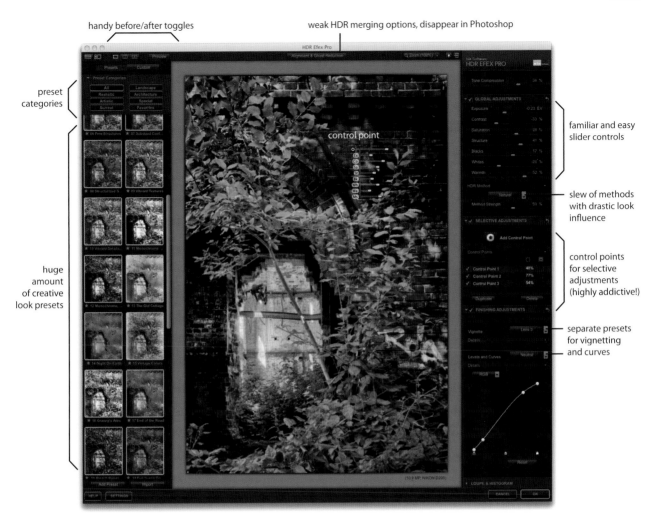

handy before/after toggles

weak HDR merging options, disappear in Photoshop

preset categories

familiar and easy slider controls

control point

slew of methods with drastic look influence

huge amount of creative look presets

control points for selective adjustments (highly addictive!)

separate presets for vignetting and curves

Selective adjustments with control points is really the creative heart of HDR Efex, offering an unprecedented level of control. It naturally lends itself to artistic looks with highly optimized contrast according to your creative vision. The flip side of the coin is that it's extremely tempting to get carried away. Striking the balance to achieve a natural look requires an enormous amount of self-discipline when that little devil sitting on your shoulder keeps whispering, "What about a little something over there?" For an in-depth tutorial on the creative possibilities, check out section 4.4.3.

Please forgive me that the tutorial was written for version 1, which is technically obsolete. They just updated their software without ask-

ing for my permission, can you believe that? How inconsiderate! Many of the shortcomings mentioned in the tutorial are fixed in HDR Efex Pro 2. It now features a decent ghost removal (with an excellent user interface and fast preview) and the mysterious tendency to desaturate highlights is also gone. Even more important, Nik Software reduced the price from $160 to $99 (for you that's $85). So in the end, everybody wins. With HDR Efex Pro 2 you get an excellent artistic tonemapper for a reasonable price.

Nik is also a well-oiled machine when it comes to customer support. No other HDR utility is that well documented; you can even get free personal training in weekly web seminars.

$99
$85

HDR Efex Pro

💻	4/12
	7/12
	8/12
	7/12
	8.5/9
	10/9

Batch Panorama **Plugin** IBL Cafe

✓ - targeted adjustments
 - inspiring preset collection

⊖ - tempting to overtweak

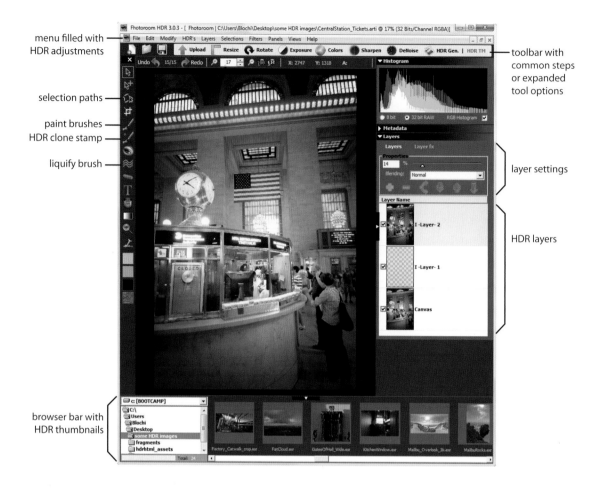

menu filled with HDR adjustments

selection paths

paint brushes
HDR clone stamp

liquify brush

toolbar with common steps or expanded tool options

layer settings

HDR layers

browser bar with HDR thumbnails

HDR Efex has excellent multithreading and runs very smoothly and interactively. It does require a beefy machine, but it sure knows how to use it. A 64-bit operating system is preferred, and provided you have enough memory, it delivers excellent performance on large images.

PRO-TIP Although not officially supported, HDR Efex can also run as a standalone program. Saving the overhead of Lightroom or Photoshop makes a real difference for smaller machines or bigger images. Just dig into the Programs/NikSoftware folder and launch it from there. You can even drag and drop an exposure sequence or pregenerated HDR image directly onto the program icon.

→ www.niksoftware.com/hdrefexpro/

2.3.19 Fhotoroom HDR

Formerly known as Artizen HDR, this program is a unique blend of universal image editor and specialty HDR tool.

On one hand, it offers a fully customizable HDR merger and a tonemapping dialog with the familiar big box of sliders. It's well equipped with solid features in both areas, but nothing really breathtaking. Especially the monolithic tonemapping dialog is a dead end because Nik HDR Efex has already disrupted the market with its selective U-Point technology. Most other tools are frantically trying to catch up now, figuring out ways to allow targeted adjustments directly on the image.

On the other hand, Fhotoroom is already a fully fledged HDR image editor. It has layers,

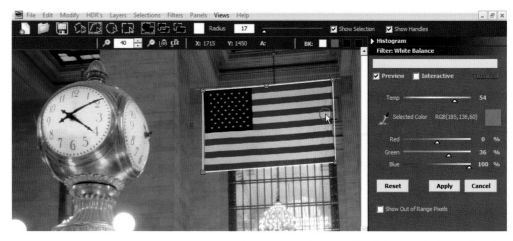

Figure 2-32: *Fhotoroom offers a wealth of image adjustments in 32-bit mode.* ◄

Figure 2-33: *Adjusting white balance only for a selected image portion is one of a million awesome things you can do with a full-featured 32-bit image editor like this.* ▲

filters, brushes, and complex path selection tools. This is really where the party starts. Fhotoroom allows 32-bit image editing way beyond the capabilities of Photoshop: lens correction, panoramic 3D rotations, white balance, color corrections, curves, noise reduction—all in full 32 bits! Throw an HDR clone stamp and paint brushes in the mix and you've got yourself a pretty amazing package for cleaning up HDR images. No matter if you want to use them for 3D lighting or feed them into another tonemapper of your choice; the ability to keep the image in 32-bit while doing all these cleanups will provide you with extraordinary flexibility. You also can selectively massage the tonal values until they look good on your screen and use old-school dodge and burn methods on complex selections, and then you're practically done with toning.

For the artistic photographer, Fhotoroom also has a plethora of 8- and 16-bit filters. Funky Bokeh effects and customizable tilt-shift blur are just the beginning. Layers let you go completely crazy with texture blending techniques, and if that's not enough, there are fully hipster-compatible vintage effects available.

Nothing is reinvented here. All features pretty much conform to Photoshop standards, so you feel at home quickly, except that if you look at it more closely, it's like a Photoshop that is fully loaded with about 10 additional plug-ins. Fhotoroom even includes a screenshot utility, batch HDR processing, a web gallery generator, and Facebook and Tumblr upload tools. Really, when you take into account the amount of features offered, Fhotoroom holds its own with much bigger applications. And all that for just under $50.

Sounds too perfect? There must be a catch somewhere, right? Indeed, stability and interface design do not really hold up. Let's just say that it always had some rough edges. Not every feature always works as expected, and the longer you have it running, the more it feels like you're dancing on a carton of eggs. Frantic clicking is strictly prohibited, and I highly recommend saving often. But if you proceed with caution, this program can be a lifesaver for VFX artists and a creative playground for artistic photographers.

↪ www.fhotoroom.com

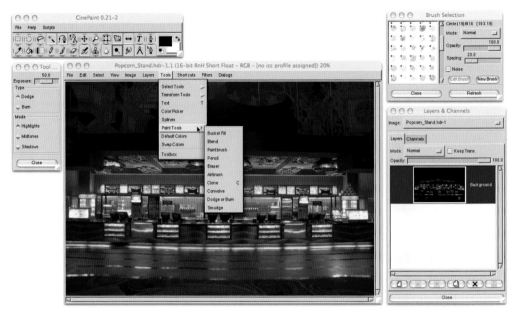

Figure 2-34: *CinePaint is the runaway GIMP that enjoyed five minutes of fame in Hollywood. It got abandoned 10 years ago and replaced by younger and prettier programs.*

2.3.20 CinePaint/GIMP

CinePaint is an interesting offshoot from the popular GIMP open-source image editor. Originally called Film Gimp, it was developed especially for the motion picture industry. Postproduction houses like Rhythm&Hues and Sony Pictures Imageworks used it as in-house software on Linux for years.

That certainly puts CinePaint in a unique position. It is entirely free to use, and it was specifically made for a very tight professional user base working with DPX and EXR files. Those users have the programmers sitting next door, so they are very quick in demanding the bug fixes they need. In-house software like this tends to have very short development cycles and is usually focused on quick solutions for specific problems. Feature wishes are typically paid for with a round of beer at the local pub. My personal feature highlights are the capability to work in the more economical 16-bit float-

ing-point mode, color-managed display, and a complete set of painting tools. Image filters are somewhat sparse, even compared to Photoshop standards.

The downside is that the old-school Linux roots are very dominant. Don't expect the interface to be eye candy. It looks more like a work tool, mundane and simple. The underlying architecture is still identical to the original GIMP, so sliders and check boxes look as ugly as they possibly can. There's a smell of eighties all over the program. Everything is divided in separate floating windows that clutter around on your screen. This doesn't really help stability, performance, or interaction speed. CinePaint tends to lock up or simply disappear when it finds out that you haven't saved for a while. There was an attempt to rewrite FilmGimp with a modern architecture, but progress has stalled for quite a while now.

In the meantime, the original GIMP project has advanced very well. It has the look and feel

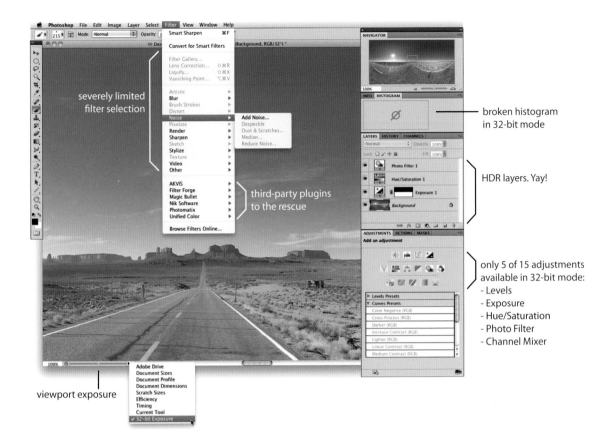

severely limited
filter selection

third-party plugins
to the rescue

broken histogram
in 32-bit mode

HDR layers. Yay!

only 5 of 15 adjustments
available in 32-bit mode:
- Levels
- Exposure
- Hue/Saturation
- Photo Filter
- Channel Mixer

viewport exposure

of a modern application, a wide user base, and an active developer community. GIMP v2.6 started to transition to use full 32-bit processing internally by incorporating a new framework called GEGL. It shows great promise, and I would be happy to replace this CinePaint article with GIMP in the third revision of this book.

If you feel adventurous, or just curious how some pros tortured themselves to work on movie effects, you can check out CinePaint for yourself. But otherwise, I rather recommend keeping an eye on the main GIMP branch.

⤷ www.cinepaint.org
⤷ www.gimp.org

2.3.21 Photoshop CS5

No doubt about it: Photoshop is the market's leading paint application. It is so popular that "photoshopping" has become the street term for image manipulation, and the only reason it doesn't appear in the *Oxford English Dictionary* is that Adobe strangled all those efforts to protect its trademark.

Photoshop has a long history of inventing useful features that quickly became the standard and got copied by all others. The Magic Wand tool is one of those inventions. Photoshop's layer system is another de facto standard. The list is long. And yet Photoshop always manages to stay ahead of the competition. Since the switch to CS version numbers, there have been plenty of additions that are

$699
Photoshop CS5

10/12
9/12
5/12
9/12
11/9
8/9

Batch IBLsafe

- content-aware fill
- HDR layers & paint brushes

- behemoth complexity

still unmatched by any other program: Healing Brush, Liquify, Vanishing Point, Content-Aware Scale and Fill—it goes on like that forever.

But here comes the catch: This feature richness is also Photoshop's Achilles' heel. All these features are based on the assumption that digital images have 8 bits and have a gamma encoding built in that needs to be accounted for. Changing this basic premise not only requires rewiring the internal data structures, it also means rethinking how each and every single feature is supposed to work. HDRI literally pulls away the carpet that Photoshop stands on. Essentially, it means rewriting the entire application from the ground up. And that's precisely what the Adobe team is doing. When you switch the color depth to 32-bit, you literally switch to an entirely new processing engine.

The transition is happening very slowly, though. In fact, it pretty much stalled with CS4. They reworked the basic functionality back up to just about the level of pre-CS times. Almost there, but not quite. Many filters are still missing. At least we have layers, paint tools, and some of the basic image adjustments. All these used to be exclusive to the Extended edition of CS3/4, but from CS5 forward, all HDR features are unlocked in the Standard edition. On the other side, Adobe took care of making new features HDR capable right from the start. That results in some absurd situations: For example, we have the fancy Quick Selection tool in HDR mode, but not a simple Magic Wand. They both do almost the same thing; it's just that one is a new breed and the other one is a classic that the engineering team never bothered to update to 32-bit. Or we can add Smart Filters to a layer, which means that the filters are never really applied but stay accessible in the Layers palette. But we have only a handful of filters to put in there—excluding the important Dust&Scratches, Lens Correction, or any distortion filter. We can use Align Content for panorama stitching or the awesome new Content-Aware Fill, but we don't even have a simple Curves adjustment. Adding insult to injury, they actually bothered to make Add Noise available instead of Reduce Noise.

Figure 2-35: *Half the tools bring up nothing but lame excuses in 32-bit mode.*

At this point, Adobe's progress can only be called schizophrenic. Marketing for CS5 had HDR written all over it, but in reality CS5 has barely any better 32-bit support than CS3 or CS4 had. Not even CS6 brought any improvement. Well, Adobe slapped *Pro* on some of the menu titles, had Greg Ward write a ghost removal feature (which is actually really good), and added a bunch of sliders to its flagship tonemapper. Other than that, there is no new HDR image editing feature that hasn't been there since CS3 Extended. Still no Curves adjustment, no Reduce Noise, not even something straightforward like Invert Mask. I wouldn't even have to update the screenshots where 90 percent of all filters are grayed out if it wouldn't be for the slightly renovated interface design. The situation is so embarrassing that Adobe decided to gently steer people away from using the 32-bit mode. So the HDR merging dialog in CS5/6 now defaults to tonemapping the image immediately to 16-bit, bypassing the messy 32-bit implementation all together. We couldn't fix it, so we will make sure nobody goes there. Great thinking, Adobe.

Despite all the shortcomings of its purposely convoluted HDR mode, Photoshop has one feature that sets it apart: stability. You can throw huge images at it, and it might choke but won't crash that easily. Also, chances are you already use Photoshop, so I will still give it first option in tutorials. With some dirty tricks and the right

workflow methods, we can get by with a feature set that looks like it's from 1995. And lucky for us there are third-party plug-ins to the rescue (more on that in section 2.7).

2.4 HDR Software Comparison

Here we go: On the next pages I proudly present the mother of all test charts!

Taking advertised feature lists for granted would have been too easy. Instead, I actually tested every feature in every software package myself. Whenever possible, I attached a three-dot rating to indicate how completely a particular feature is integrated and how well it performs. Typically, two dots are required for the software to be considered usable, and three dots mean there is nothing else to wish for.

Comparing image editing features required a special investigation. For example, white balance is commonly adjusted only in the LDR domain, either on the source images or the tonemapped image. To earn the official "HDR" seal of approval, software must be able to load an HDR file, apply the edit without clipping the extra highlight data, and allow the user to save the result as an HDR file. Only then does it qualify for a full HDR pipeline.

Note that this overview resembles the state of the software comparison in Summer 2012. This is a highly active field, and chances are that some specific features might have changed by the time you're reading this.

2.4.1 Bottom line
We will have a second glimpse at many of these programs later. In summary, not one of them is perfect for everything. They all have advantages and disadvantages, and you get the most out of them by combining their strengths.

Photomatix's fame is not completely without reason. It holds the crown in batch HDR generation and ghost suppression and has a

Figure 2-36: *Spoiled with choices*

decent tonemapper. Decent and predictable, but not necessarily best for everything. Most other programs mentioned are better in at least one specific area or for a particular purpose. HDR Expose is recommended for serious professionals that need full 32-bit editing and finishing. Nik HDR Efex, on the other hand, is the ultimate sandbox for creative looks and targeted adjustments. SNS-HDR is the newcomer with supreme control for natural looks. Picturenaut is the fastest way to inspect HDR images and offers infinite extendability through an open-source plug-in SDK. HDR Express is easiest to learn, Oloneo PhotoEngine offers unique relighting tools, FDRTools lets you tinker with the toning algorithm itself, and DPHDR has the most post-processing and finishing options. Photoshop is getting challenged hard by Fhotoroom but still remains the standard for photo retouching.

Here's a general tip: Remember that HDR files are completely portable. HDR creation, editing, and tonemapping are independent steps in the workflow and don't necessarily have to be done in the same software. You're always free to use the best tool for the job, or the one that you feel most comfortable with.

	FastPicture-Viewer Codec Pack	Bridge	XnView	Bracket	Photosphere	HDR Shop	Picturenaut	Photomatix Pro	FDRTools Advanced
Primary Class	Codec	Photo Manager	Photo Manager	HDR Photo Manager	HDR Photo Manager	HDR Utility	HDR Utility	HDR Utility Tonemapper	Tonemapper
Platform	PC	Mac, PC	Mac, PC, Linux, Exotic	Mac, PC, Linux	Mac	PC	PC	Mac, PC	Mac, PC
List Price	$15	comes with Adobe apps	free	free	free	v1 free (v3 $199)	free	$99	$50
Your Price (Reader's Discount)	–	–	free	free	free	–	free	$69	$45
HDR File Formats	EXR, HDR	EXR, HDR, PFM, TIFF32, TIFF LogLuv	EXR, HDR, TIFF32, PSD	EXR, HDR, TIFF32, TIFF LogLuv	EXR, HDR, PFM, TIFF32, TIFF LogLuv, HDR-JPEG	HDR, PFM, TIFF32	EXR, HDR, PFM, TIFF32, TIFF LogLuv, HDR-HTML	EXR, HDR, TIFF32, PSD, PSB	EXR, HDR, TIFF32
HDR Thumbnail Browser	●●●● perfect	●○○ no gamma	●○○ no gamma	●●● fixed size	●●● great	–	–	●○○	●●●
HDR Image Viewer	●●○ fixed exposure	○○○ no gamma	○○○ no gamma	●●● accurate	●●● tonemapped	●●● fast exposure	●●●●● auto-exposure	●○○ tiny inspector	●●● a bit slow
Viewport Zoom	●●● via host apps	●○○ small loupe	●●● smooth	●●○ in steps	●●○ in steps	●●○ in steps	●●● smooth	●●○ in steps	●○○ 1:1 or fit
Color Management	●●○	●●○	●●○	●○○	○○○	○○○	●●○	●○○	●●●
Exposure Alignment	–	–	–	●●○ automatic	●●○ automatic	–	●●○ automatic	●●● automatic with options	●●○ automatic +manual
Merge HDR from RAW	–	–	–	–	–	–	✓	✓	✓
LDR Exposure Fusion	–	–	–	–	–	–	–	✓	–
Photometric Calibration	–	–	–	✓	✓	–	–	–	–
Ghost Removal	–	–	–	–	●●● automatic	–	●●○ automatic	●●●● automatic +selective	●○○ manual
Manual Overrides for HDR Merging Algorithm	–	–	–	●●○	●○○	●●●	●●●	●●○	●●●●
Batch Processing	–	●○○	●●● LDR	●●○	–	–	–	●●●●● endlessly configurable	projects
Tonemapping	–	–	–	●●○ primitive natural	automatic	○○○ via plug-ins	●●● interactive natural	natural to dreamy and grungy styles	massive tone and detail control
Toning Presets	–	–	–	–	–	–	●○○ settings files	●●● thumbnails	●●○ projects
Pano-Safe Toning	–	–	–	●○○	●○○	–	●●○	●●●	●●●
Panoramic Conversions	–	–	–	–	crude HDR stitching	all format conversions	via plug-in	unwrap mirror ball	–
Basic Edits (Rotate, Flip, Resize, Crop)	–	●○○ LDR	●●● LDR	●●○ HDR	●○○ HDR	●●○ HDR	●●● HDR	●●○ HDR	●●○ HDR
Fix White Balance	–	–	–	–	–	●●○ HDR	–	●○○ LDR	●○○ LDR
Color Adjustments	–	–	–	–	–	–	–	●○○ LDR	●○○ LDR
Fix Chromatic Aberration	–	–	–	–	–	–	–	●○○ HDR	–
Noise Reduction	–	–	–	●○○ LDR	–	–	–	●●○ HDR	–
Paint Brushes, Layers, Clone Stamp	–	–	–	–	–	–	–	–	–
Stability	●●●	●●●	●●○	●●○	●○○	●●○	●●●	●●●	●○○
Large File Handling	●●●	●●●	●●○	●●○	●●○	●●○	●●●	●●●	●●●
Interaction Speed	●●●	●●●	●●●	●○○	●○○	●●●	●●●	●●●	●●●
Plug-In Version	only	Mini-Bridge in CS apps	–	–	–	–	–	LR (included) PS, Aperture (sold extra)	PS (sold extra)
Usability	●●● invisible	●○○ cluttered	●●● intuitive	●●○ okay	●○○ antiquated	●○○ cumbersome	●●● simple	●●● self-explanatory	●●○ learning curve
Interface Design	–	●●● polished	●●○ functional	●○○ very pink	●○○ feels old	●○○ primitive	●●● minimal chic	●●○ inconsistent	●●○ functional
Help & Documentation	●●● online docs	●●● online docs	●○○ user forum	●●○ brief help	●○○ brief docs	●○○ outdated	●●● FAQ, Forum	●●● FAQ, many 3rd party tutorials	●●● good PDF, FAQ, rollover tips
Languages	–	25 languages	44 languages	English	English	English	English, German	English, French, German, Italian, Japanese	English, German, Italian
Killer Feature	– upgrades entire OS	– integrated in Creative Suite apps	– quick LDR image edits	– batch process of basic edits	– luminance heat maps	– panoramic conversion	– best HDR viewer – open-source SDK	– best batch processing – selective ghost removal	– frequency curves – custom weighted merge
Achilles' Heel	– no options	– can't do anything by itself	– lame HDR handling	– awful interface	– aging away	– no EXR support	– depends on donations to survive	– low preview accuracy	– steep learning curve
Recommended for	all PC users	–	LDR image management	HDR image management	scientific applications	exceptional cases	VFX artists, all PC users	everybody	advanced users

Hydra Pro	HDR Expose	HDR Express	Dynamic Photo HDR	Photo Engine	SNS-HDR Pro	HDR Photo Pro	HDR Efex Pro	Fhotoroom HDR	Photoshop CS5
Tonemapper	HDR Utility Tonemapper	Tonemapper	Tonemapper	Tonemapper	Tonemapper	Tonemapper	Tonemapper	HDR Image Editor	Leading Image Editor
Mac	Mac, PC	Mac, PC	PC	PC	PC	Mac, PC	Mac, PC	PC	Mac, PC
$100	$150	$100	$54	$149	$40 Home $110 Pro	$129 PC $10 Mac	$99	$48	$699
$70	$100	$80	$38	$110	$77 Pro	$70 PC	$85	$36	–
EXR, TIFF32	EXR, HDR, TIFF32, BEF	*unlock required for EXR, HDR, TIFF32, BEF	HDR	EXR, HDR	EXR, HDR	EXR, HDR	EXR, HDR	EXR, HDR, PFM, TIFF LogLuv, PSD	EXR, HDR, PFM, TIFF32, TIFF LogLuv, PSD, PSB
–	–	–	–	○○○ only LDR files	–	●●● fixed size	–	●●○ no caching	●○○ via Bridge
–	●●● accurate	–	–	–	–	–	–	●○○ fixed exposure	●●● crude LUT
●●● smooth	●○○ 1:1 or Fit	●○○ 1:1 or Fit	●●○ not for toning	●○○ 1:1 or fit	●●○ stepped slider	●●● smooth	●●○ in steps	●●● smooth	●●●● extra-smooth
●○○	●○○	●○○	●○○	●●●	●●●	●●●	●●○	●●●	●●●
●●● automatic +manual	●●○ automatic	●●○ automatic	●●●● automatic +manual +pin-warp	●●○ automatic	●●○ automatic	●●○ automatic	●●○ automatic	●●● automatic +manual	●●● automatic
✓	✓	✓	✓	✓	✓	✓	○	○	○
✓	–	–	✓	–	✓	–	–	✓	–
●●● automatic +selective	●●○ automatic	●●● automatic	●●○ selective	●●● automatic	●●○ automatic	–	●●● automatic +hero pick	●●● automatic +selective	●●●● automatic +hero pick
●○○	○○○	○○○	●●●	●●○	●○○	○○○	●○○	●○○	●●○
●●●	●●●	–	●●○	●●● +interactive mode	●●● +series processing	●●●	●○○ via PS Actions	●●●	●○○
natural to artistic styles	crisp and sharp natural to hyperreal	crisp and sharp natural to hyperreal	natural, artistic, and massively stylized looks	natural, grungy, hyperreal, and stylized looks	best natural and photoreal	natural and colorful artistic looks	natural to harsh contrasty artistic styles	artistic and grungy styles	natural to artistic styles
●●● thumbnails +snapshots	●●● thumbnails	●●● thumbnails	●●○ memory dots	●●○ real-time menu	●●● thumbnails	–	●●●● thumbnails	●●● thumbnails	●●● pulldown menu
○○○	○○○	○○○	●●○	●●○	–	○○○	○○○	mirror ball, pan-oramic rotations	via plug-in
–	●●○ HDR	–	●●● LDR	●●○ LDR	●●○ LDR	●○○ LDR	–	●●● HDR	●●●● HDR
●○○ LDR	●●●● HDR	●●○ HDR*	●●● LDR	●●● LDR	●●● LDR	●●● LDR	●●● LDR	●●● HDR	●○○ HDR
●●○ LDR	●●● HDR	○○○	●●● LDR	●●● LDR	●●●● LDR	●●● LDR	●●● LDR	●●● HDR	●●○ HDR
–	–	–	●●○ LDR	–	–	●●● LDR	●●○ LDR	●●●● HDR	●●● LDR
–	●●○ HDR	–	●●● LDR	●●● LDR-Fusion	●●● LDR	●●● LDR	●●● LDR	●●● HDR	●●● LDR
								●●●	●●●●
●●●	●●●	●●●	●●●	●●●	●●●	●●●	●●●	●○○	●●●●
●○○	●○○	●●○	●○○	●●○	●●●	●○○	●○○	●○○	●●●●
●●●	●●○	●●●				●●●	●●●	●●○	
LR, Aperture (included)	LR, Aperture (included) PS (extra)	LR, Aperture (included)	PS (free for all)	LR (included)	–	–	LR, Aperture, PS, Bridge	PS (free for all)	–
●●● playful	●●● professional	●●● simple	●●○ small preview	●●● intuitive	●●● intuitive	●●● straightforward	●●● creative	●○○ small preview	●●○ convoluted
●●●● delicious	●●● modern dark	●●● modern dark	unique style	●●● modern grey	docked panels	aero-graphite	streamlined	homegrown	matured
●●○ PDF manual	●●● PDF manual, video tutorials	●●● PDF manual, video tutorials	excellent PDF, Inline Guides	video tutorials	●○○ tool tips only	●●● PDF Manual	●●●● frequent live web seminars	●●● online tutorials	●●● documentation, books, etc.
English, French, German, Italian, Japanese	English, German	English, German	English	English, French	10 languages	English, Chinese	9 languages	English	25 languages
– gorgeous interface – targeted adjustments	– 32-bit color correction and white balance	– simplicity	– light tuner – match colors	– ReLight mode – zero noise stacking	– extra highlight treatment – series processing	– full finishing toolset	– targeted adjustments – inspiring preset collection	– flexible HDR pano retouching – creative filters	– content-aware fill – HDR layers – & paint brushes
– toy appeal	– resource hungry	– simplicity	– small preview	– all killer features only in LDR	– website only in Polish	– no presets	– tempting to overtweak	– general flakyness	– behemoth complexity
Mac enthusiasts	VFX artists	beginners	artistic experiments	advanced experiments	natural looks	quick workflows	wild artistic looks	VFX artists, creatives	masochists, professionals

2.5 Forgotten Something?

Here are some quick notes on the rest of the pack. URLs are provided when available and are worth checking out.

AKVIS HDRFactory: Very recent tonemapper that is primarily aiming at creative photographers. At the time of this writing, version 1.0 can neither load nor save images in any HDR file formats, which makes it impossible to integrate in existing HDR workflows and disqualifies it from this list. Instead, it overtakes the entire photographic workflow from HDR merging to tonemapping, but it offers selective ghost reduction and capable detail enhancement in return. Should HDRFactory someday become as popular as AKVIS Enhancer (which I doubt will ever happen until it opens up), it may be included in the next revision.
↪ www.akvis.com/en/hdrfactory/

Ariea HDR MAX: Photographic tonemapper that comes in a very professional outfit and fits right in with Adobe's Creative Suite. In fact, the interface resemblance to Photoshop approaches uncanny territory. The tonemapping algorithm is powerful yet easy to use, and it includes batch processing and many finishing adjustments. OpenEXR support is deeply missed, as is any update since the initial launch in 2009.
↪ www.ariea.com

easyHDR: Another promising candidate to make it in here. Can merge exposures, tonemap, apply filters, even has a batch mode. There's also an easyHDR Pro version, which is capable of saving Radiance HDR files and has all the bells and whistles (including chromatic aberration, color management, noise reduction, panoramic seam protection, etc.). Unfortunately, I ran out of time and space and so couldn't review it in this chapter.
↪ www.easyhdr.com

Essential HDR: Formerly known as Project Wukong, this one had a pretty good run in 2007–2008. It was one of the first to offer virtually halo-free tonemapping with just a few simple sliders. Although still available and fully functional, Essential HDR has not been updated ever since. The two original developers have split up. One went on to create iPhone apps like iFlashReady, CameraFlash, HDR Foto, and HDR Artist (probably more by now). His former partner created HDR Darkroom and HDR Photo Pro instead.
↪ www.imagingluminary.com

HCR-Edit: Has surfaced and disappeared again. It used to have some unique editing capabilities, like HDR histograms and curves. Seriously, HDR curves in 2003! Photoshop in 2013—still no curves! Somebody at Adobe declared HDR curves to be "mathematically impossible," so they don't even bother trying anymore.

HDRIE: Open-source project to build a full-featured paint package. It sports paint brushes and a clone stamp brush. Got abandoned before it reached a stable state, sadly.

FrameCycler: A professional movie player for image sequences. It supports playback of EXR sequences properly adjusted with LUTs and offers a fanciful bag of extra features. Frame-Cycler is a standard tool in postproduction, so if you need it, you know about it and you have it already. Outrageously expensive; that's why it got omitted from the reviews in this chapter. Adobe recently bought this program; its future is currently unclear.

RV: This sequence player eats FrameCycler's lunch. RV is more reliable, can hold longer EXR sequences in memory, and plays multi-layered EXR files. It even includes an annotation tool that allows the director to draw scribbles over your frames.
↪ www.tweaksoftware.com

mkhdr: It's the command-line-only ancestor of all HDR merging tools, even older than HDR Shop. Rumors have it mkhdr would still generate HDR images of unmatched quality. However, I respectfully disagree.

pfstools: An all-purpose set of command-line utilities. Included are reading, writing, merging, editing, conversion, and tonemapping functions. So if you feel like creating your own HDRI application, this should be your first choice. It's also rather handy for automating tasks with simple batch scripts. Installation isn't for the faint of heart because it is distributed as open source only. You actually have to compile it yourself.

→ pfstools.sourceforge.net

qtpfsgui, a.k.a. **Luminance HDR:** A graphical user interface for pfstools. Also open source, also free, also maintained well. HDR merging with all the bells and whistles, two auto-alignment options, manual alignment correction, even selective ghost removal. Where it falls apart is with tonemapping. Although it includes all the greatest algorithms that sprung out of graphics research, usability dips down to zero. The problem is of conceptual nature: Luminance HDR is just a launchpad for external algorithms, so all it can ever do is let you configure your settings blindly and then click the Apply button to see what that tonemapping algorithm will do to your image. There is no real-time feedback, not even preview sized. That makes the workflow very cumbersome; it takes a lot of persistence to try even 10 different settings. You basically stop tonemapping when you feel defeated, not when you think this is the best result possible.

→ qtpfsgui.sourceforge.net

Photogenics: Photogenics was the first commercial paint program that stepped up (in 2002) to working internally in full 32-bit floating point.

Offers a clone stamp tool and all the image filters that you can ask for. It can even control a USB-tethered camera to shoot exposure brackets and automatically merge them to HDR. It was way ahead of its time with nondestructive image editing by treating every action as Photoshop's adjustment layers or Smart Objects do: you can always go back and change parameters or steer the effect with brushstrokes. Too bad this fine application is no longer supported. There has been no update in at least five years.

→ www.idruna.com

Pixel, a.k.a. **Pixel Studio Pro:** Very promising attempt to tackle Photoshop by Pavel Kanzelsberger. Interface and functionality was identical; you would get all the common workspace palettes, adjustment layers, even layer effects. In addition, Pixel could manage multiple workspaces, had more options enabled in 32-bit mode, and was available for every OS (including the most obscure Linux derivates). As feature complexity grew, stability and performance became a major bottleneck. A standard 10-megapixel photograph could bring it down to its knees. After working on it for more than 15 years, Pavel abandoned the project in 2009, without ever reaching a stable release version.

→ www.kanzelsberger.com/pixel/

WebHDR: A front end for the command-line version of Photosphere, running entirely off a web server. You just upload your exposure brackets, and it returns a link to the HDR image in various formats as well as a unique interactive luminance analysis. Along the way it anonymously collects the EXIF header of different camera models and makes them open to the public. Please do drop in when you have a new camera because the data collected helps software developers to support it.

→ www.jaloxa.eu/webhdr/

2.6 Compositing Software

Here is some good news for all you digital compositors: Nowadays, all compositing software is capable of working in high dynamic range. The reason is that scanned film frames, coming in as Cineon files, have been edited in 16-bit precision for a long time now. They are considered as *digital intermediate,* which already incorporates the idea of having extra headroom beyond the white point. That's the only way to have a final output lasered back to film while maintaining all the vivid highlights and smooth gradients from the original film scan. Stepping up to floating-point precision is just the next logical step, and OpenEXR has become the standard here.

Keep in mind that all these programs don't really care if you work with an image sequence or a still image. There is no reason you couldn't edit a photograph with them and take advantage of a supreme toolset and nondestructive editing in full precision. Frustrated with the limitations of Photoshop, most VFX artists I know skip right ahead to their favorite compositing package for all their HDR image editing needs.

2.6.1 After Effects

True 32-bit compositing was first seen in the Pro edition of After Effects 7. Now, in CS5, that mode is available across the board. In fact, CS5 has everything rewired to work beautifully in 32-bit, including supreme color management and proper support for linear working spaces. You can choose to tune the viewport to linear or gamma-distorted space or any precalibrated profile you might have and all your blending modes would automatically adjust themselves to work just right. I wish the After Effects team and the Photoshop team would hang out together more. Maybe Photoshop's HDR capabilities would be much better then. There is a legacy of filters and plug-ins that do not work in 32-bit, but that is often due to the fact that they

are simply obsolete because they were 8-bit hacks in the first place. OpenEXR support is excellent thanks to the inclusion of the ProEXR plug-in (more on that later). After Effects is also the most affordable program in this category.

2.6.2 Fusion

Fusion has a long history of 32-bit support, all the way back to version 3. In contrast to After Effects, this is a *nodal system,* which means that instead of layer stacks, you can build complex tree structures with different processing branches. That makes it possible to have 8-, 16-, and 32-bit branches coexist within one project. A 16-bit floating-point mode also is available, which is a great trade-off between precision and speed. Each and every effect can be applied in 32-bit, even those that are not optimized for it or where the math behind it is hitting a wall. This can be quite confusing; sometimes you spend hours hunting down the effect node that breaks everything. Fusion supports 15 extra channels embedded in OpenEXR, which can have different color depths. However, in practice you have to extract arbitrary channels into a separate stream of RGBA channels so effect nodes can actually access this data.

2.6.3 Composite

Formerly known as Toxic, this compositing program now comes bundled with Maya, 3ds MAX and Softimage. These bundles are also the only way to get it. Don't be fooled by Autodesk's freebee throwaway mentality: Composite is actually a sophisticated tool with high value on its own. The user interface loosely resembles the legendary Flame finishing suite, with the difference that Composite is built around a nodal system. Since they are both Autodesk products, Flame and Composite can work seamlessly together in a network environment. EXR support is very similar to EXR support in Fusion, where each set of extra channels requires a separate footage node to extract it from the file.

Thankfully, you can just right-click an EXR sequence in Composite's file browser, choose Import As Group, and have all the required footage nodes autogenerated and wrapped together.

2.6.4 Nuke

This used to be the in-house compositing tool at Digital Domain, so it was born right into the heavy demands of real-world production. There is some serious magic happening when the programmers of a tool are sitting on the same floor as the hardcore users of the tool. Now owned by the Foundry, Nuke has quickly become the new industry standard for film production. It is a nodal system that is customizable in any regard. The principal advantage is that you can have any number of channels carried along the processing stream. The downside is that you have to manage all channels yourself. So there is quite a steep learning curve, yet true mastery is waiting at the top. Nuke leads in OpenEXR support by being the only software that can recognize up to 64 channels as well as fully support every other aspect of this format.

There are many more compositing and color grading systems out there. The more professional they get, the more likely they can juggle all data in floating-point precision at blazing speed. Nucoda Film Master, Da Vinci, Inferno—even their names have an aura of power. However, these are beyond the ordinary citizen class. They run on specialized hardware and are prized in automotive realms, and instead of just buying them, you have to sign up with blood.

In the workshops to follow, we will have some brief looks at After Effects and Fusion, but whenever possible the tutorials will be done in Photoshop. This is simply the most common ground.

Figure 2-37:
Compositing software is used to marry filmed footage with CG elements and visual effects. But it can just as well be used to edit HDR photographs.

Figure 2-38: *The Nucoda Film Master suite fills a dark room and has three space-age crystal balls. They are glowing trackballs and steer color wheels for shadows, midtones, and highlights. All full 32-bit HDR, of course.*

2.7 HDR Plug-Ins

Photoshop remains the standard for image editing, like it or not. As outlined some pages ago, its HDR capabilities are advancing in baby steps. That way the Adobe engineers provide a fertile ground for an ecosystem of third-party plug-ins. It's sad that we need them, but it's really good that they're here.

2.7.1 ProEXR

This is probably the most important Photoshop plug-in for CG artists and ambitious photographers.

Adobe never really understood what EXR files are used for. CS6 is marginally better, but until CS5 the OpenEXR support is completely bare bones. That means all the great OpenEXR features I told you about in section 2.1.7 are purely hypothetical to Photoshop users—unless ProEXR is installed.

That little plug-in will give you access to all the different compression schemes, whether you want to step up to full 32-bit precision for archival purpose or crunch your files to half the size with the B44 compression. More important, ProEXR lets you load and save full layer compo-

sitions as EXR files. Unless you're using adjustment layers, this is a much more efficient alternative to saving a PSD file. Files are much smaller, while all layers remain intact. Panorama photographers can benefit a great deal from this. And for CG artists, who render all sorts of extra channels and layers for post-processing, this is really the best way to get them into Photoshop.

ProEXR is so useful that it's even included in After Effects CS5. Sadly, Photoshop users have to buy it extra. It's $76 for you, $95 for everyone else.

⇱ www.fnordware.com

2.7.2 OpenEXR Alpha plug-in

If all these fancy EXR features sound like rocket science to you, ProEXR might be overkill. However, there is one particularly annoying limitation in Photoshop's treatment of OpenEXR files: it loads alpha channels directly into pixel transparency.

That may be fine for many photographers, but it's a disaster for visual effects people. Some usage scenarios require that the alpha channel not be immediately applied. That means there is color data for every pixel in the image but some areas are made invisible by the alpha channel. Panorama photographers use this technique to manually refine the blending between overlapping images. For VFX work, it is also common practice to use alpha channels for separating foreground from background elements. Then the alpha is not supposed to make anything transparent; it's rather used as a selection mask for color corrections and other adjustments. Yes, technically this a misuse of the alpha channel, but many professional workflows rely on it. Photoshop, however, does not allow such flexible scenarios. It always assumes the alpha channel describes transparency and cuts away these transparent parts immediately when an OpenEXR is loaded. This destroys all residual color data.

Figure 2-39: *ProEXR brings extensive EXR support into the Photoshop world. This dialog comes up when you load an EXR image while holding the Option key (on a PC, the Alt key).*

Figure 2-40: *By default, Photoshop uses the alpha channel to cut away transparent pixels when an OpenEXR is loaded.*

Figure 2-41: *Adobe's optional OpenEXR Alpha plug-in puts an end to this destructive behavior. Alpha channels are no longer applied during loading; instead they show up in the Channel palette.*

After long and heated discussions between VFX industry professionals and Photoshop engineers, Adobe finally gave in. With the free OpenEXR Alpha plug-in, Photoshop CS5 will not touch the RGB data and instead loads the alpha as an extra channel.

Photoshop CS6 does not require this plug-in. However, the fix in CS6 isn't without problems. Every time you open an EXR file, CS6 will open a popup window asking what to do with the alpha channel—even if the file does not contain an alpha channel! Most photos don't, so for 90 percent of all users that popup window is just a useless annoyance. And once again, ProEXR comes to the rescue. You can get rid of this popup by installing the free ProEXR EZ plug-in.

↪ www.tinyurl.com/EXRalpha

2.7.3 Tonemapping Plug-Ins for Photoshop

And then there are plug-in versions of some popular tonemappers. Namely, we have Photomatix, FDRTools, Fhotoroom, AKVIS HDRFactory, Ariea HDR-MAX, and Nik HDR Efex. Most of them are really just headless versions of the standalone programs, stripped down to the tonemapping module. Nik HDR Efex is only available as a plug-in, but it also hooks into Lightroom, Aperture, and Bridge. Fhotoroom's tonemapping plug-in comes in three different editions, optimized for different tonemapping styles—Dramatic, Natural, and Dreamy—which is an interesting sidestep, considering the program itself is the closest contender to become a Photoshop replacement. Even better, they are completely free.

There is a huge workflow convenience in these plug-ins because you spend less time switching between programs. However, they all have to dance around the quirky implementation of Photoshop's 32-bit mode in general. Ideally, you'd want a plug-in to affect only a single layer in your Photoshop document, maybe even keep it accessible for further editing. But unless Adobe fundamentally changes the way switching between color depths works, all these plug-ins will end up flattening your document. Per-layer tonemapping can only be achieved with heavy trickery involving Smart Objects, history stack manipulation, or duplicate

documents. The workflow examples in section 4.4 will show you some of those tricks.

The second pitfall is that running any of these plug-ins in Photoshop requires much more memory than running the standalone versions requires. That's not really their fault. Once again, it's Photoshop squatting all available memory. But the net effect is that you can expect delays unless your machine is significantly well equipped with RAM.

2.7.4 Lightroom Plug-Ins

Many of the programs mentioned offer Lightroom integration with a dedicated plug-in. Sounds like a good idea, right? Wrong! The truth about all these Lightroom plug-ins is that they are all fundamentally flawed. Lightroom deliberately does not give any plug-in access to the RAW images. Instead, it will do an initial RAW conversion in the background, clip shadows and highlights in the process, and then hand the images over as temporary 16-bit TIFF files. That means tonemapping plug-ins have no chance to make use of all the dynamic range in your RAW files, which totally defeats the purpose. You can make it work by choosing your development settings carefully, which is explained in detail in section 3.2.4, but with the default settings, you're loosing data in the process.

The workflow convenience is just an illusion anyway. Yes, you can select your exposure brackets in the thumbnail view and then right-click to launch a tonemapping plug-in. But you might just as well drag the thumbnail stack out of the Lightroom window and drop it directly on the Photomatix/HDR Expose/FDRTools icon. That will launch the full standalone program, not just the plug-in version. This way is faster because Lightroom doesn't do a conversion in the background, and it may even be more accurate because you're feeding the original RAW files to the tonemapper. The only inconvenience is that you have to drag and drop your final toned result back into Lightroom yourself,

whereas the plug-in versions would do that for you. Well, dropping one image into Lightroom is really not a big deal.

2.7.5 32 Float

Technically, this is the Photoshop plug-in version of HDR Expose. The reason I don't mix it in with the other tonemapping plug-ins is because it can do so much more than just tonemapping. 32 Float gives you many regular image editing tools that Adobe failed to deliver in 32-bit. Noise reduction, white balance, controlled color tweaks, cleaning up the black levels—all these things can be performed on HDRs without ever leaving the 32-bit mode. This is huge for preparing images for CG lighting, but also, in photographic applications, it's utterly useful when you clean up your image before tonemapping it down. Chapter 5 will give you the full scoop on the advantages of real HDR image processing.

Of course, you can also use this plug-in for tonemapping. Just as mentioned earlier, the extra overhead of Photoshop guarantees lower performance and speed than you would get with the standalone HDR Expose.

⇨ www.unifiedcolor.com/32-float

2.7.6 Magic Bullet PhotoLooks

This Photoshop plug-in is from an entirely different mold. It's an offspring from the professional Magic Bullet suite for After Effects, which has a reputation in the visual effects world for delivering the ultimate cinematic look treatment. Some of my artist friends secretly swear by it and run every piece of footage through Magic Bullet to give it that final polish. Some even call it cheating because Magic Bullet is loaded with so many presets that this finishing process is often reduced to just slapping on one of 100 predefined looks. In this regard, Magic Bullet really lives up to its name.

On second look, however, it has an incredible wealth of image editing features. Vignetting, Selective Blur, Lens Diffusion, Color Curves,

Cross Processing—all together that's 36 tools, all in full 32-bit mode. While Unified Color's 32Float plug-in gives you a few powerful tools, Magic Bullet gives you all the rest. Even the tools that you can find in standard Photoshop, like Blurs and Levels, are more intuitive and process with better quality in Magic Bullet. The processing engine simulates the optical light behavior, and each effect is applied to the correct processing stage. For example, Tilt-Shift lens blur and vignetting happen at the lens level, which always comes before Bleach Bypass, which happens at the camera stage of processing. Section 5.2.4 shows some of these creative opportunities in action.

The professional background shows in the refined user interface and sadly also in the $199 price tag.

www.redgiantsoftware.com/products/all/
magic-bullet-photo-looks

2.7.7 Filter Forge

This is the ultimate filter plug-in. While Magic Bullet can line up 36 different tools in one linear processing stream, Filter Forge puts 120 tools at your disposal to build complex image operations. It's a full-featured nodal system in which multiple streams of processing can be branched off and converged back together. Once this nodal tree is put together, it becomes your very own custom-made image filter. The level of freedom is truly incredible. You can build anything from seamless texture generators, photo frames, and aged photo looks to convincing watercolor painting. Over 8000 premade filters are available, and you can get credits for submitting your own filter trees to this preset library. Eventually, if your filter turns out to be popular, you get the Filter Forge license for free.

The Professional edition works in full 32-bit floating-point precision and essentially replaces every other filter you would find in Photoshop. Furthermore, some of the components inside a filter can even use HDR images for lighting, so

your embossed photo frames look more realistic than ever before.

To harness the full power of Filter Forge, there is quite a learning curve involved. For purely photographic purposes, it might be overkill, but VFX and game artists that are already familiar with a nodal system will find a gold mine in here. Most filters are optimized for seamless tiling, and texture generators automatically export separate diffuse, bump, specular, and normal maps.

Officially, the Pro edition cost $399, but it's frequently discounted (up to 60 percent), and you can earn your own discount by submitting new filter presets.

www.filterforge.com

2.7.8 Atlas

This is a tonemapping plug-in for After Effects. It includes nine common tonemapping methods but with the twist that each parameter can be animated over time. Common applications are HDR time-lapse sequences or CG animations, and in the future, HDR video clips captured with your fancy new HDR video camera. It's fairly slow but very powerful, especially when used in conjunction with After Effect's excellent built-in color tools and masks. Atlas is freeware and open source; donations appreciated.

www.3dcg.net/software/atlas

2.7.9 Ginger HDR

Ginger HDR is another tonemapping plug-in for After Effects and Premiere Pro. It offers several alternative toning methods, from filmic tone curves over exposure blending to aggressive detail enhancement with local adaptation. It's optimized to make the best out of HDRx footage from a RED camera, time-lapse HDR sequences, and even the HDR video mode that you can unlock in your Canon 5D with the Magic Lantern firmware hack (see section 3.2.2).

Compared to Atlas, Ginger HDR is more powerful, more usable, and much faster (thanks

HDR Helper Dynamic Range Helper PhotoBuddy PhotoBuddy

PhotoBuddy

Figure 2-42: *The most useful iPhone apps are not those that shoot HDR images on the device, but those that assist shooting with your DSLR.*

to GPU acceleration). But all that goodness comes at a price: $149. Check out the free 30-day trial and see for yourself.

▱→ www.19lights.com

2.8 iPhone Apps

There is no shortage of iPhone HDR apps. Almost every month a new one bubbles up, typically with an icon that shows the front of a DSLR lens decorated with the buzz letters *HDR* in rainbow colors. Veterans on this platform are **ProHDR** and **TrueHDR**. Both are capable of shooting exposure brackets and then merging and toning them on the go. When these two were at the height of their game, Apple decided to integrate the HDR mode into the native camera app, and the flood gates have been wide open ever since. New-school apps battle for the most controls and the widest range of artistic looks. Some are made by people with quite a bit of HDR experience in the desktop world:

🔸 **iCamera HDR** from Jiang Duang, maker of HDR Darkroom

🔸 **Dynamic Light** from Roman Voska, maker of Dynamic Photo HDR

🔸 **Snapseed** from Nik Software, maker of HDR Efex Pro

🔸 **100 Cameras in 1** from Trey Ratcliff, creative head of StuckInCustoms.com

At the end of the day, none of these programs will actually generate real 32-bit HDR or OpenEXR files for offline processing; they're all made to process directly on the device. Well, bracketing and basic tonemapping functions are rather omnipresent on iOS anyway, so you wouldn't even need a dedicated HDR app for that anymore. For example, the excellent **Camera+** app will give you all the Clarity and Lift Shadows feature goodness you need on the iPhone.

There's only so much you can squeeze out of a sensor the size of a needle pin. Yes, I'm aware that many well-known pro photographers advocate the creative potential of iPhone photography, but in my opinion that is based on the fact that the iOS is a programmable platform. If anything, the iPhone camera's popularity shows how outdated the concept of built-in camera firmware really is. Imagine the creative potential unleashed when full-size sensor DSLRs have touch screens, app stores, and more horsepower than today's Google servers.

Until then, the real gems are apps that assist shooting with your DSLR:

Dynamic Range Helper ($0.99) and **HdrHelper** ($2.99) both do essentially the same thing: You set the metered exposures for the darkest and the brightest spot, and the apps will create a shooting plan for the optimum bracketing settings. This is especially useful when your camera is limited to three-frame autobracketing, like most Canon DSLRs. When you have a plan like this it becomes a breeze to fire overlapping bracketing bursts. In section 3.2.2, we will have a closer look at this technique.

PhotoBuddy ($1.99) also prepares a shooting plan for overlapping brackets and presents it in the nicest interface of the pack. That's the app I'm using myself. Plus, it contains a gorgeous depth of field calculator, distance measurement tools, sun- and moonrise calendars, all presented in exceptionally polished and functional design.

LightTrac ($4.99) is another favorite of mine. It's an incredible tool for virtual location scouting. HDR can certainly enhance many images, but that doesn't mean you can just polish a turd to get a masterpiece. Being in the right place at the right time is as important as ever, and with this app you can plan your day perfectly. You know exactly when and where a sunrise happens, and by zooming in on the map, you can estimate where to get the best angle. For time-lapse, landscape, panoramic—well, let's just say for any outdoor photographer this is a must. Seriously.

PanoTool ($2.99) is an inclinometer for shooting handheld panoramas. Granted, there are hundreds of better-looking inclinometer apps, but this one was specifically designed as a shooting assistant. You simply strap the iPhone to your camera with a rubber band, and a voice guides you to the perfect aim. Even though I strongly encourage the use of a tripod for HDR panoramas, this is still a pretty cool idea. More useful

Figure 2-43:
LightTrac is an indispensable tool for getting to the right spot at the right time.

for practical purposes is the included panorama calculator that helps in determining what angles to shoot with a given sensor/lens combo.

There are certainly many more noteworthy iOS apps for photographers; enough to fill a book on their own. Let's just close the "Tools" chapter right here and move on. After the break, we'll discuss image sensors, photography gear, and how to create HDR images. But first comes the exam.

Figure 2-44:
PanoTool turns your iPhone into a camera accessory for finding just the right angles for shooting panoramas handheld.

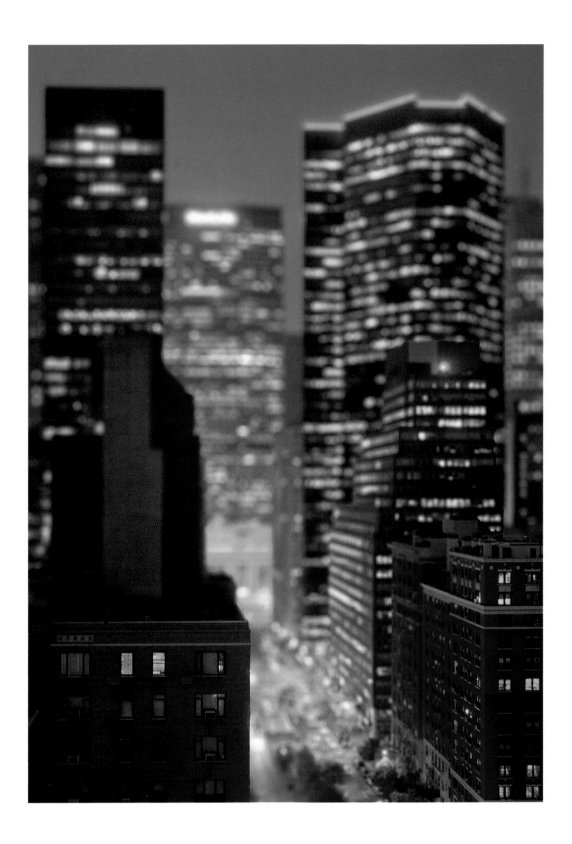

2.9 Chapter 2 Quiz

The reward for successful completion of this torturous quiz is another excellent artist portfolio. I mean, yes, technically you could just keep on browsing without solving the puzzle, but you shouldn't. My original plan was to completely cover the portfolio pages with these sticky metal flakes they use for the scratch lottery, but my publisher refused vehemently. Oh well, then please just ignore those pages until you solved your puzzle.

1. Free open-source tonemapping plug-in for After Effects.
2. Software company that has owned the TIFF file format since 1994.
3. Visual effects company that developed the OpenEXR format.
4. Popular HDR program that has become the de facto standard for photographic applications.
5. Essential Photoshop plug-in that enables layers, flexible alpha channels, and all compression schemes in OpenEXR files.
6. Rarely used TIFF flavor that can pack 16 EVs with a full color gamut in only 24 bits total, thanks to logarithmic encoding.
7. OS X-only HDR application with a distinctive Apple-like interface and a unique pin warping alignment.
8. HDR tool with an end-to-end 32-bit imaging pipeline and excellent color tools in full HDR.

9. Third-party Windows extension that enables system-wide support for RAW and HDR file formats.
10. Freeware HDR tool that is included on the DVD and hosted on HDRLabs.com. Has an open source SDK.
11. Latest name of Microsoft's highly compressed HDR image format, which is intended as alternative to JPEG.
12. Inventor of the Radiance HDR and TIFF LogLuv file formats, the Photosphere application, and HDR display technology.
13. Compression scheme of OpenEXR files, lossless and most efficient for photographic images.
14. Insanely popular image editor with gaping holes in functionality in 32-bit mode.
15. Official name of the common file format with the filename extension .hdr
16. Camera-specific file format that delivers just as much dynamic range as a particular sensor can capture.
17. Universal decoder for RAW files, used internally by many applications.
18. Common name for an embedded transparency channel.
19. Recommended HDR file format.
20. iPhone app that can create a shooting plan for extended bracketing and calculate depth-of-field, sunrise, and moonrise—and much more.

2.10 Spotlight: Luke Kaven

Luke Kaven is a professional photographer in New York as well as lucky owner of an independent jazz record label. When shooting these highly emotional portraits of jazz musicians, it all came together: His long-time relationship with the artists encouraged him to show them from a very personal perspective, and his excitement about photographic experiments drove him to HDR portrait photography. The results are truly stunning, an exceptional example of creative application of HDR methods. Let's poke his brain a bit to find out more.

CB: Luke, why did you choose an HDR technique for these portrait shots?

LK: The subjects here are mostly jazz artists whose recordings I produced. I often need to shoot portraits of jazz musicians in the settings where we customarily meet up late at night in Manhattan—in the jazz clubs, and out on the streets—for album covers, promotional material, or magazines. I had just started experimenting with Photomatix making architectural images late at night in upstate Ithaca, New York, and noticed some unusual and interesting qualities that started to emerge in low-light situations. I wondered how images like that might look with human subjects. In the process of putting together a new catalog of recordings, I persuaded the artists to give it a try.

CB: So these are album cover shots?

LK: Six of them were used by Smalls Records as album covers, a few more as inside shots.

CB: How many exposures did you shoot and was it hard to get your subjects to hold still?

LK: In most cases there were about six exposures, bracketed at ±2 EV intervals. Since the light was very low, it took nearly a minute in some cases to complete each sequence. Clearly this was the hard way to go. But the musicians are experienced world-class performers who love a good challenge, and they took the challenge seriously. Some turned out to be amazingly good at standing still, and all were very patient.

In practice, there are only two or three exposures in a sequence that contain the details of a subject's face. If the subject can hold steady during two out of those three, there is usually enough information to work with. You can also draw on the best single shot in the sequence if necessary. Where the job requires it, you can shoot the background and subject separately and composite them together later, using HDR to shoot the background and whatever method you prefer to shoot the subject.

CB: The look of your images is far from natural; instead they have a certain impressionist touch, almost painterly. Was this the intention?

LK: Definitely. The look is intended to be suggestive of various painting and illustration styles. It really suited the way I saw some of these subjects. The musicians and I are all night owls, at home in the middle of the night. It doesn't look murky to us. I wanted night scenes to be vivid and three-dimensional with a wide perspective, just the way they look to me. The stylistic twist adds a historical dimension to the portraits. The slight suggestion of pulp fiction, psychedelia, impressionism, early twentieth-century Harlem, etc. is just enough to work its way without being overbearing. Working around Greenwich Village, you still feel its artistic legacy around you, and I think that influenced me.

As it turned out, shooting HDR in low light produced some effects that I hadn't quite anticipated. Standing in low light, one sees light and color as sparse and scattered around the scene. Making a time exposure, one sees light as less sparse. But in bracketing for an HDR series, the scene is supersampled over time, and the resulting HDR file reveals a kind of dense mixing of light and color that neither the naked eye nor the traditional photograph shows. I found that small lights of varied colors would mix and paint different parts of the scene with unexpected hues. So I started to use this, and to scout out locations that would produce these kinds of effects. In these images, all lighting is found lighting, and all colors are really in the scene.

The idea of a "natural" look is somewhat specious, and it's usually defined by reference to traditional photography. But I don't think that traditional photography is "natural" either, particularly with respect to its imposition of an artificial black point and white point.

CB: Interesting idea. I just happened to experience Greenwich Village at night, and I can attest that these images really do capture the vibe of this place. Would you say that HDR enabled you to show more than just a photographic reproduction?

LK: When working with low-light HDR, the camera captures phenomena that are qualitatively very different from what the eye perceives. But traditional photographic reproduction was never "natural" either. A person's eye adaptively processes a scene locally, as directed by one's attention.

The iris dilates and contracts. In some ways HDR allows you to visually present this kind of natural compression of dynamic range in a way that is more convincing than traditional photography. Stand in a dark room looking out the window at a sunlit scene. The sunlit scene isn't washed out white, nor is the interior pure black in your visual field; you can see both things.

I think that to a degree HDR points the way to new foundations for photography. The first digital cameras by and large attempted to emulate the functions of the film cameras they replaced. That includes perpetuating what I call the "single shot theory," which says that one shot equals one photograph and that the final product is pretty much given in the act of taking that shot, with only a narrow tolerance for adjustment. While this has been a way to take good pictures, as a fundamental basis for photography, I think it has run into a dead end. As cameras become more intelligent, they will be capable of recording information in more sophisticated and flexible ways. In the future, I think cameras will record as much information as possible about a scene in the time allotted, with indefinite limits on dynamic range. The photographer will then have a wide range of choices as to how to render this information. Tools that are just beginning to evolve today, such as tonemapping and relighting, will play a bigger part in the process.

In the end, anything you can do photographically is permissible, and its value is determined by whether it serves an artistic or documentary purpose or not.

CB: How did the musicians like these images? And how were the album covers perceived by the fans?
LK: The artists were surprised to see a look they had never seen before. Ari Roland said, "I think you're onto something!" For all the time we spent hiking around downtown Manhattan looking for locations, they were very pleased.

As album cover images, they were a departure from the tradition of using black-and-white photography but held interest for confirmed jazz fans. Experience suggests that graphics on an album cover are not what motivates those unacquainted with the music to buy the records. People tend to find their own way into the music once it begins to say something to them and typically not before. But the portraits drew a surprising amount of outside attention to the artists as the artistic subjects in these popular images, and one hopes the recognition will benefit the music in the long run. This music is, after all, one of life's great treasures.

CB: What's your top advice to HDR photographers?
LK: Looking at an HDR image, particularly in the cases where HDR is an obvious feature of the image, one gets the impression that considerable work went into the production of the image,

as though the image were painted by hand. For this reason, artistic commonplaces such as composition figure even more importantly into the picture. In cases where the composition is poor, it gives the embarrassing impression that the artist spent considerable time laboring over a bad composition without ever realizing it was bad.

Let artistic considerations guide you at each step.

CB: Thank you so much for these inspiring words.

Visit www.smallsrecords.com to see how great these images look as album covers. It's also worth listening to some of the free MP3s provided to really get the full experience. These records are really creative masterpieces inside and out, so it would be a good idea to order some of these albums and support Luke and his fellow artists.

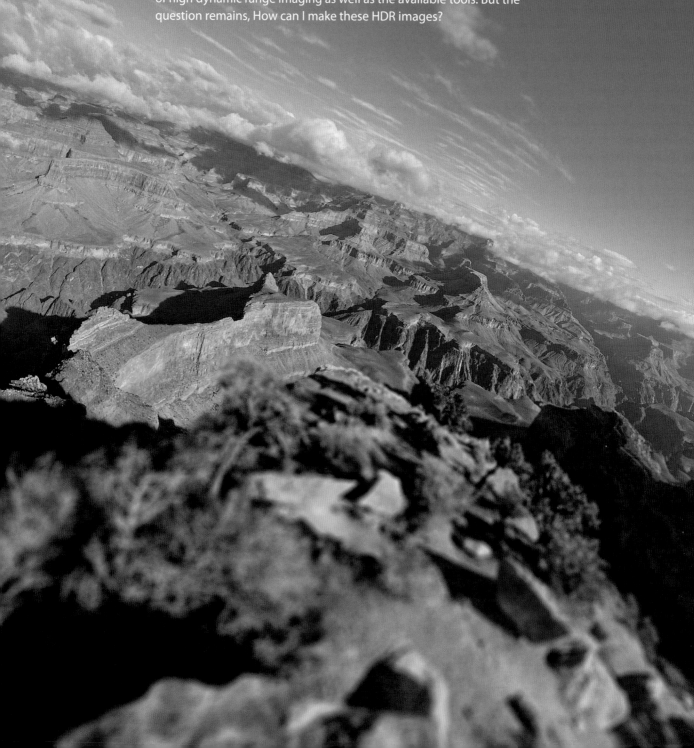

Chapter 3:
Capturing HDR Images

Now we're all on the same page about the theoretical background
of high dynamic range imaging as well as the available tools. But the
question remains, How can I make these HDR images?

Basically, there are three ways.

First, you can create them synthetically with a 3D program. These days, all 3D render engines work internally with 32-bit floating-point values. So the data is there—up until the point a final image is saved to disk. The general habit of saving an 8-bit image simply throws away most of the precious rendered data. And that's a shame, really, because it couldn't be any easier to maintain the full dynamic range of a rendered image: Just save it as a EXR file! (That's quite a large topic itself. We'll get into that later when we cover CG rendering in Chapter 7.)

The second conceivable way is to shoot an HDR image directly. Sensor technology has advanced a lot lately, and the recent generations of DSLR cameras can already be considered *medium dynamic range* capturing devices. Even in-camera HDR is already out there. It's in its infancy, though, mostly used as a marketing buzzword and restricted to the point-and-shoot level of photography. That means you can get more or less successfully tonemapped images directly out of a growing number of cameras such as, for example, the Canon G12, the Fujifilm FinePix EXR series, the Pentax K7, the Lumix DMC-LX3, and even the iPhone. But all of these advertised HDR modes are useless for real photography or CG lighting because the camera has already done the creative work by crunching all the captured range down to a JPEG. True HDR shooting, where you can capture a full 32-bit image in an instant, is just around the corner. If you have $50,000 to spare, you can already get a real HDR camera, and real HDR imaging sensors are just making the leap from research labs to mass production.

The third way would be to shoot a series of images with different exposures and merge them digitally into one HDR image. This can be done with any camera that allows manual exposure settings; even with some that don't. It requires some manual labor though, and a huge downside is that this method is largely limited to static scenes. Merging a bracketed exposure sequence into a good HDR image is a skill in its own right and will be covered in depth in this chapter.

If you feel the urge to shoot HDR images right now, you can safely skip to section 3.2 and learn about shooting and merging exposure brackets. But if you're interested in some insights on how digital cameras evolve toward HDR, you should read on.

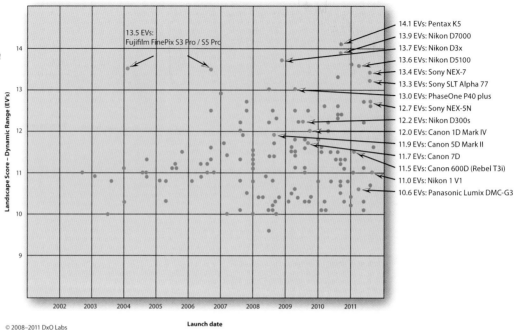

Figure 3-1:
Camera Sensor ranking on DxOMark.com used with friendly permission

14.1 EVs: Pentax K5
13.9 EVs: Nikon D7000
13.7 EVs: Nikon D3x
13.6 EVs: Nikon D5100
13.4 EVs: Sony NEX-7
13.3 EVs: Sony SLT Alpha 77
13.0 EVs: PhaseOne P40 plus
12.7 EVs: Sony NEX-5N
12.2 EVs: Nikon D300s
12.0 EVs: Canon 1D Mark IV
11.9 EVs: Canon 5D Mark II
11.7 EVs: Canon 7D
11.5 EVs: Canon 600D (Rebel T3i)
11.0 EVs: Nikon 1 V1
10.6 EVs: Panasonic Lumix DMC-G3

13.5 EVs:
Fujifilm FinePix S3 Pro / S5 Pro

Landscape Score – Dynamic Range (EV's)

Launch date

3.1 Digital Imaging Sensors

Camera manufacturers must consistently deliver innovation. Megapixel counts have reached a level that is more than sufficient; they already surpass the resolution we could get out of film. So that war is over. Consumers finally started to realize that cramming more pixels into smaller sensors isn't necessarily the best way to ensure better pictures. The new battleground is dynamic range, with the first blows being exchanged as we speak. The popular camera testing website Digital Photography Review (www.dpreview.com) picked up dynamic range as a standard test criteria a long time ago, using a backlit grayscale chart as designated test subject. If you want to know what your camera's sensor is capable of, www.dxomark.com has an incredibly well-organized database, gathered using a similar real-world test. The diagram above shows the dynamic range rankings as of June 2011. It shows, for example, that the Pentax K5 leaped ahead with 14.1 EVs, disrupting the two-year streak of reigning champion Nikon D3X.

Sensor technology is the motor of this innovation, and in this field, the dynamic range is traditionally measured in decibels (dB). By rule of thumb, 1 EV equals approximately 6 dB. Most consumer-grade sensors can capture 60 to 75 dB, which is equivalent to 10 to 12.5 EVs. By comparison, a sunny outdoor scene may well contain 100 to 150 dB (17 to 25 EVs).

So, what's the deal—what can be so hard about building an HDR sensor chip?

3.1.1 The Problem

On the hardware side, the problem derives directly from the technical definition of dynamic range. As mentioned in the introduction, it is defined as the logarithmic ratio between the largest and the smallest readable signal. Put in a formula, it looks like this:

$$DR = 20 \times \log_{10} \frac{Max\ Signal}{Min\ Signal}$$

Yes, I know, I promised no more formulas. But I broke my promise for a reason; this is actually easier to understand by looking at the formula than by reading it in a sentence. Don't even worry about the number 20. That is just a fixed multiplier that turns the result into a graspable numerical value. Much more interesting are the signal variables.

The maximum signal is the last value you can read from a sensor pixel before it gets saturated. If it got any brighter, it would just clip off. One way to increase the dynamic range would be to increase this maximum by building a very big and tough sensor. The problem with that approach is that the sturdier a sensor, the more noise it introduces and the more power it needs to operate. Generally, technology moves in the opposite direction, toward smaller and more sophisticated.

Getting a better minimum signal

The minimum, on the other hand, is the last signal that can be distinguished from noise. Essentially, we're talking about the overall *signal-to-noise ratio (SNR)*. Every sensor has some base noise that comes from the electrons in the material zapping around randomly. They are supposed to wait for some light to set them free, but nevertheless, there are always a few electrons that are too excited and break free anyway. There are plenty of reasons for that, and some of them are related to the fact that we need to count them electronically, that is, by using other electrons. But this is drifting away into the laws of quantum physics—just remember that every sensor has some kind of base noise level. If we somehow lower that noise level, we could read an even smaller signal and we would have increased the dynamic range.

Evolution

Getting a better signal-to-noise ratio is an engineering challenge that has been there from the start. The signal-to-noise ratio has always

been the prime benchmark for sensor quality. At the same time, it has always been an indicator for the dynamic range you can capture with that sensor. Right now, we hold the first wave of affordable solutions in our hands. The recent lines of DSLR cameras already deliver so much dynamic range that they have to pack it in proprietary RAW formats. But that's not the end of the line; true engineers can't just put a problem aside and call it good enough. Digital imaging is just naturally destined to evolve to higher dynamic ranges.

In the first edition of this book, this chapter was full of hopeful future projections. This time around it directly references several products and compares their approaches to extending the dynamic range. The big wave of real HDR cameras, however, hasn't hit the shores quite yet.

So let's check out what these engineers are cooking in their labs!

3.1.2 CCDs and Orange Trees

A *charge-coupled device (CCD)* sensor works just like a field of orange trees. As a pixel gets hit with light, it grows an orange, or as the scientists call it, a charge. The more light a tree gets, the more oranges it grows. Next to each tree, we

Figure 3-2: *The inner working of a CCD sensor chip is inspired by bucket brigades.*

station a helper guy. When it's time to harvest, they pluck the oranges into buckets and hand them down the row like a bucket brigade. Down by the road all these bucket brigades dump their contents into a juicer, where it is converted into a cup of orange juice. The cups are then carried into the farmhouse in one continuous stream. At the door stands a supervisor, who measures the content of each cup and writes it down in a table. Since the cups come in the order in which the trees are planted, this table becomes row by row an accurate representation of the entire field.

On a CCD sensor chip, the supervisor is called an analog-digital converter (ADC). The oranges are the charges collected by the photodiodes, the juicer is an amplifier converting charges into voltages, and the harvesters are chains of capacitors.

The general CCD design is simple enough; it was perfected over 30 years and has dominated digital imaging during that time. There is not much ground-breaking innovation to expect here anymore. High-end sensors reach 78 dB (13 EVs), but that's about the upper limit of CCD technology. As mentioned earlier, bigger and sturdier pixels give us a better maximum signal. And to reduce the noise level in CCD chips, the best thing you can do is cool them down. Cold electrons get lazy and are less likely to turn AWOL. This technique is used for professional digital backs, and to this day it works great for high-end products from Phase One, Sinar, Mamiya, and Hasselblad. It's not cheap because it involves a lot of engineering to come up with a quiet and effective cooling system. Those who shoot in digital medium and large format might not be worried about the money, but the rest of us probably won't see that cooling technology in an affordable camera.

CCD fabrication has always been rather expensive, and there are actually just a handful of factories with the equipment to produce them. In the meantime, CMOS sensors have matured.

It took them a while to reach the same dynamic range as CCDs, but now they have caught up and surpassed CCDs dramatically.

3.1.3 CMOS Sensors Are Different

CMOS stands for complementary metal oxide semiconductor, and that is the same technology that's used in microprocessors. Instead of the capacitors in CCD chips, CMOS sensors use transistors on each pixel to collect and amplify the charge that builds up during exposure. These transistors can be read directly because they already turned charges into a voltage. Put simply, you can think of CMOS sensors as memory chips with a photodiode next to each memory cell. In our analogy, we wouldn't have the helpers form a bucket brigade; they would all have a juicer of their own and bring the juice cups to the farmhouse themselves. No orange bucket is ever lifted and everybody is saving a lot of energy.

This sensor can be built in the same manufacturing plant as ordinary memory chips, so it is cheaper to make. We can read the pixels in any order instead of having to wait for the entire row to be handed through. No matter how large the sensor, we can just skip enough pixels to quickly pull a lower resolution image for the Live View LCD or video mode. And because voltages are transferred easier than charges (juice versus piles of oranges), it also needs much less power to operate. All these advantages make CMOS very attractive for use in mobile products (which includes any camera that runs on a battery).

Unlike the linear response curve typical for CCDs, these chips can react logarithmically to light. That's because transistors build up a charge in a logarithmic fashion. This behavior is very similar to an analog film curve, and so a logarithmic CMOS chip can reach a similar dynamic range. It does, however, suffer the same shortcomings as analog film: The nonlinearity allows a good color reproduction only

in the middle part of that curve. On the upper shoulder and lower knee, we might cover a lot of range, but it is compressed so tightly that even the smallest amounts of noise can distort the signal tremendously. We can achieve 120 dB (20 EVs), but only in grayscale sensors useful for industrial applications like welding and laser controllers. The quality is just not good enough for photographic applications. That's why CMOS sensors found in actual cameras are calibrated to exploit the middle part of that response curve, effectively making them appear linear again.

With so many amplifiers all over the place, there is also more noise to begin with. Imagine each harvester being responsible for keeping their personal juicer clean, and operating it without spilling a drop, and you'll see that there is a lot more room for errors now. Also, when they bring their juice to the farmhouse, it requires some clever logistics to not have them clog up the place. Especially when you're dealing with a large field of more than 8 million orange trees, you can only manage the worker crowd one row after another. This has given birth to the dreaded rolling shutter and skewed video issue, that is now commonly associated with CMOS sensors.

It's getting tight in there

Another caveat comes with this technology: We need room on the surface for those transistors and all the wiring paths. The coverage of the photodiodes, so the actual light-sensitive area, is only around 30 percent. That means only a third of the available light is being used for the image; the rest just hits the transistors and heats them up, which is not too great either, because heat causes additional noise. So we have a double-trouble situation here: light getting lost and increased noise. The solution is to add a layer on top consisting of millions of tiny lenses. One dedicated microlens for each pixel, responsible for catching all the light and focusing it on

Figure 3-3: *In CMOS sensors, charges are converted to voltages on each pixel, which is the equivalent of squeezing out the oranges as soon as they come off the tree. No more buckets means a lot of energy saved.*

the photodiode. That's a lot of engineering to compensate for a principal design flaw, yet perfecting that microlens array is what most manufacturers have focused their efforts on over the last years.

CMOS sensors needed some time to reach the quality level and resolution of the more mature CCD technology, understandable when you consider the new complexity in design. By now, not only have they caught up, but according to a market research from iSuppli.com, they turned into the dominant species with 90 percent of all sensors produced in 2010. Most newly released DSLRs have CMOS, and so do pretty much all web cams and cell phones. Canon's EOS line was among the first to use CMOS exclusively, in a design that features four transistors for each pixel and plenty of fine-tuned optimizations. Nikon had a short intermezzo with a derivative technology called LBCAST that got away with only three transistors and was to be found only in the D2H.

3.1.4 Backside Illumination

All this circuitry blocking the light from our photodiodes is a serious CMOS design flaw. We can overcome this once and for all by putting all that extra metal below the photodiode. In our analogy, we would be growing the orange trees right on the roof of the farmhouse. There would be a staircase next to each tree, and the helpers would just walk down a level and wander

through the hallways to bring the juice cups to the supervisor's station. That way the trees can grow bigger because we need no space between them for any surface paths.

It has the neat side effect that we get away with a smaller overall footprint, but there is much more complexity involved in building this. This is not your regular Kansas farm anymore; this is a highly sophisticated juice factory with trees on top. CMOS sensors with this design require specialized fabrication techniques, which diminishes the initial cost advantage of using ordinary microchip plants. Midway through production, all internal layers have to be flipped over like a pancake, so we're essentially mounting the sensor with the light shining on the back. That's where the slightly confusing name *backside illumination (BSI)* stems from. Of course, an untrained eye peeking into the front of a camera would notice no difference. *Backside* just refers to the underside of the silicon substrate the sensor chip is baked on.

Another advantage of this design is that there is less cross talk. Harvesters carrying their cups across the field in bright sunshine tend to get chatty and absent-mindedly spill some drops, maybe even pluck an extra orange on the way. Now they slurp in long lines through dark hallways, in a perfect Orwellian vision, and keep their mouths shut. That means less noise in our sensor, which effectively gets us some bonus points on the dynamic range scale. And since the wiring doesn't have to share the space with the photodiodes anymore, we can optimize it now for shorter paths and faster readout.

This is the sensor design found in the iPhone 4. The sensor is manufactured by a company named OmniVision. It used to employ these sensors in surveillance cameras, so it has spent quite a bit of budget and time on perfecting backside illumination sensors. Toshiba and Samsung also use BSI for smartphones and point-and-shoot cameras. Sony builds its latest

generation of sensors in the same way, under the label Exmor R. Just in 2009 Sony erected a dedicated factory for these sensors and puts them in camcorders as well as supplies them to Nikon. Even Canon is rumored to launch a mirrorless DSLR featuring a backside illumination sensor.

Sensor maker InVisage follows the same principle, just that here the top layer consists of a mysterious light-sensitive layer called QuantumFilm instead of plain old photodiodes. Still, it follows the same general principle: All the wiring is underneath, dramatically increasing the amount of light that is actually recorded.

3.1.5 High Gain – Low Gain

Remember that our original problem was to capture more details in shadows and highlights. We can also tackle this directly, if we read them from the sensor separately. See, whenever you're changing the ISO sensitivity on your camera, you are actually altering the conversion gain of the amplifier. By using two amplifiers with different sensitivities, we can simultaneously look at both ends of the dynamic range with the best possible precision.

Back to our analogy, each harvester would have not just one, but two juicers at their disposal. One juicer is big, the other one is small. When they pluck the oranges, they alternate between using the two. A tree with only a few oranges would barely fill the bottom of the big juicer, but every single orange would make a considerable contribution to the small juicer, and you could easily read the exact fluid amount. If the tree has thousands of oranges, the small juicer would overflow quickly, but you could still get a decent readout from the big juicer.

Well, it's easier said than done. Microelectronic circuitry design is a little bit more complicated than orange farming. This method requires more transistors for every single pixel, at least eight instead of four, which makes the

pixel much bigger. In a traditional CMOS design, that means more metal in front of the photodiode, so there is the inherent danger of drowning the high sensitivity readout in noise. Nevertheless, these sensors just reached maturity for DSLR-worthy pixel counts.

Aptina, a company with long roots back to NASA, calls this technology DR-Pix. It has a 16-megapixel sensor featuring this dual-gain method, and if you can believe the rumor on the streets Aptina ships them to Nikon for the next generation of DSLRs. Maybe even the current ones, who knows? Several other manufacturers (CMOSIS, AltaSense, Cypress to name a few) use the same technique already for HD video resolution. In terms of finished products, the dual-gain technique empowers the ARRI Alexa digital cinema camera to capture almost 14 EVs on a 5-megapixel sensor, scaled down to HD video resolution with superior sharpness. Nobody really knows for sure how the Mysterium sensor in the RED Epic camera is constructed, but as a matter of fact it also captures two exposures for each video frame in rapid succession. So my personal suspicion is that it falls into this category. I might be wrong.

3.1.6 Digital Pixel Sensor

The Programmable Digital Camera project at Stanford University has taken CMOS sensors another step forward. Under the leadership of Abbas El Gamal, this group developed the *digital pixel sensor (DPS)*. They added more transistors to the pixels, up to the point where each pixel has its own analog-digital converter and its own logic circuits. Effectively, this is smartening up the sensor; basic pre-processing steps can already be done in hardware, by the pixels themselves.

In our analogy, we would equip our orange harvesters with a cell phone, a scale, and a calculator. Yes, they may have an iPhone too. They are really smart twenty-first century people now. They don't carry anything around any-

more. They just pick the oranges from the tree, juice them, measure the content, and call in the fluid amount.

This eliminates a major bottleneck. All pixels can perform their own A/D conversion at the same time, so we have an instant digital image. Thus, the prototype at Stanford can shoot at a blazing 10,000 fps. Yes, you read right: ten thousand frames per second! On the speedometer, that's two ticks beyond "Insane Speed."

Now the trick is to run the sensor at a higher frame rate than the actual image generation. We have plenty of time to shoot several exposures for each capture, and we would still get a smooth video with 30 frames per second. The individual exposures can be combined to an HDR image at the lowest level in each single pixel. Because the chip architecture is still based on CMOS microprocessor technology, we already have a lot of experience to make these hardwired calculations. They are the same circuit designs as in a CPU or GPU. Such on-chip pre-processing also has the neat side effect of noise reduction because the resulting pixel values are an average of multiple samples. We could also realize more complex calculations at this pre-processing stage—for example, reducing motion blur or detecting edges and shapes.

Beyond photography

With such processing capabilities, this sensor technology comes very close to imitating what our eyes can do. It is a true smart camera on a chip. The possible applications go way beyond photography; there is, for example, the possibility of an artificial eye. Prototypes of artificial retina implants have already been crafted to give blind people their vision back. From this point on, imaging research is shifting to deciphering how human vision works, simply through crafting an emulation thereof and improving it incrementally by a game of trial and error. This emerging field of study is called *machine vision*. First fruits of this branch are

Figure 3-4:
Regular sensors are covered with a grid of color filters, called the Bayer pattern, that enable the chip to record color images. Replacing this with a grid of ND filters would enable HDR capturing.

advanced security systems with instant facial recognition, as seen in airports and traffic control systems. Coming up next are fully automatic cars with lane guidance, traffic sign recognition, and collision prevention systems. There are already annual robo car rallies between university teams, and Google is doing widespread field tests already. Seems like nobody wants to drive the Google Street View cars anymore.

The Stanford sensor is now commercialized by a company called Pixim, primarily in the security sector and apparently with great success. Big brands like Cisco, GE Security, Siemens, and Rainbow use them. The Fraunhofer Institute in Germany, where the MP3 audio format was invented, built a similar CMOS-based sensor with per-pixel readout logic. Its called HDRC and additionally uses the backside illumination design introduced in section 3.1.4. This sensor runs at the same incredible speed and can derive each frame from up to four differently exposed captures, which results in an effective dynamic range of 120 dB at 50 fps, equivalent to 20 EVs. IMS Vision is the commercial branch, co-owned by the Japanese OMRON company, selling these HDRC chips mostly to the automotive and medical industry.

Prospects

By nature, this sensor technology relies on advancements in processor manufacturing. The amount of pixels we can get on a chip is directly determined by how many transistors we can get on a chip. Miniaturization is the key here. Stanford's digital pixel sensor needs 37 transistors per pixel; that adds up to 14 million transistors for video resolution, and we're not even talking about HD here. If you wanted to make a 10-megapixel sensor suitable for real photography, it would take 370 million transistors, which is about equal to the Intel Core 2 Duo processor that is commonly found in modern laptops. So we are talking about the edge of technology, where manufacturing costs are immense.

I'm sure we will someday build a reliable sensor with a decent resolution that way. Until then, compromises have to be made. Making the sensor smaller enables more of them to fit on a wafer, drastically reducing per-unit manufacturing costs. And adjusting the amount of transistors to the bare minimum brings power consumption and cost far enough down that they can actually be put into a product. The general trend in CMOS is definitely heading toward this design. Our cameras have become incredibly smart in recent years, but so far all these features are done in a separate image processor. It's just too compelling to move all the fancy features closer to the image, into the sensor chip itself.

For the foreseeable future, this kind of sensor will probably set the upper limit—in performance as well as price—for high-end HDR DSLRs. In the long run, however, I have no doubt all our cameras will have their image processor sandwiched to the sensor.

Monument Valley scene

Zoom into the RAW sensor data

Overlay of the Bayer grid, showing that each pixel represents only a single color

Figure 3-5:
The Bayer pattern used in conventional sensors must be accounted for during RAW development. An overview of this demosaicing process reveals that most of the final pixel information is already derived via interpolation.

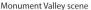

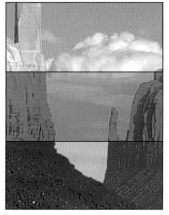

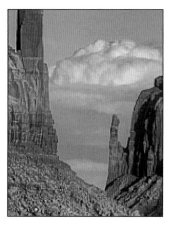

Separate look at the data collected for the red, green, and blue channel

Critical step of filling in the missing channel information by interpolation

Final demosaiced image, showing all three reconstructed channels together

3.1.7 Spatially Varying Exposure

A completely different approach was already developed in the year 2000 at the Computer Vision Laboratory, dubbed CAVE, at Columbia University. The basic idea is to cover a conventional sensor with a pixel pattern of different neutral-density filters. Pixels behind a very dense filter capture the highlights, and pixels behind a transparent filter capture the shadows. That way, they combine a two-by-two grid of differently exposed pixels to expand the dynamic range. It is a very low-cost approach because it builds on existing hardware. The implementation is a mere mechanical challenge: to align the filter pattern to the pixel grid of the sensor.

One big disadvantage is that this exposure grid can produce high-quality images only in a three-chip camera because regular cameras already have a similar pixel pattern in front of the sensor, commonly known as the *Bayer pattern*. The reason is that almost all image sensors are actually monochrome (with the notable exception of Sigma's Foveon sensor). Cameras with only one sensor chip use a grid of red, green, and blue filters to separate colors. The result is a very weird-looking image, where all pixels are just gray but alternating pixels represent red, green, or blue. To get a full color image, the missing color values are interpolated across; in a RAW workflow this is called demosaicing. Spatially varying exposure, however, interferes

with this color pattern (as illustrated in figure 3-4). It would further decrease the true color resolution of a sensor, and much more of the image would need to be computationally recovered, which is always a guessing game.

Another disadvantage is that this method can extend only the upper limit of the dynamic range. That's because ND filters can only ever block light to reveal more highlight details. They do not help with getting more details in the shadows, where we are still bound to the noise restrictions of the sensor. Still, theoretically this method can quadruple the captured dynamic range, boosting a regular CCD up to 200 dB. That's more than 30 EVs, enough for even the worst-case lighting conditions.

Panavision used this method to develop a monster of a sensor called Dynamax35. Technically, it's a 37-megapixel CMOS sensor in full 35mm format with a diagonal layout of the photosites. But the normal output size is only 12 megapixel (in film jargon, 4 k) because the sensor combines six red, six green, and six blue pixels to one image pixel. Some of these pixels are driven at varying sensitivities, which gives us the spatially varying exposure effect. Instead of demosaicing during development, this pixel combination is done in the sensor itself with a technique called pixel binning. Such massive oversampling results in up to 100 dB (17 EVs) with a crystal-clear color reproduction. It's marketed under the very appropriate name ExtremePIX and is probably going to power the successor of Panavision's famed Genesis camera. Now that's the kind of camera with a price tag so absurd that it becomes just a theoretical number again. Nobody buys a Genesis, not even the big movie studios; these cameras are built for rental only.

Meanwhile, Kodak developed a similar approach under the label TrueSense W-RGB. In Kodak's modified Bayer pattern, there is a clear patch next to the red, green, and blue filter patches. The photodiode under that clear patch gets hit with the full spectrum of white light. That alone has a significant effect on low-light sensitivity and raises the dynamic range by 2 EVs.

3.1.8 Super CCD

Spatially varying exposure has actually been used for a long time. Fujifilm picked up the basic idea early on and incorporated it in the design of its very own Super CCD sensor.

A remarkably different sensor

The pixels are arranged in a honeycomb pattern at a 45° angle instead of straight rows and columns. This is the only sensor where the pixels on the surface of the sensor do not directly translate to the pixels in the final image. They are not even square, but shaped like an octagon. According to Fujifilm, this would allow the photodiodes to be packed more tightly, surpassing the fill factor that is possible with ordinary CCDs. Critics argue that the true number of captured pixels is only little more than half of the advertised megapixel count; the other half of the image is made up by interpolation. In that regard, it hurt more than benefited Fujifilm to introduce its first Super CCD camera in 1999 with 4.2 megapixels when it had only 2.4 million photodiodes.

New direction

With the third generation of this sensor in 2003, Fujifilm made a clear effort to regain the trust of its customers. It split its sensor line in two: The Super CCD HR (High Resolution) variant actually crams as many photodiodes on the chip as pixels appear in the final image. But even more interesting is the SR variant, where Fujifilm added a secondary type of photodiode. It is much smaller than the primary photodiode, so just by design, it has a lower sensitivity. Essentially, this is the hardcore implementation of the spatially varying exposure method. The large primary photodiode captures the regular

Figure 3-6: Fujifilm has a long tradition of mixing two different types of photodiodes in one sensor. At left is the third-generation Super CCD; at right is the fourth generation.

image, and the smaller one captures the highlight details—both images are combined into one RAW file with a wide dynamic range.

Originally, this secondary photodiode type was piggybacked to the regular one, which officially nominates this sensor for the "World's Strangest Circuitry Design" award. It also did not help dealing with the critics because these photodiodes are paired so close to each other that they form a single pixel again. Fujifilm quickly abandoned this approach, and in the fourth generation, the low-sensitivity photodiode is located in the empty space between the primary pixels. This design is the Super CCD SR II; it is much more sane, which helps for using third-party RAW decoders. Fujifilm claims a dynamic range increase of 400 percent, but that is measured in linear scale and slightly misleading. Technically, the sensor delivers about 80 dB, which roughly equals 13.5 EVs. Not to make light of it—this is a remarkable achievement; it matches the exposure latitude of film material as well as the cooled-down high-end CCDs, but for a fraction of the budget.

Convincing the market

Fujifilm made a great commitment here, being the first to pin down and address the dynamic range issue. It was just a bit unfortunate with its market position. At a time when everybody was crazy about counting pixels, it was not easy to convince the public that dynamic range is a problem at all. When Fujifilm's top-of-the-line FinePix S3 Pro hit the shelves in February 2004, it was way ahead of its time and did not really get the attention it deserved. Same goes for the successor in 2007, the FinePix S5 Pro. Fujifilm specifically advertises these cameras to wedding photographers because they are eventually the first to be convinced. When you shoot a white dress on a regular basis, with no control over lighting, and your client is eager to see every detail of that expensive dress, there is not much room for mistakes. The cake is cut only once.

Bottom line is that Fujifilm is the first camera maker to have an extended dynamic range camera in the mass market. It doesn't go all the way to HDRI yet, but it certainly is a step in the right direction. On the DxOMark scale, the FinePix S3 and S5 are statistically complete outliers, with a tested and confirmed dynamic range of 13.5 EVs, ranking to this day above most other cameras.

The latest sensor generation merges both lines again by changing the sensitivity of the secondary photodiode electronically. So the chip architecture made a full round-trip back to the original layout with equally sized photodiodes. You can seamlessly switch between resolution

Figure 3-7:
The Omnirig enables shooting true HDR footage with two Red cameras. (www.e3dcreative.com)

priority and dynamic range priority or run both sets of photodiodes at full sensitivity for maximum low-light performance. This is the Super CCD EXR sensor, available in a dozen cameras ranging from point-and-shoot to DSLR models. They're easy to recognize by the EXR appendix in the name: F80EXR, Z800EXR, S200EXR, and so on. It's slightly disappointing that none of these cameras actually supports the OpenEXR format, as the names might suggest. Instead, Fujifilm rolled up another proprietary RAW format that barely any decoder can decipher correctly. Point-and-shoot models with EXR in the name even automatically tonemap all that range down into a JPEG. Maybe Fujifilm is mortally offended by the market responses, or maybe it just has too much experience as a lone warrior on the dynamic range front to notice the advent of open standards.

3.1.9 Beamsplitter and Dedicated Optics

Eventually, we don't even have to wait for that single super-sensor. With some clever engineering, people have already come up with true HDR cameras. The trick is to put a semitransparent mirror in the optical path that splits the incoming light beam to capture different exposures on different sensors—hence the name *beamsplitter*. It's an extremely effective way to jump ahead of the technology curve. Because all exposures are snapped at exactly the same

time, you can even capture flawless HDR video with this method.

A pioneer in this area is Leonard Coster. He built an exoskeleton rig that houses two Red cameras mounted in an L formation behind a 45-degree tilted mirror. It's actually meant for stereo 3D capture and was used for the opening scene of *Final Destination 5*. This particular L configuration turns out to provide the most flexibility for stereo capture because the two cameras don't get in each other's way when adjusting the interocular distance (that's the distance between the centers of two eyeballs, or in this case, lenses). With an L-shaped beamsplitter rig, you can set this interocular distance to zero and both cameras will shoot through exactly the same entrance pupil. Now it's just a matter of using an ND filter on one of the cameras and you have perfectly synchronized video streams of two different exposures. To be fair, the monstrous scale of the rig is only necessary to provide enough room for big professional cine cameras like Red One, F35, Alexa, Phantom, and so on. It does bear a striking resemblance to the 1930's three-strip Technicolor cameras, which were once used to record early color movies like *Becky Sharp* on three strips of monochromatic film. Coster dubs his construction Omnirig and makes it available for rental.
↪ www.e3dcreative.com

Of course, for DSLRs you wouldn't really need a super-sized rig like this. The recent rise of stereoscopic 3D has actually created a new market for compact beamsplitter rigs. You can now get them ready made for cameras of any size, including DSLRs. Some are even small enough to be shoulder mounted or worn on steadycam belts. For the guys at SovietMontage, a rig the size of 3D Film Factory's 3D-BS MINI (wild guess) was all it took to put two Canon 5D cameras together in the same L configuration. Their initial test clip became famous on the Internet, partly because they didn't really consider subtlety as the treatment choice for the

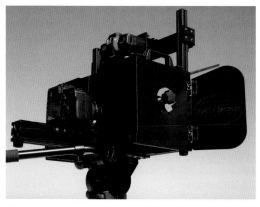

Figure 3-8: *Provocative clip from SovietMontage, shot with two Canon 5Ds on a beamsplitter rig. (www.sovietmontage.com)*

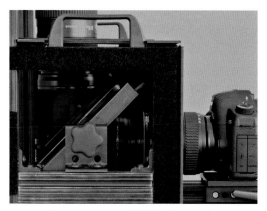

Figure 3-9: *Compact beamsplitter rig suitable for DSLR cameras. Photo courtesy of 3D Film Factory. (www.3dfilmfactory.com)*

captured material. But they certainly managed to make the public aware of the fact that HDR video is even possible. Here are some sites where you can browse the rapidly growing palette of beamsplitter rigs, some of them under $3,000.

[→] www.technica3d.com
[→] www.3alitydigital.com
[→] www.3dfilmfactory.com

If your shoestring budget doesn't even allow for those, you can also build one yourself. Do a Google search for "$100 beamsplitter rig" and you will find several YouTube videos that demonstrate what you can achieve with a bit of plywood, some angled aluminum bars, and an industrial-grade 50/50 mirror.

The inherent problem with beamsplitter rigs is that you also need two matching sets of cameras and lenses. And you need to operate them both in sync, which makes focus pulls or push-in shots a real challenge. The size of the mirror also limits your field of view, so you can't shoot with a very wide-angle lens. For a more dedicated HDR setup, you could replace the 50/50 mirror with a 75/25 mirror, making better use of the available light than just cutting some of it out with ND filters. And if you really think it all the way through, the perfect HDR rig would actually put the mirror *behind* the lens, inside the body of a multichip camera.

That's exactly what Mike Tocci and his smart engineers at Contrast Optical are doing. They built a camera prototype capable of capturing over 17 EVs in full motion by using a highly optimized mirror configuration to split the incoming light to three sensors. The first mirror lets 92 percent of the light through, to shoot the shadow exposure on the first sensor. The

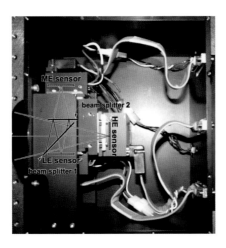

Figure 3-10:
Prototype of Contrast Optical's multichip camera with an internal beamsplitter. (www.amphdr.com)

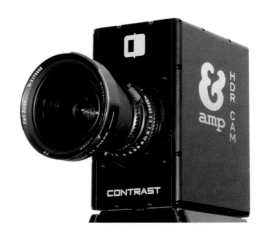

remaining 8 percent of the light is reflected, split up again by another mirror with the same ratio and distributed to two sensors responsible for capturing the medium and highlight exposure. The strong transparency/reflection ratio makes for an even higher spacing between the individual exposures, maximizing the overall dynamic range captured. It's all boxed up in a single camera body, shooting through a single lens, internally wired to give you a single video stream of the blended result. Pretty clever, huh? They even set up a website with example clips toned in aggressive styles and trademarked the catchy slogan "There's no f/stopping us!" If it hasn't gone viral on the Intertubes yet, check out their website yourself.

⮕ www.amphdr.com

All these are clever engineering tricks, useful to bridge the gap until real HDR sensors are widely available. Beamsplitters can never be perfect because they have a built-in problem with polarization. Can't beat physics; semi-transparent mirrors will always polarize light to some degree. That means you will have a slightly different highlight appearance on each individual sensor whenever you're shooting the sun glare on water ripples, a street scene through glass windows, or in a million other unforeseen situations. The only way to fight this effect is to add additional polarizers, just so

everything is at least polarized the same—but you're sacrificing quite a lot of light on the way.

And then there's the Spheron HDRv camera. The actual construction details are the best-kept secret in the industry, probably locked away in an old mineshaft somewhere in southwest Germany, guarded by mountain trolls and a dozen deadly spells. But all signs are pointing toward an alternative, yet still optical approach powering the heart of the Spheron HDRv camera. This baby shoots a whopping 24 stops of dynamic range, without polarization troubles, in more than 2 k resolution with a global shutter and a frame rate up to 50 fps. That's a lot of data. The footage is sent as one massive stream of uncompressed EXR files over fiber channel to a RAID server. This ultrafast data connection actually turned out to be the major enabling milestone, solving a problem that hasn't even occurred to other camera makers yet. Clearly, the Spheron HDRv is the pinnacle of technology in this field, the undefeated king of HDR cameras. Only a few prototypes are in existence, and they are literally priceless and circulate in some selected universities.

⮕ www.hdrv.org
⮕ www.gohdr.com

Figure 3-11:
The prototype of the Spheron HDRv camera blends the look of the '40s with the technology of the future. It's technically classified as portable, if only you stretch the meaning of this word to include a computer rack on wheels.

3.1.10 Quo Vadis?

We're currently in this awkward transitional phase. All single parts of the imaging pipeline are moving toward HDR, but strangely enough they don't seem to interface with each other. Camera and sensor makers figured out how to capture a wide dynamic range, but they concentrate their efforts on crunching it down right inside the camera to 8-bit JPEGs. At best we get yet another proprietary RAW format, but even RAW development software is laid out to render to the old 16-bit integer standard with absolute white and black levels. The reason? You can't see HDR images on your monitor.

On the other hand, we have sandwiched LED/LCD monitors everywhere, and they are well capable of displaying a vast contrast ratio. But they're all optimized to boost up 8-bit imagery because that's what most imaging sources deliver. I even talked to high-level Dolby officials, who have all the proper technology at their fingertips, just to hear that the market isn't ready for HDR yet. Ironically, even graphics cards internally do their operations in 16-bit floating-point nowadays because every imaging engineer agrees that this is better. Yet graphics cards limit their output to 8 or 10 bits at max. Why? Because that's what monitors expect. DeepColor mode in HDMI 1.3 and the related DisplayPort standard are steps in the right direction, but even those are barely ever exploited to their full potential.

It's really become a big ball of duct tape, whereas it could have been so simple. Everybody tries to adhere to each other's limitations, based on false assumptions and pretending to know exactly what the consumer needs. The legacy of 8-bit imaging is frightening. In the center of this whirlwind is the JPEG standard, an image format that no self-respecting photographer shoots anymore, or any imaging engineer can talk about without his finger nails curling up. Yet, every part of the imaging chain still tries to adhere to this most common denominator.

It takes some guts to break with old traditions, but sometimes that hard break is necessary to reach the next level. Henry Ford once said, "If I had asked people what they wanted, they would have said faster horses."

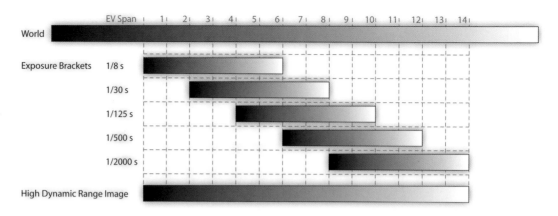

3.2 Bracketing and Merging HDRIs

The previous section revealed that real HDR cameras are definitely on the horizon but not quite here yet. In the meantime, we have to create our HDR images by other means. Now I'm going to show you how to capture the full dynamic range of a scene with today's cameras. It might take some effort and time, but with loving care and the right methods, you can get perfect results.

3.2.1 Exposure Bracketing

The basic idea is to shoot a series of different exposures. Each image represents a slice of the scene's dynamic range. That might be 6 to 9 EVs in a mediocre camera, 10 to 13 EVs in a DSLR shooting RAW. Afterward, you digitally merge these slices again and have a fully high dynamic range image.

For a successful recovery of the original dynamic range, these individual exposure slices have to overlap. Otherwise, the combination algorithms can't puzzle them back together. As a nice side effect, you get free noise reduction out of that because each pixel in the resulting HDR represents the average of the most useful parts of each exposure. Really useful are the middle tones primarily. The shadows, where all the image noise tends to get overwhelming, are generally clamped out and replaced with the corresponding color values from the lower exposures.

This sequential capturing method works best for static sceneries. If the scene changes between exposures, the combination algorithms get into trouble. So forget about sports photography in HDR! Pedestrians, cars, animals, even fast-moving clouds or twigs waving in the wind—they all tend to turn into ghosts.

A word on analog

I'm not trying to reboot the old film-versus-digital flame war. Yes of course you can make HDR images from scanned film slides; in fact, this is how it was done in movie production for a long time. The advantages are that the equipment is cheaper, capturing to film is faster than

saving to a card, and the individual exposures have a lot of dynamic range to begin with. However, a modern digital SLR camera can beat film in all those disciplines.

On the other hand, there are significant disadvantages. Film has to be developed, so you have to wait until the next day to see if your capture was successful. There is no way the exposure brackets come in prealigned because the development and scanning process adds additional movements to the slides. And most important, there is no metadata available, so you have to remember the exposure data yourself.

At its core, HDRI is a digital imaging technology. Capturing digitally is its native ground. It is possible to go analog, and the retro aspect certainly is fascinating to explore, but you're just making it harder for yourself.

Figure 3-14: **Ghosting:** *Beware of moving objects while shooting your exposure brackets.*

What is in your backpack?

The minimum equipment is a digital camera with manual exposure settings. If your camera has nothing but an exposure compensation button labeled with AE −−/−/0/+/++, I can assure you that you won't have much fun with it. You're free to give it a shot, but I suggest making HDR your excuse for getting a better camera.

At a minimum, this is what you should have:
- Decent digital SLR camera
- Whatever lenses you like
- Very fast memory card (300x and up)
- Microfiber cloth or lens pen for lens cleaning

The following are highly recommended additions:
- Stable tripod
- Remote release (cable or wireless)
- Spare batteries
- Spare memory cards

These are very useful, albeit not entirely necessary:
- Laptop computer
- Backpack with a pouch for the laptop
- USB tethering cable
- Bracketing controller (see 3.2.2)

Figure 3-13: *My backpack, fully loaded.*

Figure 3-15: *Disable all in-camera enhancements.*

Camera settings

If you are shooting JPEGs, make sure you turn off all in-camera image enhancements. Your camera is not supposed to apply any sharpening, color boosts, or contrast enhancements at this time. It is highly unpredictable what those firmware settings really do to your image. Camera makers optimize them for a single shot; chances are they are not consistent all across the exposure range. If you're shooting RAW, the firmware doesn't actually touch your image, so those settings don't matter to you anyway.

For varying the exposure, you want to use the *shutter speed only*. The reason is simple: Aperture size also changes depth of field, ISO value changes the sensors' noise behavior, and ND filters don't get you very far. Shutter speed is the one parameter that leaves everything alone; it changes nothing but exposure. You don't want your camera to adjust the white balance differently for each exposure, so set it to a fixed value or one of the factory presets. Even though this wouldn't affect RAW capture, reevaluating the white balance between exposures would still slow your camera down. That's why it's best to lock it down to something appropriate; the

Sunny preset is what I use the most. You also don't want the focus to vary. Choose a manual focus mode, and focus on your subject by hand. You can also use the AF button to fire the auto-focus once; just don't allow the camera to auto-focus all the time.

Set the ISO value as low as you can. That's more of a general piece of advice because all digital sensors show increasing noise as you ramp up the ISO value.

If you are shooting outdoors, it's a good idea to set the aperture to a high f-number. That corresponds to a small aperture size and minimizes the influence of stray light and depth of field. Most lenses have the sweet spot of greatest overall sharpness at f/8 or f/11. This is not so much a rule as it is a hint, and you are free to set the aperture lower if you are specifically going for a shallow depth of field look. But a high aperture will help maximize the upper end of the dynamic range you can capture. You want at least one exposure in which the brightest highlights are not blown out, and in broad daylight this can be achieved only by a high f-number and a fast shutter speed. However, decide on an aperture and leave it alone from now on. Some photographers prefer to shoot in aperture priority (Av) mode. That's certainly possible, but I still recommend full manual mode so you're in total control of the entire process.

Okay, let's recap. The camera is in manual mode and all these settings are fixed:

- ISO
- White balance
- Aperture
- Focus

Shooting brackets

Now you are ready to shoot the sequence of exposure brackets. If your camera has a flexible spot metering system, this is a great way to find out which exposures you need. Looking through the viewfinder, you'll see a dot pattern, with one dot marked with a cursor. Move that cursor to the darkest region, just as shown in this snapshot of my Nikon's viewfinder.

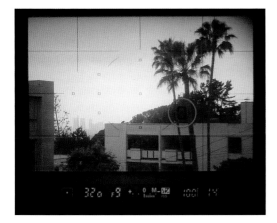

Underneath the image is a display showing you the exposure information. The first two numbers are shutter speed and aperture, and they are followed by a metering scale. Since we're in manual mode, this metering scale is our advisor now. Right now it shows several bars growing to the right.

Change the shutter speed and watch these bars. Once you have them shrunken in to the zero point, you have successfully found the exposure for the darkest region. Here it is 1/125 seconds.

This shall be our slowest shutter speed. Memorize this number!

Now do that again for the brightest region. Move the cursor over it and adjust shutter speed until the bars are gone. I am ending up with 1/800 second. This shall be our fastest shutter speed.

And this is where we start taking pictures. Decrease shutter speed in 2 EV intervals until you reach the upper mark of 1/125. Usually, it's not necessary to shoot every single EV because you will end up with a lot of redundancy and waste precious shooting time. The ideal interval when shooting in RAW is 2 EVs. Only for shooting JPEG images I recommend 1 EV intervals, to make up for data loss due to image compression.

Figure 3-16: *Dedicated light meters are sure to impress clients and other bystanders. Incident-light meters (left) are more accurate but good only for accessible indoor scenes. Spot meters (right) are more universally useful.*

Figure 3-17:
It's a good habit to always double-check the histograms of your exposures right away.

If your camera does not have a spot meter, you can use a handheld light meter to determine the exposure range. This will also make you look extremely professional in the eyes of clients and is guaranteed to bring in some bonus points on the confidence scale. But the truth is, with some practice you will develop an eye for scene contrast, and eventually you don't need to go crazy with all this metering anymore. When in doubt, shoot too many brackets rather than too few. The rule of thumb is that each pixel should be fully visible on at least two images; that means neither under- nor overexposed.

Double-check the histogram!

Turn on your in-camera histogram and double-check your bracketing sequence. Even after years of shooting brackets, I still check the histogram almost every time. Remember, we're trying to scan the entire range of light and what we're missing right here, right now, will be lost forever. That's why it is so important to tap through the exposures and watch the histogram right away! The shortest exposure should have no white pixels anymore; that means the bulk of the histogram bars should cluster on the left side and nothing should even touch the right border. On the longest exposure it's the reverse; it should not have any black pixels anymore. Here the histogram ideally doesn't touch the left border and most values are clustered on the right side.

So, how many exposures does it really take?

That heavily depends on your scene. If you actually do the spot metering it becomes obvious that most outdoor daylight scenes require three to five images with 2 EV steps. The wider the lens, the more likely you will see areas with vast differences in lighting, and then you need more images to capture it all. Night scenes often require seven images or more, especially when street lights and neon signs are visible in frame. During classic photography times, like early morning golden hour or late evening pre-dusk, the light is already beautifully balanced and three exposures are typically just fine. And a landscape shot with a long lens on a foggy day easily fits in a single exposure. Every scene is different, so there is no definite answer other than "As many as you need to cover the full dynamic range."

Typically your middle exposure is what you would normally call a well-exposed image. From there you'd extend the bracketing range both ways to capture shadows and highlights. In outdoor scenes, the clouds are typically the brightest detail, so make sure to capture them fully.

Just don't get too comfortable with shooting the minimum amount of pictures. Especially for photographic purposes, you want your longest exposure to peek deep into the shadows. Looking ahead at the tonemapping stage, you will most likely bump up these shadows, at least partially. And that's when you will get into trouble with noise when your most overexposed source image does not fully show all the

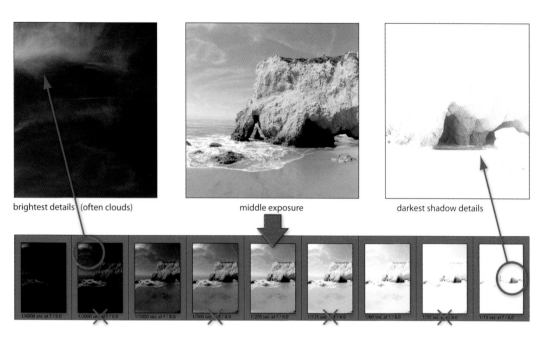

brightest details (often clouds)　　　middle exposure　　　darkest shadow details

Figure 3-18: *Typical exposure sequence in broad daylight with intervals of 1 EV. In RAW mode you can skip the crossed images and shoot with 2 EV intervals instead. For photographic purposes, shadow coverage is of prime importance and your best exposure is most likely your middle exposure.*

shadow details. Simple common sense applied, you should make sure these shadows do not appear darker in the most overexposed source photo than they will in your final tonemapped image. And if that look into the shadow realm requires the rest of the image to be plain white, then so be it. But clear detail in a deep cave or doorway that is nothing but a muddy dark spec in the rest of the series might be worth it. It's true that you can salvage a lot with noise recovery filters, but that's nothing you should routinely rely on. Instead, I strongly recommend to rather overshoot the shadows to get clean pixel data from the start. Highlights are important too, and clouds are often overlooked by beginners, but shadows are downright critical when you're planning to get a well-toned image out of the HDR.

Conversely, if your HDR image is intended for 3D lighting, you should overshoot the lights. In this usage scenario, your primary mission is to capture at least one well-exposed image of the hot center of every light source. You'd be amazed how far the luminosity of a light bulb can peak above the rest, and the pity is that individual light bulbs are often too small to see on your camera's LCD screen.

Always remember, if you shot too many exposures, you can always drop the unnecessary images later. But if you didn't take enough exposures, you'll be lost in the woods. Or as the Texans put it (insert heavy cowboy accent here): "Better to have a gun that you don't need than to need a gun when you don't have it."

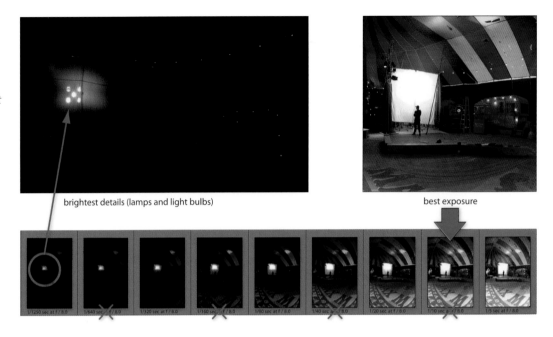

brightest details (lamps and light bulbs)

best exposure

Ghosts and other fundamental issues

Ghosting is an inherent problem of this exposure-bracketing technique. It seems unavoidable that any motion in the scene kills the basic premise of shooting one exposure after another. Very annoying.

Many HDR tools have ghost removal on their feature list, and in section 3.2.7 we will have a closer look at some of them. These software solutions have recently become rather capable, but they should be considered the last resort. The very nature of ghost removal algorithms relies on omitting some exposure details from the merged HDRI, which always has a negative effect on the overall image quality. For better results, some programs (namely Photoshop, Photomatix, HDR Efex, DPHDR, Fhotoroom, SNS-HDR, and Hydra) let you manually tweak the ghost removal to varying degrees, but it still becomes a hassle that you don't necessarily want to deal with.

The only reliable way to avoid ghosts is to not shoot them in the first place. Keep your eyes open and observe what's going on around you. When you have the slightest suspicion something was moving, just fire that exposure bracket again. Avoiding ghosts can be as simple as waiting for the bus to pass by or picking just that moment when the wind calms down and the branches of a nearby tree come to a rest. Even people can be nicely asked to freeze for a minute; that really works.

Another dirty trick is to purposely set up your bracketing range for longer exposures. If all your exposures are longer than a second, pedestrians and cars will blur out and naturally disappear. In broad daylight that technique requires a high aperture and a few strong ND filters in front of the lens. And, of course, it needs a tripod.

Also, changing shutter speed manually always leaves you prone to errors. There is absolutely no way to hold the camera still while changing the shutter with your thumb and pushing the release button several times. You will inevitably shake the camera, and this will make it harder to stack the images on top of each other. It also takes too much time, and the scene might change in the meantime, which brings you back to the ghosting problem.

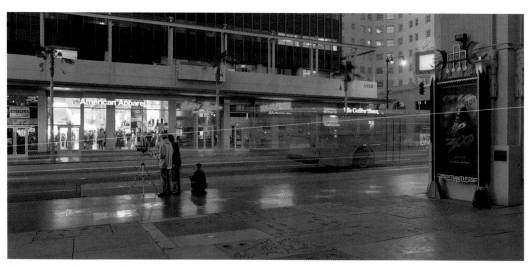

Figure 3-20: *Ghost bus: Better let it pass.*

Stability and speed—those two factors are the major bottlenecks of HDR photography. I probably don't have to explain how a tripod helps to maintain stability. Especially when you are forced to do the manual shutter fiddle, a tripod is absolutely essential. In the next section, we will look at some ways to streamline the capturing process to be less clumsy and more reliable.

3.2.2 Faster, Further, Automatic!

Most digital SLR cameras have an Auto Exposure Bracketing (AEB) feature, and that does sound like a good way to get faster and more stable. You just hold the release button and the camera zaps through the exposures all by itself. It does that in a so-called *burst mode,* which means it keeps the images in the internal memory and doesn't care about saving them to card until the entire sequence is done.

But here's the problem: Camera makers didn't design autobracketing for tomfooleries like HDR. The original intention was to give you a choice of very similar exposures for situations in which the lighting conditions may change and you have no time to adjust exposure. That could be a sports event, wedding, or other fleet-

ing moment of temporary importance. You *must* get the shot, so most cameras can take three images with ±1 EV difference in rapid succession. Well, this is pretty much useless for HDR; you get the same in the headroom of a single RAW shot. And even if you're actually shooting three RAWs, the gain is marginal.

Autobracketing should be more than a convenience feature. When you're shopping for a new camera, specifically with HDR photography in mind, a decent AEB mode should be a major decision point. Five images would be ideal, in 2-stop intervals. Unfortunately, not even a handful of cameras allow that setting. It's very frustrating to see no evolution of the autobracketing feature, considering these limitations are caused only by some ancient lines of code in the camera's firmware that some engineer once jotted down without thinking too hard about it.

At the time of this writing, the Pentax K-7/20D and Leica M9 are some of the few cameras that offer the optimum five brackets in ±2 EV intervals. Nikon has the D3, D700, and D300 with nine brackets ±1 EV, which are covering the same ground with more in-betweens. Canon's EOS line is traditionally behind with

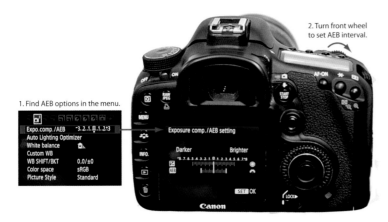

1. Find AEB options in the menu.

Expo.comp./AEB -3..2..1..0..1..2..3
Auto Lighting Optimizer
White balance
Custom WB
WB SHIFT/BKT 0.0/±0
Color space sRGB
Picture Style Standard

2. Turn front wheel to set AEB interval.

Exposure comp./AEB setting

Darker Brighter

SET OK

Figure 3-21: *Enabling autobracketing typically requires some digging through the menu. Example shows the menu path on a Canon 7D.*

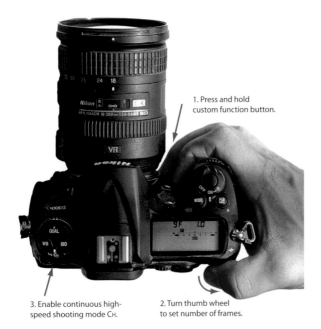

1. Press and hold custom function button.

3. Enable continuous high-speed shooting mode Cн.

2. Turn thumb wheel to set number of frames.

Figure 3-22: *It's much faster to switch to AEB mode when it is assigned to a custom function button. Example shows quick customized access on a Nikon D300s.*

a factory setting of three images ±2 EV. The Canon 7D allows at least ±3 EV intervals, which is better, but the three-frame limit keeps it from reaching the same overall range. The one exception is Canon's flagship model, the EOS-1Ds. This camera comes with driver software that lets you tailor your own extra-wide bracketing mode and transfer it onto the camera as a preset. If you are a proud owner of this baby, hook it up to your computer right now! Once you're in the field (and didn't bring your laptop), it will be too late. My personal weapon of choice, since you keep asking, is the Nikon D300s. I picked it out specifically for its nine-frame ±1 EV bracketing with eight frames per second (fps).

Shooting speed is another key figure that splits the field in good and lousy autobracketing capabilities. This is not just a matter of firmware; it's the hardware that needs to sustain a fast shooting rate. Really fast autobracketing puts high demands on the on-board processor, built-in memory, and overall quality of internal mechanics. The general rule of thumb is the more professional (read: more expensive), the faster it will bracket. A speed of 5 fps is pretty good; 8 fps and beyond classify as superb burst rate.

You can find a complete listing of all cameras with their autobracketing range and speed at www.hdrlabs.com/tools/autobracketing.html.

Shooting with autobracketing

If your camera features an AEB mode, however limited it may be, this is clearly the way to go. Typically you will find this feature in the Exposure section of the camera menu; figure 3-21 shows an example of the menu path on the Canon 7D. This book doesn't have enough pages to precisely pinpoint the AEB mode for every camera model, but it most certainly looks similar. I suggest consulting the user's manual for details. While you have the user's manual on your lap, research what your camera does to change exposure in AEB mode. Digital SLRs

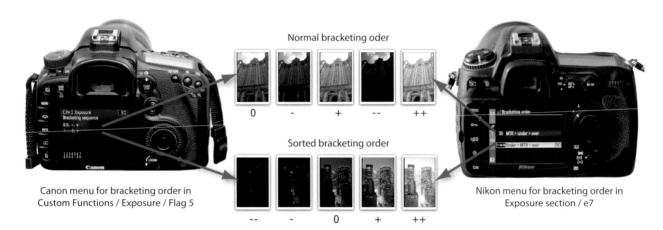

Normal bracketing oder

0 - + -- ++

Sorted bracketing order

-- - 0 + ++

Canon menu for bracketing order in
Custom Functions / Exposure / Flag 5

Nikon menu for bracketing order in
Exposure section / e7

often have a menu setting that lets you choose between aperture and shutter speed. Set it to shutter speed; that's very important.

When you're bracketing frequently, it becomes rather cumbersome to dig through the menu every time. See if your camera allows button customizations! For example, my Nikon D300s has a spare button next to the lens, which is now my dedicated bracketing switch. This way I just need to hold my magic button, use the thumb wheel to set the amount of exposures, and I'm ready to fire a bracketing sequence.

Shooting in AEB mode is different than shooting with manual bracketing because you don't actually set the minimum and maximum exposure yourself. Instead, you set the middle exposure and the camera will automatically take an equal amount of under- and overexposed images. It's still useful to perform the spot metering as described earlier, but in the end it boils down to finding a balanced normal exposure just as you would for regular photos. Checking the histogram is even more important in autobracketing mode.

Bracketing order

Another menu setting deals with the order in which the shots are taken. By default, most cameras take the metered exposure first, followed by the underexposed and overexposed

images (0,–,+). This is consistent with the original philosophy behind AEB, where your first and preferred option is to get by with a single RAW. The extra exposures keep the door open for a full HDR workflow, but you would use it only when the scene turns out to exceed the dynamic range of your sensor. Essentially, exposure brackets are your insurance, just so you can walk off the scene with the confidence you have captured it all.

Here are the advantages of the normal bracketing order (0,–,+):

- ❯ Your hero exposure happens directly after pressing the shutter, capturing the moment.
- ❯ If you get interrupted, you have at least one useful exposure.
- ❯ The stacking features in Lightroom, Bridge, and Aperture will put that hero exposure on top of the stack.

However, if you shoot a lot of bracketed exposures, maybe even mixed in with regular single shots, your picture folder will quickly turn into a glorious mess. As many images in a session are most certainly shot on the same location, they look rather similar as thumbnails, and in this jumble you just can't tell anymore what image belongs to what set. It will drive you nuts, especially when you're shooting HDR panoramas.

Figure 3-23:

Which bracketing order is right for you depends on your shooting style. (Simulated result; in reality most Canon DSLRs will deliver only three frames, sadly.)

That's where the sorted bracketing order (−,0,+) comes to the rescue:

- You can identify bracketing sets at a glance, even in a plain file browser.
- Moving objects are shot in sequence and don't look too odd when ghost removal fails.
- The shortest and longest exposure bookend the sequence, so you can quickly check the dynamic range coverage.

Downsides are the exact opposite of the messy normal shooting style: You can't use stacking in an image manager because it will use the darkest image as representation for each stack and your project folder will look like a midnight shoot. And your hero exposure does not happen directly after pressing the shutter because your camera captures the highlight exposures first. The delay is short (those are the faster exposures anyway), but it's there.

Which bracketing order works best for you is a personal decision, depending on your own shooting and organization style. Casual HDR shooters tend to stick with the normal (0,−,+) order because it blends in nicely with normal operations. Even some seasoned HDR pros—for example my friend Uwe Steinmüller—prefer this way. The sorted (−,0,+) order is best for people who get confused easily, like myself. I wholeheartedly recommend it for beginners because it really brings more transparency into the process. Sorted is also the way to go if you know for sure that you'll be using an HDR workflow and fire a lot of brackets in a row. HDR panorama shooters shouldn't even think twice about it.

The bracketing order has no impact on HDR merging programs whatsoever because they will grab the exposure settings from the metadata anyway. But it's important for *yourself*, so you can look at what you shot and feel comfortable with it.

JPEG or RAW?

Every other photo book recommends RAW as the only choice for taking pictures of supreme quality. And while that holds true for single-exposure shots, for HDR bracketing the case is not quite so clear. There are many other factors playing into this decision, enough in favor of JPEG to even out the balance. One of these factors is the need for speed. Let me sketch a comparison of JPEG and RAW, specifically with the requirements of HDR in mind, so you can decide for yourself which format better fits your shooting style.

RAW files contain more and better data; that's a fact. You can expect between 1 and 2 EVs of extra dynamic range on both ends, highlights and shadows, and in some cameras even up to 3 EVs. All this data is uncompressed and available in very high precision: 12-bit RAW files have 4,096 distinctive levels per channel, 14-bit RAW files even more than 16,000. That's enough precision to allow changes to white balance and color corrections during RAW development. Higher color precision and extra range are the reasons why 2 EV intervals are perfectly fine for shooting HDR files in a RAW format.

However, there is a learning curve attached. Getting all this fine data translated into the HDR image requires very careful processing of these RAW files. It is different from regular RAW processing of single shots, and there are enough stumbling blocks to justify a dedicated workshop, which you'll find in section 3.2.4. For now let's just conclude that the default settings in a RAW program diminish the initial dynamic range advantage almost completely. The need for proper pre-processing adds to the workflow a critical step where things can also go horribly wrong. Another clear disadvantage is that a RAW file is very large, and RAW bracketing sequences are even larger. They fill up your card, your hard drive, and your camera's burst buffer. After each RAW sequence, you have to wait precious seconds until all images are written

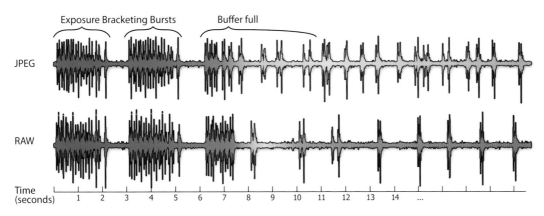

Figure 3-24: *The sweet sound of high-speed nine-frame autobracketing on the Nikon D200. Each exposure goes "ka-chick," drawn as double-spikes in this audio recording. Once the burst buffer is full, the camera slows down to a crawl in RAW mode, and the recovery takes much longer than in JPEG mode.*

to the memory card; otherwise, your shooting rate will drop tremendously. Ultra-high-speed memory cards somewhat help, but they don't solve this problem completely.

JPEG files, on the other hand, are pre-processed and compressed in the camera. They contain less dynamic range and have only 256 distinctive levels per channel, and because of gamma encoding, this data is extremely thin in the shadows (see section 1.4). In many ways JPEGs are made of pure evil; they respond badly to color corrections and tend to reveal nasty compression artifacts when you push them too hard. However, once they are merged to an HDR image, all the flexibility comes back—including the ability to change white balance and exposure. Note that these two arguments are often used to describe the advantage of RAW shooting, but they don't apply anymore when the JPEGs are taken through the HDR workflow. Section 3.3.3 will show you the vivid proof of this concept.

In return, JPEGs are much smaller files. Especially the darkest and brightest image of an exposure sequence, where only a small patch of useful information is surrounded by total black or white pixels, respond extremely well to

the JPEG compression. In a RAW format these images take up just as much space as all the other RAWs do, but in JPEG they get crunched down to almost nothing. Shooting a few more extreme exposures—just to be on the safe side—is a complete no-brainer in JPEG. Even at the highest JPEG-quality setting, a typical bracketing sequence takes up only 25 percent of storage space, so your memory card will last four times longer.

And then there's the speed advantage. The diagram above illustrates the situation where shooting HDR brackets in rapid succession fills up the camera's burst buffer. JPEGs can still be captured at a somewhat acceptable speed, but in RAW the shooting rate drops down to a crawl. And that's already a best-case scenario. Some cameras can't even shoot the first bracket in RAW as fast as they can in JPEG. That really can make the difference between 3 fps and 6 fps, so I highly recommend testing this out with your own camera. Furthermore, it's much faster to download the images from the memory card and the merging process to an HDR image goes much faster because there is less data to shuffle around.

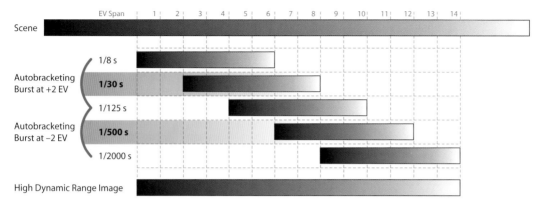

EV Span	1	2	3	4	5	6	7	8	9	10	11	12	13	14

Scene

Autobracketing Burst at +2 EV
- 1/8 s
- **1/30 s**
- 1/125 s

Autobracketing Burst at −2 EV
- **1/500 s**
- 1/2000 s

High Dynamic Range Image

Figure 3-25: *The double-burst trick is a cheap and easy way to extend the bracketing range beyond your camera's firmware limitations.*

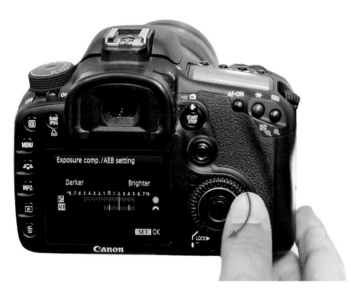

Figure 3-26: *Exposure compensation is conveniently located in Canon's AEB menu. For the double-burst trick, just turn the thumbwheel left, shoot, right, shoot again. The tick marks on the LCD screen offer helpful guidance.*

To summarize, the HDR workflow somewhat redeems shooting in JPEG format. It is most useful for HDR panorama capture or other situations where you have to fire many bracketing sequences in rapid succession. JPEG shooting dramatically accelerates the entire workflow with very little impact on the quality of the final result. However, you have to shoot in single EV steps to make up for the initially thinner data, and you must be dedicated to take it all the way through the HDR workflow. Shooting in RAW keeps the option open to just use the single best exposure. When developed correctly—and only then—RAW capture can result in HDR images of better quality, even if the difference is marginal.

The double-burst trick

If you're shooting with a Canon DSLR other than the 1D or 7D, then you're stuck with a silly AEB mode that allows only three images in ±2 EV intervals. Many tutorials on HDR recommend just using this; however, it won't take long until you find out that in many situations this will not cover the full dynamic range of a scene.

The cheapest trick is to use *exposure compensation* to fire two adjacent brackets. For example, let's say your middle exposure is at

1/125 second. Instead of shooting an AEB burst right away, first set exposure compensation to −2 EV. Now press the shutter and you will get the exposures for 1/2000, 1/500, 1/125 second. Then quickly change exposure compensation to +2 EV and let the camera rip through 1/125, 1/30, 1/8 second. The net result is that you have a continuous exposure sequence from 1/2000 to 1/8 second, widening your overall range by 4 EVs. It's not completely automatic anymore, but at least you had to manually change the exposure only *once* during shooting.

You probably noticed that this workflow captures the original middle exposure (1/125 second) twice. That's no big deal; you can drop one of the images later. Since this is most likely your hero exposure, you might appreciate the chance to select the nicer shot of the two. Feel free to avoid this double image and advance this technique to capture even wider brackets. For example, if the sun is in frame, you could center your first bracket around −4 EV, or if there are very dark shadows visible, your second bracket could be centered around +4 EV. But that's really something for advanced shooters. For the sake of forming a habit that can sink into muscle memory, it is better to stick with symmetrical exposure compensation first. Soon you won't have to think about it anymore, and your hands will set exposure compensation all by themselves: meter, −2 EV, shoot, +2 EV, shoot. Simple.

If you prefer a structured approach instead of relying on habits, you'll find a bracketing chart on the DVD based on a design by professor Kirt Witte. Just print that on a card and put it in your camera bag. If you have an iPhone or iPod Touch, there's also an app for that. Of course. It's called PhotoBuddy and includes a really awesome bracketing calculator. You can dream up the most exotic bracketing sequences, such as, for example, seven exposures around 1/125 second in 1.6 EV intervals and without overlapping exposures. PhotoBuddy will figure out the appropriate bracketing bursts for you

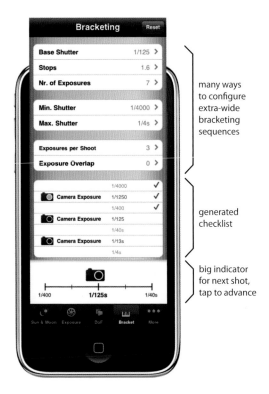

Figure 3-27: *PhotoBuddy is a helpful iPhone app for planning complex bracketing sequences.*

and present them in a slick checklist. See section 2.8 for more screen shots and other useful apps.

Here's another trick. On the Canon 5D you can make use of the shooting mode knob. Just do all your settings for the slower exposure burst in the Custom shooting mode (C setting); then select Register Camera Settings from the screen menu. This will act as a quick-access memory. Turn the knob to your regular shooting mode and shoot your fast exposure burst. Now all it takes is a quick dial of the mode wheel back to C and you can press the shutter button to shoot your second, slower burst. This switcheroo is even faster than using exposure compensation and requires less button pushing.

Handheld capture

It is absolutely possible to shoot handheld, provided your camera features autobracketing with a burst mode, and there is enough light available to keep exposure times on the fast

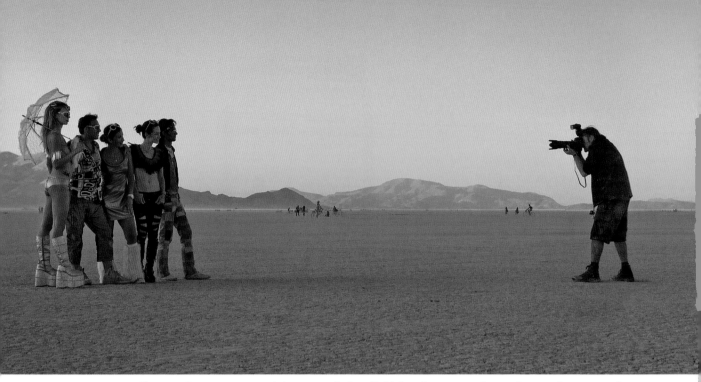

Figure 3-28: *Correct posture is important for handheld shooting. You need to get into a safe stance and rest the camera on the palm of your hand, fingers pointed forward to support the weight of the lens.*

end. You might need to break last section's rule and set the aperture to a very small f-number, eventually even raise the ISO a notch, in order to max out shutter speed. When all your exposures are between 1/4000 and 1/125 second, you should have no problems.

Get into a safe stance and hold the camera firmly with both hands. One hand should be reaching for the release button; the other hand is underneath the body with the fingers pointing forward to hold the lens. That hand's palm is now your temporary tripod plate and carries most of the weight. Count 1-2-3 to calm yourself down, take a deep breath, then press and hold the release button while exhaling. You have to get into some kind of Zen mode for a few seconds, just long enough for the autobracketing function to rip through the sequence. Try to imagine you're a tree. That helps. As mentioned earlier, JPEGs may come in handy here because they don't fill up the camera's internal buffer that fast and the burst mode remains speedy all the way through. A little drift left/right or up/

down is usually fine because panning motion is very easy to align afterward. The thing to watch out for is camera tilt. When your images have to be rotated to align them, you might get into trouble.

Another proven method to stabilize a handheld shot is the *pull-strap technique*. Lay the camera strap around your neck, and then bring the camera up and push it forward with both hands until the strap is pulled tight. Once you put enough tension on the strap, your neck will become a third anchor point for the camera and you will gain a surprising amount of stability. Of course, that posture is just as hard to maintain as holding a beer mug at arm's length, so you'd better get that shot quickly.

These are really just hints for the emergency—in case a tricky lighting situation catches you unprepared. If you keep exposure times on the fast end, you still have a 90 percent chance of getting a decent HDR image out of it. But for a critical shot, I can't recommend relying on handheld HDR bracketing.

Figure 3-29: *The pull-strap technique is an alternative way to stabilize the camera. It requires both hands and is much more effective when you're not riding a bicycle at the same time.*

Even a monopod can be a fantastic help because it eliminates the camera tilt. Monopods are cheap and light and set up in no time. If you shoot handheld because you have an aversion to tripods, you will find that a monopod leaves you all the spontaneity you love yet helps you get the shot you want. Even if the monopod just dangles off the camera, without actually touching the ground, the weight shift alone introduces a pretty good dampening factor. This technique is known as the poor man's steadycam rig and also comes in handy for filming video with a DSLR. Eliminating shake in the tilt axis alone makes a DSLR video much more watchable; it will appear less like a home video.

Anyway, for HDR you can never be stable enough. Even if you have nothing but your camera with you, your first and preferred option should always be to find some kind of pole, handrail, tree, wall—anything that you can press your camera against.

Tripod capture

True professionals, however, don't leave their house without a tripod. It's not only the failsafe method for HDR capture, it's absolutely necessary for indoor, night shots, and other low-light situations. A tripod also enables shooting at higher zoom levels and eliminates parallax shifts between exposures when the subject is close to the camera.

Indeed, it does take some time to set up a tripod, which is why many people stay away from it. But this slowdown is also an opportunity because it forces you to frame your shot more carefully and gives you a chance to think twice about the composition. Shooting on a tripod is less spontaneous but more controlled. Believe me, it will enhance your photography and take it out of snapshot land. Besides, you get a lot of the flexibility back when you leave your camera on the tripod for the entire session. When you shoulder the whole rig like a bazooka, it's actually quite comfortable on a hike. And the

Figure 3-30: *Consider getting at least a monopod. It makes a fabulous hiking stick too.*

Figure 3-31: *A tripod is the most reliable way to stabilize the camera, and it's indispensable in low-light situations.*

Figure 3-32: *I tend to hike with the extended tripod in bazooka stance, ready to shoot within seconds.*

moment you see something, you're ready to shoot in no time.

Make sure you set the tripod on safe ground. Soft dirt can take a little stomping as preparation. There will be vibration, and you don't want the legs to sink in. Lighter tripods become much more stable when you hang your backpack on the center column. Find your preferred framing, and lock it all down!

If your lens has a shake reduction feature, turn it off. This will not do you any good on a tripod. In fact, in Nikon VR lenses, the stabilizing gyro will reactivate for each exposure and paradoxically introduce misalignments.

For maximum stability and really sharp images, turn on *mirror lockup* mode as well. That's because the internal mirror of your DSLR has to get out of the way when you're taking a picture, and for that it flaps up quite forcefully. This causes heavy vibrations going through the entire tripod system, unfortunately right

in that millisecond when you need it the least. A human hand holding the camera would easily dampen that out, but a rigid tripod doesn't. Mirror lockup mode delays the actual exposure for about a second, giving the camera enough time to swing out after the mirror gets smashed on the ceiling of the body. I'm honestly puzzled as to why the mirror doesn't automatically stay out of the way for the length of the whole bracketing sequence, but as a matter of fact all camera makers design their AEB mode to repeatedly flap the mirror. Maybe the idea is to wear it out as fast as possible so you have to get a new camera sooner.

Don't touch this

You get the best results when you don't touch your camera at all. Even pushing the release button puts enough force on the body to hinder pixel-perfect alignment. With mirror lockup enabled, you can let go right after pressing the

Receiver unit ━━━━▶

Wireless remote release ━━━▶

Figure 3-33: *For pixel-perfect alignment, you need a remote release. Note that you still need to set up autobracketing on the camera. These remotes can't change exposure settings; they only give you a release button that is detached from the camera body.*

Figure 3-34: *The Phottix Plato remote eliminates dangling cables and allows hands-free shooting. The receiver sits on the flash shoe, awaiting a wireless signal from the stylish remote.*

button and have the tripod come to rest. Another common trick is to set your camera's *self-timer* to 2 seconds to delay the exposures slightly. On some cameras the self-timer works great with autobracketing. You just have to make sure it will actually fire the whole bracketing burst. If it doesn't, like on most Nikon DSLRs, try the *interval timer* instead. I learned this method from Trey Ratcliff; he's using the interval timer routinely with great success. The interval timer is usually buried deep in the camera menu; it's a good idea to memorize the button-push combination as you did with those cheat codes on Nintendo consoles. If you're using it a lot, check the manual on how to assign it to one of the spare function buttons on the body.

Consider getting a *remote release* for your camera! That will allow you to step back, just hold that button on the remote, and let the camera do its thing. A simple cable release will do; for HDR alone it doesn't need to be an expensive one. Autobracketing is done by the camera anyway, so all the usual AEB limitations still apply. The remote just enables you to push and hold the release button without actually touching the camera. My favorite gadget, though, is a rather fancy one: the Phottix Plato wireless remote. It works over crazy distances, even through walls, and if the battery runs out I can plug the transmitter into the receiver and it becomes a wired remote. It also looks extremely slick and has a blinking red light. I like that.

Figure 3-35: *Where to put the laptop? Roger Berry (www.IndiaVR Tours.com) built a simple metal tray to mount his VAIO notebook to the tripod.*

Tethered shooting

If you want to make sure every spectator stops in awe, you can also remote-control your camera from a laptop. Of course, this method is most useful in a studio setup, where you have access to a power outlet. Laptops and ultra-portable notebooks are clearly preferred for this task.

The cool thing about tethered shooting is that your computer screen becomes your view-finder. You can have a really close look at sharpness and see exactly what you get because the images are beamed via USB connection directly to your hard drive. Several remote capture applications even allow direct HDR capture. They can't magically remove the sensor limitations, but they can fire exposure brackets far beyond the native capabilities of your camera and automatically combine the individual exposures in the background. You can instantly see if that HDR image turned out nice and reshoot if it didn't. Being free of the burden of shuffling around all those source files is an immense convenience.

However, no tethering software can shoot as fast as the camera's built-in autobracketing. This is a fundamental problem, rooted in the USB connection. There is always at least a 1-second delay between frames, even more if you download the images straight to your laptop. So instead of 5 fps (the average DSLR autobracketing rate), you get 1 fps at best. You also don't want to sit your laptop down in the dirt, so you need an extra stand for it. And once you do a Google search for "laptop tripod mount," an exciting new world of expensive accessories will unfold in front of your eyes: from tether tables over monitor shades all the way to cup holders.

If you have the craftsman skills of a Roger Berry, you can also build your own laptop tray by heat-bending a piece of metal, coating it with rubber foam, and then clamping it onto the center column of the tripod.

When it comes to tethering software, the professional solution comes from Breeze Systems and is called DSLR Remote Pro. It's available for the Mac and PC, loaded with features, and allows detailed control of virtually every setting on Canon EOS and some Nikon cameras. After autobracketing, it can call up any HDR program and hand the pictures over to make an HDR image right away. It is meant as a backdoor link to Photomatix, but it really works just as fine with any other HDR merging utility listed in section 2.3. You can get DSLR Remote Pro for $129 to $179, depending on your camera model.

⊡→ www.breezesys.com

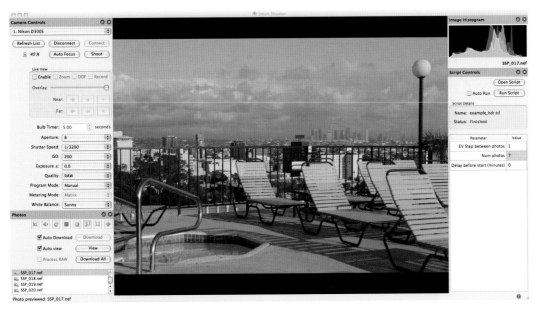

More budget friendly is an app called SmartShooter from Francis Hart. It's only $50 for any camera model, and it also works on Mac and PC. The interface is very similar to Breeze's software, maybe even a bit nicer. SmartShooter doesn't have a dedicated autobracketing mode; it has something better instead: a versatile scripting interface. It comes with over 15 premade scripts, including HDR time-lapse, focus stacking, and automatic FTP upload. The scripting language is very simple and well documented, and it's not hard to modify one of the many example scripts to exactly what you need. That means endless configurability in an affordable package.

⇨ www.hartcw.com

If you really feel the urge to impress the hipster crowd, then you should have a closer look at onOne Software's DSLR Camera Remote. It's made for iOS and runs on iPod, iPhone, and iPad. The interface is gorgeous and extremely intuitive, as you've come to expect from apps on this platform. Especially the LiveView mode is guaranteed to drop a few jaws. Even hard-boiled tech haters cannot resist the excitement

Figure 3-37: *DSLR Camera Remote for the iPad enables you to walk freely on set while taking the viewfinder with you. Your camera is still tied to a computer, but you are not.*

of watching the exact view through the lens when handed the iPad. You can essentially walk into the scene and rearrange things while taking a wireless viewfinder with you. However, all this easy-going iMagic is just an illusion. In reality this app cannot directly communicate with

your camera—it has to connect over Wi-Fi to an application that runs on a computer, which is tethered to your camera. So you're not eliminating the laptop from the equation, you're just adding another screen (and therefore another point of possible failure).

⤷ www.ononesoftware.com

There are also freeware solutions. They are much simpler: fewer features, less to no user interface, and no obligation to offer any customer support. You know the deal. But if $0 sounds just like your kind of budget, try these:

 Sofortbild App for Nikon DSLRs by Stefan Hafeneger: ⤷ www.sofortbildapp.com

 CanonCAP for Canon DSLRs by Greg Ward: ⤷ www.anyhere.com

 AHDRIA for Canon DSLRs by Sean O'Malley: ⤷ www2.cs.uh.edu/~somalley/hdri_images. html

External Bracketing Controllers

In all honesty, I do not recommend tethering your camera to a laptop in the field. Especially for landscape photographers, that would instantly add several pounds to the backpack. It also means you have to worry about one more expensive device that may drop and shatter, run out of battery, or fail in a million other horrible ways. The rule of the day is "Keep it simple."

All we need is a remote controller that enables us to set up large bracketing programs without much fuss. It needs to be robust and reliable, small enough to fit in a pocket, and flexible enough to connect to any camera. Impossible, you say? Well, not quite! There are two devices that fit the bill: the Promote Control and the Open Camera Controller.

The Promote Control is exactly what's described earlier: small, light, endless battery life, and extensively configurable. It can do massive HDR bracketing, time-lapse with delayed start, even combine the two to HDR time-lapse. It's

a robust plug-and-play device that connects to your camera's USB *and* shutter release port. USB is used for setting the exposure time, but the actual photo is triggered over the release cable. That way it can shoot much faster than any laptop tethering software, which are all USB-only. Technically the shutter release cable is an optional extra purchase, but that's just because you have to choose either the Nikon or Canon cable. This is the wrong place for penny-pinching. I urge you to get the matching shutter cable for your camera because bracketing speed is a major advantage of the Promote.

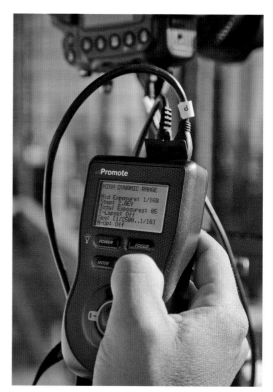

Figure 3-38: *The Promote is the ultimate HDR bracketing controller, a highly recommended addition to your camera bag.*

Especially for Canon HDR shooters, the Promote is a must-have because it will instantly let you shoot ridiculously wide brackets instead of the standard three exposures. Even Nikon shooters, spoiled by their nine-exposure bracketing, can

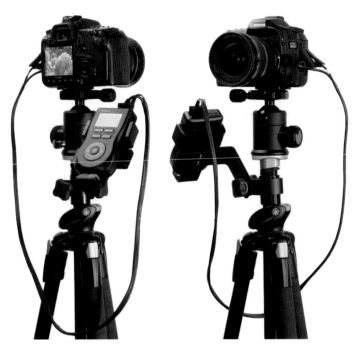

Figure 3-39: *Kellis Bellis (www.panocea.us) made a custom Promote cradle that attaches nicely to the center column of the tripod. Note how the USB cable and shutter release cable are shrink-wrapped into one.*

Figure 3-40: *All the parts for Kellis's Promote cradle can be found in a well-sorted hardware store. You'll just have to heat-bend the T-piece into shape.*

benefit greatly from taking five exposures in 2 EV steps instead. For example, at night your longest exposure may be 8 seconds, and by skipping the unnecessary single EV steps, you will save a lot of time. And if you find yourself in a situation where extreme scene contrast requires you to bracket seven or nine exposures in 2 EV steps, this device has the answer.

PRO-TIP You can even plug a Phottix Plato or Cleon2 wireless receiver directly into the Promote's auxiliary port. Any wireless controller that works with the Canon Rebel will do the trick. When they're daisy-chained like this, you'll have a wireless HDR remote controller. Now, that's something, isn't it? Some photographers love their Promote so much that they strap it directly to their panoramic head or build themselves awesome custom cradles. The device has slightly larger dimensions than an old-school click-wheel iPod, so on a lucky day you may just find a stock accessory on eBay that fits.

The Promote comes with a $300 price tag, though. Not cheap, but well justified considering its unique capabilities. In return you get extraordinary customer support. Seriously, you will not find an unhappy Promote user! I've heard stories of people getting a replacement unit via overnight express, just in time before venturing out to an important shoot. My only point of complaint is the plain interface, reminiscent of a quartz lap timer from the nineties.

→ www.promotesystems.com

If the Promote blows your budget, I have a special treat for you: the Open Camera Controller (OCC). This is an open community project at HDRLabs.com, initiated by Steve Chapman and further revised by Achim Berg. The idea is to use a Nintendo DS as a remote controller, so we have a fully user-programmable touch-screen device with a rich graphical interface to trigger our brackets. It can do even more, like sound triggering (clap or scream or shoot a bullet to take a picture), automatically

Figure 3-41: *Rick Ramirez shooting massive exposure brackets with the OCC and a Canon 5D Mark II. Or maybe he's solving a sudoku puzzle, hard to tell...*

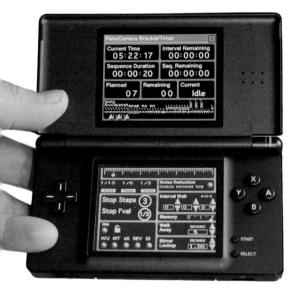

Figure 3-42: *The Open Camera Controller project turns a Nintendo DS into a universal bracketing controller.*

start a time-lapse half an hour before sunrise, or set up complex longtime exposure sequences for astrophotography. You can even develop your own shooting modes because they're all individual apps running on the Nintendo DS. The catch is, you'll have to build the connector cable yourself.

The full project description is on the DVD, along with ready-to etch circuitry plans. Nowadays you don't actually have to etch the circuit yourself. There are many Internet services that will happily do this for you. For example, in the United States you can order a ready-made OCC circuit board for $10 from www.circuitboardstogo.com. You do, however, have to break out ye good olde solder iron and follow the build instructions to complete the adapter cable. It involves sacrificing a game cartridge, putting an Arduino micro-controller inside, and frankensteining the cable from an old shutter release to it. It'll be fun, a great garage weekend project. Total cost for the parts are about $40 to $80, depending on your luck on eBay. Once assembled, the remote release cable is used to trigger timed shots, with the camera in bulb mode. It's a very universal concept; it works with Canon, Nikon, Panasonic, and Olympus cameras and can be adapted in a million different ways. The downside of the bulb-timing method is that it can't reliably release exposures faster than 1/20 second, so it's much slower than the Promote.

Over the years a great community of solder ninjas has developed in our forum, folks who build modifications and gladly jump in and help with crafting advice. Some people have successfully added a USB controller (which would make it faster), and there is a very recent push to take the project off the Nintendo platform into the iOS and Android world. Definitely check online for new revisions. I also wholeheartedly recommend the OCC project as a university course project. It teaches a whole lot about the inner workings of a camera, and

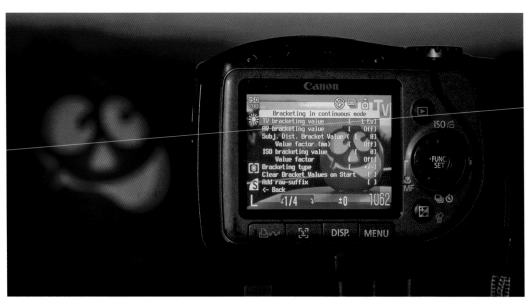

Figure 3-43: *CHDK teaches my PowerShot SX100 how to do bracketing. Suddenly this little camera is more configurable than my DSLR.*

there is a delightful sense of achievement involved when you finally hold your very own mighty powerful bracketing controller in your hand. And besides, what student wouldn't appreciate an official excuse to bring to class the Nintendo DS, a device otherwise known for banana-slinging cart race action with up to eight players over Wi-Fi?

If you're all thumbs like me, armed with a healthy fear of soldering your hand to the table, you can also order a preassembled kit from our Maker's Market. That's a place where more experienced tinkerers sell Open Camera Controllers to the rest of us. Achim Berg alone has built more than 50 devices and sent them to happy photographers all over the world.

→ www.HDRLabs.com/occ

There are many other do-it-yourself bracketing controllers around. I can't really comment on which ones work and which don't, but if you do a Google search for "Arduino DSLR" or "Android DSLR," you will find many options.

Hacking your camera

The popularity of Canon cameras, mixed with Canon's stubborn AEB feature limitations, provides a fertile ground for all sorts of crazy ideas. A custom firmware extension, made by the open source community, is certainly one of them. It's not for the faint of heart; hacking the firmware voids your warranty and can potentially turn your camera into an expensive paperweight. Chances for that to happen are extremely slim, but an element of risk always remains. However, the reward is a flurry of features otherwise out of reach as well as a satisfying sense of rebellion.

The Canon Hack Developers Kit (CHDK) is the most prominent hack available for Canon's compact cameras. Aside from virtually unlimited HDR bracketing it also enables RAW formats, additional ISO options, focus

bracketing, better flash sync, live histogram display, and much more.

It's stunning to see how capable a little PowerShot camera can become when the firmware limitations are lifted. Most features are implemented using a standard scripting language and permanently extended by a growing community of photo enthusiasts. This collective beehive mind comes up with features that the handful of official Canon engineers never thought of. At least a dozen time-lapse scripts and HDR bracketing modes are floating around, all with different flavors, made by photographers who logged many hours actually *using* their cameras in the field. For example, one HDR script performs a histogram analysis to set the exposure bracketing range automatically. And even the standard CHDK installation can be configured to switch the capture mode back from RAW to JPEG when you're bracketing in order to preserve the highest possible burst rate.

⌐→ www.chdk.wikia.com

Magic Lantern is the CHDK pendant for Canon DSLRs. Originally invented to unlock manual exposure settings for the Canon 5D's video mode, it quickly grew into a mighty powerhouse. Even after Canon fixed manual exposure in a firmware update, Magic Lantern

remains relevant for multiple reasons: You can increase the bitrate of the video capture so the footage has less compression artifacts and can actually be used in postproduction. It can display audio meters on the LCD monitor and mark overexposed areas with a zebra pattern. And of course, you can also unleash the full potential of auto exposure bracketing. The most recent killer feature is an HDR video mode, which captures a video stream with alternating exposures for every other frame.

⌐→ www.magiclantern.fm

Despite the warning earlier, both firmware hacks are actually very safe. They make clever use of a firmware loophole, where the camera will boot from a CF card. You're not really modifying the firmware itself but rather manipulating a CF card to appear bootable, and all modifications exist only in the camera's memory. When things go wrong, you'd just pop out that hacked card, the camera will boot up normally again, and your warranty is restored. Really, the only risk stems from the fact that you will suddenly have an overwhelming amount of options and you'll be able to customize your camera way beyond the hardware's physical abilities. It shouldn't come as surprise that a real-time histogram display drains your battery, and shooting 64-second longtime exposures at a bright subject may not be the healthiest exercise for your sensor.

Bracketing comparison

As with so many things, there is no ideal solution to automatic extra-wide high-speed bracketing. Here is an overview of all the different approaches.

Figure 3-44: *Magic Lantern even enables HDR Video on the Canon 5D by alternating between a high and a low exposure during video capture.*

	Standard In-Camera AEB	Double Burst Trick	Breeze DSLR Remote Pro	SmartShooter	OnOne DSLR Camera Remote	Sofortbild App	Promote Control	Open Camera Controller	CHDK & Magic Lantern
Price	free	free	$129 PC $175 Mac	$50	$20 iPhone $50 iPad	free	$300	free	free
Supported Cameras	some	any	Canon, Nikon	Canon, Nikon	Canon, Nikon	Nikon	Canon, Nikon	Canon, Nikon, Sigma, Casio, Olympus, ...	Canon
Computer Required	—	—	Mac or PC	Mac or PC	Mac or PC + iOS Device	Mac	—	Nintendo DS	—
Connection Type	—	—	USB	USB	USB + Wi-Fi	USB	USB + shutter cable	shutter cable	—
Bracketing Speed	●●●	●●○	●○○	●○○	●●○	●○○	●●●	●○○	●●○
Bracketing Range	●○○ mostly poor	●●○ doubled	●●● unlimited	●●● unlimited	●●○ +/– 5 EVs	●●● unlimited	●●● unlimited	●●● long exposures unlimited	●●● unlimited
HDR Time-Lapse	only some Nikons	—	✓	✓	—	—	✓	✓	✓
Direct HDR Merging	—	—	via external programs	via external programs	—	✓	—	—	—
Focus Stacking	—	—	✓	✓	—	—	✓	—	✓
Large Image Display	—	—	✓	✓	✓	✓	—	—	—
Scriptable	—	—	—	✓	—	—	—	✓	✓
User Interface	●●○	●○○	●●○	●●●	●●●	●●●	●○○	●●●	●○○
Field Usability	●●●	●●○	●○○	●○○	●○○	●○○	●●●	●●○	●●●

3.2.3 Calibrating Your Camera

What? Where is that coming from? I already shot my brackets, and *now* you're telling me my camera needs calibrating?

All right, OK. If you are one of those photographers who never care about white balance or color spaces, you may safely skip ahead. This behind-the-scenes section is intended for the curious people, those who can't resist the temptation of pushing a button that is clearly labeled "Don't ever push this button!" You know, the type of guy who gets told "Go on, nothing to see here" and stops and asks, "Why? What *exactly* am I not supposed to see here?"

What the camera response curve is all about

Quick reminder from section 1.4: Pixel intensities in regular 8-bit images are distributed according to a gamma curve, so they make better use of the measly 256 levels available. Well, in order to reconstruct a linear HDR image, that gamma needs to be stripped out. This is called *linearizing,* and it needs to happen first. Otherwise, we will never be able to seamlessly puzzle the full luminance range together.

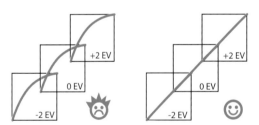

Figure 3-45: *Source images need to be linearized before they can be merged to an HDR image.*

We need to talk about the part again where the in-camera software takes the linear sensor data and applies a gamma tone curve to bake it into a JPEG. Remember when I told you that each and every device is calibrated to a 2.2 gamma value? Sorry—that was a lie. (Note to myself: Stop fooling your readers!)

The reality is much more complicated. Sensors are not always 100 percent linear and identical. Even the same camera model can feature different stocks of sensors, which have slight manufacturing differences in the way they respond to light. Furthermore, camera makers tend to slightly distort the tone curves of individual channels to apply a special "brand look." That can be the beautiful skin tones of brand X or a smooth roll-off in the highlights that makes brand Y look more like film. Back in the film days, they all had their secret sauce in the form of actual differences in the chemical and physical structure of the film material. Now it's all software, and manufacturers just fiddle with processing parameters and tone curves. They all do it to some extent, even if they don't admit it.

What that means is that there is not necessarily just a simple gamma relationship between the true linear world luminance values and the pixel levels as they appear in a JPEG. It might be close, and it gets closer the more professional the camera is. But there is still that bit of uncertainty where we are even uncertain of how far it is off.

That's why clever scientists found a way to recover the tone curve that has been applied. It works by analyzing the images themselves and comparing the pixels' appearance across the entire spectrum of exposures. It really isn't as complicated as it sounds. When a pixel is exactly middle gray at one exposure, how much brighter is it 4 EVs up? And does it get a slight blue tint 2 EVs later, just before it clips? That's the kind of questions answered here. The results are drawn as a graph that precisely describes what world luminance is mapped to what pixel level: the camera response curve.

It's exactly the same thing as a lookup table in cinematography—a tool that you can apply from now on to all images for taking out the device-dependent inaccuracies; a color management tool similar to the ICC profiles that sync your screen to your printer, but with the twist

that it syncs your HDR images to the world. The curve is the recipe, the source exposures the ingredients, and the HDR image the cake we are going for.

Does that really work from just looking at plain images?

Well, it depends.

Reverse engineering that curve from a bunch of images gives you a better chance of success when the analyzed pixels are close to gray to begin with. You know that kind of machine logic from automatic white balance programs: The average of the image is assumed to be gray, so only what is redder than the average will be registered as red. An algorithm has no sense for the beauty of a sunset and therefore will insist on calling a majority of it gray. Camera curve recovery algorithms are not as picky as white balancing, though. What makes them trip are images in which individual channels clip off earlier than others. For example, when a blue sky is very dominant in the image, then blue will most certainly be the channel that clips off before red and green do, so that sequence may result in a false camera curve. Shooting a primarily neutral scene for calibration is the best way to prevent this.

Also, the quality of the camera curve gets better the more images you have. If you have only three images, there is not much data for the algorithm to look at. So that's yet another reason to overshoot the dynamic range.

A very problematic case is at hand when the in-camera software is trying to be extra smart and applies a different tone curve to differently exposed images. The intention might be to turn over- and underexposed images into something more pleasing, but to the reverse-engineering algorithms this is fatal. There just is no single curve to extract that would be valid for all exposures.

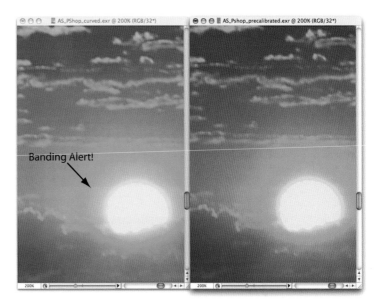

Figure 3-46: *Photoshop's default behavior is self-calibrating each bracketing sequence. This may eventually result in a bad camera curve (left). Using a pre-calibrated camera curve can result in a much cleaner HDR image (right).*

Gamma or self-calibration or predetermined curve? That is the question!

First of all, a generic gamma is better than a bad camera curve—that is, one that is derived from images with a dominant color, insufficient range coverage, or a different white balance. A bad curve can screw you up and introduce weird color banding. There is not much sense in redoing that curve for every HDR image because then you will inevitably have that one set with a lot of blue sky in there, which will give you a bad curve. The curve is not dependent on the scene anyway; it's your hardware and firmware that get measured in here.

For general photography, a standard gamma curve works great. If you are primarily interested in a pleasing image, love the particular look your camera gives you, and plan on tweaking the colors to your taste anyway, then you're getting a very predictable consistency from a generic gamma curve. On modern DSLRs, the response curve is very close to a pure gamma anyway, and the result from a reverse-engineered curve might even be less accurate.

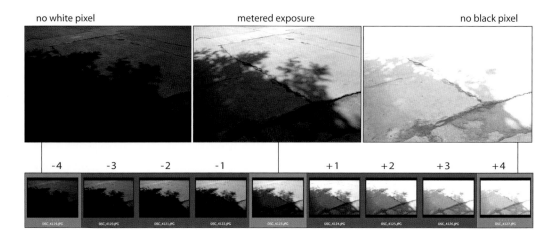

Figure 3-47:
Shooting a reference sequence for calibration is easy.

no white pixel metered exposure no black pixel

-4 -3 -2 -1 +1 +2 +3 +4

Calibration can be necessary, however, for several reasons. It is a must for lighting designers and architects, or anybody who wants to use the HDR image for deriving precise world luminance values. Capturing the lighting situation on a movie set is a common example of when you would want an accurate light probe as the starting point in a CG environment. You also need calibration if you have a couple of cameras, maybe even from different brands, and you would like their output to be in sync. And then there is the case of notorious analog photographers, where there are so many unknown factors between film development and scanning that each film roll needs to be calibrated again.

The best advice I can give you is go with a standard gamma first. If you notice weird color shifts or banding in your HDR images, that is a hint that your camera software (or RAW development process) is doing funky "enhancements," and then you will have to calibrate them away.

It also depends on your choice of software for HDR generation. Photomatix and FDRTools default to a standard gamma curve, which is usually just fine. But in Photoshop or Photosphere, the curve recovery algorithms are the default behavior. Here it makes a lot of sense to

shoot a designated calibration sequence to get a good curve out of it instead of determining one bad curve after another and having each HDR image merged differently.

Shooting a reference sequence

We need a subject that has both neutral colors and a large dynamic range. If you want to go crazy, you can use two Macbeth color charts and put one in the sun and the other inside a shoe box. But the truth is, the calibration algorithms are actually quite robust, and you won't gain a much better curve from this procedure. You might just as well shoot a piece of tarmac or a white wall.

Shoot slightly out of focus! A little blurriness helps the algorithm because then it doesn't have to deal with pixel alignment of the individual images. Don't defocus all the way though; that will result in excessive spill and bleeding highlights.

What's much more important is that you really cover all the range that you see through the viewfinder and that you do it in small steps. The maximum here is 1 EV interval; 1/3 EV is better. Remember, we want as many good colored pixel samples as possible so we can keep tabs on how they change throughout the sequence. The darkest picture should not show

any overexposed white pixels anymore, and the brightest image shall have no black pixels. Then you have scanned the entire range.

Good old HDR Shop shows the camera curve

Just for demonstration purpose, we will dust off HDR Shop to generate a camera curve. Nowadays this curve generation happens all automatically, but I want to show you what those automatic algorithms actually do. You don't need to follow along, just sit back and watch me.

When I call up that menu point, HDR Shop asks for an image sequence. Since HDR Shop is not aware of EXIF data, I have to manually set the exposure interval to 1 EV. Then something very interesting happens: HDR Shop is dropping its pants, fully exposing the bowels of its algorithm with a semimanual response curve estimation utility.

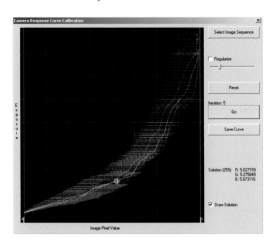

What you see here is how HDR Shop picks more and more pixel samples and looks up how they change across the exposure sequence. The graph line represents the mean value—the Joe

Average Pixel, so to say. This analysis is an iterative process and the graph is animated along to show the progress. When it starts, this average curve is very jerky and jumps around, but the longer the algorithm runs, the more samples are taken into account, and eventually the curve comes to a rest.

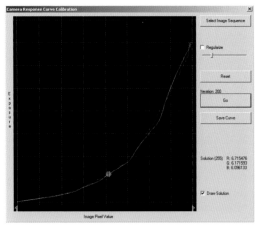

That's what the resting pose looks like after 200 iterations. The graph is still quite bumpy, with spiky scribbles on the top end of the red channel.

To smooth that curve out, I switch on the Regularize function. Now the curve turns into a rubber band and the dimples are smoothed out. Fully automatic curve generators do that as well, and it works very efficiently, as you see.

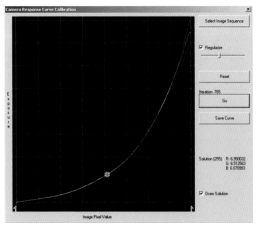

One oddity is left. See how the channels shear apart on the top end? That doesn't look right. Those are the near-white pixels, and apparently the pixel values of our images don't give us a good indication of the real world color here. Screw these pixels—I just discard them by dragging in that blue clipping guide.

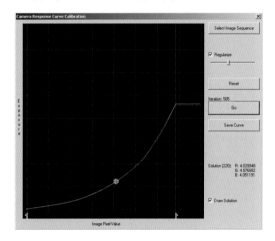

That's how my response curve ends up looking. The shape is remarkably similar to a perfect gamma curve, except that the red channel still runs a tiny bit above green and blue is always underneath. That is probably my white balance; it's just how my camera makes it look sunny. But in overall conclusion, I can proudly confirm that my Nikon D200 has a very ordinary gamma response. That means I'm well off just using the standard gamma for generating HDR images from this camera.

I hope you enjoyed this little exercise, and I hope it gave you a feel for what a response curve looks like and how it's made. You're welcome to load the source images from the DVD or try this process on your own calibration sequence. One occasion where this HDR Shop workflow comes in handy is when you want to verify a linear RAW conversion. If you succeeded and the files are really perfectly linear, the derived response curve should be a straight line. But aside from the educational value, there is really no reason to perform this manual curve generation anymore.

Calibration today

In modern programs, all this algorithmic calibration is happening behind the scenes. You just enable a check box and the curve is generated on-the-fly prior to the actual HDR image generation. All you get to see is a progress bar.

But what's really happening under the hood is exactly the same process I just demonstrated in HDR Shop. Several pixel samples are compared, obvious errors are smoothed out, and everything that is not considered reliable gets clipped off. And as you have seen with my ad hoc tweaks to that curve, a lot of rough assumptions are made in the process. Response curve recovery is not quite as precise and scientific as a single progress bar might let you think. It is an estimation, with many wild guesses thrown in the mix. How many of the dimples that I smoothed out were actually relevant measurements? Did my crude clipping eventually discard some good pixel values as well? We will never know, and neither do the automatic algorithms.

Figure 3-48: *Photomatix was never very confident in reverse-engineering the tone curve. In version 4 this option has disappeared entirely.*

I mentioned earlier that each HDR generation software handles this curve estimation differently. That is because every programmer has more or less faith in the concept of response curve recovery all together. For example, Photomatix used the cautious wording "*Attempt* to reverse-engineer tone curve applied" to label this option and removed it completely in Photo-

	Self-calibrate each exposure sequence	Load and save a precalibrated response curve	Use generic gamma response curve
Photoshop	✓ default	✓	—
Bracket	✓ default	✓	✓
Photosphere	✓	✓ default	—
FDRTools	—	✓	✓ default
Picturenaut	✓ default	✓	✓
Dynamic Photo-HDR	✓	✓	✓ default
Photomatix, HDR Efex Fhotoroom, HDR Expose, PhotoEngine, Hydra, ...	—	—	✓ default

matix 4. Now it will always use a generic gamma curve, just as most other programs do. Which is okay. Again, a generic gamma is better than a bad curve. It's not as awesome as a well-calibrated curve, but the only way to get a well-calibrated curve is by shooting a dedicated calibration sequence. And that's a process that turns most people off.

3.2.4 Pre-processing RAW Files

Shooting exposure brackets in RAW is a mixed blessing. It's true that you get better data because the camera firmware didn't even get a chance to mess with your image. It's true that RAW files have extra highlight information, resulting in more dynamic range captured in each source image. And it's also true that 12-bit or 14-bit precision in each RAW file can improve the quality of the merged result. But that doesn't mean it's all just a walk in the park. By shooting RAW instead of JPEG, you trade in the camera's firmware for a RAW converter as the factor that will crunch your original data down. Or better said: You have taken the burden upon *yourself* to do a better job in extracting useful information from the sensor data.

It's important to realize that any RAW converter's default settings *do not* do a better job. For example, the firmware in recent Nikon DSLRs can already compensate for chromatic aberrations, and Canon's firmware removes vignetting with great success. Yes, RAW con-

verters can do all this even better, but by default they do not. Modern firmware also features noise suppression that is specifically adjusted to the sensor it was made for, while RAW converters have to be carefully configured right. So, against the conventional wisdom of "RAW is always better," you can actually get a cleaner HDR image out of a JPEG series than out of poorly converted RAWs.

In an ideal world you could just skip RAW conversion; instead, send the original images straight to your HDR program and that would already make the best use of the all the data in each file. Unfortunately, in real life that is not quite the case. The concept is slightly thrown off by the fact that all HDR utilities internally rely on dcraw to convert the original images *first* and then merge whatever is left. See section 2.1.1 for a more elaborate rant about this topic. However, HDR programs are getting better at using dcraw. At least they convert the RAWs exactly the way their merging algorithm expects them to, which will make the final HDR better than if it's made from a poor manual conversion.

➤ Quick workflow: Merge RAW files directly

This direct workflow will give you great repeatable results when your source images are shot correctly. That means your most overexposed image really shows all shadow detail, and your most underexposed image has no more white pixels. The prime advantage of this workflow is that it's very fast and straightforward.

1 All you need to do is drag the RAW files directly from the Lightroom library onto the icon of the HDR program (for example Photomatix).

2 A loading requester appears. It's the same one you would get from within the HDR program except that it's already preloaded with the images, which is the convenient part. Make sure to check Show Intermediary 32-Bit HDR Image and click OK.

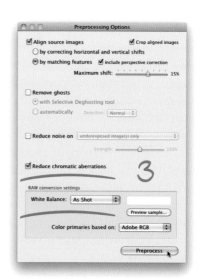

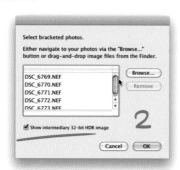

3 The HDR merge options now offer some RAW conversion settings (underlined in the screen shot). They may be limited, but they are good enough for most cases. Reduce Chromatic

Aberrations is worth checking for wide-angle shots. Also make sure it has detected the color profile you set in your camera.

4 Done. Save as OpenEXR and proceed.

I will talk about the other options in that HDR merge dialog in a minute. But the key element for merging RAW files directly is that you actually drag your RAW files directly into the HDR program. In this case, Lightroom is used only as a very expensive file browser; it will not actually touch your images.

One common misconception is that the Lightroom plug-ins of Photomatix, HDR Express, HDR Efex, and so on will do the same thing and merge RAW files directly. That's not true. They can't. Lightroom won't let them. Instead, Lightroom will always convert the RAW files to 16-bit TIFFs using the current development settings and hand over those TIFF files. That means your development settings actually matter a lot in this case.

To use these plug-ins and draw full benefit from RAW files, you have to develop them with a *flat conversion.*

A flat conversion is very different from the usual RAW processing. It's not about creating a pleasing picture; instead, it's about harvesting the sensor data with minimal losses. We're after a low-contrast image where all the available highlight and shadow details are retained. Instead of clipping off all that extra dynamic range, we want to scale it down to fit inside a regular TIFF file.

The following workflow becomes especially important when you ignored all advice from the shooting section and took only the minimum amount of exposures with standard autobracketing. In most cases this is sparse data without any redundancy that barely captures the full dynamic range. Don't worry. I'm guilty of these shots myself, sometimes even taken handheld and with ridiculously high ISO settings. That's the type of shot where it pays off to scrape every useful bit from the bottom of the barrel. The tricky part is to separate the useful bits from the noisy ones; to scoop off the cream while discarding the dead stock.

In terms of quality, you get the best conversion out of the RAW converter that came with your camera because only the manufacturer really has access to all the file specifications. However, these programs are notoriously cumbersome to work with (I'm looking at you, Capture NX), so most photographers use universal RAW management software to handle the task. That's why the following tutorial demonstrates the flat conversion workflow in Lightroom.

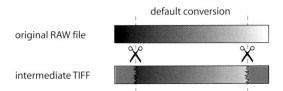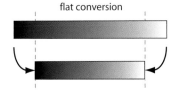

Figure 3-49: *To draw maximum benefit from shooting in RAW we need to preserve the extra highlight and shadow details with a flat conversion.*

If you haven't shot your own brackets yet, follow along with the sample images from the DVD.

1 Browse to a middle exposure in Lightroom. It should show a good range of tones because it will be our representative master for doing all development settings.

2 In the Develop module, set all Basic settings to zero. Most of them already are, you just have to zero out Blacks, Brightness, and Contrast. It's not very obvious, but the numbers in Lightroom's interface are actually editable fields—typing is often faster than finding the slider setting. Anyway, you should instantly see a fair bit of highlight detail reappear that was previously clipped.

3 Set Tone Curve to the Linear preset. Strictly speaking, this really refers to *perceptually linear*. It means Lightroom will apply a pure gamma curve during conversion; it's not really "linear" like the linear color space our HDR image will be in. But it will at least remove the default S curve that has several kinks to add punch to regular conversions.

4 There's also a preset for all of the above. It's buried deep in the default Preset list, called General – Zeroed. Typically, it takes longer to find that preset than configuring these settings by hand.

Figure 3-50: *A closeup inspection reveals how much shadow detail is recovered with these settings.*

Figure 3-51: *Careful now! If all that gets recovered is additional noise, better set the Blacks value back to 5 (or higher).*

Figure 3-52: *Setting white balance with the pipette is not always this easy.*

I know, at first sight it looks like we have just darkened the image down so far that we even lost detail on the dark end. But that is not the case at all. Zoom into the darkest corner and you will notice that we actually reclaimed some detail. This is the bottom of the barrel mentioned earlier; in fact we're getting dangerously close to the limits of the sensor here. This can also backfire. For example, the image with the palm tree was shot at ISO 3200, and here I have gained nothing but additional noise.

5 So the Blacks value is not a blind setting. You really have to inspect the darkest corner up close and decide if it's worth recovering. If you see noise here, raise Blacks again to cut it out.

6 Now it's time to set the white balance. Typically that involves grabbing the pipette and going on a hunt for a gray surface. The small navigator window in the top-left corner will show you a real-time preview as you're rolling over your image, so keep an eye on that. Personally, I often prefer picking up the white balance from a half-shade area. That will anchor all colors to the ambient light and keep some hint of golden sunshine. There is certainly some creative leeway in here, so tune it to taste.

7 If you really want to get white balance spot on, I recommend using a gray card or color checker for this. These have calibrated patches of gray paint on them, so you have a perfectly neutral target to pick. My favorite color guide is the X-Rite Passport because it folds up nicely to fit in a jeans pocket. It also has two very useful rows of slightly off-gray patches, which are specifically designed as color picker targets for tweaking the white balance just a little bit warmer or colder.

So for the very first shot of a shooting session I usually get a shot of my XRite Passport. I just hold it in front of the lens, angled halfway into the main light source, and snap one bracketing sequence as representative for the entire shooting session. Consequently, the middle exposure of that sequence is used to find these master settings.

Figure 3-53: *It's a good habit to shoot a color reference card at least once per session. That will make sure you have a neutral gray patch to pick the white balance from.*

8 Don't crop the image! This would shift the image center and make it harder to automatically align the exposures.

9 Keep all creative color adjustments (HSL tweaks or Split Toning) off for now.

10 Sharpening should be turned off as well. In reality, a tiny amount is okay, but nothing past a value of 15. If anything, you may reclaim some sharpness loss from demosaicing the sensor data. See section 3.1.7 for a schematic of the actual sensor data and the impact it has on true color resolution of a RAW file. The lesson we learned from this is that most color information is made up by interpolation and therefore RAW files are always supposed to be sharpened a bit. However, in an HDR workflow, we consider this RAW development a preliminary processing step, and our real goal is to reconstruct a new über-RAW, so to say. Lightroom simply doesn't have all the information when it looks at individual exposures, and sharpening now can amplify small pixel differences that will confuse our HDR merger and introduce extra noise. Yes, it will indeed look much softer than the default value of 25, but that only goes to show how much of that sharpness was artificially interpolated. We can easily sharpen it later when we have assembled all the pixel data that was actually captured.

11 Noise Reduction is a tricky case. If you took the earlier advice to heart and shot at the lowest possible ISO, there should be barely any noise reduction necessary. But I know how it is in the field; sometimes the situation requires ISO 800 or even higher. Then it's best to get rid of it early on. Especially troublesome is the noise floor that covers up the shadow details in the underexposed images: Too much of it and they will mess up the well-exposed pixel samples from the other exposures. So yes, by all means keep an eye on the darkest areas and use just enough noise reduction as you find necessary.

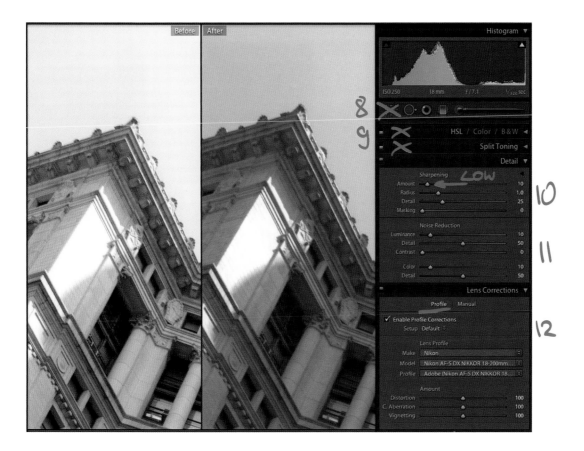

12 Lens Correction is really the important part. Now it's time to ramp up our game! Since version 3.0, Lightroom has a built-in lens database, which used to be the secret behind DxO Optics Pro's superior quality. If your camera/lens combo is in this database, this is your lucky day! Just flip the Enable switch and lens distortion, chromatic aberration, and vignetting are automatically taken care of. Mostly. Sometimes you have to go in manually.

So let's talk about the individual adjustments and see how useful they really are.

12a. Geometric Distortion is the slight barrel or pincushion warp of the lens, most noticeable on building edges and poles shot with wide-angle lenses. Correcting this can sometimes help exposure alignment because it makes the images

perfectly planar. However, finding the correct parameters manually is very hard and barely ever worth the effort. If there are no straight structures in the picture, the effect is usually too subtle to notice. And just like every operation that nudges pixels around, it will slightly soften the image. So this is some sort of personal decision: If you don't notice the effect or don't care about it, leave it off. And if this bracketing series is part of a panorama, you should definitely leave it off and have the stitching program take care of geometric distortion later.

12b. Chromatic Aberration is the color fringing you can sometimes see on high-contrast edges, most visible in the corners and near the image borders. It's caused by the physical phenomenon that different wavelengths of light are refracted slightly differently in the lens. High-quality

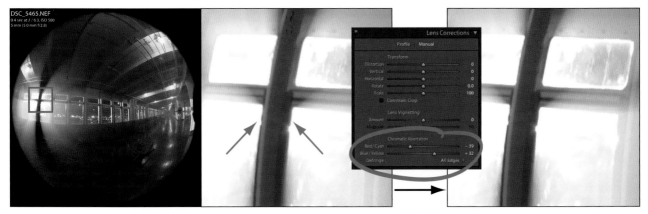

Figure 3-54: *Chromatic aberration is especially pronounced on wide-angle and fisheye lenses. But it's very easy to correct with Lightroom, even if the lens profile is unavailable.*

lenses, like the Canon L series, beat these nasty physics with optical tricks and special coatings. The cheaper a lens and the wider its field of view, the more likely you will run into problems with visible color fringes. These fringes can be purple, green, blue, or yellow, but in any case they are never subtle. It depends on what you're photographing, of course, but fully saturated purple really stands out from most scenes' content. As if this artifact wouldn't be nasty enough by itself, it becomes a real plague in an HDR workflow because tonemappers notoriously confuse these fringes with boost-worthy details and amplify them even further. So, we have to quench the problem right now, at the root.

Thankfully, chromatic aberration is very easy to correct, even manually. Despite the complex optical sources of the problem, for our image it simply means that the red, blue, and green channels have slightly different scales. Really, it's that simple.

Lightroom gives us two sliders that allow microscopic size adjustments of the red and blue channels. Green is always the cleanest of all channels, so that one stays locked and serves as reference. Just zoom into a corner and fiddle with these two adjustment sliders until all channels are perfectly aligned. It will be very obvious when you found the right settings.

Figure 3-55: *In dark scenes Vignetting Correction can be your worst enemy, because it will bring up the noise level in the peripheral image regions. Once that extra noise is carried over into the HDR image, it will give you many headaches during the tonemapping stage.*

14

13

 command+shift
 control+shift

 command+shift
 control+shift

Make sure to set the Defringe option to All Edges so it cleans up pixels that have partially clipped color channels. Defringe should always be on, even when you're using the automatic profile-based correction.

12c. Vignetting Correction brightens up the corners to compensate for radial brightness falloff. This lens flaw is most pronounced in zoom lenses and at longer focal distances. It's very hard to eyeball this correction, so it's extremely useful to have it in a calibrated lens profile. It becomes a lifesaver for stitching gigapixel panoramas shot with longer lenses. But this feature can also go horribly wrong. In low-light situations it will scrape a lot of noise from the lowest end of the luminance scale, and this will fool the HDR merge program into considering this noise as useful pixel values. For night shots, it's often better to leave vignetting compensation alone so the weighting function of your HDR merger can do its job and use the properly exposed pixel values from some longer exposure instead. Even artistically, vignetting often adds character to an image and focuses the eye. I find myself often adding more vignetting later anyway, so there is very little need for this to be corrected now.

In summary, chromatic aberration is really the only lens problem that desperately needs correction. The other two are matters of personal taste and occasional necessity, but they have unwelcome side effects that may outweigh the

benefits. Even when a calibrated lens profile is available, the safest lens correction setting leaves out distortion and vignetting.

13 All settings are configured. Now we have to apply them to all the other images. Hold Command+Shift (Ctrl+Shift on the PC) and select the first and the last image of the stack. Now the entire bracketing sequence should be added to the selection. If you shot a longer session with exactly the same camera settings, you can include them all in this selection. Make sure your master image is still displayed and its thumbnail background is slightly brighter than the other, secondary selections. Otherwise just select the master image again.

14 Click the Sync button and confirm that you really want to sync all settings.

15 Now it gets a little dirty. This last trick is not for the faint of heart, and I would like all serious image engineers to shut their eyes for the next two paragraphs. I'm going to show you a useful hack that can save the day when your exposure sequence was just a little too tight. Like this one.

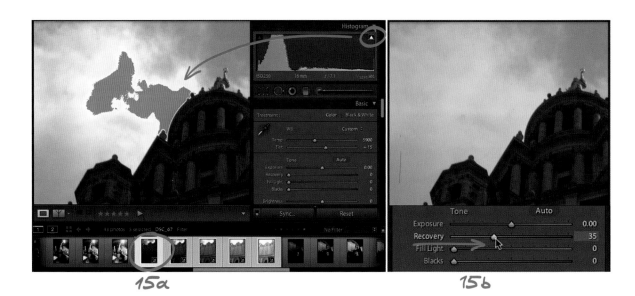

15a

15b

15a. Select the most underexposed image and turn on the highlight clipping preview. That's the tiny triangle in the upper-right corner of the histogram. See that? Some parts of the clouds are still blown out. It's amazing how bright some clouds can get, and that's why I insisted in section 3.2.1 on shooting extra-wide bracketing sequences. But you wouldn't listen! Well, in this case it was me, and yes, it does happen all the time. Clouds are nasty buggers and hard to evaluate.

15b. Go back to the basic settings and use the recovery slider until all the red patches are gone. Here it takes a setting of about 35, but miraculously there is still enough headroom in this RAW file that some cloud detail comes back. This stunt may work only in 14-bit RAWs, and it often fails when the object to be recovered is not gray to begin with. For example, if you try that on a blue sky, it is likely to turn into a gray mush or some horrible shade of cyan or pink because individual channels are hopelessly lost to the clipping demons. But clouds seem to work.

This is really just a trick for emergencies. If nothing blinks red in the highlight clipping preview, you're fine. Do not sync this recovery setting to the other images; this trick is too dirty and would only distort the tonal gradients. Also, don't even think about attempting the opposite with the shadow end. Fill light on the most overexposed image will only boost noise and not bring you any joy.

16 But now we're really done. Export all images as 16-bit TIFF files to a temporary folder. Make sure to keep the metadata intact. Use the sRGB color space if you're keen on a what-you-see-is-what-you-get workflow and you plan on

16

Chapter 3: Capturing HDR Images

using a color-space-agnostic HDR utility (like Photomatix or Picturenaut or any other that scores less than three points for color management in section 2.4). This export will take a while. Coffee break, yay!

17 Alternatively, this is the right time to use one of the Lightroom HDR plug-ins. They literally have the exact same effect as the Export button. Lightroom will process all images with the current settings to some secret place on your hard drive and then hand them directly over to Photomatix, Hydra, HDR Express, and whatnot. ◂

Of course, you can also use any other RAW processor. Just remember the basic premise: We want a flat conversion, where only sensor-related artifacts are fixed but the image is not yet prettified in any way. After all, that's what we have the HDR tools for. At this stage of the workflow we're just preparing the RAW data for them, harvesting as much data as possible.

You're doing yourself a big favor in deleting all these temporary TIFF files afterward. They're easily reexported from the originals, so they are completely redundant and wastefully bloated. If you keep all temporary files, you could easily end up spending 1 GB on a single HDR image. Believe me, there are more keep-worthy work files coming up during the post-processing workflow; this is still pre-processing.

Phew... that was a pretty elaborate description of all the gritty details of RAW pre-processing. Here's a quick recap for reference:

> **CHEAT SLIP**
> **Flat RAW conversion in Lightroom 3**
>
> - Pick a good representative exposure, ideally one with a gray card or color checker.
> - Set Black, Brightness, and Contrast to 0.
> - Set Tone Curve to Linear.
> - If necessary, adjust Black to clip out noise.
> - Set the white balance.
> - Use low Sharpening and as much Noise Reduction as necessary.
> - Enable Lens Correction by Profile.
> - Decide if you really need to correct Geometric Distortion and Vignetting.
> - If necessary, fine-tune Chromatic Aberration by hand.
> - Defringe all edges (on the Manual tab).
> - Sync all settings to all other images.
> - If necessary, use Recovery on the most underexposed image.
> - Export 16-bit TIFFs to a temp folder or launch your favorite HDR plug-in.

Lightroom 4 Update

The first beta version of Lightroom 4 surfaced just after I finished writing this tutorial. As much as I've always wanted to rush into an editorial office yelling "Stop the presses!" there seems to be very little need for that. The major points of this tutorial are still valid. The goal is still a flat conversion, and all the hints for evaluating and maximizing the dynamic range extracted from each source image still apply. A few things are different, though. Some buttons now have different names and some require different settings.

First of all, the default settings are much better now. Tone Curve is already set to Linear, and Adobe's 2012 processing engine takes much better care of protecting highlight and shadow details. All the important processing settings are already set to zero—or so it seems!

Well, not quite. What really happened is that Adobe recalibrated the slider ranges. The odd default values from Lightroom 3 have become the new zero. And our beloved flat conversion is no longer achieved by setting everything to zero, but to something odd instead. In particular, the Exposure value must be –1 EV and the Contrast value –40. Sounds weird, but that's the best equivalent of what were the zero settings before. I ran a whole lot of tests, on multiple bracketing sets, and found that this combo always results in HDR images with 1.5 to 1.8 EVs more dynamic range.

So, here is the fast-forward version of the optimum steps:

> **CHEAT SLIP**
> **Flat RAW conversion in Lightroom 4**
>
> ◉ Select the best (middle) exposure.
> ◉ Set Exposure to –1 EV and Contrast to –40.
> ◉ Set the white balance.
> ◉ Use low Sharpening and as much Noise Reduction as necessary.
> ◉ Enable Lens Correction by Profile only if you really need to correct geometric distortion or vignetting.
> ◉ Remove Chromatic Aberration should always be enabled. It's now just a single checkbox—it's no longer based on camera profiles, and there is no hand crank anymore.
> ◉ Sync all settings to all other images.
> ◉ Export 16-bit TIFFs or launch your favorite HDR plug-in.

And that's really it. All other settings should be left at default. There's no longer a need to pull dirty tricks with highlight recovery because Lightroom 4 now has these dirty tricks built right into the core processing engine. No matter what your settings are, it will always try to avoid clipped highlights. Of course, you can find a preset with these settings on the DVD.

Figure 3-56: *Lightroom 4 processing settings for a flat conversion*

Figure 3-57: *Remove Chromatic Aberration is now fully automatic and should always be enabled.*

Let's move on. All we did so far was the job of in-camera firmware. But better, much better, because we invested quite a bit more horse-power and care. Next we will have a closer look at the actual HDR merging process.

3.2.5 Merging to HDRI

You might be wondering, what's all the fuss? Can we finally make some HDR images?

Sure thing! By now you should be the proud owner of a set of expertly shot JPEG exposures or TIFF files carefully extracted from RAW images. Otherwise, you will find plenty of example sets on the DVD, so feel free to move right along.

Merging exposures to a 32-bit HDR file is really the easy part.

Nowadays the process is very automated. It always follows the same procedure: Select your exposures, confirm a few options, and click OK. Each software program differs in the amount of available options, and that's why I emphasized them in the software reviews in section 2.3. You won't need most options if everything was shot according to standard protocol (wide exposure range, rock-solid tripod, remote release, non-moving target). But real-life photo shoots barely ever go that smoothly, and that's when customization options do become important. We will go over them in a minute, but first let me show you what the actual workflow looks like in a few programs.

Picturenaut (free, included on the DVD) is a good example of software with a balanced amount of manual and automatic options. According to modern standards, it automatically detects the exposure information and sorts all source images correspondingly. But you can also edit the exposure values by simply typing in the list. That comes in handy when you use neutral density (ND) filters to capture some of the images under extremely bright conditions, work with scanned film slides, or have extracted some additional exposures from the far

*Figure 3-58: **Picturenaut** allows generating HDRIs with a balanced mixture of automatic and manual controls.*

ends of a RAW file. Not that the latter would be recommended or even necessary (as you will learn in section 3.2.9), but at least Picturenaut does not stop you from performing your own crazy experiments. Other programs that let you manually change the exposure information are Hydra, PhotoEngine, FDRTools, and Dynamic Photo-HDR.

If you want a smooth-sailing workflow, you will love how **Photomatix** makes it really easy. The interface is completely self-explanatory and offers guidance through each step. Just make sure to keep Show Intermediary 32-Bit HDR Image checked because that is exactly what we're after. Photomatix keeps several technical details behind the curtain, but the functions it offers are very sophisticated and have evolved to answer common shooting problems. It's also very selective about the options presented—when merging RAW images it will ask you more

Figure 3-59:
Photomatix gives you only the options you really need and presents them in a self-explanatory workflow.

Figure 3-60:
Photosphere lets you conveniently select the source images by thumbnails.

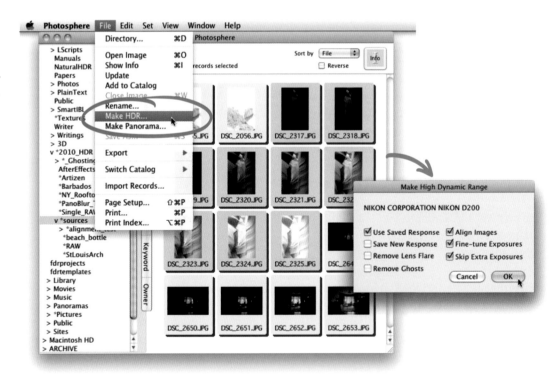

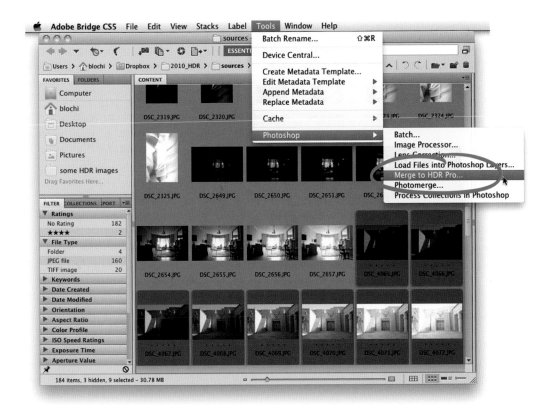

Figure 3-61:
Adobe Bridge offers similar thumbnail-based selection, but for HDR generation it needs big brother Photoshop. Same goes for Lightroom.

questions (see 3.2.4). When the EXIF data is missing, it will make a best guess and then give you a chance for corrections. HDR Efex and HDR Express/Expose have a similar fallback to ask for missing exposure information, but they won't let you override existing EXIF data. When you prefer to select images visually in a thumbnail browser, you can also just drag and drop your exposure sequence into Photomatix or use the Lightroom integration plug-in.

Photosphere, being a free thumbnail browser itself, makes this part even more convenient. Here you just select the source images and start the HDR generation from the File menu.

Visual thumbnail selection turns out to be most convenient; that's why Lightroom and Adobe Bridge have adopted this concept. The workflow is pretty much the same in both programs: Select the source thumbnails first

and call the Merge function from the TOOLS ▸ PHOTOSHOP menu (in Lightroom it's PHOTO ▸ EDIT IN). Both programs can't really do this task on their own; they hand the actual workload off to Photoshop.

In **Photoshop,** you will see a script load all images, stack them up in layers, and automatically align them. All steps are carried out in plain sight; it looks like a poltergeist taking control of your Photoshop. A little while later Photoshop's merging preview dialog comes up (see next page). At this point all the preparation is done, but the HDR image itself is not made yet.

First and foremost, you need to set Mode to 32-bit in this merging preview dialog. For some twisted reason Photoshop CS5 defaults to 16-bit mode and tries to bully you into tone-mapping the image right away. It's a popular delusion that collapsing HDR generation and

tonemapping into a single step would somehow offer an advantage. Nothing could be further from the truth. We want to create a 32-bit HDR image, thank you very much.

Notice the red tick marks on the bottom of the histogram. Each tick represents one exposure value. Only about five or six will be visible on-screen at a time; which ones they are can be set with the exposure slider underneath. Slide it up and down to inspect the dynamic range coverage. At each slider setting the preview image should look just like the respective source photo. If you notice odd banding artifacts or unnatural edges in areas where you would expect a smooth color gradient, this is a hint at a faulty response curve. As discussed in section 3.2.3, a pre-calibrated response curve can deliver more accurate results—if that curve is derived from a properly shot calibration sequence. Adobe doesn't really trust you with this, so it tucked away the response curve options behind a microscopic icon on the edge of the window. If the current bracket happens to be your calibration

sequence, this hidden menu lets you save a response curve for later use.

Also notice the green check marks below each thumbnail. You can uncheck these to exclude individual images from contributing to the merged result. Begs the question, why would you want to do that? Isn't more always better?

Less or more? Crisp or smooth?

Okay, let's see what really happens under the hood. On the next page you can see a schematic overview of the merging process with a typical bracketed sequence in 2 EV intervals.

What this chart demonstrates very clearly is that each pixel in the final images represents an average, derived from multiple exposures. Blending them together has good and bad effects. It smoothes out noise and cleans up soft gradients. But it also tends to soften fine details, especially if the images are slightly misaligned. This particular example image was shot on a monopod—the tripod alternative for people

who don't enjoy exchanging arguments with security personnel—so we're looking at the blend after the exposures were automatically aligned. Even if you use a tripod, there is always a micro-shift between images that may even be smaller than a pixel. The more images you blend together, the least obvious such minor flaws will be.

Admittedly, the difference is small. Look closely at the eye of the Pharaoh and the lines in the brickwork. The blend of all nine images is slightly softer, and it's evenly soft all across the image. Using only five input images results in crisper lines on the brickwork but also reveals a slight misalignment on the eye and renders a sharp edge where there shouldn't be any sharp edge.

Personally, I prefer the consistent smoothness of the nine-image blend and would rather sharpen the image later. But if crispy detail is your major concern, you'd probably want to use fewer input images. Specifically, you'd want to hunt down the misaligned images and exclude them explicitly. With handheld bracketing, it's also common that the longest exposure has some amount of motion blur, which will significantly mush up the blending result. It pays off to cycle through your source images beforehand in 1:1 pixel zoom to catch those jerky exposures and flag them for exclusion.

Weighting: Trim the fat!

The schematic overview reveals another problem. See how some histograms are all stacked up on the side? That indicates that a few pixels are clipped to pure white in some of the exposures. Obviously, you can't take those white pixels into account when calculating the average; they would just water down the fine color reading you get from a middle exposure. Same goes for pitch-black pixels; they are not a reliable source of information at all. So, black and white pixels in the source images are never taken into account.

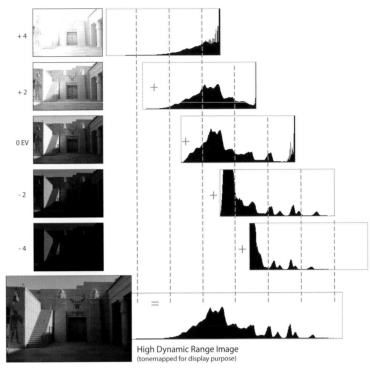

High Dynamic Range Image
(tonemapped for display purpose)

Figure 3-63: *A schematic overview of the merging process reveals how each pixel in the HDR image is born from averaging the well-exposed pixels from the source images.*

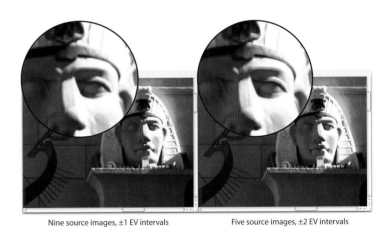

Nine source images, ±1 EV intervals Five source images, ±2 EV intervals

Figure 3-64: *More input images result in a softer and smoother HDR image.*

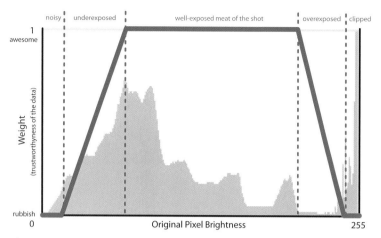

noisy | underexposed | well-exposed meat of the shot | overexposed | clipped

Weight (trustworthyness of the data)

1 awesome

rubbish
0

Original Pixel Brightness 255

Figure 3-65: *A weighting function ensures that only trustworthy pixels are allowed to contribute to the blended result.*

If the HDR merge software puts too much weight on dark pixels and your camera isn't all that awesome, a lot of noise may be carried over into the HDR image. But if it puts too *little* weight on dark pixels, it may not actually harvest the full dynamic range from all the source images. That's where each program has its own way of judging pixel reliability. They all have a weighting function under the hood, even if there is no indication of it in the cockpit.

Frankly, I'm not even sure why I'm showing you all this. It's not like you had much influence over pixel weighting. Most HDR programs are hardwired with a weighting function of their choice, which often depends on what camera the programmer happens to own. Some make a big secret out of their weighting approach, so we can only speculate what software uses what. HDR Efex seems to apply a Hat function with very steep cutoffs, which works great as long as the images aren't too noisy. Hydra appears to use a modified Triangle function, where the tip is skewed to the right. That means it builds the HDR image primarily from pixels that appear in the third quarter of the histogram. And Photomatix seems to apply a complex function with a Gaussian falloff in the shadows but steep hatlike cutoff in the highlights. Again, these are just my wild guesses, purely based on observation.

Only a few programs have a user-adjustable weighting setting. Picturenaut, Luminance HDR, and Dynamic Photo-HDR give you the choice of two or three presets. In addition, Dynamic Photo-HDR lets you experiment with custom shaped weighting functions. The most

Figure 3-66:

Every HDR software program has one of these weighting functions inside. Very few programs let you customize this.

But what about the pixels that are *almost* black and *almost* white? Well, it depends. Shadows are notoriously noisy, and there is no guarantee that a very bright pixel isn't clipped in a single color channel. It's not just a take-it-or-leave-it decision. Instead, the reliability of a pixel value is gradually falling off. That's where each pixel gets assigned a weight value that describes how trustworthy it is. The meat of each shot consists of the middle tones, somewhere around the center of the histogram, extending to the right. Those pixel values we can trust for sure, and those should contribute the most to the blended result. How quickly the quality drops from there depends on the noise profile of your camera sensor, its overall built quality, and even your ISO settings. And the quality of the finished HDR image heavily relies on the merging software's ability to assume the appropriate weight for each pixel reading.

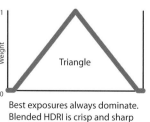

Weight

Triangle

Best exposures always dominate. Blended HDRI is crisp and sharp with the least noise carried over.

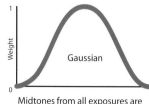

Weight

Gaussian

Midtones from all exposures are blended together. Noise and small irregularities are averaged out.

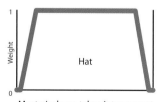

Weight

Hat

Most pixels are taken into account, extreme shadows and highlights are well covered, but noise as well.

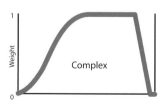

Weight

Complex

Some HDR programs use complex functions for balancing dynamic range coverage versus noise.

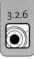

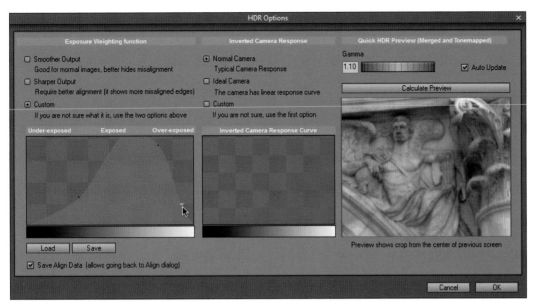

Figure 3-67: *Dynamic Photo-HDR offers extensive HDR merging options, where you can draw your own weighting function.*

extensive user controls are in FDRTools, down to the atomic level where you can specify a different weighting curve for each source image (see 2.3.10 for a screen shot).

The software differences diminish when you give a program enough exposures to work with. That way, you make sure each pixel is represented at least once in the middle tones—the sweet spot that we can all agree upon to have the best quality and that is preferred in every weighting scheme. Coming back to my merging overview, technically the three middle images would already cover the entire range of the scene. But then there wouldn't be any averaging happening on both extreme ends, and the HDR software would have to rely on marginal pixel data that is considered less trustworthy. By purposely overshooting the dynamic range, you can get a cleaner result, with noise-free shadow detail and no color clipping in the highlights. And by using more exposures in between, you can average out noise and minor misalignments.

3.2.6 Alignment Strategies

There are two fundamentally different algorithms for automatic exposure alignment: median threshold bitmap (MTB) matching and a pattern recognition logic. Both have their weaknesses and strengths that become very obvious when we take a peek behind the curtain.

Median threshold bitmap matching

The MTB method made its first appearance in Photosphere and is nowadays used in most HDR utilities. It's a pretty robust algorithm that can compensate for a wide range of exposure changes. It's very fast and preserves sharpness best, but it quickly gets to its limits when the images need to be rotated to match them up, and it can't deal with perspective distortion (i.e., wide-angle lenses) at all.

Let's use a fresh set of example pictures and see how MTB alignment works!

Figure 3-68:
A peek behind the curtain, showing the inner working of the MTB alignment algorithm.

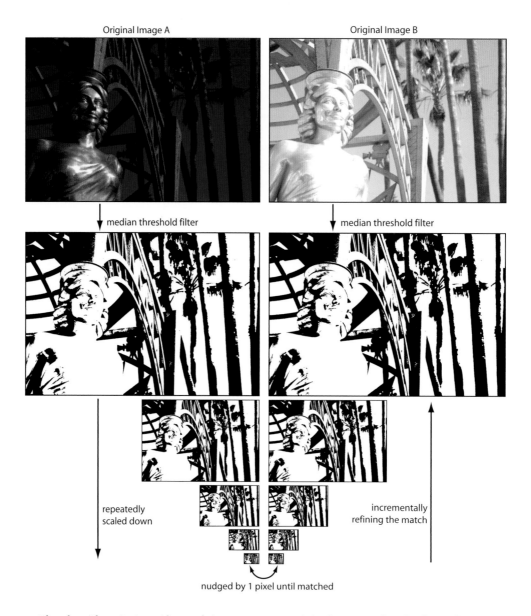

Original Image A Original Image B

median threshold filter median threshold filter

repeatedly scaled down incrementally refining the match

nudged by 1 pixel until matched

The algorithm starts out by applying a median threshold filter to neighboring exposures. The result is a pure black-and-white bitmap of each image. These get repeatedly scaled down to half their size, forming a pyramid of incrementally smaller resolution.

Then it looks at the smallest zoom level, nudges the images 1 pixel in each direction, and checks each time to see if they match. This 1-pixel nudge correlates to 32 pixels in the original image. When both small images are identical, it remembers the current pixel nudge and sets it as the starting point for the image pair one step up in resolution. Those are now nudged again 1 pixel each direction until they match up. This way the algorithm works its way up the entire image pyramid, incrementally fine-tuning the pixel nudging distance. And by the end, we have two perfectly matched images in original size.

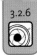

This algorithm works great, as a side-by-side comparison of the resulting HDR image shows. And it really is fully automatic!

The magic lies in the very first step. You might be wondering, what is that mysterious filter that makes these two different exposures appear the same in the first place? Well, it's simple; you can even do it yourself in Photoshop. Just for demonstration purpose, here is a mini-tutorial.

Figure 3-69: *Comparing the resulting HDR image without alignment (HDR Shop, left) with the MTB alignment (Photosphere, right).*

➤ Median Threshold filter by hand

1 First expand the histogram view to show the statistics info. This option is somewhat hidden behind a microscopic icon in the top-right corner of the histogram pane.

2 Your histogram should now be bigger and display several obscure numbers underneath. This is where you find the median value.

3 Now punch that median value into the Threshold filter, which can be found under IMAGE ▸ ADJUSTMENTS ▸ THRESHOLD.

4 And believe it or not, doing these steps for both images will result in identical bitmaps. Greg Ward figured it out, apparently inspired by this party joke where you think of a two-digit number, double it, subtract 15, multiply by 3, and all of a sudden your inquiring buddies know your age. Something like that. ◄

1 Expand histogram view

2 Find the median value

3 Run a Threshold filter with that median value

Figure 3-70: *Manual simulation of the median threshold bitmap generation*

So now you know the magic behind the Auto-Align Exposures button. It's really just a trick, followed by trial and error. In FDRTools, Nik HDR Efex, HDR Express/Expose, SNS-HDR, and PhotoEngine, this is literally what happens when you enable that check box. Photosphere, Picturenaut and Fhotoroom perform an additional rotational check during the pixel nudging stage, which sometimes returns a better match, sometimes just throws it off. That's why section 3.2.2 stresses the importance of stabilizing camera tilt when shooting your exposures. Rotation alignment is simply a tacked-on solution; it's not part of the elegant original MTB algorithm and not every software supports it. And even when rotation alignment is successful, it requires image resampling, which causes a slight loss in sharpness.

Because the general method is very similar in all these programs, they all fail the same way. On very dark images the median threshold filter trick falls apart. When the median value drops somewhere below 10, the threshold bitmaps are not identical anymore. In extreme cases, when more than half of the image is completely black, it has a median value of zero.

That's not even a real number. You can't run a threshold filter with that, therefore the MTB alignment method is destined to fail for extreme exposures.

About this little peek behind the scenes, you should remember this: As long as your images are not too dark and don't need to be rotated, you have a pretty good chance of getting automatic alignment to work with any program. When it fails, this is most certainly the fault of the darkest image, and in the final HDR image your highlights will be out of place. So make sure you carefully inspect your HDR image for misalignments!

Manual corrections

Some programs offer manual corrections that can become extremely useful when the automatic alignment fails. Namely, this manual mode can be found in FDRTools, Fhotoroom, Hydra, and Dynamic Photo-HDR. They all have more or less elaborate user interfaces for this mode.

You're probably thinking, "Bah, who needs that—if I want manual alignment I can just do that with layers in Photoshop." Well, be my

Figure 3-72: *Dynamic Photo-HDR sports a very nice user interface for manual alignment corrections.*

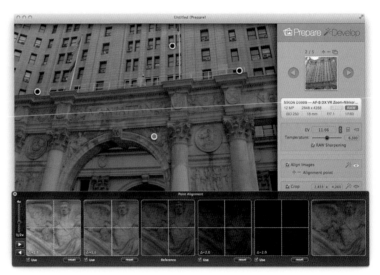

Figure 3-73: *Hydra uses control points for alignment and allows manual corrections with sub-pixel accuracy.*

guest and give it a try! When you're done shuffling layer transparencies and fighting with Photoshop's clumsy rotation tools, you will realize that this is a terribly confusing task and you will appreciate all the support you can get. A dedicated interface, like that in Dynamic Photo-HDR, is streamlined for this and takes out most of the pain. It allows you to quickly switch through the exposures in pairs and identify the misaligned offender by isolating its influence on the result. With a difference blend viewer (Hydra calls it X-Ray) it becomes very obvious how far the alignment is off. You can then move and rotate the image in microscopic steps until you have a perfect match.

Yes, it's still a bit tedious. Manual exposure alignment is rather the exception than the norm. It's a last resort that enables you to solve the trickiest merges yourself. Hydra and Dynamic Photo-HDR can also export the pre-aligned exposures, in case you'd rather merge your HDR image elsewhere. So they are sure to blend into your regular workflow.

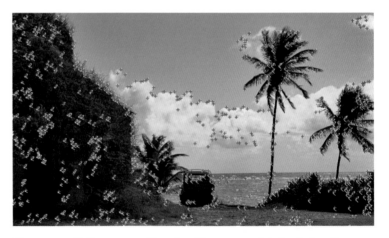

Figure 3-74: *Pattern recognition algorithms see a point cloud when they align your exposures. If you look closely, you can see tiny paths tracing the motion of my shaky hand holding the camera.*

Pattern recognition

The more sophisticated strategy to automatic alignment is pattern recognition.

This algorithm crawls through the image, uses military-grade voodoo to find distinct edges and corners, and marks them with a control point. When it has done that for all images, it compares the dot patterns formed by the control points and matches them up. This is really

all the explanation I can give you; it sounds simple on the surface but relies on a scary amount of math and formulas. Pattern recognition can compensate for huge image shifts in translation, rotation, and even distortion.

The pitfall is that this algorithm can get confused by repeating textures (like tiled floors) and large-scale motion (like moving clouds), and in rare cases it tries to align the wrong things. It also takes a bit longer to calculate, and the pixels get necessarily smudged up slightly when dragged halfway across the canvas. So you are certain to lose a bit of sharpness. But with today's pixel counts that isn't really a problem, and nevertheless the alignment result is typically very accurate.

Hydra, Photomatix, and Photoshop use this method. It is in fact the very same Auto-Align Layers function that is found in Photoshop's Edit menu. The algorithm is sort of a stepchild of panorama-stitching algorithms, hence full-time pano stitchers like PTGui, Autopano, and Hugin turn out to be excellent tools for HDR alignment as well. The Hugin module for image alignment is actually a standalone program, and makes a guest appearance in Luminance HDR and a handful other open-source programs.

Figure 3-75: *Photomatix offers both auto-align strategies. Feature matching is the more powerful option.*

➤ Prealigning exposures in Photoshop

Photoshop's pattern recognition method is clearly the most sophisticated one. If your everyday HDR utility throws up its arms and walks away whistling, chances are Photoshop will still deliver a perfect automatic match. So here comes a useful trick that allows you to use Photoshop for exposure alignment but still perform the actual merging process in your favorite HDR tool. It's a very straightforward workflow.

1 Select your exposures in Lightroom.

2 Right-click one of the exposures and choose EDIT IN ▸ OPEN AS LAYERS IN PHOTOSHOP. It will take a while to load all of the exposures, but you don't have to do a thing. It's a convenient back door that comes in handy on many occasions.

In Bridge you can achieve the same with TOOLS ▸ PHOTOSHOP ▸ LOAD FILES INTO PHOTOSHOP LAYERS.

Alternatively, from within Photoshop itself, choose FILE ▸ SCRIPTS ▸ LOAD FILES INTO STACK.

3 Select all layers and choose EDIT ▸ AUTO-ALIGN LAYERS.

4 Wait. You have enough time to enroll in an online college and graduate.

5 Since all layers were shifted against each other, you will see some transparent borders now. So you have to crop the image. Zoom into each corner and cycle through the layers to really crop away everything with only partial information.

6 Now select FILE ▸ SCRIPTS ▸ EXPORT LAYERS TO FILES.

7 A dialog with options will appear. Choose the same file format as your original images and click Run. ◂

Figure 3-76:
Automatic ghost removal can easily deal with chaotic patterns. Different programs give different but equally pleasing results.

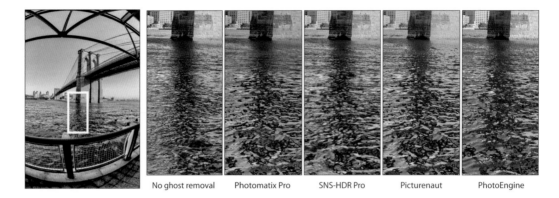

No ghost removal Photomatix Pro SNS-HDR Pro Picturenaut PhotoEngine

You're now left with a prealigned exposure sequence, ready to be merged to HDR. Sadly, all exposure data was lost in this shuffle. That's when it becomes critical that your HDR utility lets you specify the exposure offset manually. Most do, even if it's not that obvious. For example, Photomatix and HDR Efex will jump into emergency mode and present a requester you probably didn't even know is there.

Wrapping up

Every bracketing sequence can be aligned.

Your first line of defense is to minimize camera rotation during shooting, which instantly raises the success rate for auto-alignment in every HDR program. But if it fails, all hope is not lost. Pattern recognition in Photomatix, Hydra, and Photoshop are still very likely to work just

fine. The latter two can be used to prealign your bracketing sequence and then go on with your standard procedure. In the rare case no automatic solution will do, Dynamic Photo-HDR and Hydra offer great tools for manual alignment. It's a bit of work, but not overly tedious.

So there you go: Handheld bracketing is indeed a viable option. Nowadays you can align everything no matter what.

3.2.7 Ghostbusters!

Sometimes you have to face the evil side of exposure bracketing: ghosts. Even if you try everything to avoid it, every once in a while things just move and spoil an otherwise perfect set of exposures. Then you know it's time to bring out the Proton Packs ... excuse me, ghost removal algorithms.

Figure 3-77:
High-contrast details and multilayered motions are tricky cases for automatic ghost removal. Sadly, these are also very common cases and the artifacts are very obvious.

No ghost removal Photomatix Pro auto/strong Photomatix Pro selective Photoshop CS5 auto/hero pick

Most programs now have an option to remove ghosts during the HDR merging process. However tempting, you should not get into the habit of leaving it checked "just in case." That's because this option will tell a program to use as little information from as few source images as possible. It will operate under the assumption that blending pixel values from different exposures is a bad thing. Instead, it will try to establish a single exposure as the dominant source of information and use the rest of the exposures as supplemental sources only. The result is more noise and less color fidelity, most noticeable in the extreme ends of the dynamic range. For that reason, ghost removal should be used only when an exorcism is really necessary.

There are two major types ghost-related problems to distinguish. One is a *general haunting*, the other is *distinct phantoms*. Both can be defeated but require slightly different measures.

General haunting occurs when the wind moves some twigs, leaves, grass, or water waves. These elements typically make up large uniform areas, rustling around and moving in chaotic patterns. Without ghost removal, the merged result looks like motion blur. If the motion is very fast in relation to your shooting rate, the pattern may change so much that a straight merge turns into smudgy pixel mush.

This is the least problematic ghost type because it doesn't really matter which of the source images becomes the dominant provider of pixel information. Fully automatic ghost removal can work this out just fine. The results from different programs are not identical though. Most notably, they tend to pick different hero exposures. If there are multiple haunted areas — for example, moving clouds *and* moving water — they may even use different hero images for each area and patch them together into an HDR.

Each program has its own secret ghostbuster algorithm. Differences between the programs are how well they can detect motion, how well they can remove the unwanted parts from the side exposures, and how much information they still use from the non-ghosted areas. Failure in any of these tasks will introduce artifacts, which can be even more offensive than leaving ghost removal off all together. Here are some typical artifacts:

- Semitransparent residual ghosts. (It couldn't find them all.)
- Duplicates and chopped-off bits. (It didn't clean up properly.)
- Clipped highlights and shadows. (It picked the wrong hero image.)

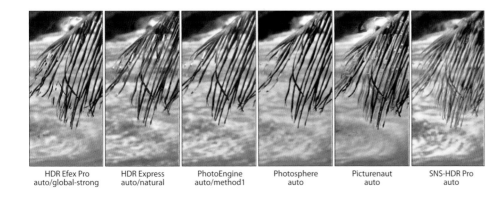

| HDR Efex Pro auto/global-strong | HDR Express auto/natural | PhotoEngine auto/method1 | Photosphere auto | Picturenaut auto | SNS-HDR Pro auto |

Some programs have a setting for strength, which refers to a more or less aggressive cleanup strategy. These settings never cause a dramatic improvement. Instead, it's much better to have a selection of different programs at hand because the next program will attack the ghosts with a completely different algorithm. Another strategy is to omit some of the in-between exposures beforehand because that can force a stubborn algorithm to make at least coherent choices about optimum patches, leaving less to clean up afterward. Figure 3-77 gives you a taste of these artifacts.

Waves are easy. The real challenge involves high-contrast details and overlapping motions. For example, dark palm leafs rustling in front of white surf waves are extremely difficult because the reconstruction algorithm will unlikely find a single hero image that shows the questionable area completely unclipped. This problem is much too common; it comes up every time we have trees with fiddly greens silhouetted against the sky. To make things worse, these high-contrast details attract the eye, which makes any artifacts in these areas unpleasantly obvious.

Confronted with such a hardcore case, automatic algorithms quickly run out of stream. PhotoEngine, Photosphere, and Photoshop CS5 seem to hold out the longest. The latter two actually use the same algorithm. Yup, it's from Greg Ward again—the Gyro Gearloose of HDR was Adobe's go-to guy for the new ghost removal in CS5. From the usability standpoint, Photoshop also has the advantage of letting you choose the hero image yourself, and that alone makes the result much more predictable.

Here is how it works.

➦ Photoshop's guided ghost removal

After you load your exposures, the merging preview comes up.

1 Enable the Ghost Removal check box.

2 Now one of the source thumbnails is marked with a green frame. This is your hero image. You have to look very closely because it's a very thin outline. In most cases Photoshop has chosen a middle exposure, but that may not necessarily be the best choice.

3 Click a different thumbnail to promote it as the new hero image. Use the exposure slider below the histogram to observe the effect on the overall dynamic range. If your chosen image is too bright, there won't be enough highlight information extracted, turning the bright end of the merged HDR into flat gray splotches.

4 If your hero image is too dark, the darkest shadows are likely to flatten out.

5 When you find a compromise, double-click the exposure preview slider to reset it to zero. Then confirm with OK.

This global hero-pick method is unique to Photoshop CS5. It's a very rudimentary way to have some influence on the outcome, but it can already clean out 90 percent of all hauntings in clouds, bushes, and rustling trees. ➦

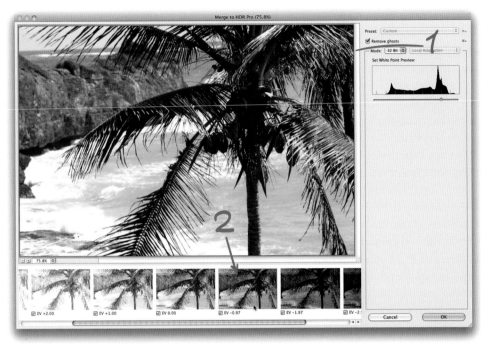

Figure 3-78:
Photoshop's guided
ghost removal: Once
enabled, the hero image
is marked with a green
outline.

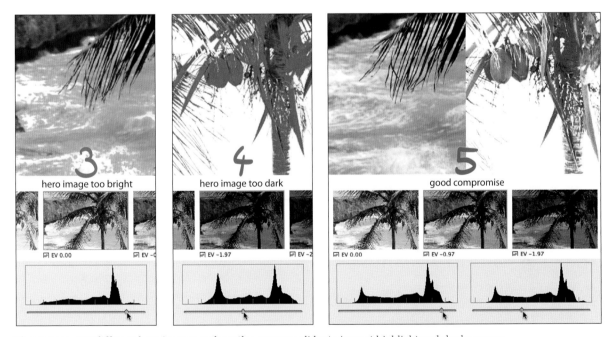

Figure 3-79: *Try different hero images and use the exposure slider to inspect highlight and shadow areas.*
Settle with the best compromise.

Distinct phantoms are the second kind of ghostly nuisance. They are caused by people or cars moving across your shot. Phantoms are not that easy to resolve by automation. Especially difficult is the notorious case of a guy with white shirt and black pants who seems to mysteriously show up wherever I shoot an HDR image, breaking every automatic algorithm. Same goes for shiny cars; there simply is no single hero exposure that shows the highlight on the windshield and the dark tires both un-clipped. More than likely the algorithm will make wrong choices about localized hero ex-posures and you will end up with free-floating limbs or headless bodies. So you have the choice between zombies or phantoms. Persistent cases like these require manual intervention.

See, here's the thing with fully automatic ghost removal: Unless it works flawlessly all the time, it's no good. You can compare it to the old dream of autopiloted cars. You wouldn't want to sit in one that gets you to the destination 90 percent of the time. It's just not safe. And un-til we have a robo-car that takes every possible combination of unfortunate events into consid-eration, you're better off steering yourself. Some level of computer assistance is appreciated, like traction control and collision warning, but ultimately you're the pilot and you make the judgments. Same goes for ghost removal. User-guided selective ghost removal is the hottest trend right now, and it's the best way to ensure great results all the time. That's why Photo-matix, Hydra, Dynamic Photo-HDR, Fhotoroom, and (to some extent) FDRTools have a special mode for that. Out of that bunch I recommend Photomatix for ease of use, paired with just the right amount of computer assistance.

So here comes another practical tutorial. As usual, you're encouraged to follow along with the images from the DVD.

➤ Photomatix's selective ghost removal

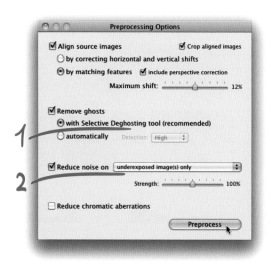

1 After loading the image, choose the Selective Deghosting tool in the Preprocessing Options dialog.

2 Also check Reduce Noise on Underexposed Image(s) Only. We might need it because this particular sequence was shot handheld with ISO 320.

3 A new interface appears that is actually very self-explanatory. Bring up the brightness slider to reveal the mess on the street.

4 Inside the big viewport, your mouse pointer is in fact a lasso selection tool now. Draw a loose outline around the ghosted area. Make sure to encompass all faint occurrences. For example, here I'm tagging the entire crosswalk area, in-cluding the cab and all pedestrians.

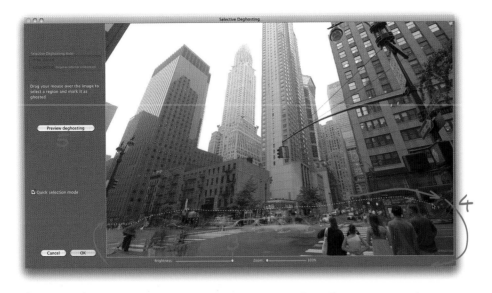

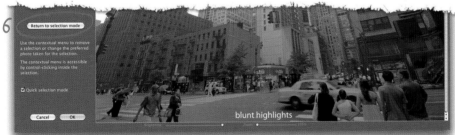

blunt highlights

5 Click the Preview Deghosting button. That will kick the automatic algorithm into gear, which will refine the selection, clean up the side exposures, and blend an HDR image together.

6 Nice, eh? If you look closely, you'll see that the cab lost its sparkle; the highlights are slightly washed out now. No problem, we can change this. During preview mode, the viewport is locked though, so return to selection mode for further tweaking.

7 Right-click inside the selected area to choose a different hero image. In this example, the cab even seems to be in a nicer position in the −1 EV photo. How convenient! As with Photoshop's global hero pick, a compromise has to be made between preserving highlight detail or shadow detail. But the advantage is that we don't have to

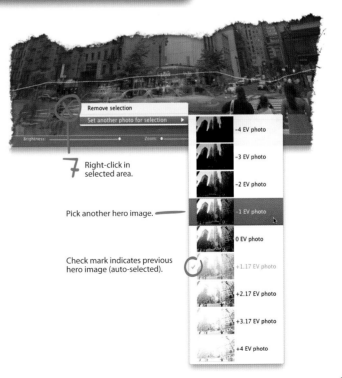

Right-click in selected area.

Pick another hero image.

Check mark indicates previous hero image (auto-selected).

make that decision for the whole image. In contained areas, such a compromise is much easier to find and gives some leeway to creative decisions like these.

8 Switching back to preview mode confirms that this is a nicer composition. The deeper blacks hint at the fact that we sacrificed some of the shadow detail, but that's why we turned on noise reduction.

9 Let's do the same for the tree on the right. Select the area, pick a hero exposure, preview.

10 When you're pleased with the preview, click OK.

That's basically it. You repeat the drill for each ghosted area, constantly toggling between selection mode and preview mode. If you constrain your selections to areas of even light levels, it's much easier to find an appropriate hero image. With some practice you will intuitively know where to partition the image. Selected areas can touch each other but shouldn't overlap. Avoid crossing large uniform areas with your lasso, such as, for example, blue skies or flat walls. Photomatix will do some blending magic, but the seams are better hidden when you loosely follow around feature lines in the image, as we did with the awnings of the storefronts here.

Admittedly, it is a bit more work, and you may want to try some fully automatic solution first. But it will get the job done for sure, and the result is much more controlled. Hydra and Dynamic Photo-HDR use a more convenient selection brush instead of the old lasso, otherwise the concept is similar: Instead of algorithmic guesswork, you pick out the ghosts and nominate the hero exposures yourself. For this selective workflow it pays to have more in-between images because it gives you more choices from which to pick hero images for composition reasons. And since the deghosted areas end up showing only patches from individual exposures, RAW files provide better material for this.

Here is another trick I learned from Greg Downing to persuade any HDR generator into making ghost-free images: Just paint those pesky phantoms out of the original brackets first! All you need is a hard black brush without anti-aliasing, and then you can paint over every ghost in each source image (except your hero image, of course). You could do that with your finger on the iPad and send that batch right over to one of the happy little mobile HDR apps. It works because of the weighting schemes discussed in section 3.2.5: Pitch-black areas are always considered underexposed, invalid, unworthy to contribute to the HDR blend. That's why such a rude preparation method can force every HDR merger into a decent blend, even it doesn't have any ghost reduction feature at all.

Optical Flow

Automatic ghost removal is an ongoing quest. The next step in evolution is trickling down from high-end visual effects software. It's called *optical flow* and it's commonly used for such interesting things as stabilizing handheld footage, creating slow motion effects by calculating in-between frames, and reconstructing 3D depth from a stereo pair of images. Under the hood these optical flow algorithms are similar to pattern recognition in how they work, but

Figure 3-80: *Another fine example for selective deghosting in Photomatix. Notice the strategic placement of the patches and the improved look with carefully chosen hero images.*

Figure 3-81: *Optical flow is hard-core science fiction robotic vision stuff. This algorithm figures out the motion of every pixel and may be the future of alignment and ghost removal.*

they take it to the extreme. Instead of making point clouds of the most dominant features, they figure out the speed and direction in which each feature is moving. And they do that for every single pixel—if they can't find a feature to grab onto, they fill in the blanks with interpolation and then iteratively refine.

Applied to HDR brackets, that would actually catch two birds with one stone: Ghosting

and alignment problems solved in one swoop. It wouldn't only know when the camera moves, it would also detect moving clouds and gently nudge them back into place. Instead of picking the best image of a ghost and dropping the rest, it would actually align all pixels individually. Some researchers even go as far as determining the motion between frames with sub-pixel accuracy and then use that information to reconstruct a super-resolution image and remove motion blur. That's different from simply upscaling an image or just sharpening; it actually shows more pixel detail than any of the originals and seriously smells like science fiction. Currently, PhotoAcute is the only software program even attempting to tap into this field, with arguably limited success. But I expect we will see optical flow algorithms used in many other programs soon.

3.2.8 Inspection Time

The first thing to do after merging exposures is to inspect the quality of your fresh HDR image. Ideally, you have sucked every bit of useful information from all the source images. Even if you don't really care about the 32-bit image itself and would rather storm ahead to the creative tonemapping phase, you should always remember that a clean HDR image is the base for a pristine final result. Artifacts present in the HDR image are more likely to become pronounced than decreased by the tonemapping process. Yes, it sounds like stating the obvious, but I still see many people skipping this important HDR inspection step.

Specifically, you need to check for the following artifacts:

- *Range coverage:* Is there anything clipped on either end?
- *Noise averaging:* Are shadow details crisp and clear?
- *Intensity stepping:* Unnaturally sharp edges around the highlights?

- *Response curve:* Any strange color shifts in smooth gradients?
- *Alignment issues:* Do high-contrast edges have a double image?
- *Moving objects:* Any ghost sightings?

None of these artifacts are unavoidable, and you're doing yourself a big favor by catching them early. The preceding sections gave you plenty of hints on alignment strategies, response curve calibration, and ghost removal techniques. Now is the time when you can still go back and revisit your merging settings, maybe even redo the HDR image in a different software. Otherwise, all the energy you spend during the tonemapping stage might be wasted on suboptimal material.

What it boils down to is that you have to inspect highlight and shadow regions at a 1:1 pixel zoom level. In a clean HDR image, you can dial the exposure slider up and down and it will always look as good as the respective source images. In a sparkling HDR image, it will look even better than any of the source images. It's that simple.

Exploring HDR images in Picturenaut

Picturenaut is probably the best HDR inspector. It loads any HDR file with record speed, and its no-fuss interface cuts right to the chase. On the bottom of the window is a simple slider for adjusting the viewport exposure. When you flip the Auto switch next to it, Picturenaut autoexposes based on what you're currently looking at. You can zoom in and out with the mouse wheel, pan around the image with click-and-drag, and Picturenaut automatically adjusts the viewport exposure just like your camera does in auto exposure mode.

I urge you to give it a try with any of the HDR images from the DVD. You will notice that such a closeup inspection of highlight and shadow areas is not only useful for catching mistakes, it also helps you to build a mental inventory of

1:1 pixel zoom

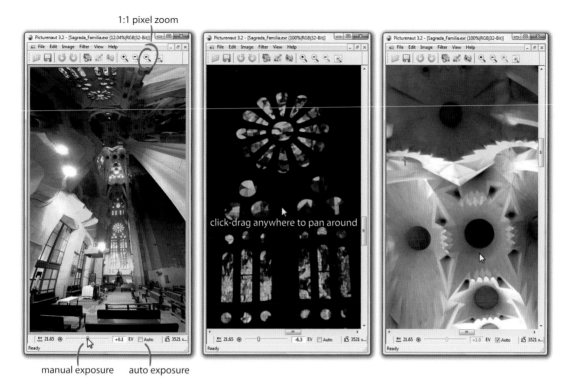

manual exposure auto exposure

Figure 3-82: *Picturenaut is an excellent tool for closeup HDR inspection. Exploring highlight and shadow details is essential to catch mistakes early on and helps in setting mental goals for the tonemapping stage.*

all the details that are hidden in the image. You get to see them in their unfiltered state, with true-life brightness relationships. Explore the image and take mental notes of which details are worth emphasizing, how they appear under these neutral conditions, and how much exposure adjustment it takes to make them show up. All these observations will be helpful guides during the tonemapping stage because you will intuitively know how much highlight compression or detail enhancement it takes to hit the sweet spot.

Navigating Photoshop in 32-bit mode
Photoshop is a bit of an oddball because it has three different ways of controlling exposure in an HDR image.

First and foremost, there is the viewport exposure (labeled **A** in the screen shot 3-82 on the next page). Just as in Picturenaut, it is a quick access slider on the bottom of the window. By default this slider might not be shown; you have to enable it in the menu behind a microscopic options triangle. It's no coincidence that this slider occupies the same space as the scroll bars. Adjusting the viewport exposure slides the visible exposure window through the dynamic range of the image, very similar in concept to scrolling around at a higher zoom level—that isn't really cropping the image either. It affects how the data is shown on-screen, but it does nothing to the pixels themselves. Editing and retouching an HDR image can be a bit strange because you're fiddling with more image data than your screen can show you at a time. You

Figure 3-83:

Photoshop's three ways of exposure control: A is the viewport exposure, B is just weird and should always be zero, and C is a permanent exposure change.

will find yourself sliding the visible exposure window up and down quite often just to double-check if your changes have had an effect somewhere else. So this quick exposure slider is your friend. Double-clicking it will always set it back to the center position, which is the default exposure.

Then there's an exposure setting in the dialog that appears when you choose VIEW ▸ 32-BIT PREVIEW OPTIONS (**B** in the screen shot). This one is weird and can cause a lot of confusion. Technically, it calibrates the center position of the viewport exposure slider. Remember the exposure preview slider in Photoshop's HDR merging dialog? Section 3.2.5 shows a screen shot. These values are linked to each other— whatever you had as the exposure preview in the Merge to HDR dialog will appear as the value in these 32-bit preview options. The trouble is, only Photoshop knows about this setting, so when it is set to anything but zero, your HDR image will look different in all other programs than it does in Photoshop. It will even wreak havoc with plug-ins like Nik HDR Efex and 32 Float because they can see only the real

exposure levels of the pixel data. So make sure this sketchy exposure adjustment in the 32-bit preview options is always zero. The easiest way to make sure is to always double-click the preview exposure when merging HDR images in Photoshop. That will zero it all out.

If you want to change the exposure permanently, use the exposure option under IMAGE ▸ ADJUSTMENTS ▸ EXPOSURE (**C** in the screen shot). That will actually change the pixel data, so every other program will recognize this exposure change. It sounds scarier than it is; there is no quality loss whatsoever due to the flexible nature of floating-point color values. In fact, if your HDR initially comes out too dark I highly recommend scaling the exposure right away until the viewport looks like your normal middle exposure. This is absolutely necessary for using the image in 3D programs. It also ensures that you can identify the image in a thumbnail overview, and it helps every third-party tone-mapping tool to get its algorithms aligned right. Just for the sake of repeatability, I tend to perform this exposure adjustment in full EV steps. And it goes without saying that you get predict-

able results only when your viewport exposure is zeroed out (double-click the slider below your image).

Got it? We have three stages of exposure control in Photoshop:

A: The viewport exposure slider on the bottom of the window. That's what is used for inspection. It's essentially a nonpersistent scroll bar for dynamic range.

B: Some weird preview exposure, hidden in the View menu. Double-check that it is zero because Photoshop may set that value when it creates an HDR image.

C: Permanent exposure change in the IMAGE ▸ ADJUSTMENTS menu. This will scale the pixel values and therefore change the default appearance in every program.

Note that Photoshop always performs some internal color management. Whatever exposure window you choose will be adjusted according to the monitor's profile. So even though the 32-bit color values themselves are kept in linear space, you look at them through gamma goggles. This is in fact the correct behavior because it makes your HDR image look natural on your monitor. Picturenaut, Bracket, and HDR Shop behave the same way, as does every program that scores at least two points as an HDR image viewer in the comparison sheet in section 2.4.

HDR viewer in Photomatix

Photomatix takes an entirely different route. Here the 32-bit HDR image is displayed in its naked linear form. It looks like a super-high-contrast image because it has not been treated with the gamma tone curve that your monitor expects. This is not a bug but a design choice intended to rush you to the tonemapping stage.

So the large viewport that appears right after merging a fresh HDR image is pretty much useless for any quality evaluation, purposefully so. Instead, Photomatix offers a dedicated inspector window, called the HDR Viewer. It behaves like a loupe that sits on the sidelines and shows

Figure 3-84: *Photomatix's HDR Viewer shows a small area under the mouse autoexposed and corrected for display. It takes a bit of practice to use this periscope for inspecting highlights and shadows, but it works.*

a 100 percent magnification of the area directly under your mouse cursor. As you roll over the HDR image, it will autoexpose that small area you're pointing at and show it properly gamma-corrected. It takes a bit of practice to use this HDR viewer to inspect highlights and shadow portions because you have to keep an eye on that 190-by-140-pixel-sized peephole and not on your cursor. It's a little bit like operating a periscope or eating chocolate with a knife and fork. But it works fast, the autoexposure is reliable, and it's pretty sweet as soon as you get the hang of it.

So that was the inspection phase. Most certainly you will do that checkup in the software you just used to make the HDR image. And depending on your findings, it might be worth going back and remerging with some different settings or trying different software all together.

3.2.9 Pseudo HDRI from a Single RAW File

In the first edition of this book I argued that only exposure bracketing is the real deal. Well, times have changed. The last five years have brought us cameras that are so much more advanced that I have to revise my statement: If the scene contrast fits within the dynamic range your camera's sensor is capable of, you can perfectly generate a pseudo HDR image from a single RAW file.

However, keep in mind that all image sensors provide you with a window of best color accuracy and least noise in the middle tones, just right of the center of the histogram. That's the sweet spot. Unless you have a moving target or other limiting reasons, you're still better off shooting multiple exposures, just so every luminance value in the scene falls within that sweet spot at least once. But if you happen to bump into Elvis and really have no time to prepare, yes, go ahead, shoot a single RAW.

This new opportunity is very welcome because it puts an end to ghosting and alignment issues. Prerequisite is that you have a camera of the latest generation. DSLRs in the upper price range, like the Nikon D3 and Canon 5D, already employ some advanced CMOS sensor technology, as described in section 3.1. I highly recommend checking the *landscape score* on DxOMark.com to see how much dynamic range your camera can actually capture in a single RAW. A good indicator is low noise at high ISO settings, which is nothing more than a simple way to make use of a high signal-to-noise ratio, the little brother of dynamic range. If your camera offers a choice between 12- and 14-bit RAW, definitely choose the higher number.

Currently RAW files provide the only way to tap into the full dynamic range captured by the sensor. Hopefully camera makers will someday get tired of inventing new RAW variants or at least offer a standard format like EXR or JPEG-XR as a third alternative. Until then we have to carefully convert this RAW file.

To make best use of your sensor, you should do two things:

- Set your camera to the lowest ISO value possible.
- Shoot one stop overexposed.

That's important because we need all the precision we can get when we bump up the shadows in tonemapping. Higher ISO values deplete available signal-to-noise ratio by boosting up the signal. More noise in the shadows also means less effective dynamic range in the source material. And shooting one stop overexposed will make sure we actually use all the value range of the sensor. One stop is generally safe to recover; don't let the in-camera histogram fool you. Of course, you should first do some tests to confirm that your camera actually delivers one EV headroom in RAW files, and also make sure not to overexpose too far because after the headroom is used up, it will clip dramatically.

No detour necessary!

Don't listen to Mr. Smarty Pants on some Internet forum telling you to extract three different exposures and remerge them to an HDR! Thousands of people have independently come up with this invention, and they are all equally wrong. This is a bogus detour that will do nothing for you. At best such incestuous practice will leave you with tons of big in-between files; in the worst case your HDR merger will make mistakes when puzzling the full dynamic range back together from the pieces. You're much better off to convert the RAW file directly.

That's right. You can literally just drop a RAW file straight into your tonemapping software. Photomatix, Dynamic Photo-HDR, HDR Express, and FDRTools have special modes for this; check the table in section 2.4 for other compatible options. Note that you will actually have to open the RAW file directly in these programs instead

Figure 3-85: *Faux Elvis at the Little White Chapel in Las Vegas. If you have to catch the moment, a single RAW might be all you have time for. It can be converted to a faux HDR, but it won't be as glamorous as the real thing.*

of using their respective Lightroom plug-ins. As you should know by now, Lightroom will do a preconversion to 16-bit TIFF, clip all the valuable highlight range in the process, and only hand the remainder over to a plug-in.

However, there is a more diligent way to do it. Dedicated RAW developers have many other advantages over the quick and dirty conversion these HDR utilities can offer. Smooth workflow integration and high-quality lens correction are some of them. A single-file workflow is still the best option; you just have to be more cautious. The trick is to develop the RAW file with flat conversion without any clipping.

Figure 3-86:
The first goal is a flat conversion without clipping. When used with caution, Recovery and Fill Light are your friends here.

1 Open your RAW file in Lightroom's Develop module.

2 Set Blacks, Brightness, and Contrast to 0. Equivalent settings in Lightroom 4 are Exposure −1 EV and Contrast −40.

3 Tone Curve should be set to the Linear preset. So far that's the standard procedure from section 3.2.4.

4 Click the triangle in the upper-right corner of the histogram for a Hot Pixel preview, and use the Recovery slider just until there are no more blown-out highlights. Don't overdo it; values over 30 may introduce edge artifacts. In Lightroom 4, this setting is called Highlights, and you have to move the slider to the left to achieve the same effect.

5 If the shadows still have clipped areas, use just enough Fill Light to make them come back. In Lightroom 4 this slider is called Shadows. As with Highlight Recovery, if you push it too far you will introduce edge artifacts. Use the triangle in the upper-left corner of the histogram for a clipping preview again.

6 Observe the histogram closely. Keep in mind that the best area to retain your data is just right of the center. So if your image looks very dark now, and there is still room on the right side of the histogram, then it's best to push Exposure up just enough so the bright end doesn't clip. Again, using the clipping preview is essential here.

7 Adjust Lens Correction, White Balance, Sharpen, and Noise Reduction just as you would with any regular shot. Compared to the workflow for developing bracketed sequences, you're fairly unrestricted here because you don't have to account for consistency across all exposures. If the image requires touch-ups, feel free to use the clone stamp. You can also crop it, or apply

Figure 3-87:
Feel free to crop and adjust the image to your taste as long as the histogram does not show any sign of clipping.

perspective corrections. Doing all these adjustments in a familiar environment is the reason you're going this route in the first place, so make good use of them. Even color tweaks are possible, although I recommend putting off drastic color changes until you see where the tonemapping process takes the image.

8 Export the file as a 16-bit TIFF file for your favorite tonemapper. ◄

Equivalent settings are to be used for other RAW converters like Aperture, Bibble, and DxO Optics Pro. Just remember the point of this exercise: to extract a flat, low-contrast image in which neither highlights nor shadows are clipped. It's okay when the details appear washed out. They will be retained in the 16-bit TIFF file because this is a bigger container than your original RAW file anyway. Your tonemapper will dig these details all up again; that's exactly what it's good at. But it can't do anything for plain white or pitch black pixels, and that's why preventing clipping should be your number one priority here.

Figure 3-88:
Final image after toning in HDR Efex Pro and applying some finishing touches in Photoshop.

If the tonemapper of your choice doesn't know how to turn a 16-bit TIFF into pseudo HDR, you can simply open it up in Photoshop or Picturenaut, change the color depth to 32-bit, and save it as OpenEXR. Both programs will correctly strip the gamma and convert the file into a valid floating-point HDR that every tonemapper will accept. However, with modern HDR tools, that is no longer necessary. You actually don't even have to clutter your drive with temporary 16-bit TIFFs anymore. Instead, this predeveloped RAW image is perfectly suited for the Lightroom plug-ins that so many HDR utilities offer.

Obviously, such pseudo HDR images are no good for 3D lighting. But you will be surprised at how much a good tonemapper can get out of this material. Tonemapping and post-processing techniques in various artistic styles are covered extensively in the next chapter. For now let's just conclude this tutorial with the notion that careful RAW development is the key to make a pseudo HDR technique work.

3.2.10 Batch Me Up!

On the opposite end of single RAW extraction there are these endless bracketing sessions that keep your CMOS sensor smoking for hours. Whether you're shooting the hell out of the perfect lighting situation or gathering the source material for HDR panoramas, the net result is often a daunting pile of images to be processed. In that case, batch processing is your ticket to pass unharmed through the mountains of mayhem into the peaceful valleys behind.

The most configurable batch processor can be found in Photomatix. It will alphabetically crawl through a given folder, always merging a preset number of images. The dialog may look intimidating at first, but it's really all explained well. Each processing step is accompanied with a Settings button that will bring up the full settings panel you've seen elsewhere in the program. In practice, you get the best results when you first go manually through the full process using the first bracketing series because then your batch settings will default to the previous settings used. Take your time to double-check all settings, including naming options. Once the genie is out of the bottle, you will have a long coffee break anyway.

In the Advanced options, you can also tell Photomatix to auto-detect bursts of images based on the time-stamp difference between shots. However, I still recommend presorting the images yourself in folders named 5er, 7er, and 9er. It's always a good idea to stay organized because that time-stamp detection gets tripped up easily when you shoot some bursts right after another (as is recommended for HDR panoramas).

Many other programs have batch processing as well. Typically

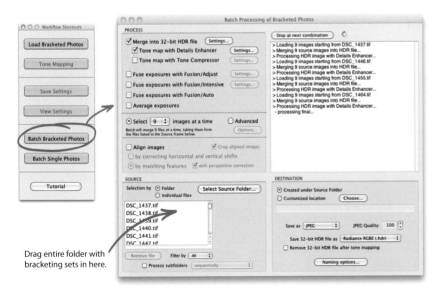

Figure 3-89: *Photomatix is the undefeated king of batch processing. Although intimidating for beginners, all the options become clear when you're working with it.*

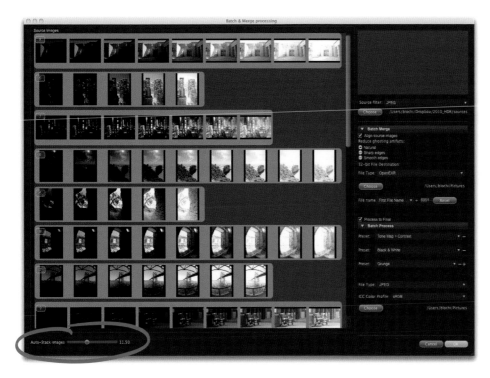

Figure 3-90: *HDR Expose has a clever way to visualize and fine-tune the detection of bracketing sequences, making the result much more predictable.*

this is an exclusive feature of the Pro editions. A few of them have some sort of edge over Photomatix in one particular area. In HDR Express, for example, the autodetection is actually usable because it gives valuable feedback up front and lets you interactively adjust the time between bracketing bursts to a perfect fit. Hydra does the same, although it can't deal with more than seven exposures per set. SNS-HDR Pro has the option to downsize each image right away, which is very useful for HDR time-lapse and general preview purposes. PhotoEngine and SNS-HDR can both pause for each generated HDR image to allow manual adjustment of the tonemapping parameters. So there is quite some brain sauce spent on innovation in this area. But in terms of overall performance, the most comprehensive and production-proven batch processor remains Photomatix.

When the batch process is all done, you'd normally proceed to the inspection stage, pick the ones you like, and eventually merge them again with more carefully selected options (for example, selective ghost removal) or try merging in another software program. Same goes for the on-the-fly tonemapping. It's nice to have a quick preview, but at the end of the day you'll just use it to identify the images that have potential and then keep working on them. After all, there is so much more we can do with the HDR image. Tonemapping right away, with blindfold settings, is a bit like peeling an orange and throwing away the inside.

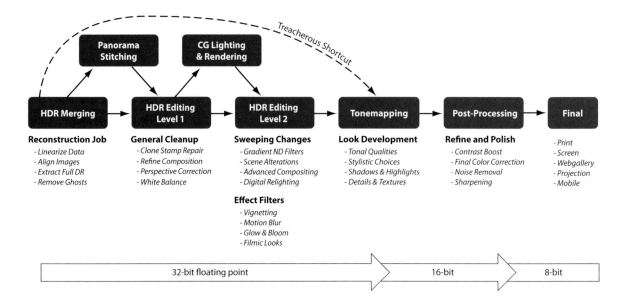

Figure 3-91:

Workflow overview of the things to come, containing a few spoilers. Getting as much as possible done in 32-bit should be the goal. The reward is a refined HDR master image that retains full creative potential.

3.3 Cleanup in Photoshop

Alright friends, we have our HDR image. What's next?

The case is clear for 3D artists and compositors. They are well aware that high dynamic range data is the most flexible working material they can get, and they will protect it at all cost.

Most photographers will tell you the next step is tonemapping because an HDR image doesn't fit the limited range of your monitor. Wrong! If you have read Chapter 1 carefully and understand the nature of HDRI, you know that this is missing the whole point.

Don't throw it all away yet!

There is nothing super magical about an HDR image. It's all just pixels waiting to be messed with, but better pixels that are much more forgiving when you apply extreme edits. Imagine the HDR image as raw clay that you can form into whatever you want. Why would you burn that raw clay into a hard block now just so you can destructively chisel the final form out of it? Wouldn't it make much more sense to massage the clay into a good model first, then put it in

the oven to solidify that form, and sand and polish afterwards?

To speak in more photographic terms, here we have an image that exceeds the tonal range and qualities of a RAW image. Wouldn't it be great to keep it like that for as long as possible? Well, we can! That's what a true HDR workflow is all about! The goal is to do as much as we can right here, right in the HDR image.

The workflow diagram above identifies what processing step is best performed at what stage. Panorama stitching and CG lighting/rendering are optional, minor detours so to speak. But the central place, where everything comes together, is HDR image editing. Skipping straight to tonemapping is often recommended in manuals for tonemapping tools (surprise!), but ultimately this is a treacherous shortcut that robs you of a few key opportunities. It takes you beyond the point of no return, that is, when you're stepping down to 16-bit and ultimately to an 8-bit image. HDR image editing is a wide field. So wide, in fact, that all the new creative possibilities for sweeping image alterations fill an entire chapter, Chapter 5. For purely photographic purposes, where the image content isn't supposed to be altered, the advanced levels of HDR editing are

not always necessary, of course. Some general cleanup often fits the bill just fine; enough to prepare an image for hassle-free tonemapping. But even this basic level of HDR editing gets ignored far too often. That's why I made it part of this HDR creation chapter.

Admittedly, working in 32-bit requires more processing power and memory. It doesn't help, either, that Photoshop's 32-bit mode is functionally crippled. But if you browse back to the crazy desaturation experiment in section 1.5 and refresh your memory about the lossless nature of floating-point images, you will realize that it's worth the trouble. You never know when you might need the precision from the original photographs again. It might be next month, when a new fancy tonemapper comes out; it might be next year when you buy your first true HDR monitor! Or it might be a couple of years down the road, when your creative eye has changed and you'd love to revise an image. You certainly don't want to start at zero and do all the mundane stuff like exposure alignment and ghost hunting again. No, you want to start out with a refined HDR master image that is ready to go.

That's why it is a good habit to clean up your HDR image in 32-bit mode.

3.3.1 Dust and Object Removal
For example, you can dust off small mistakes now. That might be dirt particles on the lens, residual ghosting artifacts, or simply things disturbing the composition—generally speaking, all the stuff you don't like at all, the same kind of blemishes an old-school photographer would dust off the negative. There is no reason to leave obvious flaws in. If you put this off until after the tonemapping stage, you will find yourself removing the same dust spots over and over again, every time you want to try a new look. Worse even, you may stray away from experimenting because of all the work that had to be redone afterward. Clean up your image right away and be done with it once and for all!

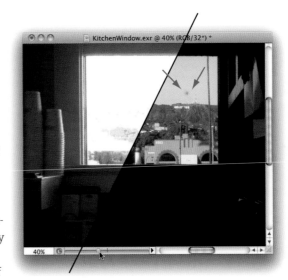

Figure 3-92:
Watch out for dust spots hidden beyond the monitor white.

The Clone Stamp brush works just fine in 32-bit mode, ever since Photoshop CS2. I assume you know how to operate it: Alt+click on a good spot, then scrub out the bad spot. So, it's just like in regular images.

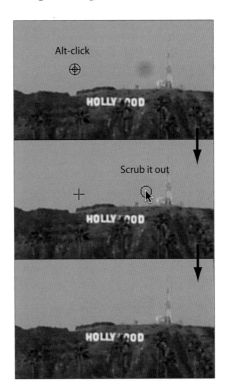

Figure 3-93:
The good old Clone Stamp tool works just fine in 32-bit mode.

The only difference is that you have to watch out for things hidden beyond the monitor's white point. Remember that an HDR image is

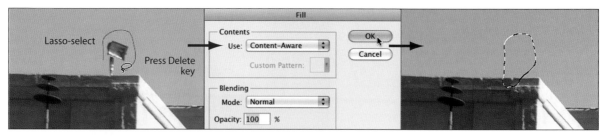

Figure 3-94: *Content-Aware Fill is even easier to use. Laughably easy, in fact.*

Figure 3-95: *When Content-Aware Fill makes a wrong guess, just try running it again on a smaller selection.*

Figure 3-96: *Content-Aware Fill gets really inventive in crafting plausible image completions. It sometimes appears to have some artificial intelligence on its own.*

more than meets the eye. You will only spot these hidden mistakes when you do the closeup inspection I talked about in section 3.2.8, making good use of the viewport exposure slider. And as soon as you see something weird, get it out!

In Photoshop CS5, you can also use Content-Aware Fill. Just circle a bad spot with a lasso selection and press the Delete key. If you prefer using the mouse, the alternative is to right-click and select Fill from the context menu. Done, just like magic. Content-Aware Fill works great on clouds, skies, grass, buildings, almost everything. The algorithm will analyze the image details surrounding your selection in respect to colors and shapes and find some plausible elements elsewhere that would make a good insert. Then it goes ahead and clones these elements in, one by one. The resulting patch may be cobbled together from dozens of sources, always blended in perfectly. Sometimes it comes up with some surprisingly creative insertion, where you have to look twice to find out where it stole the elements from. Content-Aware Fill is reason enough to update to CS5 if you're still on an older version of Photoshop. It's a massive time-saver.

When Content-Aware Fill fails, it does so in spectacularly surreal and funny ways. Normally, you just need to run it again on a smaller selection; otherwise, you can always fall back to the good old Clone Stamp tool.

3.3.2 Perspective Correction and Cropping

This is another basic step that is ideally performed at this raw HDR stage. Defining the framing early helps to concentrate your attention on the important parts. Otherwise, you may become subject to *Temp Love*, which is the scientific term for putting off a necessary adjustment until you got so used to the current state that you get stuck with it. That's why you should crop early and crop tight.

► Reframing in Photoshop

1 If you don't trust your eyes, select VIEW ▸ EXTRAS to turn on the grid overlay. Make sure Grid is selected in the Show submenu underneath.

2 Press Ctrl+A for Select All and Ctrl+T to get into Transform mode. You should now have crawling ants around your image and small square handles on the corners.

3 The first thing you would do is rotate the image. Move the cursor close to a corner handle, just outside the image, and as soon as it turns into a small curved arrow, you can swivel the image around. Pick a dominant line (usually the horizon or the edge of a building) and align it to the grid.

4 Then hold the Ctrl key and move the corner points. The image will shear out so it always stretches between the corners; nudge them around until the remaining vertical and horizontal lines conform to the grid lines. Eventually you will also have to hold Shift to keep these corner handles from snapping to the frame margin. When it looks good, press Enter and turn off the grid again. Now that image is nice and straight.

5 On to cropping. In my example, something disturbs me about that pillar on the right. It doesn't match the straight architecture, and it's not important for this image anyway. So I reframe it to focus on the more interesting parts, cropping that pillar out. ◄

Figure 3-97:
Enable the grid overlay in the View menu.

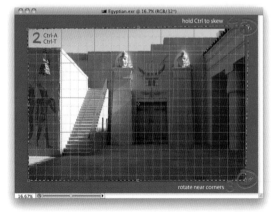

Figure 3-98:
Enter Transform mode and use the corner handles to straighten the image.

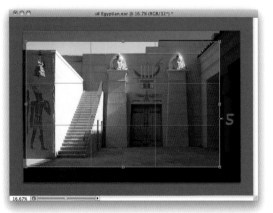

Figure 3-99:
Use the Crop tool to refine the framing of the shot.

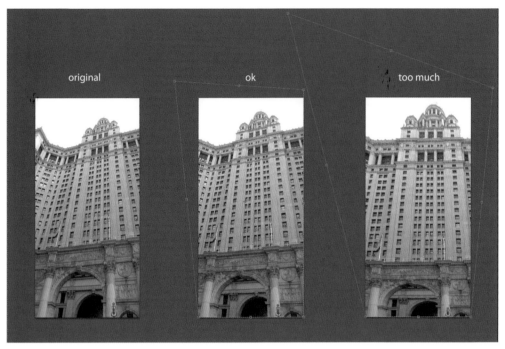

Figure 3-100: *Too much straightening can put optical strain on the image that becomes unbearable when the apparent viewpoint is conflicting with other depth perspective clues.*

Notice that this new composition excludes some dark areas that would have called for special attention during tonemapping. Well, not anymore. There's no point in adjusting your tonemapping parameters for things that will eventually be cropped off, so this is a classic Temp Love trap. Eventually, you may be lured into foul compromises when framing after the fact. Also notice that cropping the image has shifted the image center to its final position. This will be important when you apply a vignetting effect during look development. Several toning tools have vignetting built right in, which is awesome, but they will not look right unless applied to the final crop.

Deciding on your final framing now will smooth out the path for all the things to come.

Perfectly straight is not always the answer

Especially high buildings can look really wrong when straightened out completely. If you had to look upward to see a window on the upper floor, then this is simply the perspective you shot it from. Not only the convergence of major lines is defined by this perspective, but also minor elements like window boards and the way things recess in depth. These perspective clues will stay in the picture and will conflict with a perfectly ironed-out perspective, ultimately making your viewer's mind go cross-eyed. That's the uncanny feeling of looking at an optical illusion, where the interpretation of perspective flips back and forth between two contradicting options. The image will look fake and wrong. There is a middle ground, where you can still straighten an image for aesthetic reasons while keeping everything balanced. From experience, I would say it might be 50 to

80 percent straighter, but that depends on the image itself and your own threshold. Just keep an eye on it and hear the alarm bells ringing when you find yourself moving Photoshop's corner handles too far: The flat angle you're looking for may conflict with the inherent perspective clues in the image.

3.3.3 Perfect White Balance

White balance is a very important step. If you haven't set white balance during RAW development yet, now is the perfect time. The name is totally misleading because we are really balancing out the colors here. *White* simply stands for the most neutral color we can think of. In fact, it's so neutral that it doesn't even count as a color anymore. White is just a very bright gray, or the opposite of black. It's perfectly colorless.

At least it should be colorless. But in reality, it never is. Before I get into the theories of human perception again, let's look at an example. Today's victim is the panorama Frozen_Waterfall.exr from the DVD.

The image shows a bright morning sky spilling through the trees of the Sierra Madre Mountains and a frozen river reflecting the first sun rays. This could be a great generic HDR panorama for CG lighting, if there wasn't that cold color temperature. It becomes obvious during the dynamic range inspection that there is a cold blue tint all over the image. That somewhat kills the green of the trees, and the little patches of sunlight don't appear as golden as they should. So we have to fix it.

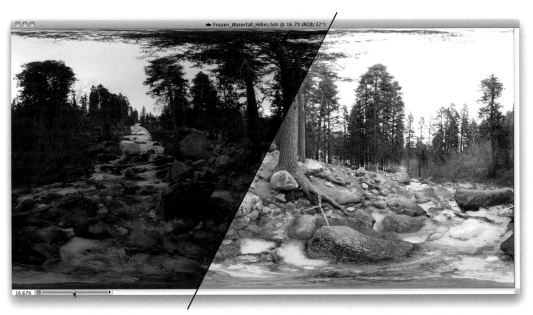

Figure 3-101: *When the dynamic range inspection reveals a blue color cast over the image, this is a clear sign that the white balance is off.*

➤ White balance in Photoshop

1 Bring up the Levels panel from the IMAGE ▸ ADJUSTMENTS menu. Levels is one of the most underrated tools, but it's all we need for adjusting white balance. But beware: The histogram can't be trusted here; all it shows are the on-screen color values, not the underlying HDR data. We all know that the whites are not really clipped. Just ignore that histogram for now. Instead, activate the little eyedropper icon on the right. This is the color picker for the white point.

2 Right-click anywhere in the image and a pop-up menu will appear. Here we can specify the area from which the picker is pulling the color. We most certainly don't want to pick individual pixels, but rather the average of a small area.

3 Now let's go on a hunt for white. We're looking for a spot that should be white but currently is not. Finding such a spot is not quite that easy sometimes. You would think the ice-covered waterfall is white, but it really isn't. In reality, the ice is reflecting the sky and that gives it a natural blue sheen. Clicking there will tint the rest of the image with the complementary color, overshooting into the reds.

4 Apparently, there is no true white reference in this forest. And that is the case with about 99 percent of all images. Pure white is just hard to find in nature. The appearance of brightness is really caused by a surface bouncing more light back, and thus the brighter an object, the more

its color is affected by its surroundings. That's why white is a very poor scale for defining color neutrality. On top of that, in 8-bit imaging, a white pixel is most certainly just clipped anyway. Makes you wonder how that white balance thing was ever supposed to work at all, right?

5 Well, it hardly ever worked. That's why gray is normally used as the color neutral standard. For example, that big boulder is supposed to be colorless. You probably have your 18 percent gray card or professional color checker (as seen in section 3.2.4), but in a pinch I just look for nice boulders.

Go ahead, pick the white reference from the boulder. This will actually mark the boulder as screen white. As a side effect, this will brighten up the entire image. Pretty wild, huh? In traditional imaging that would have been a fatal move. This poor 8-bit histogram is giving us a taste of it. It has huge gaps all over, and half of the image would be clipped, gone to digital nirvana. You'd never do that to an 8-bit image; that's why scientists have specifically invented the middle pipette icon to pick a gray reference. However, Photoshop's gray picker is not working correctly in HDR mode, so make sure to stick to the white picker only!

6 Instead, we can scale the brightness easily back with the Output Levels slider. Simply drag the white point slider to the left until the image arrives at a normal exposure level. Done. ◢

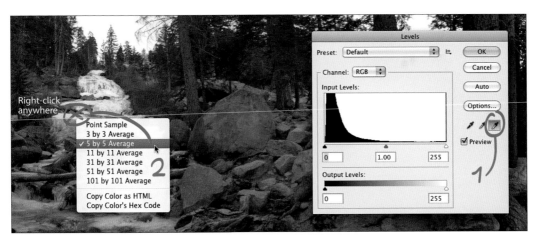

Figure 3-102:
Select the white point color picker in the Levels tool and expand the sampling area.

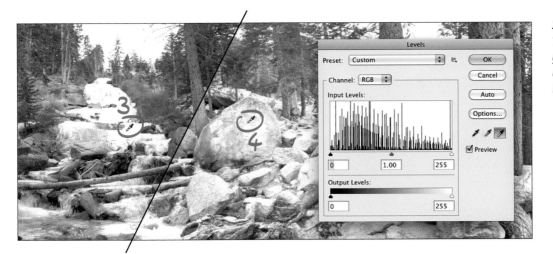

Figure 3-103:
The waterfall is no good as a white reference, but the gray boulder will do.

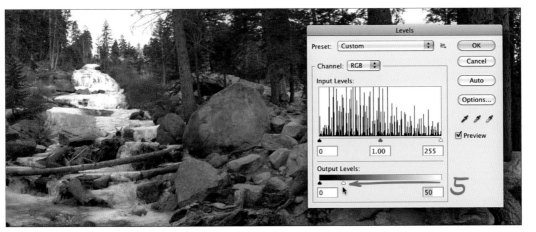

Figure 3-104:
Adjusting the white point setting in the Output Levels slider brings the exposure down again.

Figure 3-105:
The final pan-
orama after toning
and some funky
twisting.

Looks much more natural now. Trees appear juicy green, the ground looks dusty, and the sunlight patches have that golden-hour sheen. A good white balance really makes all the difference! This is an essential step when the HDR image is supposed to be used for 3D rendering.

Even in a purely photographic workflow it makes a lot of sense to adjust white balance now instead of later. In 32-bit, we still have all the flexibility formerly only known from RAW files, so extreme adjustments are gracefully handled without ever losing any quality. There are certainly creative opportunities to create a warmer or colder look by purposely offsetting the white balance, and some tonemapping utilities give you some controls for this as well. But that's for later, during look creation.

Consider this a restoration phase. The goal is a 32-bit master HDR image that is as natural and color neutral as possible. If you make this a habit, you can later step into the tonemapping phase with all your images on an even playing field. This will ensure that toning presets really apply the intended look, and it will maximize the range of creative adjustments you can expect from these tonemapping tools.

DSC_5568.JPG
0.5 sec / f/ 6.3, ISO 320
10.5 mm (AF DX Fisheye-Nikkor 10.5mm f/2.8G ED)

Figure 3-106:
Stairwell of the Chelsea Hotel, New York. Ninety source images go into one HDR panorama, for efficiency and speed shot as JPEGs. Unfortunately, the white balance is way off.

No limits!

If the white balance workflow in Photoshop felt a bit clunky to you, that's because it is. You have to be very careful not to touch anything in the Levels tool except for the sliders I have just pointed out. Black point slider, gray slider, black picker, gray picker—they are all evil in 32-bit mode and will destroy your precious HDR data. You're literally dancing on eggs when using this tool. Then there's the useless broken histogram that sits in the corner like a boogie man, a permanent reminder that Adobe stopped caring about 32-bit HDR several years ago.

Aside from all these discomforts, there are two hard limitations in Photoshop's Levels tool:

- You have to round-trip the undesired brightness change by eyeballing. It's impossible to get back precisely to the original exposure level.

- If you can't find anything gray in the image, you're screwed. There's no easy way of fine-tuning the color correction, let alone using another known color as reference.

That's why I recommend using the 32 Float plug-in for the job (or the stand-alone version HDR Expose). The tutorial subject will be another HDR panorama, this time shot at the staircase of New York's famous Chelsea Hotel. This will also give me a chance to put some hard facts behind the wild claims in my RAW versus JPEG discussion, section 3.2.2.

It's very easy to imagine how shooting and handling the 90 source images is less painful in JPEG format. However, adjusting white balance on JPEGs is out of question. But that's not a problem, really. They are immediately batch-merged to HDR (see 3.2.10) and then stitched to a panorama (see 6.4), and now we have an HDR master image that has all the flexibility we could wish for. Come along, the pano is on the DVD as well!

➡ **Better white balance in 32 Float**

Figure 3-107:
After all source images are merged and stitched, the 32 Float plug-in is called from the Filter menu.

1 Start 32 Float from Photoshop's Filter menu.

2 It will immediately apply some automatic tonemapping, but that's just because in its day job 32 Float is actually classified as a tonemapping plug-in. No worries. One click on the Reset preset will set everything to zero, and we're ready to use its talents for the dark arts of 32-bit editing and refinement.

3 Expand Color Settings in the Operations list. If you're on a laptop, you may have to scroll down the list to find it.

4 Grab the White Balance picker, and once again we're on a hunt for a white patch.

5 The obvious choice in this image is the plain chalk wall. Click it and marvel at the wonderful clean result! No brightness shift, no unexpected tinting or hue changes, nothing but well-balanced neutrality all across the entire exposure range. Notice how the green wall ahead is still green, even though previously you could barely make out a difference between all the walls. It also worked out the subtle lime color of the marble floor, which was completely obscured. Unified Color's processing engine has a sophisticated way to treat luminosity and colors separately, and that really seems to make a difference. It's very protective of the original saturation levels, and there is no crosstalk between channels. If

Figure 3-108:
First choose the Reset preset; then open Color Settings and grab the White Balance picker.

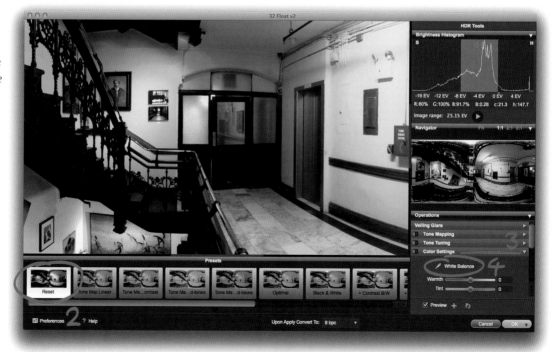

you'd look at this on a professional waveform monitor, the graph would probably show unicorns dancing on a rainbow.

6 If you feel the need to fine-tune the result, just expand the 2D-White Balance section. This reveals a color field. It's actually a closeup view of a color circle representing the entire gamut. We can navigate this view the same way we navigate the main viewport: right mouse button for panning the view, mouse wheel for zooming. Mid-gray is in the dead center, marked with a tiny square. On the outside we have all colors with maximum saturation. A microscopic *x* marks the adjustment target based on the color we just picked. I parked the mouse pointer on it for the screen shot, otherwise you'd never find this peewee *x*. Whenever you can't find a good gray target in the image, you can always move this *x* marker to find the perfect white balance.

7 Then there is veiling glare removal. It's turned on by default, it's a unique feature of 32 Float, and it has the effect of rinsing a color cast from your darkest shadows. Actually, it rinses haze from the entire image, but it's most noticeable in the blacks. The mysterious veiling glare addressed here is an optical effect caused by scattering light in the lens. You've all seen it before; it's the washed-out haze you get when shooting against a strong light source (like the sun). Glare is a close relative to lens flares, except that it happens on the frontmost lens element and it lies like a layer of colored fog on the entire image. Cheap lenses show more veiling glare, and it's most pronounced in plastic lenses like that of a Holga camera.

In this particular image there is no such veiling glare present, so this feature doesn't really do anything. In other cases, this glare may actually contribute to the mood, and if you find it artistically pleasing, then by all means leave it in. Section 5.2.3 even goes into length about how to add veiling glare to enhance the photorealism of CG imagery. But if crystal-clear blacks are a concern of yours, let's say for architectural photography or real estate, then veiling glare removal in 32 Float is your friend.

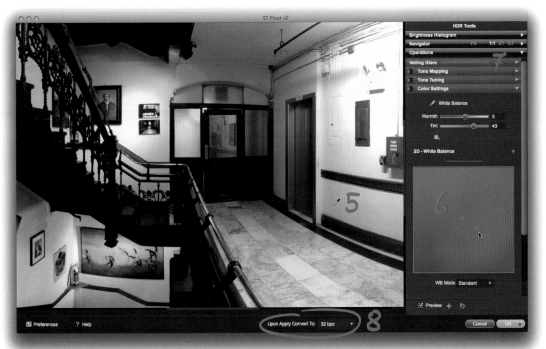

Figure 3-109:
Picking the white off the wall gives an impressively clean result that can even be fine-tuned in the 2D-White Balance field. Make sure to specify 32 bpc as the output format before clicking OK!

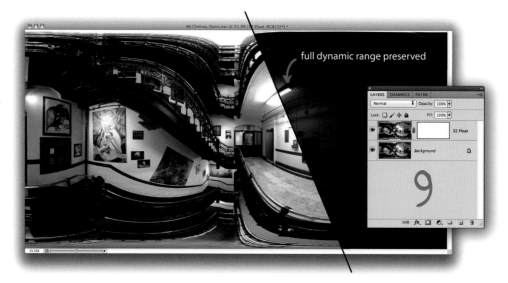

Figure 3-110:
Back in Photoshop, all adjustments are found on a new layer.

full dynamic range preserved

8 Set the output to 32 bits per channel. That's the most important step. Otherwise the plug-in thinks you're done with tonemapping and chops everything down to 8-bit. For an end-to-end HDR pipeline this output option *must* be set to 32-bit.

9 After clicking OK, you'll find yourself back in Photoshop. A quick wiggle on the viewing exposure slider confirms that the highlights are not clipped and the white balance was properly adjusted across the entire dynamic range. Being a good sport, 32 Float has not actually touched the original image but added a new layer instead. That's very handy for a quick before/after check. You can also lessen the adjustment just by reducing the opacity of this new layer.

10 Flatten the image and save as OpenEXR. Voilà. Our master HDR image is done.

If you're using 32 Float frequently for this type of cleanup work, it's a good idea to tune the preferences for an even smoother end-to-end 32-bit workflow. You configure it to always open a new image with the Reset preset and no veiling glare correction applied. Then it's just a matter of three clicks to set the perfect white balance.

Of course, you could now keep on tonemapping in 32 Float. But the point is, you don't *have* to. It's easy to imagine that a neutral white balance will be a much better starting point, no matter what your software choice will be. Presets that include a particular warm or cold look will now have a chance to apply exactly the intended style. All colors are separated nicely, minimizing the risk of exaggerating a color cast further down the road.

In a nutshell: Those are the basic adjustments commonly used in a photographic workflow: cleanup, refining composition, white balancing. They all work equally well on HDR images, some even better, so why wait?

Still, we haven't even tapped into the full scope of opportunities yet. I haven't shown you any of the cool new stuff that has no preceding counterpart in low dynamic range (LDR) image editing. There is so much more to gain when we keep working in floating-point precision that it would cause this chapter to explode. I am talking about hardcore image editing with an entirely new level of control. The big guys in movie postproduction used to do this for years, and there is a lot to be learned from them. If you're ready for the next level, check out Chapter 5 on HDR image editing and compositing.

3.4 Chapter 3 Quiz

Here we go again, another challenge for that soggy tissue behind your eyes. Some questions are screamingly obvious, others are rather tricky. If you can answer 18 right off the bat, you're entitled to call yourself "Illustrious Grandmaster of HDR Shootery" in public. With 12 answers you can still claim the title of "HDR Expert." But with a score below 5, thou shall be doomed to read this chapter again.

1. Method for judging the trustworthiness of a source pixel value.

2. Curve describing the relationship between scene luminance values and pixel values.

3. Device to trigger shots without touching the camera.

4. Graph representing the distribution of tonal values. Should keep an eye on it while bracketing.

5. Recommended equipment for stabilizing your camera.

6. Four settings need to be fixed for exposure bracketing: ISO, Bracketing, Aperture, and

7. Sensor in some Fujifilm cameras that uses photosites of two sensitivities to extend dynamic range.

8. Common alignment algorithm based on median threshold bitmaps.

9. Shooting an exposure sequence in rapid succession.

10. Optical mirror device that can be used to capture two exposures simultaneously.

11. Undesired effect caused by moving objects while shooting an exposure sequence.

12. Short for Open Camera Controller, a DIY project to control a DSLR with a Nintendo DS.

13. Popular camera brand that cripples most of its DSLRs to measly three-frame AEB.

14. Lightroom preset for the optimum starting point to pre-process RAW files for HDR merging.

15. Camera setting used to vary exposure for HDR bracketing.

16. Unique remote controller for unlimited bracketing. Connects via shutter release *and* USB port.

17. High-end video camera featuring an HDRx mode to capture footage with up to 17 EVs.

18. Sensor type based on microprocessor technology, now more common than CCDs.

19. Firmware hack for Canon DSLRs that enables advanced movie capture and HDR bracketing.

20. Tripod alternative that prevents camera rotation and thus helps alignment.

3.5 Spotlight: Michael James

Michael James is a professional real estate photographer in Florida. His clients are real estate agents, builders, and architects. Michael was very quick to adopt HDR into his regular workflow, and he became a strong HDR advocate by sharing his thoughts on www.hdriblog.com. He shot more than 700 properties in the last four years, delivering about 20 HDR images each. That's a track record of well over 14,000 HDR images captured and tonemapped for commercial use.

Between teaching one-on-one classes and traveling to the next beach mansion

CB: What is the major difficulty in real estate photography?

MJ: Real estate photography is regarded as one of the most challenging endeavors in photography because of its extremely high dynamic range scenes. Many times the photographer is faced with capturing not only the entire dynamic range of the interior, but also an entirely separate dynamic range of the outdoor view through windows and open doors.

Architectural photographers have traditionally shot at sunrise or sunset when attempting to capture interior and exterior in one shot. In the film days, this was the only practical way to get the shot captured on one negative without doing

CB: But it's not really practical to shoot only at sunset or sunrise?

MJ: Well, no. My clients often request to shoot at various, very specific times of the day. Especially when the key shots of a property are rooms that overlook a pool, the beach, or the bay, my photos need to show this gorgeous vista revealed through the windows or doors that swing open. Shooting these scenes during the day ensures a massive dynamic range from interior space to exterior view. Traditionally, that's when flash techniques are needed to light up the interior.

CB: How did your workflow on location change since you're using HDR?

MJ: A major increase in speed to capture a scene. Using HDR as my lighting method means I can move quickly with just my camera and tri-pod. Pre-HDR workflow I would have to haul in lots of gear and then constantly move around flash units as well as tweak power settings until I achieved good exposures. Sometimes I'd need to move units around several times knowing I'd mask out parts of each frame in postproduction. The constant moving of lighting was extremely time consuming.

CB: How long does a shooting session take you now, and how much time do you spend on processing?

MJ: I like to take my time at a property, but if it is a rental property where a cleaning crew just finished and it's only a few hours until a new guest will be checking in, I can get that property shot only because of HDR workflows. I have been known to shoot a three-bedroom, two-bath property in 40 minutes flat. I don't like being

rushed, but in a pinch I can get it done thanks to HDR.

Processing is similar in that I could spend hours tweaking a photo in 32-bit to add all sorts of extra lighting to backs of chairs or to highlight features in a room if I so desire. However, many times I'm under a deadline, and Realtors and rental companies want quick turnaround times (under 24 hours). I can fully edit a bracketed series from a 3bed/2bath property in about 3 to 4 hours.

CB: Wow, that's quick. How much of that is batch processing, and how much manual work on the look?
MJ: When I am doing a shoot for a real estate agent (quick turns), I will batch-process using

RAWs, then finesse the tonemapped version in Photoshop. Often a third of the shots will require me to reprocess from RAW or batched HDR files and then manually tonemap to get the exposure correct. Most of the time in that workflow is spent tweaking the tonemapped version in Photoshop.

My preferred workflow when I have ample editing time is to pre-process everything in Lightroom and then export 16-bit TIFFs to merge to HDR, then tonemap. The reason is because so much can be tackled ahead of the merge, such as chromatic aberration, Lightroom's amazing noise reduction, white balance and color balance tweaks, mild clarity and sharpening, and sensor dust. Especially useful is the ability to use localized brush adjustment layers to deal with color

casts in specific areas of the photo. This flow is heavy on the front end in Lightroom but requires very little Photoshop work after tonemapping.

CB: Your style looks rather natural, as if the images could well be single-shot exposures. Is that what your clients call for?
MJ: Absolutely. If anything looks remotely over-cranked to them, they call me out on it and ask me to retake the shot. Of course, this often means I just need to reprocess it more carefully. Many of the builders, architects, and interior designers are used to working with photographers who use flash, which has an accepted look to it of course. If my shots look "HDR" to them, they reject them.

As far as natural, one of the biggest side

benefits is that because I'm not firing flash, the images reflect the lighting the builder or designer added to the room. Track lighting suddenly is accenting the room as it was intended to and not overwhelmed by a flash unit. Daylight that naturally spills into a room does so as it would if you were there. This is the number one reason why beach rental companies use me. When their client arrives at the unit, it feels like the photos they viewed online.

CB: What's in your camera bag?
MJ: Nikon D3 and a Nikon 14–24 mm f/2.8G lens are my primary tools. Ninety percent of my shots are accomplished with that combo. Then a range of old Ai-s manual focus Nikkor primes from 20 mm to 135 mm. I have a standard 10-pin shutter release cable for the D3 in order to not touch the camera to fire a bracket. In addition, I carry a Promote Control, which is a separate device that connects via USB and goes beyond the D3's capabilities for bracketing very large dynamic range scenes. I also have a Nikon SB-800 Speedlight, which gets used infrequently.

CB: What is the best advice you can give to a beginner in HDR imaging?
MJ: A tripod is your friend. A stable tripod will save you headaches in post.

Then, overbracket your scene and shoot tighter brackets. The biggest complaint I hear from folks who went on vacation and shot AEB sequences is that they wish they had captured more than just a 3 AEB sequence using +/−2 EV. Sometimes their overshot was too overexposed or the underexposed was too underexposed, thereby leaving that person with just two usable shots to merge. Or worse, the scene they shot was such a high dynamic range scene that they still have muddy blacks and blown-out whites because 3 AEB at +/−2 EV wasn't enough to capture the dynamic range of the scene.

If they shot tighter and larger brackets, they would have more choices in post and less regrets

about missed shots. In fact, you'll spend more time messing with your camera's settings trying to get off one decent 3 AEB where both the under and over seem to be balanced well with the middle exposure than if you just overshoot the scene one time from the get-go.

CB: Better safe than sorry! Great advice to put on

You can read more of Michael's practical tips and tricks on www.hdriblog.com. That's also where you can schedule a one-on-one training session in real estate photography. Or you can go to his portfolio website at www.digitalcoast-image.com, hire him to cover your own beach-front property, and then watch the master at work.

Chapter 4:
Tonemapping

"You don't take a photograph, you make it."
That's what the great Ansel Adams once told his students.
Nothing could summarize the process of tonemapping better:
We will now make a photograph out of the HDR data, claiming
an extremely active involvement in the process.

Tonemapping is a technical necessity as well as a creative challenge.

It's pretty much the opposite of what we did in Chapter 3: In HDR generation, we reconstructed the full dynamic range of a scene by assembling it slice by slice from the source images. That's very straightforward, and the outcome is either right or wrong. In tonemapping, we compress the dynamic range so it fits back into a low dynamic range (LDR) image. As you remember from Chapter 1, this is necessary because only LDR images can be directly printed or shown on a regular screen. Here the outcome is not so clear; there are millions of ways to do it. Technically, it's impossible anyway. We're trying to squeeze something very big into a tiny container.

There is no ideal result. It just won't fit completely. So we have to make compromises. The whole trick is to make good use of the tonal values available and redistribute them in a way that makes sense. This redistribution is where the name "tonemapping" stems from. We map the tonal values from an HDR image to an LDR image. How exactly that is done depends on the image content itself, how much dynamic range it really contains, and last but not least, our artistic intentions. Sometimes it just takes a little squeeze; sometimes it is like pushing an elephant into a phone booth.

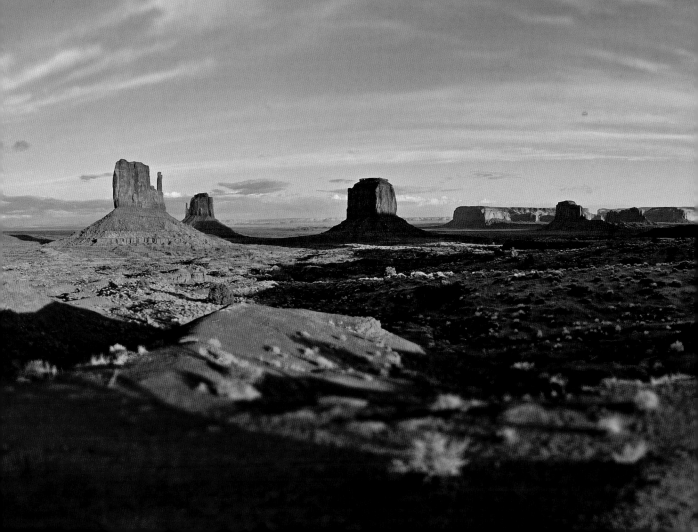

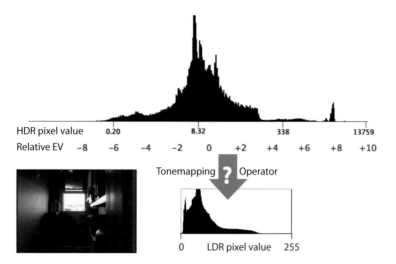

Figure 4-1:
The tonemapping problem: How can we squeeze HDR pixel values down to an LDR image?

Back to normal

Read this out loud: *high-dynamic-range to low-dynamic-range conversion!* After you're done with tonemapping, you don't have an HDR image anymore. It's bogus to point at a JPEG that just happens to be made via tonemapping techniques and still call it an HDR image. You wouldn't label a JPEG a RAW image just because you shot it that way. Some may argue that the dynamic range of the scene is still contained in the JPEG, but that is not the case. What you're left with is the *visual impression* of a higher dynamic range. Applesauce might contain everything that was an apple, but it is not an apple anymore. Maybe there are whole pieces mixed in, maybe it contains all the best of 20 apples, but there is no doubt that the resulting sauce is not an apple anymore. Instead, it is a refined product that has undergone many processing steps so it can be more easily consumed. Same goes for JPEGs derived from HDR images via tonemapping: They are processed for easy consumption via ordinary devices, meticulously refined according to your finest artistic judgment, and they are low dynamic range by definition.

It's certainly appropriate to hint at HDR as a capturing method or workflow used. But if this is all that comes to mind when finding a label for your image, it may be time to double-check your artistic intentions. I don't mean this in an offensive way. It's just that nothing in "Check out my HDR image" indicates that you thoughtfully *made* this photograph instead of just *taking* it through a few technical processing steps.

4.1 Hello Operator?

So we are looking for a tonemapping method, a general set of rules that describe how the dynamic range is stomped together. Simply cutting off the extra bits doesn't always look so good; we're looking for something better, some kind of filter or histogram compressor or tone curve adjustment or smart algorithm. Everything is allowed as long as it starts out with HDR values and returns some nice LDR representation of it. It's a black box that can do whatever it wants to the image. HDR in, LDR out—that's all we ask for.

These are new kinds of functions that cannot be categorized in the traditional way. Instead, they form a tool category of their own: tone-mapping operators (TMOs). Because there are no official rules about the inner workings of a TMO, this has become a favorite playground for young computer scientists. As a result all sorts of algorithms emerged, sometimes with radi-

cal new approaches. Some of them have spilled over from related fields, like machine vision, video processing, medical and astronomical imaging. There is also no real naming convention for TMOs. Some names give a hint of what's happening inside the black box; some point out a desired result; some are simply named after the inventor.

Despite all their differences, there are really just two major strategies involved. This divides the huge variety into two classes: *global* and *local* operators. Global operators convert the full image in one swoop, whereas local TMOs do different things to different parts of the image.

All programs introduced in Chapter 2 fit in either one of these categories. Some of them even have a local *and* a global operator under the hood, and some programs share very similar algorithms. Before we get into the hands-on workflow tutorials, let me first give you an overview of some common tonemapping operators. By no means will this be a complete or in-depth description; that would be a book on its own. In fact, there are several technical books on this topic—see the appendix for a reading list if you're interested in all the gritty math and formulas. My goal here is just to give you an idea of what kinds of unique approaches there are out there, what you can expect from them, and how to judge the result.

For demonstration purpose I chose four test images as somewhat representative cross sections of real-world scenes:

- **Evening Clouds** – 12.5 EVs – When the setting sun illuminates thick storm clouds from below, you get these burning skies; a breathtaking sight that never comes out convincing in a plain LDR snapshot.
- **Walk of Fame Figurine** – 11.5 EVs – Chrome highlights at high noon are traditionally hard to capture because you're shooting directly into a reflection of the sun. Cars in daylight present the same problem.

- **Times Square at Night** – 21 EVs – Neon city lights at night are another common source of extreme dynamic range.
- **Kitchen Window** – 18 EVs – The Classic. The view out of a window from a dark room presents a real challenge.

Who said paper books can't be interactive? Fold the next pages halfway to compare any pair of TMOs side by side. Mind you, these examples do not reflect how easy or hard it was to create each image, nor do they represent the one and only style that can be achieved with each operator.

4.1.1 Global Operators

Global operators apply a tone curve to reduce the large overall contrast until it fits within the output range. The entire image gets the same treatment, hence the name *global*. Different global operators vary in the kind of tone curve they use. It can be a fixed curve, not unlike a characteristic film curve. It can be calculated from the histogram itself, and it can even be a different tone curve for each color channel.

All global operators share three characteristic traits: They are very fast (up to flawless real-time performance), they are immune to halo artifacts, and they preserve the edge wrapping of panoramas.

Exposure and Gamma

Technically, this can hardly be called a tonemapping operator at all. It's just a simple snapshot of the current viewing exposure. Highlight detail that doesn't fit in the tight tonal range of LDR imagery will simply get cut off. Exposure and gamma are always applied in that order: Exposure sets the limits first (and cuts off highlights), and then the gamma operation boosts shadows and midtones (as explained in section 1.4).

In many ways, this is akin to snapping a picture with a regular digital camera because their

Figure 4-2: *Photoshop's tonemapping operators appear when you're reducing the color depth of a 32-bit file.*

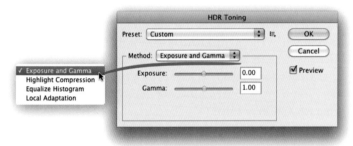

Figure 4-3: *Exposure and Gamma is the first method in the HDR Toning dialog, and it only bakes down what you currently see on screen.*

firmware does exactly the same. Except that we're now using a virtual camera. The result looks very similar to the source image of the respective exposure. But it's not quite identical: Our virtual snapshot camera works with better data that is already distilled and refined, and we can choose an arbitrary exposure in between all our source exposures. So we have more freedom. Think of it like the workflow difference between meticulously framing a shot in-camera and taking a wide-angle photograph and later using a digital crop to get exactly the image you want.

Essentially, this method is always applied in the background when we're looking at a

32-bit image in Photoshop. Your monitor is an 8-bit device, remember? So, some form of tonemapping is always necessary to display our 32-bit file, even if it's temporary, and exposure/gamma is simply the most straightforward method. The default monitor profile determines the gamma value, and we have three ways to set the exposure: the viewing exposure slider on the bottom of the window, the 32-bit preview option in the View menu, and the exposure adjustment in the Image menu. If the difference between these options isn't all that clear right now, browse back to section 3.2.8 for a reminder. The important fact to remember is that this display mapping is nondestructive and temporary.

But we can also apply exposure and gamma permanently. This is effectively tonemapping the image file, baking the 32-bit pixel data down to 8-bit. It is required when you want to save the image in an LDR image format (JPEG, PNG), and it's an irreversible conversion. Consequently, Photoshop's tonemapping dialog appears when you reduce the bit depth in the IMAGE ▸ MODE menu from 32-bit down to 16-bit or 8-bit.

Photoshop's HDR Toning dialog offers four different methods (read "tonemapping operators"). Exposure and Gamma is the first one. In a sudden mood for mischief, Adobe changed the default setting in CS5 to be the last method, which is so overly complex that you have to look twice to find the Method dropdown menu at all. Also note that Photoshop's default gamma setting of 1 means in this context that the current monitor gamma is burned in, and as discussed in section 1.4, that is really the gamma value 2.2 for a standard sRGB profile. The Gamma slider in this dialog is more of an additional gamma boost—just another adjustment that makes the applied tone curve more or less steep. Visually it behaves like a global contrast, pushing the darks more or less up.

Exposure/gamma is a classic conversion that is not smart at all. But it's very predictable; you get precisely what you see. When you dodge and burn your HDR image by hand into exactly what you want (I will show you in section 4.4.5 exactly how), this method is the perfect fixative. It only bakes down what you currently see on screen. Plug-ins like HDR Efex and 32 Float, which can perform all their magic without ever leaving 32-bit mode, also require this simple exposure/gamma conversion as final step.

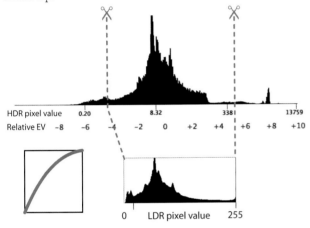

| HDR pixel value | 0.20 | | | | 8.32 | | | 338 | | 13759 |
| Relative EV | −8 | −6 | −4 | −2 | 0 | +2 | +4 | +6 | +8 | +10 |

0 LDR pixel value 255

Figure 4-4: *Exposure/gamma simply cuts a slice of the HDR data and turns it into an LDR image.*

Logarithmic Compression

When a simple gamma curve emulates a digital snapshot camera, logarithmic compression emulates the tonal distribution of analog film. Specifically, it mimics the smooth highlight roll-off, which is the signature trait of film material and the most important reason analog appears so natural to us.

In Photoshop's tonemapping palette, this is the second method: Highlight Compression. It's also available as a display mode in the 32-bit Preview Options dialog box, which is an often overlooked advantage. Instead of clipping, this method will always protect the highlights. It pins down the brightest pixel to the maximum LDR value of 255 and converts the rest in a logarithmic manner. It's fully automatic; there are no options here. At least that's what the Photoshop dialog says. However, with a trick you can actually gain a tremendous amount of control over the result. Here's how that works.

Figure 4-5: *The trick for controlling the Highlight Compression method is to enable it in the View menu first.*

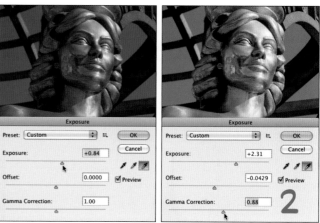

Figure 4-6: *Now Photoshop's simple Exposure adjustment can be used to interactively tweak the look.*

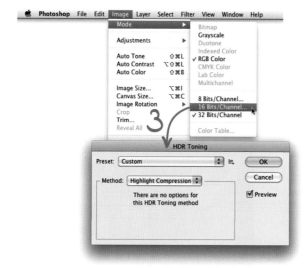

Figure 4-7: *The actual tonemapping dialog has no options, but that's okay. You don't need them anymore.*

1 In the 32-bit Preview Options dialog box, set Method to Highlight Compression.

2 Choose IMAGE ▸ ADJUSTMENTS ▸ EXPOSURE and play with the sliders in the Exposure dialog. These sliders behave in a slightly different way than they normally do because highlight details always have the right of way. Nevertheless, they are extremely interactive and easy to control.

3 When you're happy with the tonal distribution, just bake it all down by performing the bit depth conversion in the IMAGE ▸ MODE menu with the Highlight Compression method. ➥

This mode works great when your major concern is to protect the highlight details. As long as Highlight Compression is activated as the display method, the histogram is always anchored on the brightest end. Exposure and Gamma sliders now control how steep the logarithmic intensity decay across the midtones and shadows is. You can push exposure adjustments much further than you normally could because highlights will only get increasingly compressed instead of blowing out to white. Even though this mode is listed as having no options, it is actually one of the most versatile and intuitive ones. You have the entire toolkit

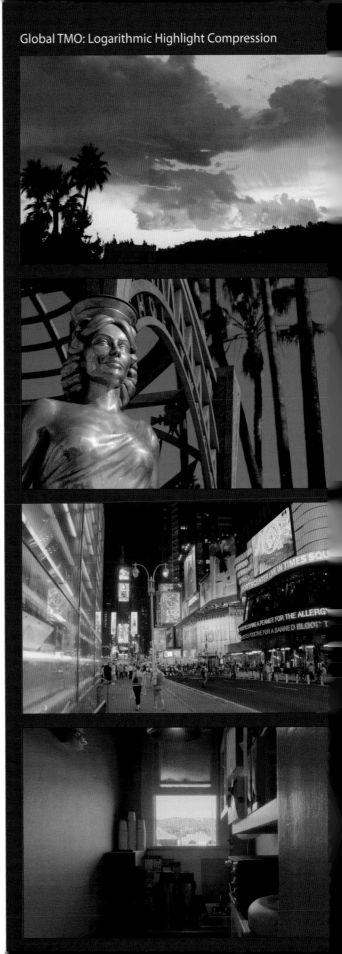

of Photoshop's image adjustments at your disposal—including levels, gradient layers, paint brushes—and you always have a precise full-sized preview of the result.

Logarithmic Highlight Compression gives best results for scenes containing a medium dynamic range, where analog film capture is actually plausible. It has a natural tendency to render vibrant colors in bright areas and highlights. The example images demonstrate how well that works for night shots and colorful skies. However, it fails badly on the kitchen window where the inside and outside are just too many stops apart.

Photoshop is by far not the only place where this TMO can be found. Picturenaut's Adaptive Logarithmic, FDRTools's Receptor, and Dynamic Photo-HDR's Auto-Adaptive method are all implementations of the same tonemapping operator, wrapped in more traditional user interfaces with all the relevant parameters accessible as individual sliders. It's a very common operator, a true TMO classic. You can find traces of it everywhere, even as a core component in more complex operators. When implemented in its original form it's often called Drago, named after the inventor, Frederic Drago.

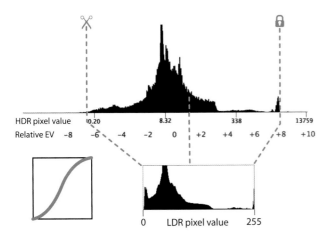

Figure 4-8: *Logarithmic Highlight Compression mimics the smooth shoulder roll-off from film to keep the brightest details in view.*

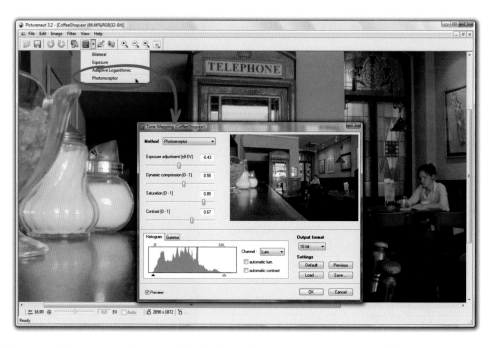

Figure 4-9: *Picturenaut offers a particularly fast and accurate implementation of this algorithm. Notice the natural color appearance, especially on the sugar sprinkler.*

Photoreceptor

This operator is based on the idea of emulating the rod and cone receptors in the eye instead of a film response. It also uses an S-shaped tone curve, which looks very similar to a logarithmic curve. But it's not quite the same. Here the steepness of this curve is dependent on the overall brightness of the image, which takes the adaptation effect of the visual system into account (see section 1.2). The exact shape of that curve, and how adaptation changes it, is based on data from real physiological experiments. Mad science that involved measuring and cataloging the electrical stimuli that occur in the eyes of turtles, geckos, and fish under varying conditions went into this. I'm not a medical expert qualified to wonder how representative that can be of a human retina, but I'm glad the curious surgeons dodged that question.

In the context of all this research, Photoreceptor deals with an adaptation level instead of a mere photographic exposure setting. The idea is that an eye is always adapted to a certain level of illumination, and that not only determines the appearance of all other intensities (by reshaping the tone curve) but also focuses the sensitivity of the cone receptors responsible for color perception. When some image elements are several stops brighter than this adaptation level, the monochrome rods become dominant.

For us, the net effect is that this TMO compresses colors very faithfully as they get closer to white. They get gradually desaturated, preventing hue shifts and oversaturation. The example images with the chrome figurine and the sugar sprinkler demonstrate very well how extra-bright highlights are kept crisp and clean. But when the most interesting colors happen to be found within that highlight end, as in the clouds example, this desaturation might be an undesirable effect. And the kitchen window

finally shows the limits of this algorithm. In scenes with such massive dynamic range, our vision heavily depends on the local adaptation mechanism, which the Photoreceptor algorithm simply does not account for.

You can find this algorithm in many programs, but the best implementation is in Picturenaut. It's extremely fast and interactive and always works on the full-size image. Instead of relying on the small preview, you can zoom into every corner and see your changes take effect right away. Watching the image change and the histogram squish and squash in real time, while you're dragging a slider, makes the process completely intuitive.

Most other implementations of this TMO are simply called Reinhard, named after the inventor of the algorithm, Erik Reinhard. Popular sightings are Photomatix's Tone Compressor mode, V-Ray, an HDR Shop plug-in, and a whole lot of command-line utilities. There are variations of this algorithm in the local TMO class (additionally accounting for local adaptation), and its core ideas are also an integral part of many other tonemappers.

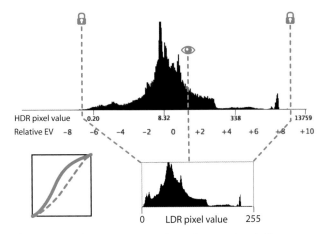

Figure 4-10: *Photoreceptor emulates the receptors in the human eye, with particular emphasis on faithful color reproduction. It replaces the concept of exposure with adaptation level.*

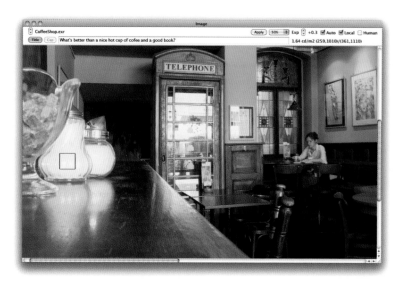

Figure 4-11: *Equalize Histogram is the TMO that powers the automatic viewport exposure in Photosphere.*

Equalize Histogram

This is Photoshop's third operator, and this time there are really no options. Equalize Histogram is 100 percent fully automatic. It doesn't apply a fixed-rule tone curve, but rather tries to iron out the histogram directly.

Imagine the histogram built as a physical sand castle on a table, and then imagine gently rocking the table. Wherever there is a mountain peak, it crumbles apart. Empty gaps and parts with very few values will be filled up. That has the effect of maximizing visual contrast in the image. Why? Because peaks in the histogram represent the largest amounts of pixels, and spreading these tones out means that the majority of the pixels of the image will get a contrast boost. It actually works both ways: When the image happens to have really low contrast, the dynamic range is expanded instead of compressed.

It's basically the same algorithm as the good old Auto Levels, with the exception that it never leaves gaps in the histogram. There is always some in-between HDR value to fill in the gap.

Well, that sounds all too fantastic, but in the real world the pure Equalize Histogram method barely ever looks good. Photoshop tends to crunch the range on both ends together, and we end up with deeply blocked shadows and highlights that don't really stand out anymore. The overall contrast boost across the midtones is incredible, but we lose a lot on the way. If anything, this is useful as a supplemental layer.

A better implementation of this histogram adjustment algorithm can be found in Photosphere, behind the Auto exposure switch. Photosphere has a built-in protection for shadow details; it simply doesn't allow the tonal values to clump together on both ends. As the name Auto suggests, it's fully automatic as well, but it also works in conjunction with the Local switch. In that case, you can zoom in and pan around and Photosphere will apply this TMO only to the current crop region.

Even though you won't find many other pure implementations of this TMO, the histogram equalizer is used as a component in many other tonemappers. Some use it as a pre-processing step, some as post-processing, some dress it up as a contrast slider.

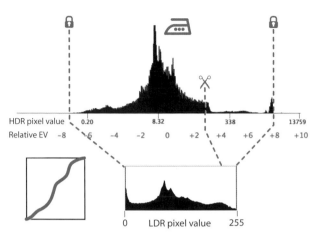

| HDR pixel value | 0.20 | | 8.32 | | 338 | | 13759 |
| Relative EV | −8 | −6 | −4 | −2 | 0 | +2 | +4 | +6 | +8 | +10 |

0 LDR pixel value 255

Figure 4-12: *Equalize Histogram is ironing out the histogram itself, maximizing midtone contrast by cutting out major gaps in tonal distribution.*

In a nutshell

Global operators always present a trade-off between overall contrast and detail rendition, especially in highlight and shadow areas. They do work well for scenes containing a medium dynamic range. But for the kitchen window, for example, none of the global operators do a good job. Photoreceptor comes close to delivering a natural look, and logarithmic compression brings out beautiful colors, but they still don't manage to get the most out of the material. This is where local operators shine.

4.1.2 Local Operators

Local TMOs are more sophisticated. Instead of applying the same tone curve to the entire image, they treat each pixel individually—well, not exactly single pixels, but groups of pixels called *local neighborhoods*. These groups can be the immediate surroundings of a pixel or determined by a complex set of rules considering shapes, colors, and light sources. Your adjustments then balance brightness, color, and contrast for these local neighborhoods instead of the whole image. The idea is to simulate the local adaptation mechanism of human vision (see section 1.2 for a refresher).

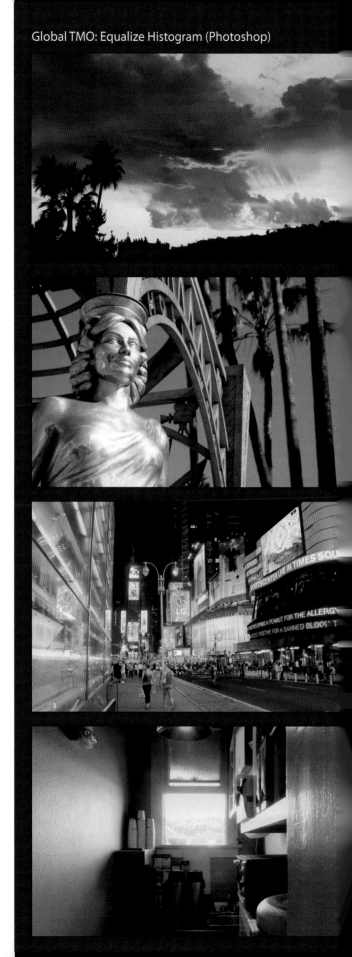

Figure 4-13:
Local tonemapping operators internally use separation masks like these to treat bright and dark areas differently.

Figure 4-14:
Photomatix's Details Enhancer has one critical parameter, which influences the softness of the separation mask. A soft mask gives a more natural look; a hard mask a more surreal look.

Imagine two pixels with identical color values but in opposite corners of the source image. After a global TMO is applied, they are still guaranteed to have equal color values. But after a local TMO is applied, one pixel can be significantly brighter than the other. It's all about the neighborhood.

Sounds very mysterious, doesn't it? Well, it's actually quite simple. You can visualize it like this: These operators internally generate a mask that is basically a blurred version of the luminance channel. Good ones use the expensive type of blur that has a threshold for preserving hard edges (like Photoshop's Smart Blur or Surface Blur).

Once the local tonemapper has a decent mask, it can, for example, separate the window view from the rest. Then it can reduce the exposure in that area without sacrificing contrast anywhere else. It could even make the window view darker than the interior. Also, it could do entirely different things to the shadow regions or even treat multiple levels of gray as a separate zones and boost the contrast for each one.

Obviously, the success of a local tonemapper is highly dependent on the quality of this separation mask. If the blur bleeds across the window frame, there is no more separation happening on that edge. Then you get halo artifacts. If that blur is not wide enough, each pixel is its own local neighborhood and all the details will be mushed together. Figuring out a smart (and fast) edge-preserving filter is an ongoing challenge for researchers.

How this separation mask is made, and what is to be done with it, are key elements that set local tonemappers apart from each other. Each program has a different set of controls too. But if there are sliders labeled Radius or Smoothing, these refer to the amount of blur and you know that you have a local TMO in front of you.

Photomatix – Details Enhancer

This TMO is the shooting star that made Photomatix famous—and consequently has contributed to the popularity of HDR in general. The photographic community just loves Details Enhancer.

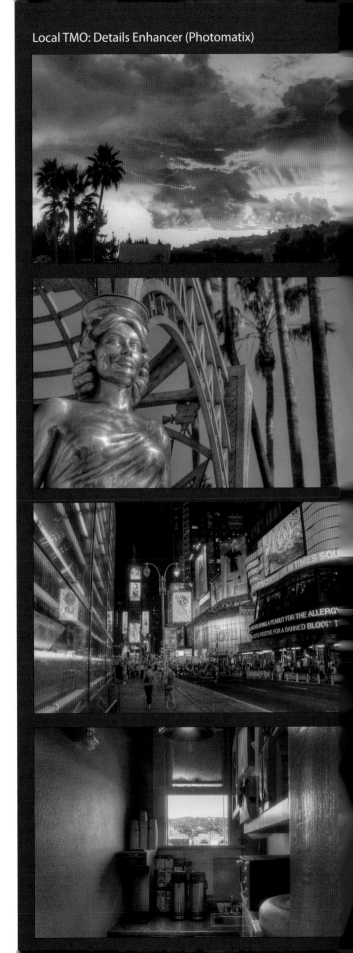

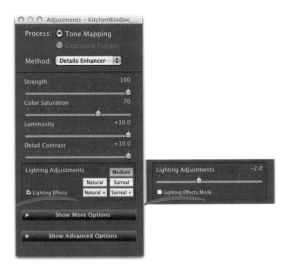

Figure 4-15: In the standard mode of operation, Lighting Adjustment can be tuned with a slider in much finer increments. This slider ranges between the Medium and Natural setting.

The basic set of parameters is very simple, but there are many more tucked away in the More and the Advanced Options sections. It takes a fair bit of experimentation to get familiar with them all. How to tame Photomatix will be explained in a hands-on workshop in section 4.4.1. Right now I just want to demonstrate the general concept.

The most critical parameter is called Lighting Adjustments. When all the other settings change the appearance of local neighborhoods, Lighting Adjustments defines the *separation* between them. More specifically, it regulates the smoothness of the separation mask. That's why this parameter used to be called Smoothing in earlier versions of Photomatix. (In all fairness, this slider cranks on a few more complex things in the algorithm, but this is the best way to visualize the effect.)

If the separation mask is very soft, then all other adjustments smoothly blend into each other and the result looks more natural. The more hard edges are retained in the mask, the more defined is the separation between light and shadow regions. Then all the other parameters affect smaller areas, and the adjustments are much more confined to these areas. That has the effect of emphasizing details, and when this effect is exploited to its fullest, the result turns into a slightly surreal look.

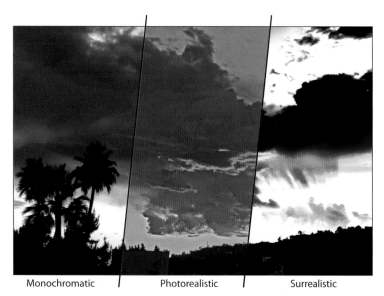

<div style="text-align:center">

| Monochromatic | Photorealistic | Surrealistic |

</div>

Figure 4-16: *Photoshop's built-in presets for Local Adaptation are completely hideous and not helpful at all.*

come out of Details Enhancer, an intangible characteristic that can only be described as softly glowing.

Photoshop – Local Adaptation

Now let's have a closer look at Photoshop's flagship tonemapper, Local Adaptation. It's been there since Photoshop CS3. In CS5 it was extended with new parameters and became a default option (that you cannot change). It also became the standard output option of Photoshop's HDR merging dialog, which was a pretty lame attempt to short-circuit the entire photographic HDR workflow and bully third-party tonemappers aside.

Adobe takes great pride in the fact that all the new parameters offer a huge range of look adjustments. But the truth is the Local Adaptation operator is now less usable than it was before. Ninety percent of all possible slider configurations produce hideous halo artifacts and clipped highlights; even the built-in presets are downright terrible examples. While Local Adaptation in CS3/4 always churned out a fairly natural look, it's actually very hard in CS5 to make a decent picture with it at all. Originally, this section of the book featured a detailed tutorial on Photoshop's Local Adaptation and how to get the most out of it. This second edition focuses on damage control.

Since Photomatix has such a large user base, its algorithm was constantly refined according to user feedback. At this point it's probably the most evolved tonemapper, perfectly tuned in to provide fine granular control for looks between realistic and slightly stylized. That means you're pretty safe from shooting over the extremes now, but you're also slightly limited when exploring hyperrealistic or harsh-grungy styles. There is an underlying tone to all images that

➤ Working the Toning Curve

Load an HDR image in Photoshop and bring up the tonemapping dialog with the IMAGE ▸ MODE menu.

1 Start with the Default preset.

2 Ignore all the sliders; focus on the toning curve instead! It has a true HDR histogram in the background; the red tick marks on the bottom

indicate one EV span each. The whole trick is to shape a custom curve to precisely define how the HDR tonal values are mapped to LDR. To do that, you have to make yourself familiar with the histogram first.

3 When you hover over the image, your mouse pointer turns into an eyedropper icon. Drag it around with the mouse button held down and

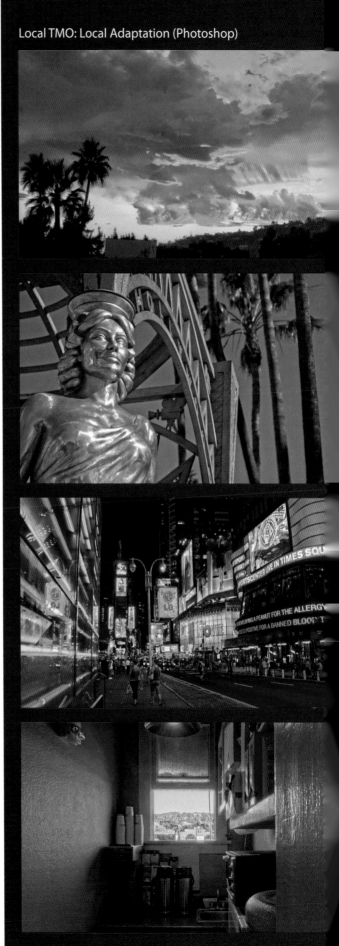

watch a little circle dance up and down the tone curve. That circle points you to the part of the histogram that represents the pixels under your mouse. So your first task is to identify all the peaks in the histogram. In this example, the large peak in the middle represents the gray storm clouds, and the small hill on the left side represents the tree line.

4 Ready to change some tonal values? Hold the Command key (or Ctrl on a PC) and click on an area in the image that you want to change. This will drop a point on the curve at exactly the right location. Now you can move that point up to brighten that area or down to darken it.

5 A good strategy for raising local contrast is to surround a histogram peak with two points and then spread them apart vertically. The steeper the slope between these two points, the higher the contrast boost. This will have a whiplash effect on the rest of the curve. You can use the Corner option (below the histogram) to set a curve point to linear interpolation, or you can simply add a few more curve points to anchor down the other brightness values exactly where you want them. Add as many points as you want, just make sure that each subsection of the curve goes uphill.

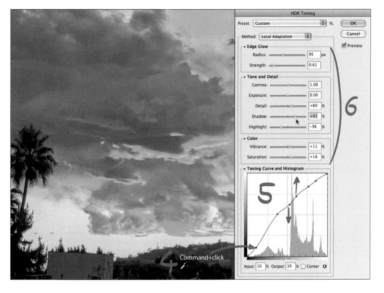

6 Once the image is in the ballpark, you can experiment with the sliders. Now there isn't much to lose anymore, and you can always set them back. Most sliders have rather dramatic effects, but not in a good way. Move them more than halfway to either side and they will introduce clipping and horrible halos. Pay close attention to the actual parameter values; for example, the Detail slider goes up to 300 % and that really means extreeeeme. The Highlight and Shadow sliders are pretty useful to control the brightest and darkest tones, and Saturation and Vibrance do pretty much exactly what you would expect. But generally speaking, let caution guide your steps and adjust these sliders only in tiny increments. And when a slider doesn't improve the image, set it right back to where it was.

Technically, the sliders in the Edge Glow section control the local aspects of this operator. Remember the blurred separation mask? Radius sets the amount of blur, and Strength is a luminance threshold to define where to blur and where to keep sharp edges. Both sliders together separate the image into larger patches of different luminance—the local neighborhoods. The toning curve is then applied to the average of these local neighborhoods (instead of the direct pixel values). I know that this sounds convoluted, but that's because it is. In practice, you have to simply play with these two sliders until you find a fragile balance where you see the least amount of halo artifacts.

The real power lies in the toning curve. If you master the curve, the force will be with you. It allows you to reshape the tonal range just the way you want it. Yes, it can get tedious at times; especially annoying is the fact that this curve window is locked in size. So the granularity of this control is limited to your pixel-perfect aiming skills. Hardcore gamers clearly have the advantage here.

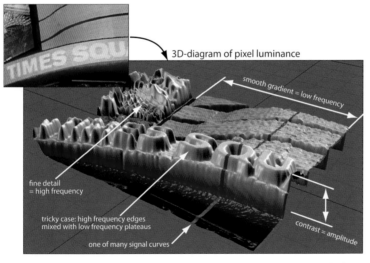

Figure 4-17: *For signal processing, an image can be visualized as a grid of curves with overlapping frequencies.*

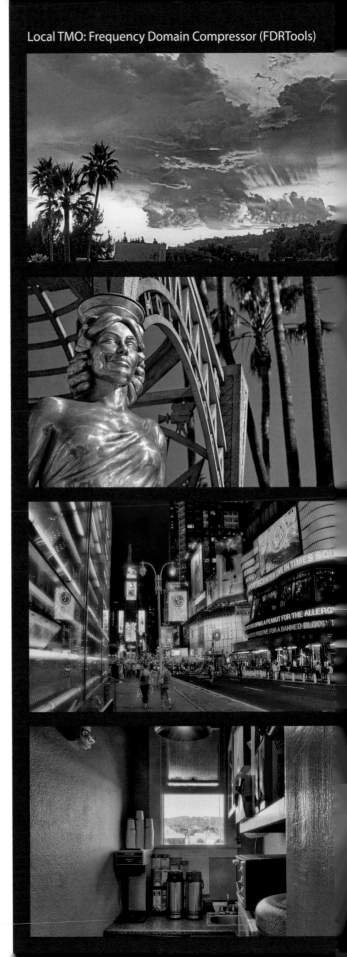

The Frequency Domain

Initially, local tonemappers were designed to *preserve* detail contrast while compressing the overall dynamic range. In the photographic practice, however, it quickly became apparent that there are huge opportunities for enhancing and exaggerating detail contrast. That brings up two questions: What does an algorithm consider as detail? And how can it isolate detail from the rest of the image, for the sake of controlling it independently?

The answer lies in the frequency domain. Remember that engineers have a habit of considering images as a signal? In section 1.1, I used the work of Beethoven to explain the concept of a signal curve. From the engineering perspective, any image can be described as a bundle of frequencies. Smooth gradients are low frequencies and finicky details are high frequencies. Isolating these frequencies in a clean fashion is not much different than stripping a singer's voice from a pop song to turn it into a karaoke version. Well, except that an image signal has two dimensions (width and height), while audio only has one (time). But the general approach to frequency filtering is very similar.

Nowadays all local operators fish for high frequencies in your image. What they present to you as a slider called Detail Strength or Structure is in fact an amplifier for those high frequencies. The tricky part is that high frequencies can also occur on medium-sized details. For example, the text *Times Square* in the night shot example has hard edges where the signal curve is very steep. That steepness registers as high frequency as well. A good tonemapper will distinguish between the small wobbly bits in a signal curve (which are high-frequency details that are supposed to be amplified) and hard edges (which are high frequencies that should only be maintained but not amplified). Some programs are successful in making that distinction (like PhotoEngine or Photomatix), and some are not (like Photoshop).

I admit, this is a pretty strange peek under the hood of tonemapping algorithms. Most programs keep the details of their frequency modulation to themselves because it really is a terribly technical way to talk about images. The only program that lets you play with the frequencies directly is FDRTools.

➤ Contrast equalizer in FDRTools

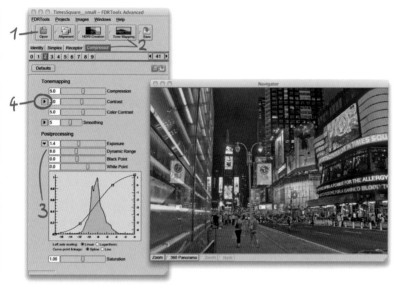

1 Open an HDR image in FDRTools.

2 Switch to Tone Mapping mode and choose the Compressor method. That's the local operator in these parts.

3 Use the Postprocessing options to regulate the output for good visibility. Exposure brightens everything up and a smooth S curve gives the image some nice overall contrast. These are fairly straightforward settings. With these settings, we have defined the output contrast, which is of course limited.

4 The question now is, Which contrasts will make it from the HDR space into the limited output space? That's where it gets interesting. Click the small triangle next to the Contrast slider in the Tonemapping section to expand a frequency curve.

5 This curve is basically a contrast equalizer; it works just like the audio equalizer in your music player. On the horizontal axis you have all the different frequency bands at your disposal, and by moving curve points up or down, you can now boost or dampen any frequency you wish. Try shaping some curves that match the equalizer presets in your music player and you will notice that the best results are achieved with a balanced mix of low and high frequencies. ➤

So, even though FDRTools's name is officially spelled out Full Dynamic Range Tools, I like to think of it as Frequency Domain Toy. Aside from the educational value, the direct access to individual frequency bands is a very powerful approach to tonemapping tricky images. It takes some practice and twisted thinking, but once you get into the groove of the frequency domain, you'll have unlimited flexibility to invent your own looks.

Decomposition & Recombination

This is the youngest and most promising concept in the design of tonemapping algorithms. The principal idea is to disassemble the HDR image into several LDR components and then create the final image by remixing these components. One huge advantage is that all the heavy computations are done upfront. When the user interface comes up, we're literally just blending several layers of regular LDR images together, and that can easily happen in real time. Yes, it's all just a trick—but a damn good one!

So, what could be those components extracted from an HDR image?

One way is to generate a base version with one of the global tonemappers and then collect all the lost details in a detail map. By the mysterious ways image mathematics work, such detail maps can be derived as the normalized difference between the detailed original and the less-detailed base version. A lot of the newer tonemappers use such precomputations to give you very quick feedback when you're ramping up the Detail slider. An algorithm could also break the image down in exposure slices, optimize them with multiple filters, and recombine them using exposure fusion. That's what SNS-HDR does. Another way to skin the cat is to split an image by frequencies into separate layers for large, medium, and small details. Section 4.4.4 shows you an excellent example of how this method can be done manually and turned into a tonemapping workflow with unprecedented control.

It gets really funky when this decomposition is done in *meaningful* ways. Researchers have already found ways to estimate lighting directions by analyzing the way shadows in the image are falling, which allows them to separate real object colors from shading and lighting effects. And by means of finding repeating patterns, they

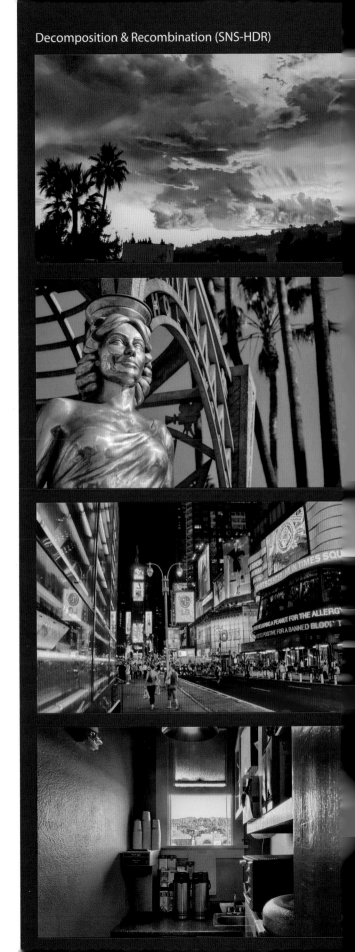

Decomposition & Recombination (SNS-HDR)

can differentiate between textures and objects. Some research projects even identify objects themselves by comparing them with a blueprint database and then literally deconstruct an image into its semantic components. That's when algorithms are getting so smart that they classify as an AI assistant. They want to be called by a catchy first name and have a fine sense of humor. A lot of these things exist only in research papers so far, and we can only guess what artistic toys we will get for reassembling these layers. But I wouldn't be surprised to see a tonemapper come up with a "Face Protection" feature.

Anyway, this is where the field of computational photography is blooming, and in five years that would probably be a subject of a book on its own.

In a nutshell

Tonemapping operators (TMOs) convert HDR images to LDR images. There are two fundamental classes: global operators and local operators. Global operators apply a fixed rule to the entire image; local operators do more complicated stuff. They react to the content of the image by evaluating the local neighborhood of each pixel, emulating the local adaptation mechanism of human vision and using the frequency domain to isolate and enhance details. In short: global operators are more predictable and local operators are more powerful.

4.2 The Art of Toning

Does all this talk about tonemapping sound like rocket science to you? I can't blame you; the last pages do appear awfully academic. What I was showing you was a mere analytical overview of several tonemapping operators so you get a rough idea of what's going on under the hood. In real life, however, none of these approaches alone will get you all the way to the final destination. In real life there is much more creative tinkering involved, and applying a TMO is only one step in the workflow—an important step, but by far not the only one. In the 10 years since photographers have picked up tonemappers, they have used and abused them in every thinkable manner, and by now these tools have matured into creative powerhouses that go well beyond the plain academic purpose of compressing HDR to LDR images.

The science of tonemapping has now become the art of toning.

Toning is a slightly sloppy term that I overheard in casual conversations between HDR photographers. It describes the creative process of using whatever means necessary to derive a nice photograph from an HDR image. *Toning* is very similar to the terms *color timing* and *grading* in cinematography, which describe, in an equally unspecific and technically incorrect manner, almost the same process of sweetening an image and altering it in creative ways. Yet these terms sound cool.

I will use *toning* whenever I'm talking about the creative aspects of tonemapping. It's a tiny linguistic twist that helps me make the text flow more natural, and I encourage you to do the same. *Toning* doesn't sound like rocket science, and it subconsciously conveys a much more active involvement on the part of the photographer. Yet, it's still a million times more accurate than the faux pas of labeling the final result an HDR image.

Figure 4-18: *Natural toning is the invisible art of improving an image in unobtrusive ways. When it's done successfully, nobody suspects that the image couldn't be captured in a single shot.*

4.2.1 Disciplines and Objectives

There are lots of different possibilities, with a wide scope of results and more powerful options than ever before in digital imaging. And to quote Uncle Ben, "Remember, with great power comes great responsibility." At the end of the day, tonemapping serves a particular purpose, so it's a good idea to keep the objective in mind when you're making stylistic decisions.

Natural toning

Also referred to as *true-tone-mapping,* this discipline is an invisible art very much akin to the art of visual effects. Natural toning is supposed to be unobtrusive; the visual style should not deter from the main image subject. Ideally, nobody will recognize that HDR was involved in the making—or that the image was even retouched at all. It's not about artistic expression. It's about creating an image that looks like it was shot with an ordinary camera but incorporates more dynamic range than a camera could

actually handle. Here HDRI and tonemapping are just tools used to get around hardware limitations. The advantage can be highlight recovery, noiseless shadows, or mastering difficult lighting situations. Professional real estate photographers, who are facing the "Room with a View" problem on a daily basis, have become masters in natural toning. Their clients want properly exposed images, not artwork. Processing artifacts that draw the attention away from the main subject have to be avoided at all costs. The most common artifacts are halos, excessive coloration, and tone reversal, and any one of them will spoil the natural appearance. We will have a detailed look at all these artifacts in a little bit.

Excessive digital processing is nothing new. Since the invention of the saturation slider, it's been very easy to overdo an image. With an HDR image as the starting point, there is just more information to pull from, and especially with local operators there is a huge temptation

Figure 4-19: *The new impressionism takes photography on an off-road trip. This painterly style is only one of a million ways this can go; it doesn't even try to hide the fact that the image was heavily processed.*

to go too far. Global tonemappers are generally safe to use because they are immune to artifacts. Yet there is more to gain from local TMOs, and if used with caution, they can seriously enhance an image. The line between too little and too much is very thin. How much is enough is often a matter of personal opinion.

Natural toning is probably the hardest and yet least-appreciated branch of tonemapping. Drawing the parallels to visual effects again, it's the invisible effects that require most work and carefulness. Everybody knows that a spaceship battle is created all digitally. You couldn't film that, so that's a very obvious visual effect. It just has to look cool; the primary objective is to go crazy and make it burst of creative energy. On the other hand, an example for an invisible effect is to convincingly replace a live-action airplane, maybe because the script calls for a 747 instead of an airbus. But that was not available when the scene was shot, or maybe production couldn't even afford a plane in the first place. Creating a photo-realistic airplane from scratch

takes just as much effort as creating a spaceship, but you have been successful only when nobody sees that you did anything at all. The correct compliment to the artist would not be "Awesome VFX" but rather "What, there were VFX in there?"

The same goes for an image toned naturally. You have already failed when somebody comments, "Love your HDR processing." That's why this kind of tonemapping is not in the public spotlight. It has less of a wow effect. When it's done right, barely anyone takes notice. Only a before-and-after comparison makes people appreciate the achievement.

New impressionism

If you don't care about a natural look but rather want to create a piece of art, then you will just love how local TMOs allow you to squeeze every little detail out of an image. Once you completely twist the ratio of detail contrast and overall scene contrast, the image turns into something painterly surreal. We are not used

Figure 4-20: *This backstage area of a burlesque circus literally called for a twisted gritty look. If looking at this image makes you hear hysteric clown laughter over an off-tune melody, that is completely intentional.*

to seeing that in a photograph, but *painterly* is the key word here. Painters cheat the scene contrast all the time; it's part of their artistic arsenal. With creative toning techniques, this is now part of a photographer's arsenal as well.

We've discussed before how traditional photography and the sensation of human vision are two different sides of a coin. And when an artist creates an image according to his or her personal interpretation of a scene, there is no point in arguing that it doesn't look real. If you're looking at a Vincent van Gogh painting and mumble, "What is this crap—sunflowers don't look splotchy like that," then you're missing the point of what art is all about. And people in the gallery would give you funny looks. At least now they would; back in the days when painting just started to convey these new forms of artistic expression, there was a lot of resistance from the traditionalists, calling it a trend that would fade soon. History repeats itself, but this time it is photography that is evolving away from purely realistic imagery toward something that is more of an artist's personal impression of a scene. And what is a "truthful

representation" anyway? When a skilled artist manages to capture the emotional beauty of a scene, the intangible living essence, there might be even more truth in that than just the mere physical reality of turning incoming light into pixels.

It's worth exploring the possibilities and taking photography to the next level of artistic expression. So there you go: Start playing, express emotions, find new styles! One inherent danger is lingering within, though. That's when you allow the style to be dictated by the software. But with some practice and a clear target in your head, you can literally elevate your image to new dimensions. Just do me one favor. Don't call it HDR anymore! New styles deserve a new name. Call it impressionistic, painterly, hyper-realistic, grunge, glamour, anything original. The generic term *HDR* would be an understatement; it doesn't say anything about your stylistic intentions. Bring up the confidence to admit that it was *you* who toned the image and not some generic software "making it HDR."

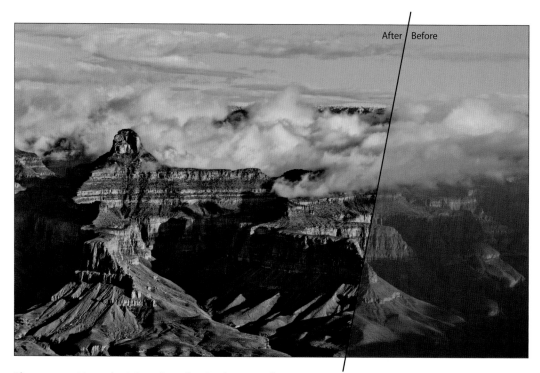

After | Before

Figure 4-21: *Atmospheric haze is easily wiped away with tonemapping techniques. Recovering all these details from the murky shadows is exactly where local TMOs excel.*

Haze removal

Landscape shots often have a lot of atmospheric haze, especially when a vista stretches far into the distance. Sometimes that may be a desired effect, but more often you would rather see clearly all the way to the horizon. It's not exactly what they're designed for, but local detail enhancement algorithms just happen to be well suited for enhancing clarity and punching through this haze. And that works even though the overall scene contrast typically doesn't justify a real HDR shoot—a single RAW is normally all you need for this application.

Just like natural toning, this is actually a reconstruction job. It's very tempting to overshoot, especially when you start to discover more things than you could actually see with your naked eye. But ultimately, you want this to be a natural image that looks like it was shot on a clearer day. It helps to mentally set this goal up front.

Since you're boosting contrast in the horizon area quite a bit, this process needs very clean and noise-free image data to begin with. Otherwise the image will break up and look manipulated. Shooting RAW is essential, at the highest possible bit depth and the lowest possible ISO. Browse back to section 3.2.9 for some hints on pseudo-HDR conversion. Even if the hazy horizon will fit in a single RAW, it doesn't hurt to combine multiple exposures just for the sake of averaging out the last bit of noise.

Texture extraction

When people think about using HDRI for computer graphics and VFX, they often overlook the applications of tonemapping for preparing texture images. The importance of good reference

Figure 4-22: *Extracting texture details and eliminating the lighting effects—these are extremely useful tonemapping effects for creating texture maps for computer graphics and games.*

material cannot be overstated. Ideally, it should be free from direct illumination and shadows; instead, we need to see the material, texture, details, and shape.

By classic doctrine such texture images need to be shot under overcast lighting, or at least in the shade. But it's not always that easy in real life. What do you do on a car commercial shoot in the middle of the desert? The car doesn't actually run; this is going to be your visual effect. It's noon and there is no shade anywhere. There is a group of lurkers called crew, but they certainly won't push that car around just so it's lit nicely for you. Instead, they give you precisely 15 minutes to do your thing, while they leave for lunch break. What do you do in a situation like that, when you have absolutely no control over lighting? Well, you take what you can get and shoot brackets like a maniac. Back in the office you have all the time in the world to merge, stitch, and tone something useful together. In this example it resulted in a 7,000-pixel-wide texture for a Ford Mustang, stitched from three views and nine exposures each.

In this context, the point of tonemapping is to take the lighting out. Once the image is texture-mapped on a 3D object, you will ap-

ply your own light anyway. Shading, shadows, glare, reflections—all these things do not belong in a texture map. It doesn't even have to be an extreme case like this harsh sunlight in the example image of the Mustang. Almost any photo with nonuniform lighting has some sort of lightness gradient that makes it hard to turn it into a seamless texture map. So, tone like the devil, and use local operators to suck all texture details out.

Real-time rendering

Video games have become incredibly sophisticated in recent years by borrowing many techniques from visual effects production. Essentially, modern games are rendered computer graphics, running on real-time engines that simulate real-world HDR lighting and create a constant stream of high dynamic range imagery.

Ironically, what gamers call the "HDR Look" used to be the direct opposite of what photographers commonly associate with this term. Early games featuring HDR were rendered in super-high contrast, with blocked shadows and blown-out highlights, often accompanied by dramatically exaggerated glare and lens flare

Figure 4-23: *Tonemapping plays an essential role in real-time rendering. It defines the look and enhances the cinematic appearance of high-end games like* Uncharted 3 *by Naughty Dog.*

effects. Everything was simulated correctly according to the books, but it didn't really look so convincing until game makers started to master tonemapping.

In this real-time context, the tonemapping operator can be considered the virtual camera the game is shot with. It has to dynamically meter the exposure as the player travels across varying lighting conditions and constantly readjust exposure accordingly. But that is only half the story. A simple exposure adjustment doesn't make it cinematic enough, and that is where most early games failed. Nowadays tonemapping operators also take on the role of virtual film stock. These algorithms use complex rule sets and custom tone curves to keep some indication of detail visible in shadows and highlights. The way the tones in between are distributed and how that virtual film stock responds to colors are nowadays crucial elements to define the look of a game. That can be the gritty bleached look of a militaristic ego shooter or the award-winning picturesque look of the *Uncharted* adventure series—in any case, the tonemapping style is meticulously crafted to express a certain mood and support the overall art direction. High-end games even contain a data track, where the game artists can animate exposure and other tonemapping parameters along with the camera motion, so it becomes a truly handcrafted experience.

Typically, games use global tonemappers for performance reasons. Local enhancements will surely come up in the future, but they are not urgently necessary because game makers have total control over lighting and textures anyway. They can simply tweak their world to have a lower contrast to begin with. However, these real-time tonemappers are still capable of adapting dynamically to changing lighting conditions and applying some very controlled looks. That makes them work well for batch processing, time lapse, and HDR video.

Local Tonemapper Global Tonemapper

4.3 Best Practice Tips

Exploring the wide range of toning possibilities is fun, but it can also become overwhelming. The sheer amount of different looks available makes it often hard to decide what way to go. Most people start out wild, experimenting with the surreal and ecstatic side before they tame down to use HDR in socially acceptable doses. This might be the most joyful journey in your life as a photographer, and I highly recommend following your intuition and finding your own path.

However, allow me to sketch out a rough map of aesthetic concepts to take along on your journey.

4.3.1 Seven Aesthetic Considerations

These are not rules set in stone. They might not even be guidelines. They are just some ideas to meditate over, designed to put some rational reasons behind your toning decisions and show you how these decisions will affect the perception of your image.

Details attract the eye

Classic HDR tutorials always concentrate on recovering maximum detail everywhere. But is that always helping the image? Compare detail enhancement with the way focus is used in photography! We pay a lot of money for fast lenses that enable shots with a shallow depth of field and a nice bokeh effect—essentially showing *less* information in the out-of-focus area. Here is the lesson to be learned from that: When the entire image equally bursts of detail, your audience doesn't know where to look first. It implies that everything is important, which is the same as saying that nothing really is.

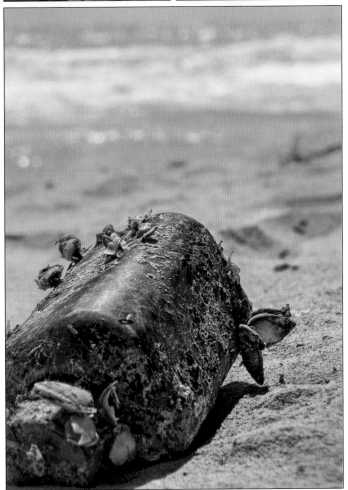

Figure 4-24: *A crusted bottle that I found on the beach. Tonemapping foreground and background separately helps to concentrate the amount of detail to the focused area.* ▶

Mixed together, using the Local TMO version only for the focused areas.

Figure 4-25:
Burned-out in-dustrial ruins. The magic of this place is somewhat lost when there is too much to see at once.

Making every detail obvious is often counterproductive.

Leaving some things to discover can keep it interesting.

Detail is your tool to guide the viewer's eye to the most important area; it's the visual equivalent of an exclamation mark and can be used for the same artistic purpose as focus and sharpness. The twist is that detail enhancement is much more subliminal; the viewer doesn't have to realize that his attention is guided to a particular area of interest. When used in tandem with focusing techniques, selective detail enhancement can have a tremendous impact. The actual workflow is dead simple: Just tone-map the image twice, one version soft and one harsh, and then use soft masks to transition between them in Photoshop. Section 4.4.4 shows this technique in a tutorial.

Even if you're not actively using this technique, you should stay alert for the eye-grabbing effect of detail rendition. When a random object in the scene happens to react to your to-nemapper with exaggerated detail, it may steal away your viewer's attention. Clouds are very prone to this behavior, which is perfectly fine as long as these clouds are *supposed* to be the key element of the image.

Never underestimate your audience

You might be able to produce an image that perfectly emulates the way human vision adapts to local contrasts. But until you have the technology to directly implant this into a viewer's brain, consider that the same mechanism is working in your viewer's eye. If your image is on a print or on a screen, it will be looked at by another human observer, passing the same local adaptation filter again. Give your viewers a chance to let their eyes work, allow them to actually discover things in the image. Otherwise, they might feel unchallenged. If you make

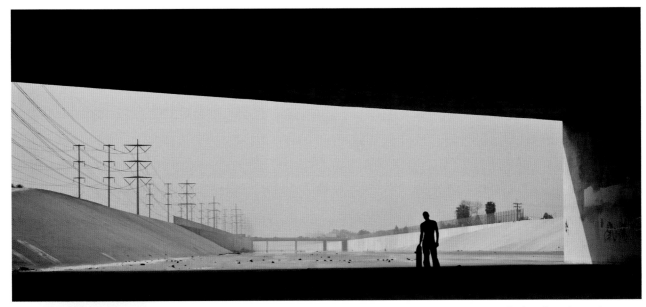

Figure 4-26: *This shot of a skate spot at the L.A. River works better as a silhouette. It's a rather bold example that doesn't require any HDR techniques at all—just take it as a reminder that deep shadows are perfectly suitable image elements.*

every single detail screamingly obvious at first glance, there is nothing left to discover and your image ends up flat and one-dimensional. In fact, it even gets harder to grasp the core content of a photograph when every single detail is waving its arms yelling, "Here, here, look at me." It's too much information, and that makes it harder to find a point of entry to get into the picture.

It's just like storytelling in mainstream blockbuster movies versus authentically interesting movies. Blockbusters are so dumbed down that they have to rely on fancy special effects to attract an audience. Their stories are flat, and everything is explained and spelled out in big letters. But the really interesting movies let you unfold the story yourself. They allow you to read between the lines, and they have a second layer of interesting things happening that you catch only when you see it the second or third time. It appears that these movies are more realistic, but of course that is a very carefully constructed realism according to the director's

vision; it's some artist's imaginary reality.

Photographs are no different. You want to provide an obvious structure to grab the attention of your audience and then hold it by hiding some details in the subtleties of light and shadow. People will see them, don't worry; you just have to make the image worth exploring.

Don't be afraid of the dark

Deep shadows are perfectly suitable image elements. They may contain subtle details, but if you keep them just barely visible you actually help the discovery score that I just mentioned. More important, deep shadows give an image the impression of overall contrast. A common beginner's mistake is to bump up all shadows at all costs—regardless of whether this boost is beneficial to the image or not. Sometimes that just washes out the beautiful lighting. Sometimes the mood goes overboard completely. Sometimes a silhouette may even be more interesting.

Figure 4-27:

Figure 4-27:
Wide-angle shot of Bryce Canyon at dusk, toned with harsh local adjust-ments and aggres-sive detail boosts in HDR Efex. Browse to this book's introduc-tion to compare the visual appearance of a larger print.

At thumbnail size the image has a slightly artificial feel ...

... whereas a cropped section at original size appears natural.

If you really think about it, compressing the dynamic range so far down that everything lands in the midtones technically results in an extra-low dynamic range image. That may be a desired effect when you're specifically tone-mapping for output to an LDR device (let's say the Amazon Kindle), but in most other cases an image without any shadow depth just appears stale. Ironically, such overall flatness is the sig-nature look of images subtitled "My first HDR."

The real benefit of HDR processing lies in the fact that you can *steer* the shadows to fall exactly where you need them to. But if you eradicate shadows completely, you're giving up that opportunity.

Size does matter

Let's remember how the local adaptation mechanism in human vision works: It changes the appearance of brightness for different areas *within the field of view*. Now consider that this also applies to the situation when your image is being viewed.

If your image is rather small, covering only a fraction of the viewer's field of view, it will be perceived as one coherent area. All your viewer will respond to is the large-scale contrast and structure, and if that is overpowered by small details, the image will appear noisy, cluttered, artificial. This problem is very pronounced when images are posted online because your

audience will get the first impression from a thumbnail-sized version.

Conversely, if you intend to print your image in 24-by-36-inch poster size, you can expect it to cover a rather large field of view. As your view-er's eyes wander across the image, only small portions will be perceived at once; the rest will be pushed into peripheral vision. In this case local contrasts are the dominant impression and stronger tonemapping settings will work to your advantage. The same applies to panora-mas in an interactive web display because the online panorama player will never show the full image, just a much smaller crop.

It is a good practice to work on your image in the actual presentation size, to make sure it achieves the desired effect. If that size is too big to fit your screen, zoom in and pan around. Your viewer's eyes will do the same. The hardest task is to create an image that looks right at any size because you will have to strike a very delicate balance between small-, medium-, and large-scale contrasts. It helps to keep an eye on the thumbnail-sized Photoshop navigator window, but you'll most certainly achieve a compromise at best. If your final presentation size is known, you can optimize visual impact when you con-centrate your efforts on making it look great in the exact output size.

Define your output medium

Tonemapping for screen display involves different rules than tonemapping for print. The principal difference is that colors on screen are mixed by adding light together, whereas in print the colors subtract each other. Okay, that sounds more like a technical reason, but it has consequences for our perceptual habits.

Looking at a print, we are most sensitive to clipped highlights because in those areas, we only see paper white. This means, literally, all we see is the paper and its structure, which makes the image visually fall apart. Glossy photo paper reveals its sparkling micro-crystal coating, fingerprints really stand out, and it gets even worse when you print on canvas for the purpose of fine art. Unprinted spots on canvas never look good; we instantly recognize the woven structure of the fabric as on an unfinished painting. So the priority when tonemapping for print is highlight protection.

Screens are the exact opposite. Here, blocked shadows show up as black splotches. And since most people have their monitor's brightness cranked up to 11, these aren't really black but rather muddy, darkish splotches without any texture. In large black areas, people see all the dirt on their screen and start thinking about scheduling a dusting session instead of adoring your photo or movie. I don't really know what it is, but pitch black never looks right on any screen and is therefore an outlawed color in screen media and TV production. That's why shadow detail has priority when you're tonemapping for screens.

Figure 4-28:
Screen display is most sensitive to blocked shadows, but in a print, highlight clipping looks the worst. Try it for yourself: Hold a print against your monitor and compare the appearance.

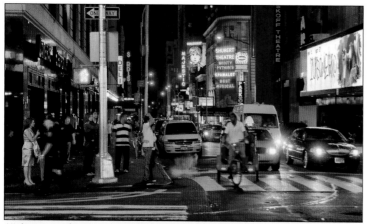

Night scenes often turn out more colorful than the human eye actually sees them.

Desaturated and tinted with a pale blue, the image is more realistic but less stunning.

Figure 4-29: *New York street corner at night. If you aim for a realistic look, you have to let go of the stunning colors.*

Conversely, straight black on paper and full white on a screen are somewhat acceptable. At least they don't pull us out of the picture entirely, and if used with caution, they can maximize to the overall contrast.

At night all cats are gray

Looking at a night scene, our eyes sacrifice color vision for contrast enhancements. Neon lights may peak out of this scheme, but the general saturation level at night is nevertheless perceived lower than by day. Cameras do not share this behavior. Especially long-time exposures

often turn out much more saturated than what we really see, and when combined in an HDR image, all this recorded color information is accurately preserved.

Toning night shots can therefore reveal an unexpected amount of color. This can yield surreal and otherworldly effects, which can be rather stunning and are worth exploring for expressive looks. But if the toning is intended to create a natural look, excessively vibrant colors will work against your goal and should be muted down. Many scientific papers have been published on this topic and resulted in tone-mapping operators like Photoreceptor, designed to suppress colors as human vision would. That doesn't mean you have to restrict yourself to using special TMOs, but it helps to keep the general concept in mind.

What's acceptable, and may actually be desired, is a pale blue tint. That might be rooted in the fact that cold blue moonshine is the archetypical illumination at night, or that our eye's color receptors (cones) are actually less sensitive to the blue end of the spectrum than our contrast detectors (rods) are. But maybe it has even less to do with human vision than our cultural experience of looking at images and movies. This blue color cast in night scenes is also known as *movie-dark*, and it's always been the film industry's favorite trick to avoid the black splotch problem mentioned earlier. Blue can still carry a lot of contrasts and details, and it will still *feel* dark without actually *being* dark. It's such a strong impression that the pale blue tint alone implies that we're looking at a night scene. That comes in rather handy when shooting day for night, as section 5.1.1 demonstrates with a tutorial.

Texture versus lighting

One side effect of enhancing texture detail is that it reduces the appearance of shading and light. You can have both to a certain degree, but you can drive only one up, at the cost of the

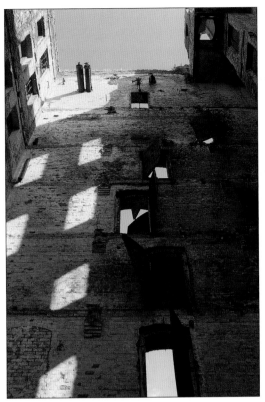

Toned with emphasis on lighting.

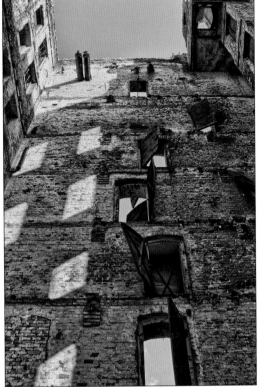

Stronger settings emphasize textures.

Figure 4-30:
Inside of a burned-out paper mill. A stylistic decision has to be made between focusing on lighting effects or texture details.

other. Once again only you can decide what the right balance should be, depending on the effect you're going for.

Images with dominant texture detail have a descriptive and revealing character and are often perceived as harsh or grungy. Dominant light and shading puts the focus on mood and emotion; and when you concentrate your efforts on emphasizing these qualities you achieve an effect that can be called dreamy or glowing. There are countless variations between these extremes, and if you're clear about your own intentions, you shouldn't have a problem finding the texture/light balance that works best. This is also a case-by-case decision, heavily determined by the image content.

4.3.2 Systematic Approach with Zones

Maybe we can learn a thing or two from the old masters. Ansel Adams became famous in the first half of the last century for his exceptionally well-exposed landscape photographs, even before color photography and automatic light meters were common. His photographs had so much visual impact that even the bigwigs in Washington were moved to open a flurry of new national parks in his wake.

Among photographers, Adams might be even more famous for teaching his technique. The key element of his method is *previsualizing the outcome,* which means mentally evaluating how luminance values in the scene should be represented as tonal values in the print. He basically pictured the final photograph in his mind's eye first. According to this predetermined target, he would decide on the correct

exposure, taking into consideration the limitations of the film material and already sketching out a plan of how to use selective re-exposure techniques in the darkroom to create the final print. Literally, he drew scribbles on paper describing the areas where the exposure needs to be dodged or burned, complete with little numbers indicating by how many EVs. Do a Google search for "Ansel Adams Printing Notes" for some fascinating insights.

Sound familiar? Considering our HDR images are truthful digital representations of the scene, Adams's method is in fact a road map to successful tonemapping. It was shamefully neglected since the advent of autoexposure, encaged in program modes of point-and-shoot cameras, but the thought process behind is now more relevant than ever. So how did Adams do it, and how can we transfer his wisdom to the digital age?

Enter the zone system

Adams's trick was to divide the overall scene contrast into distinctive levels of shades, called zones. This provides a mental reference frame of how things are supposed to turn out in the final result, just as a coordinate system provides the reference frame for a chart. Many photographers live and breathe Adams's zone system in its original form, but I think it should rather be seen as a guideline than a set of strict rules. What really counts is the idea of working toward an anticipated result, and thinking in terms of zones provides the training wheels to do that.

Originally, Adams defined 11 zones, numbered with Roman numerals.

Zone 0 is pitch black, V is mid-gray, and X is total white. Roman numerals are a small but important detail because if you squint your eyes and forget for a moment that they repre-

sent numbers, they could also resemble graphical tick marks surrounding the V in the center of the scale. With one glance at the roman VII you can tell that it is two zones (ticks) away from the middle V. If regular numbers were used you would only see a 7; and that by itself doesn't tell you what the center is or how far away it is. So, roman numerals carry a built-in meaning that is useful for easy recognition.

The elegance of this approach is that each zone equals one EV span, conveniently in sync with a good film's latitude—the dynamic range that can be captured on a film negative. That makes it technically very accurate, even today. But for many people, including myself, the visual gray difference between each zone is too small, which ultimately works against the goal of providing a helpful mental framework. It's too tempting to just give up and go with your gut feelings.

So let's derive a simplified version; a mash-up of Ansel Adams's zones, some common sense, and the fundamentals of mixing a palette for oil painting. You will see that seven zones are really all we need to consider. Instead of building them up one by one, let's deduce them step-by-step by repeatedly dividing the tonal range.

The first and most basic division would be *Black*, *Midtones*, and *White*.

Black and white are really just the upper and lower end of the scale; that's where pixel values are clipped off. You want to avoid these zones unless you have a special effect like silhouetting or background isolation in mind. More useful are the tones just before these end points—the *Shadows* and *Highlights*.

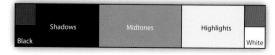

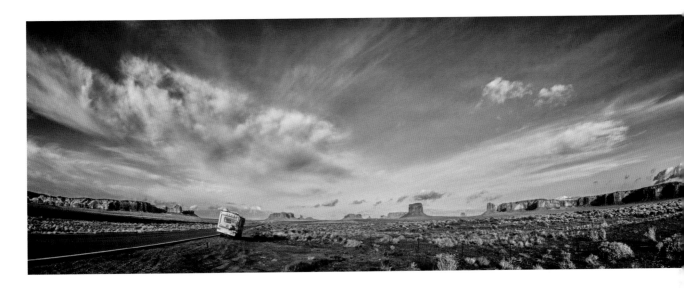

Figure 4-31:

A caravan stuck on the road to Monument Valley.

In a way, these five zones are already the de facto standards of digital image editing, simply because they make so much sense. They are enough to describe broad structures and basic layouts. However, it's a pretty far stretch to compare it to the fine differentiations of Adams's zone system. For some meaningful image evaluation, we need another subdivision. So let's split the center into darker tones, midtones, and brighter tones.

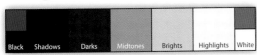

These three middle zones are the meat of the image, where we can see most of the form and shading. And voilà, that's all we need: seven zones total, five of them actually useful for holding color information (because black and white can't) and three zones in the center to hold the main subject. This is the easy zone-esque system.

Call them by name!

We don't even need to number these zones. Names are just fine: *Black, Shadows, Darks, Midtones, Brights, Highlights, White*. It's much more intuitive that way. The idea is now to look at an HDR image and point out what image element should belong to what zone. This will get our mind clear about their relation to each other and give us a rough ballpark figure of how bright each image feature should be.

For example, let's evaluate this landscape shot from Monument Valley by naming each element. The clouds are mostly in the *Brights*, occasionally dipping into the *Highlights* zone. I want to create some stark contrasts, so I set them in front of a *Midtone* sky. The table mountain in the background goes into *Midtones* as well, taking a center stage in this shot. The rest of the ground spreads across *Midtones* and *Darks*, and the long distinct shadows should clearly be in the *Shadows* zone. The caravan is a special point of interest that should stand out as a *Highlight*.

Yes, it's so simple that it almost sounds silly. But when frantically dialing on all those knobs and sliders in a tonemapping program, we can now constantly evaluate if the image elements still live up to their names—for example, if the clouds on the horizon still seem bright in comparison to the midtone table mountain. We could also hear the alarm bells ring when halfway through the tonemapping process the long shadows on the ground are brightened up until

Figure 4-32:
Zone chart of the assignments for this image.

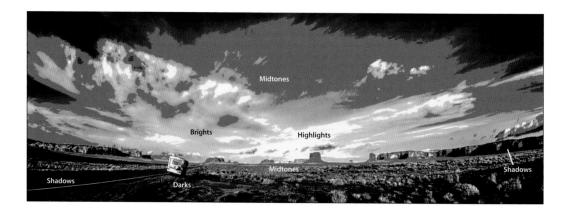

they appear merely darkish. Because then they would blend in with the dark ground, and the clear separation of the shadow zone would disappear. Thinking in zones provides a much-needed sanity check and becomes utterly useful when faced with a myriad of "what if..." decisions. Pick a zone name and stick to it.

Sometimes the zones are harder to see than you would think. It helps to squint your eyes and scale the image down to thumbnail size. In Photoshop you can also use a stepped gradient layer to get a visual representation in the form of a zone chart. In fact, there's a gradient preset for you on the DVD, and I will show you in section 4.4.1 exactly how to use it. But don't feel obliged to slavishly stick to that preset; the exact definition of each zone's brightness range may well depend on the scene and your own rendering intent. We're not after image metrics anyway, but rather the visual impression—so it's completely fine to trust your instincts when calling out the zones. Also, nobody says you have to populate every zone. If you're specifically going for a more painterly look, you may choose to settle everything in the *Midtones* with only a few *Highlights* sticking out. But at least this zone-esque system gives you a language to formulate your goal, which will lead to a very straightforward toning workflow.

If all that sounds too sloppy to you, there's nothing holding you back from applying the same thought process to Adams's original zone system. Then you would assign 11 zone numbers instead of names and stick to those assignments throughout the tonemapping process. Just do a Google search for "Ansel Adams Zone System" and prepare for an afternoon of heavy reading. Personally, I will use this easy zone-esque system and scatter a few more of these handsome zone charts throughout the book.

4.3.3 Beware of Common Artifacts

No matter what your artistic intentions are, you should always be aware of some particular artifacts that may appear when processing HDR images. For natural looks you want to avoid these artifacts, for impressionist pieces you want to keep them at least under control, and if you feel artsy today, you may want to embrace them. But in any case, it always starts with your ability to spot them.

Halos

Bright glows around dark edges are called halos. They often appear on high-contrast building edges against a bright sky or between the branches of a tree. Halos are a dead giveaway that an image was doctored; in appearance they are very similar to over-sharpening artifacts or a heavy-handed Unsharp Mask filter. There can also be dark halos (dark glows on bright edges), but these are less common and less obtrusive.

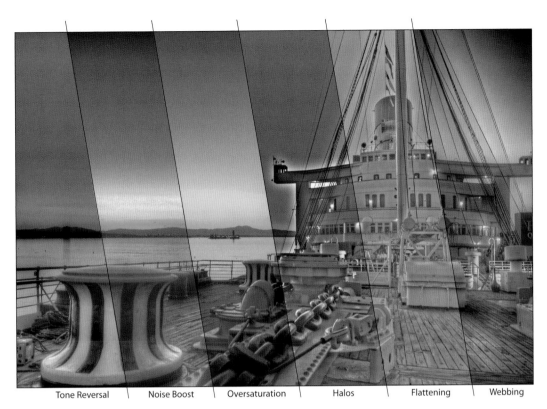

| Tone Reversal | Noise Boost | Oversaturation | Halos | Flattening | Webbing |

Figure 4-33:
Compilation of typical tonemapping artifacts, each one driven to the extreme.

Global tonemappers are immune to halos, and most local tonemappers nowadays have a dedicated halo reduction built in. In some rare cases, halos can also benefit an image by adding a strong separation between foreground and background.

Tone reversal

This term means that large image areas have swapped overall brightness levels; for example, the sky may suddenly appear much darker than the foreground. Some people call it *contrast reversal,* and it can also happen on a smaller scale. An obnoxious example is a dark spot in the middle of a lightbulb. Tone reversal is often accompanied by halos as the result of excessive noodling with the image. Global tonemappers are immune, and when using local TMOs, thinking in zones is the best way to keep a thumb on tone reversal. Used with caution in the context of artistic toning, tone reversal can lead to very dramatic results and may even be a desired effect.

Noise boost

Local tonemappers are like watchdogs, trained to snoop out details everywhere. Especially when applied without smoothing or with a small radius value, they sometimes confuse residual noise with valuable details worth exaggerating. Smooth gradients like clouds, clear skies, and flat walls are often affected and start looking grainy. One way to prevent this is to start off with a cleaner HDR image. Shoot at the lowest ISO and consider shooting more exposures with smaller EV steps so the noise will be averaged away during the merging process. Another way is to treat the affected areas afterward with a noise removal filter. Noiseware, Topaz DeNoise, Neat Image, and Noise Ninja are all great solutions for that.

Oversaturation

Although not directly connected to tonemapping, excessive color saturation seems to be a common problem. There is just too much temptation in discovering colors in places where you couldn't see them with your naked eye, and it's very easy to get carried away. Before you know it, you're stabbing your viewer's eye with a rainbow. Which can, I admit, also be fun sometimes. Just keep in mind that deep shadows and specular highlights have a crisper look with less saturation. After all, this is a matter of personal taste; nevertheless, I recommend turning the saturation slider all the way down first and then incrementally raising it slowly until it seems enough. Often you will end up lower than expected. It helps to do this on a properly calibrated monitor. But if you really want to embrace oversaturation for artistic purposes, make sure to tonemap directly into a wide gamut color space. Again, to judge the result you also need a wide gamut monitor, properly calibrated.

Flattening

When all highlight and shadow zones end up in the midtones, the dynamic range compression was taken too far. The image turns flat, and there is barely any global contrast left. This can be the result of obsessively exaggerating local contrasts and making every small detail span over the entire range of tonal values. The net effect is that every zone averages at the same midtone level. It's sometimes hard to judge when viewing the image full screen, but it becomes very apparent in a small size. Keeping an eye on the thumbnail-sized version in the zoom navigator usually does the trick. A more elaborate controlling method is visualizing the zones.

Sometimes a flat look is actually desired as an intermediate processing step for further refinements in Photoshop. It also sets the basis for painterly and stylized looks.

Webbing

Webbing is a very unique effect that happens to only a few specific images. Wires, poles, or tree branches, anything that is thin and crosses large sections of the sky, can effectively divide the background into cells. Local tonemappers, in all their smartness, have a tendency to treat each cell differently, which breaks the continuous gradient of the background into visible compartments. When this problem occurs, it is very persistent. Instead of twiddling with the settings and eventually sacrificing detail contrast just for the sake of suppressing this webbing artifact, you're better off making another version with a global tonemapper and patching it over the affected area in Photoshop. Even better, when the wires are unwanted anyway (as they often are), remove them in 32-bit mode *first*. Section 3.3.1 shows you exactly how.

Figure 4-34:
The zone system is a great crutch to keep tone reversal under control.

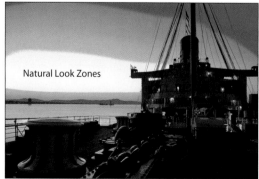

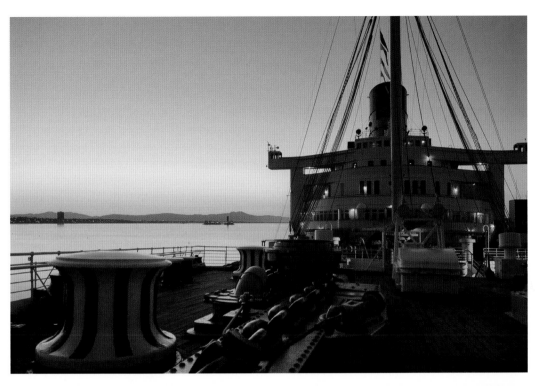

Figure 4-35:
Sunrise at the front deck of the Queen Mary. *Natural look with Picturenaut's Adaptive Logarithmic + PhotoEngine + HDR Expose, avoiding all artifacts to 100 percent.*

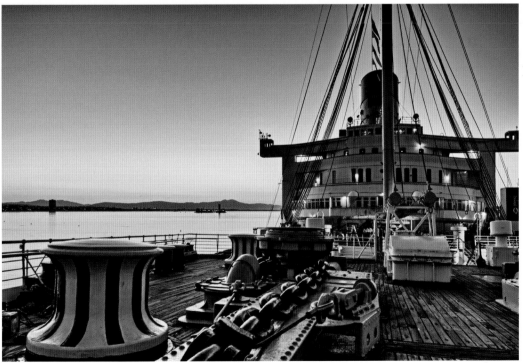

Figure 4-36:
I didn't actually have to get out of bed for this shot, which was a blessing and a curse. To my burning eyes after working an all-night shoot, the sunrise looked more like this to me—or felt like this, at least. Grungy looks may leave some leeway for tone reversal, but it's still good to keep an eye on artifacts before they sneak up on you. This image was made with HDR Efex + Photomatix + FDRTools.

4.4 Workflow Examples

Let's dive into the nuts and bolts of practical toning techniques. On the next pages, I will walk you through some exemplary case studies. This will be a tonemapping boot camp, introducing the actual workflow from start to finish in classic step-by-step tutorials. The point of this exercise is to make you familiar with some cherry-picked HDR tools, what settings are important, and the thoughts behind the creative decisions. I deliberately chose a completely different workflow for each example, just to cover more ground. In reality, every technique would work on every example, so they are completely interchangeable.

Because tonemapping is a relatively new discipline in image editing, there is no real standard of how functions are supposed to work. Esoteric slider names like Structure and Lighting are rather common, and often they will do something other than what you expect. At the end of the day, usability is king, and after you have tried several different programs, you will find the one that matches the way your brain works. There will be an *aha* moment, and from there on you can trust your intuition. You will also find out that most software differences are only surface deep: If you know how to use two or three of them, you can pilot them all.

Just reading this chapter won't get you anywhere. The only way to learn toning is to practice toning yourself. It's that simple. I highly recommend you move along with the HDR images provided on the DVD and then practice the same workflows with your own images several times. Soon you will figure out how to do it better, and that's when you have found your flow and I can consider my job done. I don't think of myself as a great photographer at all; your own photos are most certainly more exciting. Take your artistic inspiration from the guest artists scattered throughout this book, combine it with whatever I can teach you about the craft, and you'll be skyrocketing in no time. On the DVD you'll even find demo versions of all the programs used, so what are you waiting for?

Oh, one last thing before we can start.

Figure 4-37:
Monitor calibration is dead easy. Devices like the ColorMunki do all the work for you.

Calibrate your monitor today!

I know. That sounds like your mom reminding you to clean up your room. But seriously, I mean it! Toning involves a lot of meticulous tweaks to colors and contrasts, and there is no bigger frustration than taking your final image from a bad monitor to a calibrated one. Or anywhere else, for that matter. If your own monitor is not calibrated, everything you produce on it will look wrong to you in print, on the Internet, or anywhere. You might just as well work with purple hippie sunglasses on. All the intentional color choices you'll make, all the contrast and detail decisions—nobody will ever know about them because people will see something completely different. An uncalibrated monitor is throwing a giant monkey wrench into the whole concept of What-You-See-Is-What-You-Get. Calibrate your monitor, lad! Mom said so.

There is an abundance of color calibration devices out there. Myself, I prefer the X-Rite ColorMunki because it can also calibrate a printer and comes with a fancy pouch. Other products are Datacolor Spyder3, X-Rite Eye-One, PANTONE huey—any of them will do. They all work same way, and it's usually all automatic: You stick the device on your monitor, the software will display several color swatches, and a colorimeter inside the device will measure what it sees. Then it compares that to what the color should be, shows you how to adjust the monitor's brightness and contrast to get a closer match, and finally, generates a color profile that maps the remaining difference. Your screen will pop when this profile is pushed into your graphics driver, and then you're all set. The first time you do this drill is the hardest because the change will be so dramatic that you will want to switch it off again. Everything will look tinted blue or yellow. Don't worry, your eyes were just adapted to looking at the wrong colors all the time. After 10 minutes, you will have the opposite sensation when you switch it back.

Indeed, these devices can be expensive. I still urge you to get one. Don't put this on the back burner. Get a cheap one if you want. Pool together with a photo buddy. Rent one from your local photo store. Whatever fits your bill, but do calibrate you monitor today! It's recommended that you recalibrate every month, but quite frankly, a monitor that's at least in the ballpark is still better than a monitor that has never been calibrated. While you're at it, I strongly recommend wiping your monitor clean before each calibration. That thin layer of dust is guaranteed to mess up the black levels and distort the result. And besides, I can tell you from experience that nothing makes you feel more stupid than discovering that the spot you've been trying to clone stamp out for the last half hour is actually a speck on your monitor.

4.4.1 Monumental Landscape (with Photomatix & Photoshop)

 Finally, here comes the indepth Photomatix tutorial you've been waiting for. Thanks to Photomatix's popularity, this is the first HDR program most folks get in contact with, and it's also the first one they struggle with. It's not your fault. As explained in the quick review in section 2.3.9, Photomatix is a great all-round software package, and it excels in merging ghost-free HDR images (see section 3.2.7). But its tonemapping capabilities are average, to be honest, and it's not the easiest program to control. No big deal; the real secret lies in post-processing anyway.

Because this is the first tutorial in this series, it's moving extra slow. Don't worry, we will pick up the pace soon enough. As techniques increase in complexity, the later tutorials will reference things from earlier ones. For now, let's get started with a natural look, done with the most elemental toning workflow.

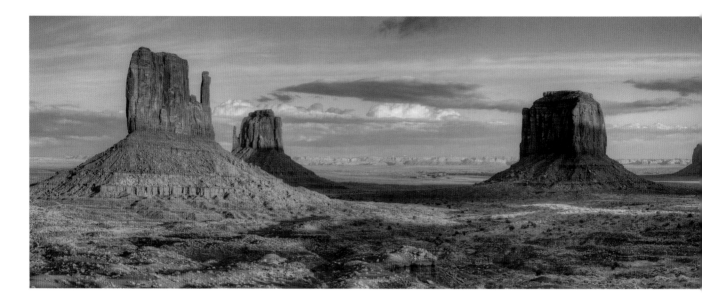

Figure 4-38:
This tutorial walks you through the creation of this Monument Valley shot.

Our tutorial subject shall be Monument Valley—a staple landmark of the American Wild West. Well, technically this is not even United States soil, but a small enclave of Navajo land. Don't even think about going there without an SUV or truck! Regular cars won't get you around the rough terrain, and the tour buses look like bobbing clown cars on a roller coaster.

I shot this image using nine-frame auto-bracketing bursts on a Nikon D200. Fixed white balance, aperture, focus—you know the drill.

The image you see here is actually just a section of a much bigger panorama. It was shot in several segments, all merged to HDR with Photomatix's batch processing (see section 3.2.10) and then stitched to an HDR panorama using PTGui (see section 6.4.6). Granted, this was the long route to arrive at this HDR master image, but that's just because I really enjoy panoramic photography and its built-in freedom to reframe after the fact.

➤ Part A: Getting started in Photomatix

Figure 4-39: *Start by loading the image and clicking the Tone Mapping button.*

Load MonumentValley_TightCrop.exr from the DVD into Photomatix to practice along. You can find the full-size panorama right next to it, so if you dislike my framing, feel free to crop your own version.

1 Photomatix initially opens the HDR file without any gamma correction, so it looks very dark and has ultra-high contrast. No reason to panic; everything is still there. That's just Photomatix's way of gently suggesting you should click the Tone Mapping button. Now.

Figure 4-40:
Welcome to Photomatix's tone-mapping preview!

2 The preview window appears. For the sake of faster interaction, Photomatix only lets you adjust the settings on a scaled-down preview image. Your first task is to set the preview size as high as your computer can handle.

Photomatix traditionally has problems with preview accuracy because its tonemapping algorithm always adapts to the image content. Especially, very sharp HDR images can loose their brightest highlights when they are scaled down, and then the algorithm will calibrate itself differently and your settings will have a slightly different effect on the full-scale image. The preview has become more trustworthy in recent Photomatix versions, but nevertheless, for total peace of mind, crank up the preview size!

Click the + loupe icon several times, and if the image gets too big for your screen, reduce the window size with the zoom slider. Note that the slider resizes only the window, but the loupe icons actually increase the size of the image itself.

3 Several built-in presets give you a rough overview of possible style directions. I always start with the Default preset, which is a good starting point for a natural look, and then I close the preview window to get it out of the way.

4 Photomatix offers two different tonemapping operators. Details Enhancer is the one that matters, and that's also the default setting.

5 There is also a very good hint mode in Photomatix. These hints are really incredibly helpful but easy to overlook: Click the purple orb all the way at the bottom of the settings panel (labeled with ?), and it will expand to a text box. Now you can roll over each slider and that text box gives a detailed description of what that slider does.

The amount of sliders in Details Enhancer can be a bit frightening, especially when you unfold the collapsed More Options and Advanced Options sections. Don't worry. Most of these sliders do very little. Only the first section is really important.

Here are my recommended tactics to find out what a slider does:

❯ Move it all the way to both ends.
❯ Observe how these extremes impact your image.
❯ Now find the point in the middle that looks best.

That may sound terribly simplistic, but in real life that's the best way to learn what's going on. Granted, for that you wouldn't need this book. So let me walk you through the settings in the recommended order of adjustment.

➤ Part B: Tonemapping with Photomatix

1 Lighting Adjustments is the most important slider! Lighting Adjustments (formerly called Smoothing) defines the size of the areas that are considered *local neighborhoods,* which is pivotal for all local contrast enhancements. Small values emphasize smaller details at the cost of overall contrast. That results in crisp and hyperreal looks, but it can also introduce halos. Larger values emphasize larger shapes and global contrasts, such as, for example, the division between sky and ground. Generally large values result in more natural looks, and emphasize lighting rather than textures. What setting to choose totally depends on the image content, the scale of shapes and objects, and the general distribution of light and shades.

Lighting Adjustments has such a pivotal effect that I always adjust it first. I incrementally drag the slider to the left, until the detail enhancement seems to grab onto the long shadows, and stop just before halos around the rock faces become obvious. A value of −4 seems to be fine here. That's totally subjective, of course.

2 Lighting Effects Mode is a small check box that changes the Lighting Adjustments slider into a button board of five presets. This is the classic mode; it's how Photomatix used to work until 2009, and it was brought back upon massive user request. Lighting Effects Mode allows a much wider range of looks, but the five-step control is also much coarser. For orientation, the slider ranges approximately between the Medium and the Natural settings. So, if you have moved the Lighting Adjustments slider all the way to the left already and you would like to go even lower, that's when you switch to the Lighting Effects Mode option and set it to Surreal. I can't really recommend it, though, because the Surreal presets are really harsh and will cause severe halos and noise artifacts.

3 Detail Contrast sets the amount of detail enhancement within the local neighborhoods we just defined. Lighting Adjustments regulates the scale, but Detail Contrast sets the *strength* of the local contrast boost. Generally, this strength can be pushed far up. Here I settle with a value of 4, but often I end up higher.

4 Strength regulates how far the dynamic range is compressed overall. It's the top setting because it takes care of the most basic tonemapping function: lowering the global contrast until it fits our LDR display. How much strength you need depends on the amount of dynamic range present in the original. High-contrast scenes need a higher value. Lower values generally tend to look

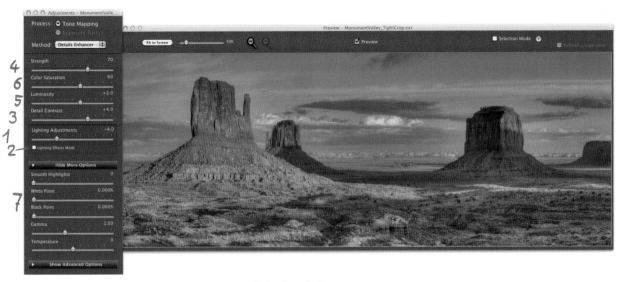

Figure 4-41: *The basic settings in the recommended order of adjustment.*

Figure 4-42:
Lighting Adjustments is the most pivotal setting, and that's why it should be set first.

more realistic, partly because they will keep you from overcompressing the global contrast. High strength values, applied to scenes that have a low contrast to begin with—that's a sure recipe for an artificial look. For this image, I find the default value of 70 appropriate.

5 Luminosity is used to lift up the shadow areas. Unlike the name might imply, it has almost no influence on the bright parts and highlights. A quick wiggle on the Luminosity slider is also a good way to see how big the local areas selected by your Lighting Andjustments setting really are. Generally, I bring the shadows up just until the

shadow details become visible but try to keep it as low as possible to maintain global contrast in the image. Luminosity values that are too high mush the shadows together with the midtones, which gives the image a flat and boring look. Thinking in zones is helpful here: We want to keep the image alive and maintain at least *some* tonal distinction between dark, medium, and bright areas.

6 Color Saturation is pretty self-explanatory. It does exactly what you would expect. Sometimes I pull this slider all the way down, just so I can better identify my zones and find just the right

settings for the other parameters. Give it a shot! Without the distracting colors your brain will be much more tuned into judging luminance zones and tonal contrasts. When you're done, you can still raise the saturation until it's enough. Here I decide that a value of 60 makes the colors pop just fine.

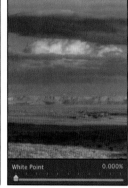

Figure 4-43: *Watch out for clipped white areas, and reduce the White Point setting if necessary.*

7 **White Point** and **Black Point** are direct equivalents of the Levels control in Photoshop. At this stage you have to make sure there is no clipping happening on either end. I tend to set these two controls to 0, even if that makes the image slightly darker. Only occasionally, when the global contrast is so weak that I can't make out the zones anymore, do I find it worth raising these values slightly. The exceptions are night scenes with a few mega bright lights and chrome surfaces with super-bright sparkles. In such cases, the White Point setting is useful to shave off some of the brightest peaks. But normally I set Black Point and White Point to 0 and leave Gamma at 1.

All the mission-critical settings are now covered. At this point the image should be looking slightly flat, but the zones should still be clearly readable. That means there shouldn't be any pure white or black on the screen, but you should be able to clearly point out shadows, dark tones, midtones, bright areas, and highlights.

8 Let's quickly go through the rest of the settings that are hidden in the More Options and Advanced Options sections. These settings are used for fine-tuning, and their effects are much more subtle. But at the same time, access to these finer nuances is what pros love about Photomatix. It's all about the details, so now you really need a large preview. Even better, open the Loupe window by clicking on an area with interesting details. The gap between the two table mountains will do.

9 **Micro-smoothing:** This one is closely connected to the Lighting Adjustments and Detail Contrast settings. It dampens their effect on the tiniest details found in the image. Or, let's say if Lighting Adjustments defines the maximum size of local neighborhoods, Micro-smoothing sets the *minimum* size of details that are considered as enhancement worthy.

A setting of zero literally enhances everything, increasing apparent sharpness of all details. It's often used for hyperrealistic looks. But zero Micro-smoothing can also lead to a lot of visual clutter, and if there is noise in the source image, that noise will get an extra boost as well. Finding the right value for Micro-smoothing unlocks the true power of Photomatix. It should be high enough to avoid artifacts and kept as low as possible to ensure crisp texture details. A value of 3.0 is a good compromise for this image; it keeps the pebbles from overpowering the larger rock faces.

10 **Smooth Highlights** and **Shadows Smoothness:** These two settings drill down Micro-smoothing even further, helping you out of the

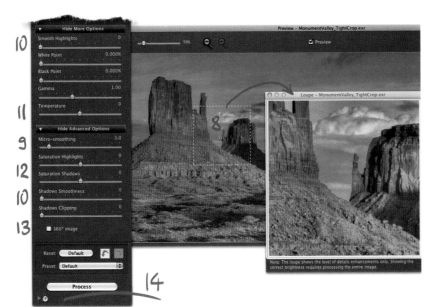

10
11
9
12
10
13

14

Figure 4-44:
The loupe is neces-sary to see the effect of Micro-smooth-ing, Smooth High-lights, and Shadows Smoothness.

dilemma of getting the sharpest possible micro-details *without* boosting noise.

Usually there is only one critical area where noise and halos become really obvious. On daylight shots that's the clear blue sky. Raising the Smooth Highlights value just a tiny bit, while keeping a close eye on the Loupe window, can often wipe grainy skies clean. Raising it a lot can even overrule a low Lighting Adjustments value (but only for the sky) and clean out halos in the process. In night shots, the Shadows Smoothness slider helps keep the noise in the night sky and other dark areas under control. Shadow tones often have more noise to begin with, so it often takes higher Shadows Smoothness settings.

The slider right below, Shadows Clipping, you shouldn't have to touch at all. It's meant for situations where your shadows are literally drowning in noise and your last resort is to cut them off. Well, if that happens you should reconsider your shooting method and browse back to section 3.2.2 for some hints on extending your bracket-ing series. In this example image, the sky is noise free already because I purposely overshot the dynamic range.

11 Temperature: The overall white balance should already be fine in the source material, be-cause you set it either during RAW development or directly in HDR space. So, tweaking the color temperature here is almost pointless, unless you feel the immediate urge to creatively alter the mood now. In that case, this is your last chance to do it in a lossless manner. Photomatix's color temperature ranges between warmer (more yel-low) and colder (more blue).

12 Saturation Highlights and **Saturation Shadows:** Adjusting the saturation of highlights or shadows independently isn't necessary for this image either, but on occasion these two sliders come in handy for problem solving. For example, lowering Saturation Highlights helps to eradicate a color cast on snow fields, chrome highlights, or the disc of the sun. On a sunset shot, however, you might want to raise Saturation Highlights to really bring out the sky colors. Same goes for Saturation Shadows. Strong luminosity settings, on a landscape shot with very high dynamic range, may not only reveal all the textures in the shadow areas, but also amplify an ambient blue color cast. Reducing Saturation Shadows just a hair can already get rid of it, keeping the look

more natural. Problems shots like these can be tackled with these extra saturation sliders. But normally I leave them all at 0.

13 360° Image: This last check box makes sure the left and right edge of the image get exactly the same treatment and afterward fit seamlessly together. This is absolutely critical for panorama shooters; everyone else can safely ignore this check box.

14 Done. Press the big Process button and save the result as 16-bit TIFF. ◄

So that was the extended rundown of Photomatix. I start my initial settings in that order, but because most parameters are interconnected, I always end up hopping around for fine adjustments. For example, raising Micro-smoothing will often allow me to lower Lighting Adjustments further without getting artifacts. Lowering White Point will slightly darken the image, so I compensate with more luminosity and strength to bring the shadow details back up.

Here is a quick recap:

CHEAT SLIP
Tonemapping with Photomatix

- Load an HDR file and press the Tone Mapping button.
- Increase the preview size and start with the Default preset.
- Set Lighting Adjustments and Detail Contrast to sketch out the intended style.
- Set Strength and Luminosity to balance out a nice separation of the tonal zones.
- Set White Point and Black point to minimize clipping.
- Balance detail enhancement versus noise exaggeration with Micro-smoothing.
- If necessary, smooth out noise and halo artifacts in the sky with Smooth Highlights.
- For night shots use Shadows Smoothness instead.
- Process and save as 16-bit TIFF.

There's no need to get overzealous with each setting. Photomatix's preview is not that super accurate anyway. Just remember that our image is supposed to look slightly flat, with low contrast and without clipping. We only need to get the look in the ball park by using Photomatix's special talents to compress excessive dynamic range. The final look comes together during post-processing. For that you need to maintain as much tonal quality as possible. That's why you should always save 16-bit TIFFs out of Photomatix.

We're halfway there. Finishing touches include a contrast boost, noise removal, final color tweaks, and sharpening. Essentially, this means treating the 16-bit TIFF from Photomatix like a freshly developed RAW image. If your regular photo workflow is centered around Lightroom, Aperture, or some other photo organizer/editor, then this is where you should perform these final adjustments. For this tutorial, however, I will proceed with Photoshop.

► **Part C: Finishing with Photoshop**

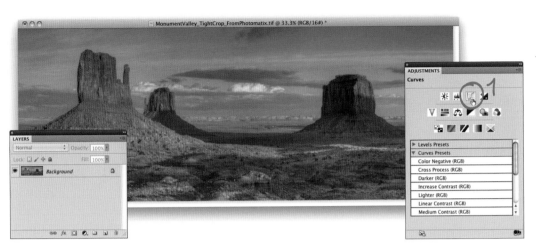

Figure 4-45:
Load the result from Photomatix into Photoshop and add a curves adjustment layer.

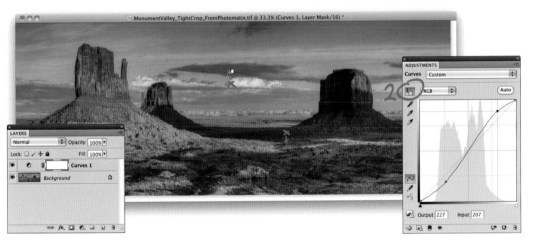

Figure 4-46:
With the finger icon enabled, you point directly at the image to edit the curve.

1 Contrast boost with curves: This is a common standard procedure. To work in a nondestructive way, use a curves adjustment layer on top of the Background layer from Photomatix. You can start with the Medium Contrast preset, or just shape a slight S curve from scratch.

2 In touch with the image: My favorite way of using the Curves tool does not even involve clicking in this small curve graph at all but rather to work the image itself. For that, you have to

enable the little finger icon in the corner of the curves window. Now when you're moving your mouse over the image, you can see a small circle dance up and down on the curve, indicating the brightness level of the pixel under your mouse. Simply click on a shadow portion in the image and then drag the mouse downward to darken it. That's right—literally pull down the shadows! It will automatically create a new curve point and adjust it accordingly. Do the same thing on a cloud again, but drag the mouse upward to

Figure 4-47:

Setting the curves layer's blending mode to Luminosity isolates its effect to tonal contrast only and maintains the original colors.

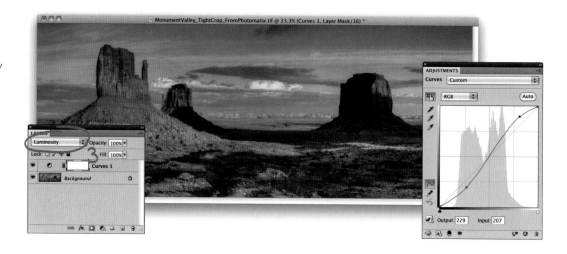

Figure 4-48:

Select all the areas where noise is really obvious. Most certainly that is the sky or other smooth uniform areas.

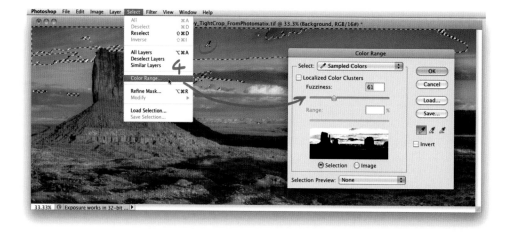

brighten it. Voilà, a perfect S curve, interactively created, giving the image just the contrast boost it needs!

Perfect? Well, take a closer look at the blue sky. Notice the color shift? The smooth steel-blue gradient that was already tapping into very bright territory has now shifted to baby blue. This is a common problem when curves are applied in RGB color space. It has something to do with each color channel being treated equally, but let me spare you the technical details. Fact is, curves in RGB space always have a side effect on saturation and color balance.

3 Luminance curves: That's why retouching professionals recommend the LAB color space for most tonal adjustments. *L* stands for the pure luminance, and *A* and *B* are designated channels for chromaticity. Technically, the correct way to increase contrast is to convert the color space, apply the curve only to the luminance channel, and then convert the color space back. In real life, however, all that conversion quickly becomes cumbersome and breaks the creative flow.

Instead, just change the blending mode of the curves layer to Luminance. That has the same effect, minus the hassle. Now we only increase tonal contrast but leave saturation alone.

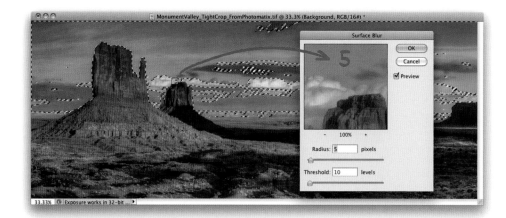

Figure 4-49:
Applying a Surface Blur filter to the selected area is sure to eliminate noise and wipe the sky silky smooth. Use a low Threshold value to keep hard edges.

If you're in for happy accidents, you can always change the blending mode back to Normal—I do that occasionally myself. But in my standard workflow I prefer to address colors in a separate step later on.

4 Selective noise removal: If there is noise left after tonemapping, it shows up mostly in large uniform areas. Clear skies, wispy clouds, and flat walls are typical problem areas. The trick is to run noise reduction only on the areas where the noise is obvious. Who cares if there is a bit of noise in front of busy details; nobody will ever notice. Applying noise reduction to the whole image would only force you into compromises to protect these fine details. Instead, it's much better to selectively remove noise *only* where you can actually see noise.

Well, this image actually came out pretty clean already because I shot enough exposures and we used rather conservative settings for Lighting Adjustments and Micro-smoothing in Photomatix. But for the sake of demonstrating this technique, select the Background layer and choose SELECT ▸ COLOR RANGE from the menu. Now use the color picker on the blue sky. You can hold Shift to pick additional colors, such as, for example, the flat gray clouds. There's no need to be extra accurate; just watch the selection

preview to ensure that the big mountains remain largely unselected.

5 Now run a noise reduction filter only on that selection. You can choose FILTER ▸ NOISE ▸ REDUCE NOISE from the menu; however, my favorite alternative is FILTER ▸ BLUR ▸ SURFACE BLUR. Since the filter is constrained to areas that are *supposed* to be uniform anyway, blurring the noise away works wonders. This particular type of blur has a threshold value; edges and details that exceed this threshold contrast will not be blurred. So, with a rather small value of about 10, our Surface Blur filter will not touch the clouds or cliff edges at all, even if the initial selection was a bit sloppy. But the rest of the sky will turn silky smooth, no matter how noisy it was.

As an alternative, there are many high-tech plug-ins available for removing noise: Noise Ninja, Topaz DeNoise, or Noiseware are what many of my friends swear on. But honestly, I have found a selective Surface Blur filter good enough for 90% of all images.

6 Zone check: Section 4.3.2 explained how useful the zone-esque system is to evaluate the result. So here comes my little cheat to visualize the zones. It's a Gradient Map adjustment layer!

Figure 4-50:
The much-needed sanity check is provided by a Gradient Map adjustment layer. It visualizes the distribution of photographic zones (shadows, darks, midtones, brights, highlights).

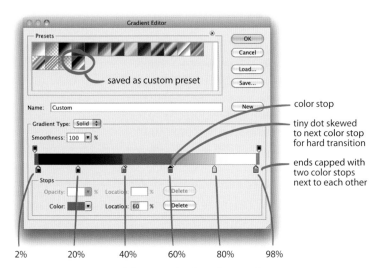

saved as custom preset

color stop

tiny dot skewed to next color stop for hard transition

ends capped with two color stops next to each other

2% 20% 40% 60% 80% 98%

Figure 4-51: *Anatomy of the Zone Check gradient in the Gradient Editor. You can also find this as preset on the DVD.*

black and white are defined as the extreme ends of the tonal scale. That's where clipping occurs, so these zones are remapped to blue and red to indicate clipping preview. It's a little tricky to set up the gradient itself, but thankfully you only have to do it once and can then save it as a preset. Or just import my preset file from the DVD. There's also a Photoshop action to create this gradient layer, which saves the extra click of selecting the preset.

With the gradient map it becomes very easy to see how the zones form nice continuous shapes. This is a good indication that our tonemapping settings preserved large-scale contrasts. The big mountain on the left is mostly settled in the midtones, nicely contrasted to the long patch of shadow and the dark mountain behind. Getting zones staggered in depth is always fortunate because it separates foreground from background and creates a natural sense of three-dimensionality.

By comparison, an overcooked image would have dark and bright zones scattered all over the place. That's cool as long as you're intentionally going for an effect-driven look. But for natural looks, the zones should form nice continuous shapes. The rule of thumb is as follows: When you can

This tool can be found on the bottom of the Adjustments palette; it's one of those tools that never really get the attention they deserve. A gradient map takes the intensity of a pixel and finds the corresponding color on a predefined gradient. By default that would be a smooth gradient, useful for sepia or cyanotype effects. But when used with a stepped gradient, the image is reduced to display only five shades of gray: shadows, darks, midtones, brights, and highlights. In addition,

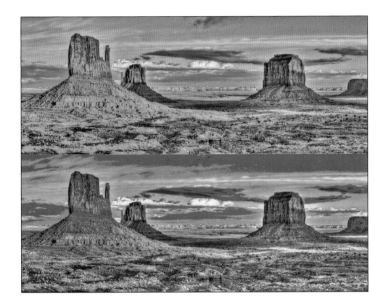

Figure 4-52:
Nonrealistic toning styles do not show such clear zone separation. For natural images, the zone view should consist of simple and quickly identifiable shapes.

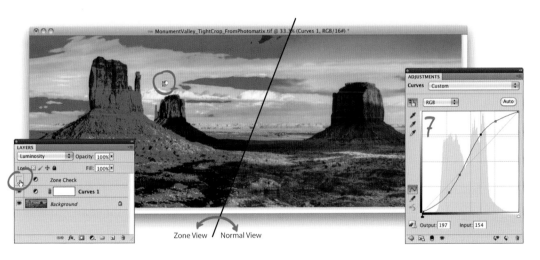

Zone View / Normal View

Figure 4-53:
Optimizing tones and contrast—even using the interactive finger method—can now be done in normal view or in zone view. You can switch views anytime just by turning the Zone Check layer on or off.

clearly identify the major subjects in this crude zone overlay, then you have a strong photo. If the zone overlay looks like a Shepard Fairey image, the image has a natural style. If it looks like a Monet, it is impressionistic.

7 Fine-tuning tones: I do, however, notice now that the bright zone is a bit underrepresented. So there is still some room to increase overall contrast. The cool thing about adjustment layers

is that we can just go back to the curve editor for fine-tuning.

So, let's brighten up the background sky. The interactive finger mode works just fine, even when the zone view is displayed. It takes just a little nudge on the sky to lift it into the bright zone and another nudge on the foreground to sort out the shadows. Photoshop automatically adds the corresponding points to the curve (of course, you can also work in the curve window

Figure 4-54:
Fine-tuning colors with a Hue/Saturation adjustment layer, also in interactive finger mode.

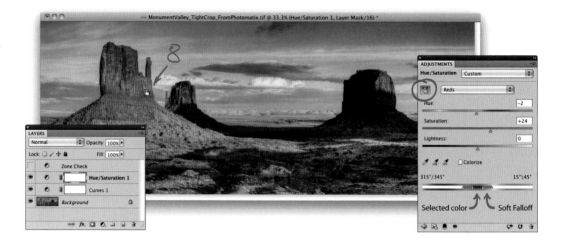

if you prefer). Turning off the Zone Check layer shows the effect of this change to the actual image, and indeed this tweak adds some nice extra punch.

8 Fine-tuning colors: So far we have looked at only the tonal distribution and have optimized brightness and contrast. I prefer to resolve white balance and major hue shifts in the original HDR, just to have it done and out of the way. However, as we're getting close to the finishing line, this is

Figure 4-55: *When you're sharpening the background layer, the preview shows the old colors. But that's okay. It's still the smarter way to sharpen.*

the last chance to do some fine adjustments to the colors.

So let's stack another adjustment layer on top, this time *Hue/Saturation*. Just as with curves, my favorite modus operandi is to stay in touch with the image. Again, that's what the little icon with the finger is for. With that finger icon activated, click on the blue sky close to the horizon and drag the mouse to the right, interactively boosting the saturation for the sky. The initial click has actually selected the cyan range in the Hue/Saturation panel, and it takes a saturation boost of 30 percent to please me. At this point I really must insist on a steel-blue color for the sky, so I also nudge the Hue slider to 15.

Proceed to the rocks, applying the same workflow again. Click somewhere in the middle of the main rockface, and drag right until the saturation is about 20. Then drag the Hue slider just a hair left, −2 feels like just the right type of Indian red. All highly subjective tweaks, of course. There is also no point in even attempting this color fine-tuning if your monitor is not fully calibrated.

9 Sharpening: Almost done. Let's just add some final sharpening. My preference goes to the Smart Sharpen filter because it has the coolest name. Well, it also preserves smooth gradients and is more robust against oversharpening

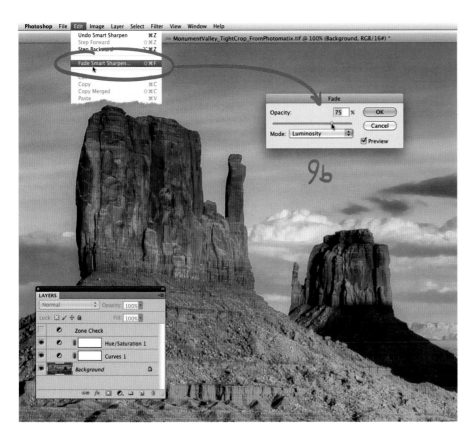

artifacts, but who cares for legitimate reasons? Smart Sharpen. The latest hippest addition to Photoshop. Better.

If you want the very very best, you can restrict this filter to luminance. It serves the same purpose we discussed for the curves adjustment: Sharpening only the luminance channel will prevent RGB-related artifacts, protecting us from adding color fringing around edges.

And this is how it works: Select the background layer and select FILTER ▸ SHARPEN ▸ SMART SHARPEN from the menu. Feel free to use strong settings like Amount 50 % and Radius 1.5 pixels.

Click OK and immediately select EDIT ▸ FADE SMART SHARPEN from the menu. This menu point is always there but changes to "Fade ... the last thing you just did." The window shown in the screen shot (for step 9b) appears, and we can change the Mode setting to Luminosity. Here we can also reduce the opacity of this effect to 75 %, which is a very convenient way to mix some of the original image back in.

10 Yay! Finished. Time to save the image as a PSD file. This will be the toned master final. ◄

With the exception of noise reduction and sharpening, all changes are just adjustment layers, leaving the tonemapping result from Photomatix untouched. So we worked mostly nondestructively. This has the advantage that you can easily drop the same adjustment layer stack on a completely different image—very handy for processing a series of HDRs shot in succession.

Also, you can now safely delete the 16-bit TIFF from Photomatix because this image is still present as the background layer in the PSD. The 16-bit TIFF is a completely redundant waste of space; it can be easily re-created from the original EXR file. If you have a fast machine with heaps of memory, you can also use the plug-in version of Photomatix instead. That enables you to stay in Photoshop for the entire time, skipping this temporary 16-bit TIFF file all together.

➤ One more thing

For final presentation—no matter if that is online or in print—the image needs to be further broken down. That involves flattening all layers, converting the color profile to sRGB, and reducing the color depth to 8 bit. These should always be the very last steps. Consider them the equivalent of sealing an envelope.

Now it's ready to save as a JPEG, and off it goes to a web gallery or the printer.

I don't recommend saving this final 8-bit file in another format. Saving it as a JPEG makes it clear that this is the absolute final end result, taking away the temptation to touch it up later. If you want to make changes, do that in the archived 16-bit master PSD. That's where you have much more wiggle room, and most tweaks can be done best with the adjustment layers that are already there. By comparison, an 8-bit flattened TIFF only gives you false hope, but it's really not much more editable than a JPEG. ◂

That was the detailed rundown of a basic toning workflow. Here is a short version for your camera bag:

CHEAT SLIP
Fundamental toning workflow

❯ Tonemap an EXR with Photomatix, with focus on highlight and shadow detail recovery.

❯ Save out a temporary 16-bit TIFF that looks slightly flat and has low contrast.

❯ Load the TIFF in Photoshop.

❯ Boost contrast with a Curves adjustment layer, with the blending mode set to Luminosity.

❯ Optional: Select noisy areas and reduce noise with Surface Blur.

❯ Use the zone gradient overlay for a sanity check.

❯ Fine-tune tonal distribution with the Curves layer.

❯ Fine-tune colors with a Hue/Saturation layer.

❯ Apply the Smart Sharpen filter and limit the effect to Luminosity via EDIT ▸ FADE.

❯ Save the master PSD.

❯ Flatten layers, convert to 8-bit sRGB.

❯ Save final JPEG.

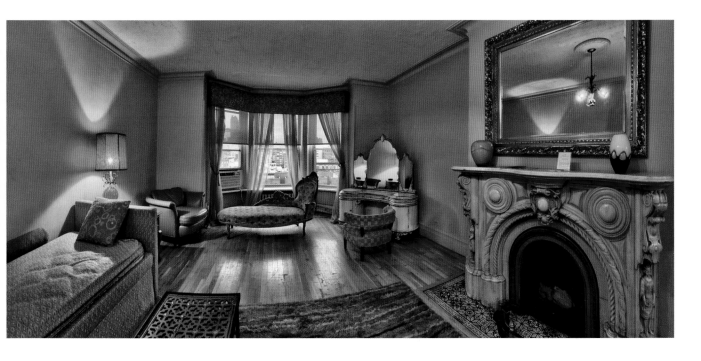

4.4.2 Rear Window of Room 822
(with PhotoEngine & Photoshop)

 Let's move on to a real classic: the beauty shot of an interior with a window to the outside. What most people regard as a worst-case scenario is the daily bread for professional real-estate photographers. And just as Michael James revealed in the interview earlier, HDR techniques come in very handy here.

The tough question is, How far can you take the look and still stay true to the location? My particular example, room 822 of the Chelsea Hotel, illustrates this problem pretty well. It is a moody, dark room with orange walls and warm interior lighting, which stands in strong contrast to the cold evening light coming through the windows. There is an opulence of playful detail in the furniture, in plainspeak referred to as kitsch, paired with the very expensive kind of grungy run-down charm. It's sort of the architectural equivalent of an haute couture punk-rock T-shirt. The challenge is now to strike a bal-

ance between compressing the dynamic range, recovering details, maintaining the mood, and exposing that certain glam rock flair.

This tutorial will introduce you to Oloneo PhotoEngine and a useful generic trick for problem solving in Photoshop. The image happens be to a panorama again; that's why it shows such an unusual wide angle. The left and right sides of the image are actually opposite walls of the room. Workflow-wise, the image went through the same processing steps as the shot from the last tutorial. Multiple bracketing sequences were batch-merged to HDR in Photomatix and then stitched together in PTGui. This image uses a Vedutismo projection, which is a special panoramic perspective inspired by seventeenth century paintings, and has the special property of keeping architectural lines straight. If that spurs your interest, definitely check out Chapter 6. For now it shouldn't really matter where the HDR comes from.

Figure 4-57:
Room 822 of the Chelsea Hotel, New York. Madonna lived here before she got famous. Avid fans might recognize the location from her book Sex.

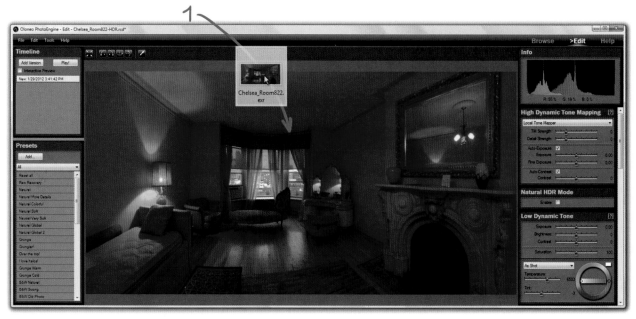

Figure 4-58: *Gentlemen, start your PhotoEngines! That's what the image initially looks like.*

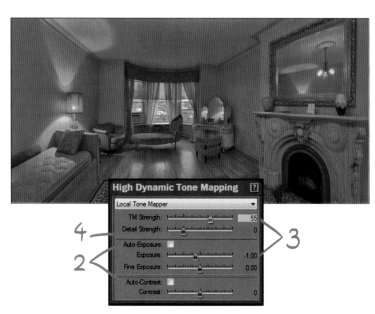

Figure 4-59: *Turn off Auto-Exposure and Auto-Contrast. Then use TM Strength and Exposure to reduce the overall dynamic range.*

PhotoEngine is only available for Windows. I'm running it on a virtual PC under VMware Fusion, and it works just fine without any performance penalties. So, having a Mac system is no excuse to sit this tutorial out. Go ahead and install the demo version from the DVD!

1 **Load Chelsea_Room822.exr** from the DVD into PhotoEngine. You can double-click its thumbnail in PhotoEngine's integrated image browser or just drag and drop it from Windows Explorer into the program. Similar to Photomatix, PhotoEngine has a whole lot of controls that are all interconnected in some way. But don't worry; they are sorted by importance from top to bottom (roughly), and we really only need the first part.

2 **Auto-Exposure and Auto-Contrast:** These two check boxes are responsible for keeping exposure and contrast steady and optimized. Sometimes this may be useful, but more often they add to the confusion of everything being

interconnected. Besides, we will optimize contrast later in Photoshop anyway. The first goal is, once again, to create a slightly flat image in which neither highlights nor shadows are clipped.

3 TM Strength and Exposure: Both sliders are now used together to reduce the overall dynamic range. You will notice that TM Strength pushes brightness from the bottom up, which means it brightens up the entire interior, affecting the shadows most. It also has an effect on the window, even if ever so slightly. Lower the Exposure value to keep the window steady in brightness. For this image, a TM Strength setting of 55 and an Exposure setting of –1 seem to be a good balance between indoor and outdoor.

4 Detail Strength finally adds some pop to the image. Now we're talking! This is the magic slider responsible for local contrast boosts, and it allows a pretty massive range of adjustment. Detail Strength goes all the way to 300, just like the Detail slider in Photoshop's Local Adaptation dialog box. But the difference is that this one is extremely resistant to halo artifacts.

Instead, you have to watch out for clipping. In this image the critical areas are the window reflections on the floor. A Detail Strength setting of 90 is about the highest you can go before all the nice scratches on the hardwood floor are blown out.

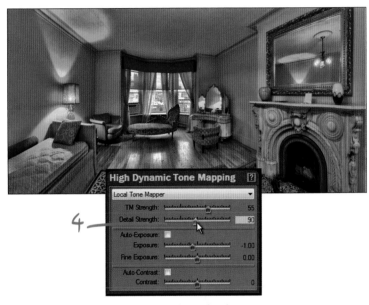

Figure 4-60: *Use Detail Strength to boost local contrasts.*

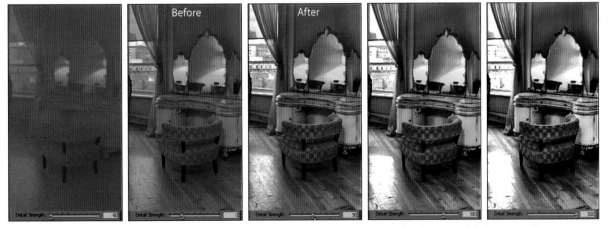

Figure 4-61: *Detail Strength is mighty powerful and very halo resistant. Watch out for clipped highlights instead!*

Figure 4-62: *Smooth gradients can become posterized by this detail boost. A good way to balance such finer nuances is to adjust contradicting sliders in pairs.*

Figure 4-63: *Switch to the Advanced Local Tone Mapper option for the complete set of detail controls.*

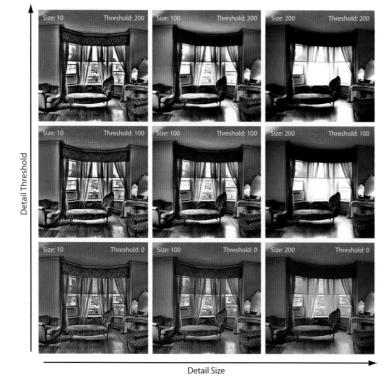

Figure 4-64: *The difference between Detail Size and Detail Threshold becomes more clear when you temporarily raise Detail Strength to full 300.*

Figure 4-65: *Edge Sharpen allows fine-tuning of halo artifacts that appear around extra-bright light sources.*

5 Balancing Contrasts: Clipping can also happen in individual color channels, which becomes most obvious when smooth gradients start to posterize. To keep Detail Strength as high as possible, we have to inconspicuously lower the global contrast further. It's a balancing act.

That's where the opulent amount of seemingly contradicting sliders comes in handy. My favorite method is to adjust them in pairs. For this image, it turns out that raising Brightness to 50 *and* lowering Fine Exposure to −0.65 smoothes out the lamp shine on the wall but keeps everything else.

It takes a bit of dabbling with the good old trial-and-error method, but thankfully PhotoEngine's real-time feedback makes that process

Figure 4-66:
That's a keeper!
Save the image
as a 16-bit TIFF.
Everything is tuned
in just right. Every-
thing except for
white balance...

fairly painless. Don't be afraid to make mistakes; you can always go back in the timeline to a previous state.

6 Advanced detail controls: So far we used only the basic controls that are also available in PhotoEngine's little sister application HDRengine. Now it's about time to switch to the Advanced Local Tone Mapper option (with the drop-down menu on top of the slider list). This is the real deal! Now we have all the knobs for fine detail adjustments we could ever wish for.

Detail Size defines what is considered boost-worthy detail by sheer size. It's similar to Photomatix's Lighting Adjustments feature, except that the adjustment is isolated from overall contrast (and therefore has a more subliminal effect). Detail Threshold, however, adds another dimension to the detail selection problem. It separates local neighborhoods by luminance so it can better account for sudden shifts in brightness. The hard window frame is a perfect example.

Granted, the visual difference between these two parameters is very subtle. Browse back to section 4.1.2 and look at the underlying separation mask again, and it may make some sense. Detail Size is like the blur radius of that separation mask, and Detail Threshold keeps the blur

from creeping over hard edges. Together they work as a pair. At first glance they seem to contradict each other, but when you get to the bottom of it, they give you a lot of control over the result. Finding the right balance is easier when you temporarily push Detail Strength all the way up, so the effect is more exaggerated.

For this image I settle with a higher Detail Size value (to protect long, smooth gradients on the walls) and a lower Detail Threshold value (to suppress halos around the window). With that new, refined definition of what "detail" actually means, I can increase Detail Strength to 120.

Edge Sharpen is the third parameter, and this one is really for obsessive fine-tuning. You have to zoom in to a very high-contrast edge to see any effect at all. When worked right, Edge Sharpen can remove halo artifacts, or at least make them more unobtrusive.

7 Save as a 16-bit TIFF. All the tonal values are now distributed perfectly. There's no significant clipping, all gradients on the walls are smooth, and details are rendered with good clarity but without exaggeration.

However, we're not quite done yet. The super-warm light inside is a bit too much. It looks nice on the walls, but the fireplace is in fact built out of white marble, which is hard to believe given

Figure 4-67:
Use the color picker to sample the white balance from a white object inside the room.

Figure 4-68:
The difference between daylight and incandescent lighting is striking. No matter where you set the white balance, part of the image looks wrong.

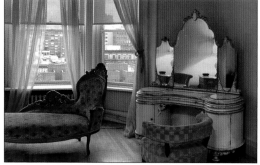 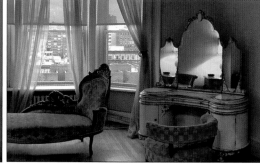

that strong orange tint. (Actually, it's fake marble—it sounded hollow when I knocked on it. But you get the idea). That's because the white balance is currently set for the daylight coming through the window.

8 White Balance: Let's change the white balance to the interior!

Grab the color picker (click the rightmost icon above the image) and find some white spot in the interior to sample. For example, click on the vase above the fireplace to set the white point. Holy Moly, Batman! Stunning, isn't it?

What we previously accepted as natural light from the outside now turns into a deep blue, like an ice-cold punch in the face. The marbleish

fireplace looks nice, and the gold painted mirror frame can now be identified as such, but overall the room is robbed of all its mood. The problem is that the color temperatures of incandescent lighting and daylight couldn't be farther apart. Just for kicks, alternate between clicking on that fireplace and the bright cloud patch outside the window. The difference is striking! You can also use the color temperature slider to travel from 2500 K to 7000 K. There is no middle ground, as you will notice, only a range of foul compromises where both areas (inside and outside) look a little bit wrong.

The best we can do is to save another 16-bit TIFF for the interior colors.

Conflicting light colors are very common with this type of interior/exterior shot; the problem is just not always that pronounced. We're looking at a worst-case scenario here, exaggerated by the orange walls and the extra-warm interior lighting. Every real estate shot in HDR presents a similar issue. Even if the window itself wouldn't be visible, the mixed lighting would be just as problematic for a traditional single shot. Veteran photographers often carry a bunch of replacement light bulbs with different color temperatures, and in Hollywood movies it's rather common to cover the windows with a color filter, maybe even block the sun and replace it with a spotlight the size of a refrigerator.

See, the tricky part is that human vision not only adapts to huge differences in brightness, it also adapts to differences in color temperature. PhotoEngine did a really great job dealing with the first part, compressing the dynamic range in a believable way. But no HDR program can adaptively compensate for differences in color temperature. Sure, some programs offer selective adjustments (HDR Efex, SNS-HDR, Hydra),

Figure 4-69: *In Hollywood, nothing is left to chance when it comes to lighting. See the resulting moonlit hallway in the background of the Chapter 2 Quiz.*

but that's when it gets very fiddly. They are hard to steer and unpredictable in the transitions between one color temperature to the other.

So ultimately, this is a universal problem. And the only truly reliable solution is just as universal: Make two versions and blend them in Photoshop!

➤ Part B: Finishing in Photoshop

1 Load both images in Photoshop and copy/paste the inside-adjusted image on top of the outside-adjusted image. It will become a perfectly fitted layer.

2 Because it's always good to stay organized, name the layers accordingly by double-clicking their names in the Layers palette.

3 Select the top layer (Inside) and create a layer mask by clicking the third icon on the bottom of the Layers palette.

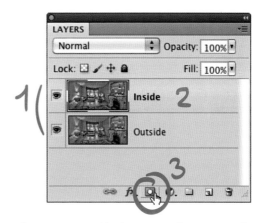

Figure 4-70: *Load both images as layers, name them and create a mask for the layer on top.*

Figure 4-71:
Use a large soft brush and paint on the layer mask to reveal the underlying Outside layer.

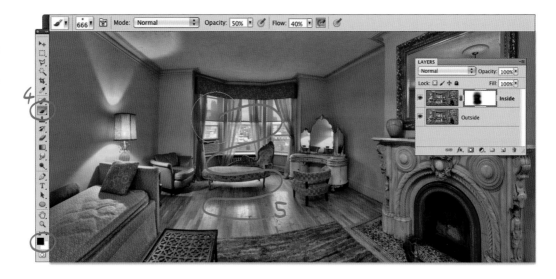

Figure 4-72:
Keep on scribbling, frequently switching foreground/ background color with the X key until you have the perfect version selected for each area.

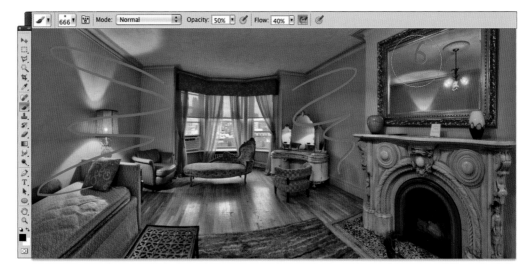

Figure 4-73:
That's what my layer mask looks like. It's no Rembrandt, but it does the job.

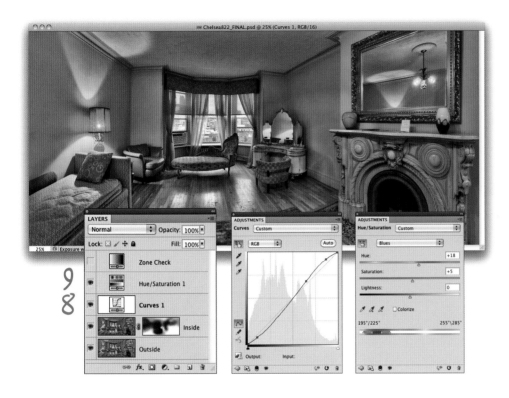

Figure 4-74:
Finishing touches with Curves and Hue/Saturation adjustment layers.

4 Make sure the layer mask is selected and grab a large soft paint brush, about 600 pixels wide. Set Opacity to 50 % and Flow to 40 % and enable Airbrush mode. The foreground color should be black.

5 Gently brush over the window area to make the top layer transparent, revealing the layer underneath. Whenever you want to add some of the top layer back into the mix, just press X on the keyboard. That will swap the paint brush color with white, which in the context of a layer mask means "more visible." For example, I do like to keep a hint of the blue tint visible in the reflections on the floor, so I fine-tune the mix with a single quick stroke of white.

6 The walls actually had a nicer color in the outside-adjusted version, so keep on painting across the walls. There's no need to be precise here because our layers already look pretty similar.

The beauty of using two premade versions is that both are plausible by themselves, and even a 50/50 mix is unlikely to introduce any new weird color transitions. So, you can't mess up! Just keep on doodling, frequently switch paint color with the X key, and see what works best for each area.

7 Alt+click on the mask thumbnail in the Layers palette to double-check your matte. Mine ends up looking rather crude but does the job just fine. From now on, it's pretty much the standard procedure, as explained in the previous tutorial.

8 Fine-tune tones with a Curves layer, adding a bit of extra pop. In this case I appreciate the slight color boost that comes with it, so I do not switch it to Luminosity mode.

9 Fine-tune colors with a Hue/Saturation layer, tweaking the reds and blues to be just right.

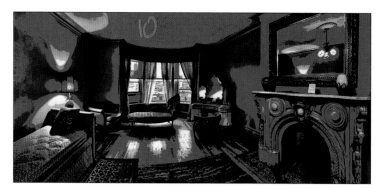

Figure 4-75: *The zone check is slightly busy but still very readable.*

10 About time to get a sanity check from my trusty zone overlay. It turns out rather busy, but that is to be expected when part of the task was to expose all the gritty interior details. Most of the room is settled in the midtones, room corners recede into the darks, and the window stands out as highlight.

11 Save the master final as a PSD.

12 Flatten all layers.

13 Add some final sharpening with the Smart Sharpen filter.

14 Convert to 8-bit and save the final JPEG.

And voilà, done! Granted, the final image does have a slightly stylized look. With real estate photography, it's always a gamble between natural appearance and glorified presentation. The key is to show the character of a location, not just the snapshot of a room. Inside-outside shots have no appealing "natural" reference, simply because they were not possible prior to HDR, not without excessive flash lighting, which would definitely not preserve the original mood. But hey—Michael James already told you everything about this.

> **CHEAT SLIP**
> **Toning an interior shot with a window view**
>
> - We used PhotoEngine's TM Strength and Exposure controls to regulate the overall tonal range.
> - Balanced local and global contrasts with Detail Strength, Fine Exposure, and Brightness.
> - Recovered a lot of extra detail with the Advanced Local Tone Mapping controls.
> - Took great care to avoid clipping and preserved smooth gradients.
> - Saved two versions as 16-bit TIFFs, with different settings for White Balance (daylight/tungsten).
> - Loaded both versions in Photoshop as layers and named them.
> - Used layer masking to combine the best of each.
> - Fine-tuned with Curves and Hue/Saturation.
> - Sanity-checked using the zone overlay.
> - Flattened all layers and finalized with Smart Sharpen.

4.4.3 Urban Exploration and Grunge Looks
(with HDR Efex & Photoshop)

Out of all the possible ways to treat an HDR image, the full-on *grunge* look is certainly the most provocative. This style is all about emphasizing all the dirty little micro-details with harsh local contrast enhancements. Texture is king here; the grittier and dirtier the better. It's probably not the best look for wedding photography because it does strange things to wrinkles and the slightest skin imperfections. Brides just don't like the grunge treatment on their faces. Trey Ratcliff was once suspected of beating his kids when some overly empathic parents saw his experimental HDR portraits. But used in the right context, the grunge look can be rather powerful and certainly evokes strong emotions.

Urban Exploration (shortened to UrbEx) is particularly suitable because this photography niche is all about finding forgotten places and discovering beauty in decay. Things like industrial ruins, car wrecks, abandoned mansions, and run-down neighborhoods are popular places of interest. Typically these places have very little supportive light, but they are also perfectly motionless and you have all the time in the world for extra-wide bracketing. So, it's a perfect fit for HDR shooting.

You'll find the most rewarding subjects by going places where you're actually not supposed to go, which is really part of the fun. As an urban explorer, you basically snoop out spots similar to the spots a graffiti artist might hope to find, except that you're *taking* pictures instead of leaving them behind. In fact, you'll often encounter the most phenomenal graffiti pieces hidden after stretches of spooky stairwells and mazed hallways, and those are always worth a tip of the hat and a subsequent photograph. Of course, I don't endorse breaking the law or climbing over barbwire fences, and if you let yourself get caught, I don't know you.

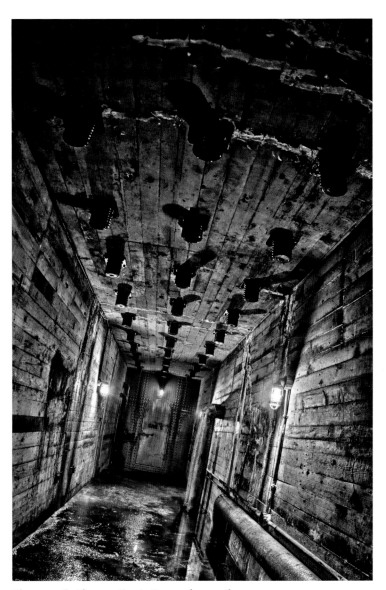

Figure 4-76: *The question is, Do you dare go there (in terms of both location and toning style)?*

Probably the most important advice in this book is to *always play it safe!* Don't sneak into half-collapsed ruins wearing flip-flops! Sturdy shoes, long sleeves, and a cell phone for emergency calls are essential, and at extreme locations your equipment bag should also include gloves, a flashlight, and a hard hat. The full-on construction worker jumpsuit might look

ridiculous, but as a matter of fact it is the ideal urban camouflage outfit. You will be practically invisible and nobody will question the purpose of your presence. If possible, bring a buddy under the prospect of a shared adventure. He will be very useful as equipment mule and eventually may save your life by lifting those 200 pounds of fallen rubble off your feet.

So let's get started with the tutorial. Just for you, I slipped into the basement of an old power plant near Long Beach and took this creepy hallway picture. I honestly don't know what's behind that door at the end; never dared to turn the handle. It might be a gate to the dungeon dimensions, or it might simply be flooded.

For toning this shot, Nik HDR Efex Pro is my weapon of choice because it provides an incred-ibly wide range of creative look adjustments and naturally leans toward the gritty side. Technically, HDR Efex could be called up directly from Lightroom. But I do not recommend that because Nik's exposure merging module is rather weak. Instead, I sent the original expo-sures to Photoshop CS5, taking advantage of its excellent alignment. I made sure Photoshop's HDR Merge dialog is set to 32-bit output, and when the HDR image was done, I double-checked the 32-bit Preview options in the View menu to be all zeroed out. Then I went through the standard cleanup procedure first, includ-ing cropping, framing, and minor clone stamp repairs. Sections 3.2.5 and 3.3 tell you everything about these steps; for now just assume the HDR file is ready-made.

➤ Part A: Tonemapping in HDR Efex Pro

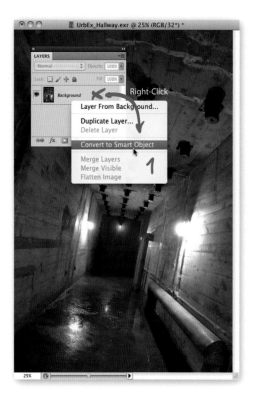

Figure 4-77:
Load the image in Photoshop and turn it into a Smart Object.

Load Urbex_Hallway.exr into Photoshop to move along with me. If you don't have HDR Efex, install the demo version from the DVD. It should detect your Photoshop version and install as a plug-in.

1 Working Smart: The first thing to do is turn the image into a Smart Object. Simply right-click on the background layer in the Layers palette and select Convert to Smart Object from the context menu. This little trick will ensure that we can later open the HDR Efex plug-in and change the settings. That might not always be necessary, but it's a good habit to work nondestructively whenever possible.

2 Open HDR Efex by choosing FILTER ▸ NIK SOFT-WARE ▸ HDR EFEX PRO. The interface will take over the entire screen. Right off the bat you can choose from a bunch of presets. They were all submitted by actual photographers and employ a massive variety of very different looks. Go ahead and explore the presets. Since HDR Efex is all about creative tinkering and exploration, most

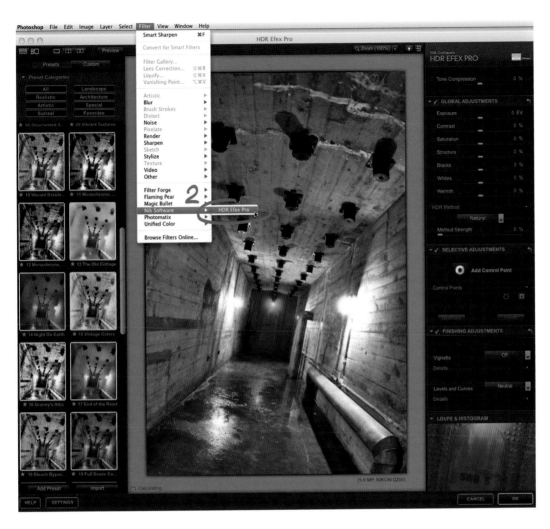

Figure 4-78:
Start the HDR
Efex Pro plug-in
and play with the
wonderful preset
collection.

people first browse the presets for a good starting point and then refine according to taste. For this tutorial, however, let's start from scratch with the defaults (first preset).

The sliders on the right are conveniently sorted in the recommended order of noodling, from top to bottom.

3 Tone Compression: This will bring down the overall scene contrast so there are neither blown-out lights nor blocked shadows. Essentially, this is the main tonemapping control, and the isolated top position underlines its importance. The amount of Tone Compression you need is highly

dependent on the scene, and if you'd be allowed to change only a single slider after browsing the presets, grab this one. Lower values result in a more realistic toning, preserving the large-scale contrasts and overall lighting situation. Higher values emphasize small-scale contrasts in the textures. For my intended grunge look, 70% seem very appropriate.

4 Global Adjustments: The sliders in the next section are somewhat interconnected. Exposure, Contrast, Blacks, and Whites tend to cancel each other out, so prepare for a lot of jumping around between them. Also, HDR Efex has one particular

Figure 4-79:

First steps: Reduce global contrast with extra care to protect highlight colors, and then raise Structure to boost texture details.

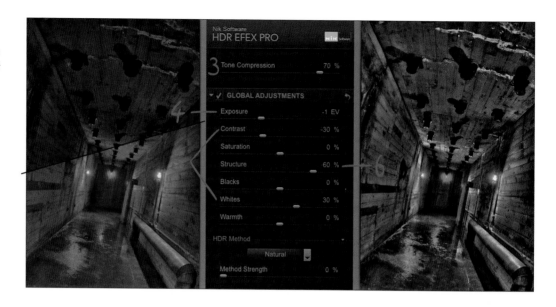

Figure 4-80:

The Method menu is a treasure chest of wildly different styles. My favorites are those that start with C and S, but you should really try them all.

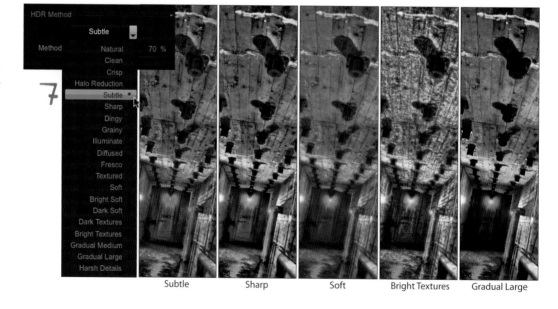

weakness, and that is a mysterious tendency to loose saturation on the bright end. When you're bringing down highlights later, their colors will appear washed out and faded. So as a general strategy, I recommend working the other way around, starting with a darker image with good highlight rendition, and then brightening up the

shadows. Putting this strategy to practice, I'm first changing Exposure to −1 EV to reveal the wall texture in the bright areas next to the wall lamps.

5 Now the image is very dark. As a counter-measure, I lower Contrast to −30 %. In addition,

raising the Whites slider (white point) will clamp into the bright end of the tonal range, further brightening everything up. Intentionally, this intermediate image appears a bit flat, so we have more tonal range available for boosting detail. Extra tip: If you click on the number above a slider, it will turn into a text field and allow you to type in exact values. And to return a single slider back to the default, just double-click on it.

6 Structure is next. This is our first "wow" slider. It will boost texture detail in a nicely isolated fashion, not affecting the overall balance of brightness and contrast established earlier. Setting Structure to 60% seems good for now.

7 Mad Methods: The most critical setting for styling the look is the Method menu. There are 16 possible settings here, which correspond to four unique algorithms with several different subvariations. This is the real treasure chest of HDR Efex, a fortune cookie jar where every draw makes you see the image in completely different ways. The names are slightly esoteric and sound more predictable than these methods really are. You really have to try them all out and see for yourself.

Any preset with *gradual* in the name works well for an atmospheric and natural look that is pretty similar to what you would get with Photomatix. Presets with *soft* in the name create a dreamy mood, as if the lens would be covered with gel. Dingy, Fresco, Grainy, and anything with *textures* in the name will add some strange fractal noise or grain that can easily overpower texture detail from the image. I tend to stay away from those. My personal favorites are the methods that start with **C** and **S**: Clean, Crisp, Subtle, Sharp. For this image I choose the Subtle method (which is in fact not subtle at all), and a strength of 70%.

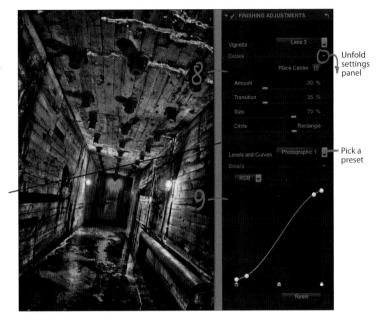

Figure 4-81: *Vignette and Curve controls in an HDR program are never really necessary, but they are useful for designing an extreme look in one go.*

8 Finishing Adjustments: All the way on the bottom we have the post-processing controls built right in: vignetting and curves. Both have handy preset pull-down menus, which will get you in the ballpark right away. By default you see nothing but the presets. To expand the detailed settings, you have to click the word *Details* underneath. It's so tiny, that it's very easy to overlook; took me weeks find it.

So let's apply a strong vignette with the preset Lens 4 and customize it to be more rectangular.

9 Two things you should know about these curves. First, by changing the curve for the R, G, and B channels separately, you can dramatically change the color mood. This is what many of the creative presets from the initial thumbnail palette do. If you create your own coloration here, you can wrap it in a custom preset and have that look at your fingertips for the future. Second, and that is the catch, none of these finishing controls have access to the original HDR data. Technically,

Figure 4-82:
Play with the individual curves for the red, green, and blue channels to create a cross-processed color style. When you find a nice look, save a preset!

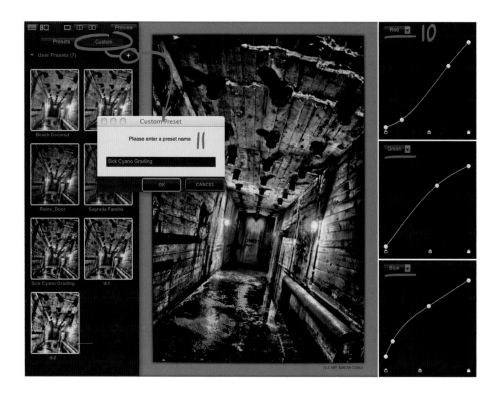

they are not part of the tonemapping algorithm anymore, so all they can access is the image as it is currently displayed on the screen. For example, the lamp on the right-hand wall is clipping at white, and no curve setting can change this now.

So, the curves here are not better than the curves we would apply in Photoshop afterward. Maybe even a bit worse because we can't set the blending mode to Luminance or use the interactive finger mode. They are here only for convenience, to be carried along with the look presets. It's not a particular flaw of HDR Efex; all curve controls in all HDR programs behave that way.

I'm still willing to take my chances this time. So, let's start with the curve preset called Photographic 1. It adds a standard S curve and some hefty punch to the image.

10 Use the RGB drop-down menu to switch the curves graph to individual channels. Altering these tone curves individually is the generally

accepted method for cross-processed looks. When it comes to such extreme color grading, curves have always been the choice of professionals. They might be hard to learn at first, but they offer unrivaled freedom, and HDR Efex's real-time feedback is extremely helpful to see what you're doing. So, just give it some play time.

After some fiddling with all three curves, I settle on a sick cyan grading. Red is dipped down, green is lifted on the right (highlight) side, and blue is raised and lifted on the left (shadow) side. Special tip: If you accidentally drop a new point on the curve (believe me, you will), double-click that point to delete it.

11 This is a good time to turn this look into a preset.

12 Selective Adjustments. Get ready for Nik's killer feature: U Point technology! That means targeted adjustments, contained to selected

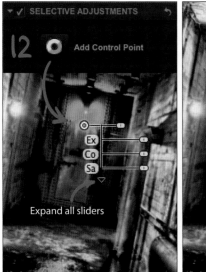

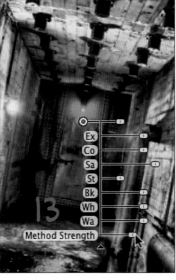

Figure 4-83: *Control points allow selective adjustments directly on the image. They are awesome.*

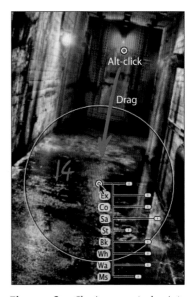

Figure 4-84: *Cloning a control point.*

areas. It is completely awesome. For example, I'm not so happy with the red warning light in the center; the aggressive texture detail exaggeration results in some tone reversal in the glow gradient. Let's fix that now. First, click the big circle button to enter control point mode, and then click just below the red lamp to set a new control point there. A small set of sliders will appear; it looks a bit like a fishbone. The three lower legs represent Exposure, Contrast, and Saturation controls, just for this area. The label for each slider is the first two letters of the name but expands to show the full name on rollover. The tiny triangle on the bottom expands the tree to a full set of adjustment sliders.

13 Now lower Structure to −60 % so the toning will pick up less texture and more of the light gradient. Tweaking Method Strength to −30 % and Saturation to +30 % further enhances the glow, making the alarming red stand out more.

14 Pretty cool, eh? The same could be done to the red reflection on the floor. Hold the Alt key down, click on the control point we just made, and move the mouse downward to pull off a copy. Drag that new control point to the puddle on the floor. You will see the image update while you're on the move, so you should have no problem finding just the right spot where the effect works best.

15 We have lost a bit of the harsh textures on the door now. Easy to bring back with another control point. This time I'm setting Saturation, Black Point, and Method Strength to +30 % and Warmth to +80 %. But most important, I'm using the top slider to increase the circle of influence.

16 Notice that the area of influence is determined not only by the size of that circle, but also by the original color directly underneath the control point. Because we dropped it on the lower part of the door, it picks up on the dark green colors only and leaves our previous adjustments to

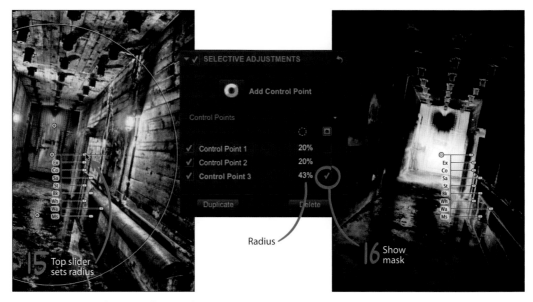

Figure 4-85: *Control points affect similar colors in a defined radius.*

the red glow untouched. So, these control points act on a soft circle, based on a selection of similar colors. To see exactly what is being affected, turn on the mask display in the control point list. The mask display is a helpful insight into the way Nik's U Point system works, indispensable for double-checking the effectiveness of a control point. We can change the size of the circular area, but unfortunately we can neither change the range of selected colors nor change the shape of the soft selection.

17 These control points are pretty addictive. Nik's manual does not warn you about the little devil on your shoulder who keeps nagging, "What about a little tweak over there?" Ten minutes later I have added four more points to the ceiling and the walls, all copies with +30 % Contrast, −30 % Saturation, and −30 % Structure. This is how you can take control of a larger, noncircular area: Clone a control point multiple times and select all copies with the Shift key held down. Now they will be in sync, and you can change a

slider on either one of them and the setting will apply to the entire group.

Moving a control point to the far right side of the image, the interface gets super confusing. All sliders flip over to the other side of the central axis. The confusing part is that this also flips the direction of the sliders themselves: To lower a value you now have to slide a knob to the right. It helps to just look at the length of each fishbone, regardless of the direction. Short bars mean lower values; long bars mean higher values.

18 **PRO-TIP** You can also link control points together permanently. After Shift+selecting them, press Command+G (or Ctrl+G on PC) to form a group. Now only the first point will have the controller fishbone; the rest of the group is represented by tiny dots. Power users might find this mode helpful to nail down the selection to a complex shape or manage large amounts of control points. Personally, I don't really like it as much as the plain old Shift+selection because these extra dots are so easily overlooked. To

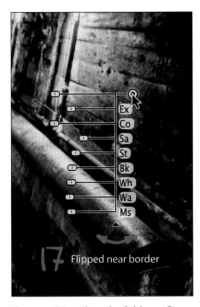

Figure 4-86: *When the fishbone flips over, all slider directions are inverted.*

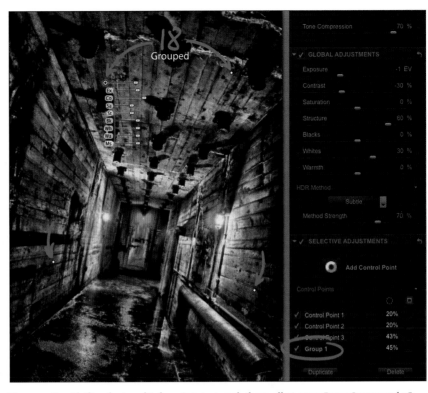

Figure 4-87: *Shift+select multiple points to tweak them all at once. Press Command+G (or Ctrl+G on PC) to group them permanently.*

explode the group again, press Command+Shift+G (or Ctrl+Shift+G on PC).

Now this really has to stop! No more control points. Shut up, little devil! I'm just gonna click OK now.

Many photographers don't even bother with all the early steps and instead use these control points to style the entire image. But that's not really what they're meant for. One problem is that control points don't give you access to the full range of sweeping look changes. They can vary the look, but they can't redefine it completely.

The second, more severe problem is that control points are not saved with presets. After you click OK, they will just do their job and then disappear to some digital nirvana. You won't be able to replicate the exact look on another image. You can't go back to tweak a control point when you find a minor flaw, even if it's just 10 seconds after you clicked the OK button. There is only one way to preserve control points and their settings: when HDR Efex is applied to a Smart Object. And that's exactly why we started this way.

Ready for the last round?

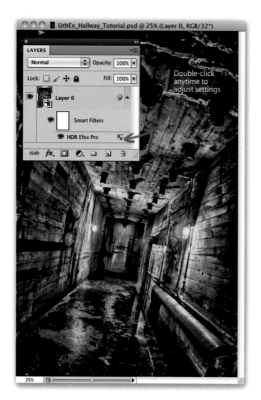

Figure 4-88: *Save the image as a PSD now! All your HDR Efex settings will be preserved and still editable.*

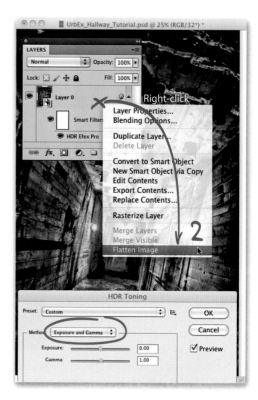

Figure 4-89: *Flatten the image and convert it to 16-bit mode with the simple Exposure and Gamma method.*

1 Photoshop's Layers palette now shows HDR Efex applied as a smart filter. Save the image as a PSD, and you can go back to the filter anytime by double-clicking it in the Layers palette. This PSD file is your insurance so you don't have to start all over in case you later find out that a minor tweak is required.

2 Officially the image is still in 32-bit mode, even though the dynamic range has been depleted and the Exposure slider doesn't reveal any extra highlight details anymore. Without the Smart Object trickery, HDR Efex would have already baked it all down to 16-bit automatically, but because we insisted on having a traceback history

available, we have to do that ourselves now. That means flatten all layers and switch the mode to 16-bit. Photoshop will interfere with its own HDR Toning dialog; to preserve the current look, just set Method to Exposure and Gamma.

3 The rest of the post-processing work can now be kept at a minimum because we already applied curves and colors tweaks inside HDR Efex. Of course, nothing is holding you back from applying more tweaks. After some reevaluation, I think I did end up shifting colors more into green and boosting contrast once more. The grunge look can take any sort of extra filters because we don't have to hide the fact that the image was

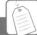

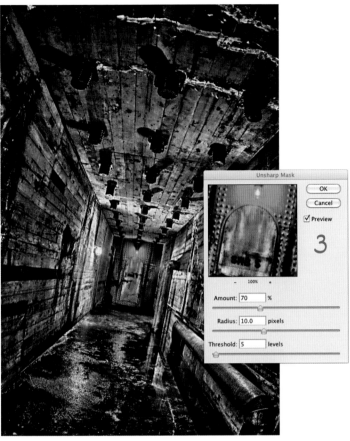

Figure 4-90: *The grunge look can sustain any amount of additional filters, such as, for example, a heavy-handed Unsharp Mask.*

post-processed. For example, a hefty-dosed Unsharp Mask filter will do it well (Strength 70 %, 10.0 pixels wide, with a threshold of 10). And an additional 40 % Smart Sharpen at 1.0 pixels is the finishing blow. Done.

Of course, this resulting image is highly subjective. It always is. But if you really worked along with me, you should now have a pretty good idea how HDR Efex works. And if you applied your own artistic judgment instead of slavishly punching in my numbers, your version will certainly look better.

CHEAT SLIP
Grunge look with HDR Efex

- Start with an EXR in Photoshop.
- Turn the background layer into a Smart Object.
- Start HDR Efex and try some preset looks.
- Use Tone Compression to bring down global scene contrast.
- Lower Exposure to protect highlight colors.
- Use Contrast, Whites, and Blacks to balance overall tonality into a flat look.
- Enhance texture detail with the Structure slider.
- Decide on a style with the HDR Method drop-down menu.
- Use vignetting and curves for further look development.
- Save a preset.
- Selectively refine and correct the look with control points.
- Clone and group control points to affect large irregular areas.
- Save the resulting smart filter in a PSD, so we can go back if necessary.
- Flatten layers, and bake down to 16-bit mode.
- Post-process with large-scale Unsharp Mask and standard Smart Sharpen.

Now go and have fun grunging up your own HDR photo!

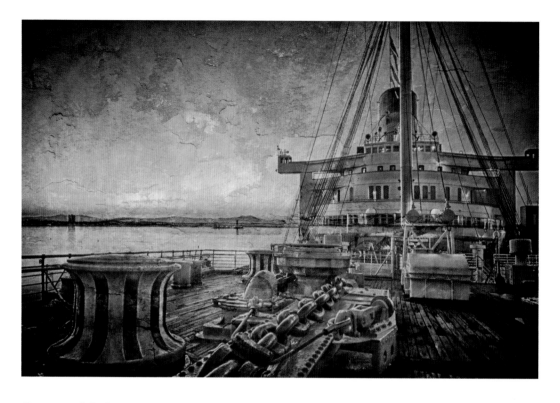

Figure 4-91:
Steel skies over the Queen Mary: *Texture blending is a fun technique to grunge up an image even further.*

Keep a straight face

If there are people in your image, this treatment can be brutal. The generally accepted method is to steal at least their faces from one of the original exposures and blend them on top. You may also try using control points to locally lower Structure and Method Strength, smoothing out the skin while maintaining at least the overall color grading. But ultimately you will most likely end up blending a face from the original middle exposure back in, at least partially, just to reduce the creepiness.

Figure 4-92: *I've included some of my favorite textures in the DVD content for you to play with.*

Further down the rabbit hole

Still not gritty enough for you? Or maybe your image happens to contain large uniform areas without any detail suitable for amplification? Clear skies maybe, or flat walls? Then you might want to look into *texture blending*. This technique actually comes from punk graphic design and resembles the traditional way of creating a grunge look. Nothing about it is particular to HDR imaging; it works with any image, always has. But it's a lot of fun and the technique is surprisingly simple.

First, you need some texture images. That can be a closeup photo of a dirty wall, rusty metal, rocks, planks. If you haven't shot any of that yourself, you can freely use my personal texture collection from the DVD or download some from www.cgtextures.com.

➤ Texture Blending

During tonemapping, aim for a flat look with a good amount of detail recovery and lots of saturation.

1 Open your toned image in Photoshop.

2 Drag and drop a texture image directly into the Photoshop document.

3 The texture comes in as new layer in Place mode. That means it conveniently has the transformation handles for adjusting placement and size already applied.

4 Set the new layer's blending mode to Overlay with 70 percent opacity.

5 Still in Place mode, move and scale the texture layer until it covers the entire image. Try lining up dominant texture details with things in the image. For example, the horizontal crack in this example texture works perfectly when lined up with the horizon. You can also flip or rotate the texture with the context menu that appears when you right-click anywhere on the image.

6 When you're done with placement, simply double-click or press Enter.

7 Have fun with it. Try other blending modes like Soft Light or Luminance at varying opacity values. Stack multiple textures, or maybe use some textures only for certain areas.

8 Flatten the image when you're done, apply some Smart Sharpen, convert to 8-bit, and save.

Figure 4-93:
Quiet meadows in Barbados, re-imagined as weathered paint on wood using the textures from the DVD.

And of course, you can also use the standard post-processing techniques from the first tutorial to spice it up. Use a Curves adjustment to add just the right amount of punch and Hue/Saturation to claim full control over colors. But the most important part is step 7: Have fun exploring. Once you let loose and start seeing your photo transform into a piece of personal expression, there are all kinds of places you can take this. A fun weekend exercise is to pick a topic like "weathered poster," "punk rock flyer," "moldy book cover," "Renaissance fresco" and then style your image in that direction.

4.4.4 Two Steps Forward, One Step Back (with Anything & Photoshop)

Let's get back to the challenges of creating a realistic image. I want to show you my favorite technique, and that is to mix and match multiple, differently toned layers.

Indeed, all tonemapping programs claim to deliver the perfect result right out of the box, and that might even be true if you just fumble long enough with all the settings. But the reality is that the sheer amount of possible adjustments often makes it incredibly hard to stay on course. Incrementally small tweaks to multiple detail enhancement sliders often accumulate, and before you know it the image has flipped over the edge of the natural look into the surrealistic valleys behind.

That's why I keep using a multilayer approach, and that has never failed me so far. It's fairly simple: I process the image with several tonemappers, extracting different levels of

detail each time. That includes a global tonemapper and one or two local tonemappers. Blending them all together in Photoshop will then result in the final image. The point of this exercise is to figure out how much detail I can scoop from the source material and then sanity-check it against a completely natural rendering of the scene to finally arrive at the sweet spot in between. I call this technique *double dipping*. If you want a more scientific name for it, call it multi-scale tone and detail manipulation. There are actual papers written on this topic; go ahead and google that term! Essentially it's the manual version of the decomposition & recombination approach described in section 4.1.2.

In all honesty, I didn't really sit down and invent this technique by systematic planning. It rather came together by persistent twiddling. A lot of the tonemapping decisions just boil down to gut reactions. Sometimes I love a certain aspect, and after continuous noodling I realize that aspect is gone. But then another corner of the image looks really good. And starting out completely fresh, tonemapping the original HDR in another program, will lead to another completely different image that has certain aspects I also like. So blending them all into one is a natural reaction. After many talks with other photographers, it turns out that this technique is the dirty little secret used by many creatives. So no, I don't claim it as my invention. Make versions and blend them together—that's the basic concept. In the details, everybody has their own habits.

Here are my habits, based on the things that I caught myself doing over and over again.

1 Load Landscape_Arch.exr in Picturenaut and open the Tone-Mapping dialog with the Adaptive Logarithmic method.

2 Play with the sliders until the image shows good overall scene contrast. Don't even worry about details and texture. Concentrate on shaping out the distinction between light and shadow.

The small preview is perfect for judging the zone distribution, but you can also zoom into the main viewport to inspect the major areas of interest. Special tip: When you turn off the Automatic Luminance and Automatic Contrast check boxes, two new sliders will appear below the histogram. Use these to set black and white points and minimize clipping.

Figure 4-95: *Use a global tonemapper to balance the overall scene contrast. I prefer Picturenaut for that because it's quick and easy, but any global TMO will do.*

Figure 4-96: *Make a second version with a local tonemapper. Explore how much details can be extracted. Really push it off the cliff, but avoid major halos and clipping.*

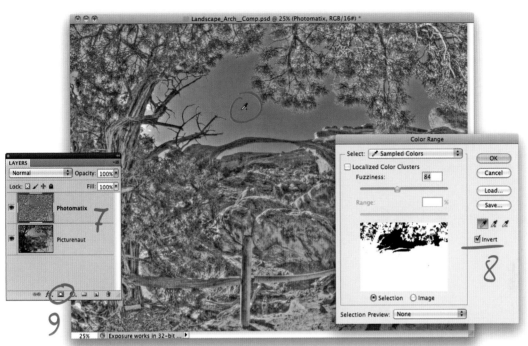

Figure 4-97:
Stack both versions as layers in Photoshop. If there are artifacts left in the Photomatix version, this is a good time to mask them out.

3 When you're done, click OK and save as a 16-bit TIFF.

4 On to the second round. Load the original EXR file in Photomatix and tonemap it with Details Enhancer. Now you need to scrape out all the texture details, without regard to overall lighting whatsoever. Don't be wussy this time; feel free to crank up all the sliders to the maximum. Just make sure nobody's watching over your shoulder while you do this. Your spouse might call for a divorce and your photo buddies might never talk to you again.

5 Try to avoid major halos. Going over the top in Photomatix can quickly introduce some of these buggers. That's when the Smooth Highlights slider comes in handy. In this example, it efficiently removes the halo around the arch. Use the white and black points to max out the contrast in the texture details, but avoid clipping.

6 Click Process and save as a 16-bit TIFF.

7 Now load both versions as layers in Photoshop. The one from Picturenaut is on the bottom; that will be our baseline. Name the layers accordingly (for the sake of good habits).

8 There are still a few noticeable halos around the fine twigs and leafs. Let's clean that up, once and for all. Choose SELECT ▶ COLOR RANGE and sample the blue sky color. Hold the Shift key to add multiple shades of blue, especially from the edge of the halos. Also make sure to enable the Invert check box.

9 With the Photomatix layer still selected, click the Matte icon on the bottom of the Layers palette. Bam! The perfectly smooth sky from the layer underneath comes through.

10 Now comes the magic moment. The Opacity slider of the top layer now acts as mixer between

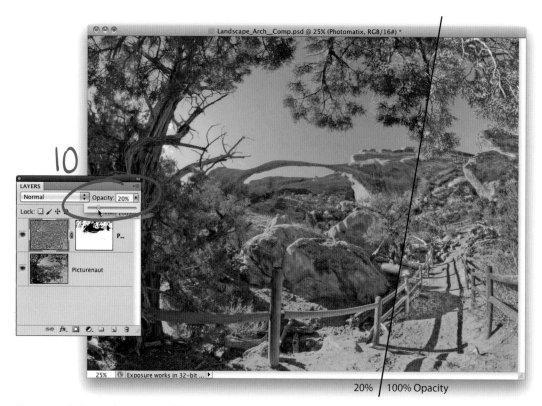

10

20% | 100% Opacity

Figure 4-98: *Lower the opacity of the top layer to regulate the ratio between lighting and detail contrast.*

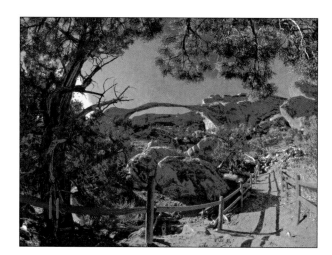

Figure 4-99: *Use a zone map overlay to visualize how much of the detail layer can be used before the image gets cluttered.*

global contrast and detail rendition. It couldn't be more convenient, really. We have literally transplanted the control over the amount of detail into the post-processing stage and can now fine-tune it very precisely with real-time speed. Since

both layers were derived from the same HDR file, they match up with pixel-perfect precision. In my experience, 20 to 30 percent Opacity is enough to accentuate texture details, but that obviously depends on how brave you were in Photomatix.

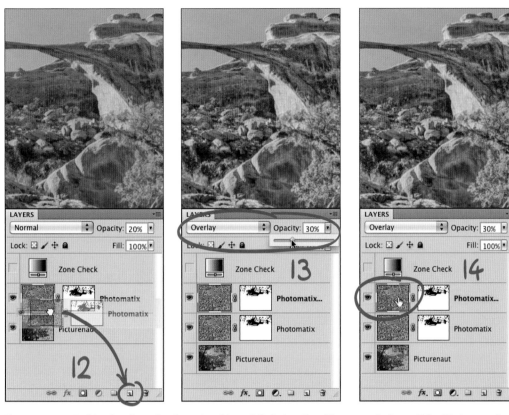

Figure 4-100: *Build a detail overlay layer to add a subtle but noticeable amount of pop. If it adds too much vibrance, just desaturate that layer.*

11 Here's another cool aspect of having such control over the amount of detail in Photoshop. You can now stack the good old Zone Check gradient layer on top and get instant feedback on how much clutter the detail layer introduces. The cleaner the shapes of gray, the more distinctive your shadows/midtones/etc. are and the more realistic the image will appear. It's a really helpful tool to visualize the ratio between lighting and texture, and you can immediately see when the details overpower scene contrast.

12 And now comes the cherry on top! Duplicate the Photomatix layer by dragging it onto the Create Layer icon on the bottom of the Layers palette.

13 Set the new layer's blending mode to Overlay and raise its opacity slightly. That will give the image the extra kick! It's a much more unobtrusive way to blend the details back in because in Overlay mode this layer is never fully opaque. It only modulates the layers underneath, as if you were to project a trans slide onto a print. It emphasizes texture details but doesn't replace them.

14 It also boosts the colors in the shadows and highlights. Sometimes that is good (because it makes everything more vibrant), but in this case the colors were already fine. No worries; just use IMAGE ▸ ADJUSTMENTS ▸ DESATURATE to make this a pure grayscale layer. This way the overlay makes the texture details only brighter or darker but leaves the colors completely untouched.

Figure 4-101:
A closer look at the new detail layer and how it can be enhanced with a heavy Unsharp Mask filter.

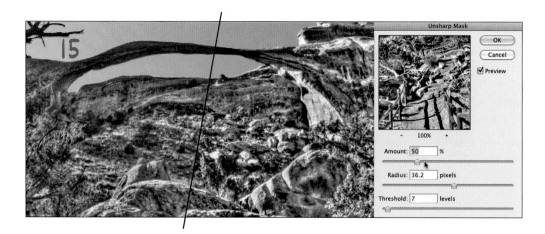

Figure 4-102:
After Curves and Hue/Saturation adjustments are added, the final layer stack is complete.

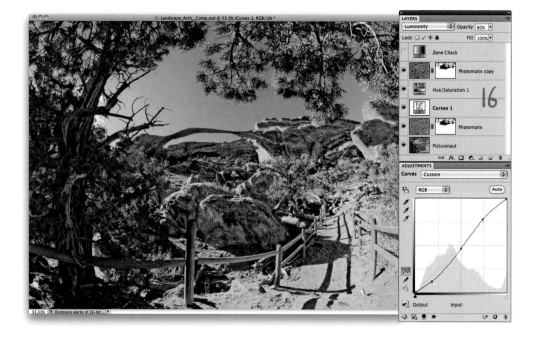

15 That new detail overlay really does the trick! If you took an isolated look at the layer itself, you would see a very busy collection of high-frequency details. The way the Overlay mode works is that every pixel brighter than mid-gray will brighten the layers underneath and every pixel darker than mid-gray will darken them. That's why it blends in so gracefully; mid-gray pixels don't do anything, and the overall balance of the image remains untouched. For natural images you may also try the Soft Light blending mode; that one is even more subtle.

If you want to emphasize larger structures (instead of the small texture detail we extracted here), you can also apply a large-scale Unsharp Mask filter to this layer. That's completely optional, of course. But the point is that this Photoshop layer stack is flexible enough for such a change; you wouldn't actually have to go back to the local tonemapper to change the detail size.

16 The rest is standard procedure. Add a curves layer with Luminosity blending mode to fine-tune the tonal distribution. Fine-tune colors with a Hue/Saturation adjustment. This image is getting a bit too colorful to pass for realistic, so I'm reducing the saturation of the reds by −30.

Out of habit I place these two finishing adjustments underneath the detail layer in the final layer stack. Right now it doesn't make much difference, but sometimes I purposely don't desaturate the detail layer and then the vibrance boost comes out nicer when this layer is on top.

Now the final layer stack is complete. Special tip: The easiest way to play with some different opacity values is to just select a layer and press a number on the keyboard. Press 1 for 10 percent, 2 for 20 percent, and so on. That way you can keep your eyes fixed on the image and more directly see if that change is an improvement or not.

17 Save the master PSD.

18 Flatten all layers, apply Smart Sharpen, convert to 8 bit, and save the final JPEG.

There are countless variations to this technique. You can experiment with different layer blending modes or further overcook the detail layer with some harsh filters. Many people like to blend the original center exposure back in where they have maxed out all the Lightroom adjustments. Possibilities are endless.

The best part about this technique is that the detail amount is now controlled with the Photoshop layer stack. You can dial in as much or as little detail as you wish, all in your familiar Photoshop environment. Even if your intended look is more on the surreal side, it's a great convenience that you can just mask out the sky (or other areas that didn't turn out so great) and have a plausible replacement ready. No need to make any compromises during the actual tonemapping phase. There is also no fuss about preview size or how the tonemapping settings will affect the final result because by the time you make decisions about details, you're already working on the final image. All the computationally heavy lifting has already been done when preparing the layers, so everything you do in post-processing is extremely interactive and fast.

CHEAT SLIP
Double dipping technique

- Tonemap one version with a global TMO, optimizing the overall distribution of light and shadows.
- Tonemap a second version with a local TMO, using aggressive detail boosts. Dare to go over the top.
- Make sure neither of these versions have clipped highlights or shadows.
- Stack up both versions as layers in Photoshop, the local one on top with 20 to 30 percent opacity.
- Optional: If there are visible artifacts in the local version, select the affected areas and create a layer mask.
- Duplicate the top layer and set the copy's blending mode to Overlay.
- Optional: If the color vibrance boost is unwelcome, desaturate the new detail layer.
- Fine-tune tones with Curves and colors with Hue/Saturation adjustments.
- Fine-tune the detail ratio by changing layer opacities.
- Save the master PSD.

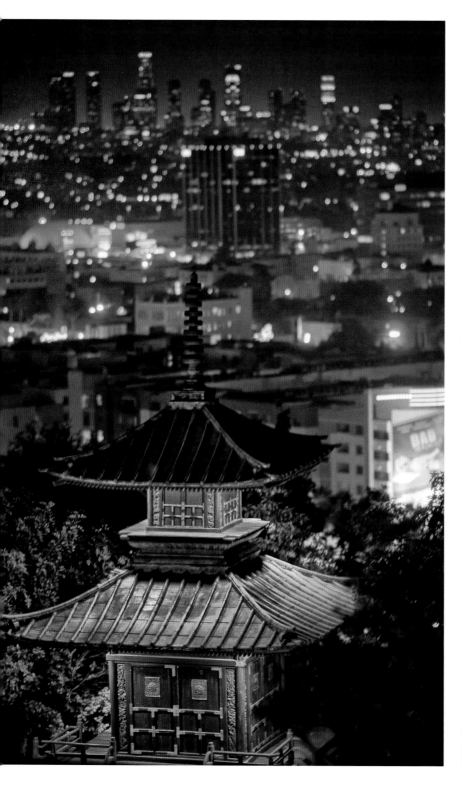

Let's do another one, shall we?

The next example is the view from the Yamashiro restaurant in Hollywood. The backside of the menu claims that this little pagoda is 600 years old and was carried over from Japan brick by brick by the restaurant founders. Yeah, right! It's a pool bar with a nice view of Hollywood and Downtown L.A.; it's certainly worth a visit when you're in town, but probably not of historical importance.

In this tutorial, we'll take the double-dipping technique one step further and implement the selective detail enhancement mentioned in section 4.3.1. If you really worked through the last tutorial, you can probably guess what's coming.

Figure 4-103: *The Yamashiro garden is great dinner spot when you're visiting Hollywood.*

➤ Mixing it up at the Yamashiro

Load Yamashiro.exr from the DVD to follow along.

1 Global pass: This time I don't want to wait for my virtual PC to boot, so let's just use Photomatix's Tone Compressor to get a broad feeling for the scene contrast. As you learned in section 4.1.1, this is also a global TMO and a close relative of Picturenaut's free Photoreceptor operator—kind of like the cousin who got a real job.

I tried in the past to use a local operator for this pass, but it turns out the inherent restrictions in a global operator are actually helpful to stay on track. The image may appear washed out and somewhat underwhelming, but it's guaranteed to contain the original order of all tonal values. Global operators have no chance of introducing tone reversal, halos, or extra noise. That's why they are perfectly safe to use for this natural base layer; you couldn't possibly push the settings too far.

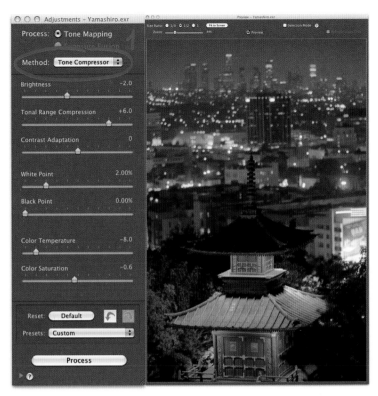

Figure 4-104: *Photomatix's Tone Compressor method shall now be our global TMO.*

2 Local pass: Just to mix things up a bit more, let's use HDR Efex for the second version. Take no prisoners, push Tone Compression and Structure all the way! Throw a good amount of the Crisp method in the mix. Explore how much local contrast can be found on the pagoda, and boost it all up.

Don't even bother tweaking things with control points. The fun part about the double-dipping technique is that the tonemapping part becomes a quick creative jam session where you're laying down bold strokes. No need for compromises; the image doesn't have to look good everywhere. If the mid-ground buildings look dirty, that doesn't concern me a bit. Clipping is the only thing to avoid because pure white or black areas won't blend well.

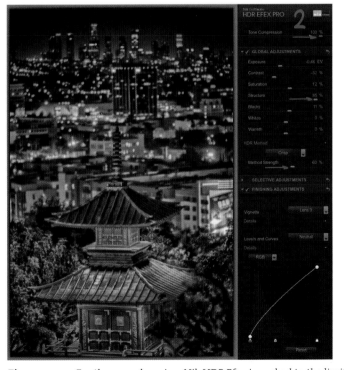

Figure 4-105: *For the second version, Nik HDR Efex is pushed to the limits.*

Figure 4-106: ▶
With both versions loaded as layers in Photoshop, compare them and choose your favorite area.

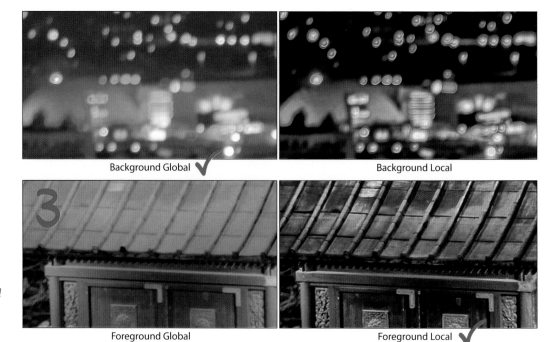

Background Global ✓ Background Local

Figure 4-107: ▼
Adjust the top layer's opacity to maintain as much detail as necessary in the foreground, and then make a layer mask to reveal the good parts of the background.

Foreground Global Foreground Local ✓

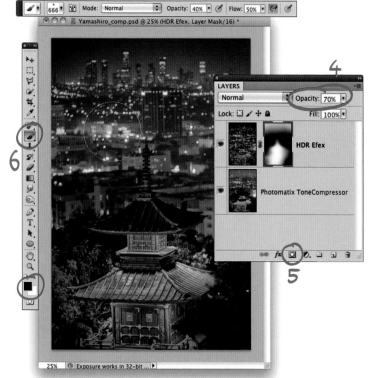

3 Make a plan: Load both versions as layers in Photoshop, once again with the harsh local toned version on top. Now is the time to make up your mind and come up with a plan. Flip the top layer on and off and compare them first. Keep a mental checklist of your favorite features of each.

In this example I really like the softness of the background in the global version. Especially nice are the lights around the blue dome of the Arclight movie theatre. Checked. In that same area, HDR Efex did funky things to the bokeh (in all fairness, most local tonemappers mess up defocused parts). But on the pagoda, that extra detail looks awesome. It's a touch on the painterly side, but that's to be expected when we're tonemapping with the big spoon. Still, the lower roof of the pagoda is the best part about the local version. Checked.

4 Blend it: Now keep your eyes fixed on your favorite part of the local version (pagoda roof) and slowly lower the opacity of that layer. Stop just before the look you love is gone. It's about finding

a balanced compromise with just the right amount of detail. For me, that sweet spot is 70 percent here. That shall now be the maximum we will ever see from that layer.

5 With the top layer still selected, create a layer mask.

6 Mix it up: Grab a large soft brush and set the foreground color to black. Gently paint on the layer mask to reveal the nice areas of the background. As a reminder, you can switch to white paint color with the X key and change brush size with the square bracket keys [].

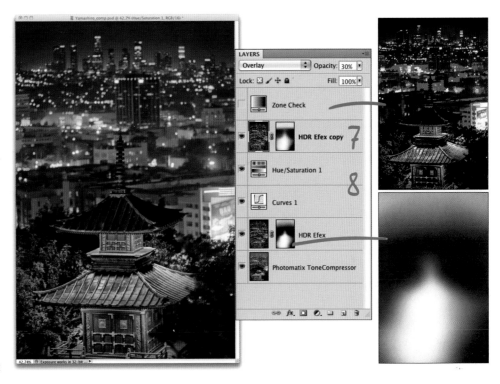

This is really the creative part. And it's as interactive as it can be. I probably spend more time brushing details in and out than moving the sliders in either of the tonemapping programs. For example, it turns out that keeping small amounts of the harsher version on the top of the frame accentuates the distant skyline quite nicely. The bushes on the left can also take a touch more detail, but the bushes on the right seem better when they are silhouetted. Even if this wouldn't be such a narrow depth-of-field shot, the ability to precisely steer the amount of detail (and the viewer's attention) is an incredibly powerful photographic tool.

7 The rest of the workflow is just as described in the preceding tutorial. Duplicate the top layer

and set it to Overlay mode with 30 % opacity for some extra pop. No desaturation applied here because in this case, the color vibrance boost is a welcome bonus.

8 Fine-tune tones with Curves and colors with Hue/Saturation. Once again, I slightly reduce the saturation of the reds to give it a more realistic feel. But I can't resist boosting the greens because that pagoda roof is just too awesome.

9 Save the master PSD.

10 Flatten, apply Smart Sharpen, convert to 8-bit, and save the final JPEG.

Figure 4-108:
The final mask is very simple but insanely effective. And the workflow for creating the rest of the layer stack is standard procedure.

So now you know my favorite path to natural toning. Generating the layers, which is technically the only part of the workflow that can be called tonemapping, is typically the quickest part of the workflow. All the really creative things, the thoughtful balancing of details and

lighting, happen in postproduction. It's the composite where the image becomes alive. And it's the composite where I can do minor creative tweaks anytime later.

To speed up the process, I actually turned my favorite layer stack into a Photoshop action. All that's is left to do is decide on the right blending amount and eventually paint a few masks. You'll find my action on the DVD, but I encourage you to exercise the workflow a few times all the way through and then record the repetitive steps yourself. When tonemapping is done with batch processing, this quickly becomes a slick assembly line for mass production.

I keep switching out the tonemappers, but the basic premise is always the same: one global operator as ground truth layer and one local operator for working out the details. That seems to be the golden combo. Since part of the method is to drive the local tonemapper to the extreme, there is plenty of fun in exploring the image, and the difference between programs really shows. HDR Efex seems to be good for medium-sized details with a lot of contrast and texture. HDR Expose and Express have mysterious ways to bring out clarity and sharpness in tiny details. SNS-HDR results in a similarly crisp style and is particularly good for working out highlight details. And FDRTools lets you to extract any kind of detail when you're brave enough to dive into the frequency equalizer. Sometimes I blend the results of different local tonemappers, but after more than two local layers, the composite gets confusing.

4.4.5 Manual Dodge-and-Burn Techniques (with Photoshop)

Let's take a deep breath and reconsider the main purpose of tonemapping: compensating over- and underexposed areas to return a pleasing image. There's actually no pressing reason to throw fancy algorithms at this problem. Especially when you're aiming at a natural style,

you can just as well reexpose individual parts of the image by hand.

This approach is not new at all. In fact, it is the oldest trick in the book. It's exactly the same as dodging and burning in the analog darkroom. Back in the days, there was the film negative with much higher dynamic range than photographic paper could handle. The opportunity to fix that problem occurred during the enlargement process. That's when a special projector (called enlarger) shines light through the negative onto light-sensitive photographic paper, producing the actual print. You could lower the exposure in selective areas by holding a cardboard circle on a stick into the projected light beam. That's called *dodging*. For raising the exposure, you would hold up a cardboard mask with a cutout hole, restricting the light beam to hit only those areas that need to be darker. That's called *burning*. (Memorizing the difference is easy when you associate *burning* with the apocalyptic effect of a loupe on ant societies).

Ansel Adams used these techniques extensively, up to the point where it's safe to call him the most prominent HDR artist of the analog era. He had no access to fancy plug-ins; a cardboard circle on a stick was always good enough for him. And even though no tonemapping tutorial will tell you, you have exactly the same power in good old vanilla Photoshop. Correcting exposure by hand means that you can literally massage the dynamic range piece by piece until it fits the tonal range of your monitor. There's no magic here. Just manual labor paired with precise control over the result. *You* are the tonemapping operator.

In the most basic form, you could just make a selection in Photoshop and use the exposure control from the IMAGE ▸ ADJUSTMENT ▸ EXPOSURE menu. Of course, real pros use adjustment layers for a non-destructive workflow. Here's how the manual dodge-and-burn technique really works.

➤ Selective exposure adjustments in Photoshop

Figure 4-109:
Select an overexposed area and create an exposure adjustment layer.

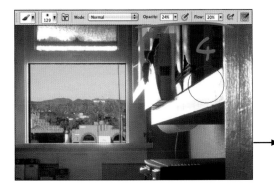

Figure 4-110:
Gently paint on the layer mask to reduce exposure in other areas. Adjust your brush frequently.

Load the infamous KitchenWindow.exr image from the DVD. No really, stop reading and open the image in Photoshop now! I will wait for you.

1 Start off with a rough selection of the most overexposed area, such as, for example, the window view. In this particular case, a simple rectangular selection will do; otherwise, you may want to use the mighty powerful Quick Selection tool.

2 Create an exposure adjustment layer with the widget on the bottom of the Layers palette. It comes conveniently preloaded with a layer mask representing your initial selection.

3 Tune the exposure to taste. Make good use of the Gamma Correction slider to control visual contrast.

4 Pick a soft brush with very low opacity/flow settings and paint on that layer mask to apply the same exposure adjustment to other overexposed parts. It's really quite simple: White paints the effect in, black removes it again, and you can switch between these two paint colors by pressing X on the keyboard.

5 How well the mask fits is really up to your skill with the paint brush. You can bring up a mini-menu to change the brush size and hardness just by right-clicking anywhere. I do that very frequently; it's much faster than moving the mouse (and my work focus) to the Tools palette on the side. The Smudge and the Blur tools are also great helpers for fine-tuning the mask, but your best friend is definitely a Wacom tablet.

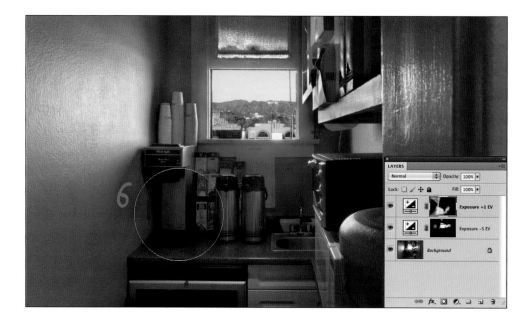

Figure 4-111:
Add a positive exposure adjustment layer and gently bring up the shadows.

6 You can stack another adjustment layer on top for bringing up the shadows. Use a very large, soft brush and gently touch up the general shadow areas, and it will all blend together naturally. You'll see the details emerge from the shadows, exactly where you want them and exactly how strong you want them. Since adjustment layer settings can be changed at any time, you can always fine-tune the overall strength after painting the mask.

7 Once you like what you see, you just bake it down. Flatten all layers and convert the image to 16-bit with the simple Exposure/Gamma method. That's it. ◄

This technique is very similar to traditional exposure blending, where you would manually merge the original photographs by painting masks for the best-exposed parts. But it's less confusing because you don't have to take care of layer order, blending modes, or anything like that. Instead of handling separate image layers, you have only one base layer plus some flexible exposure adjustment layers. Can't beat the elegance in that.

It's true that Photoshop always had dedicated Dodge and Burn brushes. However, they are not as effective as this technique because they are restrained to 8- and 16-bit mode. Confronted with the blown-out window, they are completely useless. When you think about it, these brushes were never living up to their names. Dodging and burning in LDR is simply not the equivalent of modulating the exposure on the way from a negative to a print. Instead, it's more like meddling with the print after it has already been developed. Besides, these brushes are destructively applied to the actual image. So Adobe actually did us a favor by not enabling the Dodge and Burn brushes in 32-bit mode because it forces us to use nondestructive adjustment layers. Thank you very much.

Advanced techniques

Manual exposure adjustment is the
entry gate into the Valhalla of 32-
bit editing. Once you step in there,
anything can happen. Chapter 5 will
show you a few more extreme ex-
amples. The key element is that you
have full access to all the original im-
age data at any time, including far-
end highlight and shadow details,
instead of relying on what the tone-
mapping algorithm has left for you.

Let's exercise this technique on
another image. In the next tutorial
we see the return of the Manhattan
municipal building, and the tutorial
will introduce a few tricks for creat-
ing these exposure masks.

Figure 4-112: *The Manhattan municipal
building, right across the street from
New York City Hall.*

Figure 4-114: *Fine-tune the selection.*

Figure 4-113: *Use the Quick Selection tool to select the sky.*

Figure 4-115: *Add an exposure adjustment.*

Browse back to section 3.2.4 to see how the original RAW photos were developed, then merged to HDR, and finally perspective-corrected in 3.3.2. This workflow starts with loading Manhattan.exr from the DVD into Photoshop.

1 Here the sky is a pretty irregular shape. Time to use the Quick Selection tool.

2 Draw a few course selection strokes across the sky. An expanding blob of crawling ants that indicates your selection will appear. Chase down little ant islands, especially on the border, until the entire sky is included in the selection.

3 Zoom in on the roofline and use a smaller selection brush to include some of the finer details. Hold the Alt key to subtract from your selection and Shift to add to it. With the Auto-Enhance check box enabled, this is really a matter of seconds.

4 Zoom back out to see the whole image in context and create a new exposure adjustment layer.

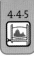

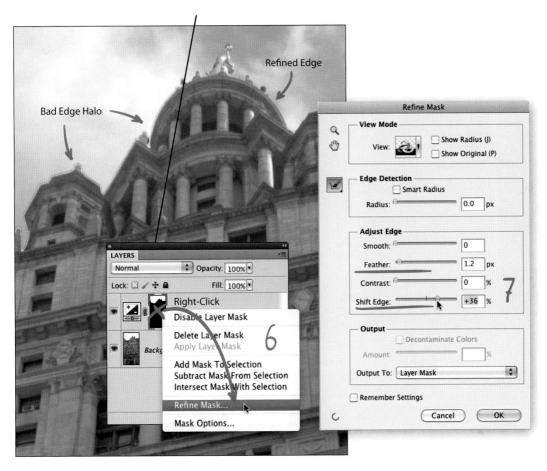

Figure 4-116: *Use the Refine Mask dialog to fix the edge halo.*

5 Play with the settings until the sky is nicely exposed. An exposure value of −2.4 EV and slight nudge on the Gamma slider seem to work. However, with such a strong adjustment, the edge of our mask becomes apparent now. It looks like a thin halo, not unlike what some tonemapping operators would produce.

6 Once again, zoom in on the roofline to have a better look. That edge halo is surprisingly easy to fix. Simply right-click on the mask icon in the Layers palette and select Refine Mask from the context menu.

7 The Refine Mask dialog is one of the most underrated new features in CS5. It's really awesome. It combines all the important tools for fine-tuning a mask in one slider box, and it gives you real-time feedback all along the way. Use the Shift Edge slider to shift the edge of the mask closer to the building. Slightly increase the Feather value to soften the mask, and you're done! Our exposure adjustment is now perfectly constrained to the sky, with a cleaner separation than most tonemapping operators would be able to produce.

That's how you build a hard-edged exposure mask. Now let's make a very soft exposure mask to brighten up the lower part of the building.

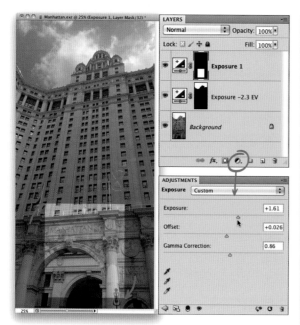

Figure 4-117: *Draw a rough box selection in the shadow portion and create a new exposure adjustment layer.*

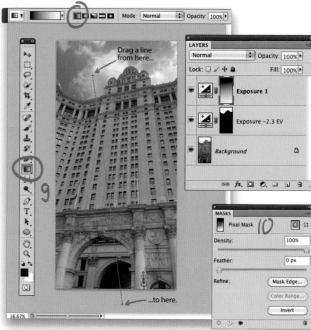

Figure 4-118: *Use the Gradient tool to fill the mask with a smooth gradient.*

8 Select a simple rectangle somewhere in the shadow area and create a new exposure adjustment layer. Play with the Exposure and Gamma Correction values until that selected patch looks properly exposed.

It's a very formulaic workflow: *First* make a selection, *then* adjust exposure. That way the adjustment layer starts out with a mask, and you can start tweaking the exposure settings right away. In this case, it's just a temporary mask, and we will override it in the next step. But it's good to have it as a simple before/after indicator while you find just the right exposure settings for the target area. It's less fuss and more straightforward when you make this preselection a persistent habit.

9 Grab the Gradient tool and make sure the linear gradient type (first icon in the Tool Options bar) is selected. Now drag a long line vertically across the image. That will fill the layer mask with a smooth gradient, causing the exposure adjustment to fade out gracefully. Experiment with different placements for the gradient, just by drawing it multiple times with different start and end points.

Soft gradients are an excellent way to balance exposure across large areas. This is the direct equivalent of a graduated neutral-density filter held up in front of the camera, with the exception that you can still draw on the layer mask with a large soft brush to fine-tune the effect. For many landscape shots, this is really all you need.

10 Here is one last tip for working with masks. Photoshop has a special Masks palette that gives you quick access to a few common operations that come in handy with masks. You can make a mask brighter (Density), softer (Feather), or invert it quickly. And the Mask Edge button brings up

the powerful Refine Mask dialog shown earlier. All very useful stuff, and that's why I recommend keeping this palette open whenever you work with masks. If it's hidden, you can summon it by choosing WINDOW ▸ MASKS.

11 Done. Flatten all layers and bake everything down to 16-bit.

12 Proceed with post-processing (Curves, Hue/Saturation, Sharpen). Oh, and save the image!

I know that all this sounds incredibly primitive. But you know what? It works like a charm; it always did. There is very little guesswork involved with this workflow. At any given moment you're completely in touch with your image, and you see the result progressively take shape.

Sometimes, however, it can get tricky. When an image has a lot of high-contrast details (for example, foliage against the sky), you have a hard time creating the mask. Hard selections with the Quick Selection tool get tedious, and smooth gradients simply don't cut the cheese. But fear not, here comes the advanced solution: Drum roll please... a luminance mask!

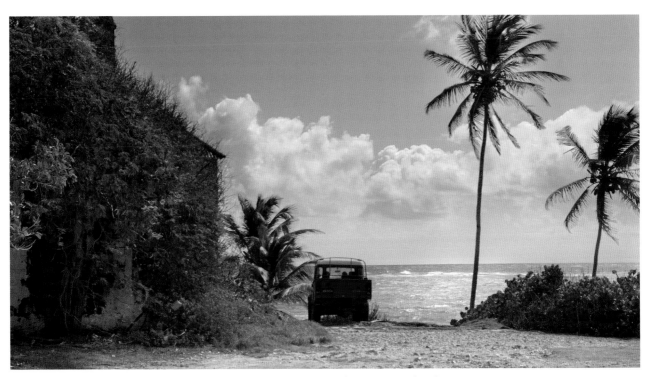

Figure 4-119: *A lonely jeep on the beach. The ragged foliage edges call for some special tricks.*

Figure 4-120:
Adjust exposure by +1 EV for better shadow visibility.

Figure 4-121:
Apply Image creates a mask from the luminance of the image. Make sure to enable the Invert check box and then click OK.

For this tutorial you need Lonely-Jeep.exr from the DVD.

1 Create a new exposure adjustment layer and set it for good shadow visibility. An increase of +1 EV will do. Yes, I know, I told you to always select something first, but this particular technique is the exception to the rule. With nothing selected, the mask starts out white and the exposure adjustment is applied to the entire image. Clouds and sky may get blown out, but don't raise Exposure so far that edge details on the foliage disappear.

2 With the layer mask still selected, choose IMAGE ▸ APPLY IMAGE. That function will fill the mask with the luminance channel of the image itself.

3 Enable the Invert check box in the Apply Image dialog! That's pretty important because for strange reasons only known to Adobe, neither the IMAGE ▸ ADJUSTMENTS ▸ INVERT command nor Invert Selection work in 32-bit. Lucky for us that whoever is responsible for these debacles forgot to disable the Invert check box in this particular Apply Image dialog (and in the Masks palette shown in last tutorial's step 10).

4 Pretty good, eh? With the inverse luminance channel as mask, the exposure adjustment is now perfectly fitted to the shadow portion. Alt+click on the mask thumbnail to see how the mask looks. Notice how cleanly the edge follows all the twigs and greens.

The mask is actually a little bit too detailed. All the little gray spots on the left are not doing us any good because they only dampen the exposure boost we want in the shadows. You could

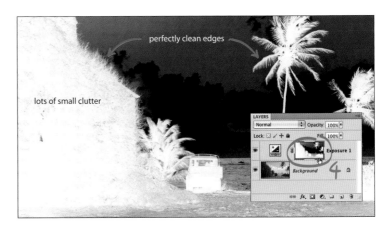

clean it all up with a brush, but there is a faster and easier way. Before moving on, Alt+click on the mask thumbnail again to switch back to the normal view. We're more interested in the *effectiveness* of the mask than the mask itself.

5 Now choose FILTER ▸ BLUR ▸ SURFACE BLUR. Set Radius high enough to smear out the small rubble in the mask, and set the Threshold low enough to preserve the clean edges. Click on a few key areas in the image to check the edges in the preview.

Figure 4-122:
Alt+click on the mask thumbnail to see the new mask.

Figure 4-123:
Use Surface Blur on the mask to clean up the clutter while preserving the edges.

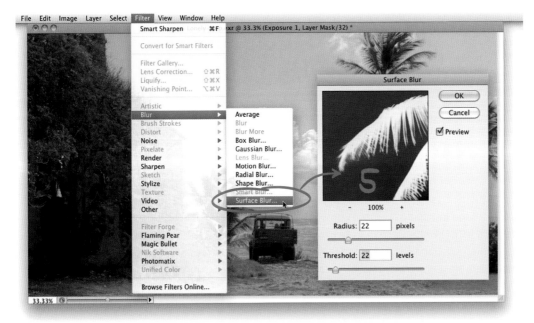

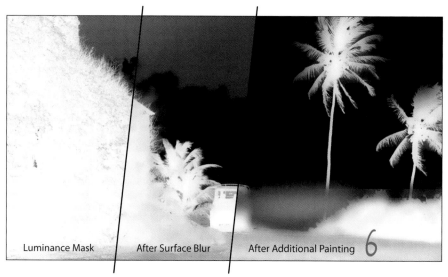

Luminance Mask After Surface Blur After Additional Painting

Figure 4-124: *Surface Blur helps, but the final mask is done with a large, soft paint brush.*

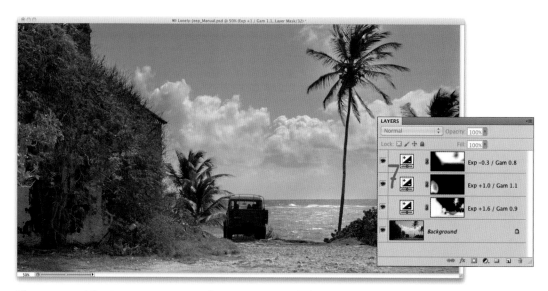

Figure 4-125: *After two more exposure adjustments are stacked up, the image is done.*

6 Congratulations. You have just created your own custom tonemapping operator. Compare all these steps with the introduction to local operators in section 4.1.2 and you will see that local tonemappers are doing pretty much the same.

Except, of course, now you have much more direct influence. You can still paint on that mask. If you use a large soft brush and stay away from the precious edges, it's fairly easy now to clean up the sky and really target the exposure adjustment to the places where it makes the image better. In my mask, for example, I gently brush in a bit more exposure into the distant glare on the ocean. And remember, you can still fine-tune or blur the entire mask with the Refine Mask tool from the preceding tutorial.

7 The next two layers are just soft painted again. One is raising the exposure by one more EV in the darkest area on the left because I just found a tree growing through the big black hole in the wall there. Who'd have thought? And the second (top) layer generally covers clouds and sky. This layer isn't so much about the exposure shift, but the 0.8 gamma correction for a subtle contrast boost.

8 That's it. Apply standard finishing touches in 16-bit, and then ship it!

Even if this manual workflow seems like a lot of work, you should try it at least once. Performing all these steps yourself has immense educational value. It will help you to understand when and why a local tonemapping operator has trouble separating shadows and highlights. You see how halos on high-contrast edges happen— sometimes as the result of clumsy paint strokes (believe me, I know what I'm talking about), sometimes as the inevitable consequence of a tricky subject.

Moving pictures

Should I tell you the secret? Oh, why not: These techniques work perfectly for toning HDR video. This is exactly how movies have been digitally graded for a very long time.

Nowadays you don't even need a fancy high-end production suite. After Effects is extremely powerful, yet easy to learn. For simple gradients and exposure shifts, you wouldn't even have to scratch its surface. It's literally the same as in Photoshop. Luminance masks and blur operations are topics of any self-respecting After Effects course and classify as intermediate-level skill at best. The most complex thing to generate would be a hand-drawn mask, and for static camera angles (as most HDR time-lapse clips are), you can easily paint that mask for the first frame in Photoshop. After Effects links right up to Photoshop, and it can even load your layered PSD for a jump start.

If After Effects sounds like something you'd like to get into, don't miss the After Effects tutorial in section 5.2.3!

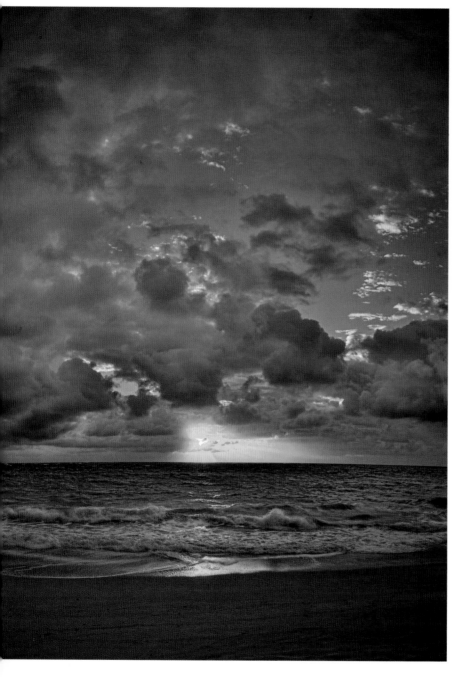

The final frontier

Okay, I'm running out of tutorial space in this subchapter. Before my editor comes knocking on my door with a Taser gun, let me just quickly rush over the last one. This is a combo technique of pretty much everything described earlier. If you can follow it, there is nothing I can teach you anymore about toning manually. Then you'll be ready to graduate to full-on 32-bit editing in Chapter 5.

Figure 4-126: *I camped out on this Barbados beach starting at 5:00 a.m., waiting for a burning sky to happen. But the local weather god strategically placed thick storm clouds on the high sea to block the sun. When it finally broke through, this magic tranquil moment emerged.*

► Final frontier

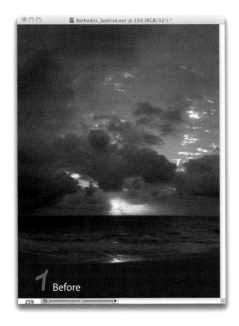

1 Before

2

Standard Preview Highlight Compression

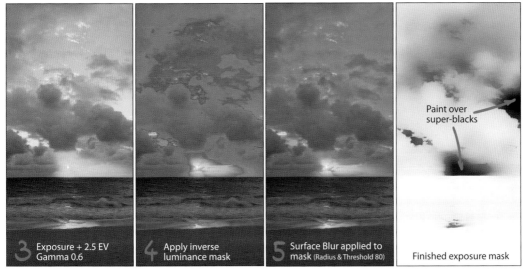

3 Exposure + 2.5 EV
Gamma 0.6

4 Apply inverse
luminance mask

5 Surface Blur applied to
mask (Radius & Threshold 80)

Paint over
super-blacks

Finished exposure mask

1 Load Barbados_Sunrise.exr in Photoshop.

2 A strong hotspot like the direct sun is hard to handle with masks alone. For a smoother workflow, open the 32-bit Preview Options from the View menu and set the Method to Highlight Compression. We will run the entire workflow in this viewing mode, so the highlights will always be protected. Note that this is not tonemapping the image down; it only changes the way we look at the 32-bit data (see section 4.1.1 for details).

3 Add a strong exposure adjustment (+2.5 EV, Gamma 0.6) to bring out the clouds.

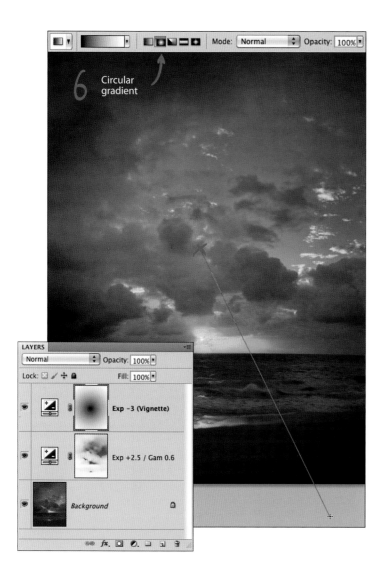

white, will react very differently to the Shift Edge slider.

One word of warning, though: The Apply Image trick can sometimes introduce negative pixel values to the mask. These have the odd effect of inverting the exposure adjustment, which means in this case that the affected areas will become darker instead of brighter. You can't see these super-blacks when you're looking at the mask (because your monitor can't show them), but you will notice the effect. In every other program you can explicitly limit an effects mask to floating point values between 0.0 and 1.0, but Photoshop is... well, let's call it *special*. To be safe from super-black holes in your mask, I recommend gently overpainting the black areas with a very dark gray.

6 Let's add a vignetting effect. The setup follows the familiar structure: First create a −3 EV exposure adjustment, then fill the mask with a circular gradient. Despite the simplicity, this is the most accurate vignette you can possibly create. Vignetting in a real lens is caused by light loss closer to the edge, which results in a lower exposure there. And that's precisely what we're simulating with this setup. Just putting a black stencil on top of an LDR image, which is the traditional way to add this effect, is absolutely not the same. For example, notice the small white cotton ball clouds on the right border. They are so bright that they still appear white after the exposure shift. With an old-school vignetting effect they would simply turn flat gray.

To tweak the midpoint of the vignetting effect, you can simply use the Shift Edge slider in the Refine Mask dialog.

4 Use Apply Image to create a luminance mask. Remember to check the Invert option (because we want the shadows to be selected).

5 Run a strong Surface Blur filter (Radius 80, Threshold 80) on the mask to smooth out the cloud detail. Refine Mask with a large Feather value works fine as well because the edges are not really critical here. Try it and see how the look is different. You can also try shifting the edge with the Refine Mask command. A mask like this, that has no clear distinction between black and

7 Our layer stack already emulates pretty well what's happening inside a local tonemapping operator. One aspect is missing, though: the extra detail boost from exaggerating higher frequencies. Right now we're only maintaining details, but we can't really boost them. No? Of course

we can. The trick is to merge the double-dipping technique from section 4.4.4 with the Smart Object workflow from section 4.4.3 and bring it all together here.

Ready? Okay. Duplicate the background layer by dragging it onto the new layer icon on the bottom of the Layers palette.

8 Turn the new layer into a Smart Object. You can either use the context menu of the Layers palette (right-click and select Convert to Smart Object) or choose FILTER ▸ CONVERT FOR SMART FILTERS from the regular menu. Doesn't matter; they will both do the same.

9 Now apply a tonemapping plug-in. That could be HDR Efex again, but in this case I use the plug-in version of Photomatix's Details Enhancer. Purposely pushing the settings a little bit over the top yields in all the fine details extracted. After you click the OK button in the plug-in, this entire layer is technically tonemapped down to 16-bit. But since it's wrapped into a Smart Object, it can happily exist inside our 32-bit document.

10 Lower the opacity of the new layer until the details blend nicely with the rest. I find 30 percent opacity quite appropriate.

11 You can also selectively remove or dampen the tonemapping effect from specific areas. That's what the standard Smart Filter mask is for. Here I painted a soft black stroke over the big hole in the clouds to restore the deep blue sky behind and remove the halo that Photomatix introduced instead.

12 Next is fine-tuning colors. Hue/Saturation works exactly the same as in 16-bit. Even better, actually, because it has access to better data. See the crazy color experiment in section 1.4 for proof. Here the Hue/Saturation adjustment layer manages to recover the purple of the clouds and cyan of the Caribbean from the 32-bit HDR. And

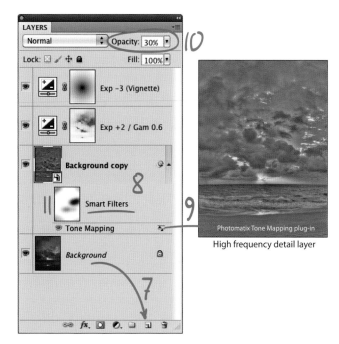

High frequency detail layer

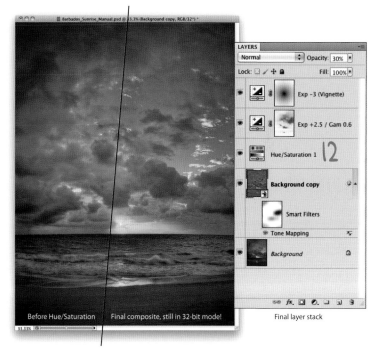

if my memory isn't completely glorifying the past in general, this sunrise really looked like that. Or felt like that. Or something. Who cares—when you come up with a better artist statement, it can pass as art!

13 That's really as far as we can keep the composite in 32-bit mode. The last fine-tuning steps still need to be done in 16-bit mode. Curves in 32-bit are considered mathematically impossible in the land of Photoshop, and any sort of 32-bit sharpening will introduce nasty artifacts (sorry for that bad advice in the first edition).

So, to finalize the image, flatten all layers, convert to 16 bits with the Highlight Compression method to maintain the current look, and add curves and sharpening. Done. ◄

The most compelling part about this workflow is that the image stays in 32-bit mode almost all the way to the end. If you switch the 32-bit preview options back to the standard Exposure/ Gamma method, it becomes very obvious that all the original dynamic range is still there. The only step that slightly degrades the data is the additional detail layer. But when you change that layer's blending mode to Linear Dodge (Add), it even increases the dynamic range. The overall composite is a prettified but still fully valid 32-bit HDR image. You could flatten all layers and save it as an EXR file. You could double-tonemap it. You could even use it for 3D lighting.

In summary, this section should have made the point that you don't have to rely on tone-mapping plug-ins or obscure black-box algorithms. Manual dodge-and-burn techniques are always an option, and a very powerful one.

4.4.6 Painterly and Stylized Looks

It's no coincidence that many HDR photographers gravitate toward painterly styles. Traditional painters have already perfected the art of representing extreme contrasts in a medium with very limited tonal range. Essentially, they performed tonemapping only with a brush and a decent dose of imagination. Painting is a process of deconstructing a scene, filtering it through the mind's eye, drilling down to the essence, and then expressing it on canvas. The actual brush work is a craft, but the art of painting happens in your head.

Our digital tools have now blurred the line between photography and painting. The key is that they can separate an image into its elemental components: form, light, and texture. These are the categories in which painters think. Toning in artistic ways follows the same deconstruction and re-creation process.

Now, what does that mean in terms of practical application?

Contrary to popular belief, painterly styles can be characterized by showing *less* detail. You need to simplify the image, remove nonrelevant clutter, and focus on the things that your inner painter's eye cares about. Also, you can substitute actual contrast with color contrast. Once you throw the idea of photo-realism out the window, you can go completely nuts with saturated and vibrant colors.

In technical terms, such treatment is called non-photo-realistic rendering (NPR). This is a pretty wide field; just consider the long evolution of traditional art and the wealth of different painting styles it has produced. It's almost

Figure 4-127:
My first pumpkin
carving is a bit of
a self-portrait. It
actually scored
second prize in the
local neighbor-
hood pumpkin
competition.

pointless to go through a hands-on tutorial because it can show only one of many different looks this can lead to. I'll try anyway; maybe there are some ideas here that tickle your inspiration.

➤ Painterly Pumpkin

1 Load Pumpkin.exr from the DVD in Photoshop. If you paid close attention to section 3.2.2, you will notice that this image was taken with a compact Canon PowerShot, super-charged with the CHDK firmware hack. Who said you need a big camera for HDR? Me? Did I? Well, I was wrong.

2 Bring up Photoshop's tonemapping dialog by reducing the bit depth with the menu option IMAGE ▸ MODE ▸ 16 BITS/CHANNEL. Increase the Shadow slider and lower the highlights. The goal is to reduce the overall contrast by a considerable amount. In this case, it takes an extra kink in the toning curve to further bring up the shadows.

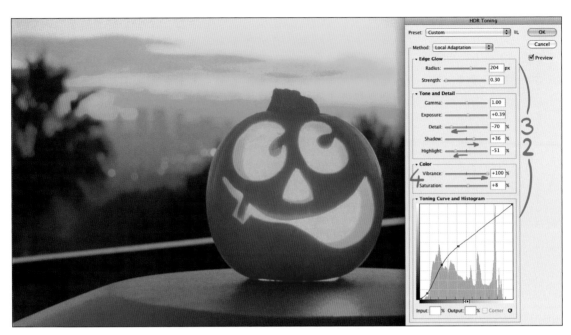

Figure 4-128: Tonemap for a low-detail, low-contrast, but highly saturated look.

Figure 4-129:
Use the Surface Blur filter to smooth out the remaining surface details.

3 Lower the Detail setting. This slider is connected to Radius and Strength in the Edge Glow section. Play with these settings to define what detail should go and what should stay. Find a good setting that emphasizes the lighting but eliminates the fine textures. Even though Photoshop's Detail slider is terrible at its intended purpose of *increasing* detail (see section 4.1.2), it does a pretty good job of *removing* detail.

Figure 4-130: *Duplicate the background layer and run the Find Edges filter.*

Figure 4-131: *Desaturate the layer and overpaint unwanted edges with white.*

4 Finally, ramp the Vibrance slider all the way up. This will boost all the subtle colors, leaving those alone that are already saturated. Here the goal is to even out the saturation levels and make everything equally colorful.

5 When you click OK, the image is already halfway there, but it can still be simplified further. Select Surface Blur from the FILTER ▸ BLUR menu and try to find some good settings that accentuate the object edges but smooth out texture details. The lower the Threshold value, the higher the amount of edges that will be blurred. And the higher the Radius value, the smoother every surface will appear.

6 You can make it look even more illustrated by adding black outlines. It's a bit cheesy, but I like it. And it's very easy to do. Simply clone the Background layer and select FILTER ▸ STYLIZE ▸ FIND EDGES. This filter typically comes out very colorful.

7 Convert the layer to grayscale with the IMAGE ▸ ADJUSTMENTS ▸ DESATURATE command, and then remove all undesired edges. An image filter can't distinguish between object edges and random edges caused by lighting or other things. You want to keep the main object outlines but delete all the edges in the background. Just paint over them with white. You can fine-tune this layer with a blur and a contrast enhancement, or even

Figure 4-132:

Figure 4-132:
Use Multiply blending mode for the edges and finish it off with some massive color boosts. Adjusting curves in per-channel mode is a great way to simplify the color palette.

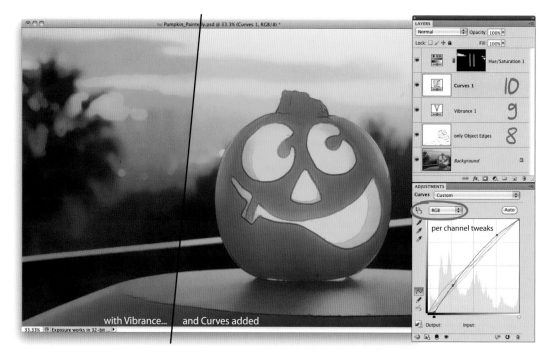

sketch on it. How about scribbling in a few lines on the little stumpy hat? Use a tiny hard brush, and then slightly blur over it.

8 When you're done fooling around, set the blending mode of this outline layer to Multiply.

9 Now let's work on the colors. Add a Vibrance adjustment layer and set it to +50 percent Vibrance, but leave Saturation alone. This will further unify the saturation level across the entire image.

10 Add a Curves adjustment and fine-tune contrast just as we always did. For expressive styles, it's also beneficial to work with a clear and simplified color palette. Curves are perfect for that; you just have to tweak the individual color channels.

For example, here I'm boosting the blue channel in the shadows, which introduces a slight purple tint. But on the highlight side, the blue

channel is lowered to let more of the red and green through. In section 4.4.3 we did a similar color grade with the RGB curves in HDR Efex, but you will see that it's even more convenient inside Photoshop. That's because you can simply select a channel to work on and use the interactive finger tool to make your adjustments directly on the image. Just try it. Select the blue channel, click on the finger icon in the Curves panel, then click on the dark bushes in the background, and drag upward to boost blue right there. Easy.

11 The image is technically done now. I do notice a red spot in the palm tree that I don't like because I want the pumpkin to be the only super-red thing. For the sake of separating foreground from background, I'm adding a Hue/Saturation adjustment that reduces red saturation, and I'm painting a crude mask to constrain it to this particular area.

12 Finished. Save! ◄

As you see, there are many great uses for the edge-preserving Surface Blur.

I must admit, this pumpkin image didn't really have that many details to begin with. It may even appear to be a rather uncontrolled slap-on-filter type of technique. Well, then let's ramp it up a notch. The next tutorial shows you how to claim more creative control over the result and how to simplify images with an exorbitant amount of detail.

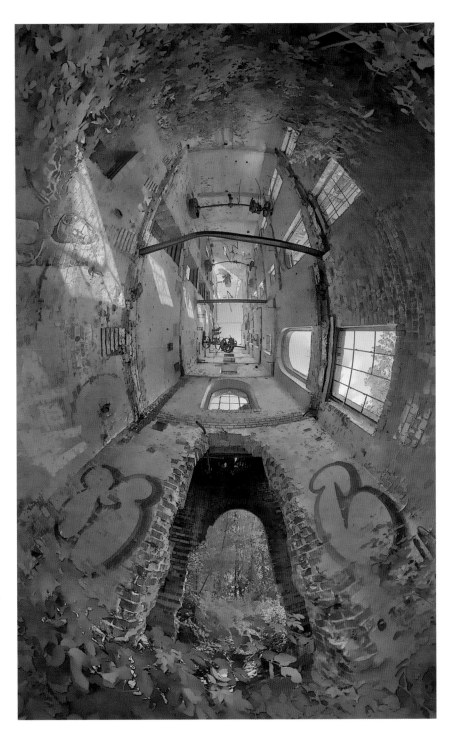

Figure 4-133: *Ultra-wide angle of the old paper mill ruins, looking straight up. I did not dare stand there for very long because the rusty machinery pieces hanging far above appeared to be first-class torture equipment with many pointy spikes. They rocked gently in the breeze too.*

Figure 4-134:
Tonemap twice, one version smooth and the other with harsh details. Stack them up in Photoshop and create an empty layer mask.

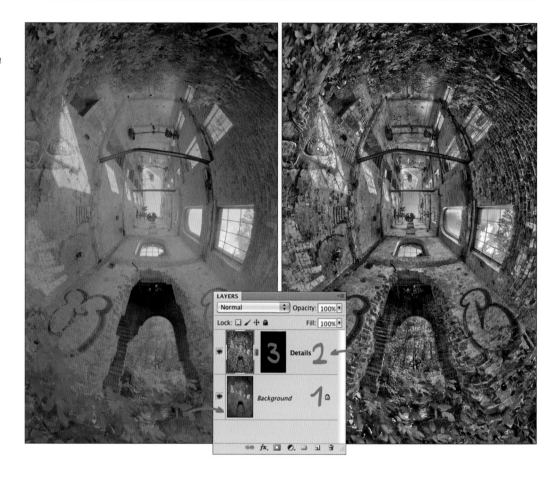

You probably caught the drift by now that this is primarily a post-processing technique. You can start fresh with PaperMill-Twisted.exr or just load PaperMill-Twisted_Start.psd to jump right into Photoshop.

1 First create a smooth low-contrast version. Aim for lots of saturation, low detail, and clear indication of lighting. This shall become our baseline, the underpainting so to say.

2 Tonemap the image again, but this time aim for a heavy detail boost. You can use practically any tonemapper for these steps, whichever you feel most comfortable with. I made both versions in PhotoEngine with identical settings, only varied the Detail Amount slider from −30 to +120.

3 Stack up both versions in Photoshop, with the detail layer on top. Create a layer mask and press the hotkey Command+Delete to fill it with black (Ctrl+Delete on the PC).

4 Grab a medium-sized paint brush with 50 percent opacity and flow. Set the foreground color to white and draw some strategic strokes on that layer mask. You want to pepper the underpainting with detail in those areas that matter. Trace the corners of the room, the outlines of windows, and a few nice patches of stonework. Maybe

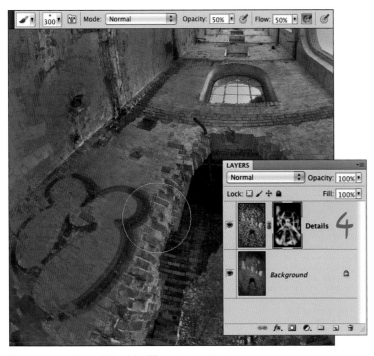

Figure 4-135: *Reveal the detail layer in strategic areas.*

Figure 4-136: *After you switch to 8-bit mode, all filters are unlocked.*

put a bit of detail on the foreground greens to provide an entry point into the picture.

It's similar to the workflow in section 4.4.4, where you hand-pick the points of interest and make them stand out more clearly. The difference is that you don't have to worry too much about smooth transitions; you can use a smaller brush and really pepper in small pockets of detail. The idea is to distribute high-contrast edges that will tell the edge-preserving blur where to put a hard transition.

5 Flatten the image and convert it to 8-bit. That's necessary to unlock all of Photoshop's image filters. Now you can select FILTER ▸ BLUR ▸ SMART BLUR.

6 The Smart Blur filter is similar to the Surface Blur from the last tutorial, but slightly different. It has finer controls, and it generates more of a paint daub look than an airbrushed look. But at its core it is also an edge-preserving filter, which is just what we need. As rule of thumb, use the

Figure 4-137: *Smart Blur is an excellent filter for simplifying the image.*

Figure 4-138:
Duplicate the layer and use Poster Edges from the Artistic filter gallery to create the outlines.

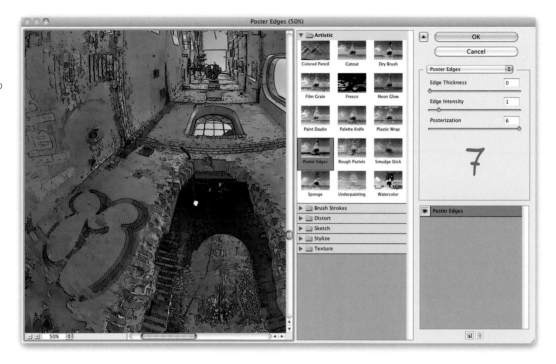

Figure 4-139:
Remove the outlines where they are inappropriate, and tone them down. Done.

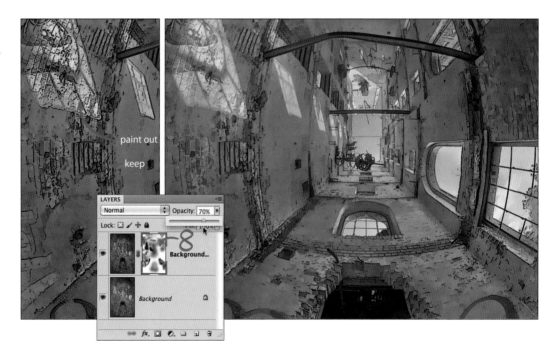

same value for Radius and Threshold. Lower values will keep it more realistic; higher values make it more stylized. Somewhere between 10 and 20 is where I like it best, but experiment yourself. I settle for 17. If you're using very low values below 5, you get a slightly stylized hyperrealistic look that actually works great for almost all images.

Unlike Surface Blur, this filter does not show a preview on the full image. So make sure to inspect critical areas with the small preview peephole, such as, for example, the corners of the room.

7 Duplicate the Background layer and select FILTER ▸ ARTISTIC ▸ POSTER EDGES. This is the high-tech version of the Find Edges filter, and it opens a nice big preview. I tend to be conservative with my settings to keep things subtle, so I'm using Edge Thickness set to 0, Intensity set to 1, and Posterization set to 6.

Photoshop's filter gallery offers plenty of opportunities to let the inner Rembrandt out. Good things to try are Dry Brush, Watercolor, and my all-time favorite, Sumi-e. You will notice that all these filters produce a much more organic look when the image has been prepared the way we did it, by preselecting the amount of detail and purposely creating vast smooth areas. In this example, notice how the black edges are drawn only on the corners and selected pieces of brickwork, without cluttering up smooth walls.

8 But of course, even the Poster Edge filter isn't smart enough to know where the outlines look appealing and where not. So the final step is to create yet another layer mask and remove the outline effect wherever it looks ugly. Shadow lines or lighting patches, for example, look better when kept clean. In other areas you may just want to tone the effect down. Ideally, such special effects are used to accentuate the image but not overtake it. Applying a filter is not really the creative part, but deciding on the strategically best placement is. ◄

In the CG world we would call this particular style a toon shader, for obvious reasons. There is a myriad of styles between photo-realistic and this one, and another myriad beyond. That totals up to two myriads of styles unlocked with these tutorials. Not bad, eh? Try this technique, take it apart, combine it with the others. Be gentle with the Smart Blur filter for hyperrealistic styles, apply it with much heavier settings for an illustrated stencil style, or throw a potpourri of artistic filters in the mix to invent something completely new.

But the fundamental elements remain the same:

❯ Aim for a very low overall contrast at first.
❯ Increase the local contrast of those details that you care about.
❯ Even out the saturation levels by adding lots of vibrance.

❯ Unify the color palette, and try to establish a strong color contrast.
❯ Simplify the image.

I will be very honest with you. That stylized look is 90 percent post-processing. Unless the scene really shows an enormous dynamic range, you may not even need an HDR image for that. And before you browse back to section 3.2.9 to catch up on the proper technique to turn a RAW file into a pseudo HDR image, hang in there with me: You can do it all in Lightroom.

Surprise of the day is the Lightroom function that enables this look: It's Noise Reduction! That's right, the ultimate detail killer, the grim reaper of fine textures! If you drive up Noise Reduction far enough, it will somehow pick up on larger structures and overpaint them with an idealized version. It's really hard to describe but amazing to see live!

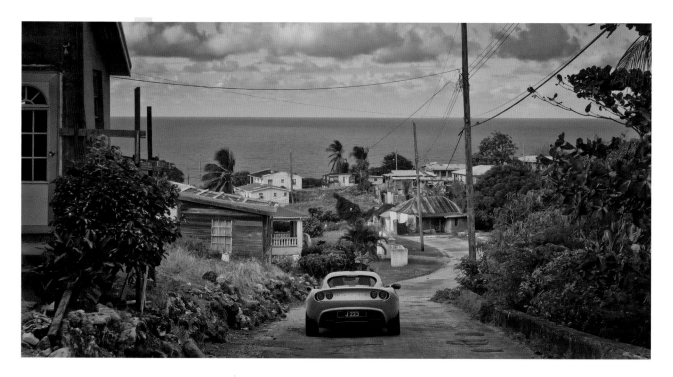

Figure 4-140:
A trip to the beach. My friends say that this image style looks like HDR, which is ironic because there was no HDR software involved whatsoever.

☛ Creating a stylized look directly in Lightroom

Try this on a RAW file from the DVD or any of your own images:

1 Pump up Recovery all the way and add a good amount of Fill Light. Now adjust Exposure to set the mood. Brightness should be magically anchored on both ends, as much as there is to pull from this RAW file, so you're really just deciding where the midtones should land.

2 Increase Clarity and Vibrance. Clarity adds structure and local contrast; in essence it is a local tonemapping operator. Or some sort of bastard child thereof. And Vibrance was described earlier; it boosts the saturation of all the subtle shades with the result of evening out all saturation levels. I love that effect so much that I sometimes lower the Saturation slider just so I can add more vibrance.

3 Now push Luminance Noise Reduction all the way up! It will go through a phase where it first blurs out the noise, then eradicates fine textures. But at the maximum setting, it traces medium-sized structures and turns them into patches of pure color. Under the hood, Lightroom's Noise Reduction is an edge-preserving filter, which is exactly what painterly styles need. With the Detail slider, you can steer how large or small the stylized color patches are.

4 Sharpening further emphasizes the effect because it now picks up on the hard edges left over from Noise Reduction and makes them more distinct. So, use plenty of sharpening.

5 Finally, use Split Toning to unify the color palette. Move the Hue sliders for highlights and shadows to complementary colors. That's an old painter's trick to make colors harmonize with each other. In Lightroom you can easily find

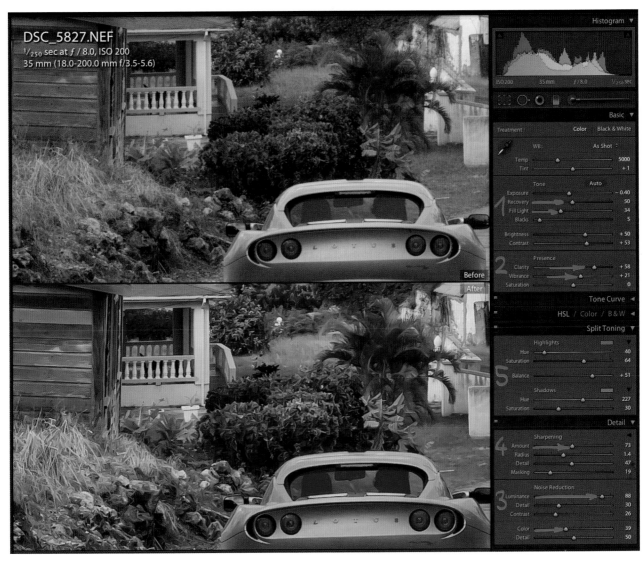

complementary colors by leaving half the length of a slider space between both knobs. There are actually six tiny tick marks above the Hue sliders,

so when you count out a distance of three tick marks, you're right there.

Figure 4-141:
Lightroom's Noise Reduction is an excellent edge-preserving filter. Applied with a heavy hand, it can stylize any image beyond recognition.

This technique works literally on every image. It can stylize HDR images that have already been tonemapped, but it works equally fine on straight RAW photos. Even people shots and portraits come out very nice because any imperfections of the skin just disappear.

There is an interesting coupling effect between all these parameters. Fill Light may bring up more noise than actual image detail, but all that disappears again. Eventually even the slightest fluctuations in shadow noise are smeared together into paint splotches that look no different than the paint splotches elsewhere.

Figure 4-142: *This slightly stylized treatment works very well for people shots because it smoothes skin and faces along with every-thing else.*

Figure 4-143:

Initially I considered this shot lost due to severe underex-posure, but it turns out you don't really need much shadow detail for a stylized look.

Original RAW (default settings) Photorealistic Painterly/Airbrushed

At first glance, these images convey the illusion that there is detail everywhere, but if you look closer, all that detail turns out to be imaginary. Noise Reduction has stylized everything to crude paint patches, which are further emphasized by Sharpening and Clarity.

Even though this Lightroom trick bypasses the HDR workflow altogether, it certainly uses the same algorithmic components that run under the hood of tonemapping operators. Core building blocks are edge-preserving filters, frequency modulation, and the separation mask to distinguish between shadows and highlights. If you bought this book just to learn about painterly styles, hopefully the revelation that it's all possible in Lightroom does not disappoint you.

4.4.7 Toning 360 Panoramas

Panoramas are typically stitched together from multiple segments, shot in different directions. If you shoot enough segments, you get a full 360-degree view. It makes a lot of sense to shoot and stitch panoramas in HDR because you will almost certainly come across very

bright and very dark regions as you pan around. Chapter 6 will teach you everything about this; here we will just concentrate on toning.

The final presentation of most panoramas is often a virtual tour, where the viewer can interactively pan the viewport around, just like Google Street View, but of course with better photographic quality than Google's robots can deliver. The key observation is that the viewer will always see only a fraction of the whole image at a time. That makes panoramas a prime example for the "Size does matter" principle mentioned in section 4.3.1. Even when the intended look is strictly natural, you can maximize impact by incorporating a stronger-than-usual amount of local adaptation in the image, leveling out the huge changes in brightness with local tonemappers.

There is one stumbling block, though: The left and right edge of a 360 panorama have to fit together because that's where the surround view wraps around. Local tonemappers, however, rely on examining the immediate surrounding of a pixel to decide how to treat

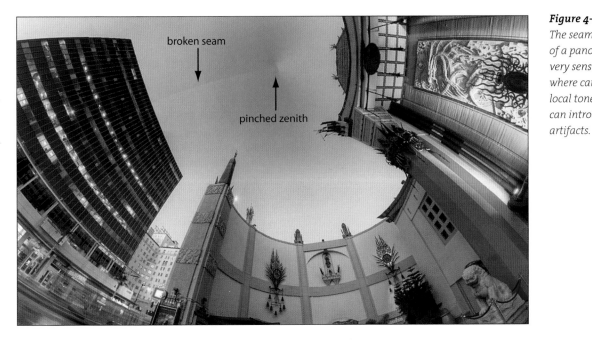

Figure 4-144:
The seam and poles of a panorama are very sensitive areas, where careless local tonemapping can introduce bad artifacts.

it. If they ignore the fact that the image actually continues on the other side, they break the panoramic continuity and the result would be a visible seam. That's why Photomatix, FDRTools, Dynamic Photo-HDR, SNS-HDR, PhotoEngine, and Artizen have a special "360 pano" check box. It tells the algorithm to look at the other edge when it gets to the image borders.

If your favorite tonemapper doesn't have a panoramic option built in, here is a generic foolproof workaround.

➤ Panorama-safe toning

Open your HDR panorama in Photoshop. Use Footprint_Court.exr from the DVD if you don't have any panoramas yet.

1 Double-click the background layer to unlock it. Photoshop will ask for a new name; the default Layer 0 is just fine.

2 Duplicate Layer 0 twice.

3 Open the Canvas Size dialog from the Image menu and set the image width to 125 percent.

4 Move the top layer to the right until the edge lines up with the layer underneath. It will snap into place as soon as the edges come close. If it doesn't, make sure the VIEW ▸ SNAP menu option is enabled. Snapping makes moving the layer in place very easy; it's just a gestural mouse flick in the general vicinity instead of meticulously nudging the layers pixel by pixel.

5 Move the middle layer to the left until it snaps into place. When you have Auto-Select enabled in the tool options (as is the default), you can just click on an element and instantly start moving it.

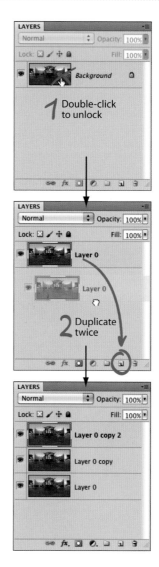

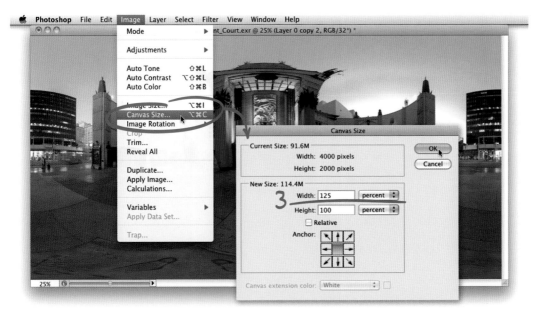

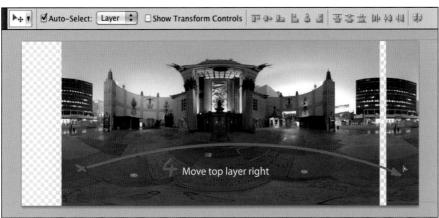

4 Move top layer right

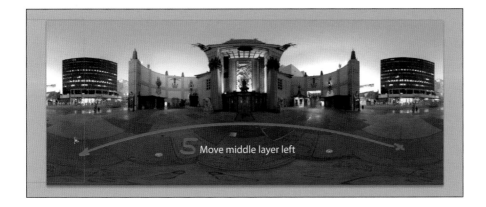

5 Move middle layer left

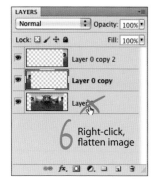

6 Right-click, flatten image

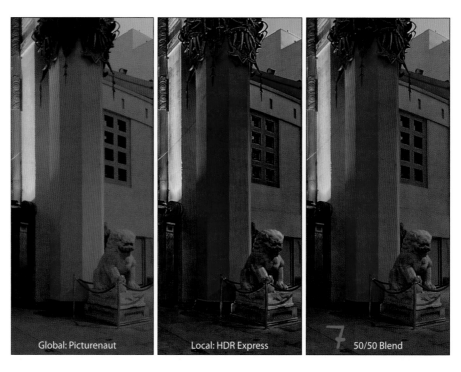

Global: Picturenaut Local: HDR Express 50/50 Blend

6 Flatten the image. Now we have a whopping 450-degree panorama. What used to be a left and right seam is now continuous image area. Any local tonemapper will do the very same thing to both sides. For example, you can fire up 32-Float to massively enhance clarity or get creative with HDR Efex. You can also use Blur or Unsharp Mask filters without fear of destroying the seam. Yes, be fearless!

7 For toning, I prefer the double-dipping technique from section 4.4.4, with Picture-naut's trusty Adaptive Logarithmic as global tonemapper. The local component is done with

HDR Express this time because it's so simple and returns the same tack-sharp clarity as its big brother HDR Expose (see section 2.3.13 for instructions on how to unlock EXR file loading in HDR Express).

8 Once both versions are layered up in Photoshop, it's time to decide on a blending amount. Remember, only a limited portion of the image will be seen in an interactive panorama viewer, so zoom in to make an informed decision! In a normal image I would settle with a 70/30 ratio for global/local blend, but in a panorama 50/50 is more appropriate.

What the canvas extension didn't account for are zenith and nadir. These are the upper and lower edges in the flat panorama, but they will be wrapped to the point directly above and below in an interactive view. That means these areas must be treated absolutely uniform, otherwise they will turn into pinched spots. Most local tonemappers, even those with a 360 pano option, completely ignore this fact (with the notable exception of FDRTools).

9 The easy fix is to mask out the local detail layer in the composite. Grab the Gradient tool and pick the second tool preset (foreground to transparent). Set the foreground color to black.

10 Now draw a line from the top edge to about a quarter of the way downward. Hold the Shift key to make sure this is really a perfectly straight line. When your gradient is tilted, the layer mask is no longer symmetrical and you scratch the left-right seam.

11 Do the same from the bottom edge to one quarter upward, again with the Shift key held down. Now both poles are protected because we see only the global tonemapper there.

12 Add Curves and Hue/Saturation for fine-tuning, and sweeten the look of the image to taste.

13 When you're done, use IMAGE ▸ CANVAS SIZE to set image width to 80 percent. That will crop the image back to the original size. ◂

Of course, you could also extend the canvas in explicit pixels, but then you'd also have to remember the original pixel size to set it back at the end. With all that tonemapping action happening in between, I tend to forget that original

size. That's why I prefer universal percentages: 125 and 80 percent are easy to memorize, provide just about the right amount of extra space for filters, and guarantee a smooth round trip (because they are mathematically reciprocal). Steps 1 to 3 are completely brain dead; they can also be wrapped up in a Photoshop action, which—you guessed it—is on the DVD.

Just for the record, PTGui also has an integrated tonemapper that is often undeservingly overlooked. Since PTGui is primarily a panorama stitcher, it is 100 percent aware of the obscure image geometry. And if this sentence was just mumbo jumbo to you, then you haven't read Chapter 6 yet. That's where you will also get introduced to more accurate ways to fix zenith and nadir.

In a nutshell
Tonemapping offers an unprecedented level of control over tonal distribution and detail rendition in your photographs. These are new creative dimensions to consider. It pays off to think in zones and to stay alert of the aesthetic rules that affect the perception of your image. Detail can quickly turn into clutter and overdone tonal range compression can quickly result in a flat look.

In the creative toning workflow, however, tonemapping is only one step. A considerable amount of look design is done in post-processing, some of the algorithms have already trickled down to LDR image editors, and nothing holds you back from polishing the tonal range directly in 32-bit mode with manual dodge-and-burn techniques.

4.5 Chapter 4 Quiz

Test yourself before you wreck yourself.

It was rather tricky to find hard facts suitable for quiz questions in such a creative/subjective chapter. Nevertheless, some concepts you should have internalized, even if it's just for the sake of knowing the rule before you break the rule.

1. Class of tonemappers that treat the entire image equally.
2. Class of tonemappers that adapt to image content and treat each pixel in dependency on its neighborhood.
3. Shadows have priority when tonemapping for screen media, but what has priority for prints?
4. Photoshop's flagship tonemapper.
5. System invented by Ansel Adams to previsualize tonal distribution in the final image.
6. Toning style that appears as if it could have been shot in a single exposure.
7. Common artifact of image regions swapping their brightness relation. Can also be embraced for artistic purposes.
8. Photomatix's flagship tonemapping operator.

9. Common artifact; bright glow around a dark edge.
10. Name of the second darkest zone in the zone-esque system, where the first texture detail and graduation emerges.
11. Selective adjustment technology in Nik HDR Efex, using control points.
12. Technical classification of an image that has undergone tonemapping.
13. Short for tonemapping operator.
14. Signature tint of night shots, known as "movie-dark."
15. Artistic style that leans on painting as art form, moving away from realistic photography.
16. Casual term for tonemapping, that also includes post-processing and creative look decisions.
17. Short for urban exploration.
18. Common artifact of all highlight and shadow details getting compressed into the midtone zone.
19. Provocative style that concentrates on emphasizing gritty details and harsh local contrasts.
20. Photomatix's most important setting; controls the ratio between local and global contrasts.

4.6 Spotlight: AntoXIII

Flickr is probably the single most influential thing that has happened to photography. All of a sudden the photo community is globally connected. Like-minded people who may have never met in real life now find each other right away and start fruitful discussions. Photographic trends are picked up within a week, instantly refined, and developed further by someone halfway around the globe.

Truly, online photo communities have kicked photography into an accelerated state of evolution. HDR literally caused a firestorm on Flickr with more than 3 million toned HDR images uploaded, still counting. With everybody commenting on and rating everybody else's pictures, the cream naturally rises to the top. To keep up with the Zeitgeist, I built an automated gallery on HDRLabs that dives into the Flickr database and digs up the 30 most popular HDR images of the current month. One of the photographers, whose images consistently rank high in this Top 30 list, is known as AntoXIII.

CB: Anto, what's your background?
AG: My name is Anthony Gelot, but all my friends call me Anto. I live in Paris, France. Before getting into photography, I didn't really love this city, but now I do. I started in photography four years ago. At first I was shooting beautiful pictures of my newborn daughter, and quickly photography has become a drug for me.

CB: Well, you certainly manage to capture the beauty of Paris well, in very eye-popping colors. Is that due to HDR?
AG: I have a Nikon D700 that allows me to bracket up to nine photos with exposures ranging from −4 to +4. I use it to expose every area of

the photograph correctly, preventing the sun or night lights from burning out and fully resolving details in the shadows. HDR was the key for my photos. Without it I was never satisfied with the result. When I think of a monument or a place to shoot, I go there when the weather is good. I watch out especially for a good sky because it's often gray in Paris. Once arrived, I try to find a good framing and wait for the right time to trigger the shot. Sometimes I wait for more than an hour until there are no people or cars, which is also very hard in Paris.

I'm also color blind. Not fully, but close. It wasn't really an issue before that new passion.

Thanks to HDR I was able to produce photos with more vivid and saturated colors without them being disturbing for the others, and it's easier for me than trying to get accurate realistic colors. I still do my white balance with Photoshop. My real main issue is with chromatic aberration. I have a lot of trouble to see it and fix it.

CB: When you're toning an HDR image, what do you look out for? Are you working toward an intended look?
AG: I don't start with a precise idea in mind. For every treatment I try many settings until I have something appealing to me without really hav-

ing thought about it before. Sometimes I'm surprised because I find the final version better than what I was expecting, and some other times the HDR is not working; then I switch to another photo or I try a classic treatment on it.

CB: Is photography your job or your hobby?
AG: No way. Unfortunately it's just a hobby. My real job is policeman.

CB: Ah, does that explain the shot with the motorcyclist and the van?
AG: Ah ha ... many people asked me if it's a true picture, especially people who don't know my real job. I wanted do this kind of picture for a long time. One day I brought my camera to work and joined my friend during one of my patrols. We found a street with fewer civilian cars and

very quickly did this shot. I got on my friend's motorbike as passenger, he rode it between the police cars, and I did the photo. My colleagues were very happy to take part in that shot; big thanks to them!

CB: Your portfolio looks pretty diverse. What do you enjoy shooting most?
AG: I more feel at ease with monuments and buildings. They don't move and I can take my time to shoot them!

CB: HDR photographers notoriously get in trouble with security officers for using a tripod. Has that ever happened to you?
AG: Well, thanks to my status, I got some exceptional authorizations that I fully took. And yes, unfortunately in Paris and other places, the tripod is often forbidden. Even without doing HDR, the fact that you can't use a tripod in all the best spots is a real pity.

CB: Your images always get a lot of comments on Flickr. Are the comments helpful for you to improve as a photographer?
AG: On Flickr all comments are very positive. It's rare that people say what they really think; everybody is kind because they want good comments on their own pictures. Because of that I never leave a comment if I don't know what to say. If I think the image is bad, I explain why and give advice on how to improve it. I think this helps a photographer to progress. At least for myself I can say that it helped me a lot to get started in photography when someone left me a constructive comment. Especially me with my color blindness, I expect honesty from people, so I don't stay with a photo that I thought was great but turns out to be a failure in terms of treatment or composition.

CB: Do you also take part in photo discussion forums? Are they better places to find useful advice?

AG: At first I took part in discussions on some French photo forums, thanks to which I discovered Flickr. I then participated in some French groups on Flickr itself, where it was possible to exchange with passionate people. Now I must admit that with my family, my work, the photography itself, I have less time than before to visit the forums.

CB: You're also a member of several HDR groups on Flickr. Why are there so many, and do you keep up with all of them?
AG: Following all of them is pretty much impossible. At some point I was asked to be administrator on a few of these groups, but my free time issue focused me on one group where I try to gather the HDRs that inspire me. There are certainly too many groups dedicated to HDR, I suppose because everybody wants his own. The side effect is that we surely miss a lot of real pearls.

CB: Do you have a post-processing formula that you follow each time?
AG: Not a real formula, but generally I use Photomatix and Photoshop. For each HDR picture, the treatment in Photomatix is different; it always takes some time to play with different settings. I can't just save a preset and run it on all pictures. Once Photomatix shows me something that I like, I open it with Photoshop. Here I improve sharpness, remove noise with the Noiseware Ninja plug-in, and use Color Efex Pro from Nik Software to enhance contrast and tonal contrast. After that I often erase objects or people who just disturb the picture.

CB: What do you think is more important for the look of the final picture, tonemapping in Photomatix or post-processing in Photoshop?
AG: Hard question; both are important. Without tonemapping, I can't do my picture, and if I don't finish it in Photoshop, it will be the same. Each software program contributes 50/50 to my final

shot! But one thing is certain, post-treatment is very important to me; it's like a drawing on my original shot, and I can be more creative.

CB: What's your top advice for HDR shooters?
AG: Having a camera with good autobracketing is important. Unfortunately, three images are often not enough. Use a tripod. And withstand the temptation to just pull all the sliders in Photomatix to the extreme. Many beginners make this mistake; for myself, this was the hardest lesson to learn when I started out.

CB: Thank you for these valuable insights.

If you want to see more of Anto's work, open up your browser and head to www.flickr.com/anto13. More than likely you will also find his most recent work on www.hdrlabs.com/gallery/hotonflickr.php, alongside many other breathtaking photographs.

Chapter 5:
HDR Image Processing

This chapter is not about tone-mapping. Or better said, it's about all the things you can do without tone-mapping. We will have a closer look at image editing in floating-point space.

See, all these tonemapping tools are pretty self-ish. They can do their magic only because the underlying HDR data has this incredibly fine color resolution. So fine that it's almost analog again. But a tonemapper would use it all up and leave you with plain old 256 steps in each color channel. Maybe more when you're saving 16-bit files for post-processing (as you should), but nevertheless, highlights brighter than on-screen white are crunched down and the rich tonal graduation found in the original floating-point data is gone. Gone and no longer available during all subsequent editing steps. Tonemapping ends the HDR pipeline.

But it doesn't have to be this way. It was never meant to.

"Being 'undigital' with digital images" was the title of one of the earliest papers on HDRI, written in 1995 by the visionaries Mann and Picard. And that is what it's all about. Working directly in floating-point space brings photography back home, into a world where you think in f-stops, gradient ND filters, adding light or taking it away without ever getting worried about digitally degrading your image into pixel mush. Believe me, once you have tasted the full sweetness of HDR image editing, you don't ever want to go back.

Also keep in mind my 5-year forecast of real HDR monitors becoming ubiquitous. Section 1.6 explains in detail that even the current generation of flat-screen panels has unused potential that is just waiting to be unleashed by a unified HDR media standard. You want your images to stand out on the next-generation devices. The point of a full HDR imaging pipeline is that you can sweeten your images *without* reducing the dynamic range.

5.1 Taking Advantage of the Full Dynamic Range

The techniques I'm about to show are all derived from digital compositing. Just a couple of years ago, ridiculously expensive movie production suites were the only systems capable of working in floating-point precision. That, and the fact that they lift all the weight of 32 bits in real time, were their major selling points. Nowadays, every off-the-shelf compositing package has the same capabilities (albeit not necessarily the same speed). So these techniques work in After Effects, Fusion, Nuke, you name it.

However, I will demonstrate them in Photoshop. Why? Because I can. HDR layers, paint brushes, and adjustment layers in Photoshop CS5 allow me to do so. Previously these capabilities were exclusive to the extended editions of CS3/4, but in CS5 the fully featured 32-bit mode is unlocked for everybody. Whereas "fully featured" is a relative term, part of the challenge is to find ways around Photoshop's limitations. In section 4.4.5, you saw how selective exposure adjustment works. Well, that was just a fraction of where 32-bit image editing can go.

Special update notice: Just after this chapter was rewritten Adobe released Photoshop CS6. This update did not, however, add any relevant new features to the 32-bit mode. That's sad in general, but in the context of writing this book I'm very thankful for that. All the workflows described here for CS5 are still completely valid, all the workarounds are still necessary, and if you switch CS6 to the lightest color theme (in the PREFERENCES ▸ INTERFACE menu) all the screenshots will match exactly what you see on your screen.

5.1.1 Day for Night by Blocking Light
This is one of my favorite tutorials. We're going to create some movie magic, just as professional matte painters do on a daily basis. We will change daytime into nighttime. You would

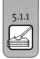

be amazed how often that is done in TV production, simply because filming at night is a scheduling nightmare. Shooting day for night is a classic example of a visual effect. It has been practiced in the film days as well as in the early digital age, but it has never been as easy to achieve as this.

➤ Sunlight to moonlight

1 Feel free to work along with the Egyptian. exr from the DVD. Go ahead and open it in Photoshop.

2 We start out the very same way it would be done with a real camera: with a blue filter in front of the lens. In digital terms, that would be a new solid layer with a dark-blue color. The color is chosen according to what I feel the darkest shadows should look like.

Figure 5-1: *A dark-blue solid layer is the foundation.*

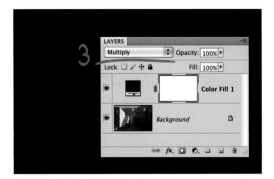

Figure 5-2: *Multiply blending mode turns the solid into a photographic filter.*

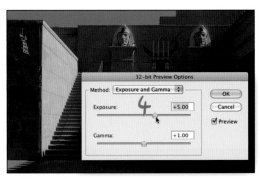

Figure 5-3: *Adjusting Photoshop's virtual exposure permanently.*

Figure 5-4: *Fixing the sky with a selective exposure adjustment.*

3 Next, set the blending mode of the new solid layer to Multiply. That makes this layer the direct equivalent of a filter in front of the lens. It blocks out light, in this case a lot of it.

A very brutal filter it is, indeed. But don't panic—it's all still in there. We just have to adjust the exposure of Photoshop's virtual camera, just as we would do with a real photo camera when we shoot through a physical filter in front of the lens.

4 In this case, we want that to be a persistent global change, so we do it in the 32-bit Preview Options dialog from the View menu. We could do the hard adjustment

Figure 5-5: *The blue solid layer is really doing all the work.*

from the Image menu as well and burn the new exposure to the HDR values, but because we will be finishing this piece in Photoshop, that 32-bit preview exposure is good enough—as long as we can keep our quick exposure slider in the center position because that slider will reset when the file is closed.

Great. Now the sunlight is moonlight. The sky is just a bit too bright for a night shot.

5 The sky is easy to fix with the selective exposure technique from section 4.4.5. Make sure to select the Background layer, grab the Quick

Selection tool, and draw some strokes across the sliver of blue to select it. Then add an exposure adjustment with the widget on the bottom of the Layers palette. It will come up preloaded with the selection mask. Now you can reduce the exposure selectively on the sky.

6 That is our basic high dynamic range composite. If you toggle the blue solid layer on and off, you can really see how effective it is. A PSD file of the current state is also on the DVD, in case you would like to dissect it. ◢

For the next steps, it is very important that there is such a huge difference solely caused by the solid layer. Our original image doesn't have much contrast to begin with—it would easily fit within the monitor range. But now we boosted everything up, beyond the white point

even, and the blue solid layer brings it down again. In the figurative sense, we were winding up the dynamic range here.

The fun is just about to start because now we're going to add a little mood to it.

➤ **It's all about the mood.**

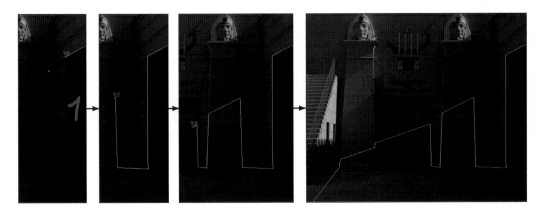

Figure 5-6: *Sketching a polygon selection.*

1 Let's imagine a torch that would spill some warm light into the scene. It could be somewhere off-screen, behind the arc to the right. So we use the polygon selection tool to roughly sketch out where the light would be hitting the walls.

2 Make sure the alpha mask of our solid layer is selected and choose the Gradient tool from the toolbar. Set it to circular gradient mode and drag out a large radius from our imaginary light off-screen.

Figure 5-7: A large circular gradient in the layer mask lets the original image shine through.

Figure 5-8: Applying a Levels adjustment to the layer mask smoothes out the light falloff.

Figure 5-9: The Smudge tool is great for fine-tuning the shadow line. Also, paint some spill light into the shadows.

That makes our darkening filter partly transparent and allows the original image to shine through. Pretty cool, huh?

3 With the mask still selected, choose IMAGE ▸ ADJUSTMENTS ▸ LEVELS. You can use the sliders below the histogram to control the mask density. For example, drag the middle knob of the top slider (input gamma) to the left for a more gradual light falloff. You could also make the lighting effect more intense by darkening the mask with the left knob of the bottom slider (output black).

4 The shadow line is still a little too harsh; in reality, there would be some indirect light spilling into the shadows. So we have to paint the spilled light in. Drop the selection, pick a large soft paint brush, and paint a touch more transparency into the mask—very gently, with a flow setting of 10 % or less.

Also, you can use the Smudge tool to massage the mask so it better fits the background. This is done using little strokes at a straight angle to the shadow lines, gently combing it over piece by piece. This has the additional benefit of softening the line; you can purposely soften it more by zigzagging across.

5 Okay, that side is done. Let's apply the same method to the little lantern on the other side. Sketch a rough selection with the Polygonal Lasso tool, and use it to paint some more transparency in the mask of the solid layer.

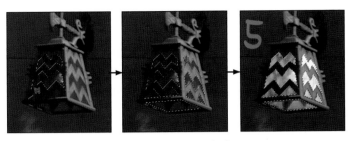

Figure 5-10: *Repeat the same workflow on the lantern.*

Figure 5-11: *Some interactive lighting adds the final touch. Notice the simplicity of the final layer stack.*

6 The final step is to add a touch of interactive light to the wall behind the lantern. Same thing again—restrict the painting area to a selection and paint within that alpha mask using a soft brush.

Done. ◂

Admittedly, a similar technique might work in 16-bit mode as well. But it wouldn't be as astonishingly simple and straightforward. We would need separate layers for the moonlight portions and warm light portions, plus all kinds of other trickery just to make it look natural again. Go ahead. Try to change the mode to 16-bit. I just did, and I can tell you it looks nasty! I refuse to print that here; you've gotta see it for yourself. And I gave up trying to repair it because either the shadows wash out or the moonlit wall turns flat, or the entire image becomes a mushy splotch.

Notice how such things were not even a concern at all in this tutorial. Believe me, it gives you great peace of mind to have the extended range available at all times and to never have to worry about clipping or banding or precision issues. It's also very convenient to think in terms of light being filtered and boosted instead of just assuming the pixels to be dry paint on a canvas.

5.1.2 Understanding the Color Picker

In the preceding tutorial, I skipped over one step very quickly in the hope it would go unnoticed. I'm talking about Photoshop's HDR color picker and how exactly the chosen color relates to what you see on the screen. Considering the fact that we are working in a wider dynamic range than our monitor can display, there's not an easy answer.

➤ Examining the light, part A

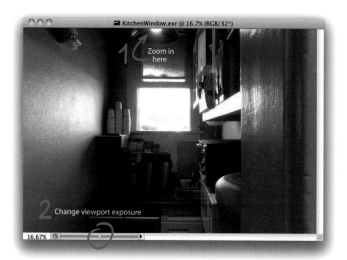

Figure 5-12: *Grab KitchenWindow.exr from the DVD.*

Let me explain that in a hands-on tutorial.

1 The subject shall be our all-time favorite kitchen window, so please come along and pull it up from the DVD!

2 First of all, let's have a closer look at the ceiling lamp that's just touching the top margin of the frame. Zoom in on the lamp and slide through the exposures. Watch how the pixels change from orange to red to yellow until they finally blow out into white. ◗

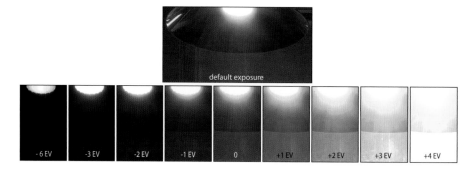

Figure 5-13: *Slide through the viewport exposures and observe the lamp.*

I know—it's tempting to assume we couldn't precisely pin down the true color of a pixel. But that is not the case. In fact, the opposite is true. We can pick colors better than ever!

Remember, what we are looking at is just a roughly tonemapped representation of the image data. We are looking through "8-bit gamma goggles." Our HDR color values are transformed for display in the very same way a camera

would take a JPEG snapshot. And if a real camera would take the +4 EV image, we would be well aware that the yellow halo is *not* the true color in that spot. When the color picker returns yellow, it is actually lying to us. It's just a very bright orange, too bright to fit in 8 bits.

The same applies here, but with the difference that we can actually tell the true color underneath. We are not locked into the yellow false coloration. But we have to adjust the

exposure for the spot we want to look at, and only then can we see the true color. You have to realize that this is an opportunity, not a disadvantage.

Try to think of it like this: Our HDR image is pure light. What we see on-screen is a snapshot, taken with a virtual camera. The light itself surely has a definite color and intensity. But its appearance in the snapshot depends upon our exposure settings. It's like virtual photography.

➤ Examining the light, part B

With that in mind, let's see how Photoshop's color picker works in HDR mode.

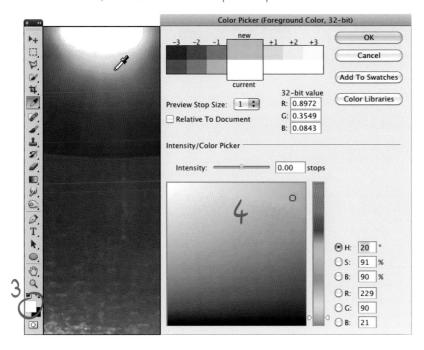

Figure 5-14: *The color picker looks different in 32-bit mode.*

3 Click the foreground color swatch in the toolbar to bring up the color picker dialog. It looks unusual at first, but it makes perfect sense once you get accustomed to the idea that HDR values describe light.

4 The lower half shows the true light color underneath the eyedropper. Notice the Intensity slider just above the color field; this is a

multiplier for light intensity. Both values together describe the light that is in our HDR image. Now take a closer look at the bands of color swatches on top. The large center swatch shows how that light color looks at the current exposure. Ergo, that is the on-screen color currently underneath the eyedropper. The additional color swatches are previews of how the same HDR values appear at different viewport exposures.

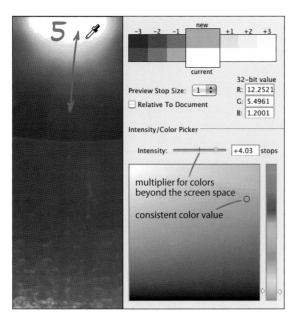

Figure 5-15: *Drag the eyedropper up across the image and watch the color picker.*

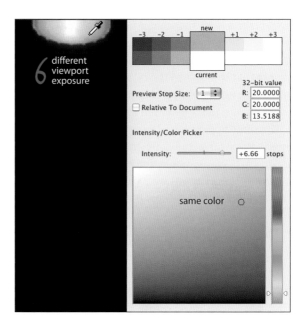

Figure 5-16: *The color is sampled independently of the viewport exposure.*

5 You should really open the image to try it for yourself, just to get a feeling for it! Drag the eyedropper across the image while holding the mouse button and watch the color picker change in real time. You will notice that the hue—the actual color component of the HDR values—stays pretty consistent. But the Intensity slider changes significantly when you hover over the light bulb, and so do the preview swatches.

6 Also, try changing the viewport exposure. You'll notice how the color preview swatches are linked to the display exposure but the HDR color sample stays consistent. It's still a fairly saturated orange with +6.66 stops intensity, no matter how you look at it.

Remember this: Everything you see in an HDR image is pure light, not just dry paint on a canvas. Therefore, the color picker returns a light color, not a paint color.

5.1.3 Painting with Light

Okay, this is where it's getting really cool! When you think the ideas from the preceding tutorial all the way through, you will realize that painting in 32-bit mode means that we are painting with light.

➤ Lighting up the fire alarm

Let's do it! You should still have KitchenWindow.exr opened in Photoshop. We will now digitally turn on the fire alarm.

1 Move the focus over to the warning lamp on the left. In the color picker, drag the hue slider down a tiny bit so we have more red in there. It's supposed to be alarming! Set the intensity so it's not too high; +3 stops is fine for now.

2 Grab the regular paint brush tool, and pick a medium-sized soft brush. Make sure to set Opacity and Flow to 20% so we can paint a bit more gently here. There's no point in pouring it out all at once.

3 Now paint some strokes across the lamp. Isn't that just awesome? We get a natural blooming effect, right out of that simple brush. Notice how the falloff goes through all the shades we saw in the color picker's preview swatches. The true light color is the same across, but it turns into a hot yellow in the center because we paint 3 stops higher than our current viewport exposure.

4 We also need a lightbulb. Let's make it one of these fancy power-saving lamps. Press the [key multiple times to lower the brush size and paint a few squiggles to indicate a fluorescent neon

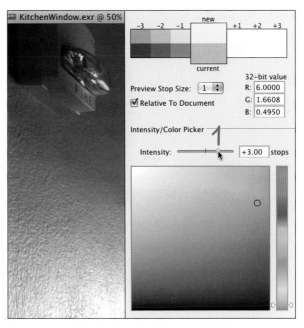

Figure 5-17: *Pick a bright red as foreground color.*

light bulb. If you want to make it extra bright, you can also increase the paint intensity in the color picker to +6 stops.

5 Let's finesse it some more. Increase the brush size (with the] key) and gently kiss in an extra bit of bloom so it feels more illuminated.

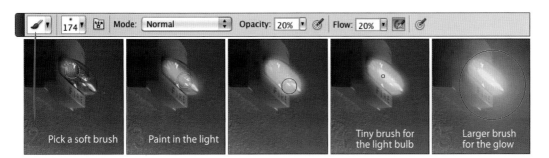

Figure 5-18: *Painting with light results in a very natural color falloff.*

Figure 5-19:
Adding a flare with fading brush strokes.

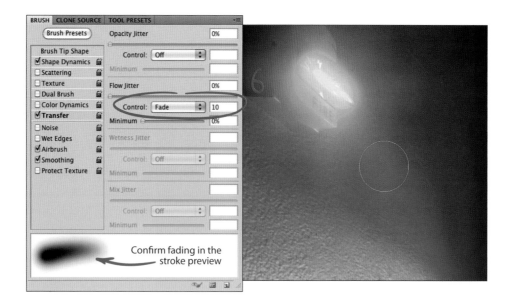

Confirm fading in the stroke preview

6 For the next step we have to tweak the brush a little. Go to the Brush settings and in the Transfer section, set Flow Jitter Control to Fade. Put in a value of 10 for the fade distance and confirm in the stroke preview that this brush really fades out. Then drag out small strokes from the center of our lamp. Try to match the flare of the ceiling lamp.

7 The last finishing touch is adding some bounce light to the wall and window frame. You already know how that goes—super large soft brush, kissing it in gently. I think you get the idea.

Painting with light is really easy because the intensity overdrive effect is doing all the work for us. We get all sorts of shades, from orange over red hot to yellow white, without ever changing the foreground color. Understanding the color picker is the first step. And as soon as you get the logic behind HDR images being made of pure scene light, you'll hit the ground running.

Figure 5-20:
The same general workflow can be used to boost the sun intensity in HDR images for CG lighting.

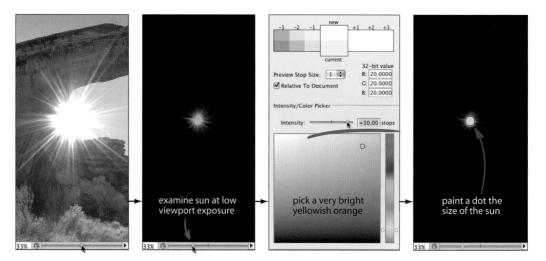

examine sun at low viewport exposure

pick a very bright yellowish orange

paint a dot the size of the sun

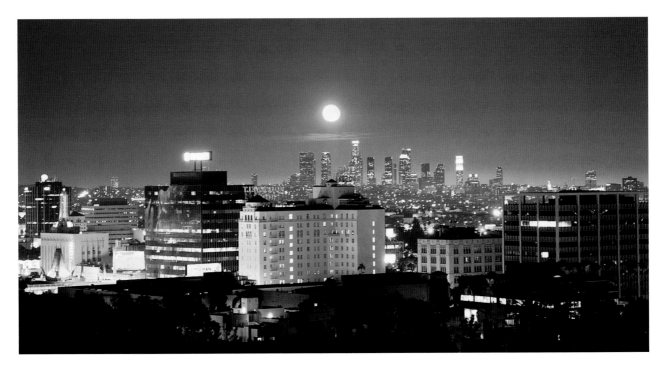

This example was a bit simplified, though. Real pros paint on a dedicated layer and leave the original image underneath untouched. Aside from working nondestructively, this has the additional advantage of allowing you to play with blending modes afterward. In this case, Linear Dodge (Add) would be a good candidate, just so we wouldn't cover up the original lamp underneath.

There are tons of other applications, from neon signs over streaking car headlights to muzzle flashes. I'm sure you will spot an opportunity when it comes your way. You can also use this technique for subtle effects, like adding a glow and volumetric light streaks to windows.

A particularly useful application of this workflow is boosting the intensity of the sun for CG lighting purposes. This may be necessary because the absolute brightness of direct sunlight is actually very hard to capture. On a bright summer day, the sun may well be 17 EVs brighter than the sky. This is far too much for most cameras' shutter speed; capturing this fully would require several extreme exposures with ND filters. And because it's such a small spot peaking out above the rest, these extreme intensities may not even make it through the

HDR merging process. That's why for all practical purposes you're better off just boosting the sun whenever you need that extra bit of dynamic range, simply by painting it in. With strict physically based render engines (as discussed in Chapter 7), this will give you proper daylight illumination with hard shadows. And you can even steer how bright and how hard the illumination should be, just by varying the amount of sun boost.

5.1.4 Color Grading with Levels

Levels is one of the most underrated controls. At first glance, it looks really simple. But as soon as you dig deeper, it unfolds into a useful color tool, especially when it works in floating-point precision. And while it holds true that there are more intuitive and powerful color tools (for example, Curves), Adobe's close-fisted approach to offering useful 32-bit tools compels us to use Levels to its full extent.

Just to whirl it up a bit, let's use a brand-new example picture. This is the view from my balcony in the direction of Hollywood Boulevard, featuring an extremely big moon over the distant skyline of Downtown L.A.

Figure 5-21:
Adding a new Levels adjustment layer.

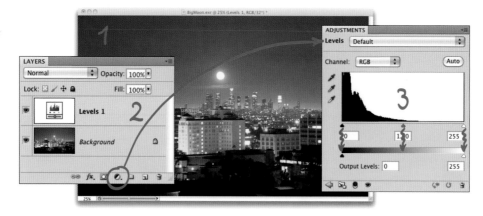

1 There's no better way to learn than experiencing it yourself, so grab BigMoon.exr from the DVD.

2 Bring up the Levels control. Pros don't burn the levels adjustment into the background; instead they add it as an adjustment layer.

3 The Levels dialog basically consists of a big histogram with a total of five knobs underneath. Let's quickly recap what they do.

The knobs are sorted in two rows, with the input values on top and the output values on the bottom. Think of them as *before* and *after* markers. In both rows we have a black point slider

(left) and a white point slider (right). The top row also features a middle slider, which is our good old buddy the gamma value.

This Levels control now works in such a way that the input values will become the output values. Imagine these sliders as being linked up with invisible springs. Whatever part of the histogram your input sliders are pointing at will be stretched to the respective output slider position.

4 For example, pull the white point slider to the left! Whatever part of the histogram you're moving it to will become the new white. All the values marked with a red overlay get pushed past the monitor white (essentially disappear), and

Figure 5-22:
The effect of the first row of controls, Input Levels.

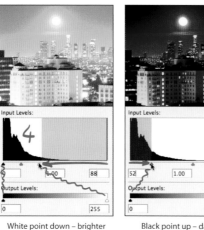 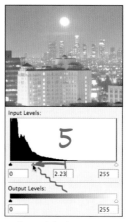 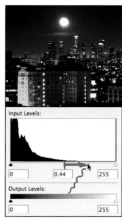

| White point down – brighter | Black point up – darker | Gamma left – less contrast | Gamma right – more contrast |

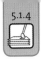

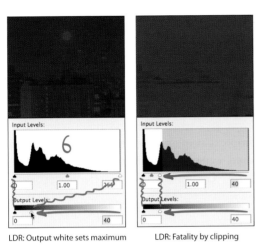

LDR: Output white sets maximum LDR: Fatality by clipping

Figure 5-23: *The Output Levels sliders are pretty useless in LDR.*

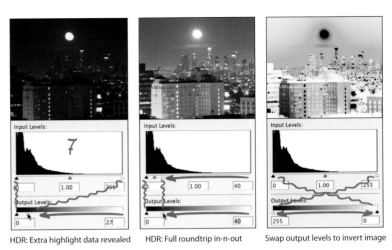

HDR: Extra highlight data revealed HDR: Full roundtrip in-n-out Swap output levels to invert image

Figure 5-24: *Output Levels in HDR behave like an exposure control.*

the small remaining window between input black and input white will expand to become the new histogram. Visually, the image gets brighter. The effect is exactly the same as increasing the exposure. You could even go as far as putting a number on the relationship: When you move the white point slider to the middle, that means all brightness levels get scaled up by a factor of 2, which is precisely what happens when exposure is increased by 1 stop. See how it all comes together?

The black point is kind of evil, though. It will push all the levels marked with a red overlay into the negative realm, and that's a place from which they are hard to recover. Better stay away from the black slider.

5 Instead, use the gamma slider for adjusting the visual contrast. Gamma skews the position of the midtones but leaves black and white points where they are. Same system applies: You select a tone in the histogram that will become the new midtone.

Okay, we got that. Notice how extreme these settings are and there is still no visible banding anywhere. The reason is the incredible precision of the data we're working with. In ye olden days

you would get severe gaps in the histogram when it was stretched out, but in 32-bit there is always an in-between value to fill the gap.

6 The HDR advantage becomes even more apparent when we look at the effect of the bottom sliders, the output levels.

The output white slider sets the target, where the tones selected with the input white will appear. In LDR (8- and 16-bit) there is no data beyond the input white point, so the output white essentially is a hard maximum. Even worse, when you're moving both white sliders (input and output), it will simply shave off all the bright levels and leave you with a muddy dark image.

7 While this output control was mostly useless in LDR, on an HDR image it can really play its cards right. Same adjustment, worlds apart. It still does what it's supposed to do: setting the target for the level selected with the input white. But there are so many more values beyond that, outside the visible histogram, and they are all coming in and filling the histogram back up. In HDR the output white is our friend—it pulls down the exposure without clipping.

By the way, if you ever find yourself in the

need of inverting an HDR image (for whatever reason), you can do this by exchanging the positions of the output white and output black sliders. The IMAGE ▸ ADJUSTMENTS ▸ INVERT function is disabled in Photoshop's 32-bit mode, so swapping the output levels is the easiest workaround. ◂

So that is the basic operation of the Levels dialog.

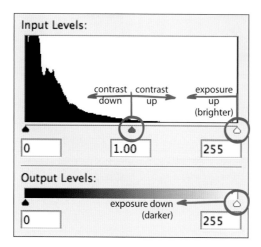

Figure 5-25: *Overview of the 32-bit effects of the Levels controls.*

Let's wrap it up with a little crib sheet of the 32-bit Levels controls and their effects. You can ignore the numerical values in this dialog; these are just leftovers from the 8-bit days of Photoshop. Most other programs label HDR levels as zero to one (0.000–1.000). What's important to remember is that input white and output white are really one and the same exposure slider, cut up in two parts. If there was more space to move the top slider to the right, we wouldn't need the one on the bottom at all.

So far we didn't do anything that we couldn't achieve with an exposure/gamma adjustment. Nothing special. The interesting part comes in when we tweak the levels of individual color channels.

When color comes into play, we need another crib sheet: the RGB color wheel. This diagram is the foundation of mixing screen colors;

it's an atlas where each color has a definite pinpoint location. Remember that we have only a red, a green, and a blue channel at our disposal—the primary colors. All the other colors must be described by their relationship to these primaries. For example, if we had no word for *yellow,* you could still explain that color to me as "opposite of blue, in the middle between red and green." Of course, if you wanted to sound smarter, you could just call it the *complementary* color of blue (although that's always risking a "Huh?" answer).

Figure 5-26: *RGB color wheel, showing the relationship of all screen colors.*

The color wheel is often sold as some sort of high color science. Ruthless professors forced generations of students to memorize it. In reality, however, the color wheel is a work tool. It's a helpful guide and it is meant to be looked at when in doubt, just like the sticker inside your car door that tells you what the tire pressure

should be. Many of my fellow artists stamp this color wheel into the corner of all their desktop images.

Armed with these two work tools—levels crib sheet and color wheel—we can now tweak the color channels.

➤ Part B: Channel by channel

So here is our starting point again.

1 The overall look is too orange for me. My train of thought goes like this: There is no orange channel. But on the color wheel, orange is next to yellow, on the opposite side of blue. So blue/yellow is the color axis that will allow me to change this color dramatically. The easy way to come to this conclusion is to find the offending hue on the color wheel and connect it with mental lines to the big RGB circles. These primaries are playing tug-of-war; when you pull on a line the color will travel through all the hues that lie along the way. Pulling toward red or green doesn't get it anywhere nice, but blue pulls it roughly across the center of the circle. It's always the longest line that opens up the largest spectrum, and that longest line is always connected to the complementary color.

Based on these observations, we have to switch Levels to the blue channel.

2 I don't mind some yellow in the highlights though. The moon and the city lights are just fine, so the highlight blue should stay pinned. Ergo, the goal is to lower the contrast of the blue channel. According to my crib sheet, that would be done by moving the gamma slider to the left. I grab a good portion of the shadow tones so they can slingshot up to become the new midtones.

3 Purple wasn't what I was going for. Apparently, there is too much red mixed in there. So the tug-of-war between the primaries goes into a rematch. Second look: Where exactly is there too much red? In the shadow and middle portion! Highlights are still fine, so I go for the gamma

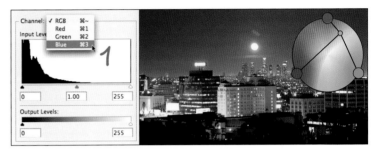

Figure 5-27: *Selecting the blue channel.*

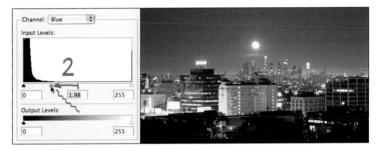

Figure 5-28: *Reducing the contrast (gamma) of the blue channel.*

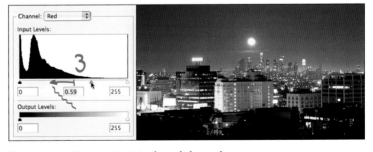

Figure 5-29: *More contrast to the red channel.*

slider again. This time, though, I grab some of these higher values on the right so they get hauled off below the midpoint.

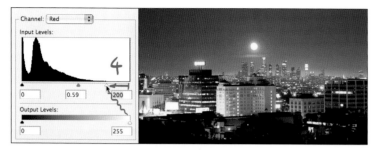

Figure 5-30:
Boosting the red channel to emphasize the haze.

4 Now I start digging this red haze layer that just appeared across downtown. If you have ever seen Los Angeles by night, you will agree that this dusty smog layer is a very distinctive feature of this town. Let's see if we can emphasize it a bit more. This is clearly in the highlight portion, and I want to boost the reds. So, the input white point is the one that needs to be tweaked now.

That's pretty much it.

In all honesty, there is not really that much thought involved all of the time. Using the color wheel as reference definitely helps with the broad strokes, but the actual tweaking process is often just done by playing with the channels and exploring where it can go. You saw how input and output white cancel each other out with a lossless round-trip—that means you're safe whatever you do.

Well, almost safe. You must be aware that we have seriously meddled with the color channels, including the top and low ends that we currently can't see on the monitor. So we cannot tonemap the result with any fancy local operator anymore. There won't be much to gain anyway; we already used up all that extra dynamic range data. To go forward from here, you need to employ the manual toning methods described in section 4.4.5 and finish up with straight Exposure/Gamma conversion to 16-bit.

The second thing to keep in mind is that Photoshop's input black level slider is evil. Do not touch it in 32-bit mode; it will introduce false colors in the deepest blacks. Note that this restriction also eliminates *Auto Levels* from the list of 32-bit-safe tools because that will optimize the black levels for each channel. And by "optimize," I mean "mess up beyond repair."

5.2 Effect Filters the More Effective Way

Several filters have proven to be much more effective when they are fed with HDR imagery. Compositing and visual effects programs have a longer history in that area because here the filters are needed to introduce all the photographic imperfections to CG imagery. These are precisely the same imperfections that photographers usually try to get rid of: vignetting, grain, lens distortion, motion blur, glare, and bloom.

5.2.1 Motion Blur

Real motion blur happens when the scene changes or the camera moves while the shutter is open. Light sources are sometimes bright enough to punch through the exposure and saturate the image even at a fraction of the exposure time. In extreme cases, this causes long streaks, as in the snapshot of the fire dancer.

The digital fake of this optical effect is done with a directional Gaussian blur. Popular blur types are linear, radial, crash-zoom, and along a custom path. Whatever the blur direction, in each case the effect is achieved by simply smearing each pixel along a motion vector. Usually that works pretty well—until there is a light source in the image. In that case, the lights are instantly smudged in with the much darker neighboring pixels, and the result is an unnaturally washed-out image.

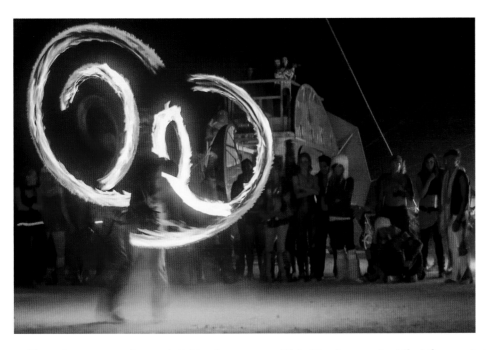

Figure 5-31: Fire dancer demonstrating some extreme photographic motion blur.

The sole presence of super-bright values in an HDR image makes these filters much more effective. And I'm not even talking about specifically crafted filter plug-ins. Let's take Photoshop's good old Radial Blur, for example.

This filter is so ancient that the user interface doesn't even allow me to set the blur center in the image itself, let alone outside the image area. Instead, I have to aim at the moon inside that tiny square field.

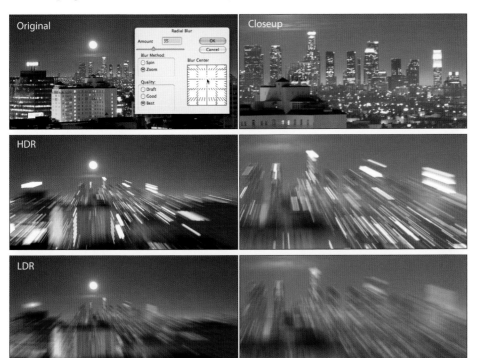

Figure 5-32: Even Photoshop's ancient Radial Blur filter works so much more realistically on HDR material.

Same filter, worlds apart. The lights in the HDR image are simply loaded with so much intensity that they have a much tougher stand against the background. They easily punch through the blur and stay vivid. My moon is zapping laser rays, hurray!

Admittedly, this is kind of a cheesy example. But the point is that faking motion blur digitally was flawed from day one. The LDR result is pretty much useless, whereas applying the same filter to HDR material delivers exactly what we would expect. It just goes to show that it doesn't take a more sophisticated algorithm to simulate the photographic effect. Instead, we can provide the cause; make the algorithm operate under the same conditions a camera operates with light, and the simple optical mechanics are automatically simulated more realistically. You want a real-world example? A decade ago, when EdenFX worked on the *Star Trek* TV episodic, we had to manually brighten up the background stars whenever the camera

panned with a spaceship. Otherwise, the stars would just disappear in motion blur. As soon as we switched to rendering everything in OpenEXR, we were able to give the stars a brightness of 800% to begin with, and the problem went away all by itself.

Below is an example in Fusion, proving that really just that extra bit of information is responsible for better quality. Even a simple Transform node, the standard tool for moving layers, gets an incredible boost in quality.

One word of explanation for readers who are less familiar with a nodal compositing system: The lower part shows a logical flow of all operations happening here. It starts with a loader on the left, loading an HDR image of my desk lamp. The second node raises the gain (a.k.a. exposure), and the third node just puts the image on a black background. From that point, the flow splits into two branches. The first branch goes straight up into a Transform node and the result is shown in viewport A. The second branch

Figure 5-33:

Moving an HDR image along a swirly motion path results in a very realistic effect, as long as it's done in 32-bit mode.

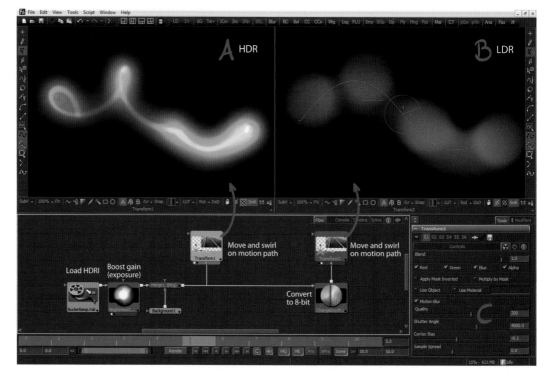

Chapter 5: HDR Image Processing

goes through a Change Depth node, where the HDR image is simply converted to 8-bit, followed by an identical Transform node, which is shown in viewport B.

Both Transform nodes move the image on a path, indicated in green. They also spin the image like a bola, so the resulting motion is a smooth swirling curve. Now I only have to tell the Transform nodes to calculate motion blur, indicated in the settings panel C. That motion is calculated with subframe accuracy and actually moves the image from one frame to the other in tiny increments.

Once again, the difference is astonishing. When the motion is calculated in 32-bit, we automatically get a glowing line along the path—a result that accurately matches the photographic phenomenon that we're trying to simulate.

5.2.2 Glow and Bleeding

In every camera manual, you will find a warning that you shouldn't shoot directly into the sun. And that's for a good reason; the extreme brightness causes the highlights to bleed out. What's happening here is that the surplus intensity spreads out in the film plate and eventually covers up darker parts of the image. Charge-coupled devices (CCDs) used to bleed primarily into vertical lines, which was a severe flaw rooted in their bucket-brigade-inspired mode of operation (see section 3.1.2). Higher-grade CCD cameras have a compensation for line bleeding, and CMOS sensors just bleed out naturally like film material. However, it's not just related to the sensor; it actually happens when the light travels through the lens. Glare is an inherent property of every optical system. It even happens inside your eyeballs. Excessive light always spills over.

A similar effect on a smaller scale is the glow that can be seen on neon lights, car headlights, or any kind of light source. Mostly this is a welcome addition to the mood; it's hard to imagine

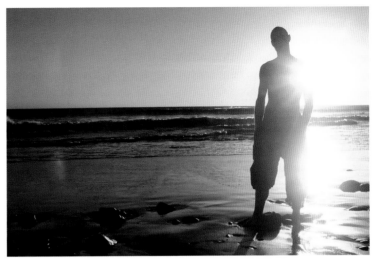

Figure 5-34: *Glare and blooming effects are caused by excessive light spilling over. It happens in every optical system.*

Figure 5-35: *Glows are adopting the colors of their light sources.*

any night shot without these glows. It triggers something in our brain that says, "Pretty bright lights," because we see it the same way with our eyes. The important thing to notice is how the glow is adopting the color of the light source. In fact, that glow is often the only hint at the light color because the lamp itself might even be clipped to plain white. Still, we instantly think, "Blue light," and not, "Blue glow around a light of unknown color." Our eyes just know.

Obviously this is a phenomenon that needs to be added to CG imagery for a realistic appearance. And because it happens at the lens/camera level, there is no point in rendering it along with the 3D scene. It's a classic post-processing effect. It can also enhance the mood of photographic imagery or filmed footage.

Glow in After Effects

Photoshop doesn't have an explicit Glow filter, so let's check this out in After Effects.

I just assume you're somewhat familiar with the After Effects interface. And if not, it's pretty self-explanatory: The timeline is on the bottom and works the same way as Photoshop's Layers palette, where you're stacking up layers from bottom to top. The Project panel on the left is where all footage is collected that will or might get used in a composition. Crucial here is the small color depth field on the bottom of the Project panel. You can Alt+click on that field to toggle through 8-, 16-, and 32-bit modes. On the right side of the screen is the list of all available effects and filters. Not every filter works in 32-

bit, but there are considerably more than in Photoshop, and they are conveniently tagged with a "32" stamp on the icon. And finally, on the bottom of the big viewport area is the control for viewport exposure. It works like the viewport exposure slider in Photoshop, just with a little nicer design and a numerical EV readout.

You might have noticed that I have rendered these little bulb buddies already blown out. Well, I built and lit the 3D scene according to real-world luminance values rather than just for a particularly good exposure. This is generally the better way to create a 3D scene. These bulbs might have to light up something else in the scene, which would require them to actually pump out a good amount of light. And frankly, I was also a bit careless because it's all kept in the HDR image anyway. Stopping down the viewport exposure to −3 EV confirms that all the glass colors are still there.

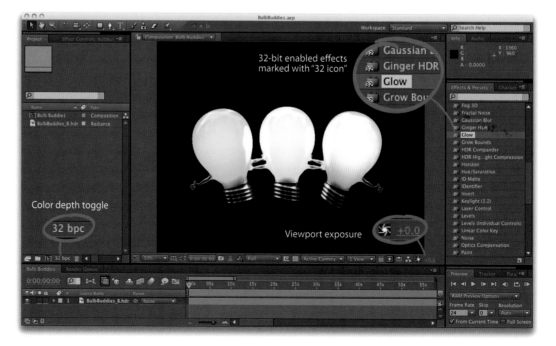

Figure 5-36:
After Effects has some special gadgets in 32-bit mode.

Figure 5-37: *Changing the viewport exposure to –3 EV reveals the colors of the glass bulbs.*

Figure 5-38: *The effect completely falls apart in LDR.*

Looks like they're switched off now. But I want them to shine!

I just drag and drop the Glow effect from the Effects palette on the central Composition viewport and start playing with the settings. The Glow effect is additive and makes everything even brighter. So I have to bring it all back down with the Ginger HDR plug-in, which is a very sophisticated tonemapper for After Effects. I'm basically treating the rendered image as if it were captured photographic footage.

If the image had been saved in 8- or 16-bit, that obviously wouldn't work at all. Let me show you how this would look by changing the color depth in the Project panel. What's blown

out in the first place will just glow white. And, of course, the convenience of adjusting the exposure is gone.

In a regular LDR workflow, I would have to take much more care in rendering the image without any clipping in the first place. And if there were other objects in the scene, I would have to start cheating and render the bulb heads separately just to suppress the glow effect on the other stuff. It's all possible, but it would be much more complex. Having the proper intensity latitude all within one file is certainly making life easier, and it guarantees a more photographic result right from the start.

Figure 5-39:
The Glow effect takes extra-bright colors into account. Here the brilliant Ginger HDR plug-in is used to tonemap the result as if it were photographic footage.

Bokeh effects

The very same HDR advantage also works for defocusing effects. Colors simply mix in more photographic ways when they are manipulated in linear 32-bit mode.

When you're defocusing a real lens, you get these distinct circles around bright highlights, called bokeh. Technically, the entire image is made up of such circles. It just happens so that on super-bright lights they become very apparent. Every ray of light that comes through a defocused lens spreads out into a cone and projects a small image of the aperture iris on the sensor. Photographers pay good money for lenses with a nice bokeh; that is, a lens where the aperture blades form nice round circles.

Figure 5-40:

Real photographic bokeh circles appear on super-bright lights, even if these lights are normally tiny and insignificant. That's why the extra highlight information in an HDR image is invaluable for re-creating convincing bokeh effects.

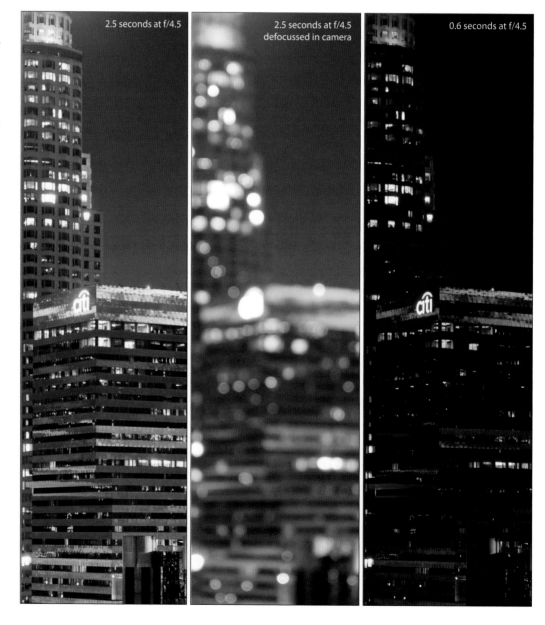

2.5 seconds at f/4.5

2.5 seconds at f/4.5 defocussed in camera

0.6 seconds at f/4.5

I put together a three-panel example for you that shows very clearly how this effect presents itself in a real photograph. The key observation is that even tiny light sources maintain their full intensity when widened into a circle. They can be so tiny that you can barely see them in a focused image. It's the light *intensity* that makes them stand out, not their original size. Just by looking at the regular exposure (left panel), you couldn't even predict where bokeh circles would form on the lower building. Maybe you could guess that the top floor windows would bloom out, but the red and green circles and the horizontal chain of four blue circles in the middle come as a complete surprise. That's where you would need the information from the -2 EV exposure (right panel). It's the tiny specks and sparkles that are luminous enough to show up in this highlight exposure that are causing the realistic bokeh look.

Sadly, Photoshop passed on the opportunity to utilize the full dynamic range for a realistic defocusing filter. Lens Blur, as the defocus effect is called here, does not work in 32-bit mode. Instead of embracing a physically correct behavior, this filter contains a separate Specular Highlight control for isolating LDR pixels with a value of 255. And then it covers them up with an artificial bokeh circle. The result is so disappointing that it's not even worth wasting a square inch of book space on it. Even though the new Blur Gallery feature in Photoshop CS6 does work in 32-bit mode, it was designed for lower bit depths and relies on the same old bag of tricks.

For convincing depth-of-field effects, your best choice is the Lenscare plug-in by Frischluft. It works in Photoshop (Windows), After Effects, Nuke, Fusion, Premiere, everywhere. Lenscare creates a bokeh effect that is indistinguishable from the real thing—a must-have plug-in for post-processing CG renders.

5.2.3 Vignetting

Vignetting is a circular light falloff toward the edges of an image. It's a lens flaw that is most pronounced at wide open apertures (small f-numbers). Every lens has it. Zoom lenses show more severe vignetting at higher zoom levels, but even prime lenses (with fixed focal length) have at least a small amount of vignetting.

Adding this lens flaw to CG images is very important for a photographic appearance, and vignetting is just as fashionable among photographers for creative look development. This is ironic because we pay extra for good-quality lenses and then we end up adding these lens flaws in post-processing. But it's just a fact that some controlled vignetting has the pleasing effect of pulling the viewer's attention to the center of the action. A good vignette simply looks more organic.

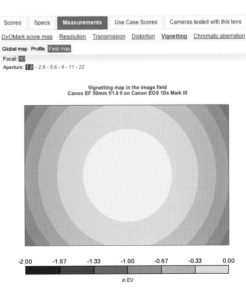

Figure 5-41: *Vignetting shown as an EV map for the Canon EF 50mm f/1.8II lens in a lens test on DxOMark.com.*

A bad vignette, however, just looks cheap. This effect is often created by painting a soft black border around an image, which is simply not realistic at all. To create a convincing vignette

Figure 5-42: *Adding a photometrically plausible vignetting effect is easy in 32-bit. This image was actually cropped from the title panorama of Chapter 1.*

effect, you have to simulate what happens in a lens. Lenses don't paint black borders; they loose light! If you look up lens reviews online, for example at www.DxOMarc.com, you will find that the amount of vignetting introduced by a particular lens is directly given as the number of EVs lost. Well, with HDR this is a no-brainer in Photoshop. The *final frontier* tutorial in section 4.4.5 has shown you how to achieve a proper vignette by creating an exposure adjustment layer, adding a mask, and then drawing a circular gradient on that mask.

So let me instead demonstrate the proper vignetting technique in After Effects. Along the way you will discover that After Effects is perfectly suitable for editing HDR photographs, maybe more so than Photoshop. After Effects veterans may forgive me when I make this tutorial meticulously detailed, but I really think every photographer can benefit from a peek over the fence. Many photographers have After Effects installed as part of Adobe's Creative Suite but have never opened it and are not even remotely aware of how well this program works for photographs.

To follow along you need the image Downtown_USBank.exr from the DVD. You also need the After Effects plug-in Colorista, which is absolutely free and included on the DVD as well, with friendly greetings from Red Giant Software.

Ready? Okay, let's go.

➤ HDR photo tricks in After Effects

In the last section I gave you a quick tour of the After Effects interface and the rough organization of the different panels. Now we will go through them all step-by-step. First, we'll concentrate on the Project panel in the upper-left area.

1 Drag the image Downtown_USBank.exr from the DVD into the Project panel. When it's loaded, it will be considered footage, and the top of the Project panel will show a thumbnail and some relevant file information. If you want to impress a pro, you can also summon a loading file requester by double-clicking anywhere in the empty space inside the Project panel.

2 In After Effects, you can't work directly on footage (like our image). Instead, all the action happens in a *composition,* called a *comp* in VFX jargon. That's our work document; think of it like a virtual canvas. So, first we have to create a new comp by dragging the Downtown_USBank. exr footage onto the third icon on the bottom of the Project panel. That's a convenient shortcut to create a comp with the exact same dimensions as our image.

3 Next, we have to configure the color space. Right next to the New Composition icon (onto which you just dragged the image) is a small text label, which currently reads 8 bpc. Click on this text label to open the Project Settings panel.

4 Project Settings is a pretty big panel with lots of elaborate text. All we need to care about are the first three options in the Color Settings section. Set Depth to 32 bits per channel (float) and select sRGB IEC61966-2.1 in the Working Space dropdown menu. Notice that this is the same color space that After Effects has auto-detected in our EXR file, as shown in the header of the Project panel.

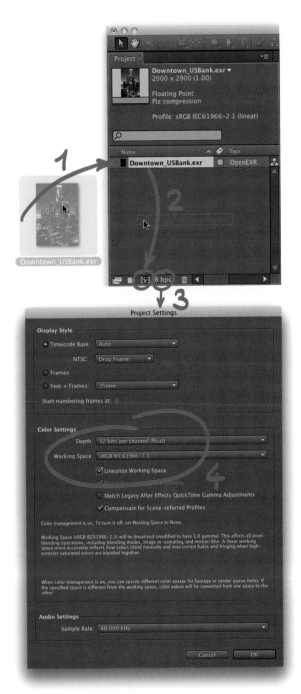

Figure 5-43: *Setting up the After Effects project: Load an EXR file and configure the color space for a linear workflow.*

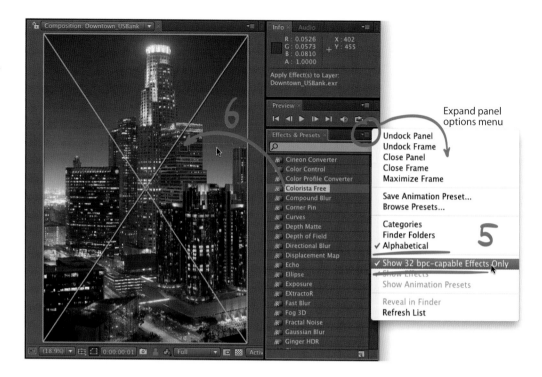

Figure 5-44:
After Effects beats Photoshop any day in the amount of 32-bit-capable filters.

Also enable the Linearize Working Space option. Now we are in a fully color-managed *linear workflow*. That means our image data will always stay in 32-bit linear sRGB space, and After Effects takes care of doing a background conversion to show a gamma-corrected representation in the viewport. In short, After Effects now behaves just like Photoshop. Great. Click Okay to close the Project Settings panel.

5 Our image should already be displayed in the big central viewport. Next to it, on the right, is the Effects & Presets panel. This is a treasure box that shows all the image filters and adjustments After Effects is capable of. Not all of them work in 32-bit, though.

Click on the widget in the upper-right corner of the Effects & Presets panel to expand the options menu. Then select Show 32 bpc-capable Effects Only. This should weed out the list considerably, but notice that it still shows about twice as many effects as Photoshop has to offer. I also

like to enable the Alphabetical sorting option so there is less digging required in submenus. That's more of a personal preference, though.

6 Scroll through the effects list until you find Colorista Free. That's the plug-in I told you to install earlier. Simply drag and drop this effect into the main viewport. While you do so, a big *X* is drawn across the viewport to indicate that After Effects understands we want to apply this effect to our main image layer.

7 The Colorista interface now shows up on the left; in the same spot where the Project panel previously was. And what a beautiful interface it is! We get three wonderfully designed RGB color wheels, representing separate color tweaks for shadows, midtones, and highlights. This is called a *3-way color corrector,* and it's the industry standard in professional color grading systems that cost more than my car. High-end systems (that cost even more than *your* car) have exactly these

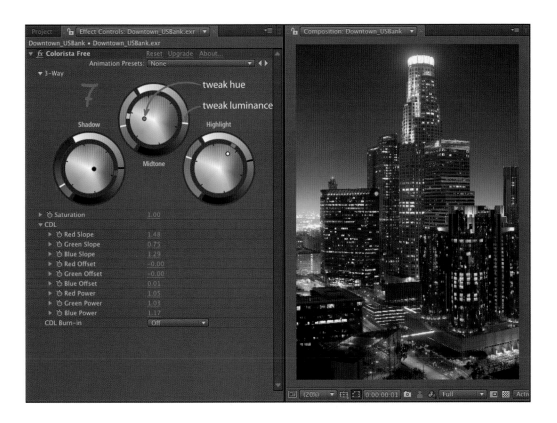

three color wheels built into the hardware as three big track balls.

Go ahead, move the center points of these circles to adjust the colors. I like my highlights pink, midtones yellow, and a touch of blue in the shadows. Compared to all the hoops we had to jump through when using Photoshop's Levels tool (section 5.1.4), this is ridiculously easy in Colorista. The funny part is that it's just a different interface. If you expand the CDL (Color Decision List) section underneath the color wheels, it shows 9 numerical values. These are the underlying parameters, which are controlled by the color wheels, and they are very much related to the parameter sliders we previously adjusted in the Levels tool. To get the hang of Levels in Photoshop, we had to imagine the color wheel (actually, use a cheat sheet), but here you're literally just pointing at the colors you would like to have mixed in.

Colorista alone is reason enough to use After Effects to edit your photographs. Seriously, there is no such simple and intuitive color correction tool anywhere in the Photoshop world. It's really weird. Photoshop engineers seem to be so eager to duplicate After Effects' video functionality, but the basic industry standard for professional color grading is missing completely.

If you like Colorista Free, you should also try the demo version of Colorista II. That's the supercharged update, which has grown so rich in features that programmers decided to give the old version away for free. In addition to the amazing 3-way color wheel, Colorista II offers highlight compression, a keyer and masks for targeted color corrections, local contrast enhancements, RGB curves, and all sorts of finishing tools.

Figure 5-46:
Creating a new layer with solid black color.

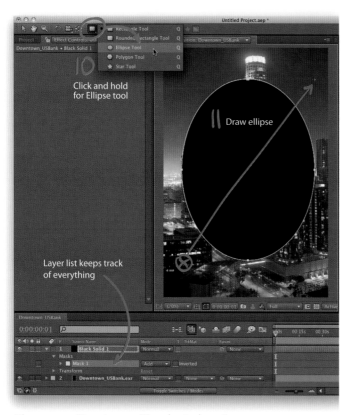

Figure 5-47: *Drawing an ellipse (vector) mask.*

The bottom area is the timeline. For this tutorial we need only the left half of it, which is the layer list. Currently it only shows one layer: our image with the Colorista effect applied to it.

Right-click anywhere in the timeline panel and select NEW ▸ SOLID in the context menu.

9 An options window comes up where you can set the size and color of the new layer. The default size matches the composition size and is perfect for our purpose. Make sure the color is set to black (0,0,0) and click OK to close this panel. The new layer will appear on top of the layer stack, covering up the viewport with black.

10 In the upper toolbar, click and hold the rectangle icon until it expands into a submenu with multiple shape tools. Select the Ellipse Tool.

11 Draw an ellipse from corner-to-corner in the viewport. You should now see a big black blob in the middle. (Ha, say that three times in a row!)

Notice that the layer list keeps track of everything we added in a hierarchical structure. On top is the Black Solid layer, which shows a Masks subcategory with Mask 1 (our ellipse) nested underneath. So that list is organized just like a folder tree on a hard drive. At the deepest level, this hierarchical structure shows the parameters and settings for every effect or element. You could dig even deeper into the background layer's tree and find the parameters for Colorista. Compared to Photoshop, every single effect here behaves like a Smart Filter, where you can change anything anytime.

8 I got so excited that I almost forgot this was supposed to be a tutorial about vignetting. Oops.

Technically, the correct method would be to add an adjustment layer with an exposure effect, but the generally accepted hack is to add a blurred black border. That's okay; I'm not here to disrupt every established workflow. So let me show you how even a hack works better in 32-bit mode.

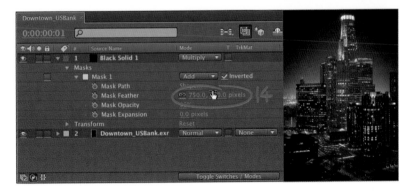

12 Unfold the hierarchy tree for Mask 1 to reveal all the settings for our ellipse mask. Also, enable the second icon in the bottom-left corner to reveal editable values for these settings. Then, click the Inverted option (because we want to mask out the border, not the middle).

13 Change the blending mode of the entire layer to Multiply and set Mask Opacity to 90%. If you can't find the blending mode drop-down, it might be hidden. Click the Toggle Switches/

Modes button on the bottom of the window. With Mask Opacity set to 90%, you can immediately see the overbright values punch through the mask, which is good.

14 Finally, soften the mask by increasing the Mask Feather value to 750 or higher. You don't actually have to type these values; just click on the number and drag the mouse right with the button held down. Every number displayed in After Effects behaves this way. They are sliders in

Figure 5-48:

The very same composition in 16-bit mode produces a stale and fake-looking vignette.

Figure 5-49:

Getting the current composition into Photoshop is very easy.

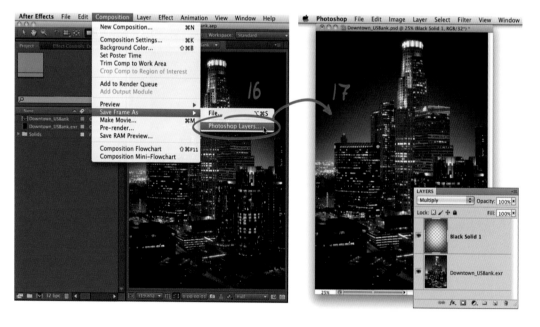

disguise. You can also push the vignette further into the corners with the Mask Expansion value or experiment with different Mask Opacity values.

15 On the surface, this technique is no different than the old-school method of creating a cheap vignette effect—except that we're doing it in 32-bit linear color space. And that makes all the difference in the world! The HDR advantage becomes very clear when you change the bit depth to 16-bit. Just Alt+click the text label on the bottom of the Project panel (which we used in step 3 to summon the Project Settings panel) and instantly you see all the highlights in the corners turn into gray mush. Even the tiny landing lights on the helicopter pad lose all their vivid colors and turn stale. It's not only photometrically incorrect, it's also butt ugly.

There's nothing wrong with taking some artistic license—an ellipse is also not the physically correct circular falloff you can see in the test chart of a real lens. But when we do this trick in a linear workflow, it is at least *photometrically plausible*. It does what you would expect to see.

16 Now here comes the ultimate trick that makes this workflow viable for photographers. Make sure the Timeline panel has the focus (should be outlined with a thin yellow frame) and select COMPOSITION ▸ SAVE FRAME AS ▸ PHOTOSHOP LAYERS.

17 Load the resulting PSD file in Photoshop. It's still in 32-bit, all the extra highlight details are still there, even all the layers are intact and—most important—the Colorista color correction is applied. Not the tiniest bit of flexibility is lost; only some sweetening on the image is gained. From here on you can proceed with any of the tonemapping techniques described in Chapter 4. For example, for the final image I used Highlight Compression to bring back some more detail on the tip of the tower and mixed some of Photomatix's Detail Enhancer goodness in, et voilà!

18 Oh, and save the After Effects project, of course, with FILE ▸ SAVE AS. ◄

I hope this tutorial will open the door to After Effects for my photographer friends. In section 6.7.3, you will learn how to animate and where to find more learning resources, and soon enough you'll be tonemapping time-lapse HDR clips like a ninja. Long-time After Effects users hopefully are now all clear about setting up a proper linear workflow and understand why that is so utterly important for creating photometrically plausible effects.

5.2.4 Film Looks

Now that you've come to page 403 in the second edition of the *HDRI Handbook,* I can tell you the truth. You're actually reading the third edition. Shocking, isn't it?

The original was my diploma thesis, and that contained a section on digitally emulating film processing. But somehow I didn't consider it important enough to be included in the book. Silly me. Little did I know about trends in photography.

The basic idea is this: We know that HDR images contain all the light from the scene. We went to great lengths to restore the real-world linear relationship between all these light values, so the HDR image is essentially a pixel-by-pixel accurate data set of scene light measurements. Now we can actually use this data to simulate the complete optical pipeline that happens in traditional film photography. This involves a simulation of the optics in the lens as well as the chemical processing in a

Figure 5-50:

A trip down memory lane with the Virtual Darkroom plug-in for Lightwave.

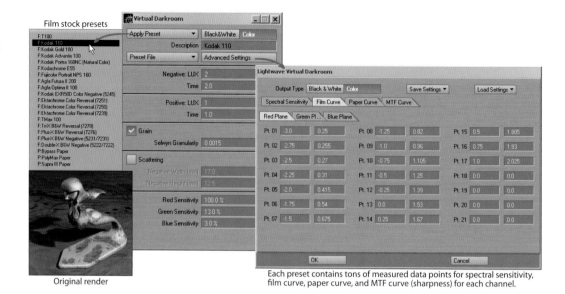

Original render

Each preset contains tons of measured data points for spectral sensitivity, film curve, paper curve, and MTF curve (sharpness) for each channel.

Figure 5-51:

Emulating real-world film material is very successful in taking the artificial flair off CG renderings.

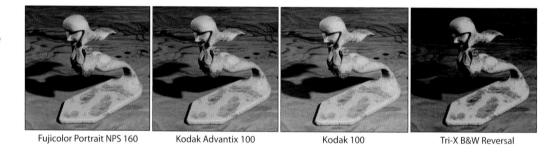

Fujicolor Portrait NPS 160 Kodak Advantix 100 Kodak 100 Tri-X B&W Reversal

darkroom. It can go as deep as using the lab-measured transfer curves of a particular film stock, calculating the densities of a negative, and then deriving a positive print using more transfer curves and heavy math sorcery. Such a virtual development process would result in the very same look as the analog counterpart. It's a very literal interpretation of the term *virtual darkroom*, which has often been abused for describing different RAW workflows.

In my original thesis, I demonstrated the process with the Virtual Darkroom plug-in for Lightwave, which is a straight implementation of some groundbreaking papers in this field. This plug-in is still unbeaten in scientific accuracy, but it's unbearably slow and about as intuitive as a brick.

Nowadays this old-school look has turned into a trend of its own. Especially popular are the looks you get with vintage and toy cameras—the muddier the picture, the better. It's called Lo-Fi photography. Mobile apps like Hipstamatic and Instagram have become insanely popular, and plug-ins like DxO FilmPack and Nik Color Efex bring this functionality to Photoshop, Lightroom, and Aperture.

For the real connoisseur, however, all roads lead to Magic Bullet PhotoLooks. Not only because this plug-in has the largest variety of preset looks, but also because it offers an insane amount of 32-bit-capable filters that every HDR photographer should have in their arsenal. All the filters and adjustments that are locked in Photoshop's 32-bit mode are in here, plus

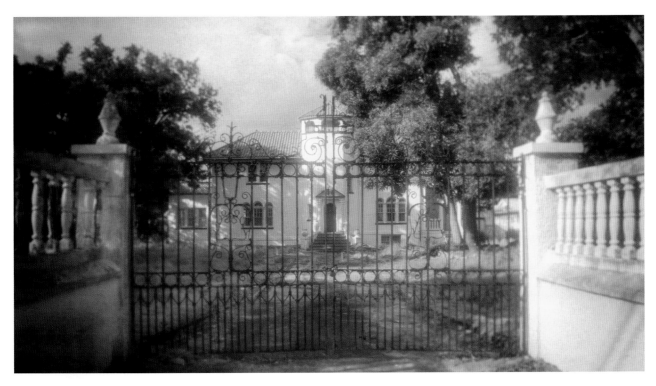

a whole lot of effects that are nowhere to be found in Photoshop.

Let me show you Magic Bullet PhotoLooks in a tutorial. Go ahead; download and install the free demo version. It will also hook into Light-room and Aperture and is just as useful for giving single RAW images a Lo-Fi makeover.

⌐→ www.redgiantsoftware.com/products/all/magic-bullet-photo-looks/

Figure 5-52:
Abandoned mansion, styled in the filmic look of a romantic dream sequence from the '70s.

▶ Filmic looks with Magic Bullet

1 Load Mansion.exr from the DVD into Photoshop and select FILTER ▸ MAGIC BULLET ▸ PHOTOLOOKS.

2

Reveal presets by moving the mouse to the left edge

3

Tool chain

Reveal tools by moving the mouse to the right edge

The plug-in interface takes up the entire screen and looks like a separate program. And in fact, that's what it is. You're looking at the Looks-Builder application. This is the heart and brain of Magic Bullet and it's also accessible from within Lightroom and Aperture. But only from within Photoshop can we actually feed it 32-bit imagery.

2 Move the mouse to the left edge of the screen, and a panel with look presets will unfold. These looks are sorted in categories that resemble specific genres. My favorites are in the Music Video category. Go ahead and try some—for example, Berlin or Dream Look.

Categories

Basic tools available in this category

Common tool presets with customized settings

Chapter 5: HDR Image Processing

You have to realize that these presets are not just re-creations of similar looks that you might have seen somewhere in a film or commercial. No, these *are* those looks. Magic Bullet is a plug-in suite with a long history in the world of video production. It's the secret weapon of many indie filmmakers and VFX artists. PhotoLooks is just the most recent offspring of that Magic Bullet family, and the look presets are completely interchangeable with the brethren plug-ins for Final Cut Pro, AVID, After Effects, and the like.

For this tutorial I want a sunny romantic look, so please select the Dream Look Alternate preset.

3 Each look preset consists of several individual tools. Once you select a preset, the tools show up in the tool chain on the bottom. The processing engine evaluates them from left to right. Note that this is very different from the presets found in HDR Efex, for example. Those were just settings for a predetermined set of processing steps, but here, the look presets define *which* processing steps are applied. In that regard, a better analogy would be a stack of adjustment layers in Photoshop.

Another specialty is that the tool chain mimics the optical path in a camera system. We have five major tool categories—Subject, Matte, Lens, Camera, and Post. Every tool has a designated place in that tool chain, so they are always processed in the correct order.

4 Move the mouse to the right edge of the screen to reveal a palette of all the tools available. This palette is organized in the same categories as the tool chain. For example, the Matte category contains all the tools that have a physical equivalent of an optical filter that can be stuck into a matte box in front of the lens. That includes warm/cold gel filters, gradient ND filters, diffusion filters, and that cheesy star filter we all love from music videos from the '80s.

The beauty of this approach is that your regular photographic experience gets you a long

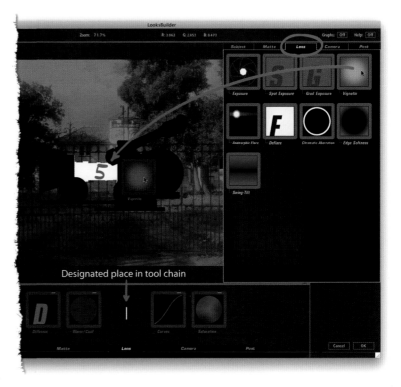

way when navigating this palette. And newbies inevitably learn more about the photographic process without even noticing.

5 Let's customize this look a bit. Switch to the Lens tab in the tools palette to see all lens-related filters.

Grab the Vignette thumbnail and drag it onto the image. As you're hovering over the center viewport, you will notice the silhouette of a movie camera appear. It indicates the drop zones of all the places where the chosen filter can go.

Vignetting is a prime example of a lens artifact, so only the lens area of the silhouette is an active drop zone and is drawn in white. Also, a small line marks the appropriate spot in the tool chain.

Figure 5-53:
Applying a vignette to the lens via drag and drop.

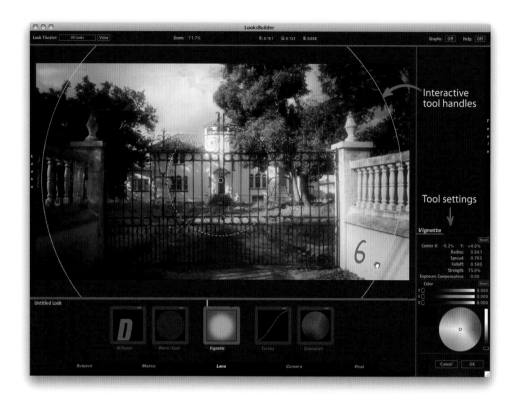

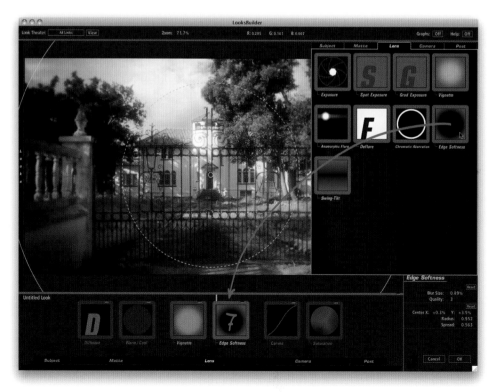

Chapter 5: HDR Image Processing

Post effects

Subject | Matte | Lens | Camera | **Post**

Exposure / Spot Exposure / Grad Exposure / Contrast

Color Contrast / Print Bleach Bypass / Telecine Net / Crush

Saturation / Ranged Saturation / Lift-Gamma-Gain / Offset-Gamma-Gain

Excellent 3-way color corrector

3-Way Color Corrector / Chromatic Aberration / Warm/Cool / Film Grain

Auto Shoulder to gently limit dynamic range

Curves / Auto Shoulder

Useful film curve presets

Basic Film / Filmlike / Full Print Bleach
Custom Curves / Custom Curves / Custom PrBlchBypass

6 Once the Vignette effect is dropped in, a yellow adjustment circle appears on the image. There is also a small dotted circle in the center; just click and drag it out to expand the midpoint of the vignette. Numerical settings are now shown in the side bar, and just as in After Effects, you can change a value just by click-dragging the number left and right. It's really as intuitive as it can be. Just tweak the vignette effect to taste. I prefer to lower Strength to 75 % and Spread to 0.7, but that's really up to you.

7 That was easy, wasn't it? Let's do that again with an Edge Softness effect. This time drag the effect thumbnail directly from the palette to the tool chain. Adjust the yellow circles to your liking and reduce Blur Size to 1 % or lower. Wonderful. Now we have the digital equivalent of a fuzzy plastic lens, like a Holga.

8 And that's really all there is to it. Once you get the concept of the tool chain, working with Magic Bullet turns into a creative jam session. Feel free to explore the tools palette; there are quite a few real gems in there.

For example, in the Post category you will find my favorite, the 3-way color corrector. I'm adding one to the end of the tool chain and configuring the settings to give the shadows a reddish-brown tint. (I did mention that this 3-way style of color correction is the professional standard, didn't I? Anybody from Adobe listening?)

Notice that the thumbnails are not only show-ing what type of effect it is, they also indicate the settings. It's really genius interface design. Look at the different curve presets in the palette. They are the same tool, pre-configured with different film curves, and so the thumbnails look slightly different. If you drop one in and change the curve, the thumbnail will actually reflect your own curve.

The last tool in the Post palette—the Auto Shoulder tool—is a bit special. All other tools are designed to work perfectly fine in the 32-bit floating-point domain and preserve—some even boost—the full HDR highlight range. Auto Shoul-der, however, reduces overbright highlights by applying a gentle logarithmic curve. Essentially, this tool is the logarithmic highlight compression TMO introduced in section 4.1.1. Many presets use it as the final step in the tool chain. I tend to turn it off, just because I prefer to finish toning in Photoshop.

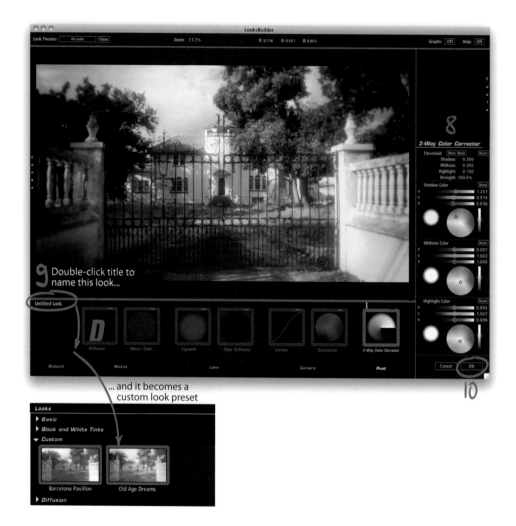

9 The last thing I want to show you is how to turn your customized tool chain into a reusable look preset. It's so simple, you will laugh.

See the title in the upper-left corner of the tool chain area? When we picked the preset look, the title said *Dream Look Alternate*. As soon as we customized the tool chain, it turned into *Untitled Look*. Well, just double-click this title and it turns into an editable text field. Type a new name—for example, Old Age Dreams—and this look will automatically show up in the Preset browser under the Custom category.

10 Click OK to apply the look and return to Photoshop. Now you can continue with any of the tonemapping techniques described in chapter 4, preferably one of the gentle manual methods (since the look is pretty much defined already). Unless you used the Auto Shoulder tool, no harm was done to the highlight range, so an image treated with Magic Bullet PhotoLooks still qualifies for 3D lighting.

Figure 5-54:
How about a spooky
night look, to get
some practice?

So this was my introduction to Magic Bullet. I encourage you to play with this plug-in a bit further; for example, this particular image is also very well suited for the spooky night look of a horror flick. Even if you have no intention of making Magic Bullet your primary look development tool, it teaches you a lot about optical effects and their correct order of application.

Of course, Magic Bullet comes in really handy for taking the artificial edge off CG images. It's like a massive pixel grinder that leaves no area untouched. You could render an untextured box on a default gray floor and the mighty look processing will give it a tangible photographic quality. When you combine a CG element with a real photograph, a quick run of Magic Bullet afterward will cover up any mismatches in color and lighting so that your CG character appears perfectly integrated. It's so effective that some artists don't even bother tweaking their 3D scene for a realistic result and instead rely solely on the photographic post-treatment. They don't really like to talk about Magic Bullet because it does feel a bit like cheating — especially when the huge selection of preset looks makes it so easy.

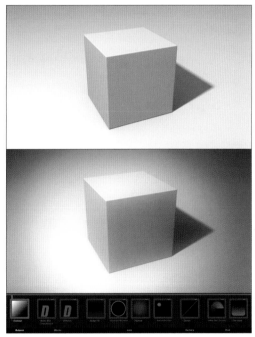

Figure 5-55: *Magic Bullet is an excellent shortcut to make CG images appear realistic.*

5.3 Common Gotchas

We're getting closer to the end of this chapter. It's been a steady climb in experience level, ever since the tonemapping tutorials in the previous chapter. This final section is for the advanced cracks, or those who want to become one. You've heard all about the advantages of 32-bit imaging, and I'm sure you will find more opportunities practicing on your own. But it would be unfair if I didn't also mention the pitfalls and hidden traps. In some parts, this next section may become rather technical; nevertheless, this is the hard knowledge that even experts need to be reminded of every once in a while.

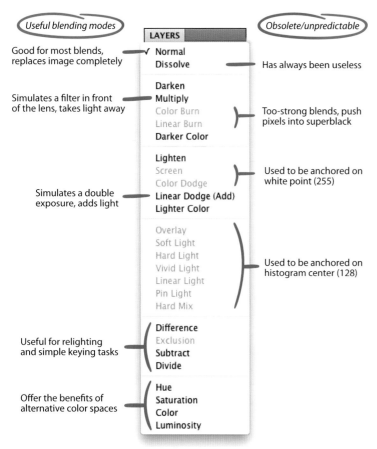

Useful blending modes — Obsolete/unpredictable

Good for most blends, replaces image completely

Simulates a filter in front of the lens, takes light away

Too-strong blends, push pixels into superblack

Has always been useless

Simulates a double exposure, adds light

Used to be anchored on white point (255)

Used to be anchored on histogram center (128)

Useful for relighting and simple keying tasks

Offer the benefits of alternative color spaces

Figure 5-56: *To avoid unpleasant surprises I recommend sticking to the blending modes that are unlocked in Photoshop's 32-bit mode.*

5.3.1 Will It Blend?

You might have noticed that I'm taking personal offense at Photoshop's tight 32-bit limitations. In some parts, however, I must admit, Adobe is right. Of course, you would never hear me say that out loud. But behind closed doors, in a private dinner conversation, you may catch me silently mouthing the words, "Look at Photoshop; that's the way".

I'm talking about layer blending modes.

Some blending modes that have grown near and dear to us are locked in Photoshop because they make no sense in 32-bit mode.

Add is the new Screen

Screen was useful in 8-bit because it could mix two layers by aligning their luminance on the bright end. But we can't use it in 32-bit anymore because there is no definite bright end in an HDR image. In mathematical terms, you could say the Screen blending mode is not defined for values over 1.0, but that sounds more like an excuse than a proper reason. So let me explain the situation differently.

Imagine that our color space is a room. In the case of 8-bit, that was our first dorm room, where we had to shuffle furniture around whenever we wanted to bring something new in. So we got reliant on all those little space-saving tricks, hidden shelves and folding tables. With 16-bit we moved into a larger apartment. We could finally move around without knocking into furniture all the time, and we had enough space to put up a workbench and take on some creative projects. Old habits still worked out. We always used to hang the chandelier from the ceiling, maybe hang some modern bookcases as well. The ceiling height was a persistent problem, though, and that big wardrobe from granny's attic only fit in after we sawed off the legs. We sort of agreed upon the fact that it looks better without the legs anyway. Now with 32-bit, we finally upgrade to an artist's loft, as big as an airport hangar and

Before / After

Figure 5-57:
Fusion allows color curves in 32-bit mode, a powerful but potentially hazardous adjustment.

topped with a giant skylight that even opens up electrically when necessary. In our new fancy HDR loft, the ceiling height is not a problem anymore. We can fit in anything, even that 30-foot metal sculpture of a killer robot we always planned on welding together. It's a fabulous space to get artistic in. The only catch is that we no longer have a ceiling to hang a chandelier from.

That's pretty much the situation in 32-bit image editing. All blending modes that depend on a fixed anchor point are simply inappropriate now. That also includes Overlay, Soft Light, and Photoshop's odd family of Hard/Vivid/Linear/Pin Light modes, which are all anchored on the center of the histogram.

Stay on the safe side

Sure, most compositing programs still offer all the blending modes. Screen, for example, may even work fine in those programs as long as no pixel is brighter than 1.0 in your image. But if just a few of your highlights are brighter than that, Fusion and After Effects will mess them up. Nuke applies some complex compensation by making exceptions for overbright values (switching locally to Max blending), but on the bottom line this is just a Band-Aid. Shoehorning Screen into working makes about as much

sense as building some elaborate framework trusses for our old chandelier, whereas our new loft really calls for a new stylish floor lamp. You may also call it beating a dead horse.

Add is the replacement for Screen. Now we can stack our values up as high as we want, so Screen is no longer required. In general, I recommend sticking to those blending modes that have the seal of approval from the Photoshop team. Everything else is unpredictable or may cause artifacts.

5.3.2 Beware the Curve Inversion!

Curves have always been the ultimate color tool for control freaks and professionals (which typically means the same people). But when curves are applied in 32-bit mode, there is danger lurking around the corner.

Let me show you the problem in Fusion. My example project has only two nodes: a loader and a color curve. By tweaking the curves for the individual color channels, I want to create a basic cross grade. That means I'm raising the midtones of the red channel and doing the opposite for the green channel. The net result is a nice purple tint. So far nothing special; in section 4.4.3 we did the same thing with post-processing curves in Nik HDR Efex.

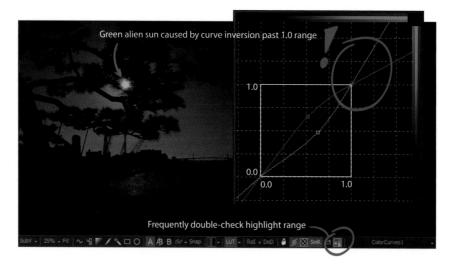

Figure 5-58:
Adjustments to the visible range between 0.0 and 1.0 are prone to slingshot around, applying the complementary adjustment to out-of-bound color values.

The tricky part in 32-bit mode is that large areas of the image are brighter than the screen can show. All that sky has color values beyond 1.0 and is therefore displayed as plain white. But that doesn't mean there is no image data in this area, and it also doesn't mean the curves wouldn't affect that image data. Worse even, they do the exact opposite of what I want them to do. The curves flip over.

The issue becomes obvious when I adjust the viewport exposure to inspect the brightest highlight range. In Fusion that's quickly done with the Normalize Image swatch on the bottom of the viewport. As it turns out, we now have a sickly green alien sun. That's because the green and red curves cross each other at the 1.0 mark! It is not a bug in Fusion; it's a fundamental issue. Both channels follow exactly the curvature I gave them. It's just that the 1.0 mark is no longer the absolute maximum, and so my curves just keep following the slope defined by the last curve point. Think of it as the exit velocity at the 1.0 mark that shoots the curves off to infinity and beyond.

Thankfully, Fusion's curve interface is zoomable, so the problem can be spotted and fixed. A simple solution would be to align all the bezier handles of the upper curve points, causing all three color curves to exit on the same path. Well actually, that can get fiddly. In practice it's easier to pin all three curves together with an

additional anchor point at the 1.5 coordinate (or even higher). This will ensure that extra-bright highlights stay the same and the color tweak is constrained to the visible exposure window. But if you want to apply the color tweak to the full image, you have to reshape the curves to maintain their relationship across the entire dynamic range. In this example, it means making sure the red line stays above the green line at all times.

Either way, fixing it is easy, once you know what to look out for. Because the curve inversion happens in those parts that are too bright to recognize, this is one of those problems that first go unnoticed. Much later, when you darken the image or maybe tonemap it properly, you end up wondering what happened to the highlight colors. That's why you need to stay alert and always watch the highlight range!

The same effect also happens on the lower end, inverting all values below 0. If this affects your image in any significant way, it means you have negative color values and you're in trouble anyway.

Photoshop users don't need to be concerned about any of this. By disabling the Curves tool all together, Adobe put on the childproof locks. You will only find 32-bit curves in image editors for grown-ups, such as, for example, Fusion, Nuke, and Toxic (a.k.a. Maya Composite). But that's okay because Photoshop's Curves tool

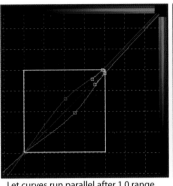
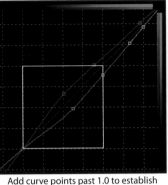

Figure 5-59: *Three possible solutions, all depending on additional curve points beyond the 1.0 mark or meticulously fine-tuned bezier handles.*

Let curves run parallel after 1.0 range to retain color tweak for all highlights.

Add curve points past 1.0 to establish gradual color tweak for the full range.

Converge curves past 1.0 to keep the original super-bright highlight colors.

hasn't changed since the '90s and is simply not up to the task. Photoshop's Curves interface wouldn't allow you to zoom out and it doesn't even have bezier handles. After Effects users, however, should be very concerned. In After Effects you're actually allowed to use Curves in 32-bit, but this tool is just as limited as Photoshop's Curves. It neither shows you how the channels shear apart beyond the visible range nor gives you any means to fix it.

Of course, the same thing happens when you tweak the RGB Gamma sliders in the Levels dialog (as we just did in section 5.1.4). If Photoshop's caretakers had thought of that, they probably would have locked away the Levels tool as well. With the Levels tool this inversion effect is inevitable and unfixable. This is the reason I stressed the fact that when you change levels on individual color channels, you cannot run the image through a local tonemapper anymore. What you see in the visible exposure range is what you get.

5.3.3 Eighteen Percent Gray
This is another common head slapper. We got pretty used to the old 8-bit sRGB numbering scheme, where we just assumed a value of 128 marks the middle of a scale from 0 to 255. But now we have to think in photographic terms. Now the scale goes from 0 to 1.0 (and beyond), and the photographic standard of 18 % mid-gray directly turns into a value of 0.18.

Sounds all simple and jolly, but in the real world this has deep implications. In a linear

histogram the values are crunched together on the left side. Any curve or levels adjustment will primarily affect the highlights. If you want to address the shadows or anything darker than mid-gray, you have to meddle with the lowest values between 0 and 0.18—and that's where things get really fiddly.

A good visualization of this concept can be found in the range selector of Nuke's Color Correct node. That's a 3-way color corrector similar to Colorista (from section 5.2.3) and it allows separate adjustments to shadows, midtones, and highlights. The range selector defines what each of these words actually mean, and because

Figure 5-60:
In linear space the shadows are huddled together on the low end, as Nuke's range selector demonstrates very clearly.

Corresponding linear gradient:

Nuke is a pure-breed linear color engine, its default range definitions clearly show how tiny the value space reserved for shadows really is.

Well, here comes the counterargument: Mid-gray has also never been 128! We were wrong all along.

Assuming 128 as mid-gray is one of the most common fallacies in classic digital imaging. Even worse, the assumed connection between 18 % gray and mid-gray wasn't ever there. They had nothing to do with each other. In traditional sRGB gamma space, 18 % gray is a value of 117, but the center luminance between black and white is in fact 187.

Huh?

Okay, brace yourself for another nutty Photoshop experiment.

I tried to paint you a picture, but it simply doesn't work in print. You have to see it on a monitor. And because you wouldn't trust an example image supplied on the DVD anyway, I made it into a mini-tutorial. It takes only 10 minutes, and I promise you will be knocked out of your socks and wonder how we could ever work on images in gamma space!

► What is mid-gray, exactly?

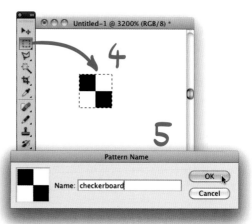

1 Create a new document, 1000 by 1000 pixels, 8-bit RGB.

2 Zoom in all the way to 3200 %.

3 Use the Pencil tool to draw two black pixels that touch at the corner.

4 Select a two-by-two pixel area that contains our two black pixels.

5 Choose EDIT ► DEFINE PATTERN from the menu. Photoshop will ask for a name. Let's call this pattern checkerboard.

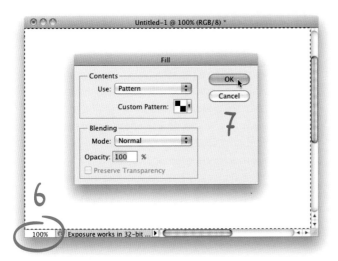

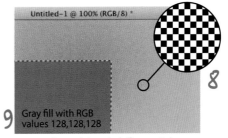

(image photographed off my monitor)

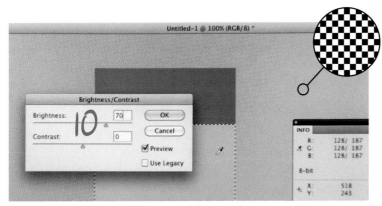

(image photographed off my monitor)

6 Zoom back out to a 100 % view and press Command+A (Ctrl+A on a PC) to select the entire canvas.

7 Choose EDIT ▸ FILL from the menu. Select Pattern as the fill method and pick our new checkerboard pattern.

8 What you now see is a perfect 50/50 mix of pure white and pure black pixels. So the overall impression is a perfect mid-gray, right? And now guess what numerical value that is!

9 Did I hear 128? Well, go ahead test that theory! Select a rectangle somewhere in the middle and fill it with 128 gray. You will notice that it stands out against the checkerboard pattern as much too dark.

10 Now let's find out what the real perceptual mid-gray is. Select the lower half of our not-so-mid-gray area (easily done by deselecting the upper part with the Alt key) and use IMAGE ▸ ADJUSTMENTS ▸ BRIGHTNESS/CONTRAST to visually match the brightness to the impression of the checkerboard fill. Probe that area with the Info palette and you will see that it turns out to be around 187 (if your monitor is properly calibrated). ✎

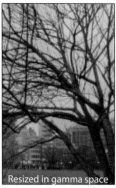
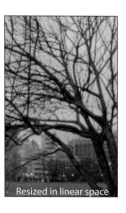

Original Resized in gamma space Resized in linear space

Figure 5-61:
Fine patterns and edges tend to darken slightly when an image is resized in gamma space.

Wow. Isn't this the weirdest thing you've ever seen? The common sense conclusion, that a gray value of 128 is the middle between 0 and 255, turns out to be off by quite a bit. You just confirmed it yourself.

Well, you're in good company. We all got it wrong. Even the Photoshop engineers got it wrong. The Fill command used in step 9 even offers a 50 % Gray option, which will in fact flood the selection with the incorrect value of 128. You can even continue the experiment by changing the zoom factor of the image you just made. When you switch from 100 % to 50 % zoom level, you will notice that the checkerboard area gets visually darker. Think about that! How can this be right? Surely the image has to be interpolated when it's shown at different sizes—but why would that process meddle with the visual brightness? And why did we never notice this before? What is going on here?

Edge case

Granted, this checkerboard image is an extreme example. It's an edge case—in the most literal meaning of the term. It contains the maximum amount of edges you can possibly have in an image. Every pixel has an edge that's in full contrast to all of its neighbors. And the problem exaggerated by this checkerboard test specifically concerns high-contrast edges and fine patterns: They are slightly skewed to the darker side every time you transform, blur, blend,

or otherwise filter an image in sRGB gamma space. Whenever a computer algorithm has to find the average between two pixel values, it will come to a slightly darker conclusion than if it did the very same calculation in linear color space. Real-world examples could be the dense network of twigs on a dead tree or grandma's plaid tablecloth. Both are maybe not the most common photographic subjects.

It's also really hard to spot the difference in a normal photograph because our eyes are comparative contrast detectors instead of precise instruments for measuring accurate brightness values. However, that doesn't change the fact that mid-gray appears to be 187 instead of 128. It's bad enough that our eyes are so easily fooled by optical illusions, and now we can't even trust the numerical logic in a computer program anymore? My head is spinning and I'm all confused now. Can you please finally solve the riddle of mid-gray, Mister HDR-book-writer?

Three words: linear color space!

What we observed was a built-in side effect of the gamma space. In linear space it all starts to make sense. Here 0.5 is the numerical middle between 0 and 1. That's a fact. Now apply the gamma conversion formula $255 \times (0.5^{1/2.2})$ and you get 187 as the result. If that math can't convince you, maybe another simple experiment will. Change the bit depth of our experimental checkerboard image to 32-bit and then use the zoom slider again. Now the visual gray value will always stay consistent.

However, there is a very good reason you had to see this effect on your own monitor. It seems to affect only screen media and how we perceive the sum of all light getting thrown at us. Your monitor is essentially a light source, and so your brain evaluates direct luminance values. But when you're looking at a print (or any other physical object), it's a whole different story. Then, your brain evaluates reflectance values—that is, how much light is reflected off a

surface. And that's where the famous 18% gray comes in.

Perceptual mid-gray in the real world

It was actually Ansel Adams who established a gray card with 18% reflectance as the photographic mid-gray reference. That was his best guess of the print density a human observer perceives as mid-gray, provided it is seen in not-too-dark or not-too-bright environments. It's not a physical constant like pi that could be determined with absolute accuracy, and it's about as precise as using the shoe size of King Henry III for measuring distances. Human visual perception is really something personal and does not adhere to strict numerical rules whatsoever, and so your own opinion about what is considered the perceptual mid-gray is just as good as anybody else's.

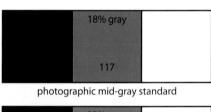

photographic mid-gray standard

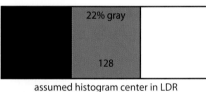

assumed histogram center in LDR

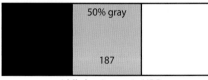

middle luminance in HDR

Figure 5-62: *Our eyes are actually very weak in estimating absolute brightness values. Ask three people and you get three different opinions of which gray value is the perceptual middle between black and white.*

However, let's see what the numbers say. If we run the 18% value through the gamma equation, that would be $255 \times (0.18^{1/2.2}) = 117$.

Do the same calculation in reverse and the gut assumption of 128 equates to 22% gray. These numbers are really close; we could argue all day long about whether it really makes any difference at all. That's why we can safely call the sRGB gamma space reasonable perceptual uniform, and that's also why it always worked great when we created images for print. It has a what-you-see-is-what-you-get character that allows making intuitive judgment calls. The gamma distortion also has the side effect that all the math behind image editing functions is close to the way tonal opacities mix in print media. It's close, by sheer coincidence, but it's never been quite accurate. It comes with a bag of issues that range from edge blending over fine pattern preservation all the way to clipping and banding.

In linear space this coincidental near match no longer exists. Now the perceptual mid-gray standard of 18% reflectance directly relates to a 0.18 value. In a way, that is much more honest. The linear space is not even close to perceptual uniform; instead, it is truthful to the photometric facts. When something *is* half as bright as something else, the numbers are halved. Then 0.5 is half of 1. But if something *looks* half as bright, then you're talking about the perceptual middle, and that would be the domain of a gamma space again.

The difference between *perceptual* uniform and *factual* uniform is the key here.

In practice

Realistically, I recommend concentrating on creating a bad-ass image rather than worrying about the numbers too much. But it's important to realize that the shadow tones are crunched together in a tiny numerical range, and memorizing some landmark values helps to get a feeling of where sliders related to highlights and shadows develop their grip. Eighteen percent mid-gray relating to 0.18 is a good one to remember.

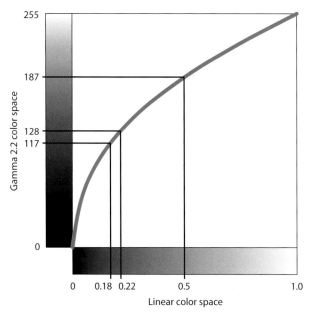

Figure 5-63: *Important landmark values and their relation in gamma space and linear space.*

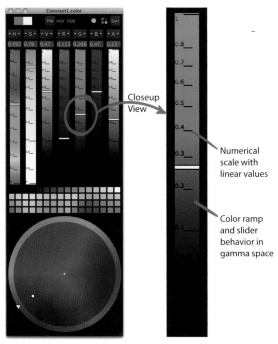

Figure 5-65: *The color picker in Nuke, showing very clearly how the slider ranges are gamma-corrected to be perceptual uniform.*

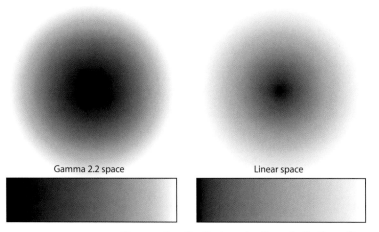

Figure 5-64: *Gradients and soft masks feather off much more gently in linear color space.*

Many unexpected tools work differently in linear space as a direct consequence of the differently skewed value range. Gradients are a good example. When you draw a gradient from black to white, every program will simply step through all the values between in even steps. In linear space you get a much softer falloff toward the bright side. This effect is most obvious in a circular gradient, which is often used for a quick mask. Sometimes that softer falloff is a really good thing, and sometimes you're drawing a mask to cover something up and then the smaller hotspot in the center does not work to your advantage.

A similar difference in falloff behavior also applies to blur filters. It's not even a question which behavior is better or worse. The point is that there is a fundamental difference that you need to be aware of, similar to the difference in handling cars with front wheel drive and rear wheel drive.

Some tools that heavily rely on a visual interface are always shown in gamma space—regardless of if you're working with linear data. For example, color pickers would be very hard to use in linear space. In my analogy, the steering wheel is always mounted facing forward,

even if the engine is in the rear. Anything else wouldn't make sense. Colors always need to be picked in a perceptual space. Once again, Nuke sets a great example by showing the linear numeric scale overlaid on a gamma-corrected slider.

5.3.4 Safe and Unsafe Resampling Filters

Even such simple image operations as resize or rotate can turn into a disaster when you're using the wrong resampling filter.

Hold on a minute—what is a *resampling filter* again? And why is it necessary anyway?

Well, whenever you transform the geometry of an image, you're not actually moving the pixels around. It may seem like that, but in reality you destroy all the old pixels and create a completely new set of pixels that hopefully resemble the image well. When an image is scaled down, the appearance of multiple pixels is merged into one new pixel. When the image is enlarged, new in-between pixels are interpolated. That's why some programs call the resampling filter more appropriately an *interpolator*. It's not an optional effect filter; it's an absolutely integral part of any image transformation. Every time an image is resized, rotated, bent, warped, sheared, transformed in any way, a resampling filter will look at the old pixels, evaluate them, and then decide on the optimum placements and values of new pixels.

It's during that short limbo moment, when the pixels are hanging between this world and the next one, that things can go haywire. Some resampling filters simply don't know how to deal with über-bright values beyond 1.0. They may introduce negative pixel values, or even infinite pixel values. Such artifacts are most common around tiny light sources or specular highlights, and they can be as small as a single corrupted pixel—but they eventually become your worst nightmare in subsequent editing steps. Small blur filters bleed out across the whole image, the complex math behind tone-

mappers collapses, programs crash without warning. And the most dangerous part is that the evildoers are exactly those filters that were designed to preserve sharpness and therefore are known in traditional LDR imaging to deliver the best results. It's our best buddies who are now turning against us.

Safe Resampling Filters	Unsafe Resampling Filters
Nearest Neighbor (Impulse)	Catmull-Rom
Box (Area)	Simon
Triangle (Linear, Biliniear)	Bessel
Cubic (Bicubic)	Cubic Sharp (Bicubic Sharper)
Hermite	Mitchell
Hanning	Lanczos
Parzen	Rifman
Gaussian (in many variations)	Sinc (in many variations)

Table 5-1: *Never use a resampling filter from the right column for transforming HDR images.*

Figure 5-66: *Image scaled to 90 % with two different resampling filters and examined at 300 % zoom.*

Responsible programs have some sort of safety mechanism built in. Picturenaut displays a clear warning message in the filter description, and PTGui brings up a pop-up requester when you try to render an HDR panorama with an unsafe filter. Photoshop has most variations of the Bicubic filter disabled in 32-bit mode, which is actually a bit overprotective. When it comes down to it, Photoshop doesn't even offer sharpness-preserving resampling filters like Lanczos or

Figure 5-67: *Picturenaut shows a clear description for each resampling filter and warns you of potentially harmful choices.*

Sinc, which would be considered unsafe in 32-bit. In Nuke, Fusion, and other professional image editors, you're expected to know what you're doing. Use the table I compiled for you and make sure to stick to safe resampling filters.

The good news is that those HDR-safe filters work much better in linear space. In fact, epic food fights break out in image engineer cantinas over the question of whether resampling an image in a gamma-distorted space makes any sense at all. It's rooted in the observation that in gamma space mid-gray is factually at a value of 187 instead of 128. The consequence (demonstrated in the previous section, 5.3.3) is that in gamma-space, fine dark patterns are likely to blend into a much too dark gray value, while fine bright patterns tend to disappear.

5.3.5 Don't Be So Negative!

When you're working in 32-bit mode, there is always the danger of getting negative color values in your image. Technically, it's good that they are allowed because it prevents colors from getting clipped off during intermediate processing steps and has the net effect of ex-

tending the color gamut infinitely (as explained in section 1.5). Some specialty applications in computer graphics literally rely on negative values; for example, motion buffers, displacement maps, and a few flavors of normal maps.

However, in practical image editing and compositing, such negative values often throw things off. They can creep in during levels adjustments, curves, even when rescaling with an unsafe resampling filter. Pulling a luminance key is a very common trapdoor, where image values can happen to fall into the negative realm (section 4.4.5 mentioned this briefly). Chances are you don't realize the mistake when it happens because your monitor doesn't show any visual difference between black and darker than black. Typically you notice it much later, when the image looks funky after it's brightened up or when negative values in a mask create unexplainable effects.

That's why professional compositing programs frequently give you the option to clip the image values. You'll find this option at the bottom of the Levels effect in After Effects, the Brightness/Contrast node in Fusion, or the

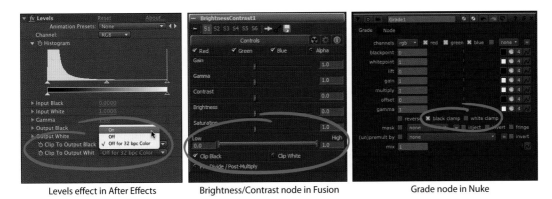

Levels effect in After Effects	Brightness/Contrast node in Fusion	Grade node in Nuke

Figure 5-68: *Clipping is a common option in professional compositing applications.*

Grade node in Nuke. In fact, Nuke's transform node even has a dedicated Black Clamp option right next to the resampling filter menu, enabled by default and intended to quench the problem at the root.

In Photoshop you need a workaround. I will not comment on how silly it is that the world's

leading and most bloated image editor does not even contain the two lines of code necessary for a clipping function. Instead, I will show you the workaround in a tutorial. I highly recommend you do this practical exercise with me, just to develop a more intuitive feel for floating-point image values.

➤ Dealing with negative color values in Photoshop

Let's use Downtown_USBank.exr from the DVD again. Go ahead, load it up in Photoshop!

1 First we need to introduce some negative values, just for the purpose of this tutorial. Here is a quick way to generate them: Open the IMAGE ▸ ADJUSTMENTS ▸ EXPOSURE dialog and drag the Offset slider to the left. An offset value of −0.05 should be enough here.

Figure 5-69:
For demonstration purposes, use Offset to shift some colors into the negative realm.

Figure 5-70: *When the Info palette is configured to show 32-bit values, you can easily spot negative color values under your mouse pointer.*

Figure 5-71: *Ramping viewport exposure all the way up makes negative values stand out.*

2 Let's see what we have done to the image. One inherent difficulty is to actually spot negative values. Make sure the Info palette is visible (WIN-DOW ▸ INFO) and use the small color picker icon to change the display mode to 32-bit (0.0–1.0).

3 Now hover your mouse over some dark areas in the image and keep an eye on the color values. See all that negativity? Notice that the regular 8-bit RGB values remain locked at 0,0,0 and wouldn't be of much of help.

That Info palette is your first line of defense. Nuke, Fusion, and After Effects also have numerical value fields, and you should always keep them in your peripheral vision and stay alert of any minus signs showing up.

4 Temporarily ramping the viewport exposure all the way up is another quick way to test the entire image for negative colors. When you still see black areas at the maximum exposure settings, chances are these are negative. That's because exposure acts as a mathematical scale factor for color values.

More specifically, exposure is applied with the formula NewPixel = OldPixel × $2^{Exposure}$. Two to the power of anything will always return a positive value. And if the old pixel value is negative, the multiplication with a positive value will only make the new pixel value sink deeper into the negative realm. Put simply, that means exposure pushes all values *away* from the zero point.

Note that under this extreme viewport exposure some pixels show up with super-saturated colors. Those are the pixels where only one or two channels are negative. There can be two reasons for that: Either the pixel is very dark (like the blue corner in the screen shot) or the pixel has a color that lies outside the regular sRGB color space (like the bright yellow windows). Both are good things. Preserving these values is one of HDR imaging's most beloved features, not a bug. Problematic are the areas that appear pitch black. Those have all three color channels at exactly zero (still fine) or lower (sure troublemaker).

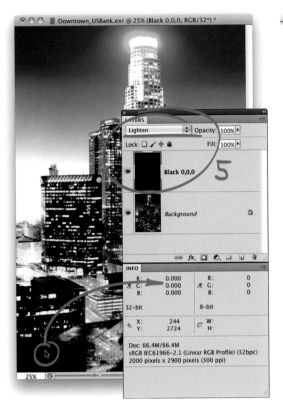

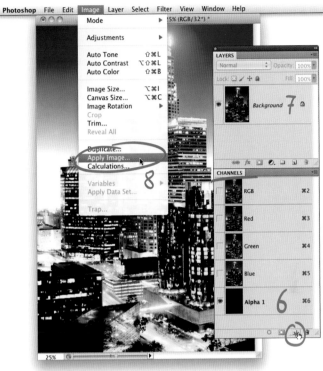

5 So how can we fix this? Well, without an explicit clipping function we have to resort to blending tricks.

Make a new layer, fill it with black, and set the blending mode to Lighten.

There is no visual difference, but if you hover your mouse over the areas that have previously shown negative values, you will see in the Info palette that 0,0,0 is now the absolute minimum value found anywhere. That's because the Lighten blending mode is special. It makes an either/or decision about every pixel by comparing the current layer with the layers underneath. If the underlying pixel is brighter, it is let through. But if the underlying pixel is darker, it will be replaced. And with 0 as our comparison value, the net effect is that all negative values are clipped off.

Of course, in a practical workflow we're most concerned about negative values in a mask. In this case we can't use the layer blending trick because that wouldn't have a direct influence on the mask itself. So you can delete that black layer for now and I will show you the universal clipping method.

6 Go to the Channels palette and create a new channel by clicking on the icon on the bottom. The default name Alpha 1 is as good as any other, and the default black fill is exactly what we need. Great. This channel will be our provider of zero pixel values.

Click the RGB channel (first in the channel list) to switch the display back to the actual image.

7 Now you can select any individual layer or matte that may have negative values. Well, right now there is only the background layer, so that will do.

8 Select IMAGE ▸ APPLY IMAGE.

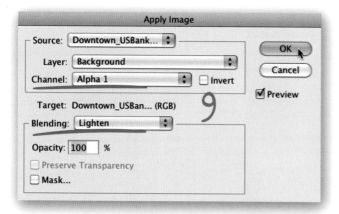

9 In the Apply Image dialog, select Alpha 1 as the source channel and set the blending mode to Lighten. Click OK and all the negative values will be clipped off. Probe some dark areas in the image with the Info palette again and you won't encounter a minus sign anymore.

It's the same method; the only the difference is that the clipping happens immediately and it can be applied to individual layers or—and this is the important part—individual layer masks! ◄

So now you know how to spot negative values and how to clip them off when they cause trouble.

Clipping off the white values is less common because those overbright areas are typically worth preserving. There are better ways to reduce the highlight range; that's what we have a million different tonemapping techniques for. Sometimes, though, you may have to clip a mask at the white point. Then the Photoshop method is similar to the black clipping workaround:

❯ Create an extra channel.
❯ Fill it with white (or the value of your preferred clipping point; often that may be 2.0 or higher to get rid of stray luminance peaks).
❯ Select the mask (or layer) that needs to be clipped.
❯ Use IMAGE ▸ APPLY IMAGE, select that white Alpha as the source channel, and choose the Darken blending mode.

In a nutshell

These are just some minor potholes on the road to success. Don't let this last section discourage you from taking the journey into the linear floating-point color space. The bottom line is that the advantages of working in 32-bit precision are liberating when compared to the old limitations of 8-bit imaging.

In 32-bit you can be careless about banding and accidental clipping, even in intermediate steps. You can just concentrate on the creative process, meddling with the image in extreme ways, because the underlying data is flexible enough to adjust. Processing steps that simulate optical effects are finally working as expected in HDR because the math behind automatically returns photometrically plausible results. You don't just edit on-screen pixels as if they were dry paint on paper; you edit the light that was captured. Optical effects like motion blur, defocussing, vignetting, glow, and blooming are all related to light rays getting disturbed on their way through the lens, and so all these effects are best simulated in a linear floating-point domain. Effects related to film material and final presentation, however, work better in a perceptual (gamma-corrected) space. That includes applying final color correction, grain, and sharpening.

5.4 Chapter 5 Quiz

You probably figured out by now that these crossword puzzles are actually textbook questions in disguise. However, I'm the first to admit that the difficulty level of this quiz is set somewhere between very hard and outrageously hard. So, if your professor does not allow you to browse chapter 5 for the answers, you can take that as further evidence that he is, in fact, the devil.

1. Optical effect of extremely bright light sources bleeding out and covering up darker image areas.
2. Type of numbers that enables all this magic of being "undigital" with digital images.
3. Family of plug-ins with a massive amount of 32-bit tools and filmic look presets.
4. Complementary color to magenta in the RGB system.
5. Middle knob of the upper slider in Photoshop's Levels control.
6. Light falloff toward the edges of an image.
7. Adobe's video compositing program, which is also perfectly suited for adding visual effects to photographs.
8. Complementary color to blue in the RGB system.
9. Resampling filter that normally produces the sharpest result in LDR images but can introduce nasty artifacts in HDR images.

10. Diagram of RGB color relationships; essential work tool for tweaking individual color channels.
11. Complementary color to red in the RGB system.
12. Integral component of every image transformation that can potentially be harmful for HDR images.
13. Effect caused by moving the camera or objects in the scene while the shutter is open.
14. Effect of defocused extra-bright highlights turning into circles or polygonal rings.
15. VFX jargon for *composition*.
16. When traditional LDR pixel values represent dry paint on paper, what do HDR pixel values represent?
17. Photoshop tool for manually smearing pixels across the canvas; perfectly suited for fine-tuning layer masks.
18. Range of HDR pixel values that may cause unexpected problems, especially when they appear in a mask.
19. Blending mode that takes the place of Screen in 32-bit image editing.
20. Essential plug-in for creating realistic depth-of-field effects in After Effects and other compositing programs.

5.5 Spotlight: Kirt Witte

Many techniques in this chapter were taken directly from the world of visual effects, where the HDR floating-point domain has been the standard work environment for many years now. Funny thing is, the collective hive mind of the photography community has now become the driving force behind new HDR techniques, and it turns out there are so many things visual effects artists can now learn from photographers. Nobody knows this better than Kirt Witte.

Kirt is a veteran photographer with more than 20 years of professional field experience. But he's also professor of visual effects at the Savannah College of Art and Design (SCAD), teaching students the art and craft of all things digital. In past years he became an avid collaborator with HDRLabs.com, sharing a massive amount of HDR tips and tricks, and we have teamed up for several SIGGRAPH presentations.

So, this interview is really special, more of a colloquial chat among friends.

CB: Do you think it's important that your students learn about HDR?
KW: Definitely! Even though HDR isn't the ultimate solution to all problems, it is an important aspect of working with 3D and visual effects. A large percentage of our students end up as lighters at companies like Rhythm & Hues, Digital, Domain, ILM, and Pixar. Therefore, it is important that they learn as many different lighting/rendering techniques as possible to help them with their professional career goals.

CB: Are you teaching everything, from photography all the way to HDR lighting in 3D?
KW: Yes, we start out covering the basics like f-stops, shutter speeds, reciprocity, and lenses. Then we move on to shooting HDR stills, chrome balls, and eventually they learn how to shoot their own high-resolution HDR multi-image

spherical panoramas. Once they have these HDR panos, we then cover generating artificial HDR panos in Vue and then have students take these panoramas into mental ray or Renderman for rendering/compositing their final CG projects into live action plates.

CB: What do your students struggle with the most? And is there some sort of aha moment that clears it all up?
KW: I have found that most 3D students do not have much experience with photography, unfortunately. They have been drawing since they were three years old, but most have not seriously touched a camera. Being able to communicate in the "Language of Film" is critical to visual effects artists.

The aha moment usually comes at the end of the quarter when they have gone through the entire HDR production pipeline and understand how they now have one more important tool for their CG tool belts. Of course, I often hear, "If I

only had more time, I would have..."

CB: You never told me that you have such a magnificent private jet. Does every faculty member of SCAD have one?
KW: Ha ha! No, we do not, but it would sure be nice. I do a little freelance photography on the side, and this was actually a photo assignment for an aviation service center. Many of these custom Gulfstream and Bombardier aircrafts cost $30 to $50 million dollars, so I think that it is probably a bit out of range of the budget. But maybe I will ask for one during my next evaluation and see what my dean says?! I have a feeling I already know the answer.

CB: When doing such high-profile work, what's the most critical thing to watch out for?
KW: Color and dynamic range. When a client spends that much money on an aircraft, they expect their photos to be perfect. They must have perfect exposures and perfect color. HDR

makes that possible. It allows me to capture the entire dynamic range of any scene and I can then choose in post which highlights, shadows, and midtones I want to use. Sometimes reality is not as good as you or your customer remember it, so the goal is to make an image that shows what something should look like instead of what it really does look like.

I use a WhiBal digital gray card for being able to get perfect color from my shots. Most aircraft interiors have several mixed lighting sources that are rarely standard color temperatures. There are these custom upwash/downwash lights, but then the light at the side of the seat will be tungsten and will be splashing onto the carpet below, so being able to tweak the colors

is really, really important. HDR Expose is perfect for that.

CB: So, HDR Expose is your favorite?
KW: Hands down, HDR Expose is my favorite. Most HDR tonemapping applications have about four controls. Photomatix, the most widely used tonemapper, only has about 8 or 10. HDR Expose gives me about 40! Having more options allows me as a photographer to have so much more subtle control over my toned images than any other program on the market at this point. I often tell my students the difference between an amateur and a professional is in the little details and subtle things. HDR Expose also has a unique Veiling Glare removal option that I have never

seen in another HDR tonemapping application. And just I love the Color Tuning feature that allows me to selectively tweak colors. I am thrilled that Unified Color is pushing the envelope of HDR. My work is simply much better due to the controls and options they give me.

CB: You're also shooting HDR panoramas to create these wonderful art pieces. What's your driving force behind them, what fascinates you about making them, and how do people react to these twisted images?

KW: Interesting question! My background is in photography, but over time I evolved to working more with 3D and visual effects. Shooting panoramas, especially for HDR, enables me to

work with both of these areas that I love.

A little ironically, I generally don't care for images that have been run through filters like "watercolor" and other effects found in Photoshop and compositing software applications. But using the Flexify plug-in allows me to create images that few digital artists can create. One of my personal philosophies that I also try to teach is to "be different!" When people view my work, I want them to think that my images are truly unique and do not look like everyone else's. Because I have been shooting panoramas since 1993, I have learned how to find optimal locations for shooting them. For example, I previsualized my flag panorama before I ever took the first photo.

People react quite differently to them. I think the majority of people are not used to seeing spherical panoramas, especially the hyperexaggerated "world" view ones. I find it funny when they cannot figure out how I can just jump up in the air and take a 360-degree panorama of the whole planet.

CB: If there is one single piece of advice you can imprint on our reader's forehead, what would that be?
KW: HDR is easy, but the more technical knowledge you have, the more creative and artistic freedom you will have to create any sort of images you want.

I advise keeping up with all the latest trends in HDR at HDRLabs.com!

But seriously, I would like to mention that tonemapping is a very subjective issue. However, for me, like good visual effects, I think the best tonemapped images are the ones that are not obviously manipulated.

Kirt continues to teach everything about HDR at the Savannah College of Art and Design; admissions are open at www.scad.edu/visual-effects. If you've already grown out of college, you can still catch his course at several conferences or read up on his most helpful tips at www.hdrlabs.com/tutorials. More of Kirt's personal and artistic work can be found at www.KirtWitte.com or www.TheOther Savannah.com.

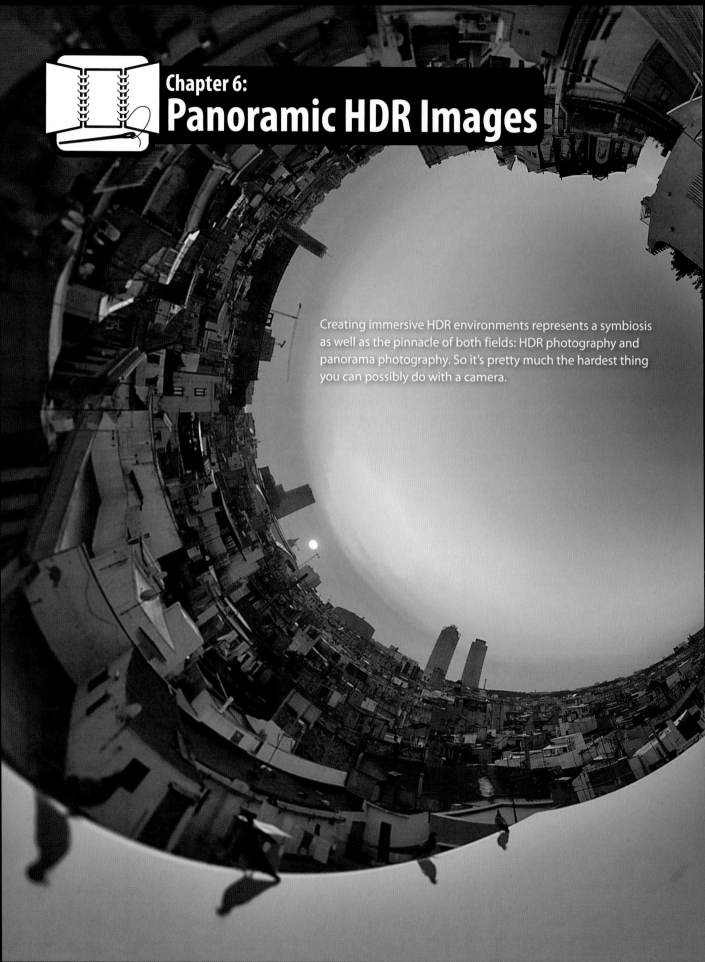

Chapter 6:
Panoramic HDR Images

Creating immersive HDR environments represents a symbiosis as well as the pinnacle of both fields: HDR photography and panorama photography. So it's pretty much the hardest thing you can possibly do with a camera.

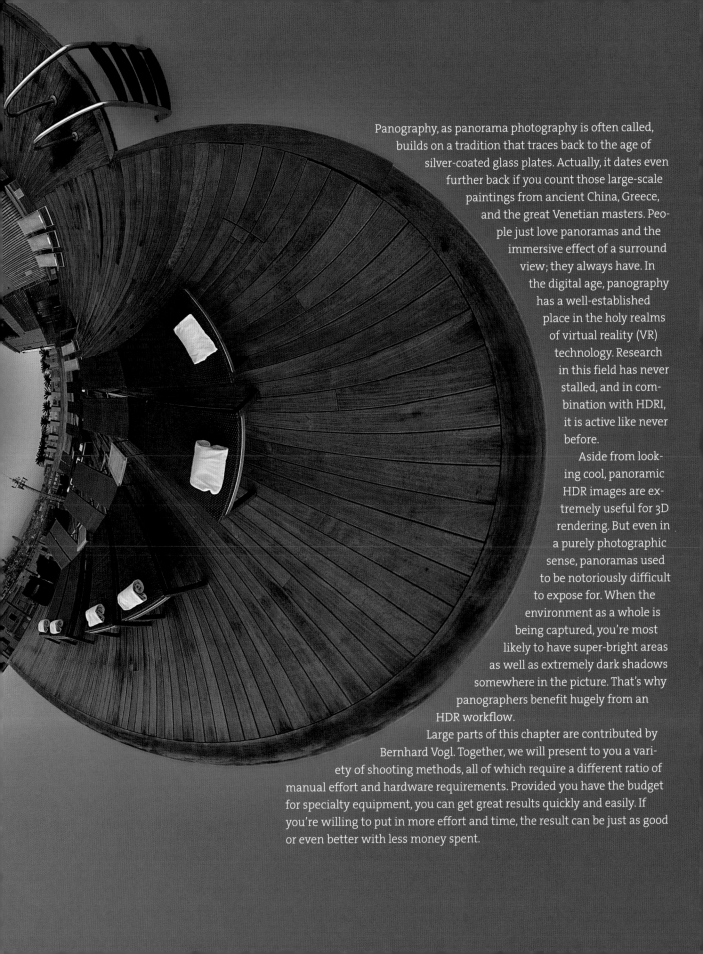

Panography, as panorama photography is often called, builds on a tradition that traces back to the age of silver-coated glass plates. Actually, it dates even further back if you count those large-scale paintings from ancient China, Greece, and the great Venetian masters. People just love panoramas and the immersive effect of a surround view; they always have. In the digital age, panography has a well-established place in the holy realms of virtual reality (VR) technology. Research in this field has never stalled, and in combination with HDRI, it is active like never before.

Aside from looking cool, panoramic HDR images are extremely useful for 3D rendering. But even in a purely photographic sense, panoramas used to be notoriously difficult to expose for. When the environment as a whole is being captured, you're most likely to have super-bright areas as well as extremely dark shadows somewhere in the picture. That's why panographers benefit hugely from an HDR workflow.

Large parts of this chapter are contributed by Bernhard Vogl. Together, we will present to you a variety of shooting methods, all of which require a different ratio of manual effort and hardware requirements. Provided you have the budget for specialty equipment, you can get great results quickly and easily. If you're willing to put in more effort and time, the result can be just as good or even better with less money spent.

6.1 Pano Lingo

Shooting panoramas is quite a bit different from regular photography. Before we dive right in, we have to ensure that some terms and definitions are well established.

6.1.1 Field of View

When a normal photographer talks about the focal length of his lens, he assumes that his conversation partner also uses the same image circle (film type, sensor size) for his imagination. In typical conversations, you will hear phrases like "shot with a 17 mm," and everyone knows "this was a very wide-angle lens."

With digital cameras, even hobbyists slowly become aware that *focal length* alone is a term without definition. Most of them circumvent this problem by multiplying the focal length with a *crop factor*, which is still based on 35 mm film and standard lenses. You will learn in the following sections that this is not a good idea.

Panorama photographers have left this one-way street and now work with the term *field of view*, abbreviated as FOV. Imagine yourself in one corner of a triangle; the FOV will define how much you can see without moving your head. Still, this is an ambiguous definition, so we have to add a direction: horizontal, vertical, and sometimes the diagonal FOV from corner to corner.

A full spherical image will display a horizontal FOV (hFOV) of 360 degrees and a vertical FOV (vFOV) of 180 degrees. This is the maximum FOV ever needed in real-world situations and covers all you can see around you.

But what does the term *spherical* mean?

6.1.2 Image Projections

The basic problem of a surround view is that by definition it has no borders. It's more like a sphere that wraps all around the viewpoint. But a 2D image does have borders and is always a flat rectangle. So we have to unfold the sur-

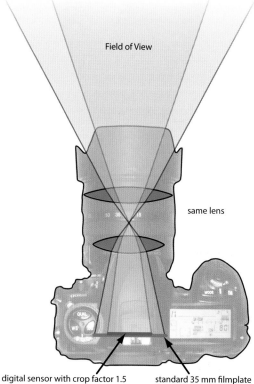

Field of View

same lens

digital sensor with crop factor 1.5 standard 35 mm filmplate

Figure 6-1: *FOV is heavily dependent on sensor size.*

rounding sphere, just like carefully peeling an orange. This is called a panoramic projection. There are different ways to do this, and each one is a compromise of some sort. It has to be because we're representing a 3D space with a 2D image. The names of projection types are standard terms in a panographer's vocabulary,

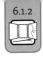

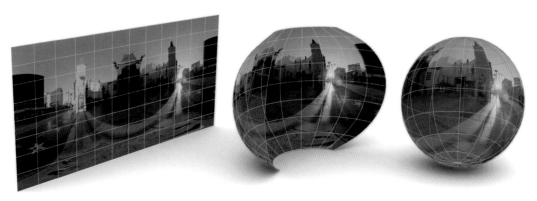

Figure 6-2:
A spherical projection is wrapped around the view like a world map wraps around the earth.

yet they exist in different dialects that you should know about.

Spherical map/latitude-longitude/equirectangular

This is the most common way of unwrapping the imaginary surrounding sphere. Note that all three names stand for exactly the same format. It can be easily recognized by the typical 2:1 aspect, and it corresponds to the transformation from a globe into a simple world map. The geographical latitude and longitude coordinates are taken directly as XY pixel coordinates. The horizon line of such a panorama equals the equator. It goes exactly across the center of the image and is mapped without any distortion.

The poles, on the other hand, correspond to the zenith and nadir points. In a brutal act of extreme distortion, they get smeared out horizontally all across the image. These special points form the top and bottom pixel line. This is important to keep in mind when editing such an image. It's generally safe to edit the center area around the horizon, but messing with the upper and lower borders will produce significant errors because they converge into a point.

Vertical architectural lines are kept straight. Good points of reference are building corners, poles, and street lamps. But horizontal lines are always bent, similar to a fisheye distortion. This is because the projection grid is tapering

together more and more toward the zenith and nadir points. What looks like a vertical band of even squares on the map is turned into a pie-shaped slice on the projection sphere.

When you're manipulating an equirectangular panorama, you have to pay special attention to the seam line. Left and right borders have to fit together perfectly. This can be assured by rolling the image horizontally, which corresponds to a rotation of the globe along the vertical axis. For a tutorial on panorama-safe tonemapping, browse back to section 4.4.7.

Because of its very well-defined image geometry, this format has become the de facto standard for panoramas. It is the general exchange format. Every program in which you could possibly create, edit, or use a panorama knows how to deal with a spherical map. It's perfect for archiving because you can always convert it to any other format your heart might desire.

Panorama size is typically measured on the horizontal pixel resolution of the spherical map. For example, a typical *8K pano* is an image with (roughly) 8000 by 4000 pixels.

Cubic map/horizontal cross/vertical cross

Instead of a surrounding sphere, we can use a cube. If our viewpoint sits dead center, there is practically no visual difference between projecting the environment on a cube or projecting it on a sphere. The only thing that counts is that

Figure 6-3:
A cubic map folds together like a toy box.

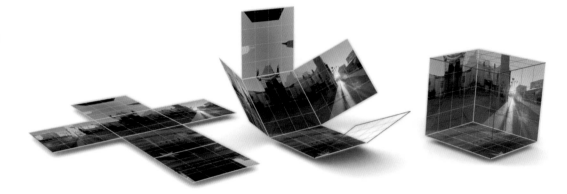

for each viewing angle, we have the proper image patch.

The cubic projection type is very efficient for VR display purposes. Computations are inexpensive because it needs only six polygons, which conveniently match the plain XYZ directions in virtual space. Mathematically, a virtual object could not be described any simpler. Hence, this used to be the native format in QuickTime VR, and even today's flexible Flash- and HTML5-based panorama viewers perform best when you feed them cubic maps. Modern graphics cards even have a special hardware acceleration for this.

There are many different flavors of this projection. It can be six individual images, all images in one long strip, or the images can be sorted into a horizontal or a vertical cross. The cross types are very easy to visualize, but in real life they are terrible to work with. They are wasteful because only half of the available space is used for the image. Even though on disk the black areas can be stomped with lossless compression to just a few bytes, it still doubles the amount of memory required for opening the image. That can make a big difference because panoramas are notoriously huge files already.

Therefore, most people use either six individual images or all in one strip. The order and direction of the cube faces are different in each

Backside wall in a horizontal cross

Backside wall in a vertical cross

Figure 6-4: *Different variations of cubic maps in cross formation.*

program, which makes it an unreliable exchange format. Instead, cubic maps are typically used as final output for Web display, in which case you'd just follow the conventions of your panorama player.

Another popular use of cubic maps is for retouching. The big advantage of this projection is that it has no fancy distortion. Each side of the cube is flat and equals a simple view in one compass direction. In fact, it is exactly like a square crop of a photograph taken with a high-quality 13.3 mm prime lens, delivering 90 de-

grees horizontal and vertical field of view. Straight architectural lines are kept straight, and the pixel density is consistent across the whole surface of the cube. This makes the individual cube face a formidable canvas in which to edit and do touch-ups. Zenith and nadir, which are the untouchable in a spherical map, are typically edited as cube faces. The only thing you cannot do is paint across the image borders. Even when the images are laid out in a strip, there is a significant perspective jump on each seam. To maintain the continuity across the seams, all image edits should be kept inside each square, away from the edges. Forget about applying global image filters like blur or sharpen.

Cylindrical map

Unlike the other projection types, a cylindrical map does not show zenith and nadir. Instead, you're looking at the inside of a cylinder with open caps. On the horizon line it looks just like a spherical map. Horizontal lines are bent, and vertical lines are kept straight. The difference is that farther away from the horizon, tall structures are not getting squashed as in a spherical map. This is most recognizable on buildings, where all levels appear equally high. However, beyond a viewing angle of 45 degrees up or down, buildings start to appear stretched instead. So the effectively useful FOV is about

90 degrees vertically. Outside this sweet spot you're essentially looking in the direction of the zenith and nadir, and that's where other projections shine.

Mercator, for example, is a special type of cylindrical projection where the stretch/squash effect of high buildings is counterbalanced to provide uniform angles all throughout the map. It comes from mapmaking and was developed because sailors were sick of drawing a straight ship course as a curved line. But just like regular cylindrical maps, Mercator doesn't work for the poles—which is probably the reason it took our nautical explorers so long to find them.

In the photography world, cylindrical projections are used mostly for partial panoramas at very high resolution. Gigapixel imagery comes to mind. These are panoramas with more than 1,000-megapixel resolution, where you can look at the interesting areas in the distance at obscenely high zoom levels but you would never care about looking straight up or down.

Cylindrical images are also often used for prints because when laid out flat they look more appealing than other projections. For CG, cylindrical maps play a minor role. You can't use them for lighting because they are not all encompassing. At best, you can use them as distant background or as a starting point for high-resolution matte paintings.

Figure 6-6:

An angular map is first extended into a cone and then shrink-wrapped to the surrounding sphere.

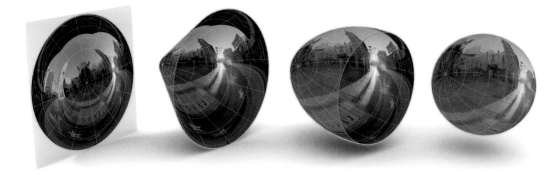

Figure 6-7:

The extreme distortion makes editing angular maps a royal pain and prohibits any image filters.

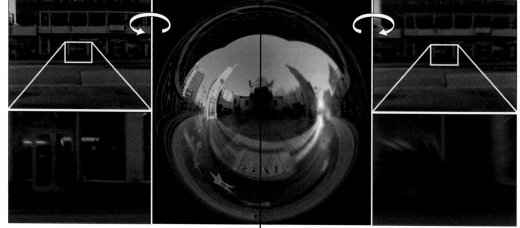

Backside of a correct angular map, circumference merges in a point. | Even a slight blur violates the image geometry and causes streaking.

Angular map/light probe

This projection has been specifically designed for lighting 3D objects with HDR images. It was mentioned first by Paul Debevec, a pioneer who basically invented the field of image-based lighting. Note that every full panoramic HDR image, no matter what projection type, is in fact a *light probe* in the literal sense (capturing and preserving lighting information). However, Debevec's legendary SIGGRAPH course *Rendering with Natural Light* in 1998 put this projection type on the map, and ever since then it is commonly referred to as light probe image.

The image geometry is similar to a fisheye lens but with a field of view of 360 degrees

and even angular distribution. Think of it as an ultra-mega-extreme fisheye that would be physically impossible to build.

In the center point we have the forward direction. Up, down, left, and right are set on a circle that is half the radius of the entire image. This is what a 180-degree fisheye would deliver. From there, our map keeps going outward in even angular steps until it reaches the backwards view, which is smeared all across the outer radius of the map. The extreme distortion makes it very hard to read for a human, and because virtually every straight line appears bent, this projection is unsuitable for any retouching work.

The advantage of this format is its continuity. There is no seam line. Except for a single point directly behind the camera, the entire environment is pictured seamlessly. This minimizes the risk of seeing an image seam when we pan our virtual camera around because then we would have to rely on the rendering software to interpolate correctly across the seam. However, when looking backwards, we do have a problem. Every mistake in the image, no matter how small it is, will be displayed as an ugly streaky artifact. That's because all pixels close to the outer circumference get distorted into a very longish shape. So the backside of a bad angular map usually looks like the valve of a balloon, with those typical stretch marks around it.

Other projections

There are plenty of other ways to peel an orange. An insane amount of other ways, to be precise. The good old tradition of mapmaking alone has contributed over 40 different projection types, all aimed at striking a good compromise between keeping relative distances, areas, and angles represented in a truthful way. Mollweide, Mercator, Robinson, and Miller are just some of the better-known projection types. Some others are purely mathematical constructs, known as stereographic, hyperbolic, and little planet. These are actually my personal favorites because they deliver unusual perspectives and crazy distortions, reminiscent of M.C. Escher.

Other projections were just recently rediscovered by analyzing perspectives in classic paintings. In fact, this is still an active field of research. Of particular interest is the Golden Age of Dutch landscape painting and the Vedutismo genre, popular in the seventeenth and eighteenth centuries. Grand masters like VanWittel, Pannini, Piranesi, and Canaletto still manage to impress with large-scale city views filled with intricate detail. They had a very creative way of dealing with perspective correction, preserving

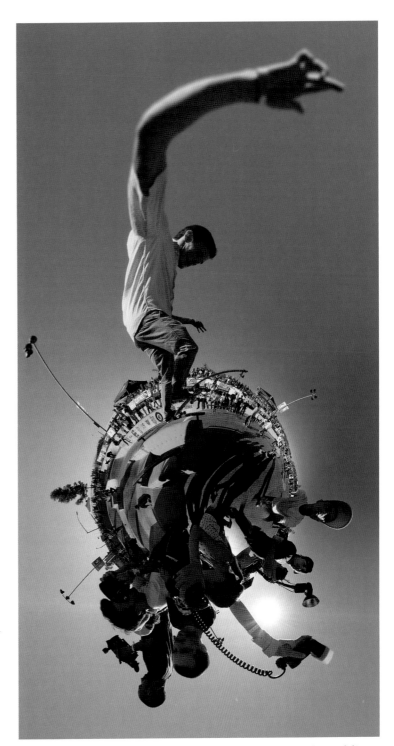

Figure 6-8: The stereographic projection, also known as little planet, delivers a fancy twist on the perspective.

straight lines in extremely wide views without making it look odd. It's quite amazing to see the perspective tricks of such master painters wrapped up in algorithmic formulas now applicable to photographs.

All these miscellaneous projection types are available in PTGui, Hugin, and Flexify. Although they don't play any significant role in preparing panoramas for use in CG or interactive presentations, they're totally awesome in creating a pretty image for print. Plus, they're just a lot of fun to play with. Snoop around this book and you'll find many more images in stereographic and Vedutismo projection.

Comparison table

Okay, let's wrap up the useful projection types. I collected all the most important attributes in a comparison table as a convenient quick reference.

	Spherical Map Latitude-Longitude Equirectangular	Cubic Map	Cylindrical Map	Angular Map Light probe
Aspect Ratio	2:1	4:3, 8:1, or 8 separate images	Arbitrary crop	1:1
Distortion	Low on the horizon, high on the poles	Low	Medium	Extreme
Breaks in image continuity	Two poles, one seam	Eight seams	Zenith and nadir not covered	One pole
Use of space	100 %	50 % or 8 × 100 %	100 %	78 %
Suggested image editing steps	Large-scale filters, retouch work near the horizon	Extended edits possible in individual cube faces	Filters, painting, retouch, and scene enhancements	None
Typically used for	File exchange between programs, archival, image-based lighting	Final web delivery, real-time applications	Print, extreme resolution panos, cinematic matte paintings	Image-based lighting

6.1.3 Yaw, Pitch, and Roll

You will stumble upon these terms when stitching and editing your panorama. The scientists call them Euler coordinates. These words describe rotating the image/camera around the various axes in 3D space; gamers and CG artists may already be very familiar with them.

- ● **Yaw:** Shifting the image along the horizon; camera moves as your head does if you swing it from left to right.
- ● **Pitch:** Panning the image up-/downward, like nodding your head.
- ● **Roll:** Tilt your head sideways, like a jet flying in a corkscrew pattern. Tilt it more, more, just a little bit more...

Figure 6-10: *The Seitz Roundshot D3 is a modern high-tech slit-scan camera.*

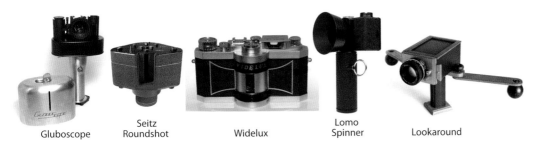

Figure 6-9:
Classic panoramic film cameras with slit-scan aperture.

Gluboscope Seitz Roundshot Widelux Lomo Spinner Lookaround

6.2 One-Shot Cameras

This is the easiest way you can think of to create a panorama, a pure hardware solution. All it takes is pushing the big red button and the camera system takes a panorama.

Traditionally, this is done with a slit-scan technique. The working principle is very simple: While the camera rotates, it slides the negative film strip underneath a vertical slit-shaped aperture. It literally scans the entire surrounding in one continuous exposure. Some cameras rotate only the lens itself, which limits the horizontal FOV to about 140 degrees but allows controlled handheld shooting. These cameras have a cult following and periodically come back into fashion. The actor Jeff Bridges, for example, is a dedicated Widelux shooter and has published a wonderful panorama book, and the Lomo Spinner was just released in 2010 as a fun film panocamera.

Modern professional slit-scan cameras work digitally, of course. And boy have they advanced! No more wooden boxes with knobby handles here. The latest Seitz Roundshot D3 model shoots 470-megapixel panoramas in only 3 seconds (www.roundshot.ch), and the Eye-scan series from KST even breaks through the gigapixel barrier (www.kst-dresden.de).

SpheroCam HDR

The reigning high-end champion is the Sphero-Cam HDR: It can take full spherical panoramas with a dynamic range of 26 EV in a maximum size of 10,600 × 5,300 pixels!

Just like digital medium format cameras, it needs to be remotely operated from a host computer—in this case, a dedicated tablet PC—but for a different reason. In reality, the SpheroCam is a complex system assembled from proprietary and off-the-shelf hardware and exclusive custom software.

The centerpiece is an electronic panorama head that slowly spins the camera with a Nikon fisheye all around. Behind the lens is a single column of CCDs, representing our modern slit-scan technology. And before you ask, no, it is not some kind of miracle CCD from the future: It shoots multiple exposures for each scanline. But that's entirely automatic; the controlling software takes care of that. The software spins the head for you, with a speed dependent on the chosen resolution and the necessary exposure times. At night, when longer exposures are needed, it spins slower. Everything is precalibrated. The software corrects for lens distortion and puts

Figure 6-11:
The SpheroCam HDR is a fully automatic capture system.

those pixel lines together in a panorama. All of that happens automatically; you just have to press the release button—or, in this case, the OK button in the host software.

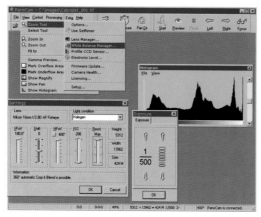

Figure 6-12: *Proprietary host software is driving the SpheroCam HDR.*

If that is still too much work for you, there is a special foolproof version—the entire software runs on a computer hidden in a watertight suitcase and the OK button is on the outside and blinks green. Even a policeman could operate this camera. In fact, this specialty version is designed for crime scene investigation. FBI and police forces all over the world simply love the possibility of panning around in an HDR panorama and looking for new evidence in the deep shadows under the bed. Just like in that TV show. (Actually, the boxed suitcase version has been discontinued because investigators didn't know where to place the suitcase without destroying evidence. Now the controlling tablet PC is mounted on the tripod.)

By now you might have guessed that all of this doesn't come cheap. You can order your own SpheroCam HDR for $60,000 directly from the German maker, SpheronVR. It comes in a complete package with tablet PC, tripod, suitcase, training lessons, and insane amounts of technical support. Essentially, you get all the goodies you would expect when buying a

Ferrari: You become part of an exclusive club of professionals, with worry-free personal support, someone to answer your urgent questions in the middle of the night, and Christmas cards from the developer. If all that is too much for you, the SpheroCam HDR is also available from several equipment rental services for a street price of $1,000/day or $3,000/week, sometimes even with an operator.

▻ www.spheron.com

Although this is a very small market, there are several competitors.

Panoscan MK-3

The Panoscan MK-3 works with the same slit-scan technique and is available at a bargain price of around $40,000. The resolution is similar, but it does not include custom remote software. Instead, it needs to be driven by the BetterLight Viewfinder software. The simple reason is that this camera really is a modified version of a digital BetterLight scanning back mounted on a motorized tripod head. This scanning back is known to many professional 4×5 photographers as one of the best in class, primarily for the Kodak CCD column and its highly acclaimed low-light behavior and low noise level.

The Panoscan MK-3 does not combine the scanned pixel rows on the fly but rather takes three turns to make three LDR panoramas at different exposures. From that point it is up to you to merge them into an HDR image.

▻ www.panoscan.com

Civetta

The Civetta comes with the same price tag, but it's a completely different beast. Named after the Italian word for *owl*, it weighs 10 pounds, and it's rain proof, snow proof, shock proof, and probably also meteor proof.

The inventor is Dr. Marcus Weiss, who coincidentally was also a cofounder of Spheron. Instead of a using a rotating slit-scan method, his

Figure 6-13: *The Civetta is named after its owl-shaped housing.*

Figure 6-14: *Hoyt Yeatman presents his HDR-Cam.*

new camera is built on Canon technology and snaps full-frame fisheye pictures with a 15 mm lens. That makes it more of a conventional panorama robot, with all the speed and resolution advantages: It shoots 100-megapixel HDR panos in 40 seconds. The downside is that you have to stitch the images afterward. But on the shooting side everything is precalibrated and fully automated; you simply operate it from the touchscreen controls of the included PDA, wireless of course. Similar to the SpheroCam, the Civetta comes with custom PC software that will allow distance measurements in the image and even 3D reconstruction via point clouds. It's used in crime scene investigation and was also spotted on the movie set for Ghost Rider.

↦ www.weiss-ag.org

HDR-Cam

This is the most exclusive system of them all. There are only six units in existence right now, and they don't even have a sales tag. You can only rent them. VFX supervisor and director Hoyt Yeatman designed this camera system specifically for the harsh reality on movie sets. For example, it was used to shoot 1,600 HDR panos for the *G.I. Joe* movie—completely unthinkable with manual methods.

Hoyt's system includes the obligatory touchscreen remote but also a set of reference balls (from mirror ball to diffuse), a calibration frame, and custom light analysis and HDR color correction software. The camera itself is housed inside a humungous carbon fiber box. If you open the lid, you'll find four Canon 30Ds outfitted with 8 mm Sigma fisheyes and hardwired to a custom remote control circuitry board. When unleashed, the HDR-Cam shoots nine-frame exposure brackets simultaneously in all directions. At the same time it will emit a loud and intentionally annoying beep sound that is guaranteed to make every crew member freeze in place. Or curl up in pain. Hence, this camera system is commonly known on movie sets as "ChirpyCam.".

↦ www.hdr-cam.com

Frankly, I can't really recommend any of these camera systems.

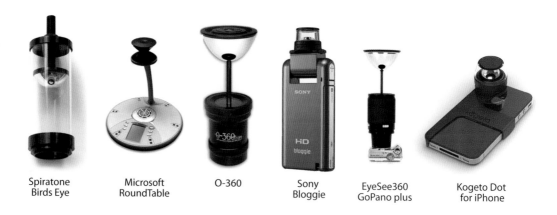

Figure 6-15:
Panoramic mirror lenses keep coming into fashion.

Spiratone
Birds Eye

Microsoft
RoundTable

O-360

Sony
Bloggie

EyeSee360
GoPano plus

Kogeto Dot
for iPhone

As tempting as it sounds to have a robot do all the work, they all have one big disadvantage: They shoot blindly. In real life, many things can happen during a shoot that may affect the image quality. For example, if there is a breeze coming up, you might want to pause to avoid ghosting. Or if there is an obnoxious flock of tourists heading your way, you might want to shoot the other direction first.

Believe me, these things happen all the time. Shooting your panorama manually gives you a chance to react to your environment and adjust your shooting method on the fly. Yes, there is a learning curve involved, but it's actually less monotonous labor than you might think. Delegating the important task of image acquisition to a robot will make it easier for you but not necessarily improve the result.

6.3 Mirror Ball Technique

On the opposite end of the budgetary scale, there is the mirror ball technique. You don't have to take out a loan to use it, but the quality is very limited. It's sufficient for image-based lighting of nonreflective 3D objects, and when it's done right, it may also be good enough for small VR panoramas on the Web. The mirror ball technique is very accessible, done quickly, and has been used in visual effects production for years.

The basic idea is this: There is a hard limit to how far you can increase the field of view in an optical lens system. Around 220 degrees seems to be the maximum; make that 185 degrees when you restrict yourself to lenses that cost less than a yacht. It is physically impossible to catch the light rays from farther behind the camera, no matter how sophisticated the lenses are. Not so with mirrors. If you don't shoot the environment directly, but the reflection of an environment instead, the maximum FOV is only determined by the shape of the mirror.

6.3.1 Looking into a Mirror

It's not a new approach. Since the seventies, all kinds of differently shaped mirror lenses have been built. They can be curved inward or outward, made into one continuous surface, or broken down in facets. Most systems are built in a compact design, just like a regular lens. Some are even so compact that they come mounted with a camera, so they can fit the needs of the surveillance industry. Whenever you see those tinted half domes hanging from a ceiling in a shopping mall, it's quite possible that there is one of those mirror lenses behind.

For panoramic photography, the convex mirror systems, where the mirror bulges up to the lens, have taken the lead. They usually come with their own software that has a hard-coded conversion into a standard panorama format built in. With the recent rise of DSLR video and panoramic video streaming, such mirror

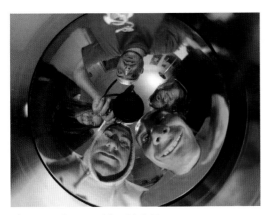

Figure 6-16: *Fun with a Birds Eye.*

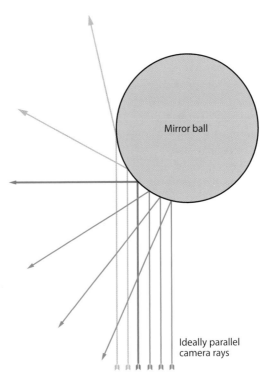

Mirror ball

Ideally parallel
camera rays

systems have become popular again. For example, Canon showed a prototype camera at Canon Expo 2010 with a 50-megapixel sensor shooting into a convex mirror, and new mirror lens attachments for mobile phones (with companion apps) seem to pop up every year.

A common problem with all those systems is that because the mirror is so close to the camera, there is a large reflection of the photographer in the center. That limits the vertical FOV to about 70 degrees (as compared to full 180 degrees). With mirror lenses, it's also very hard to focus because at that distance to the mirror you need a macro lens, and even then you can focus on either the center bulge or the rim of the mirror. Such lenses can make some cool party pictures, and panoramic video capture is certainly a fun gimmick, but for serious photography they are pretty useless. They simply can't deliver enough resolution, sharpness, and vertical FOV.

The photo above was shot with an original Spiratone Birds Eye from 1976, nowadays more of a collector's item than a usable lens. Modern mirror lenses still sell for up to $1,000, but the truth is that you can get better results with a regular mirror ball.

But that's not really 360 degrees, is it?

Yes, it is. With a fully spherical ball, you can shoot almost the entire surrounding with a single bracketed exposure sequence.

When looking at a mirror ball from the front, you will notice that the outer rim is at an extremely flat angle in relation to you. This is where the camera rays barely change direction when they bounce off the surface. You would think they shoot to the side at a 90-degree angle, but it isn't like that. Geometry teaches us that incoming angle equals outgoing angle. So, the spot where these camera rays shoot 90 degrees to the side is actually somewhere around two-thirds from the center to the rim. In the figure, it's drawn in red. Everything outward from that point goes to the area behind the ball, so on the very outer rim surface, the reflection is showing what you see right next to it.

There is a blind spot directly behind the sphere, and of course the photographer and camera are right in the center. That's why you get a better-quality panorama when shooting that ball from several sides. Two to three angles are typically enough.

Figure 6-17:

Pashá Kuliyev wrote a scientific study comparing all these different balls under lab conditions. Result? None are perfect optical devices, but they all do the job just fine.

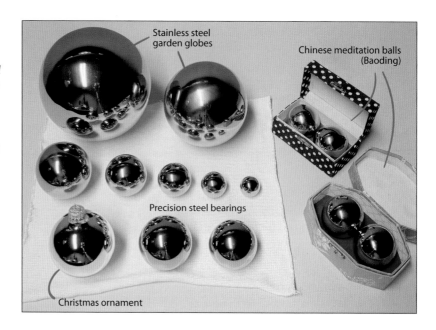

Stainless steel garden globes

Chinese meditation balls (Baoding)

Precision steel bearings

Christmas ornament

Got balls?

What you need is a shiny mirror ball. Perfectly round spheres are good, like pinballs or polished steel bearings from a hardware store. Even though bearings are not really optical devices, they are built according to quality standards and are available in multiple grades, which are rated by roughness and surface precision. High grade steel bearings larger than 40 mm in diameter are rather expensive, yet they are still likely to show tiny polishing marks on the surface. Lighter on the budget are Chinese meditation balls that come as a pair in a box and have a little bell inside. But make sure to dig through the entire stash to find a meditation ball without wobbles and scratches on the surface.

There might also be chrome-coated juggling balls available at your friendly neighborhood juggler supplies store. In fact, juggling balls from www.dube.com are pretty popular for HDR pano shooters, with the 73 mm version notoriously out of stock due to the unusual high demand. They are heavy and sturdy, and when you're performing juggling tricks, they properly stick to your arms for awesome body rolls. But

in general, anything round and shiny will do. Use your imagination. I have seen HDR environments shot with a soup ladle and they looked just fine.

Probably the cheapest and easiest mirror ball to get is a gazing ball. You can find these in a garden center or home improvement market, usually between the garden gnomes and plastic flamingos. They are made of blown glass, so take your time to select one that has the least amount of dents. If you find a good one, it will have a much smoother surface than a metal ball, free from polishing marks and micro scratches. Another cool thing about gazing balls is that they already have a neck extension on the bottom, which makes it easy to MacGyver them on a regular tripod ball head.

However, you need to be quite careful handling a glass ball. Mine broke in action, with a spectacular shower of razor-sharp disco confetti. Also, because the mirror coating is on the inside, there is an annoying secondary reflection visible on the glass surface. It's most visible on the outer rim, where the flat viewing angle causes a Fresnel effect. But don't worry;

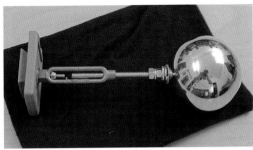

Figure 6-18: Keith Bruns's rock-solid chrome ball mount. ▲

Figure 6-19: Gazing balls from the lawn ornament department are cheap and easy to mount. ▶

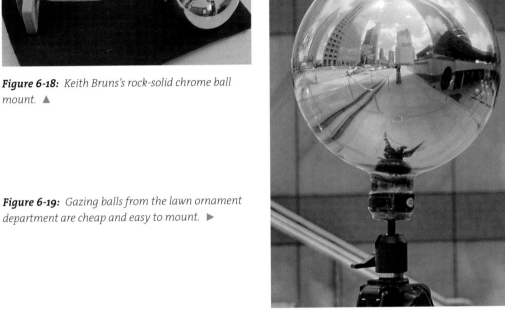

if you shoot it from three instead of two angles, you can paint out the major irregularities later. Shooting a mirror ball is more of an adventure than a true science anyway, and considering the 20 bucks invested, it's always worth a try.

Ball on a stick

First of all, you need to mount your new mirror ball on a separate tripod. Time to get a bit inventive. You want to permanently attach the ball to a mounting plate, not the tripod itself. A cheap tripod is good enough since it will just stand there untouched throughout the whole shooting process. Make sure there are no levers or knobs sticking out of the tripod head, or just remove them. You don't want them to show up in the reflection.

If you have a glass gazing sphere, you can just use plenty of duct tape to attach it to a circular mounting disk for ball heads. Because these gazing balls are meant as lawn ornaments, they already have a neck extension with a cork or rubber stopper on the bottom that will serve as a perfect connection piece.

Smaller chrome balls should be mounted a couple of inches above the tripod so the tripod reflection is smaller. If you have the craftsman skills of Keith Bruns, you can do amazing stuff with a threaded rod, a drywall hanger, lock washers, and a couple of nuts. He drilled a hole into the ball and used the drywall hanger to anchor the entire rig from the inside. The result is a rock-solid construction that lasts forever. Check out his results at www.unparent.com!

6.3.2 The Shoot

On to the actual shoot. Because you need two tripods, this shoot goes much more smoothly when you have an assistant.

➤ Shooting Technique

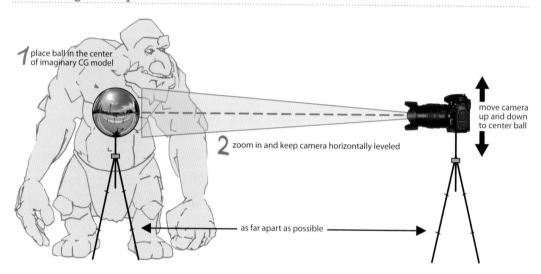

1 place ball in the center of imaginary CG model

2 zoom in and keep camera horizontally leveled

as far apart as possible

move camera up and down to center ball

1 Set up the sphere in the intended center spot of your panorama. When you plan on lighting a CG object with it, you should place the ball right in the spot where the CG object is supposed to be. The ball is the virtual lens that your panorama is taken with.

2 Zoom in as far as you can and then move backward until the ball is just filling the frame. This serves two purposes: First, your own reflection will be smaller, so it will be easier to remove it afterward. Second, you will get a nice flat view on the ball. Only when the camera rays are close to parallel can the reflection be unwrapped successfully to a panorama. Theoretically, the mathematical ideal would be that you are infinitely far away and shooting with a telephoto lens with infinitely large focal distance. In the real world, a 10-inch ball shot through a 200 mm lens on a 1.5x crop camera allows a good distance of about 20 feet. Smaller spaces might require a smaller ball.

The camera is mounted on its own tripod and leveled out exactly horizontally. A spirit level is absolutely necessary here, either built into the tripod or attached to the flash shoe. Move the camera up and down to center the ball in the frame; don't adjust the tilt angle! This is important for keeping the center points of the ball and the lens in the same horizontal plane. Remember, together they form an optical system. You want the reflection of the horizon be perfectly straight, and this is ensured only by shooting the ball perfectly straight on.

3 Now you're ready to shoot your first series of exposure brackets, by manually changing the shutter speed, by using autobracketing, or with a tethered capture setup. Fix white balance, ISO value, aperture, and focus—you know the deal. Browse back to section 3.2.1 for all the details on capturing HDR images.



| 1/512 sec | 1/256 sec | 1/128 sec | 1/64 sec | 1/32 sec | 1/16 sec | 1/8 sec | 1/6 sec | 1/4 sec | 1/2 sec |

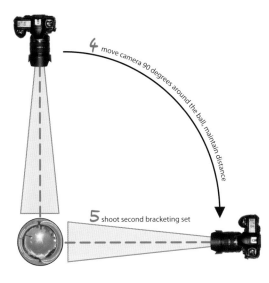

4 move camera 90 degrees around the ball, maintain distance

5 shoot second bracketing set

4 Great. Now don't touch the ball; instead, move the camera around it. The second set will be a side view, approximately 90 degrees away from the initial position. If seen from above, you would be moving from the twelve o'clock position to three o'clock, or nine o'clock, wherever there is enough room. Take care to maintain the distance from the ball and keep the zoom level. Just move back until the ball appears to be the same size it was in the first set in your viewfinder. If the ground is uneven, you will need to readjust the tripod height to center the ball. Once again, watch the spirit level to keep the camera perfectly horizontal.

5 Now shoot the second set through the same exposures you used for the first one. ◄

This is technically enough to stitch it all into one panorama. If you want to be on the safe side, you can shoot a third bracketed set another 90 degrees apart. This will give you a little bit more meat for retouching and will be your safety net if the first set didn't work out. Don't worry if you don't hit the 90-degree angle exactly; we can easily take care of that. The 90 degrees is just a ballpark figure that gives the best results out of two viewpoints. If it means you would block a light or cast a shadow on the sphere, you're free to wander farther around. There is no reason you couldn't get a working panorama out of three shots 120 degrees apart.

6.3.3 Putting the Panorama Together

The standard procedure in postproduction is now as follows:
1. Merge to HDR
2. Crop the ball
3. Unwrap
4. Stitch and retouch

This section will take you through each of these steps.

Merge to HDR

The first thing to do is merge all the exposures from each position to HDR images. If you read section 3.2 on HDR generation, you already know exactly how to do that. Use any HDR generator that pleases you. Just make sure to use a consistent camera curve; otherwise, the colors won't match up when you stitch them together. Pick either the generic gamma or your own precalibrated camera response curve and everything will be fine.

Figure 6-20:
First create HDR images for each camera position.

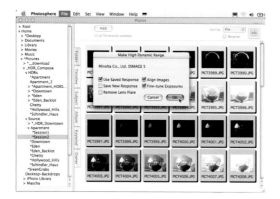

In this example, I just used my previously calibrated Photosphere and saved the images as Radiance HDRs for maximum compatibility. Did it right on the spot on my iBook. Easy. Photomatix's batch processor would also have been a good choice (see section 3.2.10).

▸ Crop and Unwrap

Back in the convenience of the Windows environment, load the resulting HDR images into HDR Shop. If you haven't shot your balls yet, or maybe you don't have any, you can also practice along with the images on the DVD.

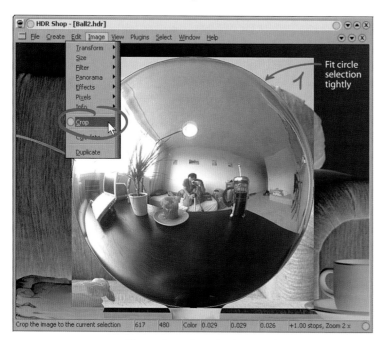

Figure 6-21: *Cropping in HDR Shop.*

1 The images need to be cropped first. For this particular purpose, HDR Shop offers a special selection tool that draws a circle inside the rectangular cropping frame. Activate this in the menu: SELECT ▸ DRAW OPTIONS ▸ CIRCLE. Now we need to fit that circle exactly to the edge of the ball. Take your time and do this carefully because the image information is packed very densely near the rim. A successful unwrap can be done only when the sphere is just touching the frame on all four borders. Use the zoom feature (Ctrl +/−) and adjust the viewing exposure (+/− keys) to see the edge clearly in blown-out areas.

Once you've got the framing right, select Crop from the Image menu.

2 Now the image is prepared for unwrapping. This is done by selecting IMAGE ▸ PANORAMA ▸ PANORAMIC ▸ TRANSFORMATIONS. A dialog pops up in which we need to specify some parameters. Our source format is Mirrored Ball, and the target is Latitude/Longitude. To get the most of our image resolution, we don't want any parts to be scaled down at this point. As a rule of thumb, this is achieved by matching the vertical resolution (height) of the target to our source.

3 The result is already a fully spherical 360×180-degree panorama. ◂

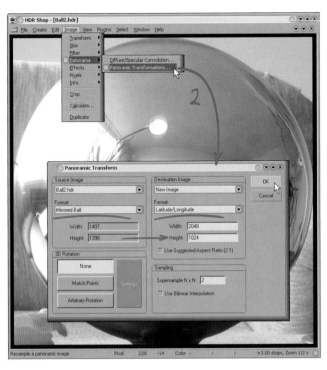

Figure 6-22: *Unwrapping with HDR Shop's Panoramic Transformations.*

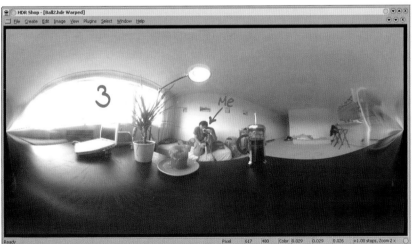

Problem areas

Now it becomes quite apparent how unevenly the density of the image information is distributed across the surface of a mirror ball. In the center of the panorama, each pixel roughly equals a pixel from the original. But the closer we get to the border, the more details are being extracted from pixels that are packed tighter and tighter. Notice the extreme pinching distortion on the outer borders! A blue coffee cup at the far right looks like it is accelerating to warp speed. This is the spot that was originally

Useful image information: ☐ Good ☐ Okay ☐ Poor

By the way, cropping and unwrapping can also be done in Photomatix. However, Photomatix's crop selection tool is a bit more cumbersome, and the Unwrap Mirrorball function does only this one transformation. I'm not a big fan of HDR Shop myself anymore, but for this one particular purpose it still is the best solution.

We will go on fixing the image in Photoshop, so if you really hate switching applications in one workflow, you can do all of the previous steps in Photoshop too. It's just a bit less accurate because Photoshop doesn't show you the handy cropping circle. And for unwrapping, you will have to buy the plug-in Flexify from Flaming Pear. On the other hand, that might be the best 35 bucks ever spent, considering that Flexify will take care of your wildest panoramic remapping needs, in full HDR and with a nifty live preview. It knows more panoramic mapping methods than Christopher Columbus and can even render printable origami-style folding globes, complete with glue lines. A common

hidden behind the sphere. Our unwrapping algorithm has smeared the pixels from the selection circumference inward because it has no other choice. The real information content in this spot is zero.

Unfortunately, the sweet spot with the best unwrap quality shows the photographer. That's why it is so important to shoot the ball from a maximum distance. Even when we recover that spot with information from the second set, we have to replace it with a patch of lower quality.

Figure 6-23:
Flexify brings panoramic transformations into Photoshop.

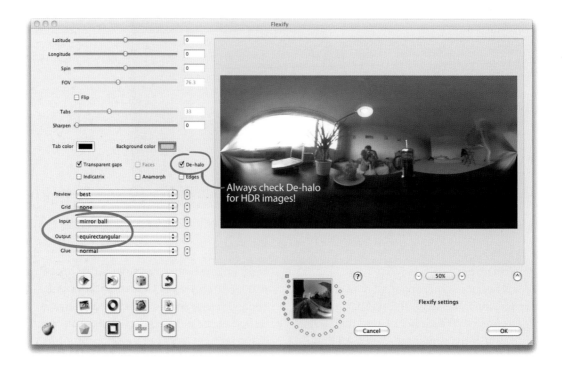

transformation like unwrapping a mirror ball can also be recorded in a Photoshop action. That way the Flexify interface is bypassed completely and the unwrap operation becomes a single push button in the workflow.

Stitching the balls together in Photoshop

My example panorama was shot from three different sides in my living room. This particular panorama is as problematic as it can be. The ball was way too big for that small room, so we have a lot of perspective shift between the three different images. Distortion caused by wobbles in the glass surface is quite extreme. And to make things even worse, I was very sloppy shooting those images and didn't snap the same range of exposures for each. It's a worst-case scenario in every respect.

But fear not; there's nothing we can't fix in Photoshop!

➤ Aligning the layers

To follow this tutorial, pop in the DVD and load the image Combine_Start.psd! You'll see that I have already stacked up all three unwrapped ball captures in layers.

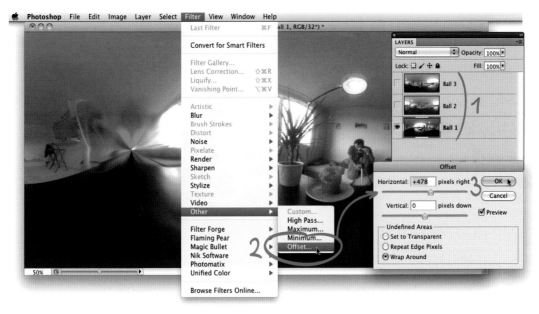

Figure 6-24:
Preparing the base alignment to see the pinching spot.

1 Hide the two top layers and select the background layer.

2 Select the menu option FILTER ▸ OTHER ▸ OFFSET. This is an ancient image effect for moving an image layer. It has the special ability to wrap the image content around the image borders, just as Pac-Man can move past the right screen edge to come back in from the left. Remember this Offset filter; we will use it a lot for editing panoramas (and other seamless images).

3 Use the Offset dialog to shift the image about one-third over. We want to see the ugly pinching spot as well as the handsome photographer's reflection. This will be our base alignment for retouching.

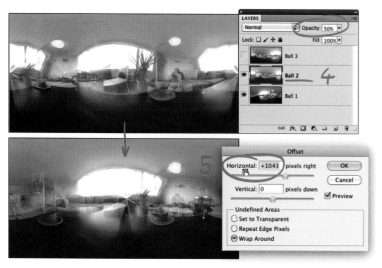

Figure 6-25: *Visually align the second layer with the Offset filter.*

4 Now activate the second layer and set its opacity to 50%.

5 Use the Offset filter again and slide the second layer until it roughly matches the first one. Especially with a big image, the sliders become very jumpy, moving the image in huge increments. For fine adjustments, do this instead: Click on the slider title *Horizontal* and drag the mouse left or right. This will move the image in single pixel steps so you can really align the layers with accurate precision. This is a general Photoshop trick that works almost everywhere. Just watch for the mouse pointer to change to a finger icon with tiny left/right arrows when you hover over a slider label.

6 Cool. Set opacity back to 100% now. We only needed this layer to be semitransparent for alignment.

Repeat steps 4 through 6 to align the third layer, even though we might not necessarily need it.

Now you can switch through all the layers to get a feel for the good and the bad areas. You will see that the pinched spot and the photographer are on every image but in different positions. It also becomes clear why the 90-degree offset between Ball 1 and Ball 2 is more effective than the 180-degree offset between Ball 1 and Ball 3. When you shoot the supplemental image from the opposite side, these two unusable areas only swap places. Only Ball 2, shot from the side, shows these areas in a relatively clean way.

The next step is to blend the usable areas into a complete panorama.

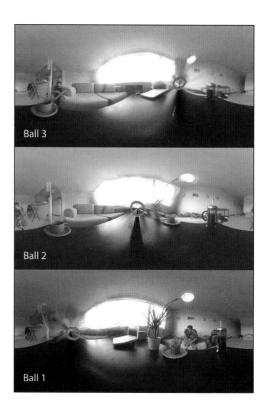

Figure 6-26: *All three layers after alignment.*

➤ Combine the good parts

We start out with getting rid of the photographer.

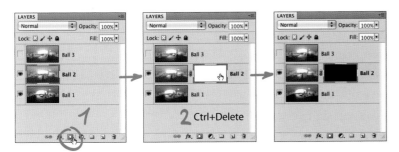

Figure 6-27: Setting up a layer mask.

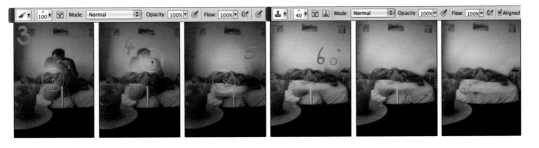

Figure 6-28: Rubbing out the photographer and fixing the leftovers with the Clone Stamp tool.

1 Create a mask for that second layer. Just click the little icon on the bottom of the Layers palette.

2 Fill the new mask with black. That's quickly done by pressing Ctrl+Delete. Now you're ready for some rub-through action!

3 With the mask still selected, pick up the paintbrush tool and select a fairly large brush size. Soft, round, 100 pixels will do. The foreground color should be white, background black.

4 Zoom in on the photographer's reflection and rub it away!

5 Fine-tune that mask with a smaller brush. Press the X key to switch between rubbing the second layer in or out. Painting with black brings back the corner of that candle, for example.

6 Some artifacts are left—the shadow on the wall and the tripod legs. Unfortunately, we cannot steal these areas from the other images, so we dust off the good old Clone Stamp tool now. Alt+click on a good source spot, and then just paint on at the target spot.

7 At this point it becomes quite obvious that the first layer is a bit darker. Well, that was me screwing up the exposures at the shoot. Nothing to worry about. Select the actual image layer and choose IMAGE ▸ ADJUSTMENTS ▸ EXPOSURE. Usually those glitches happen in even EV intervals. In this case, it takes an exposure correction of −0.5 EV to fix it permanently. ➤

All right, here we are. Gone is the photographer. Let's see a quick before and after.

Before

After

Sweet. Now, that might read like a lot of work, but it really took only 15 minutes. It goes much faster when the layers actually line up; that is, if I just would have listened to my own shooting advice. However, this is the workflow that will 100 percent lead to the desired result, no matter how badly you screw up. It is as non-destructive as it can be. You can paint this layer mask over and over without changing any image content. Black rubs the supplemental layer out, white rubs it in. You can also readjust the exposure as often as you want because there are no quantization errors or clamping in HDR land.

Round two

We're halfway there. The big ugly pinching spot is left. In order to have the same level of flexibility when we go on, we'll need to bake down the changes we did so far. That way we can change the exposure of the patch or reposition it whenever we need, without affecting the spot we already cleaned up.

1 Drag the second layer onto the New Layer icon on the bottom of the Layers palette.

2 Shift+select the two bottom layers and choose LAYER ► MERGE LAYERS. The faster way to that option is using the context menu that comes up when you right-click the selected layers.

3 Now we just fill that layer mask of the copy with black again (Ctrl+Delete) and we have everything laid out as fresh material for the second round of touch-up action.

Getting rid of the pinching hole is now just an application of the same workflow again.

4 Do a first-pass rub-through by painting into the alpha with a large soft brush.

5 Watch out for details hidden beyond the highlights. Frequently toggle the viewing exposure with the little slider widget on the bottom of the window to inspect the entire dynamic range. Remember, an HDR image is more than meets the eye!

Figure 6-29:
Bake down the paint work to keep yourself from messing it up again.

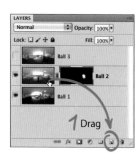
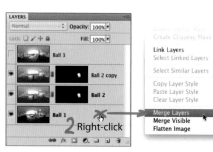
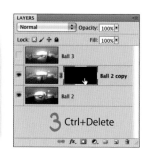

Figure 6-30:
Repeat the workflow with the pinching spot.

6 You already know the rest: Fine-tune the layer mask with a smaller brush. When the useful data from the second layer is exhausted, proceed with stealing some details from the third layer (which has been unused so far). And then use the Clone Stamp tool in the areas we have no original image data for.

7 Four things are left to wrap up the project:
- ● Choose LAYER ▸ FLATTEN ALL LAYERS.
- ● Choose FILTER ▸ OTHER ▸ OFFSET to set the final output direction, just so the interesting part is in the center and the seam goes across something boring.
- ● Choose IMAGE ▸ IMAGE ROTATION ▸ FLIP CANVAS HORIZONTAL. That's because we have been working with a mirror image all this time. Instantly, you will realize why it always looked so odd, especially when you have billboards or signage with text in the image.
- ● Save the final image as an EXR file and do the Happy Dance! ◄

All in all, that took about 40 minutes. But I'm overly picky and my mouse arm moves sluggishly; you'll probably be done faster.

In the reality of VFX production, all these elaborate paint fixes might not even be necessary. There is only so much quality you can expect from a mirror ball; it's mainly limited by polishing scratches (metal balls) or wobbles (glass balls). You might just as well use a single ball capture and just blur out the photographer and the pinched spot. In Chapter 7 you will learn that photographic quality, details, and resolution are actually less important when the main purpose is to extract the lighting information for 3D applications. What counts is complete surround coverage of the entire dynamic range, especially of all significant spikes in highlight magnitude. That's why the mirror ball technique is still quite popular for light probes in VFX production. It's cheap, quick, and good enough to extract the diffuse lighting.

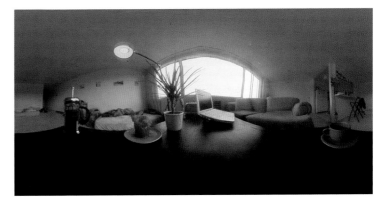

It's a different story when the planned CG object has a lot of reflective parts (for example, CG cars) or if the panorama is intended for print, backgrounds, or VR display. That's when real photographic quality counts, and that's when you need to ramp up your game with segmental capture.

Figure 6-31:
The final HDR panorama, 100 percent handcrafted.

Figure 6-32:
Sectors should over-lap by 25 percent.

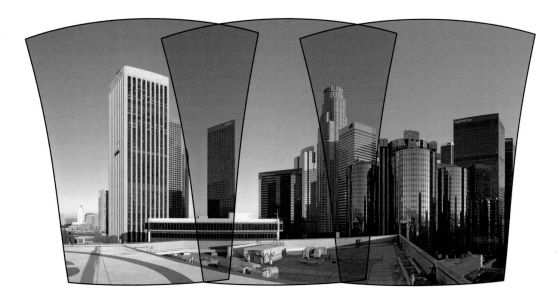

6.4 Segmental Capture

This is the world of flexible image acquisition. In the following sections we will discuss methods of capturing panoramic images of pristine quality with virtually every piece of equipment you can imagine. We will also compare practicability and ease of use, and you will learn to avoid some common pitfalls during image assembly.

Segmental capture does what the name implies: You divide your surroundings into a certain number of segments that are photographed and then stitched together in a separate step.

6.4.1 Basic Premises

To be able to process these segments, we have to follow three basic rules: Sectors must overlap, the camera must turn around the nodal point, and you need to shoot consistent exposures.

Sectors must overlap!

After shooting, you have to stitch adjacent images together. Without overlap, you can't precisely position them. A good overlap amount is

25 percent, giving you enough room to correct small mistakes and join the images together with a smooth blend.

Turn around the nodal point!

While shooting, you must rotate the lens around the nodal point. Technically, the better term would be the *no-parallax point*. This is the only usable rotation axis where foreground and background won't change their relative position in the photographed sectors.

A classic example of two lenses that don't meet the nodal point are the human eyes. Look at your surroundings and alternately close one of your eyes. You will notice that foreground and background change their position to each other. This parallax shift is very important for stereographic viewing, but for panoramas we need to see every detail in our surroundings exactly the same way for each sector we are photographing.

Unfortunately, standard tripod mounts are roughly at image-sensor level, while the nodal point is inside or even in front of the lens. This is the reason most scenes require a special panoramic tripod head.

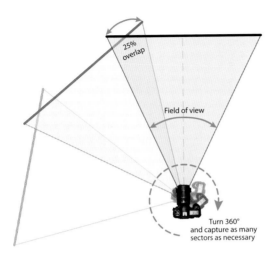

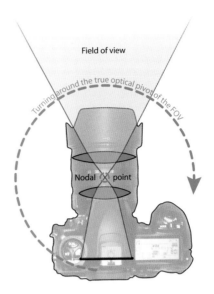

Shoot consistent exposures!

All sectors must have the same exposures. Without using the same exposure settings, we will face the problem of varying image characteristics. Especially critical is the dynamic range covered in each one. In the context of HDR, you need to shoot the same bracketing sequence in each direction.

Modern stitching programs like PTGui, Hugin, and Autopano can compensate for mistakes to some degree with advanced features like photometric calibration and viewpoint correction, but for a hassle-free workflow you're still better off following these three rules at the time of shooting.

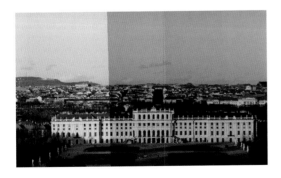

6.4.2 Getting the Right Gear

Any camera with manual exposure capabilities would do, although it is a good idea to use a decent SLR camera. You need easy access to manual white balance and exposure settings. Furthermore, the camera should have an autobracketing feature and a fast burst mode. This is important for capturing HDR sequences in a painless way. See section 3.2.2 for some deeper advice on camera models and ways to extend your bracketing range.

Tripod

I assume you already own a tripod. That one should do.

To have a small footprint in your panorama (that's the area that will be covered by your tripod when looking down in the panorama), you should consider a ball head instead of a big three-way head.

If you're shopping for tripods anyway, I can wholeheartedly recommend those from Manfrotto. I have two, and they have never failed me. One is made of aluminum, which is on the heavier side but is rock solid. The other is made of carbon fiber, which makes it noticeably lighter on the inevitable hikes to the good spots

for landscape photography. Still, for accessible locations I prefer the heavy aluminum tripod for the extra bit of stability. An excellent model is the Manfrotto 055XPROB because it allows the center column to be extended all the way and tipped out by 90 degrees. In this configuration it looks like a crane, holding the camera from the side. This is very useful for capturing an extra down shot to cover up the footprint.

Lens

Choosing the right lens is a compromise between final resolution and the number of segments required (which translates directly to overall shooting speed). Resolution and therefore detail rendition will rise the longer your lens is. But you should consider the amount of data you're collecting when you're shooting for HDR.

Let's make some rough calculations: A 17 mm wide angle lens on a Nikon D300 (1.5 crop sensor) would need about 10 horizontal segments in three rows to cover a full sphere. This makes 30 shots for a standard LDR panorama. Multiply this by the number of brackets you need to cover the full dynamic range of your scene. Assuming seven brackets for a typical outdoor scene, we end up with 210(!) images to shoot—almost one gigabyte of JPEG data just for a single panorama! On the other side, all the data collected will actually show up in the final image. It will be huge and sharp and detailed. Only the sky is the limit here.

Standard wide-angle lenses cannot get you very far in the FOV they can capture. They make a lot of sense for partial panoramas in very high resolution, but for full spherical panoramas you should consider getting a fisheye.

Figure 6-33:
The Manfrotto 055XPROB is an excellent tripod.

Fisheye lenses

In the 1960s, Nikon sold a special camera called the Fisheye camera or Sky camera. It was a device built to enable meteorologists to take images of the full sky dome in one shot. The images were captured using medium-format film, and the device was sold as an all-in-one package including the camera body, a winder, and a case. The lens in the package was a 16.3 mm f/8 fisheye, developed by Nikon back in 1938.

Figure 6-34: *Nikon's Sky camera from the sixties.*

Two years later Nikon released the first interchangeable fisheye lens, a monster weighing more than 2 pounds, extending so far into the camera that it was mountable only when the camera's mirror was permanently locked up.

By 1969 and 1970, Nikon released several modernized fisheye lenses, the Nikkor 6 mm f/2.8 and the 8 mm f/2.8. These were still monstrous lenses that overruled decent telephoto lenses in size and weight and at a price others would spend for a brand-new luxury car. I'm not even exaggerating—we're talking about an 11-pound glass bulb the size of a hub cap in the $30K range. So, why would someone want to use such heavy and expensive equipment?

It's all about the field of view you can capture with one single shot. An 8 mm circular fisheye for 35 mm SLRs can capture a field of view of 180 degrees—that's exactly half of your surroundings! Add a second shot in the

opposite direction and you're done! The legendary Nikkor 6 mm f/2.8 even shoots 220 degrees, which still to this day makes it the widest lens ever. It actually looks behind the camera!

Circular or full frame?

Such extreme fisheyes are called *circular* because the captured image is in fact a circle in the center of the film plate. About half the sensor pixels go to waste, which ultimately limits the final panorama resolution a lot. On a 12-megapixel camera like my Nikon D300S, that yields in 4K panoramas. In return, the massive FOV coverage enables ultra-fast capture in busy public places and makes you fly like a ninja in-and-out of movie sets. It's also very convenient for creating larger volumes of work for a virtual real estate tour. Even though two circles in opposing directions are possible, in a practical workflow it is much better to shoot in three directions 120 degrees apart. That way you actually have some overlap for a seamless stitch and the angles to shoot conveniently match the spaces between the tripod legs.

Full-frame fisheyes cover 180 degrees FOV diagonally, from corner to corner. That means the entire image sensor is used and your final panorama will have twice the resolution. The price to pay is that you have to capture twice as many photos. On my D300S, I get an 8K panorama from shooting six sectors around. Actually, it takes two more angles: one up and one down. So there is an additional inconvenience involved to cover the entire sphere, yet with some practice it is manageable and the additional detail captured is very visible. The 6+2 sector shooting style with full-frame fisheyes is a nice compromise between speed and final resolution and is preferred by most panorama photographers.

When you're shopping for fisheyes, it's important to realize that some of them are specifically designed as full-frame fisheyes for cropped sensors. Even though optics and mount

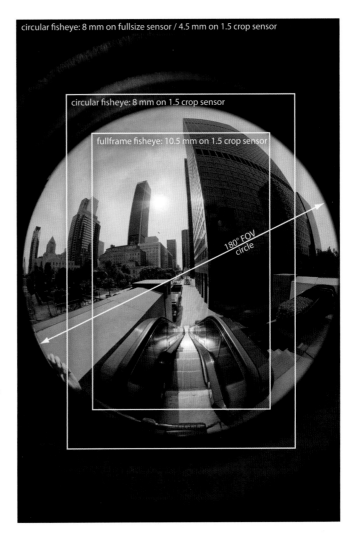

circular fisheye: 8 mm on fullsize sensor / 4.5 mm on 1.5 crop sensor

circular fisheye: 8 mm on 1.5 crop sensor

fullframe fisheye: 10.5 mm on 1.5 crop sensor

180° FOV circle

may be compatible with a full 35 mm sensor DSLR, the additional field of view you would gain is blocked by a lens hood. And this lens hood is often not removable; it's fully integrated into the mechanical structure of the lens housing. It has to be sawed off or ground down. This procedure is called "shaving the fisheye" and involves bringing heavy abrasive machinery within millimeters of the expensive glass, with the potential of ricocheting chips and splinters. Unless you have nerves of steel and a very steady hand, I recommend leaving it to an expert like Tobias Vollmer. He has done it

Figure 6-35:
Fisheye images with common lens/sensor configurations.

Figure 6-36: *The Nikkor 10.5mm fisheye is my favorite workhorse for panorama shoots.*

Figure 6-37: *The Sigma 8mm is a popular circular fisheye.*

hundreds of times and offers a lens shaving service with satisfaction guarantee on www.360pano.de/en.

Here is a list of some popular fisheye lenses.

- **Nikkor 10.5mm f/2.8:** Full-frame fisheye with pristine sharpness and very little flare, which makes it the favorite lens of most panographers. I own it myself and love it. The lens is made for Nikon's DX sensor format (1.5 crop factor), but many people shave off the lens hood to convert it into a circular fisheye for FX format (full-size) sensors. Even many Canon shooters use this lens, although that requires a mechanical lens adapter and removes autofocus capabilities.

- **Sigma 8mm f/4 or f/3.5:** Circular fisheye that is available for a wide range of cameras. There are several different revisions of this lens around, with optical performance varying between average and great. Sigma reportedly has no problem sending a replacement lens from a different batch, so make sure to run a few lens tests to check for lens flares and edge sharpness.

- **Peleng 8mm f/3.5:** Circular fisheye with universal T2 mount, typically sold with a lens adapter ring to fit any camera. It's an old-school all-metal construction, built in the fine tradition of Russian rocket science. Focus and aperture can only be operated manually. It's one of the most affordable fisheyes, but

expect above-average lens flares and internal reflections.

- **Samyang 8mm f/3.5:** The best fisheye in the affordable (all manual) class. It delivers a unique stereographic projection, where the image is less compressed toward the outer image circle. The result is that these peripheral regions contain more usable pixels for stitching and the overall pixel yield is more comparable with the Nikkor 10.5mm. This lens is built in Korea and also sold rebranded as Rokinon, Vivitar, Bower, Falcon.

- **Canon 8–15mm f/4L:** Unique fisheye zoom lens that can smoothly transition from a circular image to full-frame coverage on a full-size sensor camera. This makes it the most versatile but also the most expensive modern fisheye lens. Like all of Canon's L-series lenses, it is built to the highest quality standards. It delivers extreme sharpness all the way to the outer edges and is virtually immune to flares.

- **Tokina 10–17mm f/3.5–4.5:** The only other fisheye zoom lens. It's actually a Pentax lens, which Tokina outfitted with fully functional Nikon and Canon mounts. Designed for cropped sensors, it acts as full-frame fisheye at the widest 10 mm setting, with the option to shoot higher resolution panoramas at 17 mm. Shaving makes it a cost-efficient alternative to the Canon 8–15mm lens (with slightly lower optical performance).

- **Sigma 4.5mm f/2.8:** Widest circular fisheye around, enabling the quick three-sector shooting style on more affordable cropped sensor cameras all the way down to the micro four-third sensor class. Mounting this lens on a full-size sensor is pointless and will only result in a peephole-sized image circle. Some specimens of this lens are rather fuzzy on the outer edges and show heavy chromatic aberration.

- **Sunex 5.6mm f/5.6mm:** This fisheye is comparable to the Sigma 4.5mm f/2.8 in terms of usable FOV coverage and optical quality. The difference is that the Sunex "Superfisheye" has a fixed aperture and fixed focus at hyperfocal distance—there's absolutely nothing to adjust here. This makes it a bit cheaper than the Sigma, completely foolproof, and easier to convert to micro four-thirds with lens adapters.

Panoramic heads

A panoramic head represents your central piece of equipment for technically correct panoramas by enabling you to rotate the camera around the nodal point. The choice of panoramic head affects the way you capture the segments and it should closely match your camera and lens configuration.

You can roughly distinguish between three groups of heads: universal spherical heads, high-precision heads, and specialized fisheye heads.

Universal spherical heads

This is the most common and versatile type. Universal heads consist of three rails that allow you to freely adjust camera placement in every 3D axis. Such heads are especially useful if you plan to shoot with several lens types. They are perfect for getting started in panorama photography and they will serve you very well as long as you are willing to spend some time for setup on location.

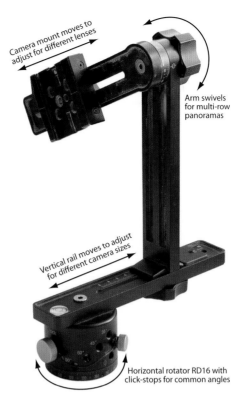

Camera mount moves to adjust for different lenses

Arm swivels for multi-row panoramas

Vertical rail moves to adjust for different camera sizes

Horizontal rotator RD16 with click-stops for common angles

Figure 6-38:
The Nodal Ninja 5 is a great universal panorama head.

A typical specimen is the Manfrotto 303 SPH. It's built industrial style: very heavy and bulky to survive even the roughest treatment. Nothing will happen to this head if you throw it carelessly in the trunk of your car. The opposite is more likely, actually—all the metal rails on this head are milled down to razor-sharp edges, and ever since I bumped my forehead hard on one of its corners, the 303SPH is not my friend anymore. It's a tank, and it leaves scars.

A good alternative is the Novoflex VR-System. Both heads are built from standard pieces with only some added parts specifically designed for panographic needs. This also allows you to reorder missing or broken parts—a bonus you shouldn't underestimate because spare parts for specifically built heads may become very expensive.

My personal favorite is the Nodal Ninja 5. It not only has the coolest name, it's also very light and leaves a minimal footprint in the panorama (as opposed to the bulky Manfrotto that always seems to get in the picture when I'm shooting with fisheye lenses). The Nodal Ninja

is very robust and has so far never failed me. It comes in a padded travel case, which always turns some heads when I unpack the panohead and assemble it like a sniper rifle.

Figure 6-39:
My Nodal Ninja, stowed away like a sniper rifle.

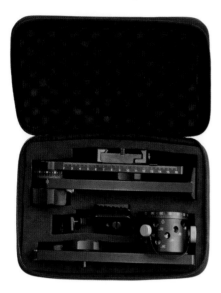

Like most universal heads, the Nodal Ninja is a system for which you order the different pieces according to your needs. Bigger cameras require longer rails to maintain the full range of adjustment. But the most critical part is the horizontal rotator on the bottom. It has an internal barrel with very fine grooves that will mechanically lock the orientation into exactly the angles you need. This click-stop mechanism will be your best friend when shooting. Do not try to save money on the rotator; get a good one with variable presets and adjustable lock stiffness. It will last you forever and enable a flexible shooting style.

High-precision heads

The most common head in this group is built by a company called 360Precision. This type of head is built for a particular camera/lens combination. All the adjustable knobs and rails are stripped away. Instead, the physical construction of the head implies a single mounting position for the camera, precalibrated to give optimum results with the lens it's built for. So you trade in versatility for ease of use and guaranteed accuracy.

The basic idea is that using the exact same rotation angle for shooting the sectors gives you 100 percent repeatable results. And that makes panorama stitching much easier. Instead of analyzing the images later to find out how to puzzle them together, you can apply a predefined template to your image set and everything falls right into place.

If you plan to create a lot of panoramas, the investment in a high-precision head will pay off quickly. They're also useful for shooting featureless panoramas—with images that do not allow automatic control point creation (e.g., images with a large amount of sky, white walls, or similar).

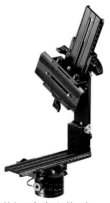

Universal spherical head:
Manfrotto 303SPH

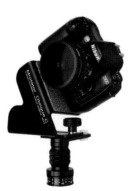

Full-frame fisheye head:
Agno's MrotatorC

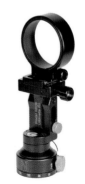

Circular fisheye lens ring mount:
Nodal Ninja Ultimate R1

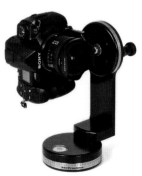

High-precision head:
360Precision Absolute MK2

Fisheye heads

These heads are built specifically for fisheye lenses, typically even for one particular lens. Similar to the high-precision heads, they are stripped down to a fixed calibration, but the focus on fisheye lenses means they can be made from even less material. That makes them very small, light, travel-friendly, and affordable.

The Agno's MrotatorC series is an example of such specialized heads. The tilted camera mount is built for the Sigma 8 mm fisheye and makes the most efficient use of the diagonal FOV. It allows you to shoot a full spherical panorama with only three shots, unlike the usual four shots with a 90-degree tilted camera.

Lens rings are also popular fisheye heads. See, our principal problem is still that the nodal point is located somewhere inside the lens. And instead of this elaborate framework to position the camera correctly, the lens ring provides a surprisingly simple alternative: Just hold the lens directly at the nodal point. The camera hangs freely off the back, but that's okay—lens mounts are built to sustain a camera's weight. When you connect a big telephoto lens, the camera hangs on its lens mount as well.

A particularly powerful combo is the lens ring fisheye head attached to a long pole. You know those toy laser swords that extend to six times their length in a snap and glow in the dark? They're awesome, aren't they? Telescopic panorama poles work the same way, and they are even more awesome on account of being lightweight carbon fiber rods with lockable segments and internal steel cables for enhanced stiffness through tension. Some of them have a tiny tripod stand with a click-stop rotator on the bottom, and they are available in lengths of up to 20 feet. Shooting from such an elevated position gives you an aerial-like perspective and is perfect for crowded places, events, excavation sites, or otherwise inaccessible locations.

Many pano shooters started experimenting with painter poles and flag poles, but most end up getting the specialized panorama poles from Fanotec (Nodal Ninja), Agno's, or Manfrotto. Microphone booms (from Gitzo, for example) are also reported to work well.

Robotic heads

If you're either lazy or plan to shoot from a position where the camera is out of reach, you should consider a robotic head. Marc Cairies, Dr. Clauss, Panoscan, Seitz, and GigaPan offer solutions that will position your camera and release the shutter without any manual intervention at all. Robotic heads are available in different grades of robustness and precision, ranging

Figure 6-40:
Nodal Ninja owner Bill Bailey (left) just learned that his Fanotec pole is longer than the competition's. By a hair.

Figure 6-41: *Gavin Farrell shooting a massive HDR gigapixel panorama with the GigaPan Epic Pro and the Promote Control. See the result at www.gavinfarrell.com!*

Figure 6-42: *With the blueprints on the DVD, you can build your own panorama robot.*

from the GigaPan Epic Pro for $900 to Dr. Clauss's legendary Rodeon VR Station for $9,000.

Since all these panorama robots have a custom computerized controller for the motor, they nowadays all double as a bracketing controller to fire extra-wide HDR sequences with any camera. Older (or cheaper) models without HDR mode can easily be pimped up by daisy-chaining them with a Promote controller.

All the limitations of one-shot systems mentioned in section 6.2 also apply to panorama robots: They require hauling around a lot of gear, they always need a certain setup time, and they don't react to unexpected events happening in the scene. Being complex battery-driven devices, they also present another potential point of failure. Believe me, I have seen the sad look in Greg Downing's eyes when his panobot failed him on a mountaintop. After power-hiking uphill for two hours to catch the sunset, you really don't want a loose gear or snapped belt to stand in your way.

Just to rotate the camera into three positions for fisheye capture is barely worth the risk and trouble. Even six positions with a full-frame fisheye can still be shot faster and more reliably with a regular panorama head and a good click-stop rotator. Robotic heads play their cards when you want to shoot with a longer lens for super-resolution panoramas. Then you get into shooting multiple rows, and that can easily get confusing by hand. You wouldn't be the first to forget where the starting point was or to vertically drift off just enough to leave a long scar of uncovered area in the middle of your panorama. Pano robots can easily shoot a dense grid of

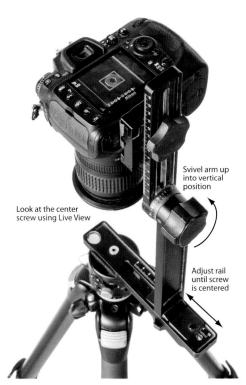

Look at the center
screw using Live View

Swivel arm up
into vertical
position

Adjust rail
until screw
is centered

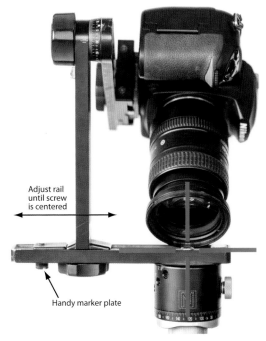

Adjust rail
until screw
is centered

Handy marker plate

Figure 6-43: *The down-shot method is a quick and easy way to calibrate the first panohead axis.*

Figure 6-44: *Alternative method: Touch base at the center to calibrate the first axis.*

10 rows with 30 positions each, and they hit all these sectors with precision and accuracy.

Of course, a true hardcore panobuff would just build a motorhead himself. On the DVD you will find construction plans for an HDR pano robot based on the LEGO NXT platform, complete with blueprints and the required driver software. It requires spending a weekend in a metal shop, but afterward you have a quality robot that you truly own for very little money. This DIY project is brought to you by the New Zealand Media Design School class of '08 (www.mediadesignschool.com).

6.4.3 Finding the Nodal Point

Okay, so you got yourself a nice panohead and a wide-angle lens. Maybe even a fisheye. And now you have to put it all together in a way that the panohead will rotate the camera around the nodal point of the lens.

First axis

First you have to ensure that the center of the lens is exactly above the pivot of the head.

A quick and dirty method with a spherical head is to tilt the camera downward and then make sure the viewfinder's center aligns with the rotation axis. Every panorama head has a screw directly on the rotation axis, which is left exposed exactly for this purpose. Simply turn on Live View, swivel the upper arm all the way up so the camera looks down, and then adjust the vertical rail on the panorama head until this screw is directly in the center.

This down-shot method is done with minimal effort, but it's not quite as accurate as you would expect because camera sensors tend to be mounted with a slight misalignment.

A more precise technique is the touchdown method: Utilizing a bigger and longer lens, you can tilt the camera down until the lens touches the adapter. Seen from the front, the tangent of the lens's outer circle must touch the base exactly above the rotation axis.

Left angle

Right angle

Gap between
foreground and
background object

Figure 6-45: *The gap test: Rotate the camera left and right to see if the gap opens or closes.*

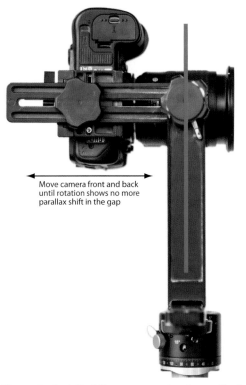

Move camera front and back
until rotation shows no more
parallax shift in the gap

Figure 6-46: *Adjust the panorama head accordingly.*

Once you have this vertical rail adjusted correctly, you should mark the rail position with a Sharpie. Good panoheads even come with a little marker plate that can be tightened right on the spot. This calibration is valid for every lens; you will have to re-adjust only when you use a different camera or change the camera height by using an additional battery adapter.

Second axis

Now you will need two vertical lines, one very near the camera, another one far away. A good setup is to have two doors in a row or a door and a window. It's up to your imagination to use whatever you want.

Place the tripod in such a way that you can see both verticals nearly lined up. Only a small gap should be left. This gap must not change while the camera is rotated.

Take a picture with the camera rotated to the left and one rotated to the right. Both shots must include the gap you are observing. In my example, it is the black line between the front and rear door. Now check the appearance of this gap. If it opens, the lens is rotated behind the nodal point. Adjust the camera forward. If it closes, the lens is rotated in front of the nodal point. Adjust the camera backward.

If the gap doesn't change between shots, you have found the correct nodal point for your lens and focal length. Congratulations!

Once again, it's a good idea to mark this calibrated setting on the panohead with a Sharpie or some duct tape. This setting is unique to each lens, and I recommend double-checking it whenever you swap the lens.

Fisheye lenses and the nodal point

As usual, fisheye lenses are special: Their nodal point is dependent on the angle of rotation. So if you calibrate your panohead for a fisheye, you have to do this by moving the camera by the same angle you're planning to shoot with later.

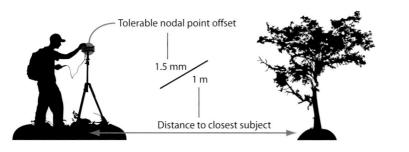

Tolerable nodal point offset

1.5 mm

1 m

Distance to closest subject

However, on the Sigma 8 mm and Nikon 10.5 mm lenses, the nodal point sits right on the golden ring marking on the front of the lens. Call it a happy coincidence or wisdom of the lens makers who apparently are aware of the preferred shooting angles with their fisheyes. Most precious, that golden ring is.

How accurate does it have to be?

When you're far away from everything, such as on a tower or in a helicopter, you don't really need to worry about the nodal point too much. What matters is the parallax error, and given enough distance you end up with a no-parallax *zone* instead of a single no-parallax point.

For each meter distance from the subject, the mighty gods of optical physics grant 1.5 mm tolerance for mounting the camera. Below this tolerance the parallax error will be smaller than a pixel anyway. Eva Hopf figured this out. Doubtful souls may check out the mathematical proof at pt4pano.com, but I would say that feels about right. In a formula it looks like this:

> nodal tolerance
> = distance to closest subject × 0.015

When you're shooting the vista from a 100 meter tower, your safe zone is as big as a dodgeball, but when the closest object is 1 meter away, it's the size of a grain of rice. Flat ground doesn't count as closest subject because that can be easily corrected during the stitching process with automatic viewpoint correction. That means you can really use this tolerance to your advantage: Position yourself 10 meters away from the closest structure and you already have a cherry-sized safe zone (15 mm). That's a lot!

Not that I encourage lax shooting practices for beginners, but it's worth mentioning that in real life it's much more important to take the shot when you have the opportunity than to be overly worried about your setup.

Almost there. But before we can start shooting, we need a plan.

6.4.4 Planning for the Right Angles

If you're a beginner in panoramic photography, you may have wondered why so many people use their camera in portrait mode. The reason is simple: It's easier to stitch! As mentioned earlier, the sky is the limit. I mean literally, the sky limits the resolution we can get out of a series of shots.

Look at the image above and the reason becomes clear: To stitch a panorama, we need distinct image features to know where two adjacent sectors meet. Although the actual footwork will be done by automatic matching

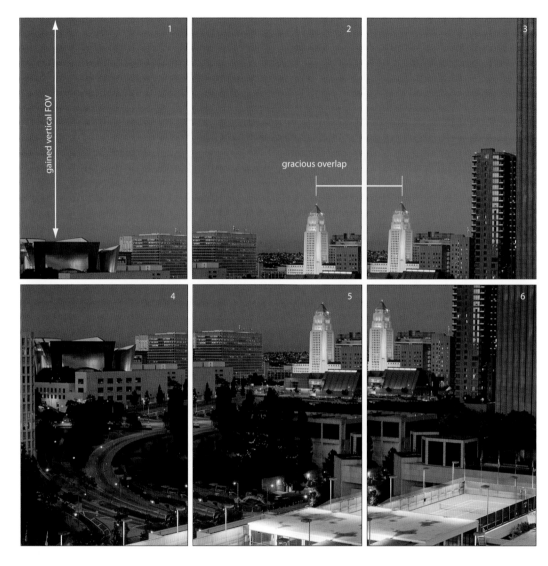

algorithms, they need some detectable details to grab onto. Clear sky or wispy clouds aren't distinct enough. By using the camera in portrait mode, we can make sure we still use as much of the sky as possible and add some extra viewable vertical degrees.

This principle becomes especially important when you're shooting a multirow panorama. Against all intuition, it's best to place the horizon very low in the first row of shots. When seen by themselves, these may look oddly com-

posed, but in the overall scheme you gain a lot of vertical coverage.

What counts is that each image has some distinctive details that link it to its neighbors. You're basically creating a jigsaw puzzle, and as long as you can see at a glance how the puzzle pieces belong together, an automatic stitching algorithm will have no problem assembling the panorama. You just have to give it the right amount of clues. A good shooting plan is human readable and saves you a lot of hassle later.

Figure 6-48: *The pano calculator at www.hdrlabs. com/tools is a good tool for planning a pano shoot.*

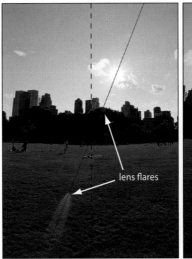

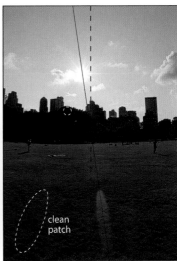

lens flares

clean patch

How many sectors do we need?

The official back-of-an-envelope formula goes like this:

$$\text{shots needed} = 1.3 \times \frac{\text{hFOV of your panorama}}{\text{hFOV of your lens}}$$

Example: The hFOV of your lens in portrait mode is 60 degrees. You plan to shoot a 360-degree panorama, so your rough estimation would be 1.3 × 360/60 = 7.8. Add some spare overlap and you need eight images, one every 45 degrees or whatever click stop your panorama head offers in the proximity.

Repeat the same for the vFOV of your panorama.

Example: A full spherical panorama calls for 180 degrees vertical coverage, and your lens delivers 90 degrees vFOV in portrait mode. That makes 1.3 × 180/90 = 2.6. (You didn't use your calculator now, did you?)

The only difficult part is to figure out the real FOV with a given lens/camera combination. For your convenience, there's a pano calculator at www.hdrlabs.com/tools that will help you figure out the exact numbers. The calculator also has an iPhone version, which works just like an app when the bookmark is added to the home screen.

Now we have our estimated number of shots needed for the panorama. Next we should consider how to place these sectors in our scenery when shooting.

The routine rule of thumb: Don't part anything!

This applies to smaller objects in your scenery, but especially to bright lights. If you shoot inside a room, try to capture all windows and lights in a way that they don't cross the image boundary. If this is not possible, try to place your seam in the middle of the bright region.

Dealing with the sun

To make things more complicated, it's crucial to place the sun in the middle of your image. Although you can't completely avoid it, chances are higher that your lens's optical flaws (like lens flares) will be kept as low as possible.

Sometimes, however, lens flares are unavoidable. Especially annoying are inner-lens reflections and secondary ghosted flares because they often cover up important image details and are hard to correct without resorting to the Clone Stamp tool. But optical geometry comes to the rescue: These flares are always located on a diagonal line from the sun through the image center. The trick is now to shoot two images with the sun on opposite sides of the middle. This way the lens flare wanders across the background and you can pick the best parts of each image to assemble a panorama that's as flawless as possible.

Figure 6-49:
When lens flares are unavoidable, your best bet is to shoot two pictures with the sun on opposite sides of the middle.

6.4.5 The Shoot

Now that you know all the terms and technical details, we can start shooting our first panorama. This will not be a "cooking recipe" but more of an introduction into the art of panorama shooting, which ultimately is a life-long learning experience. And that's exactly what's so great about it.

As long as you're not familiar with the process of panorama creation, I recommend using this checklist to pack your gear.

Equipment Checklist

☐	Camera	
☐	Memory cards	Formatted and ready to go.
☐	Batteries	Make sure they are fully charged.
☐	Lens	
☐	Tripod	Double-check for tripod plate.
☐	Panorama head	
☐	Remote release	Check batteries!

Useful additions

☐	Screwdriver/Leatherman	Handy to tighten a loose screw.
☐	Duct tape (silver)	To fixate the focus ring, tighten the tripod, make small repairs on the spot.
☐	Bracketing controller	Promote control, OCC (see section 3.2.2 for options). Make sure to include all cables.
☐	Neutral-density (ND) filters	Eventually necessary for shooting HDR light probes in direct sunlight.
☐	Gray card/color checker	Allows perfect white balance when shot at least once per session.
☐	Portable image storage	Useful for longer sessions and as immediate backup solution.
☐	GPS waypoint recorder	Great for hiking trips, allows geotagging panoramas based on their time stamp.

Camera settings

Everything that was said in section 3.2.1 applies here as well: no image enhancements, ISO fixed at the lowest possible setting, and locked white balance, aperture, and focus. Different shutter speeds are used to vary the exposures during bracketing. We're going to shoot a hell of a lot of images, so JPEGs make much more sense than RAW here. That way you can avoid a file-handling nightmare later on and ensure that your camera stays in high-speed burst mode throughout the entire panorama shoot.

Set the camera to predefined "sunny" white balance. "Sunny" has the widest gamut of all predefined settings, so it is even advisable for indoor mixed-light situations.

Also disable in-camera image rotation. Otherwise the camera gets confused when you're shooting the zenith image straight up, and the autorotation is also rarely taken into account when you're batch-merging the exposures later. I've gotten burned by autorotation many times before, and it's always very annoying to manually go through a sequence to make sure the images are all oriented the same way. Better turn autorotation off right away.

Next, you need to set up your bracketing range. The number of brackets you need to capture and which ones they are depends on the intended use of the panorama.

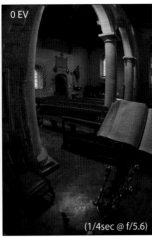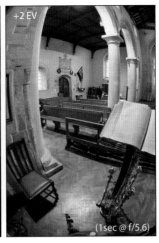

-2 EV	0 EV	+2 EV
(1/16sec @ f/5.6)	(1/4sec @ f/5.6)	(1sec @ f/5.6)

Figure 6-50: *A typical bracketing set for photographic purposes.*

Photographic workflow

This is the minimalist approach, where the intention is to get a nicely tonemapped LDR panorama. You want to go easy and use autobracketing, even if that means you may be limited to three exposures with 2 EV steps. The trick is just to align these exposures in an optimal way, which ultimately depends on how strong you want to tone the image.

For natural looks we're mostly interested in extra highlight details. That's when you want to shift the available bracketing range for the brightest shot being the "normal" exposure. This is the exposure the camera will measure for the scene, and in the example shown in figure 6-50 it already includes all the details we want to see in the shadows. On the other hand, the bright window is still blown out two stops below. We need another −2 EV stopped down to capture this extra detail.

For artistic looks it's often better to keep the metered exposure in the middle of the sequence. That will add a longer exposure to the brightest end, which captures a cleaner noiseless version of the shadow detail. That will allow you more elbow room for creative look adjustments and detail enhancement during the tonemapping process.

Light probe workflow

To get the perfect HDRI for use in 3D applications, you don't want any highlights to be clipped at all. Otherwise, you'd loose valuable light information that would give your renders that extra kick.

So we need extra-wide bracketing sequences. If you want to be absolutely sure to get everything you need, use a spot meter to measure the boundaries of the bracketing range. In-camera spot metering can also be useful; just remember that your camera's field of view will not fully show the bright hotspots of all light sources. You'd be amazed how bright the center of a lightbulb is, even though it might be smaller than a pixel on your camera display. Better add some extra EV steps to your measured brightest value to be sure to include all the lights.

Figure 6-51: *Capturing light probes requires extra-wide bracketing.*

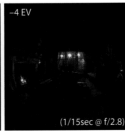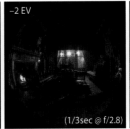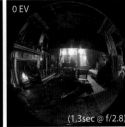

-8 EV	−6 EV	−4 EV	−2 EV	0 EV
(1/200sec @ f/2.8)	(1/50sec @ f/2.8)	(1/15sec @ f/2.8)	(1/3sec @ f/2.8)	(1.3sec @ f/2.8)

The one exception is the sun. It's just way too bright. There's one school of thought that says to use additional neutral-density (ND) filters, but that throws up a heap of practical problems: Most fisheyes are too bulky for a filter thread on the front, and few fisheyes have a filter slot on the camera side. So you're mostly restricted to regular wide-angle lenses, which delays the entire shoot. You'd also have to write down a note about your ND filter choice because it won't show up in the EXIF data. And what for? In my experience it's barely ever worth the trouble. There is no mystery in terms of what to expect from the sun. It's round and bright. As long as you make sure the actual circle of the sun is clearly visible on the darkest exposure (so the immediate surroundings are no longer blown out), you can easily boost the sun intensity when the need arises (see section 5.1.3). Eventually that won't even be necessary for 3D lighting because you can just use a standard 3D light as a supplemental light source and get even more creative control out of it (see section 7.3.3). So, don't worry too much about capturing the full sun intensity, but make sure to measure accurately for the brightest light.

Now measure your darkest spot and calculate the needed EV steps to cover everything in between. Depending on your EV spacing, you should now have a shutter speed sequence like this: 1/15 – 1/60 – 1/250 – 1/1000 – 1/4000. Once again, section 3.2.1 has some more detailed information about setting up proper exposure bracketing.

Take notes

Even when you're used to shooting HDR panoramas, it's still a good idea to jot down the minimum and maximum exposure values you intend to shoot. Also include a quick sketch of your shooting plan, with a box representing each sector. Armed with such a work sheet you can confidently repeat the bracketing sequence in every direction necessary. Check off a sector as soon as you're done with it.

Figure 6-52: *A work sheet like this is a great shooting help for beginners.*

Believe me, it's very easy to forget a sector or slip into a different bracketing sequence. Capturing HDR panoramas takes a long time, and you are definitely not the first one who will be disturbed while trying to concentrate on the shoot. A work sheet makes sure you really get every photo you need. It puts structure in the workflow and serves as a reference record for later. You can find an empty work sheet template in the appendix and on the DVD, and I highly encourage you to make good use of it.

Now shoot as fast you can!

It is crucial to capture all exposure brackets of each sector before the scenery changes too much. There may be people walking around, and even the sky is an issue with the wind moving the clouds. Software can eliminate such movements to a degree, but the algorithms certainly can't do miracles.

Fast shooting is easy with automatic bracketing. Browse back to section 3.2.2 for details on Auto Exposure Bracketing (AEB) modes and external bracketing controllers. For full HDR panoramas, you should practice at home to develop the best method for your camera/lens/head combo.

If you get lost while shooting, rewind and start over from the last step you're sure you finished. It can be very disappointing to discover at

home you have missed one sector, resulting in a useless HDR panorama.

Consistency is your friend.

Once you find a shooting plan that works, stick to it. You'll get faster and more confident all by yourself. Soon that routine will turn into muscle memory, and then you'll be able to concentrate on your environment instead of your gear. A good plan, for example, is this:

- Start at the sun.
- Go through the sectors clockwise.
- Capture the same set of exposures for each sector.
- When you arrive back at the sun, aim up and shoot a sky picture.
- Aim down and shoot the ground.

Of course, that plan's particulars differ for each camera/lens/head combo.

Here are some tricks for shooting with fisheye lenses:

- With circular fisheye lenses (e.g., Sigma 8 mm on full-size sensor), you should tilt the camera slightly upward. This will cover the zenith area of the panorama better and make stitching easier. The only thing you'll loose is the nadir, which is blocked by the tripod anyway.
- The same circular fisheye allows you to shoot the panorama with only three sectors. Align each shot with the gap between your tripod legs and you have the best possible nadir coverage. When it's stitched together, all you're missing is a small triangle with a tripod leg in each corner.
- With full-frame fisheye lenses (e.g., Nikkor 10.5 mm on 1.5 crop sensor), you can tilt the camera slightly downward to cover the complete floor except the tripod. Now you need only one additional zenith shot and your full spherical panorama is completely covered.

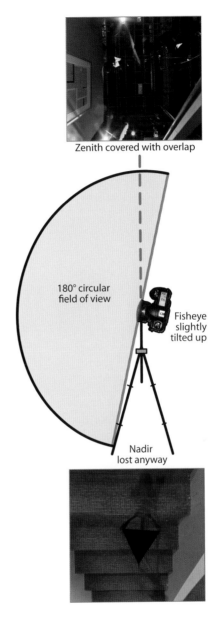

Zenith covered with overlap

180° circular field of view

Fisheye slightly tilted up

Nadir lost anyway

However, if that slight tilt-down means you would crop the top of a building in front of you, then shoot straight.

Make yourself invisible.

It's easier said than done. Leaving no trace of yourself in the picture is really the high art of spherical panos. You always need to stay behind the lens, and by the time you're done covering every sector, you have danced around your camera in a full circle. If you have friends or crew with you, invite them to join your pano-dance. Be careful when you're shooting a vista from a high cliff—I have repeatedly found myself in situations where I was so concentrated on the shooting process that I did not realize the immediate danger of standing with my heels hovering over a 100-foot drop—and then got the chills afterward. I recommend a wireless remote release (like the Phottix Plato) that will allow you to hide in a safe place when there is just no way to get behind the camera.

Next problem: Where do you put all your gear? Unlike in regular photography, you can't just throw your camera bags, jacket, and extra equipment behind you because eventually you'll have to shoot in that direction as well. Hiding it out of sight isn't always the best option, especially in urban places where it's an open invitation to evildoers. Consolidating your gear in a backpack is really the best you can do. Keep it on your back, or store it away in the dead spot directly underneath the tripod. You might as well hang it from the center column and use the weight to give the tripod some extra stability.

Also take notice of your own shadow. Directly behind the camera is not always the best place to stand. A typical beginner's mistake is to cast long shadows into a panorama, and you will curse your own mindlessness when you later have to fix it in Photoshop. It's much easier

Figure 6-53: Learn from my mistakes. Watch out for your own shadow! And for heaven's sake, get off your bicycle when you're shooting panoramas!

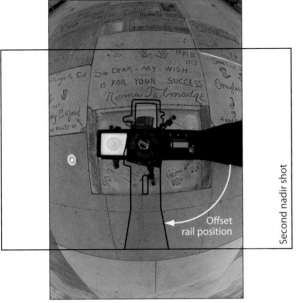

Offset rail position

Second nadir shot

Third nadir shot (handheld)

to paint out the rather small shadow of a camera than the shadow of an entire person. Maybe crouching down for a minute can save you an hour of self-hatred. The same goes for your own reflection. I made it a habit to wear a black shirt when shooting urban or indoor environments, just so I can be at peace with the guy who keeps showing up in window reflections.

Kirt Witte even recommends aligning two legs of your tripod with the sun so their shadows overlap. Then you will have one less shadow to paint out later.

Shooting the nadir

The nadir point is especially hard to cover because that's where your tripod is. Beginners shouldn't worry about it, really! In a Web presentation nobody will look directly downward, and just in case somebody does, most panographers put their copyright stamp in this spot. This rather tiny tripod spot isn't critical for CG lighting either; in VFX production it's often just filled with the generic floor color. But if the pano bug has really bitten you, then a full 360-degree image with a clean nadir is the

next interesting challenge en route to the pinnacle of craftsmanship and quickly becomes an obsession.

Here's the easy way: After you're done with the regular sectors, just turn the camera downward and shoot two exposure brackets of, well, your tripod. Why two brackets? Because each single picture shows the arm of the panorama head that holds the camera. And because that arm is extending toward the lens, it occludes large parts of the ground. Turn the head about 90 degrees for the second shot and it will occlude a different part of the ground. Later you can extract the good parts and puzzle them together. You will, however, still have to paint out the center piece of your tripod. So, this technique is reliable but not ideal.

Ideally, you want to get a clear shot of the ground, without any tripod at all. In good lighting conditions, when you can keep all your brackets faster than 1/60 of a second, you have a pretty good chance of getting that clean nadir shot with no additional tools.

The trick is to pick up the entire rig, carefully rotating the camera as best you can around the

Figure 6-55:

Swing the tripod out of the way for the down shot.

nodal point. It works best when you swivel the tripod around one of the legs, putting two of them down again to form a "duopod." Then pull it all back just a little bit more and turn yourself into some sort of third tripod leg. Or rather a crane, because you now hold the entire rig on an extended arm from the outside. Most of the weight rests on the duopod legs in the front, but you have to balance it carefully by holding the arm steady and pulling with constant force.

With some practice you can do all that while keeping your stare fixated at the lens and the imaginary nodal point. Now you have to take a deep breath and shoot one exposure bracket quasi-handheld. Yes, it's very sketchy, and no, it does not always turn out well. But at least you made the effort and gave everyone around you a good laugh.

6.4.6 Putting It All Together

There is a huge variety of panorama stitching software, and each claims to be the easiest and best. I'll tell you what: The best one has been around for more than 10 years, but it was forced to live in the underground for most of that time. That's because it's so good that the competition tried to sue it out of existence. And it doesn't even have a graphical user interface.

I'm talking about PanoTools.

PanoTools is a set of command-line utilities and open-source software libraries. A crowd of enthusiasts keeps developing it since the original creator, Professor Helmut Dersch, has withdrawn from an obscure legal battle. Nowadays, all panorama stitchers that matter are based in some way on PanoTools. Some are commercial, some are shareware, some are freeware. But the key is that they are all compatible with each other through the original PanoTools project format. We will focus on three of the best-known panorama stitchers: Hugin, Autopano, and PTGui.

Yes, it's true that Photoshop also includes a panorama stitching feature. You can find it in the menu under FILE ▸ AUTOMATE ▸ PHOTO-MERGE. It's fully automated and requires no prior experience whatsoever. But the problem is that Photoshop gives you zero influence over the result. Load the images in, wait for an hour, and then you can either like the result or not. Dedicated panorama stitchers, on the other hand, offer a specialized toolset to fine-tune alignment and blending, and even correct for shooting mistakes. These tools have evolved over years of photographic practice; the results are completely under your control and are of far superior quality.

Which way to go?

Several workflows are now possible to get from our exposure brackets to an HDR panorama.

1. The old-school way:

Stitch LDR panos with any stitcher, and then merge them to HDRI.

⊕ Most of the work done with LDR images; hassle free and fast.

⊖ Slightly misaligned source images result in blurred HDR panoramas.

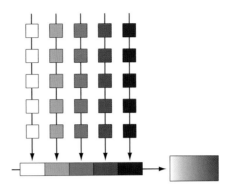

2. The careful way:

First merge HDR images, and then stitch those with Hugin, Autopano, or PTGui.

⊕ High panorama quality.

⊖ High computing power needed; slow.

3. The hybrid way:

Batch HDR creation from sector brackets; tone-mapping, alignment and preview stitch in LDR with optional final render in HDR.

⊕ High quality; fast interaction at every stage of the workflow.

⊖ More manual steps necessary; LDR result does not work for extreme lighting situations.

4. The quick way:

Direct workflow, straight from brackets to HDR pano. Works with Hugin, Autopano, and PTGui.

⊕ Very little manual work; single-step process.

⊖ Large amounts of memory and hard drive space required.

Before the arrival of HDR-capable panorama software, workflow number 1 was really the only option. It was a tedious exercise in file handling and did not always result in the best quality. Nowadays there are many more convenient options. We will have a closer look at workflow number 3 and workflow number 4 shortly, but right now I would like to share a much more fundamental piece of advice with you.

Figure 6-56:

Keeping all source images organized in subfolders pays off in the long run.

the originals into a *sources* subfolder nested inside a folder with the respective panorama's title. That way I can keep all the files that accumulate during the stitching process in that panorama folder as well, and every pano project becomes a nicely self-contained package. So my recommended folder structure looks like this:

+ panos
 + TitleOfPano1
 + sources (all source images for this pano)
 + TitleOfPano2
 + sources (...)

Get organized!

For easy processing, I recommend creating a subfolder for each panorama you're planning to stitch. Copy all images belonging to your panorama to this folder.

Use a thumbnail browser and arrange the window size until you see exactly one set of exposure brackets per row. Do a rough visual check to make sure all bracketed shots are here—no more, no less.

Don't rely on database-driven systems like Aperture or iPhoto. Make it a real physical folder, and use a basic thumbnail viewer like XnView or Adobe Bridge. Even the thumbnail view in Windows Explorer or Mac Finder will do. Lightroom is fine (that's what I use), because Lightroom will also organize images into real subdirectories. The point of this exercise is to sort out these panorama sources once and for all so you can easily feed them into a batch processor. Most certainly, you also shot a few nice single photographs on the same shooting day, which get quickly buried under the sheer number of photos taken for each panorama. That's why you need to sort them out right away and move on.

After years of shooting HDR panos, I found that proper organization is really the key to streamlining the process. Now I'm even sorting

Don't put this off. Organize your files right away. Keep in mind that subsequent processing steps build upon their predecessors. Any fault you overlook now will end up in more work down the line. Specifically, you need to double-check these points:

- ❯ All bracketing sequences are complete.
- ❯ They all cover the same range of exposures.
- ❯ All images have the same orientation.
- ❯ There are no vagabond images that don't belong to the panorama.
- ❯ All images have the full EXIF data embedded.

The last point is important. Stitching programs need the EXIF data to distinguish the source images that belong to each sector. If you feel the urge to review or change this data, you can do that using XnView, Lightroom 4, or Phil Harvey's free ExifTool.

↪ www.tinyurl.com/exiftool

If you shot RAW images, you have to make sure all the exposure data comes through the development process. In Lightroom, for example, you have to uncheck the Minimize Metadada on Export option. See section 3.2.4 for tips on how to squeeze the best data out of your RAW files, and for the sake of staying organized, develop all source images into another

subfolder nested inside the panorama project folder.

Got all that? Great. Then let's stitch!

6.4.7 Direct HDR Stitching with PTGui Pro

As you've come to expect, all the source images for this tutorial are on the DVD. There you can also find a demo version of PTGui Pro, so please come along on the ride.

Note that HDR support is only available in the Pro version of PTGui. For the sake of keeping the text tidy, I will just call this program by its first name PTGui, but I really mean PTGui Pro.

➤ Part A: Aligning the images

1 First load all images into PTGui's Project Assistant. I prefer doing this by dragging and dropping the entire stack from the file list to the PTGui window.

If the images don't show the correct orientation, use the curly arrow buttons to rotate them upright. Double-check that your lens parameters are identified correctly.

2 After you click the Align Images button, PTGui will analyze the EXIF data and try to group corresponding exposure brackets. A message will appear with the outcome and ask you for a decision about enabling HDR mode. It's all spelled out in exemplarily clear words.

The first option is to link all the bracketed images so each sector is treated as one unit and nothing will change the relative positions of the exposures to each other. This is the recommended option if you shot the panorama carefully without touching the camera.

Your alternative is to *not* link the exposure brackets and let PTGui attempt to align as many images as possible. This is useful for handheld bracketing. It has a much better chance of success than automatic alignment in most HDR mergers, simply because PTGui also takes the lens characteristic into account and does not shy away from fisheye-distorted images. However, with this second option enabled, the alignment process will take much longer and generally complicates manual adjustments later on. It also tends to lose track of the shortest

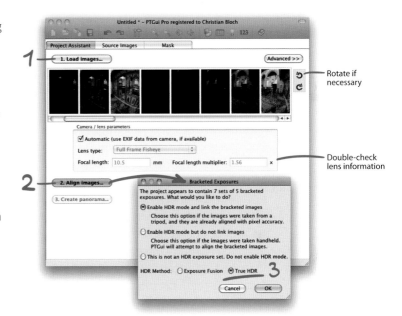

exposures. When you're shooting light probes, the shortest exposures are most likely very dark, and as explained in section 3.2.6, dark images are notorious for resisting any auto-alignment attempts.

That's why using a tripod and linking the exposure brackets is always preferred. Alignment in software is never as accurate as careful shooting. The example images in this tutorial were expertly shot by Bernhard Vogl, so please do choose the first option now.

3 Set HDR Method to True HDR and click OK. PTGui will now display a series of progress bars

Figure 6-57:
PTGui is very smart in handling bracketed exposures.

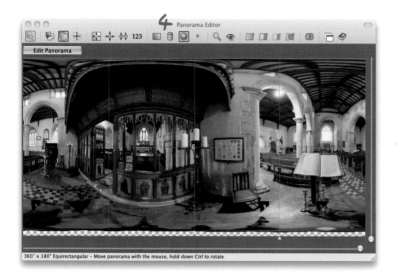

Figure 6-58:
Checking a preview in the Panorama Editor

while it analyzes the images, finds control points, and automatically aligns everything as well as it can.

4 When it's all done, PTGui will automatically open the Panorama Editor and present a preview of the result. ◄

What are those mysterious control points?

A computer can't work in a visual way as humans do. It needs some mathematical clues on how to position and transform the input images to create a good-looking panorama.

In automatic mode, you don't have to care about these clues. All PanoTools-related software packages include specialized algorithms that will automatically scan the images for distinct features. Adjacent images are identified when the same features are found in both images, and then these matches are marked with a control point.

These control points are like needle pins that are used to tack the source images together. Their relative constellation is also used to refine lens distortion parameters, so these pins literally stretch and pull the images into place.

Lots of research went into automatic control point matching, and nowadays it's pretty robust and reliable. But when the algorithm does fail, you can fix it with some manual intervention.

Looks good to me. Apparently there's a pretty powerful algorithm at work here. Assuming you have used a leveled panohead, the result should be good enough for stitching the final output. If that's the case, you can safely skip ahead to part C now.

Sometimes, however, you may encounter distortions in your panorama. It may look wavy or simply broken. In simplified panorama stitchers (including Photoshop), there's nothing you can do about it. As professionals we use PTGui so that in case the panorama needs refinement, we can dig deeper and manually check, correct, or add control points.

► Part B: Fixing verticals and mismatched control points

One indication that the automatic alignment failed is when vertical lines do not appear vertically straight or the horizon is wavy.

This one is easy: Define some vertical control points!

5 For this, we have to select the Control Points tab. Here the viewport is split in two. That's because every control point refers to two images.

In our special case, those happen to be the same. So we select the same image in the left and right window.

6 Find an obviously vertical structure in the image. Room corners are great, window or door frames, a street light, or the edge of a building. Mark the lower end in the left window and the upper end in the right window. You will notice

that a quick click will set a new point, but holding the mouse button for a second will bring up a small loupe with a crosshair. This is very handy for fine adjustments because whenever you move a point underneath that loupe, the mouse sensitivity will scale to the original image resolution.

To make the verticals self-stabilizing, you have to mark either another vertical in the same image or several other verticals in other sectors of the panorama. Usually, I tend to tag about three or four verticals in various sectors so I have an orientation clue in each direction.

Each control point is registered in a list underneath the images. Double-check that the Type column says Vert.line and change it if necessary.

7 None of these control point changes have any real effect on the image until you optimize the panorama. *Optimizing* is a general term used in every stitching software, and it refers to the algorithm that calculates the best possible image placement based on the control point configurations.

There are many different ways to start the optimizer. You can click the blue *optimize* link in the Project Assistant tab, you can select PROJECT ▶ OPTIMIZE in the menu, or you can switch to the Advanced mode to get a dedicated Optimizer tab with more detailed options. Or just press F5.

8 After optimization, the results are displayed in a dialog window.

The verticals should be aligned now, as the preview in the Panorama Editor will confirm. However, the numbers displayed in the Optimizer Results dialog give you a hint that the image alignment itself is not perfect yet. Some of these control points are too far apart in the stitched final, causing an uneven pull on the others. That may lead to a broken-looking panorama, where edges and corners from adjacent sectors just barely miss each other. In that case, we have to fix mismatched control points.

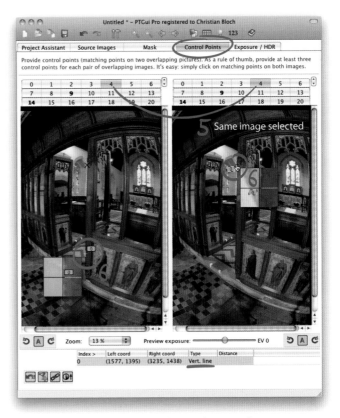

Figure 6-59: *Tagging a vertical line in the Control Points tab.*

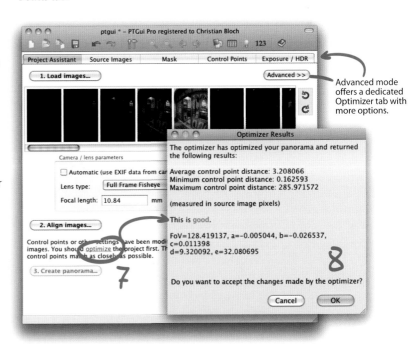

Advanced mode offers a dedicated Optimizer tab with more options.

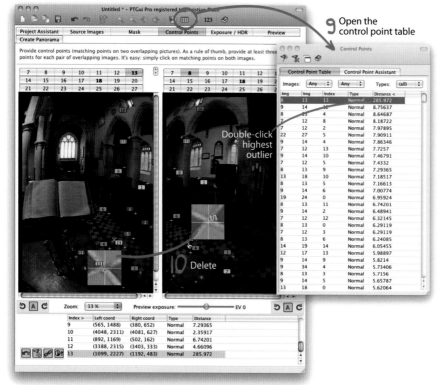

9 Here is an easy way to find those troublemakers: Click the table icon to open the control point table. This chart shows all control points found in the whole panorama. Sort them by distance. You can now double-click the worst control point and the main window will jump to the Control Points tab and put the focus on the suspect.

10 Regular image patterns like this tiled floor sometimes confuse the automatic control-point generator; it simply picked the wrong tiles. You could now correct this control point by hand. But if you still have enough points remaining, that's barely worth the hassle. Just kill it by pressing the Delete key.

After each change to the control points, you have to re-optimize your panorama (F5).

Control point creation is the central part of stitching a panorama. If you want a perfect stitch, plan on spending some time here because it has the most critical influence on the final quality.

Good and bad control points

Good control points are distributed across a wide area (as opposed to all clustered on one corner). That way small errors even each other out and the optimizer has a better chance deriving accurate lens information.

Ideally, you have control points in highly visible areas. Normally, that's what the auto-generator picks anyway, but sometimes you may have a long handrail, roofline, or carpet edge that may even span multiple images. Such long lines are very obvious to the human eye, and we really notice when they appear broken in a

panorama. In that case, it's best to distribute a few control points by hand. Pin the images together by the details you care about most.

Bad targets for control points are drifting clouds or people walking through the frame. You want the control points to be only on static objects. Thankfully, such false matches always reveal themselves with a high error distance in the control point table, so you can easily find and delete them.

When you repeatedly get bad control points stuck on objects close to the camera, that is a sure warning sign that your setup is not calibrated correctly. See section 6.4.3 for tips on how to find the nodal point.

Wavy horizons are a very common beginner's mistake, which is really a shame. They are so easy to fix with the procedure described in part B of the tutorial. You just have to make the

effort. Set some vertical control points, delete mismatching control points, and re-optimize. When you're shooting a natural landscape, you might not find a perfectly vertical structure to tack your vertical control points on. Instead, place some horizontal control points on the horizon! It really pays off to care about control points.

➤ Part C: Finishing the panorama

Everything optimized? Great.

11 Go to the Create Panorama tab and set the final resolution.

There's a handy button to calculate the optimum size, at which no pixel from the source images is scaled down. However, the *real* optimum is actually 70 percent of that. This is known as the Ken Turkowksy rule and is based on the fact that 30 percent of the original pixel values are already made up by interpolation due to the Bayer pattern. Section 3.1.7 shows an eye-opening graphic explaining this fact.

For all practical purposes, I usually set the output resolution in powers of two. Something like 8,192 by 4,096 pixels may sound odd, but it contains the magic numbers that a computer considers nice and round. It's the native resolution of the graphics card and works best when loaded as texture in a 3D program or an interactive panorama player.

As an HDR file format your preferred option should be OpenEXR with an alpha channel. In recent Photoshop versions, this works just fine, at least in the context of panorama editing. It works even better with the ProEXR plug-in (see section 2.7).

There are quite a few more options in this tab, even more when you're in Advanced mode. But don't worry; the factory defaults are well chosen and perfectly fine for 95 percent of all cases.

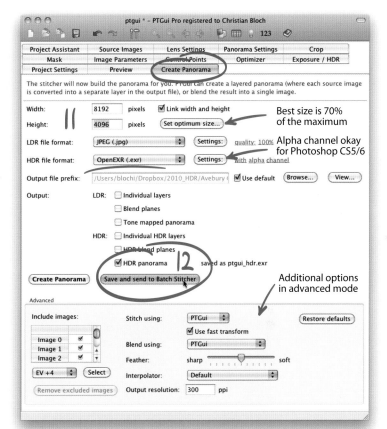

12 Check HDR panorama as the Output option and unleash the demon with the Save and send to Batch Stitcher button. The final processing is now happening as a background task.

You're already done. Your computer is not; it will have to chew on this for a while. ➤

As you can see, PTGui has come a long way. Never before has it been so easy to create HDR panoramas.

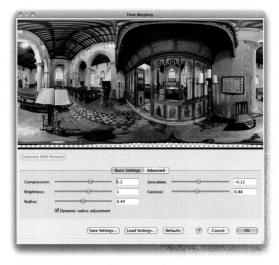

Figure 6-60: *PTGui's integrated tonemapper.*

For starters the Project Assistant in simple mode is really all you need to get results fast. But if you're willing to dig deeper into the Advanced mode, you will discover that PTGui provides a comprehensive toolset to solve even the worst-case stitching situations. In fact, it goes even further by offering a built-in tonemapper on the Exposure/HDR tab.

PTGui's tonemapper is simple and straightforward and will process the panorama on the fly during final stitching. It's a nice shortcut to get an LDR proof copy right away; however, I still recommend stitching your master image in full HDR. That way you can use all the techniques described in Chapters 4 and 5 to really finesse the image and tone it properly. Make sure to read the panorama-specific tonemapping tips in section 4.4.7!

Workflow alternative

If you want to use a different tool for HDR merging, you can do that as well. This is what the *Blend planes* option on the Create Panorama tab is for. In our example, this will generate five differently exposed panoramas, prealigned and ready to be merged. Make sure to set LDR file format to TIFF and every panorama will even have exposure information embedded. A true panoramic bracketing sequence—isn't that great?

The big advantage of this workflow is that you have more control over the HDR merging process. For example, Photomatix's selective ghost removal (fully explained in section 3.2.7) is an effective defense against tourists mindlessly walking through the panorama. Every once in a while, PTGui also has trouble blending the images correctly in HDR mode, and then it produces unusually dark spots or even negative pixel values in the overlapping areas. Blend planes are generally more reliable. And if you're used to mixing in some of the original exposures during your normal HDR/toning workflow, the blend planes are definitely for you.

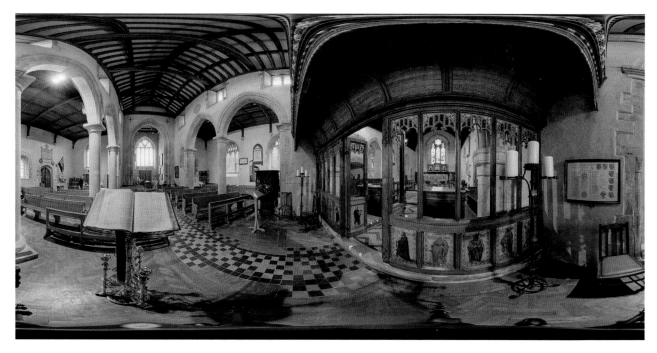

Figure 6-61:
Ta-da! Final panorama after tonemapping it properly in Picturenaut.

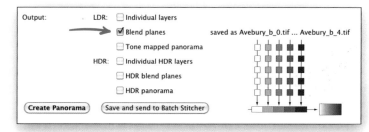

Figure 6-62:
Alternatively, you can also render a separate panorama for each exposure.

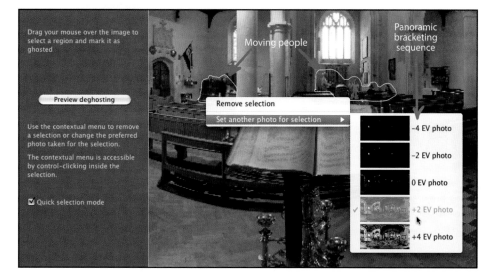

Figure 6-63:
Then you can merge them with Photomatix's selective ghost removal for a pristine result.

6.4.8 Removing the Tripod

You might have noticed that our church pan-
orama looks weird on the bottom. This is the
dreaded nadir: the blind spot directly under the
camera that is partially hidden by the tripod.

We simply have no image information there.
For panorama shooters, the nadir is like the spot
between your shoulder blades that you just
can't scratch.

But we can fix it. And here is how.

➤ Patching the nadir with Flexify

To follow this tutorial you need the Flexify plug-in demo and the image we just stitched together. It's
all on the DVD.

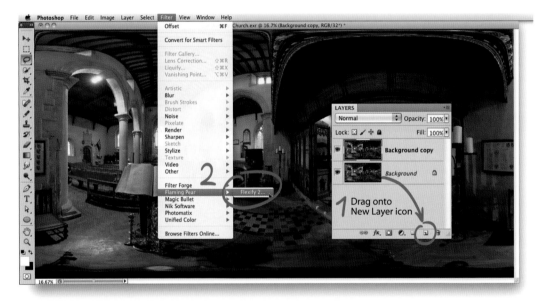

1 Load Avebury_Church.exr in Photoshop and
duplicate the background layer. The quickest way
to do that is by dragging the background layer
onto the New Layer icon on the bottom of the
Layers palette.

2 Select the new Background copy layer and
choose FILTER ▸ FLAMING PEAR ▸ FLEXIFY 2.

3 I have raved about this plug-in many times
elsewhere in this book, so I'll keep it short: Flexify
is awesome, it's perfect, you need it! In this case,
you need to set these options:

⦿ Input: equirectangular
⦿ Output: zenith & nadir
⦿ De-halo: enabled
⦿ Everything else: 0

It's very simple and very formulaic. The hardest
part is finding *zenith & nadir* in the list of over
250 output projection types, so I recommend sav-
ing these settings in a preset.

After clicking OK we have the two spots, which
were previously too distorted for retouching, laid
out side by side so they are nice and planar.

4 Now it's easy. Just zoom in on the tripod and
use the lasso tool to draw a loose selection
around it.

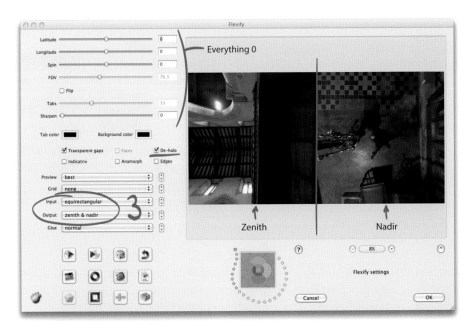

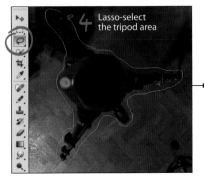

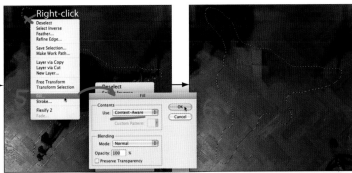

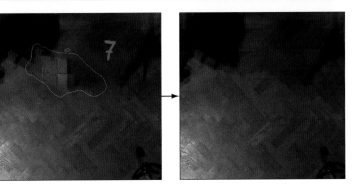

5 Right-click anywhere inside the selection and choose Fill from the context menu.

6 Make sure Content-Aware is chosen in the pop-up window and click OK. Tiny elves will now fabricate a seamless floor patch for you.

7 Eventually there will be some residue left, where inappropriate things from somewhere else in the image are patched in. Pretty inventive, these elves. Just repeat the selection/fill routine several times on smaller and smaller areas. After a few runs you should have a perfectly plausible reconstruction of the area underneath the tripod.

Delete top half (unless zenith also needed fixing)

8 When it's all done, open Flexify again and reverse the transformation. Leave all parameters at zero, just swap the input and output formats.

- Input: zenith & nadir
- Output: equirectangular
- Transparent gaps: enabled
- De-halo: enabled

Once again, that's a fixed set of settings. It works every time. Even better than saving a preset inside Flexify is recording this transformation as a Photoshop action. Then you don't even have to wait for the plug-in interface to open. Just press play and the image pops back into the old shape right away. Quick and painless. In case you're not quite sure how to record an action, you will find a premade one on the DVD.

9 After this round trip, you can barely make out what we were painting due to the heavy image distortion. But the tripod is definitely gone. Toggling the layers on and off reveals a pretty impressive improvement. The nadir patch even has a soft blending transition and perfectly fits into the original Background layer underneath.

Unless you also did some repair on the zenith, you can safely delete the upper half.

10 Now just flatten all layers and save. I recommend that you save directly over the original EXR file we started with. There's no point in keeping a version floating around that still has the tripod in it.

And that's really all there is to it. There are alternative methods using PTGui, Hugin, or even the antiquated HDR Shop. But the general idea is always the same: Unwarp the nadir into a flat projection, retouch it, and then warp it back. Flexify just provides the most streamlined workflow, especially when it's wrapped up in an action.

Another convenient workflow, although conceptually very different, is possible in Pano2VR. This little program is actually meant for authoring interactive VR presentations for the Internet

and mobile devices. But when the main developer, Thomas Rauscher, reached the top of the hill in that area, feature-wise, he also included a handy patch function.

For your convenience, a demo version of Pano2VR is included on the DVD.

Chapter 6: Panoramic HDR Images

➤ Patching the nadir with Pano2VR

1 Drag and drop ye good old Avebury_Church. exr into the designated area of the Pano2VR interface. For this tutorial we will need only the upper-left box, labeled Input. There are actually many more options, which I cropped out of the screen shot. Those all refer to VR authoring, and you can explore them later on your own.

2 After the program has auto-detected the panoramic format, click the Patch Input button.

3 Click the +Add button in the pop-up window that appears. This window is actually a list, but it's empty as of yet. Pano2VR allows for fixing up multiple regions, which will all be collected in this list, and we're about to create our first entry.

4 Another window appears where we can select the patch that needs to be fixed. Now the convenient part comes in: The preview area on top is a fully interactive panorama viewer. Simply drag the preview around with the left mouse button and use the mouse wheel to zoom. Within seconds you should have the tripod perfectly aligned in view, including any areas that you may consider a good provider of cloning sources.

5 When you have found the perfect view alignment, click the Extract button. Pano2VR will now render this patch into a new image.

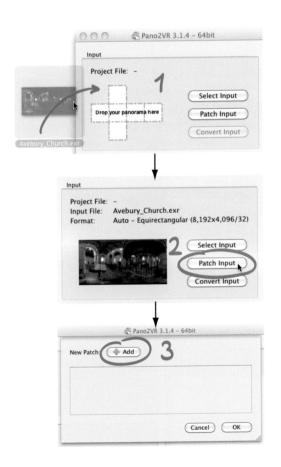

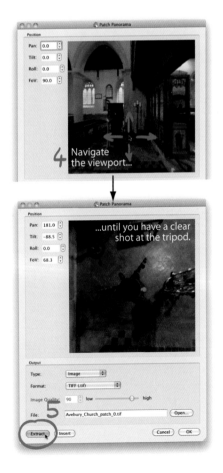

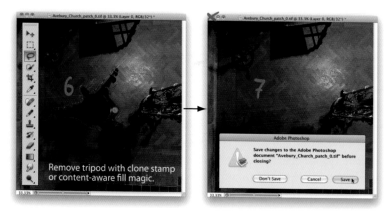

Remove tripod with clone stamp or content-aware fill magic.

6 Open this new image in Photoshop and remove the tripod. A few runs of Content-Aware fill should do the trick, just as shown in the previous tutorial. Now that everything is aligned in the most preferable way, you could even use the simple Clone Stamp tool, which has been available in 32-bit mode since Photoshop CS2.

7 When you're done, just save the image. Don't save as another version; actually save over the original patch! I usually just close it and let Photoshop's safety mechanism take care of it.

8 Now switch back to Pano2VR. It should show the patch list with exactly one entry for our image patch. The magical moment happens when you close this list window with OK. Pano2VR will detect that the patch was altered and offer to update the image patches. Yes! Yes, please!

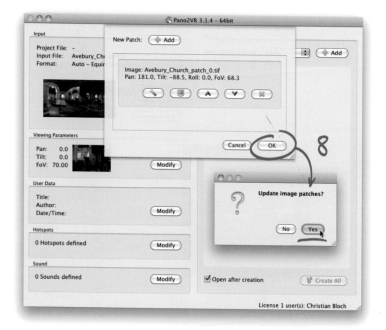

9 Mission accomplished. Pano2VR has already inserted the repaired floor into the panoramas. We just have to save it.

Technically, the entire right side of the interface is dedicated to output options. But this is a confusing wealth of features, from Flash presentations to HTML5 websites for mobile devices. All we want is the original image fixed. The quickest way to get that is to click the Convert Input button and set Type to Equirectangular (as that was the original format).

10 Think up an impressive sounding filename and finally click Convert. Now we're done.

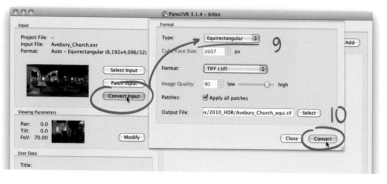

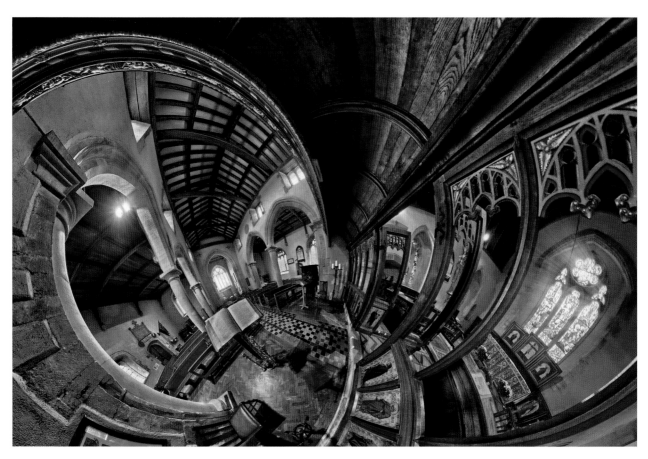

These are the two most convenient nadir retouching methods I could find. And believe me, I tried many. You should really go through both tutorials and see which one you prefer.

Flexify fits best in a Photoshop-centric workflow, where you're polishing your HDR master pano to perfection. Pano2VR, however, fits better in an assembly-line workflow, where you quickly jump through a lot of panoramas and fix up their bottoms. At no point do you actually have to load the full panorama into Photoshop. All you ever load are the small patches that are retouched. That's much faster and less taxing on memory, especially when you're editing big panoramas on a small machine.

Either way, both workflows deliver just what the doctor ordered: They work in full 32-bit, they are only 10 clicks long, and they touch only the areas that need to be fixed. All the pixels along the horizon and up are spared the double-transformation round trip, which helps preserve the original sharpness.

Before or after tonemapping?

Well, we do have more tools available in 8-bit mode. Especially the content-aware patch tool and the healing brush would be great for filling the nadir hole, but sadly, Adobe locked these tools away in 32-bit. However, there are several good reasons to complete the panorama in full high dynamic range:

1. The image will still be suitable for image-based lighting.
2. Tonemappers are easily confused by pitch-black pixels or nonexisting (transparent) areas. They will autocalibrate their slider range differently and you won't be able to use their full capabilities.

Figure 6-64:
Leaving tonemapping for last keeps all the look options open, including wild styles like these. Done with Flexify, Magic Bullet Photo-Looks, HDR Efex.

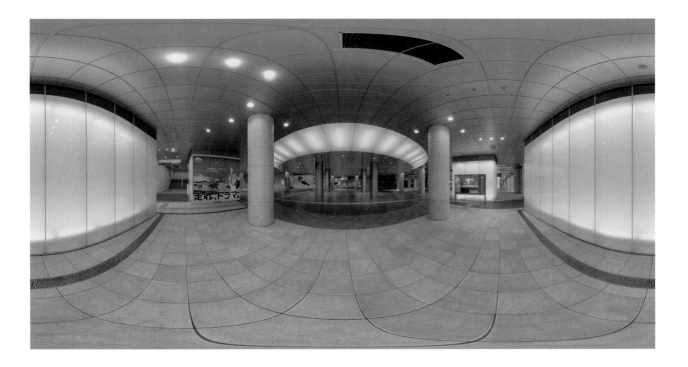

Figure 6-65:
This subway station is a pretty challenging example because the tiles on the floor and ceiling make stitching errors blatantly obvious.

3. Even the tripod itself can lure local tonemappers into brightening up the surrounding areas of the floor. It presents an unnecessary contrast that will be taken into account (for no good reason).

And besides, toning is a creative process where you decide on a certain look. It's something you want to save for last. Ideally, you want to keep it open and flexible in case you want to try a new look. Completing the panorama, on the other hand, is a purely technical reconstruction. There is in fact a perfect result that you will never have to revise again. Do it in the master HDR image and be done with it once and for all. Consider patching the nadir an integral part of the regular cleanup routine described in section 3.3, along with dust spot removal and white balance correction.

Even better, when you have taken my shooting advice in section 6.4.5 and photographed a clean nadir separately, you can directly include that in the initial stitching process. The tutorial in the next section will show you how.

6.4.9 Hybrid Stitching Workflow

This is my favorite workflow: First merge all source images to HDR, tonemap proxy versions along the way, use those to set up the perfect alignment, transfer the stitching parameters to the HDR images, and then finally, render a flawless HDR master pano. This may sound like a long and winding road, but in practice this workflow is actually very fast and interactive. The critical advantage is that we can always use the best tool for the job and exercise total control over each stage of the process. That makes it a winner for me.

Let me show you the workflow in an example. The subject is a subway station in Tokyo's futuristic Shiodome district. Along the way I will also reveal some secret trickery that will hopefully give you some ideas for solving any kind of problematic stitching situation.

We start the same way we did before: Arrange all images in a thumbnail viewer so that you can easily double-check your exposure brackets. If everything is cool, we will make HDR images first and then tonemap them.

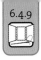

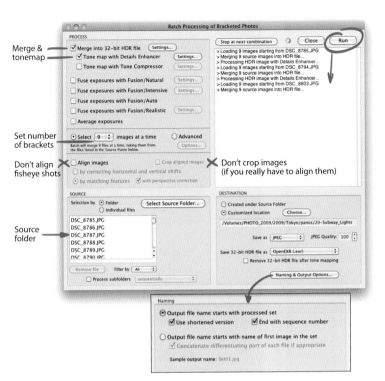

Merge & tonemap

Set number of brackets

Don't align fisheye shots

Source folder

Don't crop images
(if you really have to align them)

Figure 6-66: *Photomatix's batch processor prepares all the images for us.*

Batch HDR merging for panorama stitching

Open Photomatix, select Batch Bracketed Photos from the workflow shortcut palette, and navigate to the folder with the source images. Note that you may have to manually enter the number of brackets. Photomatix assumes three by default, but we have nine in our example. For tonemapping, choose Tone map with Details Enhancer with the default settings.

Uncheck the Align images option when you're working with fisheye images. Photomatix can't cope with fisheye distortion anyway, so all it could possibly do is mess up. You can use alignment only when you shoot with a longer lens, but even then you have to make sure the Crop Aligned Images option is unchecked. Our stitcher expects all images to have identical pixel dimensions.

As output formats pick JPEG and OpenEXR. In the Naming & Output dialog, enable the first two options: Use shortened version and End with sequence number. This will ensure that the images are saved with the shortest possible

filenames, and you will see in a minute why this is useful.

Special warning for Mac users: You have to choose PREFERENCES ▸ FILES and disable the option Save EXR files with Mac OS X API. It's a long story, but the bottom line is that Apple's native EXR support is buggy, which leads to all OpenEXR files getting saved with a different

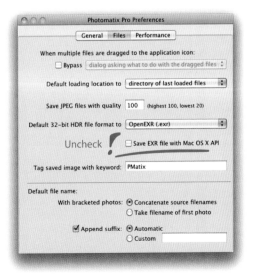

Figure 6-67:
Mac users need to uncheck this one option in the Photomatix Preferences for EXR files to be saved correctly.

Sort by file type

Drag JPEGs into PTGui

Figure 6-68: *JPEGs with identical filenames.*

base exposure. We can't have that for panorama stitching. Everything must be consistent across all sectors, and that's why it's critical that you uncheck this option.

Click the Run button and get yourself a cup of coffee. This might take awhile.

Double-check and refine

When it's done, you will find a new subfolder called PhotomatixResults1. It holds the HDR images as well as the tonemapped LDRs. Move it to the main project folder (one level up) and examine each image closely for noise, misalignments, and ghosts. If something went wrong, run the batch process again with various HDR generation options until you have the best possible result.

If the shadows are noisy, turn on noise reduction for the second run. If there is excessive ghosting, try ghost reduction. At the end of this iterative process, you will have golden sectors that really make the most out of the source material. Section 3.2.8 gives you a few more tips for a proper quality inspection and hints at solutions for improvement. I have a tendency to shoot more than I need and reshoot a sector at the slightest sign of a mistake. Then I just weed out the worst shots during this inspection.

In this case, I have already done the prep work for you. Let's get started with the practical tutorial, where you can follow along with the images from the DVD.

► Stitching the tonemapped images with PTGui

Copy the Subway-Lights folder from the DVD to your hard drive and drag all the tonemapped JPEGs from the PhotomatixResults1 subfolder into PTGui. Little bonus tip: It's easier to select the JPEGs in an Explorer/Finder window when you sort the folder by file type.

1 Switch to Advanced mode and rotate the images upright.

Take a closer look at the images I provided here. The first six are the standard set for full-frame fisheye capture, panning around

horizontally in 60-degree steps. While shooting, I was watching the scene and noticed pedestrians walking through the first sector. So after finishing the routine, I turned the panohead back and reshot the affected sector several times. Then I rotated the camera straight up for the zenith shot, followed by two shots straight down with varying rotations. These are the nadir shots that are guaranteed to stitch well because they are still shot from the nodal point. They are my insurance. At the very end I pulled the tripod back and tipped it over (just as shown in section 6.4.5) to

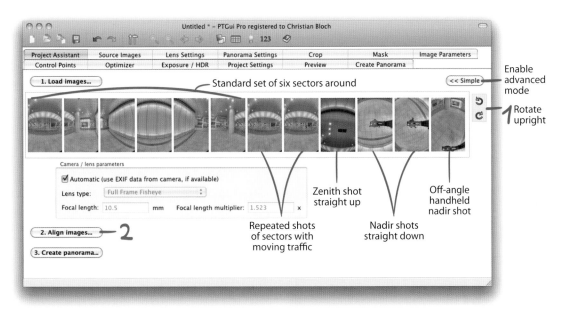

Enable advanced mode

Rotate upright **1**

Zenith shot straight up

Off-angle handheld nadir shot

Repeated shots of sectors with moving traffic

Nadir shots straight down

2

Figure 6-69: In this advanced tutorial, we're working with an extended set of sectors.

get a clean photo of the spot directly underneath it.

That's the extended set of panorama sectors. And now let's see how they come together.

2 Click the Align Images button. The automatic control point generator will find a lot of details in the tonemapped images because Photomatix has already adjusted each sector for best visibility. So the automatched result of this method is often more accurate to begin with.

3 Go to the Control Points tab and define some verticals. This is also easier now because fewer images are loaded and you therefore have a better chance of finding suitable sectors by switching through the numbered image tabs. Mark about three to six vertical lines in different sectors and re-optimize by pressing the F5 key. So far that's the standard procedure, as shown in section 6.4.7.

4 But now we're getting tricky! Go to the Mask tab and select images 9 and 10. These are the nadir shots with the tripod in it. By the way, these

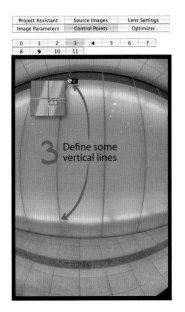

3 Define some vertical lines

shots illustrate very clearly how Photomatix brightened up the surrounding floor in an attempt to enhance the details on the tripod. Well, thank you very much, but we will now paint out the tripod anyway.

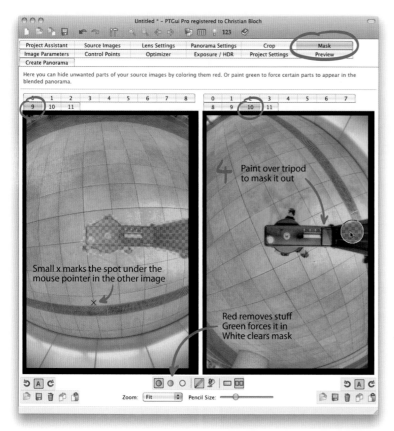

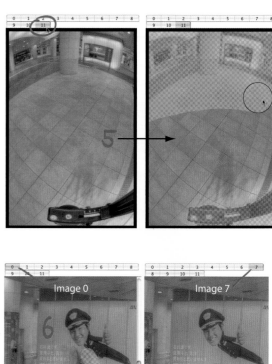

Figure 6-70: *The Mask tab makes it easy to exclude certain areas from the panorama.*

PTGui's Mask tab is simple and effective—borderline ingenious. On this tab your mouse is a masking brush, and you simply draw a crude stroke across the tripod. The pencil size is adjusted with a slider on the bottom. That's also where you can switch between the three paint colors, which are red (for removal), green (for enforcing a part to appear in the panorama), and white (for clearing the mask). Easy, right?

5 There's very little we need from the off-angle nadir shot (image 11). The walls in the background are much better represented in other images, so you can safely paint out the whole upper half.

6 And then there are these pesky pedestrians walking around. It happens all the time. You can't really prevent it, at least not easily. There was one assignment where the police blocked off all traffic on a busy New York street just so I could capture an undisturbed panorama of the location. Believe me, nobody was more surprised than me. Such VIP treatment was a hitherto undiscovered exception to the rule; normally the arrival of people in uniforms is a signal to get the last shots quickly and pack up the gear.

Under regular circumstances, reshooting the trafficked areas and masking them in PTGui will do the trick just fine. In this example, simply switch through all the images of the same sector (0, 7, 8) and scribble the people out with red paint. For every passerby there is bound to be an

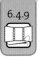

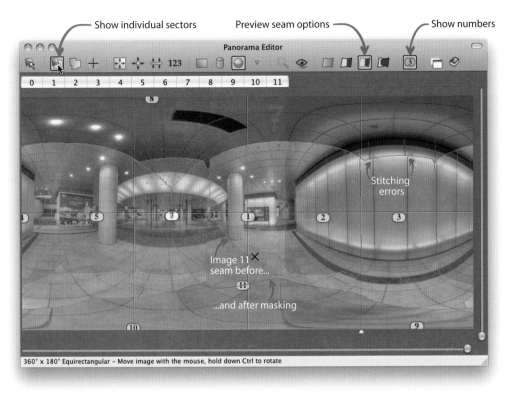

Show individual sectors — Preview seam options — Show numbers

Panorama Editor

0 1 2 3 4 5 6 7 8 9 10 11

Stitching errors

Image 11 seam before...

...and after masking

360° x 180° Equirectangular – Move image with the mouse, hold down Ctrl to rotate

Figure 6-71: *Keep an eye on the Panorama Editor. It shows what you did and what you need to do next.*

unobstructed background somewhere in this stack, and PTGui's dual-pane viewport tells you exactly where. It's so convenient that I do my closeup inspection of the merged HDR images right here. If I can paint out a ghost, fine! If I can't, then I remerge that sector more carefully in Photomatix. PTGui will then automatically detect and reload updated images.

7 If you have the Panorama Editor open, you can see the effect of all this masking almost in real time. It will update after every paint stroke and show the fully blended result (which it didn't do in HDR mode, so this is another advantage of working with proxy LDR images). When you have accidentally masked out too much from too many sectors, the Panorama Editor shows a transparent hole.

Play around with the toolbar icons in the Panorama Editor for some alternative preview modes. Number overlays are useful for identifying the sectors to paint in, and even more useful are the red seam lines. During the final rendering, the overlapping areas of adjacent sectors will be blended smoothly, and the red seam lines in the preview run directly through the middle of these soft blends. Basically, they mark the spots where the blend will be at an even 50/50.

You don't want these red seam lines to form odd nooks and crannies. For example, the off-angle nadir patch (image 11) was shown with a large triangular spike in the middle of the panorama, and painting the mask in step 5 fixed that.

8 What the Panorama Editor also reveals are quite a lot of stitching errors. Some of them will

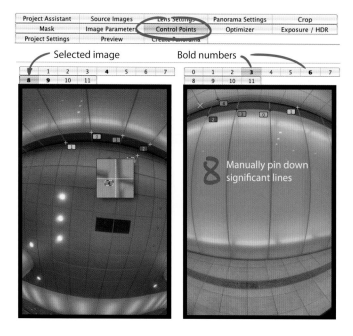

Project Assistant	Source Images	Lens Settings	Panorama Settings	Crop
Mask	Image Parameters	Control Points	Optimizer	Exposure / HDR
Project Settings	Preview	Create Panorama		

Selected image Bold numbers

| 1 | 2 | 3 | **4** | 5 | 6 | 7 |
| **8** | **9** | 10 | 11 | | | |

| 0 | 1 | 2 | **3** | 4 | 5 | **6** | 7 |
| 8 | 9 | 10 | 11 | | | | |

Manually pin down significant lines

be hidden by the soft blend, but if you want a perfect result, you should add a bunch of manual control points. It's time-consuming work, but well worth it.

When you're in the Control Points tab, notice that several numbers in the image switcher tabs are printed in bold. Those bold markers show which images are linked with the one currently selected in the opposite pane. For example, if you select the zenith image (number 8) on the left, and there is only one bold marker on the right, that means the entire zenith dangles on a string, attached to only one other image. So that is yet another sure sign that the zenith image needs more control points, preferably connecting it to yet unlinked images, pinning together exactly those lines that obtrusively miss each other in the Panorama Editor.

It's not as tedious as it sounds; you really should try it. The control point editor is very smart; it gives helpful suggestions, and as soon as you have three control points linked, it will automatically move your mouse pointer to the corresponding spot. And now that we have fewer

images loaded, your manual control points have more weight.

9 Sometimes, however, it can also be problematic to have *too many* control points. Control points in corners are bad, and so are control points in areas that we specifically masked out. And most important, the handheld off-angle image should have control points only on the floor, none on the walls.

Also check the control point list to identify the worst of these buggers, and delete them. And, of course, regularly press F5 to run the optimizer and see the effect of all these control point edits.

10 There are also strategies for squeezing a better result out of the optimizer. Go to the Optimizer tab and enable the Advanced mode. The window will explode into a massive table with a gazillion check boxes. No worries. It's actually quite simple: Only the image parameters that are checked will be affected by the optimization algorithm. Unchecked parameters are locked.

The trick is now to constrain the optimizer. Typically, the images shot horizontally have the best control points, whereas zenith and nadir images (here the last four) are notorious trouble-makers. Knowing that, we can optimize in two passes.

For the first pass, uncheck the last four images in the rightmost column (labeled Use control points of). Enable the lens distortion parameters (leftmost column) and run the optimizer.

For the second pass, disable all lens distortion parameters and use all control points from all images. In addition, enable the viewpoint correction for the last four images. Now run the optimizer again and you should have a much better result.

That's the basic idea. Use the more reliable data first, and then prevent the less reliable data from muddling up the result. Try a few combinations of settings—sometimes it's better to lock yaw, pitch, and roll for all the regular images on this second pass. You can also try including the

Fewer control points here

More here

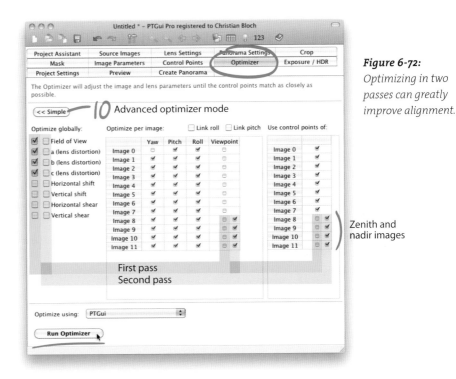

Figure 6-72:
Optimizing in two
passes can greatly
improve alignment.

Zenith and
nadir images

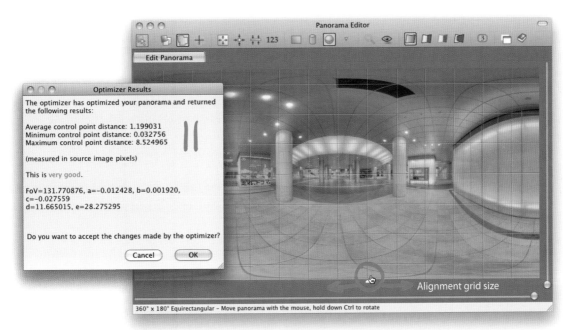

sensor shift (most sensors have a slight misalignment) or viewpoint correction for all images (in case your camera was not precisely at the nodal point).

11 Refine your control points and re-optimize until the optimizer gives you an average distance of less than 3 and a maximum distance not higher than 10. Usually, you should be done after three or four passes.

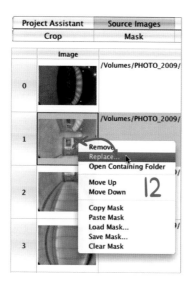

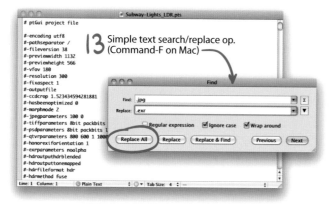

Figure 6-73: *Replacing all JPEGs with EXRs in a plain text editor is not the sexiest way, but it sure is the fastest.*

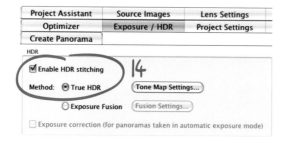

What we have now is a tonemapped LDR representation of the panorama.

Maybe this is already what you wanted. In that case, you can stop here. All the cool kids keep going and create an HDR panorama, though.

12 Go to the Source Images tab, right-click on the first thumbnail, and choose Replace from the context menu. A file requester will come up, already pointing to the JPG file, and you simply pick the EXR file that lies right next to it. Do that for all of the source images.

13 If that doesn't sound sophisticated enough for you (or your panorama has 20 source images), here's a shortcut.

Save the project and open it in a text editor. That's right—despite the obscure.pts filename extension, PTGui project files are human-readable text documents, just like the classic PanoTools stitcher files. In fact, those formats are compatible. Now it's easy. Just run a search-and-replace operation, swapping every occurrence of ".jpg" with ".exr". And that's it. Load the modified project file into PTGui and you're back in the saddle!

There are three final steps.

14 Go to the Exposure/HDR tab and enable HDR stitching with the True HDR method.

15 Set the output options in the Create Panorama tab, just as we did in section 6.4.7. HDR panorama should be your first choice for final output.

But now that the source images are pre-merged HDR files, you can also use the option to export individual HDR layers. That will give you a warped version of each source image, perfectly fitted into the panoramic space. I often use that as a safety net. If necessary, you can stack either one of these layers on top of the HDR panorama to manually cover up minor blending mistakes in Photoshop.

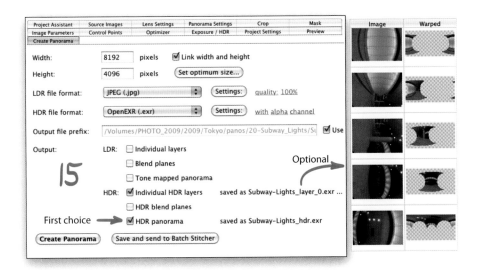

16 Click the Create Panorama button and go have another cup of coffee. Expect your computer to eat up a decent amount of resources in the meantime. ◄

Why HDR?

You might be wondering why all this fuss just to get the final stitch done in HDR when we already had a perfectly fine panorama from the intermediary tonemapped LDR images. Well, there are two reasons I highly recommend this workflow: First, for image-based lighting it is imperative to have a full 32-bit HDR panorama. And second, it's better to tone the panorama as a whole instead of toning each sector individually.

All local tonemappers work adaptively on the image content, and specifically they adapt to the image brightness. So they will deliver a very different result for an image that shows mostly white clouds than for an image that shows the ground, even if that has the same white cloud visible in the corner. In our tutorial panorama, the zenith shot was aimed straight into the ceiling lights, which lured Photomatix into compensating for the extra peak in brightness. That's why the zenith image turned out considerably darker than the rest. You're facing the very same problem in every outdoor panorama that has one segment shot directly into the sun. And it's happening with all local tonemappers; adapting to the image brightness is part of their magic.

It becomes a real nuisance when you stitch the images together because PTGui will have to blend across very incoherent regions. In step 11 of this example, you can actually tell that there is a soft dark spot on the ceiling. After you switch to the full HDR method, all source images are on an even playing field. Now you can post-process the entire panorama at once. You can make much better look decisions based on the overall context, and you can make full use of every bit your sensor initially captured. You're no longer stuck with halos and other artifacts that have been introduced during blindfolded batch tonemapping.

Going the extra mile really does pay off. The teaser image you saw at the beginning of this

Figure 6-74:

Post-processing the HDR panorama results in a much better image (right) that could not be achieved with the intermediate LDR panorama (left).

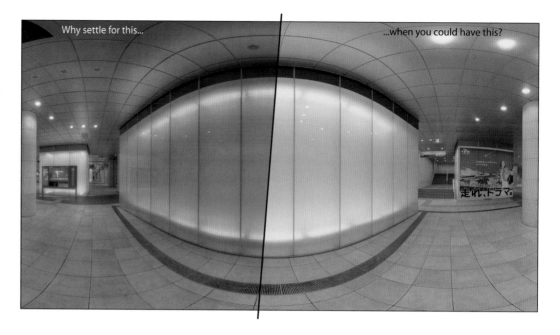

tutorial looks so much better because it was derived from the HDR panorama. These are the additional post-processing steps I did:

- Minor nadir patching with Flexify to get rid of my shadow (section 6.4.8).
- White balance and color correction in 32 Float (section 3.3.3).
- Tonemapping with the double-dipping method (section 4.4.4), using Picturenaut's Photoreceptor as the base layer and Photomatix's Details Enhancer as the detail layer.

Yes, I'm probably repeating myself here. But I won't grow tired of making a strong case for the full HDR workflow because I still see so many people *knowingly* skip it under the illusion they would save time. They don't. They end up investing more time meddling with the final print, fighting artifacts and color problems that could have been completely avoidable.

Some miscellaneous hints

- PTGui Pro is awesome, but at $190, it's also quite expensive. If that's out of your budget

range, you should take a look at Hugin. This program is the open-source twin brother of PTGui and is completely free. User interface and functionality are the same. You could even follow this tutorial with Hugin instead of PTGui. However, PTGui is the choice of professionals because it has mightier algorithms under the hood. The automatic control point generator, the optimizer, and the blending engine will give you much better results in PTGui.

- If you always stick to the same shooting plan (the same sectors in the same order), you can save one stitched project as a template. Then you can apply this template to the next batch and everything will pop right into place. Templates were originally intended for high-precision panorama heads, where every sector is shot with pinpoint accuracy. But they are just as useful for universal panorama heads, even if you can get the angles only approximately right. The initial prealignment via template will give the control point generator an extra hint, resulting in more and better control points.

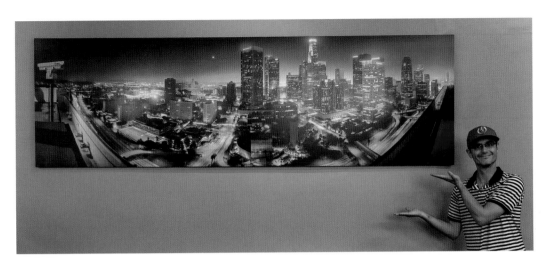

Figure 6-75:
Gigapixel panoramas make fabulous big prints.

- It's a good idea to save the lens profile from an exceptionally well-stitched panorama. This will preserve all the optimized lens distortion parameters and give you a much better starting point for the future than purely relying on the EXIF data. In PTGui, lens profiles are managed with the Lens Database button on the Lens Settings tab. Hugin even includes a separate lens calibration utility, and Autopano Giga works directly with Adobe's lens profiles.

- All the mentioned pano stitchers can manage different lenses within one panorama. That can come in handy when you shoot the wide open sky with a fisheye lens and the interesting areas around the horizon with a longer focal length. This mixing ability is not restricted to physical lens types; it also includes equirectangular images. That means you can easily insert a patch into a previously generated panorama or mix two partial panoramas together. Possibilities are endless.

- Multiple CPUs are a mixed blessing. They can reduce render time, but only when you also have copious amounts of RAM. PTGui will try to load and warp multiple images simultaneously, and this can backfire badly when they don't all fit in the available memory. Hyper-threading can also cause more overhead than benefit. It pays off to experiment with the number of simultaneous threads to use in the Preferences/Advanced section, to dramatically increase render speed. For example, on my dual-core MacBook Pro, the optimum number of render threads is two.

6.4.10 Big, Bigger, Giga

Gigapixel panoramas are a whole different story. While PTGui and Hugin offer precise control over every minuscule detail of the stitching process, Autopano Pro is much better suited for handling massive amounts of source images. And that's exactly what you get when you shoot a vista with a long lens rotated in small increments: an avalanche of individual photographs that somehow need to be fused together into a super-resolution panorama.

Technically, it's not much harder to make a really big panorama. The methodology is the same: Create control points, refine them, optimize, and render. It's just a logistical challenge as well as a serious exercise in patience. When every other click triggers a 30-minute progress bar, there's not a lot of room for trial and error. Gigapixel panoramas are not for beginners. They're something that you work your way up to. And you inevitably will, because the reward

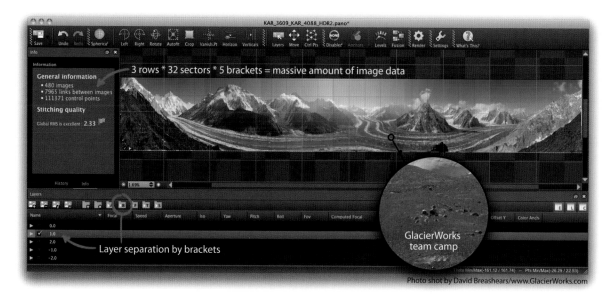

Photo shot by David Breashears/www.GlacierWorks.com

Figure 6-76:
Autopano Pro is especially well suited for handling huge panoramas.

is pictures with such incredibly rich detail that you can print them as big as a wall at the maximum resolution. They become explorative art pieces themselves. Especially in interactive web presentations, the near-infinite zoomability makes gigapixel photography appear to be a medium of its own.

This won't be a real tutorial section; the source images wouldn't fit on the DVD anyway. But I would like to share a few tips that will help you over the hill and make you feel comfortable giving big panoramas a try. And there's also an interesting story behind this example image.

GlacierWorks

Sometime in 2009 my phone rang. Suddenly I was talking to David Breashears, one of the great mountaineers of our time. He has led over 40 expeditions, climbed Mt. Everest five times, and filmed numerous documentaries in the Himalayan region. While for most of us the melting of the glaciers is just a sad scientific fact that we may be remotely aware of, David became an eyewitness. And he was horrified. So he made it his lifetime goal to document the extent of glacial recession and show the shock-

ing evidence to researchers and the public alike. For that, he researched the exact locations from which the early Everest pioneers Wheeler, Sella, and Mallory shot panos on photographic plates almost 100 years ago. Then he went back up there and reshot these panoramas with state-of-the-art methods. Needless to say I felt honored to contribute to such a grand project by stitching some panoramas for David.

I can't print the final images here because this book isn't 30 feet wide. To fully appreciate them in the context they were meant for, you have to see the interactive zoomable versions at www.GlacierWorks.com.

Right now, let's just concentrate on the technical side.

Preparation

All source images should be shot at critical focus, ideally with a tack-sharp prime lens. Shooting just slightly off-focus negates the point of all this tiling and stitching; you might as well just take a single wide shot.

When developing the RAW source files, ensure a perfect vignetting correction! Longer lenses show more vignetting to begin with, and after stitching, all the individual light fall-

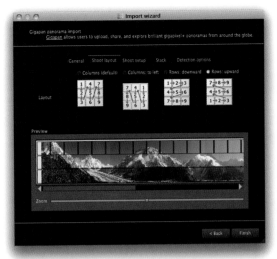

offs turn into very persistent striping artifacts. It's especially obvious on clear sky. Instead of one smooth gradient, you will get soft vertical stripes that are extremely hard to correct afterward. That's why you should use a lens profile during RAW development and even out the vignettes right away.

Autopano

When it comes to stitching, the Autopano advantage starts with the Import Wizard. It has plug-ins for common robotic heads, where you can just load the configuration file that the head provided and everything falls into place. Even if you don't have a robot and you meticulously shot all sectors by hand, you can still use the Gigapan plug-in to sort all the source images into a grid layout. Simply set the number of rows or columns, shooting order, and number of brackets. I rarely remember them all, but the Import Wizard's live preview makes it easy to guess. Such a prealigned grid layout will make control point detection much more reliable and puts shots with blank sky (which are often inevitable) into the right place.

Figure 6-77:
Autopano's Import Wizard with the Gigapan plug-in allows convenient and flexible prealignment.

After automatic alignment, you can refine the result in the panorama editor. This interface is also streamlined for managing large amounts of images; it uses GPU acceleration and intelligent caching to minimize loading times. Source images are represented by a circle, and the links between them are drawn as lines with a box in the middle. Each box shows two numbers: the average control point distance (here called RMS, whatever that stands for) and the number of control points in that link. In addition, good

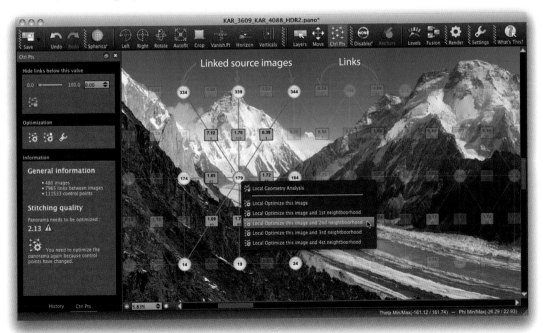

Figure 6-78:
Optimizing local neighborhoods helps in solving problem areas quickly and conveniently.

can use the local optimizer to incrementally push it toward the nearest edge, just as you would push the air bubbles out when applying a large sticker to your car door.

Finishing up

I hope these notes give you a head start in Autopano and encourage you to stitch something big. Autopano is available in Pro and Giga editions from www.kolor.com. Both editions have largely identical features, so you're perfectly fine with the more affordable Pro version.

Call me a traditionalist, but for final rendering I still prefer the blending engine of PTGui. Especially in HDR mode, PTGui just seems to deliver cleaner transitions and is easier to configure than Autopano. Thankfully, these two programs are fully compatible. Simply export the project from Autopano in PanoTools format, load that in PTGui, set the output options, click render, and take a coffee break—or better yet, an extended 10-course dinner break.

For final output you will most likely have to use Photoshop's large file format (PSB) because TIFF and even EXR files become problematic when they grow larger than 4 GB. Photomatix actually supports 32-bit PSB files, precisely for the purpose of handling gigapixel panos.

Make no mistake, pano stitching at this scale classifies as a high-performance computing task. It needs a really beefy machine with lots of RAM and CPU cores. Stitching makes full use of a parallel processor architecture; that's why Prof. Helmut Dersch's experimental Playstation 3 stitcher held the speed record for a while. Of course, that became history when Sony remotely locked up the Playstation OS and outlawed Linux installations. But the general verdict is still that a well-tuned gamer PC is the best platform for stitching gigapixel panoramas.

Figure 6-79:
Autopano's control point editor automatically finds matches based on a simple box selection.

links are colored green, and those that need work are colored orange or red.

Double-clicking on a link box opens the control point editor. When you're used to PTGui or Hugin, you will notice that Autopano treats control points quite a bit differently. It relies on quantity. But that's okay; you can still manually refine them. Instead of carefully placing new control points by hand, you just mark matching areas with a rough box selection in both images. Autopano will then use magic to automatically place tons of control points in this area.

After adding control points, you have to re-optimize the panorama of course. And this is where my favorite feature comes in: the Local Optimizer. In the panorama editor, you can right-click on the circles with the image numbers and use the context menu to optimize only the selected image and its neighborhood. This is much more efficient than re-optimizing the entire panorama again. It's faster and puts you in perfect control. So, when you have a stitching error somewhere in the middle of the pano, you

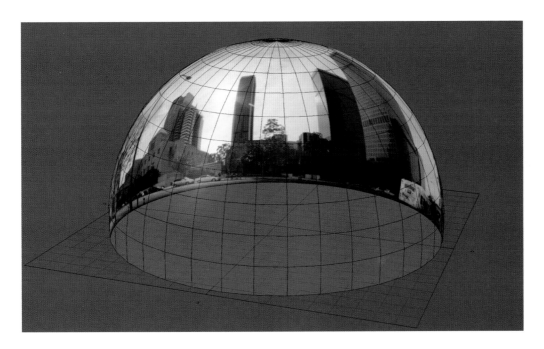

6.5 Skydomes

Okay, now let's back-pedal from hundreds of source images to only one. Skydome capture starts off with a very simple observation: The majority of natural daylight usually comes from above. If the HDR image is intended to be used only for image-based lighting, we don't even need a fully immersive panorama.

In architectural visualization, for example, it is a common practice to place a skydome around the scene. It looks like a big hemisphere, extending upward from the horizon. The CG model of the building is standing on a ground plane that covers up the lower half of the frame all the way to infinity. So we wouldn't see this part of the panorama anyway, and its light would be blocked by the CG ground plane. The same applies to many other situations in visual effects, cartoon animation, fine arts—wherever the scene is large and completely filled up with stuff.

Skydomes are not sufficient when only a CG element is to be inserted into a live-action background. Lighting on a film set always features components coming from below the horizon line, even if that is just the light bouncing off the ground. Those subtle but important nuances would be left out entirely. The second case where skydomes often fail are with highly reflective CG objects. Think of cars, shiny cell phones, or the Silver Surfer. Wherever a proper reflection is required to get the look right, a full spherical panorama is preferred. And last but not least, our particular skydome technique is not suitable for making nice backdrops or matte paintings because there isn't enough resolution to gain here.

So, whether a skydome is sufficient or not is a case-by-case decision, dependent on the project itself. Despite all these limitations, skydomes have one huge advantage: They are fast, easy, and straightforward to generate.

Shooting fast like no other

You need a fisheye lens. It needs to be fully circular, meaning the entire 180-degree circle must be visible in-frame. That's a tough call on the camera too, because most DSLRs will crop that circle off. A qualifying setup would be a full-size

Figure 6-81:
A bubble level for the flash shoe is a handy and stylish accessory.

sensor camera like the Canon 5D with a Sigma 8 mm lens or with the fancy Canon 8–15 mm zoom fisheye. For a Nikon D300, or any other camera with a 1.5 crop factor, you would need the Sigma 4.5 mm fisheye. See section 6.4.2 for a more elaborate list of options.

And now you just point that camera straight up. Since we do only one shot, we have to aim very precisely. A handy accessory is a small bubble spirit level that slides onto the flash shoe.

A panoramic head isn't necessarily required because we don't have to stitch a thing. But it helps in keeping the weight of the camera centered over the tripod; otherwise, you loose quite a bit of stability. Also, not every ordinary tripod head will actually allow you to shoot straight up—that's just a highly unconventional angle.

Watch your head! It can be tricky shooting with such a wide angle. If you don't crouch fully

Figure 6-82:
Point the fisheye straight up and watch your head while shooting.

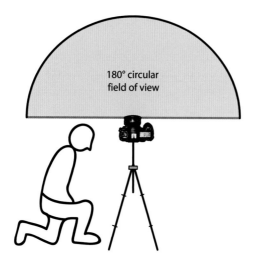

180° circular field of view

underneath the lens, you will be in the picture. Imagine the lens floating on an invisible water level and you have to dive under.

Unwrap and be done with it

Merge those exposures to HDR and save in Radiance format. Then bring it over to HDR Shop and crop the image down to the 180-degree circle, just as we did with the mirror ball.

Now call the Panoramic Transform dialog from the Image menu. The magic setting is Mirror Ball Closeup for the source format because this one actually means Fisheye. It's the same type of distortion. I have the mathematical proof on a napkin somewhere. Call it a lucky geometrical coincidence, an excessive typo in the interface design, or just a clever way to fly under the radar of the iPix patent police. I'm sure the programmers had a good reason to relabel Fisheye distortion into Mirror Ball Closeup.

Also, we have to specify a 3D rotation. Click the Arbitrary Rotation button and punch in −90 in the X axis field, which means we shot the image straight up.

That's it. The skydome is done. No stitching, no blending, no hassle. Including file transfers and HDR merging, that might be 10 mouse clicks altogether, most of them on OK buttons. Can you feel the positive vibe?

As you can see, the Sigma 8 mm even gives us a little bit more than a 180-degree field of view. If it were only upward from the horizon, we wouldn't see the road at all. We could stretch that image vertically just a little bit so the borderline is below the center. Even though the black lower half seems like a huge waste of space, I still recommend not cropping it off. It's easier to use the image in a 3D program when the overall image geometry conforms to the standard spherical format.

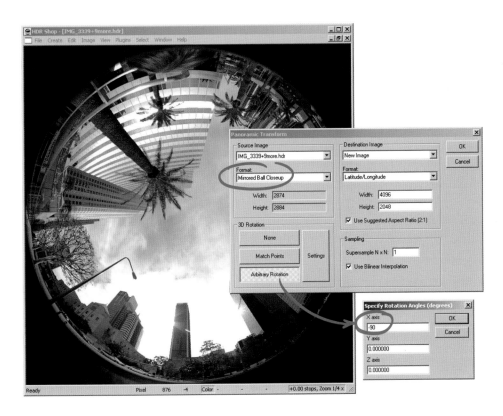

Figure 6-83: Unwrapping with HDR Shop is really the only preparation necessary.

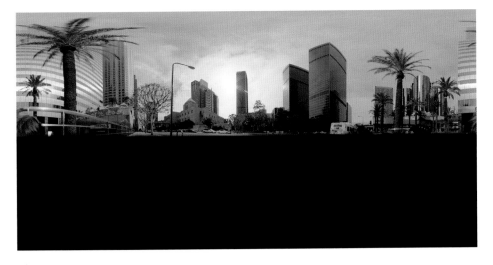

Figure 6-84: Ta-da! Done is the skydome pano.

Rescuing a hurried shoot

This is supposed to be a speedy technique. There could be times when you don't even have time to level out your camera precisely at 90 de-grees upward. In that case, you might want to use Hugin for unwrapping because it will give you the chance to adjust the angle interactively.

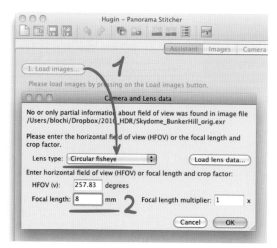

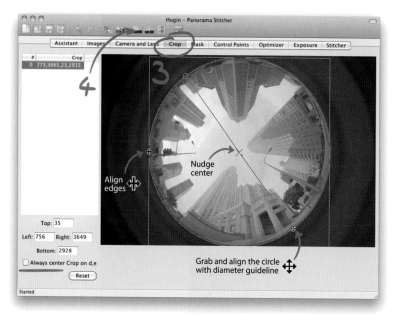

1 Load the image Skydome_BunkerHill.exr from the DVD in Hugin. It will ask you for the lens info. Make sure to select Circular fisheye for the lens type.

2 Specify the focal length of your lens (here 8 mm). If you're wondering why Hugin calculates an outrageous hFOV of 257 degrees—that includes the black border of the lens, of course.

3 We can crop the black border off right here, with Hugin's cropping tool. Just drag the guidelines around until the circle fits perfectly. The option "Always center Crop on d,e" should be unchecked if your fisheye isn't precisely sitting in the center of the sensor. Most lenses aren't. Mechanically, they always have a little bit of play on the mount and may even sit differently after every lens swap.

4 Open the preview window. Hugin has two of them. I prefer the OpenGL preview (small landscape icon with GL stamped in the corner).

5 Switch to the Move/Drag tab and you can drag the image freely across the canvas.

You see, as pure-breed open-source software Hugin is a regular candidate for Google's Summer of Code program, which annually results in a major feature boost around autumn. This awesome OpenGL preview window is one of these new features. It's really a full-blown panorama editor. Everything can be nudged and dragged around interactively, and you can even reorient the image directly on the 3D sphere. To straighten everything out perfectly, you'd simply grab the building corners and pull them toward the next gridline.

6 To stretch the image below the horizon, increase the FOV in the Camera and Lens tab.

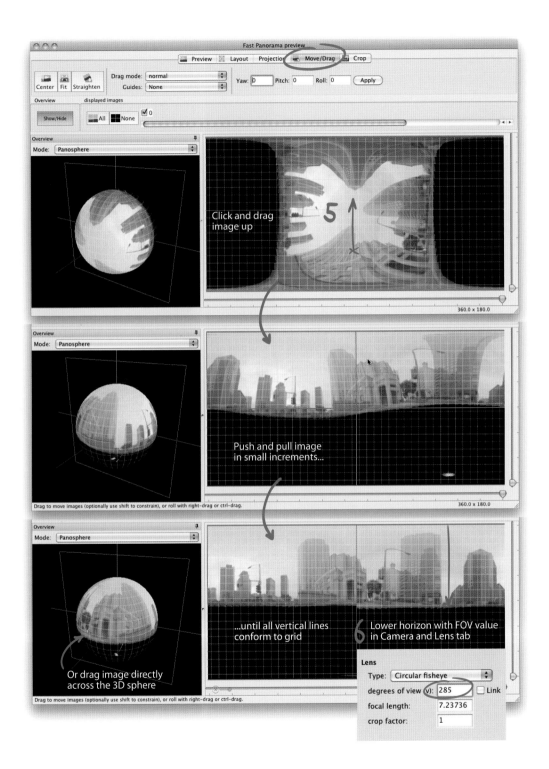

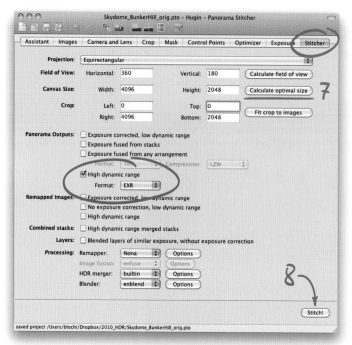

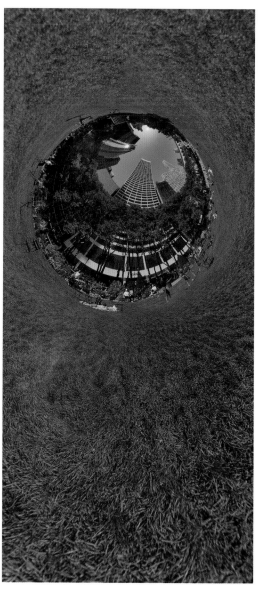

7 Finally, switch to the Stitcher tab. Only one check mark is needed, choosing High dynamic range in the Panorama Outputs section. Optionally, you can click the Calculate optimal size button, but I generally just set the canvas size to 4,096 by 2,048 pixels by hand.

8 Stitch! Done.

The general workflow in Hugin may not be as quick as in HDR Shop, but it's much more versatile. In between these two programs, handling-wise, would be the Photoshop plug-in Flexify. Here you have a preview as well, but you have to fine-tune the angular orientation with sliders instead of pulling the image directly. The third alternative is PTGui, where the workflow is identical to Hugin.

6.6 Comparison

Let's see all the different capturing techniques on the all-too-popular comparison chart!

	One-shot systems	Mirror ball	Segmental capture: wide angle	Segmental capture: fisheyes	Skydome
Equipment needed	– SpheroCam HDR – Panoscan MK-3 – HDR-Cam – Civetta – ...	– Mirror ball – Two tripods – Assistant (!)	– Panohead – One tripod	– Fisheye lens – Panohead – One tripod	– Fisheye lens – One tripod
Total cost range (assuming you already have a camera)	$40,000 to $60,000	$100 to $200	$200 to $800	$400 to $1,200	$400 to $800
Number of sectors necessary	1	2 to 3	12 to hundreds	2 to 8	1
Quality of the final panorama	●●●	●○○	●●●●	●●●	●●○
Easy to learn	●●●●	●●○	●○○	●●○	●●●
FOV coverage	●●○ Nadir missing	●●●	●●○ Best for partial panoramas	●●●●	●○○ Only upper hemisphere
Maximum resolution	Typically 10K, depends on system	Roughly equals camera res	Infinite, up to gigapixels	Circular fisheye: camera res Full-frame fisheye: 3 × camera res	camera res/2
Shooting time required	Medium 5 to 10 min	High 10 to 15 min	Very high 15 to 30 min	Medium 5 to 10 min	Low 2 min
Post-processing effort	Immediate result	Medium 30 min	Very high 3 to 6 hours	Medium to High 1 to 2 hours	Low 5 min

Which technique is the right one for you?

A **skydome** is created quickly and easily, so it should definitely be preferred when the requirements of the project don't call for a fully immersive panorama.

The **mirror ball** technique is very attractive for beginners and casual shooters because it has the lowest cost and needs just a very reasonable effort for stitching and post.

Segmental capture with a **fisheye** offers a good balance of speed and optical accuracy, thus it is the recommended technique for professional VR and on-set photographers.

Segmental capture with regular **wide-angle** lenses is useful for matte paintings and oversized prints because the resolution is literally open ended.

Purchasing or renting one of the specialized **one-shot** systems is the best option when ease of use and instant results are the major decision points. It certainly makes sense for projects of massive scope, where money is the least of your issues.

6.7 Panoramas and Visual Effects

Here comes a brand-new section, dedicated to some advanced things you can do with panoramas. Weaving them in earlier would have disrupted the flow and potentially confused beginners. Instead, the borderline between panoramic photography and computer graphics seems to be the perfect spot for the things I'm about to show you. I would even argue that there isn't a clear borderline anymore; it's more of a smooth transition between the two fields.

6.7.1 New Opportunities

Panographers are an odd species. They are extremely passionate about what they do; fascinated by the idea of preserving the most beautiful places in an art form that can best be described as *immersive experience*. They constantly refine their tools and techniques to raise the bar, to create bigger and better quality panoramas. Real panographers cringe at Google Street View, which has turned their love child into a consumable with no artistic integrity or quality standards whatsoever. But the problem is that Google Street View stole the virtual tour market away. Marketing agencies and real-estate clients are notorious cheapskates. As long as it's free, they are perfectly fine with the fast-food imagery that tumbles out of Google's robotic cameras. Well, quality panoramas can't be free, because they do require a substantial investment in gear and personal experience. You might be doing it for the love of it, but that doesn't pay the bills.

What if I told you that there is a large group of people constantly hungry for HDR panos of beautiful locations? People who have an eye for details and can recognize good quality. CG artists, of course!

I'm not even talking about the big Visual Effects (VFX) studios. Those have their own HDR pano departments; don't worry about them. But there are about 6,000 small VFX and

Figure 6-85: *Bob Groothuis made a name for himself with HDR panoramas of beautiful clouds. His Dutch Skies collection has been used in games, movies, and commercials. It became so popular that Bob published four sequels, all from his own website, www.bobgroothuis.com.*

3D animation studios worldwide that would rather purchase a pano of a Tuscan landscape than send someone to Italy to shoot it themselves. Count in tens of thousands of freelancers specializing in architectural renderings and industrial presentations, then add on top a million hobby artists rendering their very own dream car or fantasy monster and you have a pretty decent market. You could even count in the recently formed army of independent developers of mobile games.

So here is my plea to all pano photographers: Don't let all that good material rot on your hard drive. There are professional stock

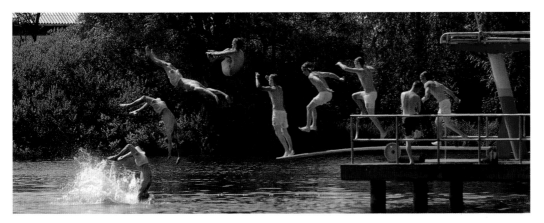

Figure 6-86:
Just do it! Jump in the cold water and sell your panos to the CG community!

agencies specializing in marketing HDR panos. Doschdesign.com is the oldest and biggest one, but 3sixo.net, cgibackgrounds.com, and moofe.com may be easier to get into.

Even better, read the next chapter to get an idea of what CG artists really need. You will find that a bunch of friends and I have created a tool that turns your HDR panorama into a turnkey lighting solution. It's called Smart IBL, it's free and open source, and our authoring program requires no knowledge of 3D software whatsoever. Armed with that you can easily market your HDR panos in your own online shop or just sell DVD collections from your own website.

And who knows, maybe one of your stock clients will even offer you a gig for on-set HDR capture?

What to shoot?

Well, there are two popular categories: specific locations and generic backgrounds.

An unobstructed view of a cloudy sky is as nonspecific as it can get and may sound boring from a photography standpoint, but this is the bread and butter that almost every 3D scene (and every 3D artist) needs. Among the car fans, open roads are always in demand, or any fancy place where a car would look good. Imagine you had a Ferrari; where would you want to take a picture of it? In what light? If there is a time and place that come to mind, go there and grab

it! Of course, landmarks are also interesting to VFX folks because they are repeatedly chosen by directors to be flattened by meteoroids or blown up by aliens. That would be the specific locations category, which is often served by assignments.

Here are some crucial requirements for useful material in either category:

1. No people.
2. Full spherical 360/180-degree coverage.
3. Minimum resolution of 8000 by 4000 pixels—more is better.
4. OpenEXR with full dynamic range, color balanced and cleaned up.
5. Some additional background plates from different angles.
6. Really, no people!

People may be great subjects for regular photography—the most interesting subjects in fact—but for this particular kind of stock photography, they are completely out of place. It's about the location and the light, and it's intended to serve as background for something else. At the end of the process it will be a part of a video clip, and I can't think of a single VFX shot that looks good with Johnny Littlebottom glued into the background, frozen in time. Traffic and distant crowds will be replaced anyway, and it would be a courtesy if you could clean

them out of the picture. You can bet the CG artist using this material will spend three or four weeks creating the foreground piece and may spend another week merging it into the background. He will end up looking longer at this panorama than you ever did, often at 500 percent magnification.

6.7.2 Set Etiquette

If you get the chance to shoot HDR images on a movie set, you should know about set etiquette. This is important so you get that chance again. It doesn't matter which of the aforementioned techniques you're using as long as you're proficient in it and give at least the impression that you know what you're doing. Personally, I prefer the fisheye technique with a Nikkor 10.5 mm on a D300S and a Nodal Ninja pano head. When things get heated up and I need to be as fast as possible, I switch to a Sigma 4.5 mm for quick three-shot capture.

Figure 6-87:
A movie set is an alternate reality, where the rain comes from sprinklers and the moon is a humungous inflatable balloon.

Pack your bag with redundancies.

Bring twice as many empty CF cards as you expect to need, spare batteries with charger, ideally a second camera body. Also bring a tape measure (or laser distance meter if you're concerned about coolness), notepad, pen, and of course everything that's on the equipment checklist in section 6.4.5. All useful additions are mandatory for on-set work. Better get a roller trolley, or at least an extremely comfortable backpack.

Talk to the AD.

On set there is a military-style chain of command in place, and all strings come together at the *assistant director* (AD). That's the person with several walkie-talkies strapped to the belt, telling everyone what to do. The director is busy directing the actors and should better be left to his devices, so the AD is the real boss of the crew. He makes sure the show goes on. Notoriously taps on his watch, too. Skipping or sidestepping in this command chain is the fastest way to get kicked off the set. You can't even ask a grip to lift a sand bag without talking to an AD first.

There may be multiple ADs swarming around a bigger set, and in that case your man is the First AD. Sit down with him beforehand and explain exactly what you're going to do. You'll want to shoot your HDR pano at the spot where your 3D object is supposed to be, which is usually right in the middle of the set. So you need the set for yourself, with all the lighting left on. There's typically a crew of more than 50 people buzzing around, and they will all have to wait for you, so this is a rather big request. The AD needs to be comfortable with you; only he has the power to stop everything and let you in.

When you explain the importance of this HDR capture, don't build your argumentation on the fact that it saves time in post-production. That never sounds convincing, because post-

production is not the AD's concern right now. Instead, stress the fact that you will enable the CG artists to use the exact same lighting as it was meticulously designed on set. Make sure the DP (director of photography) overhears this and you will have a strong advocate for your case.

Be fast and efficient.

The faster you are, the better your chances of getting a time slot when the shooting schedule gets tight. It always does, and at 3 a.m. you really don't want to be that guy everybody is waiting for. You should be able to grab a pano in under 2 minutes, ideally 40 seconds even. Practice out in the field, on a road trip maybe. Practice until it's all muscle memory and you can have a light conversation while shooting.

Go in after a successful take.

As tempting as it might be to jump in during scene setup or practice, don't do it. You would inevitably end up standing in someone else's way. You would also skip the chain of command, which greatly decreases your karma points. Chances are, you won't get what you need anyway. They might change the lighting between takes; that's often the reason there is another take in the first place. What you want to capture is the final lighting conditions, so hold your horses and wait for your cue on the side.

Be ready.

Use the wait time to get everything set up and ready to go. Double-check the nodal point alignment on your pano head, set and lock all necessary camera settings (white balance, aperture, focus, bracketing). It's a good habit to aim the camera directly at a spotlight to shoot some test brackets; you can easily do that from the side of the set. Check them on the LCD screen at 100 % zoom level. That way you make sure to have the right exposure range and focus.

Figure 6-88: *Movie sets are also organized mayhem, similar to bee hives in terms of structure and efficiency. It's best to stay out of the way while observantly waiting for your cue.*

−8 EV −6 EV −4 EV −2 EV 0 EV

Figure 6-89:

Make sure the shortest exposure includes the un-clipped light sources, even if that puts the metered exposure on the other end of the bracketing range.

Figure 6-90:

The iSlate app is handy for slating panoramas that belong to a particular shot.

Figure 6-91:

Waiting is another popular activity on set. Might as well use the time to stitch some panoramas.

Capture the lights.

Note that capturing HDR images for CG lighting may require a different set of exposures than you would normally shoot. For purely photographic purposes, your metered exposure is typically the middle of the sequence, and there would be several overexposed images to capture the deep shadow details. These shadows are good to have represented accurately when your plan is to open them up in tonemapping, but they have the least effect on the actual lighting conditions. For CG purposes we're much more interested in the light sources themselves. For example, what's the real color of a soft box or bounce card, and how bright are they really? That's why the metered exposure may well be the longest exposure in a bracketing set, allowing enough exposures to accurately capture the full dynamic range of the lights.

Now you should have everything set up and double-checked, waiting with the camera turned on. When the AD gives the signal, all that's left to do is jump forward and grab the HDR pano. You don't want anyone standing or moving around in front of the lights, so it's wise to bring that up in the initial briefing. The best way for the AD to announce your heroic set appearance is with the words, "Everybody clear the lights, 60 seconds HDRI shoot for visual effects!"

When your big moment has come, don't panic.

All eyes are on you now. Shoot your exposures with calm confidence; hurry but don't rush. Now you have to make sure the wait was worth it and you really get everything you came for. Watch the histogram on the display. If the 3D

object is supposed to be moving through the scene—for example, a killer robot chasing a damsel—shoot multiple HDR panos along the path. Double-check for focus sharpness before giving the AD the thumbs-up and walking off set.

That's pretty much it. Rinse and repeat for every set with VFX in it, sometimes even every shot. For big shows it turns out to be pretty useful to snap a picture of the slate each time. I like to just hold up my iPhone in front of the lens, with the *iSlate* app running. The script supervisor can tell you the current shot number; that's the person carrying a humungous binder covered in Post-it notes.

You'll also find out that there are long stretches of wait time. Even the most exciting movie set gets a little stale when you're on hold for 5 hours. If you bring your laptop, you can spend that time downloading the images and inspecting them on the big screen. You can even start merging HDRs and stitching them. Showing a finished panorama around on set is an excellent way to reduce friction and increase your chances of getting called in.

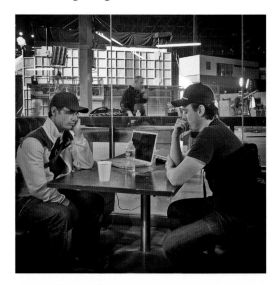

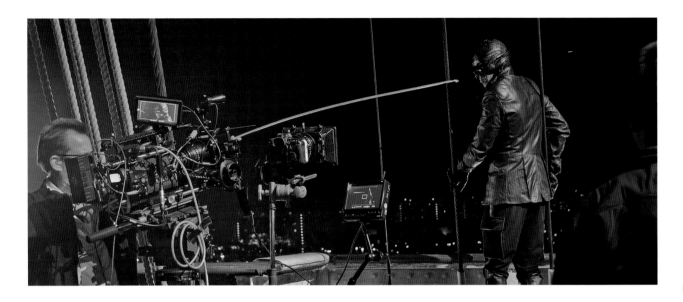

6.7.3 Virtual Camera Pans

Now that DSLRs can shoot perfectly clean HD footage, photographers are increasingly turning into multimedia ninjas. Some of the most beautiful short movies are made by photographers, entirely guerilla style. Even in the professional camp, you'd be amazed how often a Canon 5D or 7D is used in production. News reporters have almost entirely switched over, and on movie sets a DSLR is frequently spotted next to its big brother RED cam.

For your next short movie, I'd like to show you how to create a virtual 3D camera pan straight out of a panorama. The advantages are obvious: It's much more dynamic than simply sliding a 2D image across the screen, and when intercut with your regular footage, a 3D pan results in a more coherent visual flow. It's also more convenient than actually filming a camera pan. You can match the timing and direction to your edit instead of being locked to your ad-hoc decisions at the location. Also, this technique can create a perfectly smooth pan, which would otherwise require an expensive tripod head with fluid dampening.

Pano shooters are often masters in creating virtual tours online, so the first intuition would be to just screen capture such a flash presentation. Don't even waste your time trying; it will look jerky and cheap. Instead, this a perfect opportunity to get in touch with some compositing software. The technique also works in all 3D software, but quite frankly that would be overkill for this purpose. Nowadays, all compositing software has some rudimentary 3D functions built in. The basic idea is to project the panorama on a ball, put a virtual camera in the center, animate it, and then render a movie. Fusion and Nuke make this very easy, which is to be expected from professional compositing packages with a price tag north of $4,000.

However, in the following tutorial I will demonstrate this technique with After Effects instead. This program is much cheaper, and by some chance you may already own it with one of Adobe's Creative Suite bundles. The only pity is that After Effects doesn't have any real 3D primitives. All it knows is a simple floating rectangle. There are some scripts on the Internet that will glue a lot of these rectangles together to form a 3D sphere, but this is a hack at best and makes After Effects painfully slow to navigate.

Figure 6-92:
A Canon 7D used as secondary camera on set, fully pimped out with PL lens mount and HDMI control monitor.

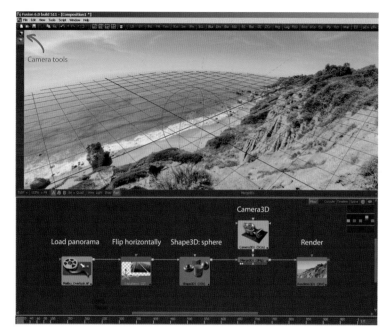

What you need is the Trapcode Horizon plug-in. All Trapcode plug-ins are amazing: Shine, Particular, and 3D Stroke are the favorites of every motion graphics artist; probably not a single trailer aired in the last 10 years that didn't benefit from the use of one of these plug-ins. Horizon plays in the same league. It delivers exactly what we need without much fuss. Just use the free 30-day demo for this tutorial and you'll see. [→ www.redgiantsoftware.com/products/all/trapcode-horizon/](http://www.redgiantsoftware.com/products/all/trapcode-horizon/)

Figure 6-93: *The 3D tools in Fusion and Nuke are perfectly suited for creating fake camera pans. If you're familiar with these professional compositing programs, you should be able to re-create this node tree with ease. For the rest of us, there is After Effects.*

➤ Setting Up the After Effects Project

This is a very detailed walk-through; any photographer can do it, even those without prior knowledge of After Effects. I'll use the GrandCanyon_YumaPoint.tif image. Grab it from the DVD if you want to tag along, which, as always, is highly recommended.

1 Open After Effects and drag the panorama image into the Project area. That's the upper-left section of the After Effects window.

2 Create a new composition by clicking the small icon on the bottom of the Project area. A window should come up, asking for size and length of the movie we intend to create.

3 Pick a preset to match your edit. For example, HDTV 1080 29.97 matches the standard video mode of a Canon 5D. Double-check the pixel size to make sure you're working in a 1920 by 1080 video standard (and not accidentally in the original size of the panorama).

4 Set the length of your movie to, for example, 300 frames (equals roughly 10 seconds).

5 Now drag and drop the panorama image from the Project area to the timeline. The big viewport should come alive. What you see there is an oversized 2D image layer. You could just move it across your canvas now, but that would be the boring type of pan without any awareness of perspective. That's what we're about to change with the Horizon plug-in.

6 Right-click in the timeline area, and choose NEW ▸ SOLID from the context menu. That creates an empty layer, which will serve as canvas for the Horizon plug-in. Name the layer Horizon just to keep things tidy, and leave all other settings at the default.

7 Locate the TRAPCODE ▸ HORIZON effect in the Effects & Presets palette on the right. Drag and drop it into the main work area.

8 You should now see the Effect Controls options show up on the left, replacing the Project area. Initially the plug-in will just render a gray gradient. Unfold the Image Map property and assign our panorama image.

9 Almost done with setup. We still need a 3D camera. So, right-click in the timeline area again, and choose NEW ▸ CAMERA. Pick a wide-angle lens from the presets, such as, for example 20 mm. We can change it anytime; this is just a good starting point.

10 Select the Orbit Camera tool from the toolbar (or just press C).

Congratulations! You have just turned After Effects into a very expensive panorama viewer. Simply click and drag in your main work area and you will see the perspective change in exactly the same familiar way it does in a QuickTime VR. Go ahead, take a look around! ◂

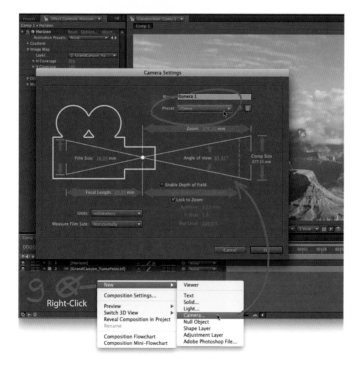

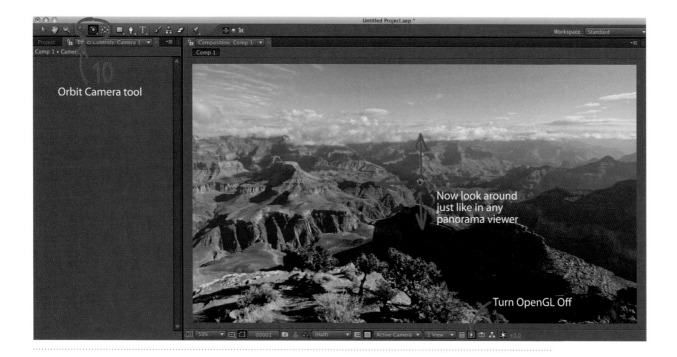

Orbit Camera tool

Now look around just like in any panorama viewer

Turn OpenGL Off

Special tip for optimum performance: Below the main viewport is a tiny icon with a lightning bolt. That's where you can tune the hardware acceleration. Turn off OpenGL to get a cleaner picture while moving the view. The Horizon plug-in renders in software anyway, and OpenGL is paradoxically just getting in the way here.

Anyway, this is our basic scene setup. Time to save the project. If you got lost, you can also grab this intermediate project from the DVD. The fun is just about to start, because now we're going to animate a slick cinematic camera move!

Here's a little snippet of wisdom from Cinematography 101: Camera moves have a beginning, a middle, and an end. Sounds ridiculously boring, but that's some sort of basic rule of the visual vocabulary in filmmaking. Don't go too crazy! I'm sure there are at least 10 interesting views in your panorama that you would love to showcase. Resist that temptation; otherwise, your viewers will get dizzy and tune out. Instead, nail it down to three views: beginning, middle, end.

If there are more spots to show, make that a second shot with a new beginning, middle, and end. Of course, you can always bend or break the rule. Your favorite Hollywood directors do that all the time. But unless you have their skills and experience, it will just look more amateurish. Nothing screams "home video" like a camera that zigzags frantically across the landscape for no good reason. Besides, a classic pan with beginning, middle, and end is much easier to animate.

☞ Animating the Camera

Animation is usually done with keyframes. That means, we only need to set a few key positions and After Effects will take care of the in-between transitions.

1 Orbit the camera to the start position—let's say a nice view of the cliff on the left.

2 Make sure the Camera layer is selected and press P on your keyboard. That should reveal the Position property. You could also unfold all the properties with the little triangle, but that gets messy very quickly. That's why pros just press the first letter of the parameter they want to animate. Impress your friends with your awesome pro skills while keeping the timeline tidy!

3 Click the stopwatch icon next to Position. That makes position an animated parameter and sets our first keyframe.

4 Now move the time slider near the end of the timeline, around frame 250. That allows for about 2 seconds hold at the end, where you can fade off in the edit.

5 Orbit the camera to your end position. I like the outlook on the right, deep into the valley. As you orbit the camera a new keyframe will appear on the timeline, indicated by a small gem symbol.

6 Drag the time slider around to preview the move. You'll notice that the camera automatically takes the shortest route between our two defined viewpoints, which is not necessarily the most scenic route. Let's fix that.

7 Move the time slider to the middle and orbit the camera up. That's our third and last keyframe. If you press the spacebar now, you should see a playback of our perfectly controlled camera pan. Nice.

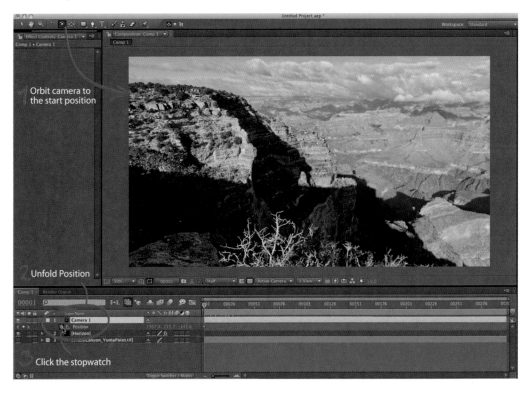

images

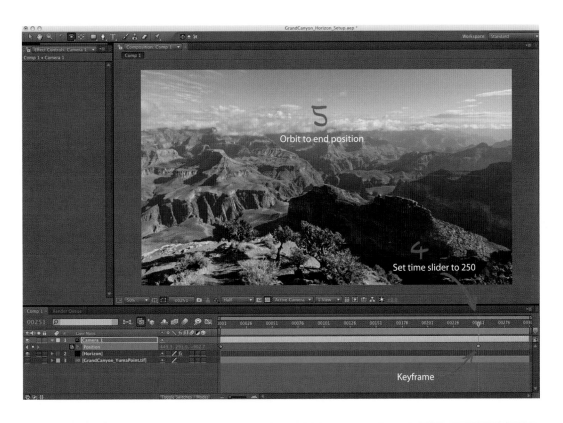

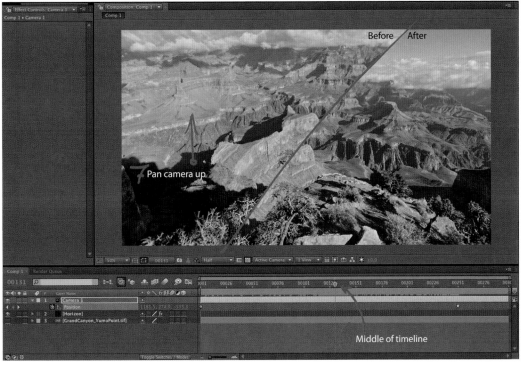

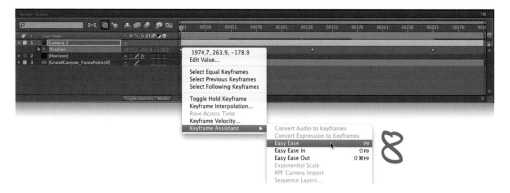

8 Still, it starts and stops quite abruptly. The easy fix is to right-click on the first keyframe and select KEYFRAME ASSISTANT ► EASY EASE.

9 Select the last keyframe and press F9. That's an even easier way to set a smooth ease-in. If you've done it right, the keyframe marker should change from ◊ to)(.

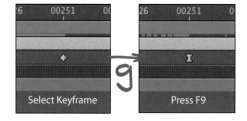

10 That should be it. Press play and marvel at the wonderfully smooth camera pan. Save the project!

11 If you wanted to further tweak the timing, you could select the position track and expand the graph view. This shows the animation speed at each keyframe. For example, you could drag the first keyframe upward, making the start a little bit snappier and allowing the camera to move a little bit slower through the middle position. You could. Don't have to. ◄

➤ Render the movie

A mandatory step, however, is to turn on Motion Blur. Without it, the movie would appear to stutter. Motion Blur really makes the difference between a series of photos and a genuine movie.

12 To enable Motion Blur, check the tiny speeding circle icon in the timeline. It's only needed for our Horizon layer. There is a similar icon above that will enable live preview in the main work area. If you have a very fast camera move, you might need to increase the quality setting in the effects controls (usually the defaults are just fine).

13 Okay, let's export that movie. Go to the menu and choose COMPOSITION ➤ ADD TO RENDER QUEUE.

14 Your timeline will change into an orgy of render settings. Most of them you can safely ignore; they are set by default to the best possible quality. Only the Output Module setting might need some attention. Use QuickTime, and as codec either Apple Intermediate Codec or Photo JPEG. Now set a filename, and you're finally ready to hit that big Render button. ➤

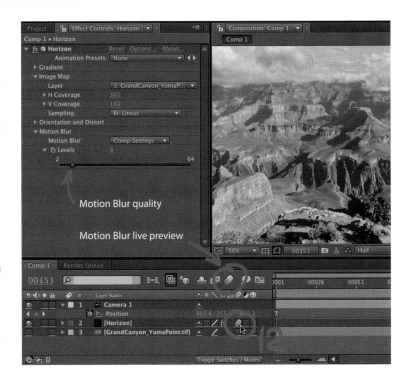

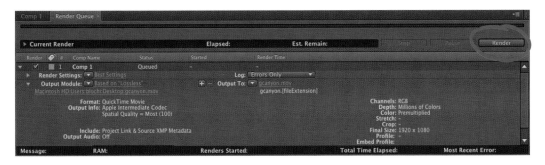

Figure 6-94:
Expressions are powerful voodoo from the secret bag of tricks of advanced After Effects jockeys. They're actually very simple. You just have to memorize the commando keywords.

Where to go from here?

This quick primer was only the beginning. Animation in After Effects is an incredibly deep topic, and there are a million ways to take it to the next level. Here are some ideas:

- Unfold all camera options to expose the Zoom parameter, and animate a smooth push in. You will notice that you can zoom in much farther than expected. As long as you keep the camera moving, you can safely go as high as a 300% magnification without the image breaking apart. Motion blur will smudge the pixels anyway.

- If perfectly smooth animations look too sterile for you, here's how to add a handheld feel: Unfold the Camera/Transform/Point of Interest parameter and Alt+click (Windows) or Option-click (Mac) on the stopwatch icon. That will open a text field on the timeline where you type in the expression "wiggle(1,15)" (without the quotation marks). Play with the numbers until the preview looks right to you. The first number is the speed (1 wiggle per second), and the second is the magnitude (15 pixels).

- Horizon also works perfectly fine in full 32-bit mode. Bring in an HDR pano, and you can animate an exposure effect as you're panning across. Given the title of this book, I should have probably used an HDR image for this walk-through. But I prefer tutorials in bite-sized pieces, so I trust you to transfer the manual dodge-and-burn techniques from section 4.4.5 to After Effects on your own.

- Increase the realism by adding vignetting and some grain. Section 5.2.3 shows you a tutorial on that. I also recommend the Optics Compensation effect for adding a slight fisheye distortion. Even better, use the After Effects version of Magic Bullet for super-cool cinematic looks (see section 5.2.4).

- Since you already have a 3D composition, you can make broadcast-quality titles by adding a 3D text layer.

- You can also add layers with movie clips—filmed or rendered CGI—to enhance the realism. An old classic is a flock of birds that will instantly breathe some life into motionless skies. I've included my favorite birdies on the DVD; feel free to experiment.

You could also create the panoramic camera effect without plug-ins, saving you the $99 for Trapcode Horizon. The alternative technique is quite a bit more complicated though: First you'd have to convert your panorama to cubic format and then use six of After Effects' standard rectangles to build a 3D cube. While not the biggest hurdle for a seasoned compositing artist, this involves too many steps to write down in a detailed walk-through. After all, I couldn't possibly explain it any better than Carl Larsen in his free video tutorial on Creative Cow. Personally, I prefer the easy workflow with Horizon. And no, I'm not getting paid to say that.

If I managed to spur your interest, you can further sharpen your multimedia ninja skills with some online tutorials. Here are some good places to find awesome video tutorials:

⤷ www.creativecow.net

⤷ www.videocopilot.com

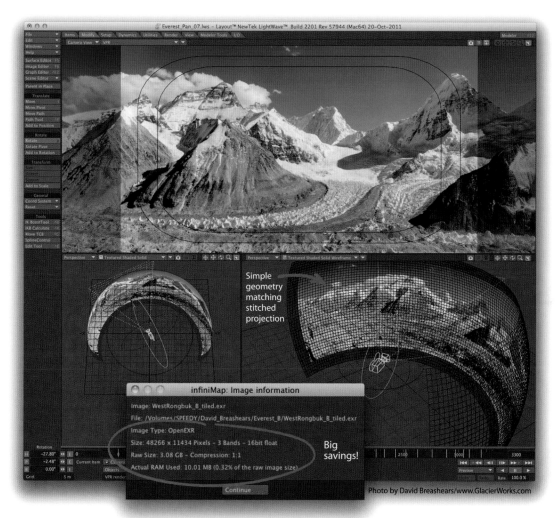

Photo by David Breashears/www.GlacierWorks.com

Figure 6-95:
InfiniMap can handle giant images with ease. Here it renders a 3 GB panorama with a mere 10 MB memory footprint.

The big guns

Gigapixel shooters may not be too happy with the After Effects workflow. These images are a major memory hog, as everybody who has ever opened an image wider than 50,000 pixels in Photoshop knows. After Effects isn't much better. When the image is really big, all the interactivity is gone and rendering becomes unbearably slow.

That's when you have to step up to a 3D program. These programs are built for handling massive amounts of data and can withstand abuse much better. Gigapixel images can be saved as tiled OpenEXR, and with the right plug-in combo (Lightwave + infiniMap, 3dsMAX + VRay, probably others), you wouldn't even have to load the entire image into memory. Instead, only the pixels necessary to fill the viewport are plucked directly out of the huge monolithic EXR file, similar to the way Google Maps reloads a tile when you move the view. Except, of course, it happens without delay. You can animate the camera with fluid interactivity and render with an adjustable amount of motion blur.

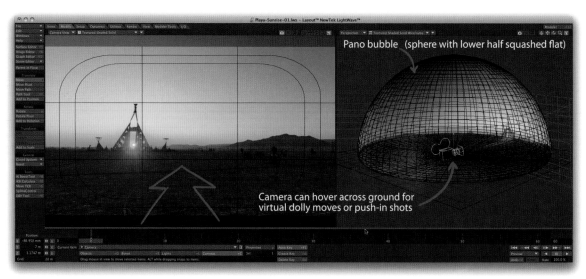

Figure 6-96: *Pano bubbles are not hard to create and already enable small camera moves.*

6.7.4 Pano Reprojection

If you want to go beyond a simple camera pan, you need to use 3D models. Actually, it's a 2.5D technique: just photos with some perspective parallax. For a full-on 3D reconstruction, you would have to rebuild everything from scratch, with accurate geometry and flat-lit textures, then simulate all materials and lighting conditions with fancy algorithms. That's about as stressful as it sounds. But here we're talking about *photogrammetry*.

For photogrammetry, we need only simple shapes that roughly represent our scene. It's only one step up from projecting the whole panorama on a surrounding sphere or box. All we need are some better projection surfaces to hold our photos. The funky part is that the result is typically much more convincing than a full 3D reconstruction. It's guaranteed to look photo-realistic because... well, you're essentially looking at a photograph!

The amount of geometry that needs to be built depends on the complexity of the scene. If you shot the panorama in a wide open area, that can be as simple as squashing the lower half of a surrounding sphere together to form a flat ground. This is called a pano bubble; some call it drop or blob.

It's a fairly common setup and works for a surprisingly large number of locations. It's enough for small dolly moves across the ground, as long as you stay within the proximity of the projection center. The farther you move away from the projection center, the more shearing will occur to elements that are below the horizon. For example, in this Burning Man pano bubble, the sun flare is projected as a long streak across the ground, which looks strange when seen from the side.

To increase the range of motion, you have to add more geometry to the pano bubble. The easiest way to do that is to park the camera in the projection center and then model directly in the camera view. Simple cubes and cylinders can get you a long way with cityscapes and architectural buildings. I made it a habit to create such primitives with several subdivisions because the additional wireframes are excellent guides for matching up the perspective of the background. Since the panorama is projected right through them, you literally just have to

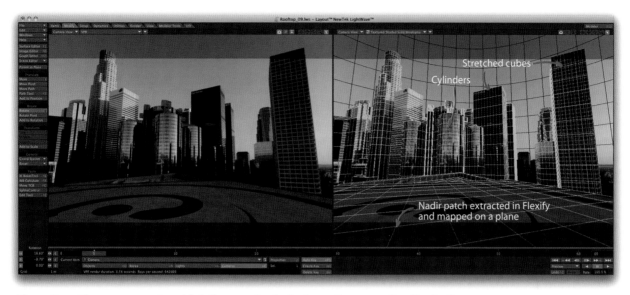

Figure 6-97: *The more geometry added, if ever so simple, the larger the range of motion for the camera.*

move, rotate, and stretch the objects until all the lines in the image match up.

For landscape scenes it's often better to work with amorphous polygon sheets, almost like the digital equivalent of draping cloth. Organic objects also have very irregular silhouettes. Then it's easier to just create the edges with alpha masks in Photoshop and make parts of the panorama transparent. For example, on the rocky cliffs from El Matador State Beach, such an

alpha mask brings in much more edge detail than any attempt at creating accurate geometry for every mossy patch of grass that hangs off the cliff.

Figure 6-98: *Irregular edges are much more easily created with transparency than with geometry.*

With such a roughly reconstructed set we can do a lot of cool things now. Unbelievable and unspeakable things:

- Find a new camera position and animate crane moves.
- See it on a fancy 3D TV or render stereoscopic images.
- Mix different locations together.
- Add new lights and virtually relight the location.
- Seamlessly integrate 3D objects and make them look real.
- Feed the set into a real-time virtual stage system and practically film our next movie on a holodeck.

I'll show you some of these after the break.

6.8 Chapter 6 Quiz

Alright friends, here comes another one of those puzzles that you've grown to know and lo ... —well, know. It's mean, it's treacherous, it melts your brain. And it gives you a warm fuzzy feeling when you actually manage to find all the right answers. Good luck!

1. After Effects plug-in for remapping spherical panoramas, indispensable for creating smooth virtual camera pans.

2. Photoshop filter used to shift a panorama horizontally, wrapping across the left and right edges.

3. Ultra-wide-angle lens with characteristic distortion.

4. Popular brand for universal panorama heads.

5. Optical pivot of the camera/lens system, critical to avoid parallax shifts.

6. High-end slit-scan camera system for fully automatic HDR panorama capturing.

7. Most important person on a movie set, keeping the order and organizing the schedule.

8. Markers to identify features in adjacent images, necessary for successful alignment.

9. Class of images with more than 1000 megapixels.

10. Cheapest method for shooting an HDR panorama.

11. Common shooting technique for capturing only the upper half of a panorama in one shot.

12. Photoshop plug-in for interactive conversion between panoramic projections.

13. Leading professional stitching program.

14. Short for field of view.

15. Rotational axis in a panorama that corresponds to nodding your head.

16. Free panorama stitching program with HDR capabilities.

17. Standard camera orientation for shooting panoramas.

18. Widest possible fisheye lens type, showing a full 180-degree circle.

19. Most common panoramic projection format.

20. Legendary set of open-source libraries and command-line programs that is the foundation for all modern panorama stitching software.

6.9 Spotlight:
Greg Downing & Eric Hanson

Greg Downing and Eric Hanson both have a long history in Hollywood as the go-to guys for HDR panoramas and challenging photographic scene surveys. VFX companies like Rhythm & Hues, Sony Pictures, and Digital Domain relied on their expertise in the creation of blockbusters like *The Day After Tomorrow, Spiderman 3, I Am Legend, Narnia, The Fifth Element,* and many more.

But then Greg and Eric switched gears and decided to put their skills into the service of all mankind. They formed the company xRez Studio, dedicated to applying high-end imaging techniques to environmental preservation and cultural heritage projects. Along the way they pioneered gigapixel panoramas and photogrammetry techniques. They also made the panoramic short *Crossing Worlds,* a declaration

of love to the American Southwest that was shown in full dome projection theaters all the way to China.

Let's get some inspiration from these noble spirits and hear what stories they have to tell.

CB: You have used pretty much every method of panorama shooting, including mirror balls, fisheye lenses, and pano robots. Which method do you prefer?
GD: In the early days of on-set capture, we started with mirror balls. They're cheap, and we already shot them for reference anyway. Almost instantly we switched to real lenses, though, because they just enable an entirely different quality level.

EH: A lot of photographers use 8 mm fisheyes; they're fast and light and deliver enough resolution for a dome or CG lighting. But we're certainly bitten by the resolution bug, so we use 24 mm and 35 mm for spherical panos, and for gigapixel

(which are mostly partial panos, not spheres), we rely on motorized and manual heads.

GD: Well, I think we're actually different minds on this.

EH: True. I got tired of being stung by technology, so I engineered my own little gear tooth mod so I can do gigapixel work with a manual Nodal Ninja head. The reliability issue of motorized heads has been an ongoing problem for us, and this manual solution was born out of the frustration over an epic failure on a mountaintop near Tucson. On the other hand, there is a lot to be said in favor of a motorized approach. We can program it to be very efficient for a spherical acquisition, and we can put the camera in remote places and control it via Bluetooth.

GD: Yeah, we can put a motorized head on a pole, hang it over a cliff or the edge of a building; there is so much flexibility. But we now always have a manual head with us, as a backup. So far we have not come across a motorized head that is really reliable, one that you really want to depend on when doing an important job. And we have tried them all.

CB: How do you find the right spot for a panorama? What do you look for when you're scouting?

GD: Well, it's interesting because you don't have the frame as a guide for composition; you're using other compositional tools. You end up having to "think spherically," think about what is interesting in all the different directions. And then you're using your own position and the alignment between subjects to guide your composition.

Of course it also depends on what your final output is. If you're composing for a print, you want to have the interesting things around the horizon. If you're planning to compose for an online experience, you want to have subjects that have a higher tilt or lower tilt. That's so there is something to see when you're navigating it interactively.

CB: You're also proud owners of the world's biggest tripod. What's the story behind that?

GD: There is this great *PanoTools* email list, a gathering of panoramic photographers from all over the world. And they became focused on creating pole panoramas, which means to find some way to elevate the camera. Everybody was trying painting poles, microphone booms, all that stuff. And someone mentioned this idea of using a flag pole. So we eBay'd ourselves one of these segmented lightweight aluminum flag poles.

EH: That's right. It actually came with an American flag on top. And then we started by using this single pole, put our Rodeon motorized panohead on top, took that over to Norway, and shot from an infamous 2,000-foot wall called the Pulpit. And the way this would work with a single pole is that we tied it down with leech lines for stabilization. So here we had about $10,000 of photographic gear on a 20-foot wobbly pole, with three guys holding these leech lines, trying to erect it next to a 2,000-foot drop. And I mean, literally, right next to it. This was a rather frightening event.

GD: Hee-hee, we made sure our insurance policy was up to date for this.

EH: I think we were able to get a fairly stunning image from there—it was definitely an original point of view for that location. But right

after that, we were so terrified that we decided to change it to a three-legged configuration. We purchased a few more of these flag poles, and we came up with a device to have a joint at the top. The setup is much easier now: We have two legs on the ground, and pull on the third to hoist it up into a giant tripod. And that seems to be working pretty well.

CB: Gigapixel panoramas are images with more than a billion pixels. Isn't that overkill?
GD: My own pursuit for gigapixel photography was initiated by a dissatisfaction of photographing vistas. I've been working as a panorama photographer for a number of years, and I would go to these amazing locations with these beautiful vistas. And then I come back, look at the photo, and I just don't have that same response I had standing there. It took me a while to figure out: It's the *detail* that's missing—and that was really the stunning part of the vista. But when I shot my first gigapixel image, I thought, "This is *it! This* conveys what it's like to stand in this place and have this view." So that was the motivation for me to capture gigapixel imagery.

It's true that for many people it has become some sort of race just for technically processing more pixels than anyone else. Many achieve that, but the pixels they're processing aren't really worth much. For example, if you have nothing but blue sky, why would you take 500 images of an empty blue sky when that could be easily created with a smooth gradient from a smaller number of shots? At extreme zoom levels you also get sharpness issues from lens diffraction, depth of field limitations, and atmospheric conditions such as heat shimmer and haze. You can also add de-bayering to that list, dropping the actual detail yield by almost 30 percent. So there you are, processing more pixels, but you're not gaining more detail. We actually down-sample our images according to Ken Turkowski's 70% rule, so when zoomed in all the way you still get a sharp image. That feeling of detail and sharpness is what we're

after. The race for more pixels is not that interesting to us, but the race for more *detail* is.

CB: Yet, you're still holding a pole position in that race with a massive 45-gigapixel image of the entire Yosemite Valley.
EH: That was done for a geologist who studies rockfall. We gave him 20 separate gigapixel images taken from different locations, which is a snapshot of the entire valley. The aggregate of that is 45 gigapixels. But within the scope of this project, I wanted to create a piece of artwork too, that was derived from all these 20 panos. We used a 1-meter DEM (Digital Elevation Model) to act as a baseline to project all these pixels onto in Maya and created a 150K orthographic view of the valley in Mental Ray. That's a linear view of the whole valley, which nobody has ever shot, or could shoot without computer graphics. That was the really big image we created, but that was done strictly for art, not for geologic purposes.

But the geologists continue to derive good use from the 20 images, which are used to document rockfall. Re-photography is the main way that they can actually calculate volume, weight, and the release mechanics of rockfall. So this was probably one of our more valuable projects, as far as public safety or welfare is concerned.

GD: So yeah, that is 45 gigapixels of imagery

accessible to the viewer. It is a collection of gigapixel images from many different angles. All the imagery is showing useful detail. You're never zooming past the degree where you're actually getting more detail.

CB: When your images have primarily documentary purpose, how much post-processing do you allow yourself, and where do you draw the line to artistic interpretation?
EH: Not enough, certainly. Part of the reason for forming our own company was to get away from computers and actually get back into nature. But it's proven to be a catch-22 because we come back with three times the amount of work we had before. It's because we have so much to process that we generally don't spend enough time on the treatment of any single image. I have a big desire to go back and re-address a lot of them. Most of our images are pretty much out-of-camera, with just a general grading made.

CB: Let's talk about your award-winning short *Crossing Worlds.* **How did you shoot that?**
GD: That was actually made primarily from spherical panoramas, shot with either a 20 mm or 35 mm lens. We also shot some time-lapse sequences, some of which were shot with a fisheye, some with rectilinear lenses, and then composited into spherical photos from the same locations.

CB: You mean even when we see a camera move in the film, you did not actually move a physical camera?
GD: That's right. It was all from stationary positions but animated with camera projection in Maya.

EH: That little film was really a production test for a feature film on the Grand Canyon that's destined for the dome theater. While Greg and another photographer were spending three weeks on the Colorado River, I was busy creating a workflow for all those images that were to come. And to do so, I went through our library of panoramic images. Another friend of ours, Gene Cooper, also brought in a series of images from the Grand Canyon. The primary thing about that dome film was using Maya to create cinematography from static images through camera projection and virtual camera moves. It was really a workflow development project that turned into a short film.

GD: What really motivated us is that in the world of dome theater, you're talking about a 4K hemispherical projection. And right now there is a gap between the available technology for capturing and projecting this type of imagery. The projection problem is solved. But there is no live-action camera capable of shooting this. So what you get in a dome theater is primarily 3D rendered work. And due to resolution requirements and the budgets available for these types of

films, the 3D artists have to go through a whole series of cheats. You end up with this 3D that looks like it's a couple of years behind of what you see in feature film and television. We wanted to do a completely different type of cheat that allowed us to sample from the real world and bring that to the dome. And that's what using the real photographic imagery and re-projection techniques allowed us to do.

CB: So your initial capture is really just a scene survey, and the computer then becomes the camera you're actually shooting with.
GD: That's right. This way we have a lot of additional flexibility. The panoramas we were working off had much higher resolution, so we weren't limited to 4K output. When we started, there were only 4K domes, but after DomeFest several 8K domes were installed in China. Really amazing dome theaters, stereoscopic even. So we were able to take the same material, and because we already had the geometry, we could re-render that for stereo, and because of all the resolution we had, we had 8K native material ready for dome projection.

CB: That's fascinating. Well, we have to come to an end, so the last question is, What's your top advice to HDR pano shooters?
EH: Don't let the tail wag the dog with technology! We're all interested in fusing art and tech-
nology, but remember this: Ultimately *we* are the arbiter of the aesthetic of the image.
GD: And I think really spending some time to understand the underlying principles is important. You'll get a lot of advice from people, like, "Ah, just go and take three brackets, and you've got an HDR." But you know, that's just not adequate enough to say that's a good representation of any scene. Once you understand the nature of HDR and what it really is, you can take the right photo given the scene that's in front of you.

CB: Thank you so much.

Greg's and Eric's work looks much more impressive as interactive presentations on xRez.com. Eric is a VFX professor at the University of Southern California, and both teach courses at the Gnomon School of Visual Effects. Greg and Eric also have some excellent tutorial DVDs on digital sets, image-based modeling, and photogrammetry in the Gnomon Library, if you prefer couch studies at your own pace.

Chapter 7:
Image-Based Lighting

In the eighties, the term computer-generated imagery (CGI) was introduced. CGI is a way to create believable pictures of virtual objects, images of things that don't really exist in the material world. These virtual things consist solely of geometric descriptions, which are designed in a 3D application or scanned in. Render algorithms form the virtual counterpart of a camera and allow taking a snapshot of this data.

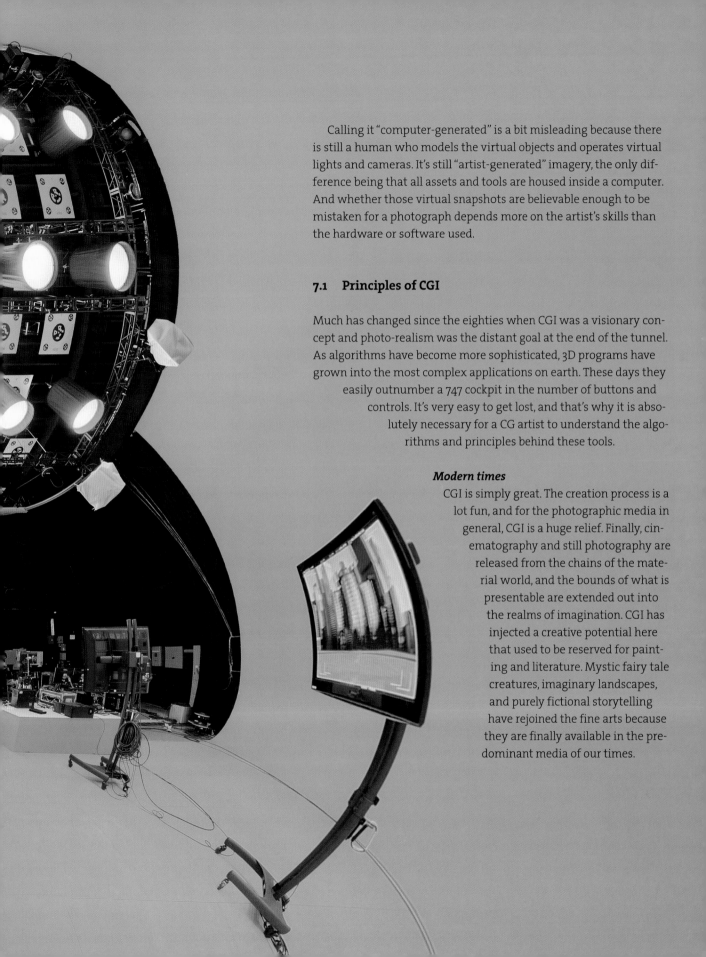

Calling it "computer-generated" is a bit misleading because there is still a human who models the virtual objects and operates virtual lights and cameras. It's still "artist-generated" imagery, the only difference being that all assets and tools are housed inside a computer. And whether those virtual snapshots are believable enough to be mistaken for a photograph depends more on the artist's skills than the hardware or software used.

7.1 Principles of CGI

Much has changed since the eighties when CGI was a visionary concept and photo-realism was the distant goal at the end of the tunnel. As algorithms have become more sophisticated, 3D programs have grown into the most complex applications on earth. These days they easily outnumber a 747 cockpit in the number of buttons and controls. It's very easy to get lost, and that's why it is absolutely necessary for a CG artist to understand the algorithms and principles behind these tools.

Modern times

CGI is simply great. The creation process is a lot fun, and for the photographic media in general, CGI is a huge relief. Finally, cinematography and still photography are released from the chains of the material world, and the bounds of what is presentable are extended out into the realms of imagination. CGI has injected a creative potential here that used to be reserved for painting and literature. Mystic fairy tale creatures, imaginary landscapes, and purely fictional storytelling have rejoined the fine arts because they are finally available in the predominant media of our times.

Here is an important fact about the time necessary for creating a visual effect: It's split up into the time required for rendering (machine time) and the time required by an artist to create the scene and set everything up. Machine time is an asset that is easier and cheaper to extend, whereas artist time is not an endless resource. At least it shouldn't be seen that way, and companies that *do* work on that premise have a hard time finding good artists. Instead of filling cubicle floors with undergrad interns who slave away all night for the price of a pizza, it's a much healthier strategy to keep a team of experienced veterans around. And the time of such veteran artists is valuable.

So, let's talk about rendering techniques with an eye on these two restraints: machine time and artist time. The trick is to balance these two factors by utilizing advanced techniques for the creation process and rendering. You'll see that there is a fundamental difference between classic rendering and physically based rendering.

7.1.1 Traditional Rendering

In traditional rendering, it doesn't matter how exactly the image is created as long as the final result looks photo-realistic. Typical rendering methods in this category are *scanline* rendering and *raytracing*. They're both based on simplified shading models like Phong and Blinn, and the general term used to describe the lighting model is *direct illumination*.

As diverse as 3D programs might look, direct illumination is the foundation on which they are all built. Light sources are defined separately from geometry, and they can have properties that would be impossible in the real world. Point lights are defined as one-dimensional items, which means they are simplified to an infinitely small point in space without any physical size whatsoever. The light itself is assumed to travel in a straight line to an object, and when it hits, we get a pixel for our image. Where it doesn't hit, we get a shadow. It's a sim-

Figure 7-1:
Even the producers of the popular TV series Chuck are not really allowed to fly a heavily armed Predator drone over the Hollywood sign. Done all digitally by Eden FX.

Nowadays, CGI is used on a daily basis to extend film sets, advertise products that haven't been made yet, and perform dangerous stunts via virtual stunt doubles. Directors and writers are fully aware of all the possibilities, and they enjoy the new narrative freedom. They trust the artists to create anything they can imagine, and they simply expect seamless integration with live-action footage. Photo-realism is the standard, not the exception anymore. That even counts for episodic television, where a new show has to deliver as much as 20 special-effects shots every week. You'd be amazed at how much you see on TV that is actually not even real. The bar is set high on the big screen, and even in feature-film production the trend is moving toward demanding perfect quality in less and less time.

ple triangulation process that completely fails to acknowledge all ethereal and most physical qualities of light. For example, the way light fades with distance is often neglected, and even when it's not, it is calculated with a linear intensity falloff, in contrast to the physical truth of the inverse square law known since Newton. Another popular light definition is parallel light, shining from an infinite distance at the scene with constant intensity all over. Or take ambient light, which supposedly comes from nowhere and brightens up all surfaces equally.

All of these are abstract models, with the purpose of simplifying calculations and reducing the machine time necessary for rendering. Armed with such crude tools to work with, we're now supposed to create a photo-realistic image. We sure can, but the creative process has more in common with painting than photography.

Faking it all together

Let me show you an example scene. By default it contains a single key light, which is considered the basic ingredient of any lighting setup—just as in a photo studio. But in CG a simple key light doesn't have the same effect. The image doesn't look close to photo-realistic at all.

Figure 7-2: *The default lighting suffers from a serious lack of realism.*

It takes a lot of time and effort to create a believable lighting situation by hand. The first step is usually to fuzz up the shadows and add some fill light. Then we have to take into account light bouncing off the wall, reflecting back onto the oranges. So we place a rim light that doesn't affect diffuse shading and doesn't cast shadows at all. It only generates a highlight. These two lights are pretty much standard procedure. Aside from leveling up the realism, fill and rim light also serve as essential creative tools.

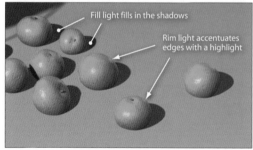

Figure 7-3: *Fill and rim lights are used to add realism and design the lighting.*

What's harder to create is the subtle effect of blocked light in crouches and corners. That's called a *contact shadow*, and it's an almost subliminal visual cue that tells us that objects are touching each other and things are standing firmly on the ground. Direct illumination can't provide that, and so we have to resort to old-school tricks. One of them is to distribute negative lights in strategic areas.

Negative lights

I know. You're probably wondering: What in the world is a *negative* light? Well, if you set the intensity of a light source to a negative value, it will subtract light from the scene instead of adding it.

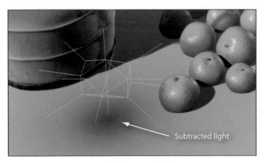

Figure 7-4: *Negative lights eat light away.*

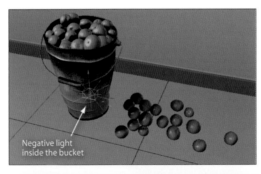

Figure 7-5: *Strategically placed negative light produces a subtle contact shadow.*

Essentially, it is an independent soft shadow that can be simply placed anywhere you want. For that to work properly, actual shadow-casting and specular influence have to be turned off. Otherwise all lighting effects are inverted:

Shadows become brighter and highlights are black. Negative lights are a bit hard to handle because they have no pendant in the natural world and perhaps with the exception of some hardcore experimental physicist, nobody has ever seen one. There's nothing intuitive about a negative light. It's always best to use a small falloff radius to keep it local, eventually even constrain its influence to particular objects.

Shadow mapping

An easier way to make soft contact shadows is by using several shadow-mapped spotlights. Shadow maps are generated before the actual rendering and are artificially softened with a blur factor. It's not very precise, but it's fast. When you shine a bunch of these lights from different angles, their shadows blend into each other and become even smoother. They also add more ambient light, of course, and a common trick is to change each light's colors just ever so slightly to bring some subtle variations to the overall light quality.

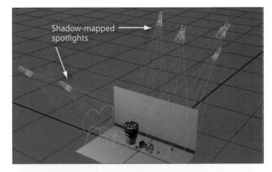

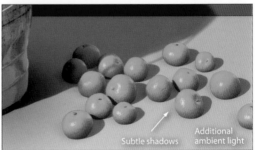

Figure 7-6: *Using shadow-mapped spotlights is a cheap way to add subtleties.*

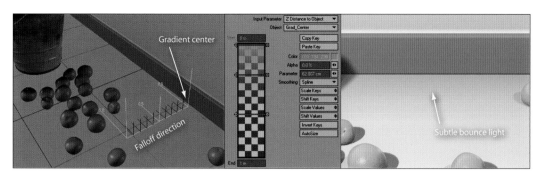

Textures and ramps

But it still doesn't look real. It's missing the bounce light that reflects off the red trim. Some of the light should be thrown back onto the ground and cast a reddish sheen right next to that trim. So we have to pull another stunt. Lighting trick number 3 is to paint that effect into the texture. This can be done in Photoshop or directly within the 3D program by using gradients (a.k.a. ramps).

A gradient has a center and a falloff. In this case, the falloff is set to a simple Z direction. When we place the center right in the corner where the floor meets the wall, this is where the maximum coloration will happen. After 1 meter, my gradient becomes transparent and the coloration falls off.

After a couple more gradients, spotlights, and negative lights, the scene looks reasonably realistic. That took me about 2 hours to set up, but it rendered in 2 seconds. More experienced lighting artists are faster. But it's hard. All the subtle nuances inherent in real-world lighting have to be interpreted by the artist and manually created in some way. The ways to achieve this are sometimes mind twisting, sometimes just tedious work—not everybody's piece of cake.

All the big 3D packages that are commonly used in production—Maya, 3ds Max, XSI, Light-Wave, and Cinema 4D—are initially based on this principle. Their user interfaces are all built around a direct illumination paradigm, and all those thousands of buttons and sliders are there for the user to find just the right settings to make the cheat work. Even RenderMan, the render engine used for all of Pixar's movies and the choice of high-end VFX studios worldwide, is at its core a plain scanline renderer and requires all these tricks and hacks. Photo-realism is certainly possible with all of these programs, provided you know your render engine in and out and have the experience to use the most abstract light definitions to your favor. It also requires a strong painter's eye; you have to be aware of all the subtle lighting effects that a regular person might not even notice. But people would notice for sure when that "certain something" is missing, even though they couldn't describe what exactly it is.

However, this approach has two major advantages: It renders incredibly fast, usually close to real time. So you have all the feedback you need. And you have total control over the result. Similar to painting, you simply do what looks right to you, not what is physically correct.

Figure 7-8: *Final rendering with manual lighting setup.*

Figure 7-9:

Rendering with global illumination automatically takes bounce light into account.

Figure 7-10:

Radiosity repeatedly fires a number of rays to determine the indirect illumination.

7.1.2 Physically Based Rendering

On the other hand, we can simulate light behavior strictly according to the laws of physics.

For the image above, it took me just the flip of a button to turn on *global illumination*. That really takes from zero to hero without any effort on my part. The scene still contains only a single key light, but it looks fairly realistic right out of the box because all the bounce light is taken into account automatically. Global illumination (GI) is the collective name for a variety of physically based rendering methods, all based on different approaches to calculate the bounce light.

Radiosity

One method that is already considered a classic approach is radiosity. Here the entire scene is divided into small patches, varying in size depending on corners and roundness of the geometry. Then the *received, absorbed,* and *scattered* amount of light is computed for each patch. That's done by shooting a number of rays into random directions. Essentially, a small fisheye image is rendered that shows the scene from the perspective of this patch—the median brightness and color of this crude fisheye rendering represent the received amount of light. In this example, if the patch in question is in the small crammed space between two oranges, it will mostly see orange and thus receive orange light.

Now we just have to look at the material settings to see which colors of the light are absorbed and to what extent. We'll subtract the absorbed light from the received. What's left is the scattered light, which is the optical property responsible for the appearance of the patch in question. This step gets repeated, but this time the scattered light from the pass before is taken into account. Sounds all scientific and complex, but in layman terms that just means that on the second run each patch can see the previously determined appearance of all the others in the small fisheye renderings. Each of these iterative passes delivers one additional level of bounce light. It usually takes about two to three bounces until a fairly comprehensive model of light distribution is formed—the radiosity lighting solution.

It's a pretty slow process because the scene essentially needs to be rendered over and over again from a million possible viewpoints. The number of ray samples (i.e., the resolution of each fisheye image) is the deciding factor for image quality, but it can also have a devastating effect on render time. That's why real-world render engines include several optimizations and shortcuts. The trick is to make every sample

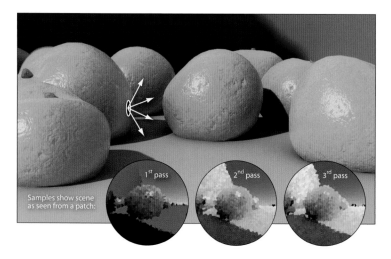

Samples show scene as seen from a patch: 1st pass 2nd pass 3rd pass

count and place the patches where it matters. Sophisticated stochastic formulas are used in what is known as the *Monte Carlo* method to predict the optimum patch size and placement.

A specimen of a highly optimized Monte Carlo render engine is Arnold. It has been around since 1999 but was never officially released. Only a few hand-picked studios have access to Arnold. Sony Pictures Imageworks, Framestore, Luma Pictures, ILM, and a few more of the big guys use it on a regular basis to render blockbuster movies, and they also made significant contributions to Arnold's code itself. Right now Arnold is one of the hottest trends in the industry, and I wouldn't be surprised to see widespread adoption once it becomes available to the public. Anecdotally, this render engine is in fact named after Arnold Schwarzenegger—so the name is properly pronounced as *Arrrnoald*.

Photon tracing

A different approach to global illumination is photon tracing. Here the light is split up in defined quantities of photons and we follow their path as they bounce around between the objects again and again. With each collision, some of these photons get stuck to the geometry. The others keep bouncing until eventually all photons are used up or a predetermined number of bounces is reached. This is done as a separate calculation before the actual rendering, and the final distribution of all photons is collected in a photon map (hence this method is also called *photon mapping*). The collection process itself is called *final gathering* and fills in the gaps between actual photon collision spots with smooth interpolation.

The principal advantage over Monte Carlo radiosity is that photon mapping doesn't slow down as much with each additional bounce because the photons get used up more and more. For the fifth and sixth bounce, there is only a handful of photons left. When these photons travel through glass, they can change the path

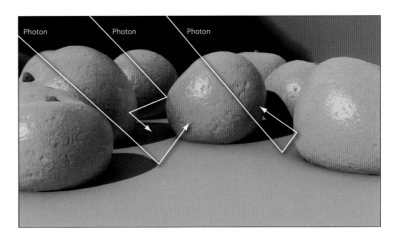

according to the refraction index, so we get beautiful caustic effects for free. On the flip side, the renderer has to work harder on large scenes and tight corners. It's like throwing a bucket of Ping-Pong balls into your apartment—chances are quite low that they will land inside the coffee cup across the room. To increase the odds of reaching that far, you'd need to throw large amounts of Ping-Pong balls (or trace a lot of photons).

Many popular render engines fall into this class. The most common example is mental ray; it used to be a separate render engine that enjoyed a brief run of popularity until it became integrated as a standard option in Maya, 3ds Max and XSI. Right now all the rave is about V-Ray, which has become the de facto standard renderer for architectural visualizations. V-Ray now contains many speed optimizations, which grew directly out of rendering practice, and so it is increasingly used for game cinematics and movies. Brazil and finalRender are two other path tracers. All these engines differ mostly in the shortcuts they take for getting a good result with fewer photons.

Unbiased renderers

There is a special category of render engines that don't take any shortcuts. These are called *unbiased,* and they simply keep throwing

Figure 7-11:
Photon tracing lets light particles bounce around like Ping-Pong balls.

Figure 7-12:
Bright objects automatically illuminate the scene.

photons until the image doesn't change anymore. They do not interpolate the missing spots in a photon map. They don't help any photons through narrow passages. They don't make any assumptions on where the photons should be distributed for maximum effect. They don't even limit their calculations to RGB color components but rather calculate physically correct wavelengths across the entire spectrum. That makes them extremely accurate, down to correctly simulating obscure optical effects like the chromatic light dispersion on a prism. But it also makes calculations painfully slow.

Maxwell, Indigo, Octane, and Fryrender are some examples of such unbiased spectral renderers. They are typically used to render high-quality still images for product design and architecture. In the film industry they play a minor role, mostly for providing an accurate reference image that is to be matched more efficiently with a biased render engine. But Moore's law is definitely on their side, and on tomorrow's pocket-sized supercomputers, the unbiased renderers will certainly triumph over the rest.

The basic premise of them all

One important principle is common to all global illumination renderers: The strict distinction between objects and light sources is abolished. Lights are just luminous objects themselves,

and when an object is illuminated brightly enough, it starts to act as a light source on the rest of the scene again.

Ten years ago these kinds of simulations could be found only in specialty software for spectral analysis, lighting design, and architectural planning. For purely artistic purposes and commercial animation work, these calculations were way too elaborate and the software much too specialized. Even though pioneering programs like Lightscape and Radiance were able to perform physically based rendering, they needed hours or days for a single image and they had to be operated via command-line scripting.

Today it's a whole different story. All traditional 3D applications offer a global illumination (GI) mode. Several simplifications to the algorithms make it work in a production schedule. In some cases, the simulation was built on top of the classic render engine—for example, in LightWave or Cinema 4D. That makes GI appear as fully integrated, and it is operated by the same controls that were originally designed for the classic engine. In other programs, which where built in a modular architecture to begin with, the render engine can be swapped out entirely. Maya, 3ds Max, and XSI are such modular programs. They've all got mental ray implanted, and it can be swapped out for the other render engines I mentioned. After such a surgery, the user gets presented with an all-new set of material and light controls and the old settings for the classic engine disappear or become invalid.

Physically plausible materials

To many artists, the GI mode appeared as yet another new feature. With such seamless integration, it's easy to forget that GI resembles an entirely different way of rendering that affects not only lights but material definitions as well.

One common misconception is the role of specular material parameters. They used to be the way to define glossy materials, but they

have absolutely no influence in a radiosity simulation. That's because they were a cheat to begin with. In the real world, highlights are the reflection of light sources. But since classic raytracing cannot follow a reflection ray to a one-dimensional point in space, a reflected light cannot be computed that way. Specular highlights, as they are used in classic rendering, are just simple dots painted on the surface. You can set the brightness and sharpness of these dots, which arguably gives you some creative control, but nevertheless this is a hack and has nothing to do with the shiny appearance of real-world materials.

Figure 7-13: *Reflection is the physically correct way to render specular highlights.*

In a simulation environment, however, objects and lights are all one thing. Lights do have three dimensions now; they have a shape and they can be reflected. Reflectance is a much better-suited material property to model highlights simply because reflection is the real-world physical phenomenon causing highlights. Whether such highlights show up

as a sharp sparkle or a smooth sheen was traditionally defined with a glossiness or highlight spread parameter. These parameters are invalid again; they only apply to the old painted-on specular hit. Instead, we set the roughness of the surface accordingly or use reflection blurring—just as in the real world.

Another concept that has gained importance with physically based render methods involves using *energy-conserving materials*.

Sounds like a mouthful, but all that really means is that an object cannot emit more light than it receives. The sum of all absorbed, scattered, and reflected light can't be more than 100 percent. It's not a new concept at all; it just has a fancy name now. Even for traditional rendering the rule of thumb was to keep all material parameters in balance. If an object is defined as 80 percent reflective, the diffuse parameter should be 20 percent maximum. Calculating the total sum gets a little trickier when you also need to consider exotic effects like subsurface scattering, Fresnel reflections, translucency, anisotropic reflections, and whatnot.

That's why most physically based render engines come with their own shaders that are internally wired to not even allow unrealistic settings. Those are the energy-conserving materials. You're doing yourself a big favor if you use them. Otherwise, you should at least ensure that your material definitions are physically plausible.

7.1.3 Rendering with Natural Light

You might have guessed it by now: When traditional lights are substituted with luminous objects, there is a huge potential to make use of HDR imagery. Remember, the sole nature of HDR images is to preserve real-world light values, accurate in intensity and color. Surrounding a 3D scene with an HDR environment literally casts this natural light into the virtual world. That's the essential idea behind image-based lighting (IBL).

Figure 7-14:
IBL means all the light rays captured in a panoramic HDR image are used to illuminate a 3D scene.

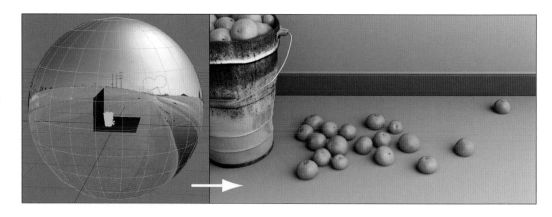

Figure 7-15:
Swapping the HDR image with a different one changes the lighting completely.

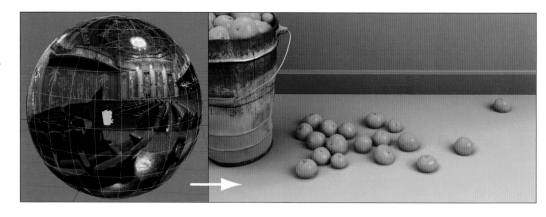

Now, this is kind of a paradigm shift. With the old-school method of lighting, it took a seriously talented and experienced artist just to arrive at a photo-realistic look. Shooting and applying an HDR environment is more of a technical achievement. It's a craft that everybody can learn, right? But does that mean there is no more need for skilled lighters? Where is the fun in making a scene look great by applying some obscure set of HDR data? Where is the creative challenge? And most important, where are the levers to pull if you want to take control over the look and feel of the final result?

Well, consider this: Traditional lighting is a craft as well. It's not just artistic talent. Tons of books out there teach it in step-by-step tutorials. It's just that with HDR lighting, photo-realism is the starting point instead of the distant goal. So you can spend more time working cre-

atively on the intended look. Traditional methods can easily get mixed in, so all the old tricks remain valid. And it also throws up a new challenge: optimizing a scene so it can be rendered within a reasonable time. The truth is, while basic HDR lighting is set up with a few clicks, render times for global illumination can go through the roof. Creative tweaking needs fast feedback just so you can try things and take the scene though a couple of variations. And we're back to the topic of finding a good balance of machine time and artist time.

However, let's not rush it. Let's first take a look at the straightforward technical craft and then find out where the playground is and how we can bend the rules in our favor.

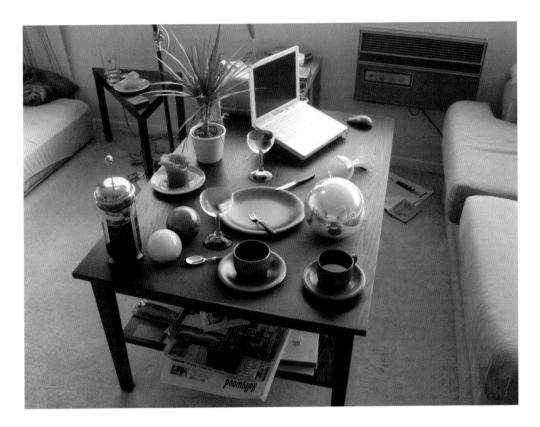

Figure 7-16:
My apartment shall be the testing ground for a brute-force render study.

7.2 Brute Force Simulation: A Feasibility Study

Image-based lighting was pioneered in 1998 by Paul Debevec and Greg Malik. In their SIGGRAPH presentation "Rendering with Natural Light," they demonstrated the basic principle quite impressively by pimping up the Radiance render engine with a lot of custom programming. Five years later, in 2003, we asked the questions, How far has IBL trickled down to commercially available software packages? Can it be used in production without writing a single line of code? Is it ready for prime time yet?

So, let's find out!

Our case study takes a look at the most basic approach to IBL. By basic, I mean the HDR image is the only light being used—no artificial lights whatsoever. No optimizations, no cheating, no extra tweaking! Just brute-force global

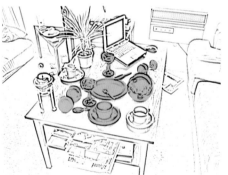

Figure 7-17:
Map of the objects that aren't really there.

illumination. This is exactly how IBL is described in the manual of your 3D software.

Even though this section is not a step-by-step tutorial, you should have no problem recreating this case study with the material provided on the DVD. It may seem like I'm heating up an old stew here, but even after 10 years this apartment scene represents an excellent sandbox for taking your first steps into the world of image-based lighting.

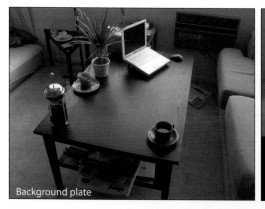
Background plate

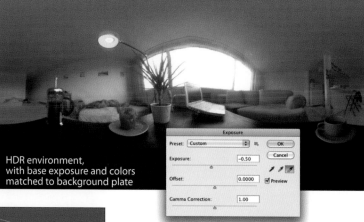
HDR environment,
with base exposure and colors
matched to background plate

Some simple 3D objects

Figure 7-18:
The basic ingredients are all on the DVD.

The basic ingredients

The starting point is a photograph with an empty table. That's called the *background plate*. I also placed my trusty mirror ball in the center of the table and shot an HDR environment. If you read section 6.3, you know exactly how this image was created.

In this case, the background plate happens to be an HDR image as well, just for the sake of simplicity. In a real visual effects production, however, the background plate is not under your control. That's what the cameraman shot, most certainly on an entirely different camera and with a very different color balance. By the time the plate lands on your desk it may even have gone through some extensive color correction.

So, the very first thing you need to do is match the HDR environment to the background plate. At the very least you need to match the base exposure, and this needs to be a persistent change on the pixel levels. Photoshop's IMAGE ▸ ADJUSTMENTS ▸ EXPOSURE EFFECT works well for this. Eyeballing is typically good enough. Simply play with the exposure slider until objects that can be seen in both images are roughly the same brightness. Don't worry about overexposed areas (they will be preserved in the HDR headroom); what you need to match are objects in the midtones. In this example, the green couch and the red candle are good points of reference. Even better reference would be a color checker card. Section 3.3.3 contains a few nice tutorials on adjusting white balance in HDR images in case you want to go further with the matching, but that's not as critical as matching the base exposure.

I also modeled some simple objects to populate the table.

Note that the coordinate system is anchored right in the spot where the mirror ball was placed. That's the 0,0,0 coordinate—the center of our 3D universe—from where the sampled lighting stems. The lighting from our HDR environment will match less accurately the farther we move an object away from this point.

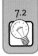

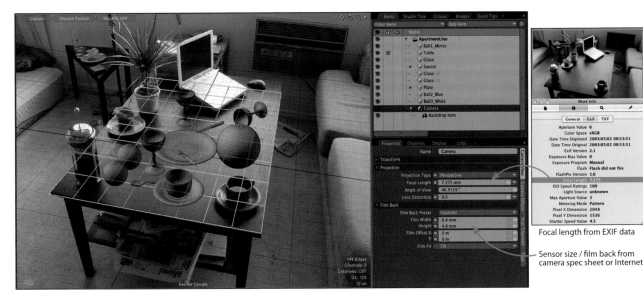

Focal length from EXIF data

Sensor size / film back from
camera spec sheet or Internet

Where does the environment image go?

Good question. You could map it on a large
luminous sphere made of polygonal geometry.
But that would be highly inefficient; it would
be wasting one global illumination bounce
just on that sphere. To simplify things, each
renderer has a special slot for the HDR image,
called environment material, texture environ-
ment, or something like that. In each case, that
will simulate a sphere of infinite size surround-
ing the scene.

Eyeballing the camera

Now it's time to match the camera perspective.
It makes our life a whole lot easier to start off
with the same zoom setting as the real camera.
To match that we need two numbers: the film
size and focal length.

Film size (also called film back or sensor size)
defines the crop factor, and it's easy to find in
the camera's manual. There are also an abun-
dance of websites where you can look up the
film size. My favorites are www.abelcine.com/
fov for movie cameras and www.dxomark.com
for photo cameras.

Focal length is next. Because this background
plate was shot with a digital still camera, we're

fortunate enough to know the focal length from
the EXIF data. If it were a real-world effects
shot, we would now rely on the notes that our
buddy the VFX supervisor took on set. Taking
notes on the lens information for each shot is
one of his most important responsibilities. If he
was busy chatting with that makeup girl again,
we need to have a serious talk later, but for now
we'll just stick to our best guess.

Once we have focal length and film size
right, our 3D camera has the same field of view
as the real one. That was really the whole point
of matching these numbers. Now the camera
perspective is easy to match by eye. The 3D
grid provides a helpful reference, and even bet-
ter is some rough geometry that indicates the
significant perspective lines. A common trick is
to subdivide large walls or flat surfaces several
times so we get a fine grid of polygonal lines as
visual guides for matching the perspective. In
this example, we just move and rotate the cam-
era until the virtual tabletop sits right on top of
the real table.

What we put on the table

In this case study, the objects were mainly cho-
sen for technical reasons. We have a big mirror

Figure 7-19:

*Matching the per-
spective: First set
the focal length and
film back according
to the real camera,
then move and ro-
tate the CG camera
until all perspective
grid lines match up.*

Use mirror ball
as guide for aligning
the HDR environment

Match the tableware
materials, using reflection
as specular component

Figure 7-20:
*Next challenge:
match the
materials!*

sphere, which allows quick evaluation of brightness, orientation, and mapping type of the HDR environment. Starting with a 3D mirror ball is a very common trick and highly recommended because it makes it so much easier to set up a scene with HDRI. Usually, you'd just make it invisible for the final rendering.

Also, we have two material test balls on the left, representing a glossy and a slightly dull object. There is a strong backlight from the large window panes showing up in all reflections and highlights. So when creating the materials, we really need to take care of reflective material properties, formerly known as specular components.

The wine glasses are there to find out if the renderer handles transparency and refraction right. Because those are usually computed via raytracing, this is questioning how well the radiosity and classic render engine go hand in hand. And just to be mean, I put a fake coffee

cup right next to the real one. Nothing could be harder because even if the coffee cup looks photo-realistic by itself, it still has to stand the comparison with the reference. Now, that is a nice little challenge!

Crowd-sourced learning experience

To test the scene in a wide variety of 3D packages, a study was conducted online. Christian Bauer provided an open forum on www.CG-Techniques.com, where we initiated the *HDRI challenge*. The scene was converted into all kinds of standard formats and made available as a free download, together with the background plate and HDR environment. Then we invited artists from all over the CG community to put their tools and talent to the test.

The response was overwhelming. Within a month, 200 volunteers participated by posting their results.

The conclusion is that the basic idea of image-based lighting works in all of the leading 3D packages: Maya, 3ds Max, XSI, LightWave 3D, and Cinema 4D. Initially we wanted to compare render times, but that wasn't really feasible because every image was rendered on a different machine and the render quality settings of different 3D programs are simply not comparable.

What we really learned from this

Especially interesting was the discussion on setup techniques that started—for the first time between users of different software packages. This intercommunication was the key element. It turned out that a lot of optimization tricks apply equally well to all programs. Some render engines were a bit trickier to configure than others, but apparently software makers also watched this HDRI challenge and so it just happened that the next update of a few render engines delivered the missing features. In retrospect, this project could not have been a bigger success.

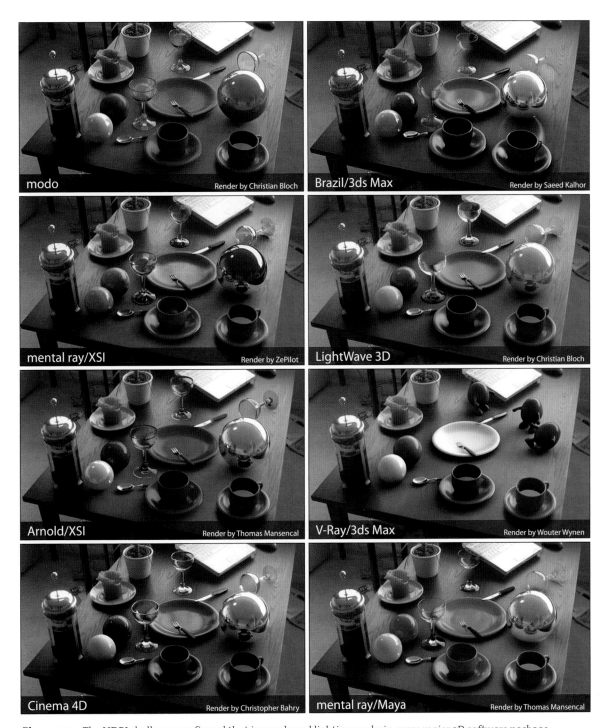

Figure 7-21: *The HDRI challenge confirmed that image-based lighting works in every major 3D software package.*

Figure 7-22: *A gang of two-legged camels invading my apartment.*

If you want to give it a shot yourself, pop in the DVD and load up the scene file! For most 3D programs, you will find a native scene file, some of them already set up. The cool thing is that once the scene light has been set, you can drop anything on that tabletop and it will look just right!

Figure 7-23:
Find the Apartment scene in a variety of 3D file formats on the DVD.

7.3 Advanced Setup Techniques

You might have noticed that all the former screen shots were skipping the most important part: how the HDRI setup was done in detail. So far I have only proven that it works, and if you actually participated in the case study, you may have a general idea of how. Now we're going to have a closer look at how it works most efficiently.

I will try to get more into the details. What I'm not going to show you are step-by-step tutorials of the buttons to push in Maya/3ds Max/XSI/Houdini/LightWave/Cinema 4D. Those buttons change with every version update, and picking one program for a tutorial would automatically make it useless for all the other users. You will have to consult your software manual to find the right buttons. What I *will* show you instead is the methodology so you know exactly what buttons to look for. Myself, I'm using LightWave and modo. But as we found out during the HDRI challenge, the setup techniques are completely universal.

7.3.1 Keeping It Straight
One particular question seems to be popping up over and over again.

Why do my HDRI renderings turn out so dark?
The issue is that you're looking at a naked linear image. For the purpose of illustration, let's place the infamous Asian dragon from the Stanford 3D Scanning Repository in front of Grauman's Chinese Theatre.

Uh, yes, too dark. The gut reaction is to increase the intensity of the HDR lighting. But hold on! There is absolutely nothing wrong with this image. It simply hasn't been tone-mapped yet. I might sound like a broken record, because you have read precisely the same thing over and over again in Chapters 3 and 4. It's a linear HDR image, and it needs to be tone-mapped. In the simplest form, we can just apply a 2.2 gamma in post-processing and we're fine.

That was a quick fix, wasn't it? However, it's not always so easy. Once you start using texture maps, they will flatten out and lose all contrast.

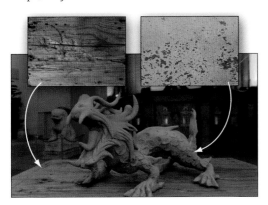

Where did the nice deep wood color go? Sure, we could meddle with the render on a case-by-case basis, but wasn't it supposed to *just work?*

So we have to dig a bit deeper.

The root of the problem

We're looking at a fundamental color management issue here.

Remember that HDR images are linear by nature, but 8-bit textures are not. All 8-bit imagery has a gamma value burned in, which has the effect of distorting the intensity levels toward the bright end. In section 1.4 the difference is pointed out in detail. What it boils down to is that HDR and LDR textures don't mix well. It's not the fault of HDRI; it's our *old* textures that have always been wrong.

Wow. What a bold statement. How come we never noticed?

Well, in traditional rendering we were used to cheating anyway, and this was just one of a million false assumptions we started off with. This was not the worst one.

But when it comes to physically based rendering, it does make a big difference. GI simulations are done strictly in linear space because that is what reality is like. An HDR image fits right in. When the image is done rendering, you have a physically correct model of the lighting conditions. It's all linear like the real world, linear like a RAW file. To see it on a monitor, we have to add the gamma encoding or, even better, tonemap it properly. It's exactly the problem that the first half of this book talks about. When you simulate reality, you have the same troubles real-world photographers have. Or better said, you have the same opportunities.

Now, let's just assume a gamma is all that is added to take a rendered image from linear to screen space. What happens to an 8-bit texture that was used in the scene? Exactly — it gets another gamma boost! It was the only part in the equation that already had the gamma in it, and now it will be doubled up. The texture becomes flat and loses all contrast. But if we don't add the gamma to the output image, it will be left in linear space and appear much too dark. The 8-bit texture itself might come through fine, but everything else is wrong.

Figure 7-24:
*When the texture
maps have mixed
color spaces, the
render will look
wrong either way.*

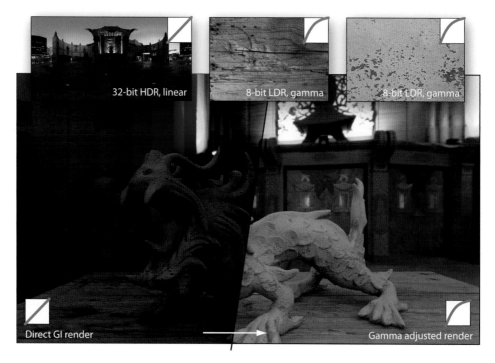

Can you see the problem? We have to consolidate all our input images to be either linear or in gamma space. Otherwise it will look wrong either way. At this point, the road splits into two possible workflows: a *linear workflow* and a *cheater's workflow.*

Linear workflow:
Strip the gamma from LDR images!

We convert all texture images to linear space. This is the correct way!

Basically, it's the same preparation that was necessary for merging an HDR image from LDR input images. In a perfect world, you would know the exact response curve/color profile/LUT of the image source and would find a way to apply that in your 3D package. Unfortunately, we don't live in a perfect world. Most 3D apps are just beginning to take color management that seriously. Currently, all we can do is apply the inverse of whatever gamma is in an image, and we have to rely on our best guess of what gamma value that could be. Mostly, 2.2 is in the ballpark for LDR images, so applying a

gamma correction of 1 / 2.2 = 0.455 would linearize them.

Now we can go ahead and render, and everything is perfectly synced up in linear space. Linear input, linear GI calculations, and the final image will still be 100 percent linear—a proper HDR image. At the end we can safely put the 2.2 gamma back in, and we're done. By that time, our textures have made a perfect round-trip through the linear realms and reappeared on the other side with full contrast and saturation.

As usual, there is a catch. Wringing an 8-bit image through the 0.455 gamma mangle has a devastating effect on the dark tones. Shadow details in the texture will clump together, and you will see serious banding artifacts once the gamma is added back in. Never ever linearize in 8-bit! The 0.455 gamma operation is reversible only when you do it in full 32-bit floating-point space.

Sounds complicated, but this is precisely how it's done in high-end VFX production. Working in linear space was even considered worth-

while long before the advent of HDRI. It fits the natural behavior of light like a glove, and it is the main secret for getting better shadow details and more natural shading. I strongly recommend doing a Google search for "linear workflow" and reading up on exactly how it works in your 3D application.

Without going too much into details, here are just a few application-specific hints:

- In 3ds Max, you have to enable the Gamma/ LUT Correction option in the preferences and set the expected input gamma for bitmap files to 2.2. Also check the option to affect color selectors and the material editor.
- In modo, every image map in the shader tree has a gamma adjustment parameter on the bottom. It defaults to 1.0 (which means no change), and you have to set it to 0.455 to linearize the texture.
- Adding a 0.455 gamma node in the Hypershade (Maya)/Rendertree (XSI)/Nodal Editor (LightWave) is the most precise way to apply this conversion because the texture has already been taken into the domain of the floating-point engine.
- In Maya 2012 (and newer), you can enable color management in the Render Settings window. Now you can even associate sRGB color profiles with mental ray texture nodes and file nodes.
- LightWave 10 (and newer) has a new CS (color space) tab in the Preferences panel, and it offers extensive control over color profiles. It's actually preconfigured for a linear workflow.
- In Cinema 4D 12 (and newer), you just need to enable Linear Workflow in the project settings and assign sRGB as the input color profile. In fact, for new projects, these are the default settings.
- The brute-force method is to convert each texture externally to 32-bit and save it as EXR. Photoshop and Picturenaut will auto-

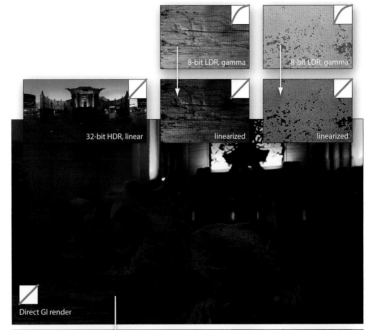

Figure 7-25: *Linear workflow: All textures are consolidated in linear space first, everything is in perfect sync, and the gamma is added back to the final render.*

matically strip the gamma that was specified in the color profile and save a proper linear file. This method is not very elegant because it will restrict you to editing the textures with Photoshop's measly selection of 32-bit tools, and hard drive requirements will unnecessarily balloon up.

Those are all solutions for linearizing the input files. There is always a second part to the setup,

and that involves putting the 2.2 gamma back into the rendered output.

- In 3ds Max, it really depends on your choice of render engine. V-Ray makes it easy because the V-Ray frame buffer features an sRGB button that will show you every test render with 2.2 gamma correction.
- Recent Maya versions have a separate color management section for the Render View window, where you have to set Input Profile to linear and Display Profile to sRGB.
- In Maya versions prior to 2011, the accepted work-around was to apply the 2.2 gamma with a mental ray lens shader.
- In LightWave's Image Viewer, the sRGB color profile is always accessible from a drop-down menu.
- Cinema 4D also has a 2.2 gamma option directly in the render view, and it auto-activates when you have Linear Workflow selected in the preferences.
- Modo automatically applies a 2.2 gamma to the render view, so you don't need to change a thing. Modo 601 actually takes the cake by offering a full-blown image processing suite that includes tonemapping and color correction with waveform monitor and histograms. Frankly, that's more color and tone control than Photoshop has to offer.

Figure 7-26:

Configuring a linear workflow is nowadays a matter of having your preferences configured right. In LightWave that's all done in the new CS tab.

Just five years ago it was a major hassle to work in a linear workflow. If there were 100 textures used in a scene, you had to manually strip the 2.2 gamma off a hundred times. Nowadays it's just a matter of configuring your preferences correctly. Color management is a pretty recent feature addition to most 3D apps, and it's still subject to frequent changes while the kinks are getting worked out. So you really should consult the manual of your particular 3ds Max/Maya/LightWave/Cinema 4D version.

However, a few inconveniences are still left.

In a linear workflow there is no more eyeballing allowed; you will have to use physically correct settings for everything. Whatever used to be your best guess for middle gray now has to be defined as 18 percent gray—the real-world photographic value for mid-gray. And just to make it a bit more complex, in your everyday 0–255 LDR color picker you'll find this 18 percent mid-gray at the 46 mark. Not very intuitive. Maya's color picker is technically showing floating-point numbers, so here you would have to pick 0.18 for mid-gray. That's not particularly intuitive either, because it doesn't leave much wiggle room for selecting darker colors than mid-gray. And the color swatch for 0.18 also looks a lot darker than the resulting color after the post-gamma is applied.

What it boils down to is this: Linear space is what you want all the internal algorithms to work in, but it's not what you want to look at. Never ever. Color pickers and every small color swatch anywhere in the software need to be color managed as well. They all need to be in perceptual space. That's why LightWave and 3ds Max offer such elaborate color space settings, with the option to interpret picked colors as sRGB and convert them silently to linear. In Maya, however, you still have to manually linearize the color picker result with a 0.455 gammaCorrect node to arrive at a "what you see is what you get" workflow. Section 5.3.3 describes the oddities of picking colors in linear space

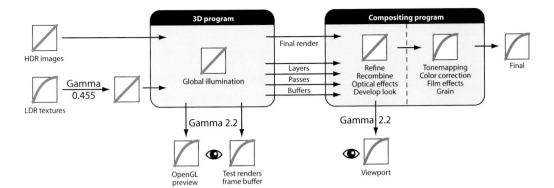

Gamma 2.2

Figure 7-27:
To draw full ben-
efit from the linear
workflow, you need
to keep it up into
the compositing
stage.

more in depth and shows you why only Nuke has the perfect color picker.

Oh, and the OpenGL preview needs to be color corrected as well. In 3ds Max, LightWave, Cinema 4D, and modo, the color management will automatically take care of applying a 2.2 gamma boost to the viewport—if you have your preferences set accordingly! In Maya you're at a loss here, but veteran Maya users learned a long time ago to mistrust the built-in hardware renderer.

Take the linear workflow to the next level!

Applying that post-gamma directly in your 3D software isn't necessarily the best idea either. It might be suitable for on-screen preview, maybe even for saving the final image in an 8-bit format. But since we want to keep all the tasty floating-point precision, we're much better off saving the final image as an EXR file and leaving it in linear space all the way into the compositing stage. Then you can take your time for a bad-ass color correction, slide the exposure up and down, apply realistic motion blur, create filmic looks, and do all the other funky stuff that post-processing in full 32-bit allows you to do. Section 5.2 explains each of these opportunities in exquisite detail.

Even if you don't plan on doing elaborate edits in compositing, it would be foolish to ignore the fact that the linear render result is a perfectly valid HDR image! Applying a 2.2 gamma is just the dumbest form of tonemapping. Every single tonemapping utility mentioned in Chapter 4 will give you a better result.

That's why the *real* linear workflow extends far beyond the 3D program.

Bottom line is this: Despite my convoluted explanation in the beginning, a linear workflow is nowadays easy to set up. The new color management options do the bulk of the work for you. All you need to remember are a few rules of thumb.

CHEAT SLIP
Linear Workflow Golden Rules

- ❯ LDR images need to be linearized. Either they get an sRGB profile attached (and color management takes care of interpreting it correctly) or the image is linearized manually with a 0.455 gamma correction.
- ❯ HDR images are already linear, so we can wave them through.
- ❯ Rendering with global illumination always happens in linear space. That's why we go through all the trouble of consolidating all input images in linear space.
- ❯ Previews, test renders, and frame buffers should all be seen with an sRGB profile or manually corrected to a 2.2 gamma.
- ❯ Final renders, however, should be saved without gamma correction as linear OpenEXR so the linear workflow can extend into the compositing/tonemapping stage.

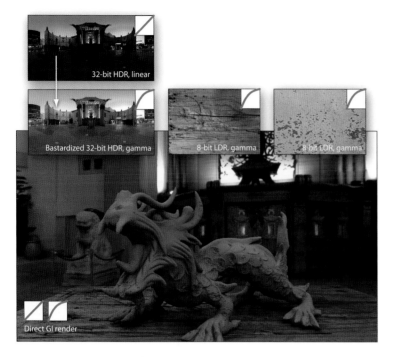

Image labels: "32-bit HDR, linear", "Bastardized 32-bit HDR, gamma", "8-bit LDR, gamma", "8-bit LDR, gamma", "Direct GI render"

Figure 7-28:
Cheater's workflow: All input images are consolidated in gamma space, and the render is left as it is.

Cheater's workflow:
Put the gamma into HDR images!

I actually considered dropping this section entirely. If you followed my advice and looked up how to configure your 3D application for a proper linear workflow, then by all means, please rip this page out of the book right now. This is a legacy cheat, an ugly hack. It is here because it fits the old-school way of doing CG, where everything is done by rule of thumb and you simply cheat your way through.

You have to be aware that even with this cheater's workflow it will not be straight physically correct rendering anymore. Instead, you bring only some aspects from that into the world of the classic eyeballing approach. You do something absolutely obscene: You add the gamma to the HDR image! By doing so, you consolidate all input images in gamma space. All lighting and shadow effects from the rendering process will still be calculated in linear space, and in the end you have a weird hybrid.

Technically, it's all wrong, but at least it will be *consistently* wrong. During each step you see exactly what you get. OpenGL and interactive preview renderers will show you when it is too

wrong and you can tweak it manually. To compensate for shadows getting too dark, you need to add some extra fill light or ambient light, for example.

Since this is a hack to begin with, there is no fixed gamma value that you can apply to each HDR image. You merely have to work it out yourself: It needs to be just high enough that the HDR image visually doesn't have too much contrast but low enough that it still pumps enough light into your scene. A generic 2.2 gamma sounds like the technically correct value, but it's not.

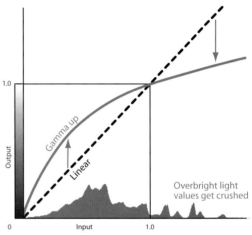

Figure 7-29: *Gamma seesaws around the 1.0 white point in HDR images.*

The reason is that gamma is a double-edged sword. It seesaws around the white point (or what appears to be the white point on-screen). That means raising the gamma will not only brighten up the midtones, it will also darken the overbright areas. But we need these über-white values; they are what make up the vivid lighting of HDRI. So a good gamma value is somewhere between 1.4 and 1.6. If that still looks too dark, you may go up to 1.8, but anything above 2 flattens out the lights entirely. Instead, you'd better give it an overall intensity boost to keep the lights up where they belong. And that will cause the saturation to go up as well, so this is another thing to be countercorrected.

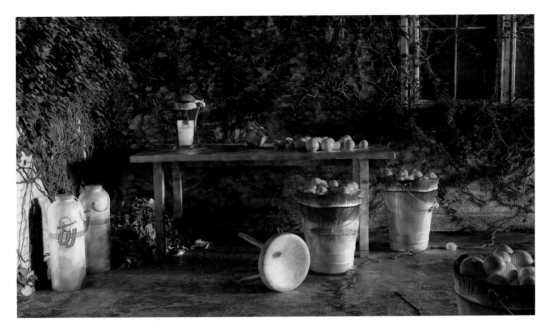

Figure 7-30:
Beauty pass: 90 per-
cent there already,
but not quite
photo-realistic yet.

In short, in the cheater's workflow you have to adjust gamma, exposure, and saturation of the HDR image to your taste. In essence it's just like tonemapping, except that you're tweaking the lighting for the effect it has on your scene, not for the HDR image to look pretty.

And how would we do that? Well, there are the same options again. In LightWave that would be the Image Editor, and in Maya and XSI you would add a Gamma node to the environment material. If there is no other way, there is still the possibility of burning these adjustments right into the file with Photoshop. That is the weakest alternative because it will screw up the HDR image for everything (and everyone) else.

Frankly, these days there is very little need for a cheater's workflow anymore. Even if your 3D application doesn't default to a linear workflow, it is definitely easy to configure and I strongly recommend doing so. Linear workflow is the norm nowadays, as it should be. The cheater's workflow is yet another one of those treacherous shortcuts. Ultimately, it doesn't get you anywhere—if you don't ever work linear in your 3D application you also won't ever experience the joy of linear compositing.

7.3.2 Compositing Is Your Friend

Were the previous sections too technical for you? Is your head spinning from gamma in and out and twice around the block, just to get back to where it was? Mine certainly is.

By the end of the day, we just want to paint pretty pictures. CGI shouldn't be like rocket science. It's not all about the perfect simulation of reality. As artists, all we care about is getting the subtle effects of global illumination. In fact, when you look at it with an artistic mindset, you might want to bend the rules of physics and take control over every single aspect.

We are also very impatient. Changing a number and waiting for a full new render to finish simply kills the creative flow. Whatever you do in 2D will always be faster than 3D.

Keep your render buffers!

Each renderer is able to spit out more than just the final rendering. In fact, there is an enormous amount of internal render buffers available: plain RGB color, diffuse shading, shadows, reflections—the list goes on forever. Photographers would give an arm and a leg for that kind of magical camera. If you want to micro-manage, you could export them all and rebuild the final output from scratch. In fact,

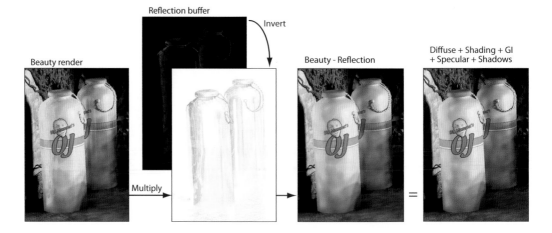

Figure 7-31:
Subtracting the reflection buffer from the beauty render is a great shortcut as opposed to building the composite up from scratch.

Reflection buffer

Invert

Beauty render

Multiply

Beauty - Reflection

Diffuse + Shading + GI + Specular + Shadows

=

that's what most books teach you on this topic. You'll get 100 percent flexibility in post when you break it all out and then puzzle it all back together. Many big production pipelines rely on this; with their strict separation between 3D and compositing departments, that's the easiest way to avoid miscommunication. Personally, I find the full-on breakout rather tedious.

In a regular production it makes more sense to get the image close to the final look right away. This will be your *beauty pass*.

By the way, I admittedly cheated on the still life I whipped up for this example. I just used Thomas Luft's free Ivy Generator and watched all the vines grow by themselves. Ivy Generator always adds opulent complexity to simple scenes; it's one of my favorite dirty secrets. I also rendered this with the cheater's workflow because at the time, LightWave was not yet the linear workflow champion it is today.

The beauty pass is definitely in the ballpark, but it's not quite photo-realistic yet. The idea

now is to use render buffers to beef it up, not wasting any time to break everything out and rebuild it from scratch but rather to go forward from here. You might wonder, aren't we losing flexibility then? Well, yes, but not as much as you'd think.

Compositing in 32-bit precision is changing the rules.

Tweaking reflections

Take the reflection pass, for example. Obviously we can use it to boost reflections by adding it on top of the beauty pass. But we can also go the other way and tone reflections down. The trick is to invert the reflection pass and multiply it from the beauty pass. It's effectively the opposite of a boost; it subtracts what has been previously added by the render engine.

For comparison, I have put in the classic forward composite next to it. It boils down to the same result. So, why would that backward approach be better now?

Well then, let me show you the juice.

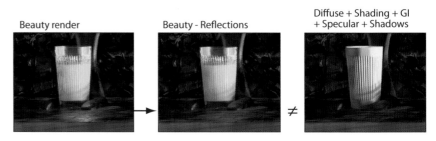

Beauty render

Beauty - Reflections

Diffuse + Shading + GI + Specular + Shadows

≠

Apparently, I would have to render the glass separately again to get that forward composite working. And then I also would need what's behind the glass... Bear in mind that this is not the most complicated scene in the world. The more stuff you have in there, the more you have to rebuild. But I don't want to end up with 20+ layers just to tone down reflections. Don't have time for that. Rendering passes were supposed to make my life easier, not complicate it. That's why it is often a good idea to use the ready-made beauty render as a starting point and work backward from there. You'd basically want your passes to be a safety net, the wildcard that you can pull out of your sleeve when a certain aspect of the render needs fixing.

Ambient occlusion—a pass like a poem

Let me confess now: I've fallen madly in love with ambient occlusion (AO). It's simply the most beautiful pass of them all. AO makes everything look so innocent and untouched. Sometimes I just sit and stare at these passes, and one day I will make an entire short film with ambient occlusion only.

At first glance, it looks just like radiosity. But it's not. It's much simpler. Ambient occlusion is based purely on geometry. The tighter a corner, the darker it gets filled in. Materials, lights, re-

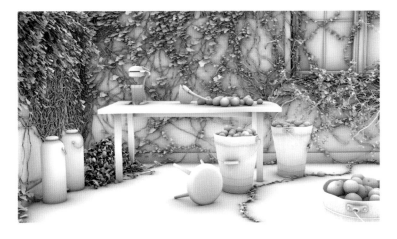

flectance properties, none of those matter. No colors bleed into their surroundings, no light is bouncing around. Only nooks and edges. That's all it is.

Eventually, that's all we need. Simple is good because it renders fast and is very predictable. And it makes even the cheapest traditional rendering look great. The AO pass can be multiplied or burned in, on top of everything or just underneath a key light pass (which is the technically correct way). You can even use it for simulating a first order bounce by using it as the alpha mask for a high-contrast, blurred-color pass. Just play with it and you'll find a million applications.

Figure 7-32:
Ambient occlusion pass: pure geometric poetry.

Beauty render + Ambient occlusion + Depth of field

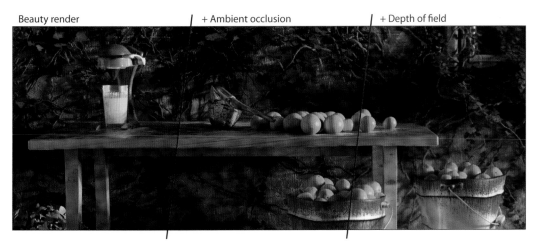

Figure 7-33:
Most renders can be subtly spiced up with an ambient occlusion pass and depth of field.

Figure 7-34:
*Depth buffer:
Ramps near to far
as black to white.*

object, derive a selection mask, or put a new element in between two objects. The most common use of the depth buffer is a very precisely placed depth of field effect.

All CG renders benefit from a little depth of field. It doesn't take much—sometimes just a 1- to 2-pixel blur at the maximum defocus spot. That's enough to eliminate the clinically sharp look that real photographic lenses rarely ever deliver. Depth of field is also a great artistic tool because you can point the viewer's eye to the important part of the image. Personally, I prefer the Lenscare plug-in from Frischluft because it generates awesome photographic bokeh effects.

Ambient occlusion is always worth a shot. Even though my beauty pass with two-bounce radiosity is much more physically correct, kissing in a slight AO with soft light blending mode does something nice to it. Makes it somewhat more vivid, more crisp.

Other than that, our depth buffer can also help to put some atmosphere in here. It's perfect for faking volumetric effects because it gives us a 2D template of the 3D scene. Just multiplying it to a supercheap fractal noise magically transforms the noise into hazy light beams. Rendering true volumetric lights would take a while, but this technique is real time.

Deeper and deeper

The depth buffer, or Z channel as it's also called, benefits a lot from 32-bit output as well. Otherwise, you'd have only 256 depth planes.

But in full floating-point precision, the depth buffer is an accurate record of the third dimension for every pixel. It allows you to isolate any

If you would be allowed to save only one extra buffer, then pick depth! This buffer is so versatile, you should always include it with every render. Treasure it and archive it. Even years later, when the terabytes of digital assets to re-render a scene may be long lost, you can use

Figure 7-35:
*The depth buffer
can turn a simple
fractal noise into
hazy light beams.*

 × + =

Fractal noise,
stretched & blurred

Depth buffer, blurred

Before

After

Before, with vignetting added in the currently off-screen corners.

Color grading with levels. See section 5.1.4 for details.

Soft glow added, large scale and low opacity. Secondary small glow.

Grain added. In blue channel grain is bigger and stronger.

the depth buffer to effortlessly convert the final render into a stereoscopic 3D image.

Without going too deep into the compositing side again, here is some general advice for working with render passes:

- Make up your mind about which passes you might need. Don't routinely blow up drive space. Either you have to pay for it yourself or you become known as *that* guy and end up sitting alone in the cafeteria.
- Run a test render of all passes, browse through your options, and work out a rough road map of the composite in your head.
- KISS-rule: Keep it simple stupid! Work backward from your beauty render whenever possible, and build up when necessary. Don't build 20-layer composites just to get back to square one.
- Try to render all your passes in one swoop. They should be additional outputs, piggy-backed on the beauty render. Ideally, they are embedded channels in an EXR.

- If you have to break out a pass as a separate render, consider rendering in half resolution. Ambient occlusion and computationally expensive shaders are good candidates for that.

Finishing touches

Let me just quickly finish off this still life. The rest is pretty much standard procedure now.

The point is, no matter how physically correct the render process is, you can't neglect the "photo" part of photo-realism. You might render something that looks real, but for photo-realism, you still have to put in all the little things that a photographer tries to avoid. They are important visual clues that whisper to a viewer that this would be a photograph. It's good to be subtle here, and it's okay when you can barely make out the difference from step to step. But when comparing start with finish, it becomes very obvious that something magical has happened here.

What has all this to do with image-based lighting? Nothing. Just thought you might like

Figure 7-36:
Finishing touches.

Figure 7-37:
The final composite can easily fool an audience into thinking it's a photograph.

to know how compositing in floating-point precision can spice up your life. It technically belongs in Chapter 5, where all the other great compositing tricks are (including a Magic Bullet tutorial in section 5.2.4 that no CG artist should miss out on). I just can't show this chapter to the photographers because they would get too envious of us 3D folks for having all these great render passes to play with.

7.3.3 Sample Wisely: Split the Light!

Back to the topics of lighting and rendering. Here is another question that appears pretty consistently once a month in every CG board.

Why are my HDRI renderings so noisy?

The crux of the matter is that all GI algorithms have to trace rays. Monte Carlo radiosity, for example, fires *x* amount of rays from each surface patch in random directions. Now, when we have an HDR image with a lot of sharp details, each of those random rays will hit something entirely different. The chances of hitting the

same spots with the next burst of rays are slim when the GI algorithm determines the light for the next neighboring patch. And so the element of chaos creeps in, manifested as visible noise. Essentially, every pixel in the render gets lit slightly differently, based on where the random rays happened to sample the HDR image.

Increasing the number of rays would be one solution. There is less chance that important areas are missed, each burst of random samples delivers a similar result, and the noise in the image disappears. But it's not really the most efficient option because then our image will render forever.

In the example on the right, going from 100 to 500 samples bumps up render time from 7 to 35 minutes. That was with rusty LightWave on my rusty MacBook; your actual mileage may vary. But the proportion will be similar. Double the samples and you double the time it takes. Even worse, to effectively increase image quality, you'll often have to geometrically increase samples, thus geometrically increasing render time.

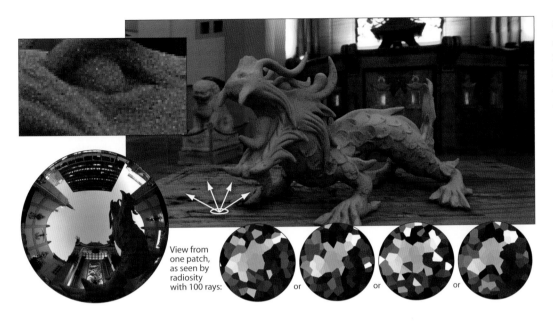

Figure 7-38:
Randomly sampling 100 rays can give many different results, which leads to sampling noise.

View from one patch, as seen by radiosity with 100 rays: or or or

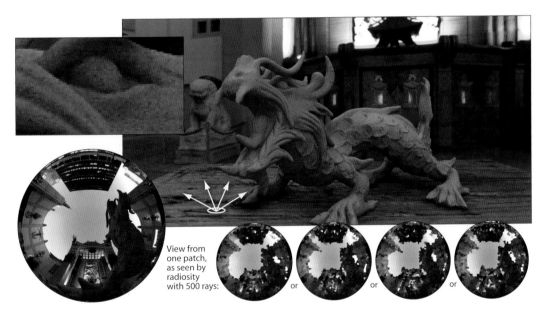

Figure 7-39:
Sampling with 500 rays minimizes the errors and gets rid of noise. But it also takes five times longer.

View from one patch, as seen by radiosity with 500 rays: or or or

The universal trick for optimized sampling

A much better solution is to scale down the HDR image and put a blur on it. This will make sure that even a small number of samples will hit very similar spots. In the end, we're only in-terested in the average of all those samples any-way because that is all we need to figure out how much light can reach that patch. So don't be cautious here—when I talk about scaling and blurring the image, I really mean it!

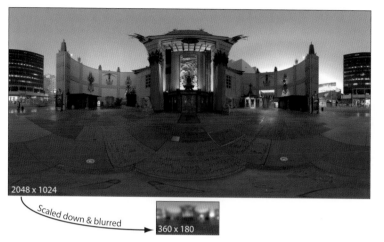

2048 x 1024

Scaled down & blurred

360 x 180

Figure 7-40:
Preparing an HDR image for noiseless diffuse lighting.

I've seen many people blur the map right within the 3D application, sometimes even by overdriving the mip-mapping value (which is actually meant for anti-aliasing). Well, let me tell you that this is quite a wasteful habit because you still have a giant HDR image sitting in memory that doesn't do you any good. You need a much bigger blur to cover the same percentage in the image, and the worst part is that this expensive blur is recalculated over and over again. Blur it once, scale it right, and be done with it!

The result really speaks for itself (figure 7-41). This example scene renders in 7 minutes again and shows even less noise than the 35-minute render. Now we're cooking! The reason is obvious: Whatever random rays are fired, they hit almost the same colors on the HDR image.

Let's stop for a minute and meditate over the fact that a small blurry HDR image delivers the same shading result as a sharp high-res HDR image but requires less render time. That's a stunning revelation, because it goes completely against conventional wisdom. When evaluating the quality of an HDR image, resolution is far less important than color accuracy and dynamic range—that is, how many stops it holds beyond the 1.0 white point. This is the reason the mirror ball method is still relevant for capturing

on-set HDR images for VFX production. It's good enough for diffuse lighting.

By the way, photon tracing does not suffer from noise the same way Monte Carlo radiosity does. But the situation is similar: As photons are bounced around like particles, they hit random spots on the HDR map. In the next frame, these will be all different errors and your animation will be flickering—a very undesirable effect unless you render a silent movie.

Importance sampling would be another solution. It means the renderer will try to shoot most of the rays into the brightest areas, where they are really needed. But even importance sampling can get confused by very sharp HDRIs, and ultimately the decision of what's important and what's not is yet another throw of the dice. You also don't have much influence over importance sampling—either your render engine has this feature or it doesn't. Arnold and V-Ray are very good at it, RenderMan caught up in 2011, in mental ray it's available only for selected shaders, and many other render engines don't have any importance sampling at all. And if you want to render hair, skin, particles, or any other exotic shaders, then importance sampling is often not available.

No matter how you look at it, the blurring technique remains useful because it is completely universal. The fancy academic name for blurry environments is *spherical harmonics,* and an entire branch of shaders and rendering algorithms has grown out of this because it's such an efficient trick. It has its limits, though: The sampling advantage diminishes with the complexity of the scene because it takes extra samples to cope with light bouncing between objects. The screen shots with the dragon already hint at the fact that geometry will still be seen in sharp detail from a sampled spot. The second limitation is that it works well only for diffuse materials (or the diffuse component of a material).

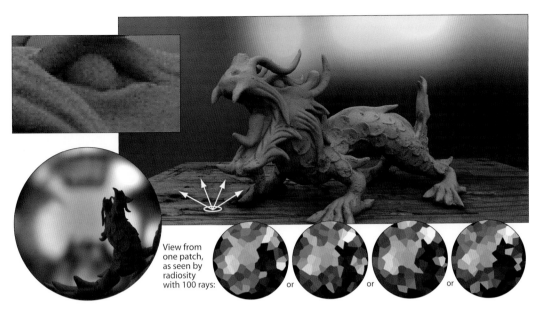

Figure 7-41:
When the HDR environment is blurred, even low sampling rates result in a noiseless render.

View from one patch, as seen by radiosity with 100 rays: or or or

Reflections

They have now become problematic.

Figure 7-42: The small blurry HDR image does not work for reflections.

Figure 7-43: The best solution is to use the original HDR image as a reflection map.

Let's swap out the dragon for a shiny car and have a look. This Mustang was completely hand-modeled by Jamie Clark and kindly donated for this book.

In reflections, we don't want to see a blurred environment; reflections are supposed to stay crisp and clean. Yet we still want to keep sampling rates low.

The trick is simple: We use the high-resolution HDR image as a reflection map. That way we kill two birds with one stone. We keep the same speed because reflection maps render practically in real time. They're very simple. And we save one level of raytracing recursion. Eventually, we might even get away without any raytraced reflections at all.

Essentially, we're splitting the HDR image into two light components: diffuse lighting and specular lighting. Diffuse is responsible for nice contact shadows and the general dull shading component; specular makes catchy highlights. Diffuse is viewpoint independent (and can be magnificently baked); specular appearance changes with the viewpoint. It makes a lot of sense to treat them separately.

Background

With all that trickery, we have forgotten one thing: The background looks all blurry now.

Figure 7-44:
Basic in-camera composition via front projection. ▶

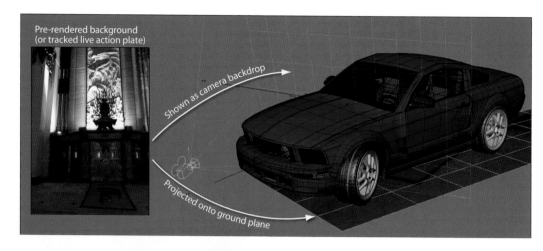

Pre-rendered background
(or tracked live action plate)

Shown as camera backdrop

Projected onto ground plane

It doesn't cost us much to render the same view without the car but with the original panorama in the background. Actually, I did that already and front-projected this image onto the ground. From the side you can clearly see a piece of carpet lurking underneath the car—that's just part of the image projected from the camera position.

It takes a bit of fiddling with the ground material to blend it with the background. Since the ground is affected by the lighting as well, it will get a bit brighter. Mixing diffuse and luminous surface settings can usually lead to a good match. With very saturated lighting, there might even be a little color overlay necessary, countertinting the lighting with the complementary color.

Camera projection is yet another one of those cheap hacks for slapping stuff together quickly. Strictly taken, I should have rendered the car separately from the ground plane. In that case, the ground render would need an invisible car in there, just to throw a shadow. Then I could build a proper composite in post-production by multiplying the shadow over the background and putting the car layer back on top. But I prefer this projection technique whenever possible. It's much simpler and takes only one render pass instead of two. Once it's all put back into one piece, nobody can tell anyway.

Figure 7-46:
The complete rig
now consists of
these three images.

Background pano / 8000 x 4000 / LDR

Reflection map / 2048 x 1024 / HDR

Environment map / 360 x 180 / HDR ──────────▶

In this example I post-processed the image with Magic Bullet by adding vignetting, color grading, and grain. Also, I added a defocus effect. Some like it that way; it puts the CG model in focus. But I always find that with such shallow depth of field most models look like, well, just toy models. It kills the scale of the scene. What sucks is that the depth of field wasn't really a creative decision. There's just not enough resolution, even in the bigger HDR image. I was forced to blur the background to hide these fist-sized pixels.

Bigger backgrounds

So the third ingredient would be a super-high-res panorama image, mapped on a simple back-ground sphere. Ideally, the resolution would be high enough that it delivers a crisp backdrop wherever we point the camera.

How high?

Well, it's the same math as when we're shooting a panorama, just in reverse. Let's say our CG camera shoots with a 45-degree horizontal FOV, which equals a 45 mm lens on a full-size 35 mm film back. So our background panorama would need to be 360/45 degrees = 8 times the intended render resolution. For full 1080 HD, that means we'd need a 15,360-pixel-wide image. In other words, insanely big.

Okay, let's compromise. If we go with an 8,000-pixel-wide pano (8K), we have just about half the required resolution for HD. It will come out slightly blurred but still acceptable in motion. But even such compromise is already pushing the limits. It's too big for Maya to show as a thumbnail in the Hypershade, and if you make that an HDR image, it will eat up 366 MB of memory—precious RAM space, which in a real production scene is better spent on geometry or textures that visibly increase the quality of the result.

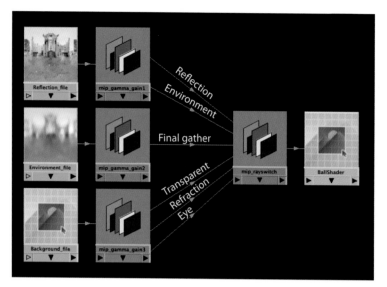

Figure 7-47:
The mip_rayswitch node handles the separation of our three components in mental ray.

Outer surface

Inner surface appears mirrored.

check said render properties for the background mesh (LightWave or Cinema 4D). In other cases, you tell the render engine to treat camera rays, reflection rays, and radiosity rays separately (rayswitch in mental ray or V-Ray).

So here are your options: The first option is to crop the background panorama to what you're really going to see in the final render and map that on a partial sphere. This path delivers the best quality, but it becomes a heap of work to adjust the texture coordinates to the limited FOV. It's a limited use case, more like a traditional matte painting, and when your camera happens to pan off the background, you will have to redo it.

The second option is to save 75 percent of memory just by toning the background down to 8-bit. As useful as full HDR backgrounds might be for compositing, you won't enjoy looking at blown-out whites and deep blacks in your background anyway. By toning it down first, you're essentially designing a preliminary look that will provide a much more inspiring backdrop on which to base your 3D scene.

How to handle the background ball

Silly, I know. It's quite obvious that our background sphere should be excluded from all lighting effects, that it should neither cast nor receive any shadows. It shouldn't even be seen by reflection, and it should not interact with global illumination. This background ball is only here for the camera, like a backdrop.

There are different ways to achieve this. In many 3D programs you have to literally un-

Flip it!

Next gotcha: We are looking at the background ball from the *inside*. It might not be so obvious, but you have to invert the mapping direction for this to look correct.

Regular spherical mapping is made for balls seen from the outside, which means the texture will appear mirrored from the inside. Text will be written backward, and objects in a panorama will swap positions. In LightWave you have to set Width Wrap Amount to −1 to fix that. In 3ds Max the texturing parameter to look for is called U Tiling −1, and in Maya I believe the generally accepted method is to scale the entire ball mesh to −1 on the x-axis (although that sounds a bit obscure to me). But every 3D program has a way to mirror the texture, that's for sure. You just have to remember to use it.

Place it by the camera!

The position matters a lot as well. Only when the background dome and camera are in the same position will the projection be right. Then it will look just as it would in a QuickTime VR.

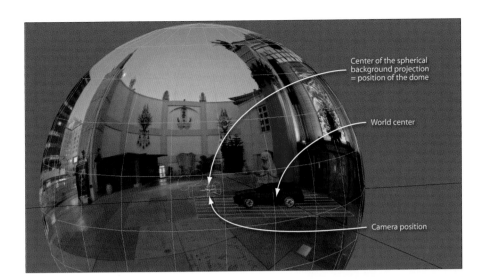

Figure 7-48:
The correct center of the background dome is the camera position.

Move the ball slightly forward and you get a fisheye-lens effect. Place the ball in the world center and you get some arbitrary distortion. Yeah, that's right—the world center is not the natural habitat for the background dome. The camera position is.

A quick solution is to scale the ball way up. This is what all the software manuals recommend, and generations of CG artists were left scratching their heads over how large the ball needs to be exactly. Well, it's not about the size at all but the relative distance between the camera and the center of the projection. When the ball is very large, our camera will always be approximately in the center, relatively speaking. Ideally, it would be a sphere of infinite size (that's what shaders and the specialty environment materials simulate, because then the projection will be perfectly distortion free). In real life, I recommend about five times the size of the rest of your scene, but more important, place it in the vicinity of your camera!

However, knowing about this effect reveals an interesting opportunity: We can spherically project our panorama on any kind of geometry. As long as the projection center is at the camera, it will visually all line up. For example, we could skip pre-rendering the background and

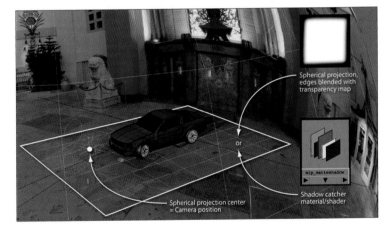

rather project the panorama directly onto the ground plane. Add a transparency map with fuzzy edges and you have a simple in-camera composite.

Figure 7-49:
The ground can now be textured directly with the panoramic background. The alternative is using a shadow catcher material.

Shadow catcher

The alternative way to create a ground shadow is by using a *shadow catcher*. That's a specialty material offered by many render engines. In mental ray it's called the mip_matteshadow shader, in V-Ray it's done with a VRayMtlWrapper material, in modo you'd need to change the Alpha Type property of a Shader layer to Shadow Catcher, and for Cinema 4D there is a free Shadow Catcher plug-in floating around.

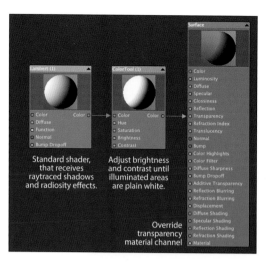

Figure 7-50:
Simple shadow catcher material in LightWave, achieved by rewiring the diffuse shading effects into the transparency channel.

A shadow catcher is a magical material that has no equivalent in the real world. It is invisible in its native state and turns opaque only where a shadow hits it. In essence, that makes it a free-floating shadow that we can place underneath the CG object to make it appear as if it is sitting on the ground. But that's only an illusion, of course. In reality, the ground texture is just part of the background panorama, and everything else floats in front of it.

If your render engine does not have a specialized shadow catcher material, don't worry. My beloved LightWave doesn't have one either. But it's surprisingly simple to make a shadow catcher yourself. All you need to do is find a way to rewire the material properties so that all the shadows and shading effects are rendered into the transparency channel of the material. In a nodal shading graph, you can just wire a Lambert shader into the transparency, maybe add an adjustable contrast/brightness control in between. That's it. Even if you find a specialist shader plug-in lacking some feature (some disregard radiosity effects), such a simple rewire of shader properties works everywhere.

Figure 7-51: *Shadow catcher in action.*

Figure 7-52: *Sharp car render, using the magic trio of high-res background, medium-res reflection map, and low-res environment light. And a shadow catcher, all in one go.*

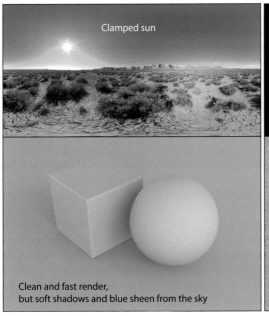

Clamped sun

Clean and fast render,
but soft shadows and blue sheen from the sky

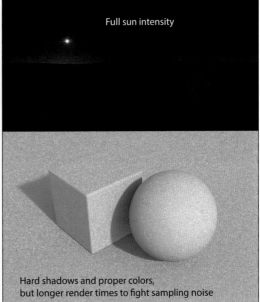

Full sun intensity

Hard shadows and proper colors,
but longer render times to fight sampling noise

Figure 7-53:
The sun creates a special dilemma: Its full intensity is hard to capture and even harder to render with global illumination alone.

Shadow catchers are extremely common in VFX production. Not only ground planes but also walls and other objects from the real background are often represented by crude geometry to catch the shadow of our CG foreground. They are typically rendered separately and handed over to the compositing department. But if it's just for myself, I tend to render everything in one go. All the action happens in the alpha channel anyway, so there is no big penalty for rendering it all in one EXR file.

Beware strong sunlight

There are several problems with HDR images that show the naked sun.

The sun is extremely hard to capture. Chances are the circle of the sun is blown out, even in the HDR image. In fact, most HDR images that you find on the Internet have the sun clipped off before its peak brightness. So instead of the warm bright color of the sun, you'll end up with a main light that's gray and faded. When used in a physical renderer, this will result in unexpected soft shadows and a slightly

dull look. Even worse is that the sky will have a disproportionately strong contribution to the lighting, flooding the scene with a blue sheen.

So, what to do? Well, you could make sure you accurately capture the disc of the sun. It may well be 10 EVs away from your metered middle exposure, so be prepared to add plenty of very short exposures to your bracketing sequence. You may even need strong ND filters to cope with midday sun. Section 6.4.5 has a few more hints on this and the associated practical problems. Furthermore, you need to be very careful during each editing step, and frequently slide your viewport exposure down to make sure Photoshop or program XY doesn't mess up your precious sun color.

The second, much easier way is to boost the sun by painting it in. Sounds like a cheap hack, but in reality we all know what to expect from our sunlight; it's really the same every time. As long as the surrounding sky is properly represented in the HDRI, meaning you have bracketed far enough that the edge of the sun disc is visible, your boosted sun will be

Figure 7-54:

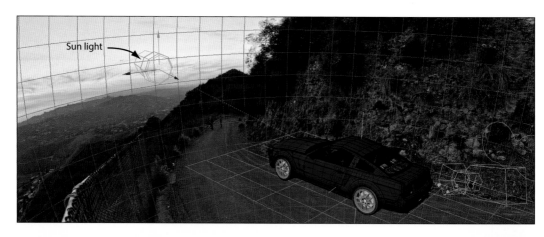

Figure 7-54:
The sun is easier to control when it's a regular 3D light and rendered via direct illumination.

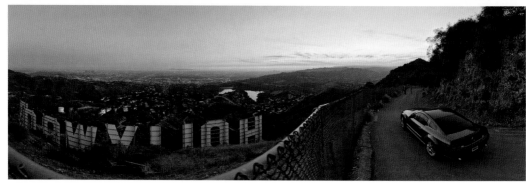

Figure 7-55:
By the way, it's also fun to render things back into the original panorama.

indistinguishable from a real capture. Boosting the sun is literally just a matter of 10 seconds: Open the HDR in Photoshop, select a round brush with 90 % hardness, pick a yellowish-orange color with +10 EV intensity, and paint a dot over the sun spot. Easy! Browse back to section 5.1.3 for a refresher tutorial on painting with light and a screen shot of the workflow I just described (figure 5-20).

The real question is, Is it actually worth the effort? Not necessarily.

Even if you manage to get an HDR image with unclamped sun intensity together, it will keep causing trouble during render time. GI algorithms tend to choke on it. Just a single sampling ray hitting that sunspot will tip the balance of all sampled rays. So you have a hit-or-miss situation, which leads to the worst noise you've ever seen.

When you really think about it, the sun is the prime example of a source of *direct illumination*. There's no point in brute-forcing it through a global illumination algorithm. In outdoor scenes the sun is your key light. So you want to be able to tweak every aspect of it. You want to set the color to match the mood of your scene. You want control over shadow direction, falloff, and fuzziness. You might even want to carefully adjust the sun angle for highlights to accentuate your model in an artistically pleasing way. Or you could render the sunlight contribution as a separate layer and then further fine-tune it in compositing.

In short, you want the sun to be an adjustable 3D light source. Photographers would not hesitate to sign over their firstborn to Mephisto in exchange for such Godlike creative control over the sun itself. Why should we 3D artists voluntarily give up that control?

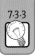

Break out the essential lighting components: direct, diffuse, and specular.

These three make up the magic combo that makes everything look real. Even when your 3D model has no textures to speak of, lighting it with a balanced mix of direct, diffuse, and specular lighting will make it look like a tangible real-world object. It simply appears to be made from a uniform material (like clay or resin), not like it's created with artificial computer graphics. And if you have a super-high-resolution panorama, you even have full freedom of framing the backdrop for your 3D model.

It's true that render algorithms have advanced a lot over the years, and most of them claim to render a perfectly clean result by using the high-resolution HDR image alone. Some of them even live up to that claim, especially those with importance sampling.

Still, breaking out the magic trio has the immense advantage that it gives you more creative control. For example, you can easily fine-tune direct lighting without affecting diffuse lighting or reflections. You might not know yet that you need this level of control, but when the director walks in the door and demands that the reflections be a little bit over there, you can't say, "Eeehrr... wstfgl?" No, the only correct response is, "Yes, sir! One second, sir! How is this? Would you also like to have a touch more pink in the sun light, sir?"

The breakout saves significant amounts of memory, bandwidth, and loading times because all three images together weight only 10 percent of the full-resolution HDR image. It is a universal trick that does not restrict you to that one "magically superior" render engine and its dedicated shaders. It renders faster because you need fewer samples for the same quality. Even when your renderer is very fast to begin with, this speed advantage can make the difference between 5 seconds per frame or close-to-real-time performance. In fact, the new breed of interactive real-time render engines benefits greatly from a proper breakout. That's why Thea Render specifically recommends this practice.

Figure 7-56:
IBL settings in Thea Render, an interactive physically based render engine. The magic breakout is specifically recommended for high-quality real-time feedback.

And the ultimate reason is that in a profes-sional production you would never render di-rect lighting, diffuse shading, and reflections all together anyway. Render them out in separate passes, and you will get fewer angry calls from the compositing department.

That's why you should do your homework and break out your lighting! It always pays off.

7.3.4 Smart IBL

You might say that I make it all too complicated: Splitting the light into diffuse and specular HDR images, putting them all in the right slot, creat-ing an extra background sphere, figuring out where the sun light should be positioned. Not to mention finding all the right flags and check marks to make it work. Isn't that just an overkill of setup work for a relatively simple task? Who has the nerves to do all that?

Back to the one-button solution

Well then, let me make it easier. Let me intro-duce you to a unique suite of plug-ins that does all the tedious setup work for you. It was created in a joint effort by a group of volunteer artists—namely Christian Bauer, Chris Huf, Thomas Mansencal, Volker Heisterberg, Steve Pedler, Gwynne Reddick, and myself—who each created a plug-in for a specific 3D software program.

We're calling it the *Smart IBL* system, or *sIBL* for short.

The idea is to put all these three images in a folder and link them together with a descrip-tion file. From that point on they are siblings. Together they form a complete lighting set. We also throw in a sun light that matches in color, direction, and intensity. The description file is the key because here we keep all the relevant setup information. Each image is tagged with projection type, size, orientation, and a whole lot of metadata. You actually don't have to care about the individual images anymore.

All you have to do is choose the sIBL set you want to load. We even include searchable key-

words and a thumbnail image so you can make an educated choice. Just pick a set and everything falls into place.

After the script is done, it's just a matter of rotating and moving the background until you find a nice composition. Wherever you turn the background, the sun light will follow. Even the environment image and the reflection map are synchronized to the background with some expression magic. The setup assistant also creates a ground plane with a shadow catcher material, turns on radiosity, makes sure the background panorama is mapped with the correct orientation, switches off the default scene lights — in short, it takes care of flipping all the hidden switches and leaves you with a decent image-based lighting setup.

Admittedly, it might not be your final lighting, but it's close. You'll have a perfect starting point. If you have your own background plate, you'll probably further tweak the HDR images to get a better color match.

The example images on the next page are direct render outputs without any postprocessing. All these lighting situations are just the push of a button apart. Because a Smart IBL rig is created so quickly, it is a great tool for seeing how a work-in-progress model looks under different lighting conditions. It's somewhat like a rapid prototyping approach. You might have guessed that I have already used this tool to light other example scenes elsewhere in this book. In fact, almost all CG renders in this book got sIBL'ed. It's one of those plug-ins that get you hooked, and eventually you forget how much work goes into setting it all up by hand.

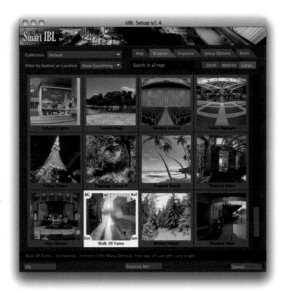

Figure 7-58: *My Smart IBL plug-in for LightWave...*

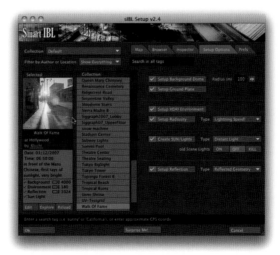

Figure 7-59: *...automates all the tedious setup steps.*

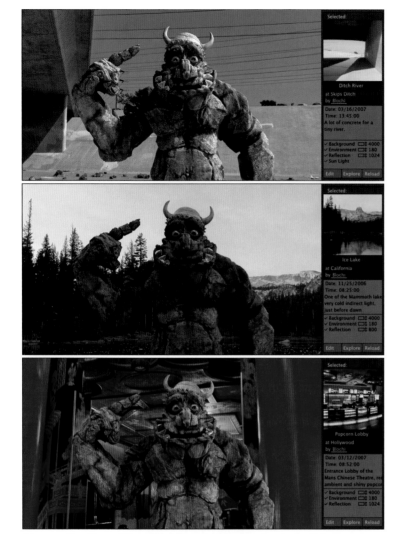

Figure 7-60: *Three different lighting situations, just a single click apart.*

A universal pipeline tool

And here comes the amazing part: It works the same in Maya, 3ds Max, XSI, and Cinema 4D! It works on Windows, Mac, and Linux. It's an entirely open system. Nothing is proprietary; there are no fancy file formats. The basic premise of Smart IBL is that it can be ported easily to any platform. For individual artists, it works out of the box with the setup scripts we provide, and it can be woven into any existing company pipeline with our open-source Python scripts.

Let's get specific. You've already seen my Smart IBL plug-in for LightWave 3D. Steve Pedler created the same plug-in for Cinema 4D. It has the same look and feel, it works with the same presets, and it builds the same optimized lighting rig—but in Cinema 4D. Steve's plug-in actually includes a few more options than mine, specifically for those fancy folks who have V-Ray for Cinema 4D installed.

The sIBL loader plug-in for modo was created by Gwynne Reddick. It actually became a little bit too successful, because shortly thereafter Gwynne started working directly at Luxology headquarters and in version 401 it had evolved into modo's fabulous (but app-specific) preset system. However, Gwynne also made a free conversion utility that will import sIBL sets di-

Figure 7-61:
Steve Pedler's sIBL Loader for Cinema 4D looks the same and does the same automatic lighting setup. But in Cinema 4D.

Figure 7-62:
Gwynne Reddick's adaptation for modo started out with the same look. His latest version, however, converts sIBL sets into modo's native environment presets.

rectly into modo's preset browser as Environment presets. Once they're imported, you can simply drag and drop a preset from the built-in preset browser into the viewport. That will create the same optimized setup that you get with the LightWave or Cinema 4D loader. In modo you can actually see the benefit best because when you turn on RayGL, the viewport updates so fast that you can literally sculpt the model while looking at the final render quality at all times.

Volker Heisterberg and Christian Bauer originally ported the sIBL loader to Maya and 3ds Max. But these ports turned out to be tricky because MEL and MaxScript are rather limited when it comes to creating rich user interfaces. Furthermore, Maya and 3ds Max heavily rely on external render engines (nobody seems to be happy with their built-in renderers), and so these sIBL loader plug-ins were impossible to maintain. That's when Thomas Mansencal came to the rescue and created sIBL GUI.

What Thomas did is ingenious and has no precedence in this utterly fragmented world of 3D applications. He made *one* plug-in that works in Maya, 3ds Max, and XSI! From a tech-

Figure 7-63:
Now you can load these presets via modo's built-in preset browser. And they look fabulous in modo's RayGL viewport.

nical standpoint, sIBL GUI is a Python script wrapped up into a stand-alone application, but the important part is that it *feels* like a plug-in in all these three apps. Not even Autodesk itself has cracked that nut yet!

Let me show you how it works.

➤ Meet sIBL GUI, the ultimate plug-in

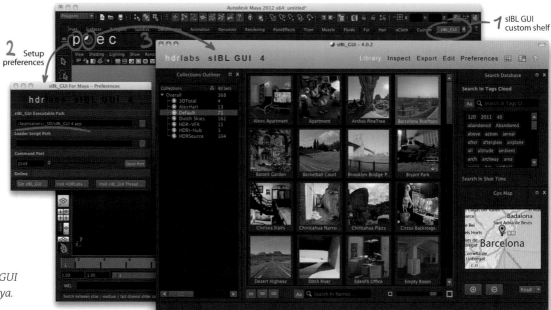

Figure 7-64:
Launching sIBL GUI from within Maya.

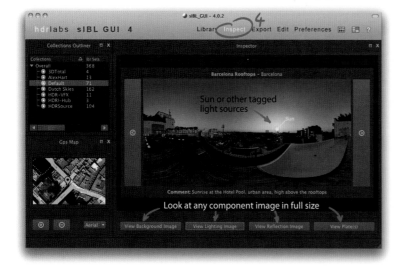

Figure 7-65:
The Inspect tab lets you browse through previews of the full panoramas.

1 What you really install is an application-specific helper script. In my example that's in Maya, and the helper script shows up on a custom shelf. In 3ds Max it would appear in the UTILITIES ▸ MAXSCRIPT tab, and the XSI script is recognized as an add-on.

2 There are four buttons on this shelf. The first one is labeled *p* for *preferences*. It opens a dialog window where you need to configure the path to the sIBL GUI executable. You can leave the second path field empty and leave the Command Port option on default.

3 The second button now launches sIBL GUI. And voilà, there you have your rich browsing interface! You can search the tag cloud (for example, for "sunny" or "indoor"), you can filter your collection by shooting time (like 4:00 p.m. to 6:00 p.m.), or you can just browse through the thumbnails until you find a lighting situation that fits to your scene.

4 Sometimes the thumbnails are not enough to get a good impression of the environments. In this case, you can switch to the Inspect tab and browse through preview versions of the full panoramas. Here you can also open each of the component images at full size and see if there is a sun light (or other lights) tagged in the image.

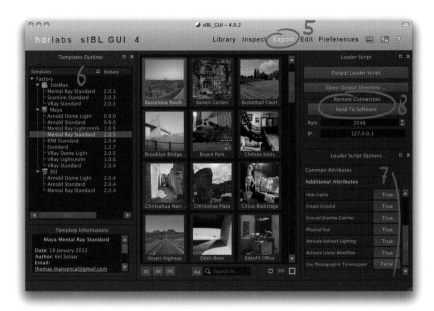

Figure 7-66:
On the Export tab you can select your preferred render engine, configure the setup options, and finally, send the lighting rig to your 3D software.

5 For my example I'm happy with the Barcelona Rooftops set, so I proceed to the Export tab. This is where the magic happens.

6 The left side shows a list of all the supported programs and renderers. What you see in this list are setup templates—little scripts that will perform the actual setup work in your host 3D application. These templates are very easy to make and tweak, and if you're a script jockey, you will find a full-blown script editor on the Edit tab for creating your very own custom lighting template.

The rest of us just select the preferred render engine from the (already quite comprehensive) list of factory templates.

7 On the right side you have the setup options. The common attributes are always the same (i.e., if you want the background, reflection, sun light, etc.). Most templates also come with additional options that are specific to a particular render engine. The defaults are normally fine, but it's often a good idea to glance over these options to know what to expect.

For example, I want to render with mental ray in Maya, and I appreciate that this template will create a shadow catcher for me, use a physical sun, and activate a linear workflow. How sweet, thank you very much.

8 My final click is on the Send To Software button.

That will open a direct communication channel with the host 3D application via the command port that was set in the preferences. So the port number (below the circled button) has to match the port number in the preference window. And what is it that sIBL GUI communicates? It fills in the blanks in the script template with the information from the sIBL set and your choice of setup options. That results in a customized setup script, which is pushed over to the 3D app and launched automatically. Pretty genius, eh?

If for some reason this backdoor link does not work (firewall or odd network configuration), you can also use the Output Loader Script button to save the script anywhere. Then you can run this script in your 3D app by hand (which in the case of Maya and 3ds Max just means you drag and drop the script file into the application window).

Figure 7-67:
The auto-generated rig in Maya.

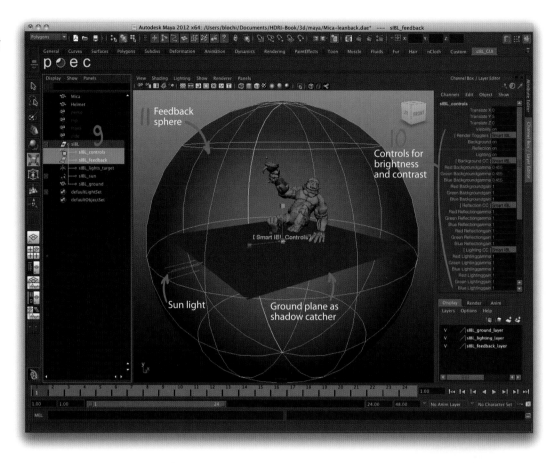

9 Let's see what that did.

The troll character is the only thing I had previously loaded in my scene. In the outliner on the left you can see a whole lot of new items, neatly grouped together. There are the ground plane, a big sphere, and a sun light. Even more nodes were created deep in Maya's bowels, and if you dare to open the Hypergraph, you can get a sense of the complexity of this lighting rig.

10 All the important parameters are accessible via the sIBL_controls node. When you have that node selected, you can use the channel box on the right to quickly adjust the brightness (gain) and contrast (gamma) of the background, reflections, and diffuse lighting independently.

11 The feedback sphere controls orientation and placement of the entire rig. The sphere itself won't show up in the render; it's just a visual guide for aligning the background. And as discussed in section 7.3.3, this sphere should be ideally placed at the camera position (or alternatively scaled way up).

So I turn on hardware texturing, and then move and rotate the camera and the feedback sphere in concert until my troll character appears to be sitting nicely in the background.

12 In reality, my troll is of course floating in front of the background. For a better integration, I need a contact shadow with the lounge chair he is supposed to chill on. Because I'm perpetually lazy, I simply duplicate the auto-generated ground plane (which already has a shadow catcher material applied) and bend a few vertices until it is roughly shaped like a lounge chair.

13 Done. Render. Cheers!

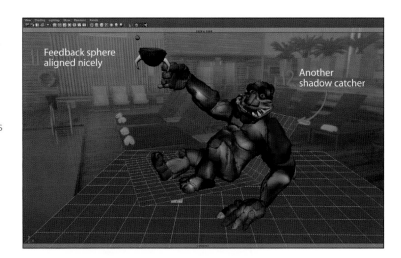

Feedback sphere aligned nicely

Another shadow catcher

Figure 7-68:
Everything aligned so in the camera view my troll appears to chill on a lounge chair.

So now you know why I didn't need to show you the exact setup steps for every software program. Smart IBL does it all for you. It unifies the workflow. With Smart IBL there is practically no difference between setting up image-based lighting with mental ray in Maya, Arnold in XSI, or V-Ray in 3ds Max—it's all done through the same user interface!

Under full disclosure I admit that this was in fact my very first render with mental ray. I wouldn't even know how to set it up by hand. But the point is I don't have to. With sIBL GUI, even a complete Maya noob like me can render a great image.

Figure 7-69:

Presets are stored in a sIBL collection folder.

folder during launch and gather all the IBL (.ibl) description files. So essentially, this is a folder-based content management system. One point of note is that sIBL GUI does use an internal database, but it also double-checks this database against the actual collection folder and recognizes new sets.

The bottom line is that Smart IBL relies on organizing HDR images in a clean folder structure. Even if all the script-fu fails for some reason, or you just don't like browsing thumbnails, you can still access every single HDR image manually.

Providers of stock HDR libraries love Smart IBL because it frees them from writing long-winded tutorials on how to use their content. All the loader scripts can register multiple sIBL collections, exactly for the purpose of inviting commercial HDR vendors. The format also includes a source link in each set and allows a certain amount of branding. The Dutch Skies 360 collections, for example, shows a steam-punk panorama viewing device (that is, a shiny chrome ball) on every thumbnail.

You can get ready-made sIBL sets (or whole collections) from a steady growing list of vendors: 3DTotal.com, HDRsource.com, HDRI-Hub.com, Evermotion.org, BobGroothuis.com (aforementioned Dutch Skies 360 collections). Occasionally you will find a sIBL set on the cover DVD of the *3D World* magazine, and I made it a habit of releasing one free sIBL set every month.

Figure 7-70:

Many stock HDR libraries are available in sIBL format now, which is a win-win situation for users and publishers.

Are you a collector?

A central idea behind the Smart IBL system is that the presets (sIBL sets) are organized in a *sIBL collection*. We tried to keep it plain and simple, so a sIBL collection is really just a folder with one subfolder for each set. It can be anywhere, even on a network location. As long as this sIBL collection path is accessible to the loader scripts, everything is fine.

When you drop a new sIBL set in a collection, it will be recognized by all the loader scripts because they scan through that collection

In a real VFX production

Imagine this production workflow: The lighting technical director (TD) is done with stitching HDR images and preparing all the lighting ingredients as a sIBL set. He did a couple of test renders and they look good. Then he moves the sIBL set from his local collection into the shared one and all the artists have it at their fingertips right away. That includes the character animators working in Maya, the LightWavers rendering the backgrounds, the Max'lers blast-

ing things into pieces with fancy dynamics plug-ins, and the Cinema artists creating the motion graphics. Everybody renders with the same lighting, nobody has to give it too much thought, and everybody is happy.

That's exactly how the lighting pipeline works at Eden FX. We made it a habit to create project-specific sIBL collections and hand-drawn sketches from the set as thumbnails. I know quite a bunch of other VFX studios that have adopted a Smart IBL workflow as well, even if they never officially talk about it. It's so easy that it feels like cheating.

Creating and editing sIBL sets

You think that was cool? Then check this out.

The icing on the cake is the sIBL editor by Chris Huf. It's a stand-alone application for preparing the HDR images properly and wrapping them all up into a sIBL set. If you ask me, Chris went way beyond the call of duty with this. This thing has more features than most other programs dealing with HDR images. And it looks pretty slick, too. It's divided into three parts, one for each task: importing, editing, and managing sIBL sets.

To make a brand-new sIBL set, you just drag and drop your master HDR (or EXR) onto sIBL-

Figure 7-71:
A rare glimpse at some of the private sIBL sets used at Eden FX, designed to help animators find the set that fits specific shots.

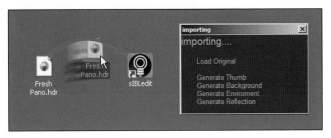

Figure 7-72:
Just drop your fresh HDR pano into sIBL-Edit to start the conversion.

Edit's program icon and it will be broken out automatically. That means sIBL-Edit will resize the reflection map, tonemap the background image, blur the environment image—all by itself.

Of course, all these are just first suggestions. When the initial breakout is done, sIBL-Edit pops up the Import window, where you can manually tweak each component image. All the tools necessary to prepare each image are collected in a convenient toolbox.

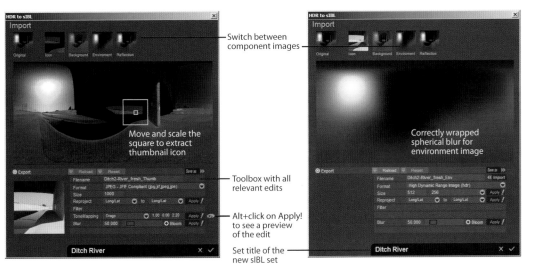

Figure 7-73:
The Import module lets you break out the component images in a convenient way.

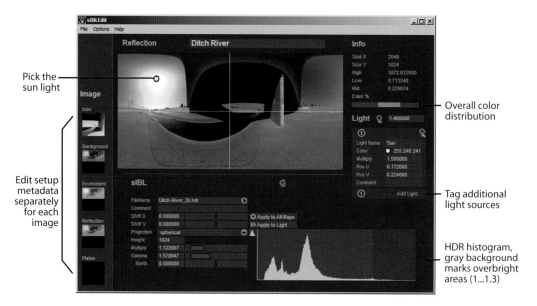

Figure 7-74:
The Edit module is the heart of sIBL-Edit, where you can edit all the setup metadata.

Pick the sun light

Overall color distribution

Edit setup metadata separately for each image

Tag additional light sources

HDR histogram, gray background marks overbright areas (1...1.3)

There's a thumbnail extractor, multiple tone-mapping operators, shortcuts for rescaling each image to common sizes, and a panoramic blur for the environment image. That blur is actually better suited for this purpose than any other. It correctly wraps around the panoramic seam, and it will also take the spherical distortion into account by blurring wider on the top and the bottom. It's an approximation, but it's superfast because it uses an iterative box blur technique. There aren't many other correct panoramic blur filters around. Your only alternatives are the Diffuse Convolution plug-in for HDR Shop (or Picturenaut) and the drPanoramicBlurSpherical plug-in for Fusion. You won't find anything like it in Photoshop.

The sIBL-Edit importer even has a panoramic remapping function. So you can literally take an HDR image from mirror ball to production-ready with a few clicks.

Once the images are all broken out, you are greeted with the Edit module. This is your worksheet, where you can swap out individual images and edit all the setup information that is stored in the IBL file. People keep asking for more automated ways to create sIBL sets, but the whole point of Smart IBL is that you need to

enrich your HDR images with metadata. That's what this editor is for. Here you type in all the comments and keywords, set the geo location (by importing KMZ files from Google Earth), and pick the sun light directly from the HDR image.

Everything is interactive here. The display reacts in real time when you set exposure, gamma, and image shift. The latter is intended for defining the north position but without touching the images themselves. It can also be handy for lining up images that were stitched separately, maybe even remixed from different sIBL sets.

This Edit module is also linked from within every sIBL loader. When you find yourself post-adjusting the same parameter in your 3D scene repeatedly (for example, brightening up the reflections), you can just quickly jump into this editor to make that adjustment permanent.

Finally, sIBL-Edit also includes a browser module, where you can inspect your collection and perform common management tasks. A basic principle behind sIBL-Edit is that it requires no prior experience in 3D applications whatsoever, so every photographer is able to turn his HDR panoramas into sIBL sets.

It's all open and free

And did I mention that the Smart IBL system is released as freeware? We highly encourage you to use it, share it, port it, and support it. We are all CG artists ourselves, with real day jobs in the VFX industry, so we didn't create this system to make a quick buck but to make our own lives easier. The more people that use Smart IBL, the better for all of us. That's why it comes with this book, fully loaded up with a starter's sIBL collection. You can find more free sIBL sets in our online archive, along with samples of commercial collections.

Or wait—no, Smart IBL is shareware! That's right, we demand that you share your best self-shot, self-created sIBL set with the rest of the CG community. Come to our forum and get connected!

↪ www.hdrlabs.com/sibl/

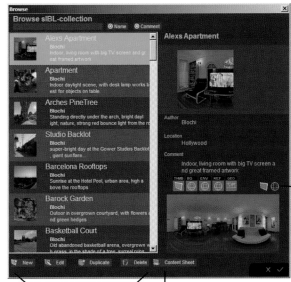

Figure 7-75:
The Browser module of sIBL-Edit.

Manage sIBL sets

Export an HTML page as reference contact sheet

Preview images with built-in panoviewer

Figure 7-76:
Smart IBL automatically creates a perfect lighting setup that makes even an untextured model appear fully realistic. Here my troll is rendered into a sIBL set that Bob Groothuis shot in a fab lab. Or maybe it's a resin model fresh from the 3D printer? Who knows?

7.4 Need More Space?

All the IBL techniques we've talked about so far started off with the assumption that we could capture the light from a single point in space, or more precisely, from the point where we placed the mirror ball or the nodal point of our fisheye camera. It's quite a stretch to assume the same lighting would be uniformly valid for the entire CG scene, or even for an object as big as car. If you shot the HDR pano in the direct sun, the entire scene will be lit by direct sunlight. If you shot it in the shade, everything is in the shade.

That's not how light works in the real world. The most interesting lighting situations always have some spatial variation. Strictly taken, our crude single-point assumption already falls apart when you look closely at reflections — the bigger the CG object, the more inaccurate the reflections of the environment will appear. Single HDR image lighting is a cheat. To make it work in a reasonably sufficient way, good enough to fool untrained eyes, remember to shoot the HDR pano from the center of the planned object.

But what can you do when the CG object is supposed to travel across the scene, crossing through a variety of different lighting situations? Well, essentially there are three options:

- Shoot a traveling light probe as HDR video.
- Capture multiple waypoints as HDR pano and blend between them.
- Reconstruct the location with 3D geometry.

Without getting into full-on tutorial mode, let me just quickly discuss each of these options and lay down a trail for further research.

7.4.1 HDR Video Light Probes

Sounds like a mouthful, but it's actually quite simple. The workflow in 3D is exactly the same as in standard IBL: You have your CG object floating in an empty virtual space. Instead of a still panorama, you're simply wrapping an HDR image sequence around this space. You're still flooding the entire scene with the lighting sample of a single point, but that point is now traveling through the location. Essentially, you can animate your character in place and let the world revolve around it, just like running on a treadmill.

Mind you, this method is not really helping with multiple characters populating the virtual space or static set extensions. But it's

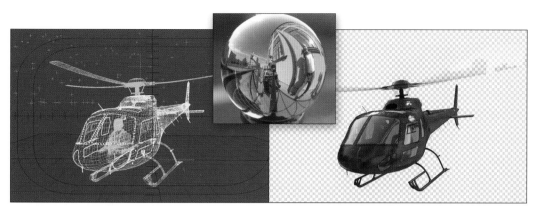

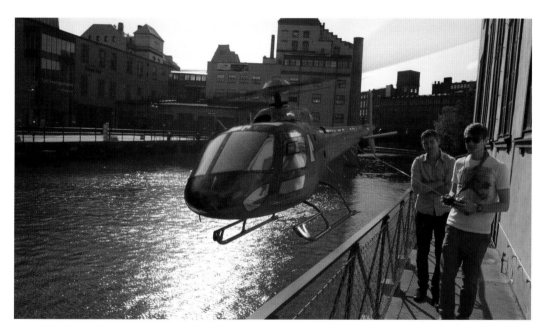

Figure 7-77:
*With an HDR video
light probe, you can
animate in place,
like on a treadmill.*

Figure 7-78:
*Composited on a
synchronized back-
ground plate, even
the reflections are
alive and seem to
interact with the
real world.*

great for driving shots, CG vehicles covering a
significant distance, or following a single char-
acter through a variety of different lighting
conditions. When applicable, the 3D workflow
couldn't be any easier—it's a shortcut for get-
ting extremely accurate lighting and reflections.

Capture setup

The only challenge is to capture this moving
HDR probe in the first place. Challenging, but
certainly no longer impossible. You can repur-
pose a 3D stereo rig as beamsplitter for film-

ing two exposures at once. Or you can use the
HDRx mode of the RED EPIC. If only the best
is good enough for you, I recommend load-
ing the Spheron HDRv camera in the trunk of
your Tesla. Eventually, by the time you're read-
ing this, you will have many other options to
shoot HDR video (see section 3.1.9 for details on
promising approaches). To make this HDR video
capture panoramic, the good old mirror-ball-on-
a-stick method comes in handy again.

A bit of sequence planning is necessary be-
cause you're already setting the motion path

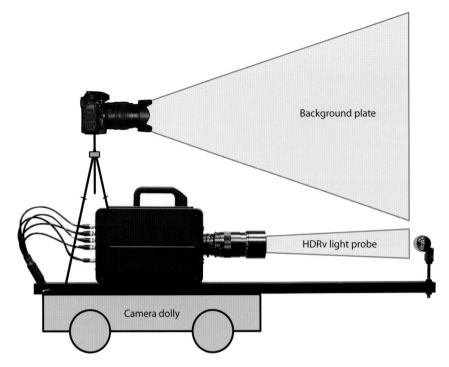

and timing at the time of shooting. Ultimately, you're predetermining all this with principal photography anyway, so it makes a lot of sense to capture this video light probe synchronized with the background plate. The image above shows a setup for this: The Spheron HDRv camera shoots straight into a mirror ball, which is mounted on a long steel pole. Both are placed on the same dolly cart as the principal camera. It helps to mount them a bit lower, so the mirror ball doesn't show up in the plate—otherwise, you'll have to make sure your CG object covers up the ball and supporting pole.

This HDR video technique is still largely untapped, and there are lots of unexplored opportunities in capturing rapidly changing environments. You could capture the light show at a rock concert, metropolitan traffic mayhem at night, or a camping site lit by campfires and fireflies.

Used for driving footage, this rig performs best when mounted on the back of a truck and pointed downward at a 45-degree angle. Not only does this lower the vertical position of the mirror ball to the approximate center of a normal-sized car, it also maximizes sky coverage by putting the sky in the sweet spot of the reflection. Ultimately, you will use this moving light probe for rendering CG cars, and then the correct sky reflection on the hood will be instrumental for creating a realistic effect.

Another setup solution would be to hang the mirror ball from above, the same way a boom mic is hung from above. That way you can give your actors something to look at so there is no confusion about the eye line. It will need wire removal in post, and instead of working with a fixed rig, you have to actually operate the HDRv camera from the sidelines to stay pointed at the ball. But by grabbing such an HDR video probe from exactly the right point in space, you will be able to place a shiny CG robot right next to your main actor with unmatched realism— down to the actor's performance showing up in the reflection.

Pre-processing

Another tricky part is that now a sequence of EXR files needs to be unwrapped. So the entire mirror ball workflow described in section 6.3.3 needs to be done in a compositing program, plus a few extra steps.

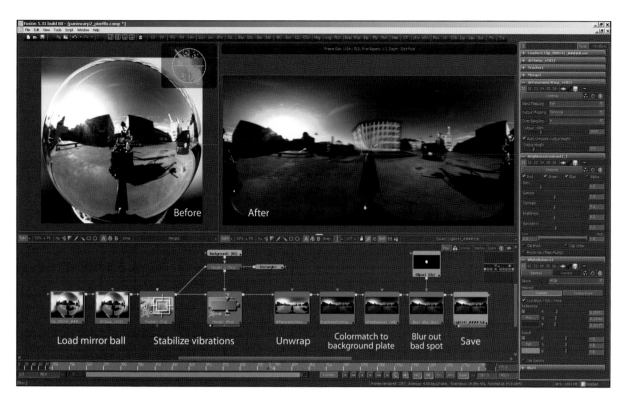

Before After

Load mirror ball Stabilize vibrations Unwrap Colormatch to background plate Blur out bad spot Save

First of all, you need to synchronize the frame numbers to the background plate. That step is easy, because you can actually see the clapper slate in the reflection of the ball. It is a panorama, after all, so you see everything.

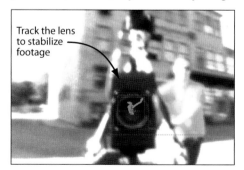

Track the lens to stabilize footage

Then it needs to be stabilized. If the mirror ball was mounted on a stick, that stick adds a certain amount of wobble and high-frequency vibration, and if you shot the mirror ball from the sidelines it's most certainly bouncing all over the frame. So you need to stabilize it either way. Thankfully, the HDR video camera is al-

ways directly in the center of the reflection. You can even push the exposure up to see into the lens that the very same video was shot with. That gives us a perfect anchor point for a tracking marker.

Unwrapping the panorama is the central step, of course. In Nuke that's easy. Nuke offers a Spherical Transform node that even comes preconfigured with the mirror ball to latitude-longitude format. In Fusion you need a plug-in for that. It's part of the free drUtilSuite pack from Duiker Research. It's a highly recommended download for all Fusion users because it also includes multiple other tools for dealing with floating-point images.

[→ www.duikerresearch.com/fusion

I also recommend adjusting exposure and white balance to match the background plate. These are fairly straightforward operations in any compositing package. Extra tip: Fusion's Gain control is a linear intensity multiplier, whereas photographic exposure is quadratic

Figure 7-80:
Getting the mirror ball sequence ready for IBL in Fusion.

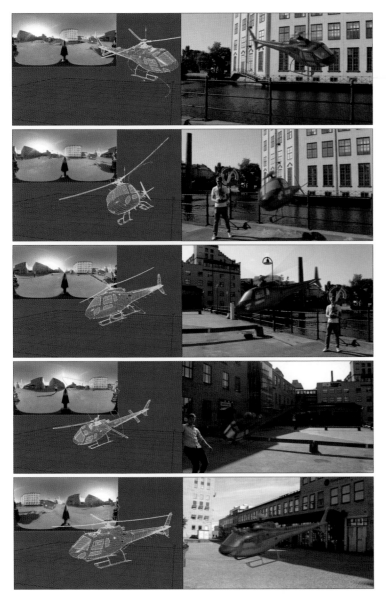

side. But now we only have a single light probe. Blurring that spot prevents hard edges, which helps to reduce sampling issues and prevent noise in the render. You could further help the GI algorithm by blurring the entire light probe (as demonstrated in section 7.3.3), but that only applies when you render mainly diffuse materials.

Easy going in 3D

All that preparation work may look daunting, but the reward is that in 3D everything comes together all by itself. It's striking how simple it is, really. If the object doesn't have to touch the ground, you don't even need to track the camera motion. You can literally just wiggle a helicopter model in front of a still-standing camera, like dangling a carrot on a stick. Lighting and reflections match automatically because it's all in the HDR sequence.

Once HDR video becomes ubiquitous, I expect this workflow to become very popular. Until then, you can download some footage from Jonas Unger's HDRv Repository and play with it yourself.

▷ www.HDRv.org

7.4.2 Blend Multiple HDR Panos

For mainly diffuse objects, where moving reflections are not a concern, you can also blend between different HDR panoramas as the object crosses from one lighting scheme to another.

It's inexpensive to capture, less intrusive than HDR video, and application in 3D is fairly simple. For single characters you'd just use a layer stack as environment texture and cross fade as you feel appropriate. If your character steps out of the shade quickly, you blend fast. If it slowly moves closer to a white wall, you'd transition slowly to a pano shot close to this white wall. Provided you have good coverage of the set, it's pretty amazing how far this simple method can take you. In the end, most individual shots can be broken down to the character

Figure 7-81:
Once the HDR sequence is properly prepared and synchronized to the plate, everything comes together by itself.

(i.e., scales in powers of 2). That means a gain value of 2 is equal to +1 EV, gain 4 is +2 EVs, and so on. In the example screenshot, I needed to go the other way, using gain 0.5 to reduce exposure by −1 EV.

Last but not least, it's very helpful to blur the pinched spot that is left after unwrapping. That is the part of the environment that was directly behind the ball, so we actually have no real lighting information there anyway. In section 6.3.3 we enjoyed the luxury of covering up that spot with a second HDR image shot from the

moving from A to B, so it often takes just the right selection of the A and B light probes to transition in between.

A more sophisticated setup would require building a network of connected waypoints in the correct 3D location. Then it's a matter of using expressions or some script-fu to derive the appropriate blending amount from the objects' distance to these waypoints. If you build this as a shader-based solution (instead of globally applied lighting), you can even have multiple objects properly lit in the same scene at once.

It's all just a cheat, of course, but a very efficient one. So efficient, in fact, that modern game engines have adopted this method to add dynamic lighting to in-game characters. Unity 3D, Unreal3, CryEngine, and Frostbite 2 are some of these engines, and they all allow game artists to strategically place virtual light probes in a game level. Game editors can also automatically distribute a grid of light probes. Then they literally render these probes using high-quality radiosity calculations, predetermining complex light interactions between the player's character and the game world. For example, when the player gets closer to a super-green wall, it will get more and more affected by green bounce light. Such an effect would be pretty hard to render in real time, but since it's really just about selecting and blending prebaked lightmaps, the blending trick even works on mobile devices.

For further research I recommend doing a Google search for "spherical harmonics lighting," "lightmass," or "irradiance volumes." The industry standard for creating such prebaked

Figure 7-82: *Virtual light probes to capture a spatial light field. Shown here in a Battlefield 3 level (running on the Frostbite 2 engine).*

Figure 7-83: *Applied in a game engine, these light probes are used to realistically shade the player's character with very little effort. Shown here in SHADOWGUN, a game by Madfinger Games on the Unity 3D engine.*

light probes seems to be Autodesk Beast, which integrates seamlessly with most game editors. If you prefer a tight integration into Maya, then the point cloud feature in the Turtle render engine will fulfill your needs.

7.4.3 Reconstruct the Set in 3D

This is by far the most labor-intensive option. It is, however, universally applicable and will provide an equally great solution for lighting many CG objects scattered throughout the scene, moving objects, and static scene enhancements. It makes most sense for reoccurring locations and longer sequences playing in the same set.

New-school automation with point clouds

A point cloud is exactly what the name suggests: a loose cloud of points in space. Think of it as the 3D version of the control points in a panorama stitcher, but much denser. Traditionally such data was the exclusive domain of 3D scanners and ridiculously expensive LIDAR devices.

Figure 7-84: *Point clouds look like raw 3D scan data.*

There are interesting new programs around that can generate point clouds via automatic image analysis. Microsoft Photosynth comes to mind. It's easy and free, but the license agreement is not without concerns. Basically, Microsoft owns all the point cloud data generated. It's automatically integrated in online mapping services and lives in the social sharing wonderland forever. That's a sure deal breaker when you want to model the set of next summer's blockbuster for a big movie studio. Autodesk 123D Catch (the unofficial successor to Realviz ImageModeler) also requires uploading your images online, even though Autodesk has not

yet decided what to do with all this data. Who knows, maybe it gets the idea to produce its own movie mash-ups. Desktop alternatives like insight3D, Bundler, MeshLab, and PhotoScan are usually more in a client's comfort zone.

Figure 7-85: *Panoramas are shot from a nodal point to minimize parallax shift.*

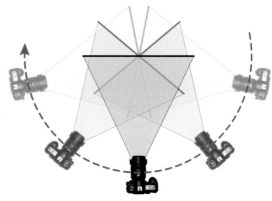

Figure 7-86: *Shooting for automated photogrammetry requires as much parallax shift as possible.*

An important fact to remember is that none of these point-cloud-based programs can import panoramas. In fact, they can't even use your original pano sectors as source images. Even though they are distant relatives of panorama stitchers, they use an almost opposite approach when analyzing the images: They look at the parallax shift between similar image elements to figure out their proper position in 3D space. It's basically a triangulation process,

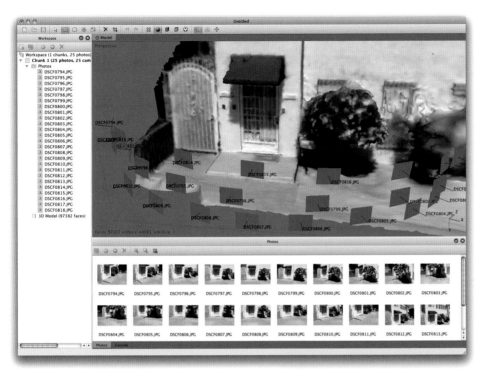

Figure 7-87: *Agisoft PhotoScan is pretty good at lining up the photos, deriving a point cloud, and skinning it with geometry.*

Figure 7-88: *PhotoScan's resulting mesh is about as good as it gets with an automated method. Still requires lots of cleanup though.* ▼

and it works best when you shoot your source images from as many different perspectives and viewpoints as possible. For panoramic shooting, however, we went to great lengths to turn the camera around the nodal point and eliminate any parallax shift (see section 6.4.3). So the images shot for a panorama do not contain any 3D information and are essentially worthless to point-cloud generators.

This point cloud technology is a bubbling premordial soup right now, comparable with the state of pano stitching 10 years ago. The hippest approach to date is to use the Microsoft Kinect or similar depth-aware sensors to create a point cloud in real time, but as of right now all these programs feel sort of hacked together. For real production use, the most promising candidate today is Agisoft PhotoScan, which combines reasonable usability with acceptable mesh quality.

↪ www.agisoft.ru

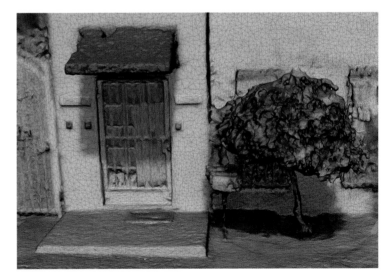

However, all automatic systems can fail, and they typically fail in the most inconvenient moment: when a deadline is approaching.

In real life it usually boils down to the tried-and-true method of modeling by hand. It's actually not as hard as you'd think. For example, you can often get a sufficient 3D representation of a

building with a simple box. And that is created faster with the standard box tool found in any 3D application than by cleaning up an auto-generated mesh with millions of irregular polygons. That's why in real production the point cloud mesh is used for reference at best and then cleaned up and remodeled in a process called *retopology*.

PRO-TIP The Mattepainting Toolkit (MPTK) for Maya is an indispensable help for such retopology work. It makes clever use of the camera positions that the point cloud generator figured out and allows projecting the original images back onto your hand-modeled mesh. Its unique strength is mixing the appropriate parts from each projection into one unified texture map.

⬐ www.glyphfx.com

Either way, there is a considerable effort involved, and in the end you have only a partial— although highly accurate—set reconstruction. The sheer number of photographs required

makes it also rather impractical to do the entire process with HDR images.

That's why I prefer a simpler solution.

Manual reconstruction from a panorama

There are quite a few advantages in using a panorama as a starting point:

- ❯ It's only one image.
- ❯ There is no confusion about lens data because a panorama has a very defined image geometry. It's spherical. That's all there is to know.
- ❯ The result is an all-encompassing model without holes. It may not be perfect in all directions, but it's certainly not showing black empty spots in reflections.

Enough with talking big, let me walk you through the workflow in a hands-on tutorial. We'll rebuild a Tokyo subway station based on the Subway-Lights.exr panorama from the DVD. Basic modeling skills in a 3D program are required for this tutorial.

► Part A: Preparing the panorama

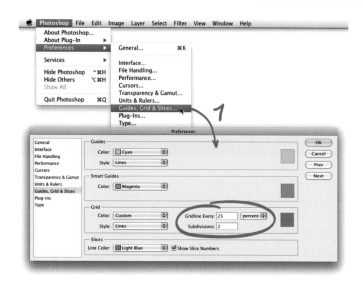

First make sure the panorama is perfectly leveled. That's best taken care of during stitching, using vertical control points. Section 6.4.9 shows a tutorial on this (using this very panorama).

To make the modeling process as painless as possible, the panorama should be oriented in a clear north direction. There's a simple way to do this in Photoshop.

1 In Photoshop, open PREFERENCES ▸ GUIDES, GRID & SLICES. Configure it to show a gridline every 25 percent with 2 subdivisions.

2 Now we have handy markers for west, north, east, and south. You can also think of it as X and Z directions if you want. I just like the mental

picture of compass directions, even though they may not match the real geographic orientation.

3 Use FILTER ▸ OTHER ▸ OFFSET to roll the pano horizontally until the major vanishing points conform to the gridlines. Try to be as accurate as possible. Zoom into the picture. For pixel-perfect control of the horizontal offset value, don't use the slider but click-drag the label instead.

4 In this case, the floor and ceiling tiles clearly describe a dominant direction. Another good indicator is the long sweeping arc of a wall's bottom edge. Roll the pano until the lowest dip of this edge sits centered on a gridline, with its tangent crossing at a straight angle.

5 Press Command+H to turn the grid overlay off now (Ctrl+H on a PC). This is one of my most frequently used keystrokes. It toggles all the guide lines on/off—very handy to get a grip of directions in a panorama, even when retouching.

6 Save the image. ◄

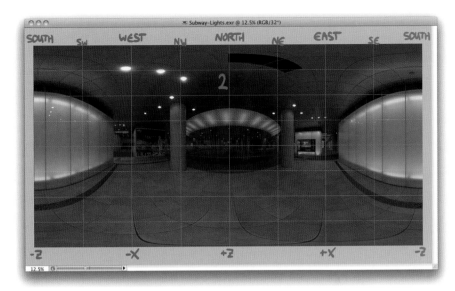

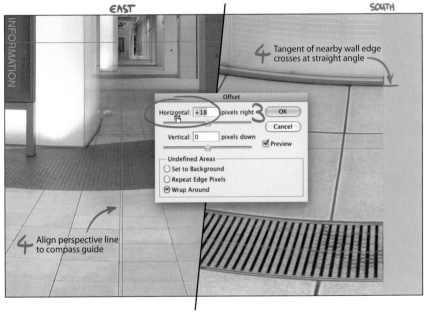

Aligning your panoramas to such clear 3D directions is a very worthwhile habit. It always helps the workflow.

Even navigating around in a simple environment map is easier this way, because you can associate things in the image with forward, left, right, and backward. Let's say you animate a character walking through the environment, then you most likely animate it along the x- or z-axis (instead of diagonally across 3D space). And with a properly aligned panorama, there is a much better chance that this axis happens to run directly down a hallway, for example.

On to the actual 3D modeling part.

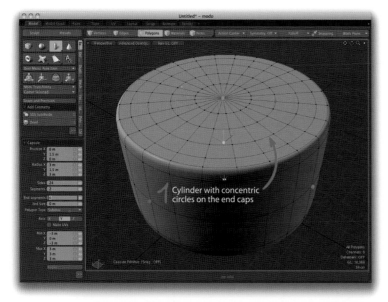

Cylinder with concentric circles on the end caps

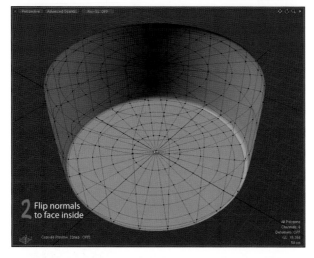

Flip normals to face inside

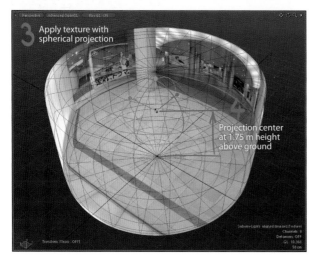

Apply texture with spherical projection

Projection center at 1.75 m height above ground

Part B: 3D Modeling

I will demonstrate the workflow in modo, but I will try to keep it generic enough that you can follow along with any 3D application of your choice. You'll see that there is actually no magic involved.

1 Create a cylinder with 3-meter radius and height.

Well, technically the most appropriate primitive for our purpose is a capsule. Cylinders have simple discs as end caps, but we need concentric circles on the top and the bottom. You will see in a minute why that is so.

2 Flip all normals so the polygons are facing the inside.

This will be our panoramic canvas. It will serve as a guide for further modeling as well as a distant background. The shape is remarkably similar to a cyclorama—you know, these round theaters from the eighteenth century where panoramas were painted on the walls. That's exactly how we're going to use it too.

3 Apply our Subway-Lights.exr panorama with a spherical projection.

Simple sentence to write, but in reality that may well take you more than 10 clicks. You have to load the image, assign the correct color space, create a material, enable OpenGL, and so on.

Apply the texture to a material channel that does not receive any shading but instead emits light. That channel may be called Incandescence (Maya), Luminosity (LightWave), Luminous Color (modo), or something similar.

If you see the text on signage in the image mirrored, make sure to invert the horizontal mapping direction (modo forced me to flip the image in Photoshop).

4 The most critical step is to place the center of the spherical projection at the same height that

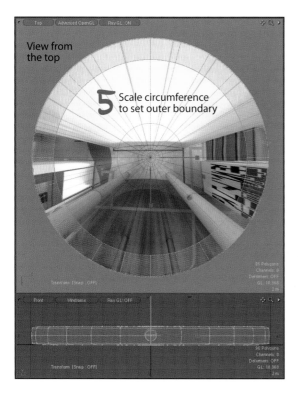

View from the top

5 Scale circumference to set outer boundary

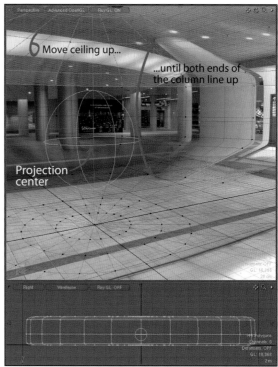

6 Move ceiling up... ...until both ends of the column line up

Projection center

the panorama was shot from. In this case, my nodal point was 1.75 m above the ground. I think.

5 Next, we need to set the outer boundaries of the environment. That's done best in a top-down view. Select all the polygons on the circumference and scale them outward. Actually, in an architectural space like this it's better to scale the first rings of the end caps as well, so we maintain the hard edge on the border. But do not scale the entire cylinder; keep the poles centered at the origin.

In this example, pushing the circumference about 20 meters to each side will do. You will notice that the ground texture gets very stretchy toward the rim. That's where our spherical projection hits the ground at a very flat angle, and that's also where the slightest orientation error in the panorama will result in a considerable texture shift.

6 Back to the perspective view. It looks a bit strange, and the columns are smeared all across the floor and ceiling, but you can definitely tell

that the back wall is now farther away. You can get a first sense of depth.

Next we need to estimate the ceiling height.

Now it would be good to have actual room measurements, and if this were a real job I would have probably taken some notes and drawn some sketches. But this panorama was shot guerilla style, right after I promised the Japanese subway officer in sign language I would take "just one more photo." Pulling out a laser range finder didn't seem like a polite (or even remotely cooperative) thing to do. Nod and smile, nothing suspicious here, nod and smile...

So that's why we have to estimate now. It's actually easy. See, when you're moving the ceiling up or down, you change the distance from the projection center and the texture will slide across the surface. It looks strange when you do it the first time, but you quickly get the hang of it. Specifically, the upper end of the column will slide across the ceiling, and at a height of 4.70 m, it roughly lines up with the lower end of the column. So that must be the proper ceiling height.

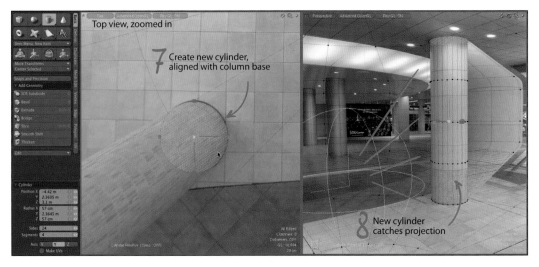

7 Zoom into the top view and create a new cylinder. Align it tightly with the column base, and make its height reach from the floor to the ceiling (0 m to, well, 4.70 m).

8 Look at the perspective view. Now it starts to make sense, eh? The new cylinder will inherit the background material and along with it the texture projection. That means the cylinder will literally catch the panorama out of the air. You just have to move it in the right spot.

If 4.70 m was a bad guess, you can just move the cylinder top *and* the ceiling up and down to adjust. The texture projection will slide across again, and somewhere there is a prefect fit. It actually looks like 4.78 m to me now.

Of course, the projection goes straight through, and there is still a kinked column smeared far into the distance. But we shouldn't worry about that right now. We have work to do.

9 We have to build the rest of the room now.

Keep using the top view as a floor plan, and build cylinders for columns and boxes for walls. Aligning the corners is always the important part, and that's what you need the perspective view for.

It helps when you build walls with several subdivisions because the wireframe grid is the only thing that shows you what you're really looking at. More subdivisions also make the OpenGL texture slide smoother. Theoretically, you would only need to build the front facades, but I prefer building solid boxes so they are easier to see in the top view.

As I said, it's not magic. Just busywork. But with every new box and cylinder you're getting a little closer to the goal. There's a peace of mind in that, which automatic solutions simply don't offer.

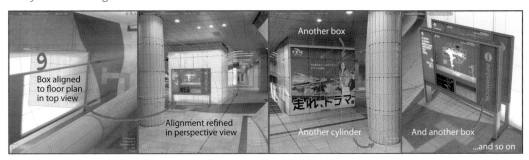

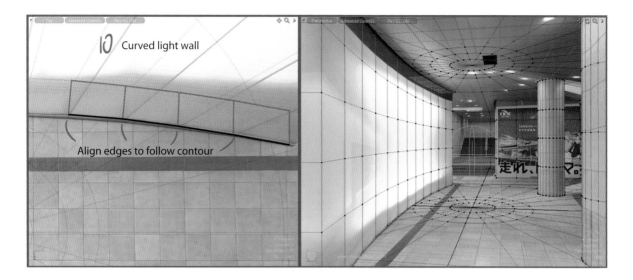

> 10 Curved light wall
> Align edges to follow contour

This is also the phase where careful alignment of the panorama pays off double. Eventually you don't even need to rotate every box. Well, okay, in this example it's a little bit off, but at least it's not at a completely diagonal angle. Most important now is that the verticals in the panorama are perfectly vertical. That's one less dimension to worry about, otherwise you would go nuts if you had to tilt every object into place.

10 The highlight of this modeling exercise is the big light wall. I can count 12 panels, so you'd make a box with 12 subdivisions on the x-axis. The wall is slightly curved, so pick your weapon of choice to deform the geometry until it fits. I like using edge tools and soft magnet selections, but there are a million ways to push geometry around—after all, that's what 3D modeling is all about.

11 I recommend building everything to the same height, just so you can plow through the modeling phase faster.

You will notice that there is still a slight tilt in the panorama—no stitch is ever perfect down to subpixel accuracy. But that's okay. We're not doing real architecture here; there is no structural integrity at risk when one column is a bit shorter

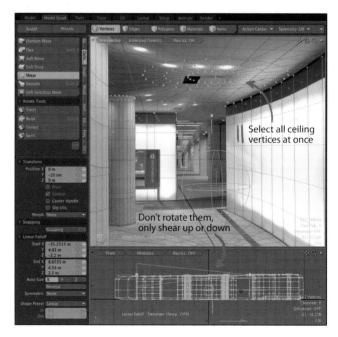

> Select all ceiling vertices at once
> Don't rotate them, only shear up or down

than the other. It just has to look good. So you can just push things into place.

Once you have enough vertical structures in place, you can select all the vertices on the ceiling and move them all at once until you have a tight fit. Don't rotate or tilt them; that would introduce slight sideward shifts. Instead, use the Shear tool or soft magnets to gradually adjust the ceiling height only on the vertical axis.

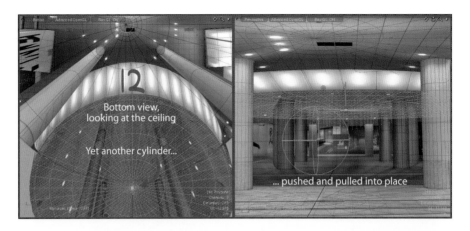

Bottom view,
looking at the ceiling

Yet another cylinder...

... pushed and pulled into place

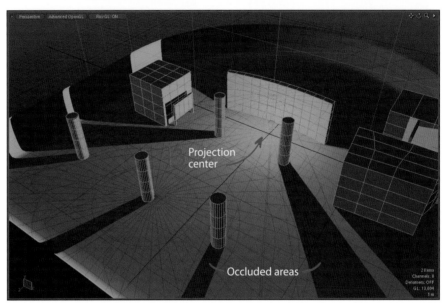

Projection
center

Occluded areas

12 Now you can add some ceiling details.

It's pretty much the same eyeball alignment method as before, with a small exception. Instead of a top view to see the floor plan, you'd use the bottom view to see a flat plan of the ceiling. That's where you align things first—for example, a large cylinder for the hanging ceiling.

Then use the perspective view to adjust the height, and finally, push and pull vertices until all the polygon edges line up with edges in the image.

13 The result is a cute collection of primitives and simple geometry. ◄

It's a very formulaic approach, and it works every time.

For outdoor locations, it's even easier because they have no ceiling. Instead of a cylinder, your

initial background object would then be a pano bubble (sphere with flat bottom), scaled up to about a kilometer.

Either way, when modeling foreground objects you can concentrate your efforts on vertical structures. Anything that sticks up from the ground and has the potential to catch the projection is worth remodeling. Of course, the complexity of these models is extremely dependent on the location, but in most cases you can get by with primitives. Cluttered piles of junk and organic foreground objects are easier represented with subdivision surfaces, draped and crumpled into the approximate shape. See section 6.7.4 for a few more examples.

Next we need to take care of the occlusions. And there are quite a lot of them in this example. When you put a point light in the same spot as the projection center, you can tell by the shadows what parts are missing.

It's a bit of a puzzle, that's for sure. The general strategy is now this:

1. Bake the projection into a UV map.
2. Separate foreground and background.
3. Reconstruct occluded areas.

Let's see how that works.

► Part C: Fixing the texture

Now, there are several approaches to this general strategy, and they all hinge on the type of UV map created.

Your gut reaction may be to create an Atlas UV map because that's a fully automatic unwrapping operation. But wait: That would be a one-way road, plastered with spikes! If you did that, you'd have to bake the texture, that is, transform all the pixels to conform to the Atlas UV map. The texture would loose sharpness, or resolution, or both. And you couldn't go back anymore.

The spherical projection has worked great so far, so why change it now?

1 Create a new UV map with the same projection parameters that we previously used for the texture projection: spherical, 1.75 m height above the ground.

This UV map makes it clear now why we wanted to have concentric rings on the initial background geometry. It simply maps better. In spherical space, these rings become horizontal lines to support the texture.

2 However, nadir and zenith are giving us trouble—as usual.

On the zenith and nadir, the geometry is made up of triangles, and these can't really span

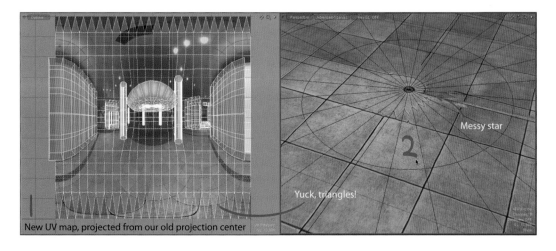

New UV map, projected from our old projection center

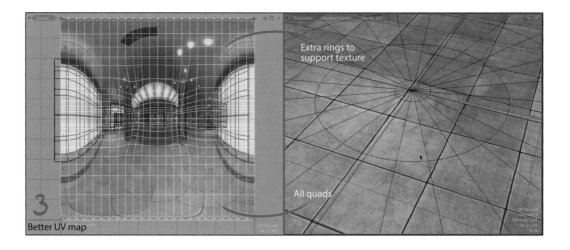

3 Better UV map

Extra rings to support texture

All quads

the image in the UV map well. Triangles show up as jagged edges, and that becomes a messy star. The OpenGL preview in your 3D application might have shown this star all the time; many panorama viewers do this as well. The triangles in the UV are really showing the root of the problem.

The simple solution: Make sure these spots end in quads. You can just slice an edge loop into the last ring of quad, scale the circle of triangles down to about a millimeter (but don't delete it), and that's it.

3 The resulting topology looks almost the same in the 3D perspective, but now the mapping is fixed.

If the UV map doesn't update after a model change, you can just re-create it. That's the beauty of a spherical projection: It's perfectly re-peatable and the only parameter to remember is 1.75 m height. You can even spontaneously jump back to the modeling stage, add more geometry, and then run it through the same UV projection. It will fit right into the existing map.

4 The next step is to separate the foreground and background. They need to be separate materials with separate images.

Basically, you need to duplicate the panorama image twice and save these copies as Subway-Foreground.exr and Subway-Background.exr. All the extra objects we added get the foreground image applied, and our initial cyclorama background gets...well...the background image. In each case you apply the image using our previously prepared UV map.

5 Time to fill in the missing parts of the background.

What you need is a 3D clone stamp tool that works directly on the geometry. Our careful UV preparation ensures that you can export the model to any 3D paint application you like. MARI is pretty hip right now. BodyPaint 3D, Mudbox, ZBrush, 3D-Coat, they all work for this—whatever suits your fancy. I just keep going in modo's integrated 3D paint mode.

This is yet another tedious part of the workflow. Now it would be good to have another panorama from a different position, or at least a few extra photos that show the occluded areas. Well, sorry there. I got nothing. Just keep on clone stamping. Sometimes it's best to copy entire walls or sections, just to fill up the space quicker.

6 Of course, you can also fix the background image in Photoshop.

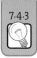

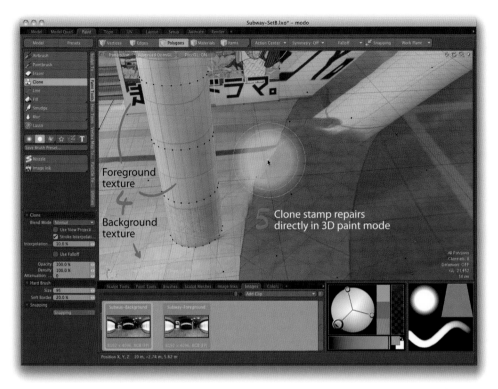

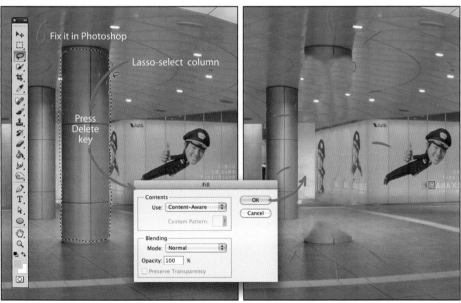

Content-aware fill is your best friend here. The downside of Photoshop is that you can't paint directly in the proper perspective. But at least the image is still in the familiar panoramic format, which means that you can very easily steal some details from another panorama. If this were an outdoor location, you could just drop in a different sky, for example.

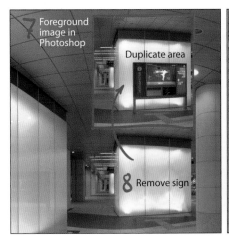

7 The good news is that these two images are really all you ever need: a background and a foreground.

Even when multiple foreground objects are staggered in depth, with multiple levels of occlusion, they can all stay textured with the foreground image. That's because we actually have a lot of space left in the UV map.

Let's look at an example. In this panorama, the information sign is technically in front of the futuristic glowing box. Both are part of the foreground. To separate them, you simply box-select the entire area in Photoshop and clone it to a spot somewhere on the top. Don't worry about blocking up the ceiling; we have that covered in the background image anyway.

8 Now remove the information sign from one of the areas, let's say the lower one. Again, Photoshop's content-aware fill works magic.

9 Reload the foreground image in your 3D application. Go straight to the UV editor, select all the polygons that belong to the sign, and move them upward. Just align them with the new location of the sign texture. Voilà, perfect separation!

Sometimes it's worth nudging the points around in the UV editor to get a better fit. And in some parts, the initial through-projection actually works to your advantage. The backside of the columns, for example, is already textured with a mirrored image of the front side. That's really the trick: Don't fight the spherical projection! Use it.

You'll see that untangling occlusions within the foreground objects is much easier than cleaning up the background. There are much smaller areas to paint out. And there is so much open space in this UV map that you can easily add more foreground objects. Everything is still open, and you can still model, re-project UVs, separate occlusions, and clean them up. With each object you add, you increase the accuracy of the reconstruction and extend the possible range of uses. ◄

At the end of this reconstruction process the panorama has turned into a virtual stage, where you can find entirely new camera angles, even animate camera moves. Pretty cool, eh? The critical advantage is that every object placed into this virtual stage will be lit perfectly. That even includes absolutely realistic reflections.

- Make sure the panorama is perfectly leveled and oriented straight.
- Create a background cylinder/dome with concentric rings on top and bottom.
- Flip the polygon normals.
- Apply the panorama as a spherical texture, projected from the same height it was originally shot from.
- Scale the outer polygons up to set the distant boundaries of the location.
- Model all vertical structures, using the top view as a floor plan.
- Create a UV map with the same spherical projection parameters.
- Separate foreground and background material, each with its own copy of the image.
- Patch the occluded areas in the background image. Use the clone stamp in 3D or content-aware fill in Photoshop.
- Solve occlusions within the foreground by editing the foreground image and UVs.

Figure 7-89: *Finished virtual stage, ready for action.*

Figure 7-90: *You can find a variety of new camera perspectives, even animate camera moves.*

Figure 7-91:
Any CG object placed here will have perfectly accurate lighting and reflections.

Such 3D scene reconstruction is a very common task in VFX production. Even if a live action background plate will be used for final compositing, the lighting and reflection accuracy alone make a 3D reconstruction well worth the effort. It can also be used as a reference in camera-tracking software like PFTrack or SynthEyes, as a spatial guide for scene layout, or—when modeled carefully enough—for creating completely virtual shots. Reoccurring sets are often handled by entire crews, and here it pays off to have many more reference photos available. Usually two or three panos provide the base and cover most occlusions, but the final scene often has all important areas filled with more detailed models.

7.5 Light Rigs

All the approaches we have talked about so far rely on physically based rendering. The light from the HDR image is pumped into the scene directly, and global illumination does the work. But can we also use it in classic rendering? Have it look as cool without waiting for radiosity to finish its crazy calculation?

Of course we can.

7.5.1 Extracting Lights

A common shortcut is to convert an HDR image into a rig of regular light sources. This technique is a bridge to the traditional way of faking soft shadows and moody ambient light, as was described in section 7.1.1.

It sounds like a hack, but it really isn't. See, when we blur the environment image, we do nothing but help the radiosity rays to be less random. They still shoot off in random directions, but they hit more uniform areas and are

Simple radiosity, 10 min Importance sampling

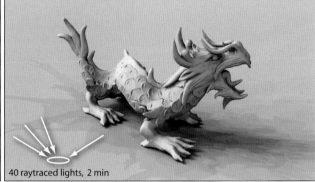

40 raytraced lights, 2 min

therefore more likely to deliver a smooth, noise-less result.

But we can also flip that concept around and look up the best rays upfront. Then we fixate them in the form of standard direct lights and render without GI. The random element is out the door entirely, and that means no more trouble with sampling noise or flickering—just a bunch of standard lights and super-quick render times.

That's the basic idea. Obviously, this technique has its own kind of artifacts. Now we have a whole bunch of overlapping shadows instead of smooth gradual radiosity shadows. I'll show you some tricks to deal with that situation later; for now let's look at our options for creating such a light rig.

LightGen

The first program that could generate such a rig was LightGen, an HDR Shop plug-in from Jon Cohen. You feed it an HDR image and it will spit out a text file with light information.

Importer scripts that build the actual light rig from this text file are available for pretty much all 3D programs. They often have no interface; they just dump the predetermined lights into your scene. It works, but it's a pretty unintuitive workflow. When the render doesn't turn out the way you want, you have to start over in LightGen and generate a new text file.

But the more serious problem is that Light-Gen isn't very smart. Lights of varying intensity will be distributed pretty evenly across the image. But that's not cool. What we're really interested in are the light rays that actually contribute to the lighting. Who cares about the dark areas in an HDR image; much more important is that our samples pick up the bright lights.

Figure 7-92:
Comparing radiosity and light dome rendering techniques.

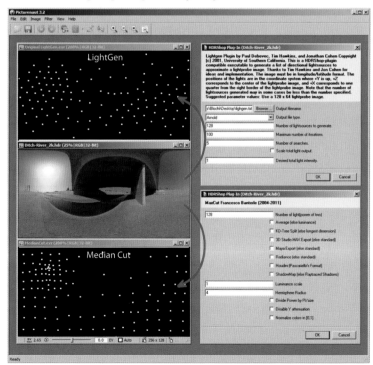

Figure 7-93: *LightGen and Banty's Median Cut are two plug-ins for light extraction. Technically made for HDR Shop, these plug-ins run even better in Picturenaut.*

Figure 7-94:
My LightBitch plug-in is an interactive light extraction utility for LightWave.

Viewport display options

Interactive light editor

Workflow assistant

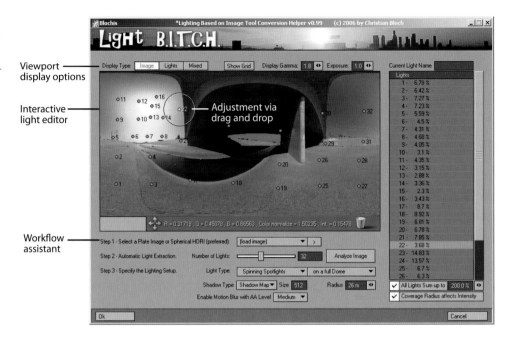

Importance sampling

What we need is a method called importance sampling. Put more lights where they make most sense. Dismiss dark areas. Concentrate samples in the brightest areas of the HDR image. Optimize the distribution to get the most bang for the buck. That's the basic idea, and an entire branch of computer graphics research has spawned off it. Two algorithms for such a smart light extraction have already become classics: *Median Cut* by Debevec gives a very fast approximation, and *Voronoi Tesselation* by Kollig and Keller is more accurate but slower.

Median Cut was made into a free HDR Shop plug-in by Francesco Banterle. It's part of Banty's Toolkit, which comes with Picturenaut on the DVD with this book. The dot pattern in the screenshot on the previous page shows clearly how much better the light distribution is compared to the LightGen result. The dots cluster around bright spots, sampling more of the light and less of the shadows. If you look closely at the options, you'll see that Banterle's Median Cut supports direct output for 3ds Max, Maya, Radiance, and Houdini.

Another implementation, which includes both classic algorithms, can be found in a utility called lightMapGen by Jeremy Pronk. Natively it runs in a command line and generates a setup file, which you'll then import into Maya. lightMapGen is freely available on www.happiestdays.com.

LightBitch

Although these tools can do the job, I was never quite satisfied with the general workflow. It simply doesn't follow the WYSIWYG paradigm because it is divided into these two steps: generate and import. Making lights blindly in external software is messing with my flow.

So I created my own adaptation as a Light-Wave plug-in. It started out as a front end for Pronk's lightMapGen. Then I wanted it to visualize the rig before the actual lights are generated. And as the work progressed, the plug-in turned into something else entirely. That's how LightBitch was born.

The twist in this plug-in is that you can manually tweak the light samples. Simply by dragging them around, you can resample from

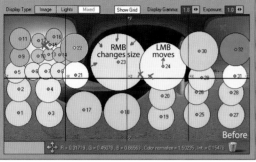

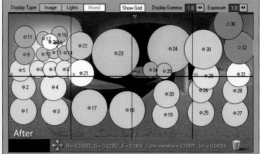

Figure 7-95:
Manually adjusting the lighting solution takes just a few clicks.

the HDR image and optimize the distribution by hand. Add new samples just by clicking in the image, and delete samples by dragging and dropping them to the trashcan. Everything is interactive; even the luminosity of all lights is listed and normalized in real time. While you drag a light around, all the numbers dance up and down to reflect the current lighting balance.

It turns out that an artist knows very well what he wants in the light rig. For example, when I feel the sun is underrepresented, I can just add a new sample. The same goes for the small blue patch on the other side of the bridge—that wasn't picked up by the Median Cut algorithm at all. So I just make some room by nudging the other lights aside and set a few extra samples.

My favorite way to visualize the extracted lights is by looking at the coverage circles. They can be scaled with the right mouse button (RMB), and aside from the visual guidance, they also serve two serious purposes. For one, they can act as an intensity multiplier. The larger the coverage of a light, the higher its intensity is weighted against the others. And second, it is used as the radius for a spinning light setup.

Ye good old spinning light trick

LightBitch can serve several kinds of rigs, but the most sophisticated one is the spinning light rig.

It works like this: Each light is parented to a null object that spins two rounds per frame. So

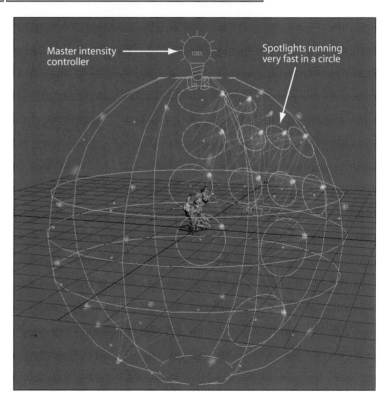

the lights run in circles, very fast. When you're rendering with a time-sliced motion blur, that smears the light along that circle. It basically multiplies the lights, depending on how many subframe passes are calculated. For example, a five-pass motion blur makes these 32 lights appear as if there were 160 of them there.

The rendered image looks virtually identical to the radiosity render from section 7.3.4, but it took only half the render time. And that was already a Smart IBL setup with optimized

Figure 7-96:
Spinning light rig generated by LightBitch.

Figure 7-97:
Mica the troll presents his new hat. Rendered in half the time with a Light-Bitch rig.

sampling rate. The speed gain compared to brute force radiosity is even higher.

Let's see how light domes compare in a slightly more scientific test scene. Back to the plain gray dragon scan! Initially, the rig was generated with 64 lights, and 40 of them remained after deleting everything below the ground plane. All images were rendered with nine motion blur passes.

So spinning these lights makes a huge difference. It doesn't cost us anything because most scenes are rendered with motion blur anyway.

And the second noticeable point is that shadow mapping is twice as fast while softening the blending areas.

It might not look precisely like radiosity, but it's a pretty good estimate. In any case, it renders much faster and is totally noise resistant. But these are not the only reasons light domes will never fully go out of fashion.

What else is cool about light domes?

- ❯ You're not locked into the HDR image. Light colors and intensities are fully adjustable and can be quickly changed for creative purposes.
- ❯ Advanced lighting effects like subsurface scattering and caustics get a particular speed boost compared to radiosity-based IBL.
- ❯ Hair, volumetric smoke, and other plug-in-based render effects are much easier to light with regular light sources. And they render much faster as well.
- ❯ Ambient occlusion is a good companion to a light dome rig because it eliminates the shadow-blending artifacts. In such a scenario, you'd use the light rig only to *add*

Figure 7-98:
The rig of spinning shadow-mapped spotlights is proven to work best.

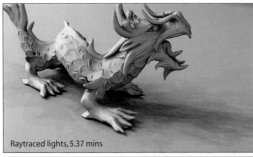
Raytraced lights, 5.37 mins

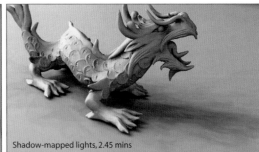
Shadow-mapped lights, 2.45 mins

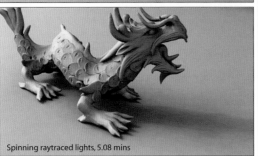
Spinning raytraced lights, 5.08 mins

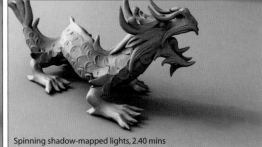
Spinning shadow-mapped lights, 2.40 mins

Figure 7-99:
Volumetric smoke,
rendered with
FumeFX and lit by
nine spotlights that
LightBitch extracted
from an on-set
HDRI.

ambient light and ambient occlusion to take it out again. Both techniques combine their strengths and cancel out each other's weaknesses.

❥ You can change the positioning of the lights and give your light probe a proper three-dimensionality. Objects moving closer to one of the lights will also be more affected by it.

❥ When you extract the light sources from multiple light probes taken throughout the location, you can quickly re-create the spatial lighting distribution in a larger set.

And of course, you'll find my fine LightBitch plug-in on the DVD for free. Why? Because I like you. Other mortals can download it from www.hdrlabs.com/lightbitch, but only you can unlock the full version with a password from this book.

Artist-driven light rigs everywhere

The semiautomatic approach to light rig creation is rather common because it empowers an artist to control the lighting instead of making him a slave of the HDR light probe. Every large visual effects company has at least one custom script for creating light domes (just as Light-

Bitch used to be an in-house tool at Eden FX), and there are countless scripts floating around the Internet for every software package.

For XSI and Maya there is BA_LightDome, an external program with a pretty sophisticated interface for controlling the light extraction process. Although it always starts out with an even distribution of lights, BA_LightDome includes many tools to drill down lights by

Figure 7-100:
BA_LightDome is
another free util-
ity for manually
extracting light
sources from an
HDR image.

Figure 7-101:
Dome light in modo. Rendered in the viewport preview without global illumination.

threshold luminance, color, and contribution to the lighting itself. In a guided workflow, you can incrementally optimize the lighting solution and then export a custom light setup script to be run in Maya or XSI. Oh, and it's freeware. So go get it!

→ www.binaryalchemy.de

Cinema 4D users rave about Lumen, a plug-in by Biomekk. At its core, Lumen is a utility for massive cloning operations, but it can also be used to replicate lights. Light domes created with Lumen stay connected to the HDR image, so when you move a light source, it will automatically update the sampled color from the image. Best of all, Lumen is fully Smart IBL compatible; it can build a light rig directly from a sIBL preset. It's compatible with all Cinema 4D versions and costs $39.

→ www.biomekk.com

Dome Lights

All the plug-ins mentioned create a dome of individual lights. That's great for creative tinkering, but if you really want to take advantage of importance sampling methods, you often end up with more than a hundred lights in your scene. And then it becomes tedious to manage all these lights.

That's where dome lights come in. This is a special light type supported by most recent renderers. It picks up the basic idea of extracting a light dome from an HDR image but flips

the idea around by encapsulating the entire rig in a single entity again. So instead of hundreds of lights, you have only one big light item that spans like a dome over the entire scene. It still acts the same way, shining light from the outside in, and when you set the amount of samples, that represents the number of imaginary spotlights extracted.

Dome lights are incredibly handy. They render with or without global illumination, they are easy to configure, and they render fairly quickly. In V-Ray the dome light is even the recommended way to set up image-based lighting; that's why it's fully supported in the Smart IBL setup assistant.

7.5.2 HDR Cookies

Here comes another secret technique that uses HDRI without radiosity!

It's about capturing the light characteristics of a real lamp and applying them to a 3D spotlight. That way we get more realistic light behavior, even with traditional rendering techniques. And this is how it works.

Grabbing a light

First we have to capture a real light and turn it into an HDR image.

No lab necessary here. All it takes is a large translucent canvas. This can be a professional backdrop screen on T stands from a photo supply store or just a bed sheet stretched across

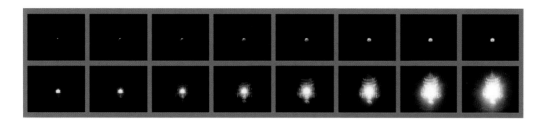

Figure 7-102:
Exposure sequence of my bike headlight.

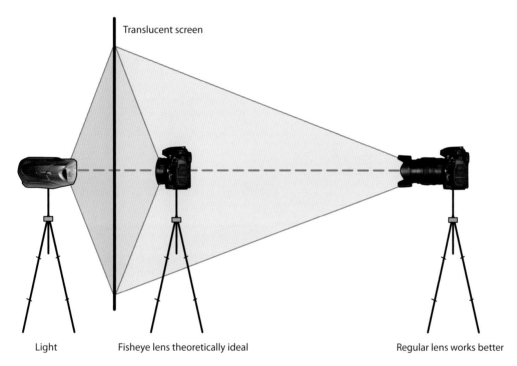

Translucent screen

Light Fisheye lens theoretically ideal Regular lens works better

Figure 7-103:
The shooting setup is easy to replicate.

a door frame. Put a lamp behind and aim it straight at the screen. It should be close enough to picture the entire cone angle on the canvas. Depending on the type of light, this distance is somewhere between 2 and 7 inches. Then, just place your camera on the other side of the screen, dim all other lights, and shoot an HDR image.

The idea is to shoot with the same optical view as the lamp itself. Ideally you'd set up a fisheye lens at the same distance but on the opposite side. However, chances are that 2 inches from the canvas is getting you into trouble with focus and lens flares. So you'd better shoot with a regular lens from farther away.

In the end it doesn't matter what lens you use because you can easily get the fisheye distortion in with Hugin (figures 7-104 and 7-105). Very very easily, actually.

Essentially, it's the opposite of de-fishing for stitching purposes. We just set the lens parameter to Normal and the output projection to Fisheye. Both get assigned the same field of view, somewhere between 120 and 140. Just play with it a bit and you'll see that higher numbers bulge the image more and keeping them both the same will make sure we keep the crop. A little eyeballing is certainly appropriate here. Hitting the Stitch button will now save a new EXR file that contains the same angular

Figure 7-104:
Hugin settings for adding the fisheye distortion.

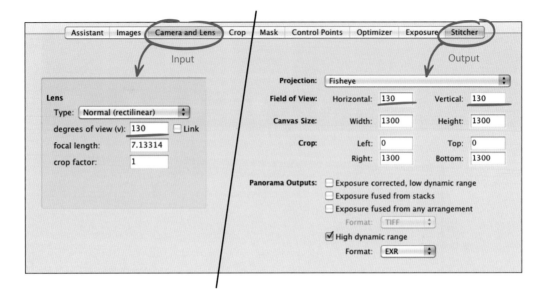

Figure 7-105:
The result is a perfect digital replica of the lamp's light output.

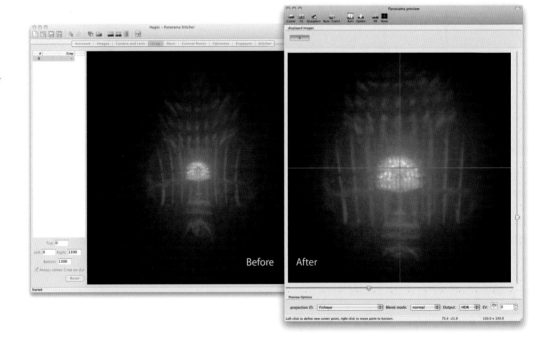

light distribution the real lamp has. Done. Now it just takes a little trip to Photoshop to blur out the linen structure of the bed sheet. Yeah, how very professional of me.

Pimp my light!

Now we're ready to roll. Let's put our cookie to the test.

In real-world stage lighting, a cookie is a little piece of cutout cardboard that is stuck in front of a light. The purpose is to cast some kind of fake shadow onto a movie set—like having the

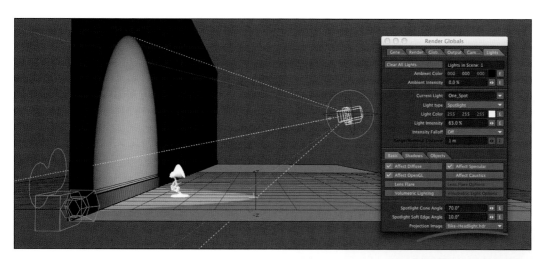

Figure 7-106:
The 3D scene is as simple as it can get.

shadow of a tree but without needing an actual tree. *Gobo* is another common term for this, but I like *cookie* better.

Our HDR cookie is a bit different from cut-out cardboard. It has color, so it acts more like a slide projection. But even more interestingly, it has extreme intensities. When we stick it on a 3D spotlight, it acts as an amplifier. All the image values between 0 and 1 (black point and white point on screen) take light away, modeling a natural light falloff. But beyond 1, it keeps going brighter, which is just awesome.

Let's have a look.

The test scene of the day is stripped down to the minimum: one floor, one wall, one intimidated celebrity lamp, and one single spotlight.

Initially, it doesn't look exciting at all, even though the supposedly magical linear workflow was used in this scene. There are no texture maps that I would have to worry about, so a simple post-gamma adjustment is all it takes to get the linear workflow going (as explained in section 7.3.1). The good news is that the scene rendered in 5 seconds.

Nothing gets touched except that the bike headlight cookie is applied to the spotlight as a projection map.

Now the image took 5.3 seconds, so it added 300 milliseconds of render time. That's nothing! We just made a huge leap in quality, basically

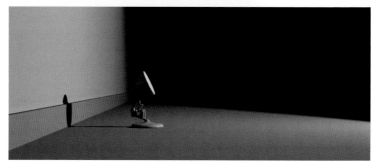

Figure 7-107: *Initial render with a standard spotlight. Lame.*

Figure 7-108: *Applied as a projection map, the bike headlight HDR cookie makes all the difference.*

for free. All of a sudden we have a fine mood in the image. And just by swapping the light cookie, we can flip the mood entirely.

Technically, that idea is not new at all. Architects and lighting designers for some time have rendered with IES light data sets, which contain accurate angular measurements of real light

Figure 7-109: *The USB worm lamp gives off cold and creepy fluorescent light.*

Figure 7-110: *My desk lamp floods the scene with warm incandescent light.*

sources taken under lab conditions by the light manufacturers themselves. Nowadays IES lights are supported in standard 3D apps as well. HDR cookies may not be as physically correct as IES lights, but for artistic purposes they are much more interesting. You can make a million variations out of each one just by changing colors, crops, and blurs, or even by painting stuff in. It's just an image, not some weirdo data set that you don't have access to.

All my HDR cookies are on the DVD, and I highly recommend experimenting with them. They work wonders for car headlights, street lamps, police searchlights, any spotlight in fact. Applied to a volumetric light, they can lend some really nice atmosphere to a scene, and in combination with global illumination, they provide wonderfully dense bounce light.

7.5.3 HDR Cards

Okay, so lighting with HDR images makes stuff look real.

But just because something looks real doesn't mean it's the perfect picture. There is a reason movie people carry truckloads of lighting equipment to film sets. They can be on the most beautiful location, with a scenic backdrop and wonderful natural light right around sunset. Still, cinematographers will always bring out bounce cards, diffusers, soft boxes, spotlights, and whatnot to design the foreground lighting the way they need it. Professional photographers do the same.

Reality is barely ever picturesque enough. In a professional production, there is always an element of purposefully designed lighting involved. Good lighting is what makes the difference between cheap reality TV and a cinematic experience. And so your HDR lighting may be a great starting point, but that shouldn't keep you from creatively tweaking it.

Light rigs and cookies are essentially serving exactly that purpose. At the most basic level, breaking out the sun into a separate key light is also a way to tame an HDR environment and gain creative control. But these techniques have their limits: They have no impact on reflections, and they can't do radical changes on the general character of a scene. For that, we have to go further. We need real geometry, textured with HDR images.

Breaking out light cards

One idea is to decompose an HDR panorama in 3D space to gain control over its individual elements. Most important elements are light sources, obviously. Things like windows, skylights, soft boxes, bounce cards, reflectors—anything that actively lights the scene is worth being broken out. There are many ways to achieve this, but the easiest solution is to do it right in your 3D application. The technique is somewhat related to the set reconstruction from section 7.4.3, but simplified.

Figure 7-111:
There is a reason movie people carry truckloads of lighting equipment around.

Figure 7-112:
Breaking out a light card is a simple modeling task. Shown here in modo. ▼

Start with a UV-mapped panorama sphere, and then use polygonal modeling tools to slice the polygons along the edges you see in the image. Basically, you're tracing the outlines of light sources with geometry. Handy tools for that are Edge Slice (modo), Add Edges (LightWave), Interactive Split (Maya), and similar polygon-cutting tools. Then you can just copy/paste the inner polygons into a new object—your new light card. It's now an independent object of its own that you can reposition and tweak according to your needs.

Once you have these light cards extracted, they become handy assets, ready to be recycled in an entirely different scene. However, the panoramic extraction method does have a few drawbacks: You're still loading the full HDR panorama every time you use that card—even though you only see the small part that was cut out. And that is only a comparably small, distorted patch.

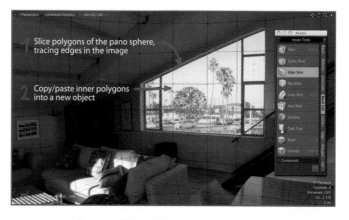

Slice polygons of the pano sphere, tracing edges in the image

Copy/paste inner polygons into a new object

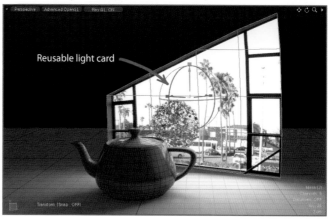

Reusable light card

Figure 7-113: *Once separated, the light card is an independent object of its own.*

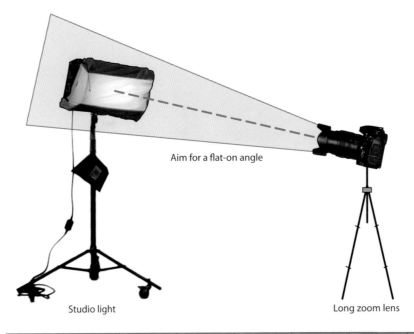

Figure 7-114:
Shooting a light source directly.

Aim for a flat-on angle

Studio light

Long zoom lens

Figure 7-115:
Two bracketing sequences of studio lights.

Figure 7-116: *Straighten and crop the HDR image in Photoshop, mask it, and save it as an OpenEXR with alpha channel.*

Capturing studio lights directly

If you're yearning for reusable HDR light cards, it's much more efficient to shoot the light source directly.

The shooting setup is similar to the one shown in the previous section, except that you're shooting straight into the light source instead of a translucent screen. So, it's much simpler. In fact, I'm hard-pressed to call it a setup at all—more of a reminder to grab a studio light when you get the opportunity! It helps when you can find a straight-on angle and zoom in until the light fills the frame.

After the bracketing sequence is merged to an HDR image, you need to refine it in Photoshop. Straighten and crop it, and eventually correct white balance (as shown in section 3.3). But most important, draw an alpha mask around the exact outline of the light. That way you can trace all the edge details much better than with

polygons, and it will result in a very organic contour. Note that Photoshop CS5 requires a plug-in to save that alpha channel in an EXR file (see section 2.7).

Playing your cards right

There are several ways to use these cards in 3D now.

One way is to use them as replacements for built-in light types. Then you rely solely on global illumination to pick up the extra-bright colors from the HDR image and distribute them as light across your scene. What you get is a very rich light quality full of natural nuances. Sounds esoteric, but it's the truth. When you can see the wrinkles in the corners of a bounce card, or the crinkly edges of torn-off diffuser foil, you can expect a lot of happy accidents during render time. It's this randomness of the real world that you're infusing into your scene. And

that works wonders against the sterile baseline of CG.

Note that this method requires high sampling rates. It really puts the capabilities of your render engine to the test. It's most useful for unbiased renderers like Maxwell, Octane, and LuxRender, where the clear distinction between lights and objects has been lifted. Regular (biased) render engines require the same material preparation as you would need for brute-force HDRI lighting: Glossy material properties should be represented by reflection or, better yet, an energy-conserving shader.

Setting up a scene with HDR light cards works best with an interactive preview renderer. That way you can very precisely design the appearance of reflections. For product shots, for example, you want the reflections to accentuate the shape of the model and follow the curvature of significant lines in the product design.

Figure 7-118:
Working with HDR cards in modo feels like a real-world photo shoot but with more creative freedom.

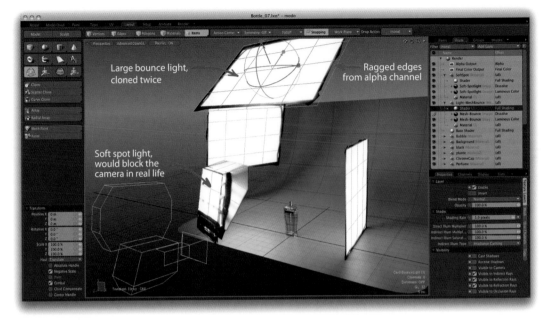

And that is achieved by putting an HDR light card with the right scale in just the right position, all while looking through the virtual viewfinder (that is, your preview renderer).

Back to reality

The funny part is that this style of lighting is extremely similar to the real-world studio lighting used by photographers. All of a sudden you realize what barn doors in front of a spotlight are for. They guide the light in the preferred direction, in the real world as well as in the GI simulation. Stacks upon stacks of books on photographic studio lighting now contain useful techniques that you can use.

You will, however, find that a quite a lot of the real-world tips and tricks are obsolete. Studio photographers can't simply clone a soft spot the way you can; they have to send a runner to buy a new one. Ha! With the virtual replicas you have total control over size, placement, color temperature, and light output. No wobbly C-stands, twirled-up power cords, or smoldering gel filters required.

Here comes the best part: You have complete freedom in placing these light cards. You can move them as close to the subject as you want. See, half the photography tricks are for keeping the lights out of the frame. But you can just flip a switch and make them invisible to the camera! How awesome is that?

More efficient are mixed-use cases, where you augment the HDR card with regular light sources (typically area lights). This way direct illumination provides clean and fast shading with a lot of customizability, while global illumination supplies subtlety and enhanced realism.

Universally useful

You will quickly see that this technique greatly extends the mileage you can get from your HDR panoramas. It's not limited to windows or hard-edged light sources; you can also card-ify a particularly beautiful sunset or some streaks of motion-blurred neon goodness. It's just a matter of painting the right alpha mask with a soft brush. You can also go beyond a simple rectangle and model the whole geometry of the light source. Do the prep work once, and benefit from it a million times later.

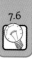

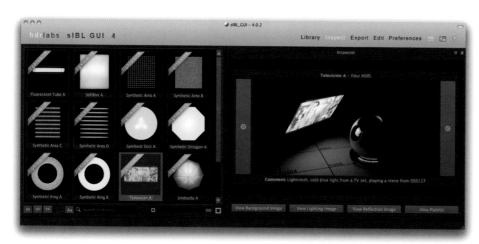

Figure 7-119:
Lightsmith is a
special preset cat-
egory in Smart IBL,
consisting of ready-
made HDR light
cards.

HDR cards turn out to be so useful that we included them in the open-source Smart IBL system. We call them *Lightsmith*. They share the same application-agnostic one-click setup, and yes indeed, we do include accurate geometry for each light, complete with a frame, barn doors, and size reference. You'll find a few of them on the DVD.

There are also several commercial librar-ies available. These are usually prepared for a particular 3D application, but conversion is a no-brainer. The real value is in the HDR images anyway.

- SLIK (Studio Lighting & Illumination Kit) for modo ⮕ www.luxology.com/store/SLIK/
- Greyscale Gorilla's HDRI Light Kit Pro for Cinema 4D ⮕ www.greyscalegorilla.com/lightkitpro/
- A&G Studio Light Rig for 3ds MAX (V-Ray/mental ray) ⮕ www.agtoolcompany.com
- HDR Light Studio Picture Lights (more about this a minute) ⮕ www.hdrlightstudio.com

7.6 Painting and Remixing HDRIs

There is also the opposite approach to creative lighting design. Instead of breaking an HDR panorama down in 3D space, you can incorpo-rate new lights directly in the HDR panorama. You sacrifice some interactive feedback of de-signing the lighting directly on your subject, but in return you get a few compelling advantages:

- Application in 3D is greatly simplified; just slap on the newly tweaked HDR pano.
- Designed lighting is 100 percent repeatable, increasing sequence consistency and poten-tial use as stock.
- Complexity of your lighting has virtually no impact on render time or scene complexity.

HDR Light Studio

Painting in the spherical domain of an HDR panorama is no easy feat in Photoshop. Pos-sible? Yes, absolutely. But easy? Not at all. The distortion of panoramic images is just too ex-treme to stay fully in control of the result (see section 6.1).

That's where HDR Light Studio comes in—a dedicated program for altering and tweak-ing HDR lighting environments. It gives you a spherical canvas, where you can create new lights and place them where you need them, all with the correct distortion employed. You can start out with background gradients or base your work on a previously shot HDR panorama.

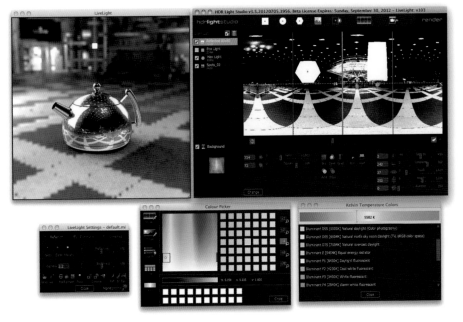

Figure 7-120:
HDR Light Studio is a sophisticated application for virtual lighting design and tweaking HDR environment maps.

You can create bounce cards with a hot center and a soft circular falloff, hexagonal light screens, flags to block light from a certain direction, or tint areas with virtual color gels. Or you can use the huge library of real photographic HDR cards that comes with the Pro version. Everything in this application is specifically geared toward lighting—the color picker alone is a work of art! You can sample light colors from any HDR image, fine-tune that pick with a chart of neighboring colors, even select from a list of common light temperatures given in kelvin. Brilliant!

Most important, HDR LightStudio brings back the interactivity that is traditionally lost with this painting approach. It comes with an integrated preview renderer called LiveLight that will accept your model in MI (mental ray) or standard OBJ format. You can even link LiveLight with your scene in Maya, 3ds Max, modo, or Cinema 4D. No guesswork required; you see your new HDR environment reflected on your own model, from the perspective of your scene camera, in real time. On top of that, HDR LightStudio also comes as a plug-in version that integrates directly into 3d applications. Currently, it's available for Maxwell, VRED, Patchwork3D, Deep Exploration, and more to come.

HDR Light Studio is dead easy to use; there is no need for a tutorial here. Just look at the screenshots and it should all become clear.

If all that sounds like a commercial plug, here comes the dampener: HDR LightStudio is damn expensive. There is practically no competition, so the price point is $625 for the standard and $940 for the pro edition (which is really the one you need). Too much, in my honest opinion. On the other hand, it does provide a serious productivity boost. All it takes is one good project for a high-profile client to justify a purchase like that. Check out the trial version yourself, and if that can convince you, make sure to pick up your 10 percent coupon on www.hdrlabs.com/tools. I put all my bargaining powers into this deal, and even though 10 percent doesn't sound like much, the actual savings amount is twice the cover price of this book.

↪ www.hdrlightstudio.com

In a nutshell

So that was the chapter on image-based lighting. As you've seen, HDR images can help tremendously in physically based as well as in traditional rendering methods. However, it is not quite the holy grail that the hype has been promising us. It's not all just plug and play. The sIBL team and I did our share to automate the tedious setup work, but real lighting design still requires a lot of creative tweaking and an artistic eye.

The key is not to take it all too literally. Don't be a slave to physical correctness. It only has to *look* real; it doesn't have to *be* real. HDRI is one of the paths leading that way, and it's a really good one, but it's not a template that you have to obey. If you know how to use and abuse HDR images to your advantage, it turns into a powerful tool that delivers more effect with less effort.

7.7 Chapter 7 Quiz

Ready for a last push? Then sharpen your pencil, put on your thinking cap, and meditate over these puzzle questions. If you score full points without peeking, I salute you with a bow and invite you to a round of beer. I really mean it; chances are you can teach me a thing or two then. With 15 points you're still entitled to celebrate with a beer from your own fridge, but below that mark you need to keep your head for reading Chapter 7 again.

1. Category of physically based renderers that do not take any algorithmic shortcuts or make predictions to speed up render times.

2. Render pass based on proximity between polygons, filling in tight corners and geometric creases.

3. Subtle effect of light blocked at the intersection where objects are touching each other.

4. Ideal position of the projection center for the background dome.

5. Automatic setup system for image-based lighting, based on preassembled presets and setup scripts.

6. Sampling method for distributing sampling rays (or lights) where they contribute most to the lighting.

7. Global illumination method based on dividing a scene into patches and iteratively refining received, absorbed, and scattered light.

8. Most useful render buffer, containing the Z distance of each pixel to the camera.

9. Special material type that is transparent in its native state and turns opaque only where a shadow hits it.

10. General practice of post-processing CG images by assembling render passes and merging them with live action.

11. Real-world physical effect causing specular highlights.

12. Special light type that encapsulates a dome of spotlights in a single light item.

13. Short for image-based lighting.

14. Proper working color space for rendering with mixed LDR and HDR image sources.

15. Excellent Monte Carlo renderer that has been around since 1999 but was never officially released to the public.

16. Unique program for editing, tweaking, and creating HDR environments from scratch.

17. Stage lighting accessory used to project a shadow into the set.

18. Spot in outdoor panoramas that is hardest to sample and therefore better represented as regular 3D light.

19. Render engine from the photon tracer family that is integrated in Maya, 3ds Max, and XSI.

20. Popular path tracer that grew out of architectural visualization and is highly optimized for render speed.

7.8 Spotlight: Paul Debevec

Paul Debevec is one of the founding fathers of HDR Imaging. Not that he invented HDR, but he's the one who tinkered with it first and figured out the practical applications. Many tools we use today are based on papers with his name on them, and he has led countless visionary projects that later turned into official techniques everybody's using today. Three papers he wrote from 1996 to 1998 at UC Berkeley—"Modeling and Rendering Architecture from Photographs," "Recovering High Dynamic Range Radiance Maps from Photographs," and "Rendering Synthetic Objects into Real Scenes"—have changed the face of computer graphics forever and are among the most cited papers in graphics research.

In 1999 he demonstrated the concept of image-based lighting to the rest of the world with his short movie *Fiat Lux*, playing dominoes with colossal monoliths in St. Peter's Basilica. All the big visual effects studios came to consult him, and he worked with them all to push the boundaries just a little bit farther every time. Whenever there is a blockbuster movie with breakthrough visual effects, you can bet Paul has been involved in one way or another—*The Matrix, Spider-Man, The Curious Case of Benjamin Button, Avatar, Tron Legacy,* you name it.

Paul now works as director of the Graphics Lab at USC's Institute for Creative Technologies (ICT), inventing more awesome stuff. Let's distract him just long enough to answer some

CB: You were merging bracketed exposures to HDR images before anyone else in computer graphics. If you think way back, what was the initial spark that led to this idea?

PD: In 1986 I was a photographer for my high school yearbook, shooting Tri-X film and developing it in the school's darkroom. For some fun, one night I shot long-exposure photos of small fireworks in the yard next to my house. When I looked at the negatives, I was impressed how each flying spark left a streak of fully exposed film, even though it passed by any location for a just tiny fraction of the exposure time. From this, I realized that a minuscule fraction of a spark's intensity could saturate the film and that there's a much greater range of brightness than what a camera could capture. This also showed me the nice effect of HDR motion blur, which is that even fast-moving lights produce saturated streaks across an image if they are sufficiently brighter than the saturation point of the film.

A long-exposure photograph of fireworks I shot

Motion-blurred example I created in 1994 of a fellow graduate student's dynamic simulation research, rendered as separate diffuse and specular passes to simulate multiple exposures and composited in floating-point HDR to achieve motion blur effects that exceeded the capabilities of 8-bit rendering techniques. The image was featured on the cover of the 1995 UC Berkeley engineering research summary.

CB: Ha, so a literal spark set you off! What did you do with it?

PD: I applied these ideas in 1994 at UC Berkeley, when fellow graduate student Brian Mirtich asked if I could help him render some interesting images of his dynamic simulation research: bowling pins being knocked over, coins colliding with each other, and dominoes falling. His work had been selected for the cover of the department's engineering research summary, but it was difficult to communicate in still images. I realized that simulating motion blur on his simulations would help, and I thought that producing some of the same bright streaks I had seen in my fireworks photos would make it compelling. So I asked Brian to render frames from his simulations separately for the diffuse and specular

components, which allowed me to multiply the specular component by a big number to create HDR highlights and then blend all the diffuse and specular images together to create the motion blur. Of course, I had to perform this multiplication and averaging with floating-point pixel values to preserve the highlights. The resulting images—even clipped in the end to low dynamic range—had the attractive bright streaks I was hoping for and appeared on the cover of the 1995 UC Berkeley engineering research summary.

Soon after, I began shooting real photographs with significantly bracketed exposures to better cover the dynamic range of light, and I shot the first spherical HDR map, or Light Probe, in the interior of the Rouen Cathedral in January 1996 while working on my SIGGRAPH 96 art installation, *Rouen Revisited,* with Golan Levin. I shot the motion-blurred image in Stanford Memorial Church in November 1996, which allowed me to show that that real motion blur could be matched accurately by blurring HDR images in my SIGGRAPH 97 paper with Jitendra Malik.

Real motion blur (left) shot in Stanford Memorial Church in November 1996, seen next to computationally simulated motion blur (right) from one of the earlier images taken with high dynamic range photography.

CB: You mentioned once that even in your movie *Fiat Lux* you ended up using additional light sources to get better specular highlights because the pure HDR reflections just didn't look right. What is your stance on technical accuracy versus creative tweaks like this?

PD: *Fiat Lux* was actually rendered as faithfully as possible with the real light in the Basilica where I shot the photographs. The area lights I added were radiometrically measured to be the same color and intensities of the bright pixel areas representing the spotlights in the vaulting and the light streaming through the windows. These 3D lights covered up the bright image spots, so the total light in the scene and the directions it came from stayed the same. The reason I replaced the lights was to make rendering efficient. Even though Greg Ward's RADIANCE had an early form of importance sampling, it couldn't sample small image-based light sources well and there were lots of sparkles. When the bright spots were replaced with area lights, the direct light was sampled smoothly and efficiently. VFX studios like Digital Domain perform this light source replacement process in their IBL pipelines all the time now.

With all that said, I think that HDR image-based lighting is best thought of as a good starting point for how to light one's scenes and characters. Before IBL, lighting artists would have to struggle simultaneously with making a shot look realistic while also making it artistically compelling. With IBL, lighters can begin with the "physically correct" answer at the push of a button and then sculpt the illumination to best serve shot and story. If this means moving the key, tinting the fill, or adding a rim, that's all great too!

CB: Did you ever imagine HDR imaging would become as popular as it is today?

PD: Like every researcher, I hope what I'm doing will impact how real practitioners accomplish their work. But when I first presented HDR and IBL, it was indeed beyond my hopes that they

would become the standard techniques they are now. Back then, people mostly used 8-bit per channel images without even performing gamma correction correctly, and global illumination techniques were looked upon as computationally expensive and artistically unnecessary. I think HDR/IBL's initial impact was to show people that there's an achievable physically correct answer to "How would that object appear in that scene?" and from there a number of forward-thinking practitioners like Sean Cunningham, Andy Lesniak, Mike Fink, Kim Libreri, and Eric Barba helped these techniques take root in visual effects production.

CB: Indeed, photo-realism has become very easy to achieve with your introduction of photogrammetry and image-based lighting. Thank you very much, by the way. Do you think photography and CGI are converging, and what would you envision this imaging technology of the future to be?
PD: Absolutely. I love how rays of real light are shining into the world of computer graphics, and the geometry and reflectance of real environments, objects, and people can now be digitized, recombined, and reimagined with breathtaking realism. In the end, it's all about emitting new rays of light back into the world of people's experience, so why not gather some from the real world to begin with? I'll know we've reached the future when a brilliant independent filmmaker, working with a small team of collaborators, can create a movie with the scope and beauty of *Avatar* on a hundredth of the budget.

CB: Or even less, considering all the new ways to capture those light rays photographically and apply all sorts of computations to them. When do you expect computational photography to hit the mainstream?
PD: Some computational photography techniques are already here: HDR imaging, tonemapping, image denoising (needed because camera manufacturers cram way too many pixels onto

image sensors), and face recognition can all be found on both consumer and professional cameras. Image deblurring techniques could see widespread use when they become more accurate and efficient. If my next smartphone had a 2D array of cameras on it, the applications for depth estimation, refocusing, denoising, and depth of field simulation would be amazing.

CB: You also built this utterly impressive device called a light stage. What's this about and how could I build one in my garage?
PD: Light stages light a person (or object) from the full sphere of incident illumination directions in a short period of time, which lets us create a digital model that reflects light in the same way as the original subject. The first light stage at UC Berkeley was a single spotlight on a wooden gantry pulled by ropes—not hard to build but it took 60 seconds to capture a face. Light Stage 2 built at USC ICT used a spinning semicircular arm of strobe lights to capture subjects in just 8 seconds and helped Sony Imageworks create photo-real digital stunt doubles of Alfred Molina (Doc Ock) for *Spider-Man 2* and Brandon Routh (Superman) for *Superman Returns*. Since Light Stage 5, and now with Light Stage X, we have a

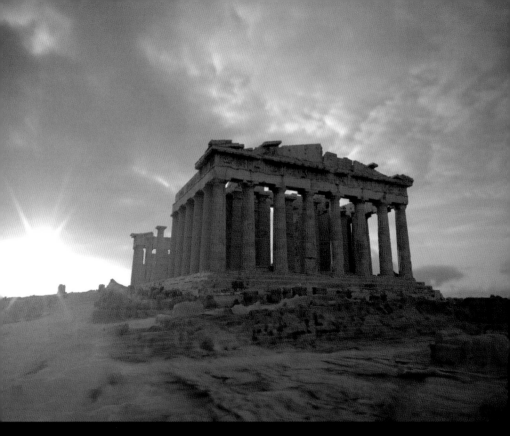

full sphere of lights that can capture people's geometry and reflectance in a fraction of second, as a real-time performance if need be. To do this, we often make use of polarized light and spherical harmonic-based lighting conditions.

CB: What's your top advice to all the CG artists out there?

PD: Have an awesome reel. Be a great collaborator but also create at least a few things all on your own. If you've ever thought about it, make your own CG animated short film and submit it to the SIGGRAPH Computer Animation Festival, where it could get seen by thousands of your peers.

CB: That's the best advice ever. Thank you so much for this interview.

Paul keeps heading the ICT Graphics Lab and occasionally teaches classes on computational

photography at USC; that is, when he's not traveling around the world to deliver keynote speeches and special courses at graphics conferences. He's a real showmaster; don't miss his presentation when he comes to your town Meanwhile, you can find out more about Paul's groundbreaking inventions on www. pauldebevec.com.

Appendix

This book was always meant as reference guide.

There's a lot of information in it, but it's rolled out in such detailed explanations that it gets hard to quickly look something up when you need help with an immediate problem. The tools in this appendix deliver exactly that: Find stuff fast, exactly when you need it.

8.1 Glossary

AEB (auto exposure bracketing): Shooting mode for automatically capturing multiple frames with varying exposure in rapid progression. Important camera-specific characteristics are number of burst frames, maximum EV interval, and speed (frames per second). ▶ 3.2.2.

alignment: Necessary for merging HDR images from photographs shot handheld to ensure pixel-perfect registration of the individual exposures. ▶ 3.2.6.

beamsplitter: Camera rig containing a semi-transparent mirror for capturing two images at once, used for either stereoscopic 3D or HDR video. ▶ 3.1.9.

bracketing: Taking multiple photographs in a row while varying one shooting parameter for each shot. In the case of HDR imaging, we are using exposure bracketing and varying shutter speed. ▶ 3.2.1.

burst mode: Shooting mode commonly linked to AEB to increase shooting speed. The camera gathers all exposures in an internal memory buffer and saves them to the storage card when the sequence is completed. ▶ 3.2.2.

camera response curve: Reverse-engineered graph that describes the color transformation between linear scene luminance values and the pixel values that a camera saved in a JPEG file. Calibrating the camera response curve can improve the quality of HDR images. ▶ 3.2.3.

CG (computer graphics): General term used for visual effects, 3D renders, and other images created on a computer. *CG* can also stand for *computer-generated* when used in conjunction with a particular element (for example, CG spaceship or CG render). ▶ 7.1.

comp: Short for *composition* or *composite*, which means an image (or video sequence) consisting of multiple layers. ▶ 7.3.2.

control point: Software marker that identifies matching features in different images, providing a guide for alignment algorithms. The images can be the exposures of a bracketing sequence or adjacent sectors of a panorama. ▶ 6.4.7.

CR (contrast ratio): Traditional way of measuring dynamic range with plain ratio numbers like 1000:1. It corresponds to a linear increase of light, which is physically correct but does not match our logarithmic perception of light. Paired with the inaccuracies in determining the smallest noticeable step, this number is easy manipulated and slightly misleading. ▶ 1.1.

dcraw: Universal decoder for RAW files, used internally by many applications. Named after the author Dave Coffin. ▶ 2.1.1.

DeepColor: Color mode introduced in the HDMI 1.3 standard, enabling transmission and display of 10 to 16 bits per channel with a wide color gamut. Support for DeepColor-enabled imaging sources is still sparse, sadly. ▶ 1.6.

density (of film): Photographic measure of the opacity of film material that has changed its state from transparent to opaque due to exposure to light. Full density looks dark on the negative and turns out white on the developed photo. ▶ 1.3.

DSLR (digital single-lens reflex): Camera with an internal mirror mechanism that allows the viewfinder to see through the lens. When capturing an image, the mirror swings out of the way to expose the sensor to the incoming light, blocking the viewfinder for the duration of the exposure. ▶ 3.2.1.

DIY (do-it-yourself): The general mentality behind creating open-source software and hardware that empowers users to do things with their camera that the manufacturer never thought of. ▶ 3.2.2.

dome light: Special light type that is available in many 3D render engines and encapsulates a dome of virtual spotlights in a single item. Dome lights are convenient to handle and allow image-based lighting without global illumination. ▶ 7.5.1.

EV (exposure value): Measurement of the amount of light that hits the sensor. The number of exposure values contained in an image is the photographic unit for measuring the dynamic range within. ▶ 1.1.

floating point: Numerical representation of data using fractional values, where infinitesimal differences between values can be properly preserved. HDR imaging is enabled by describing color values with floating-point numbers. ▶ 1.5.

f-stop: Technically the name for aperture settings, but commonly used to refer to exposure values in general. Often casually referred to as a *stop*. ▶ 1.1.

FOV (field of view): The angular coverage of a scene with a given sensor/lens combination, measured in degrees. ▶ 6.1.1.

gamma: Power law function that is traditionally applied to all pixel values in LDR images with the effect of brightening up the midtones by a large amount. Unless stated otherwise in a color profile, LDR images have a gamma value of 2.2 applied. ▶ 1.4.

ghosting: Semitransparent appearance of objects that move during an exposure sequence. ▶ 3.2.7.

GI (global illumination): Physically based rendering method that aims to create realistic CG images by simulating the behavior of light more accurately. Specifically, the effects of indirect light, bounce light, and color bleeding are calculated by GI. ▶ 7.1.2.

gigapixel: One-thousand megapixels. Images with such high resolution form a league of their own, with new challenges and unique opportunities. ▶ 6.4.10.

global TMO: Class of tonemapping operators that treat the entire image equally. ▶ 4.1.1.

halo: Bright glow around dark objects, common artifact of local TMOs. ▶ 4.3.3.

HDR (high dynamic range): Term that describes methods to capture, process, and store images with pixel values in linear proportion to scene

luminance. Thanks to a 32-bit floating-point notation, there is no upper boundary to pixel values, and there is no fixed step size between them. In popular terminology, *HDR* is also used to describe a post-processed look that is generated via tonemapping. ▶ Intro

HDRI (high dynamic range imaging): Generic overall term for HDR technology. Also used as abbreviation for high dynamic range image, describing an image file with 32-bit floating-point values. ▶ Intro

IBL (image-based lighting): Rendering method that uses HDR images (most commonly panoramas) as light source for 3D objects. ▶ 7.1.3.

importance sampling: Method for more efficient rendering by distributing sampling rays (or lights) in exactly those areas that contribute most to the lighting. ▶ 7.5.1.

latitude: Term used to describe how many f-stops of dynamic range a particular film stock can capture. Depending on the context, latitude can also be the geographic north-south position or the vertical coordinate in a spherical panorama. ▶ 1.3/6.1.2.

LDR (low dynamic range): Term that describes traditional 8-bit images that have fixed white and black points and a finite number of steps in between. ▶ 1.4.

linear workflow: General practice of consolidating and editing all image data in a linear 32-bit color space. The linear workflow is used to increase the quality of CG renders, preserve every rendered pixel value accurately, and provide more flexibility in compositing. ▶ 7.3.1.

local neighborhood: A coherent area of pixels that share a similar brightness. ▶ 4.1.2.

local TMO: Class of tonemapping operators that adapt to the image content and treat each pixel in dependency on its local neighborhood. ▶ 4.1.2.

nodal point: Optical pivot of the camera/lens system, also called no-parallax point. ▶ 6.4.3.

OpenEXR: Standard HDR file format with superior color accuracy and lossless compression. Established by Industrial Light & Magic (ILM) for the VFX industry, but now the recommended standard for photography as well. ▶ 2.1.7.

photogrammetry: Reconstruction of a real-life location in a 3D graphics program using photographs mapped on simple scene geometry. Often the geometry is also derived from the photographs. ▶ 6.7.4./7.4.3.

Radiance: Standard HDR image file format with the .hdr filename extension. Originally introduced by Greg Ward for a physically based 3D render engine with the same name. ▶ 2.1.5.

real-time rendering: Computer software updating at interactive rates (24 frames per second or higher), providing sufficient feedback for creative tinkering. Render engines that have to perform more expensive computations often return a real-time preview in lower quality, which is entirely acceptable. ▶ 4.2.1.

TMO (tonemapping operator): Generic term for algorithms that can be used to compress high dynamic range to low dynamic range. ▶ 4.1.

tonemapping: The technical process of compressing the pixel values from an HDR image down to LDR while preserving the visual appearance as much as possible. ▶ 4.1.

tonemapper: Casual term for TMO, or software capable of tonemapping operations. Not typi-

cally used to describe a person who performs tonemapping. ▶ 4.1.

tone reversal: Common tonemapping artifact, manifested as large image regions swapping their relative brightness ratio. ▶ 4.3.3.

toning: The creative workflow of creating an LDR image from an HDR image while enhancing the appearance according to artistic intentions and making extended use of the rich information contained in the HDR image. Typically this process includes the use of tonemapping operators but is not limited to it. ▶ 4.2.

shadow catcher: Special material type that is used for CG renderings. It is transparent in its native state and only turns opaque where a shadow hits it. ▶ 7.3.3.

SNR (signal-to-noise ratio): Technical sensor specification that describes the smallest readable value that can be distinguished from noise. The SNR value is critical to determine the dynamic range an imaging sensor can capture. ▶ 3.1.1.

UrbEx (urban exploration): Fun photography branch focused on subjects like abandoned buildings and forgotten places. ▶ 4.4.3.

VFX (visual effects): Digital enhancement and alteration of filmed footage of a movie. A very common visual effect is the creation and seamless integration of CG elements, and that is where image-based lighting comes in. ▶ 7.2.

VR (virtual reality): A term that was overhyped in the nineties until nobody believed in it anymore. For a long time VR was solely used to describe immersive presentations of panoramic imagery. Nowadays VR is revived by mixed media techniques that include photography, photogrammetry, CG reconstruction, reprojection, and real-time rendering. ▶ 6.7.4.

weighting function: Curve describing the reliability of pixel values in the source images based on their luminance. ▶ 3.2.5.

8.2 Cheat Slips and Useful Charts

Here is a collection of useful reference charts and quick workflow descriptions. The cheat slips are short notations of workflow techniques explained in detailed tutorials. Please refer to the section number given in the cheat slip title if you need a refresher.

Figure 8-1:
Unit conversion:
Dynamic range measured as contrast ratio and EV span. ▶ *1.1.*

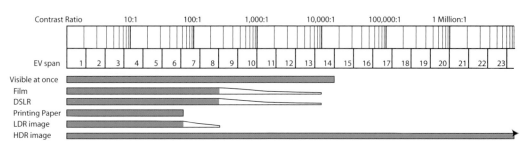

Figure 8-2:
Double-burst technique: *Extending AEB range without external accessories.* ▶ *3.2.2.*

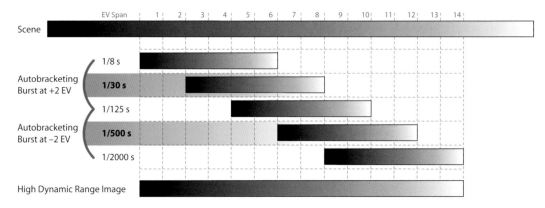

Figure 8-3:
Workflow overview: *Every processing step has an optimum place in the imaging pipeline, where image quality is preserved best and creative flexibility is maximized.* ▶ *3.3.*

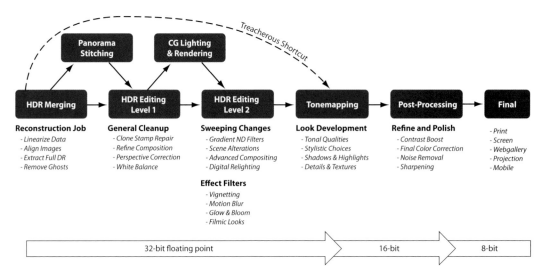

Cheat Slip | 3.2.4.
Flat RAW conversion in Lightroom 3
(or generic RAW converter)

- Pick a good representative exposure, ideally one with a gray card or color checker.
- Set Black, Brightness, and Contrast to 0.
- Set Tone Curve to Linear.
- If necessary, adjust Black value to clip out noise.
- Set the white balance.
- Use low sharpening and as much noise reduction as necessary.
- Enable Lens Correction by Profile.
- Decide if you really need to correct geometric distortion and vignetting.
- If necessary, fine-tune chromatic aberration by hand.
- Defringe all edges (on the Manual tab).
- Sync all settings to all other images.
- If necessary, use Recovery on the most underexposed image.
- Export 16-bit TIFFs to a temp folder or launch your favorite HDR plug-in.

CHEAT SLIP | 3.2.4.
Flat RAW conversion in Lightroom 4

- Select the best (middle) exposure.
- Set Exposure to −1 EV and Contrast to −40.
- Set the white balance.
- Use low sharpening and as much noise reduction as necessary.
- Enable Lens Correction by Profile only if you really need to correct geometric distortion or vignetting.
- Remove Chromatic Aberration should always be enabled.
- Sync all settings to all other images.
- Export 16-bit TIFFs or launch your favorite HDR plug-in.

CHEAT SLIP | 4.4.1
Tonemapping with Photomatix

- Load an HDR file and press the Tone Mapping button.
- Increase the preview size and start with the Default preset.
- Set Lighting Adjustments and Detail Contrast to sketch out the intended style.
- Set Strength and Luminosity to balance out a nice separation of the tonal zones.
- Set White Point and Black point to minimize clipping.
- Balance detail enhancement versus noise exaggeration with Micro-smoothing.
- If necessary, smooth out noise and halo artifacts in the sky with Smooth Highlights.
- For night shots use Shadows Smoothness instead.
- Process and save as 16-bit TIFF.

CHEAT SLIP | 4.4.1.
Fundamental toning workflow

- Tonemap an EXR with focus on highlight and shadow detail recovery.
- Save out a temporary 16-bit TIFF that looks slightly flat and has low contrast.
- Load the TIFF in Photoshop.
- Boost contrast with a Curves adjustment layer, with the blending mode set to Luminosity.
- Optional: Select noisy areas and reduce noise with Surface Blur.
- Use the zone gradient overlay for sanity check.
- Fine-tune tonal distribution with a Curves layer.
- Fine-tune colors with a Hue/Saturation layer.
- Apply the Smart Sharpen filter and limit the effect to Luminosity via EDIT ▸ FADE.
- Save the master PSD.
- Flatten layers, convert to 8-bit sRGB.
- Save final JPEG.

CHEAT SLIP | 4.4.4.
Double-dipping technique

- Tonemap one version with a global TMO, optimizing the overall distribution of light and shadow.
- Tonemap a second version with a local TMO, using aggressive detail boosts. Dare to go over the top.
- Make sure neither of these versions have clipped highlights or shadows.
- Stack up both versions as layers in Photoshop, the local one on top with 20 to 30 percent opacity.
- Optional: If there are visible artifacts in the local version, select the affected areas and create a layer mask.
- Duplicate the top layer and set the copy's blending mode to Overlay.
- Optional: If the color vibrance boost is unwelcome, desaturate the new detail layer.
- Fine-tune tones with a Curves layer and colors with a Hue/Saturation layer.
- Fine-tune the detail ratio by changing image layer opacities.
- Save the master PSD.

CHEAT SLIP | 6.4.7.
Direct HDR Stitching with PTGui

- Load all original exposure brackets.
- Rotate them to be upright.
- Run automatic image alignment. When asked, enable HDR mode with linked brackets and True HDR method.
- Sort the control point list by distance and delete the worst of these buggers.
- Define some vertical control points, ideally three to six in different sectors.
- Optimize (F5).
- Inspect the pano in the Panorama Editor.
- If necessary, pin down mismatching areas with manual control points.
- Optimize again.
- Set output size to 70 percent of the recommended maximum.
- Choose HDR panorama in OpenEXR format as final output.
- Send to Batch Stitcher.

HDR Brackets	×	Panorama Sectors
Min exposure		
Max exposure		
Stepping		
Aperture		
ND filter		Check each when done

Figure 8-4: Work sheet for HDR panoramas: *Make photocopies of this template and fill them in when you set up a shoot.* ▶ 6.4.5.

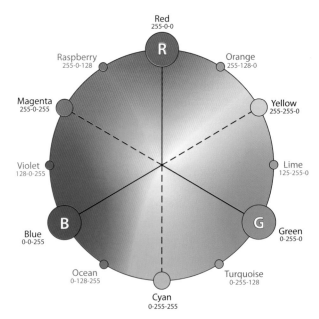

Figure 8-5: RGB color wheel: *Essential work tool for digital color correction.* ▶ 5.1.4.

Cheat Slip | 7.4.3.
Manual 3D set reconstruction from a panorama

- ◉ Make sure the panorama is perfectly leveled and oriented straight.
- ◉ Create a background cylinder/dome with concentric rings on top and bottom.
- ◉ Flip the polygon normals.
- ◉ Apply the panorama as a spherical texture, projected from the same height it was originally shot from.
- ◉ Scale the outer polygons up to set the distant boundaries of the location.
- ◉ Model all vertical structures, using the top view as a floor plan.
- ◉ Create a UV map with the same spherical projection parameters.
- ◉ Separate foreground and background material, each with its own copy of the image.
- ◉ Patch the occluded areas in the background image. Use the clone stamp in 3D or content-aware fill in Photoshop.
- ◉ Solve occlusions within the foreground by editing the foreground image and UVs.

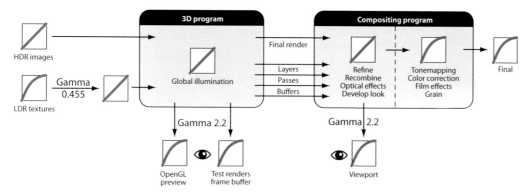

Figure 8-6: *Linear workflow: Fundamental color management rules in a professional CGI pipeline.* ▶ 7.3.1.

8.3 Recommended Literature

High Dynamic Range Imaging: Acquisition, Display and Image-Based Lighting
Erik Reinhard, Greg Ward, Sumanta Pattanaik, Paul Debevec, Wolfgang Heidrich, Karol Myszkowski (Morgan Kaufmann, 2010)

The original HDR bible, written by the founding fathers of HDR Imaging. This book holds a wealth of detailed information, although it's not easy to digest for the uninitiated. There are plenty of formulas, equations, and algorithm code. The text itself is written in a precise and rather academic style. Basically, it's a collection of all the fundamental papers that made HDR technology possible. Required reading for programmers, researchers, and engineers who need precise information for building their own HDR technology.

↪ www.hdrbook.com | ISBN: 978-0-123749-14-7

Advanced High Dynamic Range Imaging: Theory and Practice
Francesco Banterle, Alessandro Artusi, Kurt Debattista, Alan Chalmers (A K Peters/ CRC Press, 2011)

This book is written by the second wave of HDR researchers. It includes all the latest algorithms to solve practical problems that have become apparent after 10 years of HDR imaging: new-school tonemapping operators, extending the range of LDR content, error metric, HDR video compression, all the way to exotic subjects like HDR Hallucination and psychophysical experiments. The book is filled with practical code examples in student-friendly MATLAB syntax. Recommended for all developers and inventors.

↪ www.advancedhdrbook.com | ISBN: 978-1-568817-19-4

Color Imaging: Fundamentals and Applications
Erik Reinhard, Erum Arif Khan, Ahmet Oğuz Akyüz, Garret M. Johnson (A K Peters, 2008)

This book doesn't recognize HDR as the pinnacle but as the foundation of all color imaging. It finally breaks with the traditional approaches where all theory behind digital imaging revolves around the arbitrary limitations of 8-bit. Instead, this comprehensive reference guide describes a new foundation for color imaging, grounded in the physics of light and our perception thereof. Highly recommended for students and image engineers, but also useful for advanced photographers and professional CG artists.

↪ www.cs.bris.ac.uk/~reinhard/color_imaging | ISBN: 978-1-568813-44-8

Virtual Reality Photography: Creating Panoramic and Object Images
Scott Highton (2010)

As one of the pioneers in the field of panoramic photography, Scott Highton has an immense wealth of knowledge to share. He talks about photographic practice, shooting techniques,

panoramic composition, stitching, and virtual tours, and he also does not neglect the business side of the craft. You will learn about planning a shoot properly, marketing yourself, estimating a price, and negotiating with clients. This book is recommended for panographers who want to take their passion to a professional level.

↪ www.vrphotography.com |
ISBN: 978-0-615342-23-8

The Photograph: Composition and Color Design, 2nd Edition
Harald Mante (Rocky Nook, 2012)

If your main interest lies in sharpening your creative eye, Harald Mante's book is the one for you. He explores very thoroughly the rules of composition, shape, color, contrast, harmony, tension, and design. It's a very nontechnical book. Everything is explained from a conceptual bird's-eye view and demonstrated in exemplary photographs that are guaranteed to inspire you. Although written for photographers, this book is also a treasure chest for CG artists, cinematographers, and all visual designers.

↪ www.harald-mante.de |
ISBN: 978-1-937538-06-4

8.4 Last page

What a ride.

When I started this project, my friends asked me, "A whole book on HDR? More like a brochure, right? What in the world could you write in an entire book on that?" And now we're on page 600-something and I still have the odd feeling that some topics came up short.

We did indeed cover a lot of ground: from shooting tips to tonemapping tutorials, from getting your head twisted with all the technical background knowledge to lighting a CG troll with just the flip of a switch. True, many of the techniques described here are not scientifically correct, but they are working hacks that get the job done.

Keep this book on your desk. There is no way that you will remember everything. Even I have to look things up here every once in a while, and there is no shame in that.

My hope is that photographers and CG artists can equally benefit from this book. I would love to see these two communities get together, share ideas, and learn from each other. Both have some new toys now: Picturenaut and Smart IBL—two freeware tools that were born from community effort and that live now in a shared community.

The book ends here, but the saga continues on www.hdrlabs.com. This is the permanent home of our new tools, along with a community forum for all of you. Figure out new techniques and tell everyone! Show off your images and gather creative feedback! Of course, you can also talk about this book; I would love to hear your opinion. If you want to know what the heck I was thinking when I wrote a certain chapter, just come to the forum and ask.

I hope you had as much fun reading this book as I had writing it. And if you picked up something new on the way, even better.

See you at the forum.

Figure 8-7: *Visit www.hdrlabs.com for updates, additional downloads, and feedback.*

8.5 Thanks!

First, I would like to thank my interview partners Trey Ratcliff, Luke Kaven, Michael James, Anthony Gelot, Kirt Witte, Greg Downing, Eric Hanson, and Paul Debevec for their great contributions and exceptional eye candy. You made this book into something special, a truly comprehensive guide that deserves the title *Handbook*. Also, many thanks to Greg Ward for the great foreword and the invaluable technical advice, and for laying the groundwork for HDRI.

Thanks to the following people: My publisher, Gerhard Rossbach, for continuously believing in this project though I missed the deadline by about 17 months. All the fine folks at Rocky Nook and dpunkt for working so hard to make it happen. Petra Strauch for making this book really shine through such a polished layout. My boss, John Gross, for letting me off the leash and giving me the time to do this. My fellow artists at Eden FX for picking up my workload when I was gone and for teaching me everything I know: John Teska, Dave Morton, Sean Scott, Fred Pienkos, Eddie Robison, Steven Rogers, John Karner, Eric Hance, Casey Benn, Jim May, Chris Zapara, Pierre Drolet, Rob Bonchune, Stefan Bredereck, PJ Foley, Craig Edwards, Dan DeEntremont, Derek Serra, Jeff Kaplan—it is a pleasure and a privilege to work with such a top-gun team. The people from Lightcraft (Eliot Mack, Andrew Britton, Vincent Scalone, Kyle Murphey, Bobby Nishimura) and from the Universal Virtual Stage 1 (Ron Fischer and Rami Rank) for introducing me to the future of filmmaking and letting me partake in it. All the fine folks on the 3D-Pro list and PanoTools list for the fruitful discussions. Jamie Clark for the fabulous Mustang model. XYZ RGB for the dragon scan and the Stanford Computer Graphics Laboratory for making it publicly available. Bill Bailey for sending me a wonderful Nodal Ninja head.

I am especially thankful for hard technical advice in times of need from Jonas Unger, Erik Reinhard, Geraldine Joffre, Ahmet Oğuz Akyüz, Jay Burlage, Jack Howard, Igor Tryndin, Andreas Schömann, John Hable, Max Agostinelli, Stoney Winston, Roman Voska, Arty Kamshilin, Antoine Clappier, Brendan Bolles, Sebastian Nibisz, and the other researchers and developers I forgot to mention. Thanks to Marc Mehl for creating the Picturenaut application and making it available for free, Thomas Mansencal for taking the Smart IBL idea to the next level with his amazing sIBL_GUI application, Chris Huf for sIBL-Edit, and the entire Smart IBL team (Christian Bauer, Volker Heisterberg, Gwynne Reddick, Steve Pedler) for donating their time to the noble cause of making IBL easier. Thanks to all the contributors to HDRLabs: Francesco Banterle, Steve Chapman, Achim Berg, Bob Groothuis, Paschá Kuliev, Emil Polyak, Lee Perry-Smith, and the hundreds of forum members who continue to help newbies and make HDR-Labs into such a wonderful community portal. Thanks to Courtney Pearson, Audrey Campbell, and Peter Dobson from the Mann Theatres as well as the staff at the Grauman's Chinese for allowing me to shoot this great location and use it here. My thanks to USC as the photographs on pages 636, 638, and 639 were used with permission from University of Southern California Institute for Creative Technology. Finally, I thank Sven Dreesbach, Tore Schmidt, Alex Cherry, Jan Walter, Olcun Tan, and Sara Winkle for making living in this strange town bearable; Denis Thürer, Matze Gropp, Ronny Götter, Günni, and the rest of the gang for keeping it real and not letting me down; Mom and Dad for everything; and my lovely Maria for sticking with me during the sheer endless time it took me to write all this up.

Above all, I thank *you* for picking up this book.

8.6 Index

Get in the Picture!

c't Digital Photography gives you exclusive access to the techniques of the pros.

Keep on top of the latest trends and get your own regular dose of inside knowledge from our specialist authors. Every issue includes tips and tricks from experienced pro photographers as well as independent hardware and software tests. There are also regular high-end image processing and image management workshops to help you create your own perfect portfolio.

Each issue includes a free DVD with full and c't special version software, practical photo tools, eBooks, and comprehensive video tutorials.

Don't miss out – place your order now!

**Get your copy:
ct-digiphoto.com**

Do your images reflect your vision?

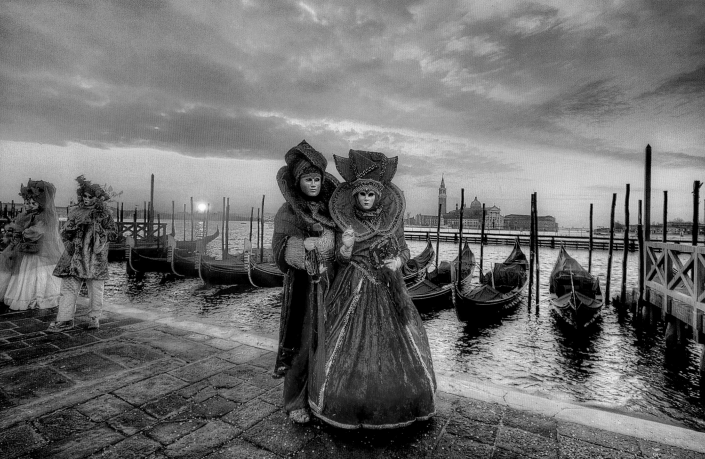

Now they can...with Photomatix!

Take bracketed photos of your scene and let Photomatix merge them into HDR. Photomatix Pro has all the tools you need for HDR processing, including ghost removal, alignment of hand-held shots, and various presets to get the look you want, from natural-looking to painterly, surreal or ultra-realistic effects. Additional features include powerful batch processing, selective deghosting tool, and a free Lightroom plugin.

Venice photo © Jacques Joffre / HDRsoft

Available for Windows and Mac OS X

www.hdrsoft.com